Manuscripts Guide to Collections
at the University of Illinois
at Urbana-Champaign

Manuscripts Guide to Collections at the University of Illinois at Urbana-Champaign

Maynard J. Brichford

Robert M. Sutton

Dennis F. Walle

UNIVERSITY OF ILLINOIS PRESS
Urbana Chicago London

Library of Congress Cataloging in Publication Data

Brichford, Maynard J
 Manuscripts guide to collections at the University of
Illinois at Urbana-Champaign.

 Includes index.
 1. Illinois. University at Urbana-Champaign — Archives.
2. Illinois — History — Sources — Bibliography. 3. Illinois
Historical Survey. 4. Illinois. University at
Urbana-Champaign. Library. Rare Book Room. I. Sutton,
Robert Mize, 1915- joint author. II. Walle, Dennis F.,
1938- joint author. III. Title.
CD3209.U728B74 016.9773 75-38797
ISBN 0-252-00599-6

INTRODUCTION

A guide to the manuscript collections at the University of Illinois at Urbana-Champaign fills a basic need of research scholars for a descriptive work on the University's manuscript resources. It brings together in one document a comprehensive inventory of all of the University's manuscript collections. While the University has had no coordinated program for the collection of manuscripts, the Illinois Historical Survey, University Archives and other offices have acquired many valuable collections. These acquisitions represent the interests of individual collectors in providing original source material for the use of scholars. Beginning in 1909, the Illinois Historical Survey collected originals and photocopies of documents pertaining to Illinois and the Old Northwest. The research interests of historians Clarence W. Alvord, Theodore C. Pease and Arthur E. Bestor, Jr. are reflected in the manuscripts in the Survey collections. The concern of Charles M. Thompson about the history of business enterprises is responsible for the University's business archives. The collecting instincts of Phineas L. Windsor enabled the Library to provide shelter for manuscript collections for many years. After World War II, the support of Robert B. Downs and Gordon Ray was responsible for the acquisition of the collections of Herbert G. Wells, Carl Sandburg and other literary figures. Since 1963, the University Archives has moved to collect the personal papers of faculty, administrative staff, trustees, students, alumni and academic organizations. In 1969, an awareness of the cumulative significance of the holdings of several manuscripts-collecting agencies led to the development of plans for this Guide.

The principal objectives have been clarity and uniformity in description, the promotion of research use and a concern for the proper description, care and housing of the collections. Terms used in the Guide conform to definitions in "A Basic Glossary for Archivists, Manuscript Curators and Records Managers" compiled by Frank B. Evans, Donald F. Harrison and Edwin A. Thompson in The American Archivist 37 (July 1974):415-433.

Minor differences in the form of entries and standards for coverage reflect long-established practices as well as the uses of the collections included. When the University is in session, the Illinois Historical Survey and the University Archives are open from 8 to 12 and 1 to 5 on week days and the Rare Book Room is open from 9 to 12, Monday through Saturday and 1 to 5 on week days. As schedules and hours are subject to frequent change, it is advisable to write or telephone in advance.

> Illinois Historical Survey
> Room 1A Library 217-333-1777
> Urbana, Illinois 61801
>
> Rare Book Room
> 346 Library 217-333-3777
> Urbana, Illinois 61801
>
> University Archives including Business Archives
> 19 Library 217-333-0798
> Urbana, Illinois 61801

I commend this work to the reader with my profound thanks to the staff and students who have collaborated in its production. Their enthusiastic cooperation in preparing the Guide is matched only by their willingness to assist scholars who will use these collections.

Maynard Brichford

CONTENTS

PART I
University Archives

Established in September, 1963, the University Archives is a research office concerned with higher education. Its chief concern is the documentation of the University's organizational responses to social needs and the intellectual contributions of individuals made possible through the interaction and facilities of the University. Its early history is described in "The Illiarch," an article in the February 1970 issue of Illinois Libraries. The Archives contains official records, publications and personal papers of faculty, students, alumni and staff. The subject content of most official records and published archival series is reflected by their provenance. The University Archives maintains a 468-page Classification Guide listing administrative units by record groups (colleges or major administrative units) and sub-groups (departments or secondary administrative units). The Classification Guide includes administrative histories, an alphabetical index and a statistical supplement. Researchers may also locate archival sources through chronological files of the Daily Illini, the Illio, annual press Reference Folders and clippings about the university from non-university sources. Subject access is provided through a general reference file and through cumulative and volume subject indexes to the Board of Trustees' Reports.

The basic finding aid in the University Archives is a Kardex visible filing system containing 5x8 control cards describing 2,995 record series. The control cards show record group, sub-group, series title, inclusive dates, volume, arrangement, acquisition date, shelf location and a narrative description of the series content in 21 lines or less. The description includes series title, a statement explaining the provenance of the series and a brief list of the types of documentation included and subjects covered. The dates of birth and death and the dates of academic appointments at professorial rank are included for personal papers. For persons attending the university, the class or dates of attendance are given. If the personal papers include correspondence, a brief list of significant correspondents may be added to the listing of subjects covered. The control cards also indicate if a supplementary finding aid has been prepared for the series and its length in pages. While the 3,712 pages of supplementary finding aids vary in form and length, they are usually subject lists taken from folder labels. Finding aids for correspondence files may be alphabetical name listings. Longer finding aids include subject and name indexes to box location, e.g. finding aids for the Roger Adams (91 pages), Arthur E. Bestor (57 pages) and Stewart S. Howe (100 pages) collections. Special finding aids provide subject control over 100,000 photographs, 3,500 sound recordings and the files of the President's Office. Another finding aid lists the archival holdings of the papers of 351 authors in the Modern Language Association's 1973 American Literary Manuscripts list. Researchers may obtain copies of specific finding aids or subject listings at cost.

The principal continuing finding aid for record series in the University Archives is an alphabetical list of 2,000 subjects showing the numbers of record series containing information relating to each subject. It is produced by a computer program from punched cards in the Archives' PARADIGM system. The program permits the periodic listing of subject codes that have been assigned to 809 record series.

The Archives section of the Manuscripts Guide includes personal papers of 268 faculty, 46 administrators, 42 students and 33 alumni and the records of 22 non-university organizations. These 411 record series are 14% of the total holdings of the Archives by number of collections and 27% by volume.

On June 30, 1975, the processed series in the Archives included

	Record Series	Volume
Official Records	663	4120.6
Personal Papers	506	1598.2
Publications	1826	730.1
Total	2995	6448.9

187 of these record series are listed in the Library of Congress' National Union Catalog of Manuscripts Collections. The last line of the series descriptions indicates the NUCMC number and the number of pages if there is a supplementary finding aid (SFA) in the University Archives. The archives of the American Library Association will be covered in a separate published guide.

The descriptions of archival records series have been prepared by many graduate student research assistants in the past ten years. The conversion of control card descriptions to Guide entries and typing the final copy has been the special responsibility of Evelyn Arvedson, Stephanie Addis, Janet Bertelsen, Catherine Catellani and Jeanne Duggan.

Maynard Brichford
University Archivist

ABRAMS, SAMUEL SCRAPBOOK, 1902-1906 .2 cu. ft.

Samuel Abrams Scrapbook, including materials from a correspondence course in advertising
taken by Mr. Abrams before attending Illinois in 1907-10. The materials include
promotional literature, correspondence, exercise sheets, samples of advertising and
related material issued by the Page-Davis Correspondence School of Advertising Writing in
Chicago. Some material relates to Abrams' violin school and other Chicago businesses.

RS 26/20/4

ADAMS, ROGER (1889-1971) PAPERS, 1812-1971 23.6 cu. ft.

Papers of Roger Adams (1889-1971), professor of chemistry (1916-57), and department head
(1926-54), including personal items relating to family, education and travel; photographs;
correspondence with family, foundation officials, businessmen, officials of professional
societies, scientists and former students; tape-recorded interviews on the chemistry
department and financial support of research and graduate work; speeches; reports;
manuscripts; reprints; books; correspondence and research on the chemistry of marihuana
(1938-41); documents about service in the Chemical Warfare Service (1917-18) and National
Defense Research Committee (1941-46), and as scientific advisor in Germany (1945-46) and
Japan (1947-48); programs of symposia and award ceremonies and newspaper clippings relating
to awards and activities. Three subject files (1949-71) contain correspondence, reports,
agendas, minutes, memoranda and newsletters relating to associations with the Battelle
Memorial Institute, Otto Haas Trust Fund, Robert Welch Foundation, Alfred Sloan Fund,
Sloan-Kettering Cancer Research Institute, International Sugar Research Foundation,
National Academy of Sciences - National Research Council, National Science Foundation,
American Academy of Arts and Sciences, American Association for the Advancement of Science,
American Philosophical Society, American Chemical Society, American Institute of Chemists,
The Chemurgic Council, International Union of Pure and Applied Chemistry, Illinois Board of
Natural Resources and Conservation, Abbott Laboratories, E. I. Du Pont Company, Coca Cola
Company, Organic Reactions, Organic Syntheses, Cosmos Club and dealing with elections,
appointment of personnel, research, awarding of grants and securities investments.
Correspondents include Wallace Carothers, James Conant, Ernest Volwiler, Robert Robinson
and Richard Willstätter.

RS 15/5/23 SFA - 91 NUCMC 72-157

ALLEN FAMILY PAPERS, 1774-91, 1804-05, 1819-28, 1833-1967 4.1 cu. ft.

Papers of the Ralph Allen Family of Delavan, Illinois, including Ralph Allen '76 (1854-
1927), Ada Eaton Allen (1858-1948), Edith L. Allen '03 (1880-), Paschal Allen '05
(1881-), Ralph Allen Jr. '12 (1889-), Eloise Allen Johns '23 and other members of
the family. The papers include correspondence, notes, publications, programs, photographs,
tape recordings, manuscripts for agricultural journals and speeches, newspaper clippings
and scrapbooks concerning the family, farms and business affairs, ties with relatives and
friends in Massachusetts and Rhode Island, schools, the University of Illinois, student
life at the University, the Farmers Institute (1888-1927), soil testing programs, ranch
life in Montana (1909-24), Reid's yellow dent corn, Tazewell County Farm Bureau,
genealogy and the personal affairs of a rural family with a lively interest in education
and scientific agriculture. Correspondents include Cyril G. Hopkins, Eugene Davenport,
Frank I. Mann, John M. Gregory, Herbert W. Mumford and Perry G. Holden. Tape recordings
include remarks by Joseph C. Blair, William L. Burlison, Paschal and Edith Allen and
Chester G. Starr.

RS 41/20/21 SFA - 10 NUCMC 69-233

ALLEN, JAY (1905-) PAPERS, 1944-1947, 1959-1965 .3 cu. ft.

Papers of Jay Allen, Music Librarian (1943-1965), containing notes on the operation of the
Music Library (1944-1947), Library Club correspondence with Jonathan Schiller (1947, 1953,
1960), the Library Association Lounge financial statement and memos (1961-1962),
acquisition of the WGN music library (1960) and daily calendars of Mr. Allen
(June 1959 - June 1965).

RS 35/3/23

ALPHA LAMBDA DELTA ARCHIVES, 1924-1966 3.6 cu. ft.

Alpha Lambda Delta Archives including correspondence, minutes, reports, newsletters, ritual,
handbooks, annual reports and photographs concerning the constitution, chapter
installations, meetings of national council, history, finances, fellowships, books, awards
and past officers (including Maria Leonard, Adele Stamp and Miriam Sheldon).

RS 41/6/3/3 SFA - 2

ALTGELD, JOHN P. (1847-1902) PAPERS, 1893-1902, 1913, 1941-1943 .1 cu. ft.

Papers of John P. Altgeld, governor and member of the Board of Trustees (1893-1897),
including magazine articles, copies of newspaper articles in the Labadie Collection at the
University of Michigan, memorial booklet and information on Altgeld's career.

RS 1/20/5 SFA - 2

AMERICAN ASSOCIATION OF UNIVERSITY PROFESSORS CORRESPONDENCE, 1934-1970 6.0 cu. ft.

Correspondence filed by the president and secretary of the University of Illinois Chapter
of the American Association of University Professors, including letters, memoranda,
reports, mimeographed form letters and statements, lists and clippings relating to
newsletters (1949-51) and minutes of meetings (1951-68); membership; dues, finances and
balances; nomination and election of officers; national office chapter letters and
bulletins of other chapters; programs and arrangements for national, regional, state and
local meetings; salary and cost of living adjustments; summer session contracts;
retirement and insurance benefits; loyalty oaths and the Seditious Activities Commission;
studies of University organization, e.g. Senate (1947) and faculty representatives (1948)
and parking. The subject file (1956-68) includes correspondence, reports, clippings and
articles on committees, membership, meetings, national policies and meetings, statutes,
academic freedom, economic status, retirements, summer employment, ethics, religion, race
relations and the Leo Koch (1960-68), Edward Yellin (1961), Staughton Lynd (1967) and the
DuBois Club-Clabaugh Act (1967) cases. The treasurer's files (1947-70) include
membership lists (1947-70) showing the name, department, position, campus and/or local
address and dues of members, record books of expenditures and receipts (1948-68) and
unbound financial records (1955-69) including audit reports, billing statements, invoices,
requisition forms, bank deposit receipts, cancelled checks, cash journals, summaries of
expenditures and correspondence with members relating to payment of dues and travel
expenses.

RS 48/1/5 SFA - 6 RESTRICTED

AMERICAN PHILOSOPHICAL ASSOCIATION WESTERN DIVISION RECORDS, 1897-1900, 1920-61 2.0 cu.ft.

American Philosophical Association Western Division Records including published proceedings
and addresses (1927-30, 1931-34, 1936, 1938-52), The Philosophers' Newsletter (1953,
1957-61) and annual meeting programs (1920-22, 1924-27, 1929-30, 1932-34, 1948-60); minutes
(1953-54, 1956); meeting announcements and calls for papers (1922-24, 1947-56);
committee reports and correspondence (1953-60); correspondence on the founding of the
Division (1897, 1899-1900, 1926-27, 1930); correspondence of Secretarys William Hay,
Robert Turnbull, May Brodbeck, Robert Browning and Morris Keeton (1951-59); membership
correspondence, rosters and nominations (1953-59); dues record (1928-52); receipts and
expenditures journal (1938-54); financial records (1952-60); Rockefeller Foundation
grant correspondence, reports and financial records (1954-59) and Fifth Interamerican
Congress of Philosophy correspondence, reports and financial records (Ford Foundation,
(1957-58).

RS 15/16/50 SFA - 4

AMERICAN SOCIETY FOR QUALITY CONTROL ARCHIVES, 1942-1971 17.1 cu. ft.

Archives of the American Society for Quality Control, including acquisitions correspondence
of John A. Henry (1970-71), publications on quality control or related topics issued by
foreign and domestic organizations or governmental agencies for the public, members and
staff of the organizations or agencies and the promotion of programs and conferences (1942-
1970); publications of the ASQC and its divisions, regional organizations and sections for
the public, members and staff of the Society and the promotion of the Society's programs
and conferences (1945-71); reprints of scholarly or instructional articles and books on
quality control; official records of the governing authorities of ASQC including
documents, minutes, financial records, budgets and reports (1944-70); files of ASQC
committees, special boards, divisions, regional organizations and sections (1943-69), the
personal papers of ASQC members or officials (M. A. Brumbaugh, E. H. Robinson, P. S.
Olmstead, C. E. Fisher, R. M. Berg, W. A. Golomski, T. C. McDermott and others) including
correspondence, memoranda, reports, minutes, agendas, newsletters, journals, promotional
materials and articles (1943-70) and photographs of ASQC officers, groups and exhibits
(1946-ca. 1963).

RS 11/8/30 SFA - 33

ANDERSON, ARCHIBALD W. (1905-1965) PAPERS, 1928-1965 7.0 cu. ft.

Papers of Archibald W. Anderson, professor of history and philosophy of education
(1940-1965), including correspondence, reports, class notes, bibliographies, reprints and
related material concerning history of education; College of Education - duties and
history; students and doctoral examinations (1944-1964); publications and reprints
(1941-1963); biographical material; policies and meetings of the Progressive Education
Association (1938-1944, 1953-1955), American Education Fellowship (1944-1953), the John
Dewey Society (1947-1965) and the History of Education Society (1961-1965); securing
contributions for and editing Progressive Education (1947-1958), Educational Theory
(1950-1965), History of Education (1949-1954), Educational Administration and Supervision
(1953-1956); Journal of Educational Psychology (1952-1956) and the John Dewey Society
Yearbooks (1948-1962) and Anderson's college and university training at Columbia and Ohio
State (1928-1938). Correspondents include Theodore Brameld, H. C. Buchholz, Orin B. Graff,
H. Gordon Hullfish, Harold Rugg, Ordway Tead, Isaak N. Thut and William Van Til.

RS 10/6/21 SFA - 6 NUCMC 67-447

ANDREWS, ANDREW I. (1895-1966) PAPERS, 1924-1966 4.3 cu. ft.

Papers of Andrew I. Andrews, professor of ceramic engineering (1925-1963), including correspondence, published articles, manuscript reports and speeches, manufacturers' literature and related material concerning porcelain enamels; properties of ceramic materials; adherence of enamels to metals; manufacturing processes; standards and tests; ceramic engineering education; meetings, programs and publications of professional associations; consulting work and the policies, curriculum and growth of the Department of Ceramic Engineering. Andrews' major work was Porcelain Enamels (1934, 1961).

RS 11/4/20 SFA - 7 NUCMC 69-234

APPLEWHITE, HARRY PAPERS, 1964-1967 .3 cu. ft.

Correspondence (September 1964 - August 1967) of Rev. Harry Applewhite, pastor (1964-1968) of the First Congregational Church of Champaign and Chairman of the Ad Hoc Committee on Vietnam of the Champaign-Urbana Ministerial Association, concerning school integration, the anti-Vietnam War movement, satellite communications, prisoner rehabilitation and a conference on the Roles of Education and Religion in Foreign Policy Formation (November 1965). Applewhite corresponded with the inmates and Chaplain Poiter French of the Illinois State Penitentiary at Menard, Rev. Louis H. Lammert (Executive Secretary of the Central Association, United Church of Christ), Senator Charles Percy and others.

RS 41/6/9/35 SFA - 1

ASHBY, ROBERT C. (1882-1958) PAPERS, 1909-1934 1.6 cu. ft.

Papers of Robert C. Ashby, professor of Live Stock Marketing (1927-1949), Chief of Live Stock Marketing, Agricultural Experiment Station (1937-1949), author of Essentials of Livestock Marketing (1953), monographs, research bulletins and articles, including correspondence, charts, articles, stockyard statistics, pamphlets, stockyard rules and regulations, tariffs, commission charges, manuscripts of articles, notes, livestock exposition catalogues and swine pedigrees. The documents relate to major livestock markets, the care of swine and horses, swine genealogy and the promotion of livestock raising.

RS 8/4/24 SFA - 3 NUCMC 71-1131

ATHLETIC ASSOCIATION RECORDS, 1883-1898 .3 cu. ft.

Athletic Association Records, including a record book containing the constitution, organizational minutes (merger of baseball and football associations - April 10, 1883), membership list (1883-86), dues payment record (1884-85) and treasurer's book (1883-85). The series includes field day programs (1883-89, 1891), indoor meet programs (1893-94), constitution (1891), regulations (1896), fall handicap games programs (1893, 1896, 1898), interscholastic athletic meet programs (1893-95), intercollegiate athletic tournament programs (1891-92), athletic and musical entertainment program (1893) and baseball handbill (ca. 1898).

RS 41/6/8/5

AUDRIETH, LUDWIG F. (1901-1967) PAPERS, 1927-1934, 1941-1948, 1954-1966 1.3 cu. ft.

Papers of Ludwig F. Audrieth, professor of chemistry (1935-1959) and scientific advisor and attache at Bonn (1959-1963), including correspondence, clippings and programs relating to his work at Bonn; a report on the status of inorganic chemistry at German universities prepared for the National Science Foundation (1963) and supporting correspondence with German directors of inorganic chemistry institutes, including Rolf Appel, Margot Becke, Georg Brauer, Werner Fischer, Franz Feher, Gerhard Fritz, Oskar Glemser, Josef Goubeau, Viktor Guttmann, Hermann Hartmann, Hayek, Walter Hieber, Robert Juza, Karl Jahr, Wilhelm Klemm, H. W. Kohlschutter, Reinhard Nast, Bertold Reuter, Walter Rüdorff, Max Schmidt, Friedrich H. Seel, Hans Siebert, Fritz Strassmann, Ulrich Wannagat and Egon Wiberg (1962-1963); reprints of articles on non-acqueous solvents, nitrogen chemistry, and inorganic compounds (1930-1934) and correspondence and related material concerning Paul Walden (1927-1957), the discovery of sucaryl (1936, 1950, 1966); military service at Picatinny Arsenal (1942-1945) and University policies and practices. The series includes lecture materials and reading supplements for D.G.S. 334, The Impace of Science and Technology on National and International Affairs (1966) and Science, Technology and Foreign Affairs, Report on Seminar, Audrieth and Chinn, Department of State, 1965.

RS 15/5/28 SFA - 2 NUCMC 67-448

BABBITT, HAROLD E. (1888-1970) PAPERS, 1922-1923, 1928, 1930, 1939-1956 1.0 cu. ft.

Papers of Harold E. Babbitt, professor of sanitary engineering (1919-1954), including correspondence, speech notes, unpublished papers and addresses (1946), abstracts for journals (1940-1953), newspaper clippings and photographs (1950 Short Course) relating to sewage treatment, water purification, garbage disposal with sewage, diatomite water filters, flow of sludge, engineering in public health and disposal of radioactive wastes in sewage. The series includes the following textbook editions: Plumbing (1928), Sewerage and Sewage Treatment (1922, 1932, 1953) and Water Supply Engineering (1939, 1955).

RS 11/5/23 SFA - 2 NUCMC 69-235

BAILAR, JOHN C. JR. (1904-) PAPERS, 1928-1969 .3 cu. ft.

Papers of John C. Bailar Jr., professor of Chemistry (1935-), including tape-recorded recollections relating to parents, youth, interest in chemistry, high school at Golden, University of Colorado, teachers, chemistry courses, master's work at Colorado, doctoral work on free radicals under Moses Gomberg at Michigan, 1928 appointment at Illinois, general chemistry courses, complex ions, administrative duties, placement work, chemical industry, Chemical Society building, Journal of Inorganic Chemistry, Division of Inorganic Chemistry, family, philosophy of science, university training, evaluation of students and research and International Union of Pure and Applied Chemistry. Dr. Wyndham D. Miles interviewed Dr. Bailar on October 9, 1964. The series includes reprints on inorganic chemistry, the stereochemistry of complex inorganic compounds and chemical education (1928, 1930-1931, 1933-1934, 1936-1938, 1940, 1944-1955, 1956-1969) and the program for the John C. Bailar Jr. Symposium on Coordination Chemistry (1969).

RS 15/5/25 SFA - 5

BAILEY, CHARLES W. (1891-1970) PAPERS, CA. 1940 .1 cu. ft.

Papers of Charles W. Bailey, LAS 1909-1913, including four pages of Bailey's recollections of student life including accounts of freshman-sophomore rivalry, student riots, discipline, pranks, student jobs, football celebrations at the Orpheum, spies at football practice, fraternity tug-of-war contests, sororities, pushball and related activities.

RS 26/20/10

BAILY, H. HEATON (1888-1957) PAPERS, 1928, 1941 .1 cu. ft.

Papers of H. Heaton Baily, professor of accountancy (1921-1957), including English and French manuscript copies and a published version of Professor Baily's March 1, 1928 address to the Compagnie des Chefs de Comptabilite in Paris on "The Organization of the Accounting Profession in the United States." The series includes a reprint of "Illustrative Problem in Elementary Accounting" (1941).

RS 9/2/21

BAKER, FRANK C. (1867-1942) PAPERS, 1884-1943 .6 cu. ft.

Papers of Frank C. Baker (1867-1942), zoologist, paleontologist and Curator of the Natural History Museum (1917-1939), including certificates of membership in professional organizations, photographs, publications, correspondence with friends and colleagues, manuscripts and reprints of articles, memorials, bibliographies of his work, biographies of scientists, programs of meetings attended, newspaper clippings and biographical material and memorials (1942-43).

RS 15/24/24 8

BAKER, WILLIAM M. (1823-1873) CLASS BOOK, 1869 .1 cu. ft.

Class book of William M. Baker, professor of English (1868-1973), consisting of his class
register for the semester beginning February 15, 1869, recording students' last names for
classes in literature, Latin and English, attendance, deportment, recitations and final
marks. Bound in front are a short biography of Baker and a carbon copy of a letter
thanking Walter J. Graham for its donation to the University of Illinois Library.

RS 15/7/27

BALDUF, WALTER V. (1889-1969) PAPERS, 1937-1970 .6 cu. ft.

Papers of Walter V. Balduf, professor of entomology (1922-1958), including correspondence
(1962-1970), publications on insect parasites, caterpillars, bees and flies (1965-1969),
research data sheets and notebooks of observations on birds (1937-1949) and insect
parasites, wasps, bees and caterpillars (1950-1969). The series includes publications on
the ecology of Great Lakes fishes (1934-1941).

RS 15/8/20 NUCMC 71-1132

BALDWIN, THOMAS W. (1890-) PAPERS, 1925-1955 .3 cu. ft.

Papers of Thomas W. Baldwin, professor of English (1925-1958), containing correspondence
with researchers, students and publishers relating to university and departmental matters,
research on the writings of William Shakespeare and student problems and requests
(1925-1955); attendance rolls, grades and comments by assistants on students' work
(1929-1941); reports of the Senate Committee on the Library (1927-1945) and reprints of
articles and reviews (1927-1945).

RS 15/7/26 NUCMC 69-236

BARDEEN, JOHN (1908-) PAPERS, 1956-1974 .6 cu. ft.

Papers of John Bardeen, professor of electrical engineering and physics (1951-),
including tape recorded interviews & motion pictures (1965, 1972), publications list &
reprints (1956-74). The interviews contain comments on theoretical physicists, scientific
communication, experimental physics, theory of superconductivity, many body theory,
publication, education, Dr. Charles Bardeen, University of Wisconsin, Gulf, Princeton and
Harvard, Minnesota, solid state physics, Naval Ordinance Laboratory, Bell Laboratories and
the transistor, xerography, theoretical physics in universities compared to industry,
considerations in coming to Illinois, recruitment of new faculty, allocation of time,
Center for Advanced Study, Physics Department, financial support, recognition, Russian
physics research, consulting work, solid state physics, scientific understanding &
communication between & education of non-scientists & scientists, the development of the
theory of superconductivity with Robert Schrieffer and Leon Cooper (1972) & the development
& applications of transistors & superconductivity (1973). Motion pictures contain a
May 1972 interview with Bardeen, Walter Brattain & William Shockley on the development of
the transistor and a Dec. 1972 Swedish film on the contributions of Bardeen, Cooper &
Schrieffer to the theory of superconductivity & their reunion to receive the Nobel Prize
in Physics. Reprints include a Dec. 11, 1956 Nobel Lecture on "Semiconductor Research
Leading to the Point Contact Transistor," a Dec. 11, 1972 Nobel Lecture on "Electron-Phonon
Interactions and Superconductivity," a Nov. 12, 1964 address at the Xerox Research
Laboratory Dedication on "The Role of Basic Research," a 1973 survey of solid state
physics, a 1973 history of superconductivity research & a 1964 nomination for a National
Medal of Science.

RS 11/10/20 SFA - 17

BAUER, FRANCES MYERS (CA. 1906-1964) PAPERS, 1923-1964 4.7 cu. ft.

Papers of Fran Myers (Mrs. Edward E. Bauer) '28, university editor of the Champaign-Urbana News-Gazette (1928-1964), including personal, social and professional correspondence about the budgets, buildings, faculty and staff, students and programs of the University of Illinois; typescript articles; scrapbooks containing newspaper clippings and college coursework; clippings of her column "The Broadwalk Tatler" (1928-1964), financial columns (1929-1930), byline stories and feature articles (1924-1964); newspaper prints of photographs related to articles; biographical newspaper and magazine articles; programs for social events and theatrical productions; speech manuscripts and notes; drafts of columns and news releases, programs, publications, manuscripts and other sources used for feature articles (1927-1964).

RS 26/20/18 SFA - 6 NUCMC 71-1133

BAUER, FREDERICK C. (1886-1961) PAPERS, 1909-1960 1.0 cu. ft.

Papers of Frederick C. Bauer, in charge of soils extension (1920-1932), Chief of experimental fields (1923-1954) and professor of Soil Fertility (1932-1954), including correspondence, notes, research papers, addresses, clippings, publications, photographs and workpapers relating to agronomy, teaching, soil productivity, the Morrow plats, experiment fields, fertilizers and McKinley Foundation.

RS 8/6/20 NUCMC 65-1305

BAYLEY, WILLIAM S. (1861-1943) PAPERS, 1884-1886, 1895, 1906-1913, 1916-1925, 1927, 1929,
 1937 1.0 cu. ft.

Papers of William S. Bayley, professor of geology (1907-1932), including a manuscript titled, "Mineralogy of the Silicates" based on notes of lectures given by Dr. George H. Williams at Johns Hopkins University (1885-1886); correspondence concerning U. S. Geological Survey field work; publications; academic positions and curricula; state geological survey work in North Carolina, Tennessee and New Jersey; the Crocker Land arctic expedition (1913-1917); graduate work; World War I service; scientific organizations and publications; Wyoming oil drilling (1925-1928); geological notes; scientific society programs (1916-1925) and publications (1895, 1912, 1920-1923, 1925, 1937). Correspondents include H. Foster Bain, Joseph Barrell, Eliot Blackwelder, Ernest F. Burchard, Frank W. DeWolf, W. Elmer Ekblaw, C. Willard Hayes, Luther E. Kennedy, David Kinley, Henry B. Kummel, Edward B. Mathews, Wilbur A. Nelson, Joseph H. Pratt, Terence T. Quirke, Heinrich Ries, Clarence S. Ross, George O. Smith and David White.

RS 15/11/21 SFA - 7 NUCMC 69-282

BEAL, GEORGE D. (1887-) PAPERS, 1914-1926, 1965 .1 cu. ft.

Papers of George D. Beal, professor of Chemistry (1918-1926), including a six-page recollection (1965) of the Department of Chemistry, Samuel W. Parr, Edward Bartow, Harry S. Grindley, Clarence G. Derick, Edward W. Washburn, Clarence W. Balke, the Chemistry Club, Oliver Kamm, Professor Beal's father, his chemical education and his decision to go to the Mellon Institute in 1926; programs for the 1926 Illinium Dinner and Phi Lambda Upsilon banquet and 13 reprints of articles relating to foods and pharmaceutical chemistry (1914-1925).

RS 15/5/26

BEBERMAN, MAX (1925-1971) PAPERS, 1955-1971 .6 cu. ft.

Papers of Max Beberman (1925-1971), professor of education (1953-71) and director of the
Curriculum Laboratory (1965-71), including newspaper clippings, magazine articles,
photographs, publications and correspondence relating to mathematics education, the
"New Math," teaching, educational methodology, the development of instructional materials,
experimental classroom trials, curriculum development, high school mathematics, "guided
discovery" and comments and criticisms on mathematics education. Supported by the
Carnegie Corporation, National Science Foundation and U. S. Office of Education, the
University of Illinois Committee on School Mathematics produced texts, teachers manuals
and teacher training film series and sponsored summer institutes. Beberman's
correspondence is in the files of the Curriculum Laboratory (1950-72) and the Committee
on School Mathematics.

RS 10/12/20

BELL, JOHN F. (1898-) PAPERS, 1932-1949 .3 cu. ft.

Papers of John F. Bell, professor of economics (1941-1966) and department chairman
(1957-1963), including correspondence, memoranda and clippings relating to wartime
economic problems while Bell was with the Office of Price Administration and Civilian
Supply (1941-1942); correspondence of Professor H. Kenneth Allen relating to property tax
collection in Illinois (1940-1942); two manuscripts on the Danish cooperative movement
(1932-1933) and Polish propaganda literature (1940-1949).

RS 9/5/24 NUCMC 69-238

BENNER, THOMAS E. (1894-) PAPERS, 1930-1962, 1967, 1969 1.0 cu. ft.

Papers of Thomas E. Benner, dean of the College of Education (1931-1945) and professor of
education (1931-1962), including correspondence, manuscripts, reports, clippings and
publications relating to the University of Puerto Rico (1930, 1969), positions at other
universities (1930-1941), needs of the College of Education (1934-1942), articles and
talks on educational topics (1931-1945), school studies (1937-1945), Chicago schools
controversy (1938), a hearing of administrative charges against Dean Benner and
expressions of faculty support (1944-1945), laboratory school plans and proposals (1945),
Austrian education (1946-1948, 1967), service as an UNESCO educational consultant in Korea
(1950-1952), a Turkish experimental secondary schools project (1954-1957) and professional
activities in the College of Education (1949-1953, 1959-1963). The series includes a 1969
autobiographical statement concerning education, Alabama School work, chancellorship of the
University of Puerto Rico (1924-1929), the College of Education at Illinois (1931-1962) and
educational work in Austria (1946-1947), Korea (1950-1952), Turkey (1953-1954), Israel
(1957) and Puerto Rico (1962-1969).

RS 10/1/21 SFA - 4 NUCMC 71-1134

BERDAHL, CLARENCE A. (1890-) PAPERS, 1920-1967 11.3 cu. ft.

Papers of Clarence A. Berdahl, professor of political science (1925-1959), chairman of the
Division of Social Sciences (1935-1939) and chairman of the Department of Political
Science (1942-1948), including correspondence; statistical and narrative reports by
departmental and university committees; drafts of addresses, lectures and talks to
professional and political groups; evaluations and recommendations of applicants for
academic or governmental positions and related material. The correspondence concerns the
American Association of University Professors (1945-1958), American Political Science
Association (1928-1958), American Society of International Law (1940-1958), Committee on
School of Journalism (1938-1947), Department of Political Science (1933-1950), Graduate
College (1933-1958), Institute of Labor and Industrial Relations (1946-1949), Midwest
Conference of Political Scientists (1939-1958), Midwest Seminar on U. S. Foreign Policy
(1952-1958), Publishers (1927-1947), University Senate (1932-1949), Social Science
Division (1934-1939), Star Course (1956-1959), Illinois Studies in the Social Sciences
(1941-1956), advisory committee on Foreign Relations of the United States (1957-1967),
and includes correspondence with Irving Wright and diplomatic historians. The series
includes propaganda materials of the Deutscher Fichte-Bund (1936-1940) and the Committee to
Defend America by Aiding the Allies (1940-1942), correspondence, records, curricula,
outlines and student papers of the Army Specialized Training Program in Foreign Area and
Language Studies (1943-1945) and publications of Professor Berdahl (1920-1952) on
international relations and political parties and elections. The series includes records
of O.S.S. Service in World War II (London, 1944) and United Nations Conference (San
Francisco, 1945).

RS 15/18/22 SFA - 5 NUCMC 65-1917

BESTOR, ARTHUR E. (1908-) PAPERS, 1852-1962 45.7 cu. ft.

Papers of Arthur E. Bestor, Jr., professor of history (1947-1962) and President and
Director of the Council for Basic Education, containing family papers (1852-1956),
genealogies, photographs, clippings, correspondence, Bible, autograph albums and diaries;
student notes from Yale (1927-1937) and teaching notes from Yale, Columbia and Stanford
(1937-1944) on history, English and American literature, philosophy, humanities,
mathematics, music and American civilization; bio-bibliography (1908-1962); biographical
(1900-1950), including family yearbooks and alumni publications; publications (1925-1961),
including manuscripts, reprints and proofs of articles, reviews, published letters,
transcripts and reports of interviews and manuscripts and reviews of books by Bestor and
related correspondence; speeches and papers read (1927-1960) at public or professional
meetings, including programs and clippings; syllabi and teaching notes (1930-1961); copies
of student theses directed (1948-1960); educational controversy material (1952-1959),
including clippings, reviews, editorials and pamphlets on Bestor's championship of basic
intellectual education and opposition to "life adjustment;" correspondence (1923-1962) with
Bestor family, professors, administrators, educators, public figures, publishers,
librarians, teachers, students and the public concerning research on Backwoods Utopias,
education, publications, meetings, speeches, awards, Harmsworth Professorship (Oxford),
history departments, faculty recruitment, Council for Basic Education interviews, public
affairs, Illinois Historical Survey, student theses and academic freedom. The series
includes the papers (12.6 cu. ft.) of Arthur E. Bestor, Sr. (1879-1944), Director
(1907-1915) and President of the Chautauqua Institution, containing material on Chautauqua
(1901-1945), University of Chicago (1896-1934), the Committee on Public Information
(1917-1920), Lake Placid Club (1920-1943), adult education (1921-1942) and Town Hall
(1935-1944).

 NUCMC 72-158
RS 15/13/26 SFA - 57 RESTRICTED NUCMC 69-239

BEUTEL, FREDERICK K. (1897-) PAPERS, 1939-1967 .3 cu. ft.

Papers of Frederick K. Beutel, visiting professor of law (1965-1966), containing books
(1939-1967), record of employment (1923-1965), a partial list of publications (1928-1965)
and the manuscript of the second edition of Professor Beutel's Bank Officer's Handbook of
Commercial Banking Law (1939, 1965). The books include Study of the Enforcement of
Bad-Check Laws in Nebraska (1957), Democracy or the Scientific Method in Law and Policy
Making (1965), Interpretation, Construction, and Revision of the Commercial Code: the
Presumption of Holding in Due Course (1966), The Operation of the Bad-Check Laws of Puerto
Rico (1967).

RS 14/2/23

BEVIER, ISABEL (1860-1942) PAPERS, 1879-1942, 1945-1955 4.7 cu. ft.

Papers of Isabel Bevier (1860-1942), professor of household science (1900-21), including
correspondence, publications by Miss Bevier (1898-1940) and the Household Science
Department (1900, 1905, 1908-21, 1927, 1929, 1934, 1938, 1945-47), manuscripts (1896-1940),
diaries (1917-20, 1922, 1924, 1931, 1935, 1940), clippings, photographs and notes about
household science or home economics, the education of women, departmental administration
and history, enrollments, the Woman's Building (1905) and laboratories, farm homes and
houses, food and nutrition, homemaking, the family, budgeting, sanitation, the Farmer's
Institutes (1907-09), extension work (1912-18), the Food Administration (1917-18),
biographical and autobiographical accounts, anecdotes recalled by students and associates
(1929-37), European travel (1927, 1931), obituaries and memorials (1942). The series
includes Miss Bevier's The House, Its Plan, Decoration and Care (1907, 1914), The Home
Economics Movement (1906), The Story of Isabel Bevier by Lita Bane (1955), five books
by Ellen Richards (1899-1910) and Miss Richards' biography (1912). Correspondents include
Eugene Davenport and Edmund James and officers of the American Home Economics Association
(1911-12).

RS 8/11/20 SFA - 6

BLAIR, JOSEPH C. (1871-1960) PAPERS, 1905-1915, 1922-1927, 1932-1954 2.0 cu. ft.

Papers of Joseph C. Blair, professor of horticulture (1900-1938) and dean of the College of
Agriculture (1938-1939), including landscape architect's drawings for Blair's residence at
601 Michigan in Urbana and a proposed Florida Avenue residence, Camp Seymour at
Decatur-State YMCA (1926), Crystal Lake Park (1905-1913) and swimming pool (1927),
University Heights addition (1907-1915, 1922-1927), Lincoln Statue (1927), Urbana-Lincoln
Hotel, Carle Park-Victory Park (1923) and Carle Sanitarium; Dean's Office correspondence
for June, 1938; publications, news releases and letters referred to Dean Blair by Extension
Editor Frederick J. Keilholz relating to land use, agricultural policies, marketing and
conservation (1939) and a reprint relating to the American Pomological Society (1933). The
series includes twenty photographs of agricultural college scenes and 63 reels of 16 mm.
motion picture film photographed by Professor Blair including films of greenhouses,
tomatoes and flowers; farm and field scenes showing corn and oats, farm machinery; the
growing, processing and packing of apples and other fruits; trees in town and countryside;
campus scenes including the 1940 commencement, and Urbana public and park areas.

RS 8/12/20 SFA - 4 NUCMC 67-449

13

BOGART, ERNEST L. (1870-1958) PAPERS, 1910-1935 3.2 cu. ft.

Papers of Ernest L. Bogart, professor of economics (1909-1941), including departmental and personal correspondence concerning academic appointments, recommendations, applications, graduate programs and requirements, scholarships and fellowships, Rhodes scholarships, Thrift Essay prize, business positions, publications, University Studies, Studies in the Social Sciences series, economics courses and curricula, textbooks, economic policy committee, lectures, leaves, summer sessions, admissions committee and work affairs. Correspondents include John F. Bell, Edward Berman, Lee Bidgood, Pembroke H. Brown, Arthur H. Daniels, Frank G. Dickinson, Frank A. Fetter, Evarts B. Greene, Otto Gressens, David H. Hoover, Merlin H. Hunter, Frederic E. Lee, Simon Litman, D. Phillip Locklin, Marion K. McKay, Royal E. Montgomery, Lloyd Morey, Charles L. Prather, Maurice H. Robinson, Charles M. Thompson, Max J. Wasserman, Gordon S. Watkins, Nathan A. Weston, French E. Wolfe, Ivan Wright and O. A. Wright. The series also contains source material, notes and published copies of Bogart's Economic History of the United States (1907-1938) and Direct and Indirect Costs of the Great World War (1919); source material and notes for War Costs and Their Financing (1921); reprints of articles (1901-1922); class record books (1910-1935) for classes in economic history of United States, England and modern Europe and correspondence, agendas, minutes, memoranda, reports and bulletins relating to Bogart's service as a member of the State Advisory Committee of the Illinois Emergency Relief Commission (1934-1935), which was responsible for work relief, rural rehabilitation, emergency education, subsistence gardens and similar programs.

RS 9/5/21 SFA - 2 NUCMC 67-450

BOODELL, CLETUS J. PAPERS, 1918 .1 cu. ft.

Papers of Cletus J. Boodell, Liberal Arts and Sciences (1917-1919), including notes on readings for the War Issues 5 course - The Ideals of the Allied Nations - taught by Professor Ernest Bernbaum.

RS 41/20/27

BOWHILL, SIDNEY A. PAPERS, 1959-1970 3.6 cu. ft.

Papers of Sidney A. Bowhill (1927-), professor of electrical engineering (1962-) including copies of outgoing correspondence with engineers in the U. S. and abroad concerning research articles on aeronomy or the physics of the ionosphere, radio propagation and rocket and satellite studies of the upper atmosphere submitted for publication in the Transactions of the Professional Group on Antennas and Propagation of the Institute of Radio Engineers, the journal of the U. S. National Committee of the International Radio Union entitled Radio Science, and the Journal of Atmospheric and Terrestrial Physics of which Bowhill was editor or a member of the editorial board. The papers also include copies of outgoing correspondence regarding program arrangements for meetings of the Institute of Electrical and Electronics Engineers, the Institute of Radio Engineers and other professional groups; joint research projects; and graduate student applications, assistantship appointments and letters of recommendation.

RS 11/6/25

BRAUCHER, ARTHUR C. (1859-1956) PAPERS, 1915 1 cu. ft.

Papers of Arthur C. Braucher '84, including Braucher's correspondence with the Chicago
Tribune, the Secretary of State and Edward J. Filbey concerning University appropriations,
the efficiency of engineering graduates compared to persons trained by engineering firms,
the licensing of structural engineers and the revocation of an architect's license.

RS 26/20/9

BRIGHTBILL, CHARLES K. (1910-1966) PAPERS, 1929-1966 3.8 cu. ft.

Papers of Charles K. Brightbill, professor of recreation (1951-1966) and department head
(1957-1966), including correspondence, mimeographed reports, copies of manuscripts,
published articles, books, awards, scrapbooks and related material concerning recreation
education, use of leisure time, meetings of professional associations, addresses and
lectures, publications, municipal recreation studies and programs, armed forces recreation
program (1949-1951), recreation for the ill and the handicapped, recreation services of
the state and federal governments, training recreation leaders, merging of professional
organizations in the recreation field, research and travel, the Department of Recreation
and Municipal Park Administration, appointments and biographical information. Professor
Brightbill served as a recreation officer with Reading, Pennsylvania (1934-1935), Decatur
(1936-1937), National Recreation Association (1938-1941), Federal Security Agency
(1942-1946), Veterans Administration (1947-1949) and the President's Committee on Religion
and Welfare in the Armed Forces (1949-1951) before coming to Illinois.

RS 16/5/20 SFA - 4 NUCMC 67-451

BROWNE, ROBERT B. (1894-1959) PAPERS, 1949-1953 .1 cu. ft.

Papers of Robert B. Browne, Director of University Extension (1934-1959) and Summer Session
(1938-1959), professor of Education 1940-1959) and Intercollegiate Athletic Conference
faculty representative (1949-1959), including "Scylla and Charybdis" (vocationalism and
culture in extension programs), "The Big Ten" (intercollegiate football conferences -
1953), "Trustees of a Heritage" (liberty, equality and libraries - 10/18/51) and Civil War
papers relating to John Hunt Morgan and Abraham Lincoln and his generals (1949).

RS 21/1/20

BRYAN, LESLIE A. (1900-) PAPERS, 1925-1968 1.3 cu. ft.

Papers of Leslie A. Bryan, director of the Institute of Aviation (1946-1968), including a
1968 tape recorded interview on the Institute, the University's aeronautics program,
research, Arthur C. Willard and Bryan's career in aviation; a list of publications and
copies of books and articles on aviation, traffic management, air and water transportation,
airport management, aviation education and Aulls-Bryan genealogy. The series includes
Congressional Committee reports on the space program (1959-62) and aviation (1954-59),
pamphlets and articles on airport management and expansion and Pial Club programs (1951-67).

RS 20/1/20 SFA - 1

BRUNDAGE, AVERY (1887-) COLLECTION, 1923-1975 90 cu. ft.

Collection of Avery Brundage '09, including correspondence, minutes, reports, photographs,
scrapbooks and publications about Brundage's service as president of the International
Olympic Committee (1952-72), United States Olympic Committee (1929-52) and Amateur
Athletic Union (1928-36); national Olympic committees; international sports federations,
Olympic and regional games; international athletic competition, sports and amateurism.

RS 26/20/37 SFA - 60

BULL, MARY L. PAPERS, 1916, 1926-1966 .2 cu. ft.

Papers of Mary Lois Bull, personnel director of the Library (1951-1967), containing the personnel office file of Phineas L. Windsor (1926-1966) and material pertaining to the installation of President David D. Henry.

RS 35/1/25 SFA - 1

BULL, SLEETER (1887-1968) PAPERS, 1919, 1921, 1927-1933, 1937-1944, 1947-1949, 1952-1956
 .6 cu. ft.

Papers of Sleeter Bull, Professor of Animal Science (1921-1956), including clippings, publications, correspondence, minutes, and reports relating to the Board of Fraternity Affairs (1947-1949 and 1952-1956) concerning fraternity regulations, publicity, rushing, scholarship, finances, living conditions, discipline, discriminatory practices, and the Interfraternity Council. The papers also include material relating to animal science concerning the feeding and butchering of farm animals, the testing and preparation of meat, and cooperative meat studies.

RS 8/7/22 NUCMC 69-240

BULLARD, SAMUEL A. (1853-1926) PAPERS, 1873 .1 cu. ft.

Papers of Samuel A. Bullard, Class of 1878, including a November 15, 1873 letter to Mr. Wesley Bullard, his father, asking for money to cover his expenses at Illinois Industrial University including references to a loan from Professor Edward Snyder, the scheduled dedication exercises for University Hall and family matters and an itemized list of expenditures from September 15 to November 12, 1873. The series includes the matriculation certificate (1874) and a LaSalle County teachers certificate (1877-1881) of Elsie Cornelia Elliott Bullard '81.

RS 41/20/20

BURDICK, LLOYD S. (1908-1945) PAPERS, 1911-1949 1.0 cu. ft.

Papers of Lloyd S. Burdick '32 (1908-1945), including photographs, newspaper clippings, publications and correspondence relating to football, wrestling and track (1924-35), construction of the Alcan Highway and Canol pipeline (1942-44), construction equipment business and family activities. Burdick played tackle for Stonington, Morgan Park Military Academy, Illinois (1927-29), Chicago Bears and Cincinnati Reds, coached football at Knox College (1934), and served as principal inspector of heavy duty construction equipment on the Alcan and Canol projects in Alberta, British Columbia, Yukon, Northwest Territory and Alaska.

RS 26/20/27 SFA - 1

BURFORD, CARY C. (1882-1961) PAPERS, 1930-1960 1.3 cu. ft.

Papers of Cary C. Burford '04, including correspondence, newspaper clippings, manuscripts, photographs and postcards concerning the University of Illinois staff and buildings, Class of 1904 reunions, the Illinois State Historical Society, the Illinois Archaeological Society, railroad history and passenger service, Abraham Lincoln, Indiana history, Indian artifacts, travel in the West and Europe, We're Loyal to You, Illinois: The Thrilling Story of the University of Illinois Bands Under Albert Austin Harding (1952) and publications and talks by Burford.

RS 26/20/17 SFA - 2 NUCMC 71-1135

BURLISON, WILLIAM L. (1882-1958) PAPERS, 1915-1942 .1 cu. ft.

Papers of William L. Burlison, professor of Agronomy (1912-1951), including reprints of
articles and addresses relating to phosphates, harvesting cereal crops, corn, soil
surveys, soybeans, cold resistance of plants and wartime crop production.

RS 8/6/22

BURNS, RUTH M. (1890-) PAPERS, 1911-1913 .1 cu. ft.

Papers of Ruth M. Burns '11, including Valedictory address (June 12, 1911) and M. A.
thesis entitled <u>William Buford, the Author of Vathek</u> (1913).

RS 41/20/29

BURRILL, EVELYN (1876-) PAPERS, 1899 .1 cu. ft.

Papers of Evelyn Burrill Lewis '02, niece of Thomas J. Burrill, including a 25-page paper
on "French Missions in Illinois" (1899), a 28-page paper on "William Pitt's Attitude
toward the French Revolution" and a 110-page paper on "The Hudson's Bay Company."

RS 41/20/28

BURRILL, THOMAS J. (1839-1916) PAPERS, 1854, 1863-1912, 1914-1916, 1931 .6 cu. ft.

Papers of Thomas J. Burrill, professor of botany (1868-1912), including a journal
(1863-1864, 1875, 1877-1878), diplomas and certificates (1865-1912), photograph album
(1890), a reminiscence concerning his boyhood (1895), appointment letters (1895-1899), and
a letterpress copybook (1904-1910). The journal includes lecture notes, definitions,
questions and diagrams made in trigonometry, natural philosophy, hydrostatics, optics,
astronomy, physiology, zoology, cosmogony and history courses at Illinois State Normal
University (1863-1864) and a diary of personal observations on crops, weather, plants,
insects, seeds and personal activity (4/6/1875 to 9/30/1875; 6/1877 to 9/17/1888). The
1895 15-page typewritten "Boyhood Biography, A Personal Sketch" by Burrill covers his
boyhood in northern Illinois, 1849-1859. The copybook contains Burrill's private
correspondence relating to drainage and timber on his Arkansas lands, assessment of his
Chicago lots, scientific investigations and university affairs (1904-1910). The series
includes copies of a school record (1854), a genealogy (1931) and correspondence about a
western trip (1915) and letters of condolence (1916).

RS 15/4/20 SFA - 2 NUCMC 65-1306

17

BURRILL, THOMAS J. (1839-1916) PAPERS, 1901-1905, 1909-1910 .3 cu. ft.

Letterpress copybooks of Vice President Thomas J. Burrill (9/9/01 to 5/18/05 and 1/27/09 to 1/21/10) containing outgoing correspondence of Burrill who also served as chairman of the Edward Snyder Loan Fund Committee and, in 1909, as chairman of the Board of Directors of the Y.M.C.A. Correspondence with Presidents Andrew S. Draper and Edmund J. James, the deans, faculty and students relates to student loans, faculty salaries and appointments, recommendations for positions, fellowships, operation of university streets and buildings, use of rooms, botanical subjects, laboratory investigations of bacilli and typhoid tests. Significant letters concern considerations affecting the choice of a new president (4/04); a five page biography of Selim H. Peabody and a three page account of the university's growth under Peabody (12/03); a report of the Snyder Memorial Committee and a three page biographical sketch of Edward Snyder (10/26/03); state appropriations (3/4/05); committee report on student class work loads (2/3/02); faculty committee appointments (10/4/02); reports of the Committee on Graduate Work (2/9/03 and 3/04); campus planning (6/26/03); founding of Sigma Xi (11/03); development of the compound microscope in the United States (7/22/04); pool tables in the Y.M.C.A. (3/6/09) and the rum traffic curse in Urbana (10/1/09).

RS 5/1/20 NUCMC 65-1306

18

CARLSTON, KENNETH S. (1904-1969) PAPERS, 1935-1966 .7 cu. ft.

Papers of Kenneth S. Carlston, professor of law (1946-1969), including the correspondence
and reports of the Committee on International Restrictive Business Practices of the
American Branch of the International Law Association (1953-1964) and the University
Committee on Forums (1959-1966); notes and printed documents relating to international
law, international legal claims, the Mexican Claims Commission (1935-1936) and the
nationalization of the Suez Canal (1954-1957); incomplete manuscript copies and reprints
of publications ("The Marshall Plan," 1946; "The Elements of Peace," 1952 and
"International Administrative Law: A Venture in Legal Theory," 1959) and personal
correspondence. Correspondents include William L. Springer, Kenneth Keniston, Samuel K.
Kopper, Earl Cruickshank and Thomas Haynes.

RS 14/2/24 SFA - 2 NUCMC 71-1136

CARMAN, ALBERT P. (1861-1946) PAPERS, 1905-1912 .1 cu. ft.

Papers of Albert P. Carman, professor of physics and head of department (1896-1929),
including a letter from Andrew S. Draper on Mrs. Carman's health (1906), Illinois Arctic
Club membership certificate (1912) and reprints on the resistance of tubes to collapse
(1905) and the effect of pressure on the aluminum rectifier (1910).

RS 11/10/27

CARMICHAEL, ROBERT D. (1879-1967) PAPERS, 1905-1964 18.6 cu. ft.

Papers of Robert D. Carmichael, professor of mathematics (1915-1947), and dean of the
graduate college (1933-1947) including correspondence, diaries, and notebooks relating to
his personal and organizational life (1913-1963); notes and manuscripts of his
autobiography, "On the Growth of My Life" (1953-1959); family correspondence and genealogy
notes (1928-1964); poetry notebooks and manuscripts (1913-1952); classics, philosophy and
religion notebooks; philosophy of science notebooks and essay manuscripts (1905-1943);
mathematics notebooks (1909-1964) on differential and difference equations, number theory,
boundary problems and value and finite group theory, with notations, manuscript drafts,
lectures, computations, bibliographic citations and reading records; theory of relativity
notebook; bibliographic notecards and manuscripts; reprints (1906-1953) and essays,
speeches and addresses on education, philosophy of science and a philosophy of life.
Correspondence, clippings, reading records and indexes. This series includes notes and
clippings relating to dissertation research carried on under Carmichael; the Chicago
section of the American Mathematical Society (1920-1921); the Illinois Chapter of the
American Association of University Professors (1929); Eunice Carmichael Roberts
(1939-1959); family meetings (1954-1956); publishers; the University of Illinois
Philosophy Club (1923); Faculty Forum; Indiana Debate on Relativity (1926); Woodrow Wilson
(1913-1916); the family farm and mathematics department and graduate college (1919-1947).
Correspondents include Oliver Carmichael.

RS 15/14/20 SFA - 15 NUCMC 72-1501

CARTER, HERBERT E. (1910-) PAPERS, 1935, 1938-1944, 1956-1960, 1963-1965 1.0 cu. ft.

Papers of Herbert E. Carter, professor of chemistry (1945-) and department head
(1954-), containing correspondence, notes, travel vouchers, brochures, reports and
reprints of articles relating to food additives, carcinogenesis and Professor Carter's
service as a member of the Food Protection Committee of the National Research Council and
National Academy of Science (1956-1960). The series includes reprints of published
articles on biological chemistry, amino acids and related subjects. The series includes
minutes, correspondence and reports relating to Carter's service on the Faculty Advisory
Committee to the Illinois State Board of Higher Education (1963-1965).

RS 15/5/29 SFA - 4 NUCMC 71-1137

CASE, HAROLD C. M. (1890-1966) PAPERS, 1915-1965 6 cu. ft.

Papers of Harold C. M. Case, professor of farm management (1922-1933), and agricultural
economics (1934-1958) and department head (1934-1958), including manuscripts of public
addresses and talks, correspondence, publications, course outlines, lecture notes,
clippings and news releases relating to farm management extension, farm accounting, crop
forecasts, the Farm Management Service, agricultural adjustment, farm debt adjustment,
mortgages and leases, farm tenancy, agricultural economics courses, departmental
organization and research programs, wartime food production, farm appraisal, post-war
European food supplies and agricultural production, agricultural conditions in China
(1946), farm legislation and agricultural policy (1947-1957), International Conference of
Agricultural Economists meetings (1929-1930, 1938, 1952-1963), international cooperation
and training programs, land use, price supports and the history of agricultural economics.
The series includes material relating to the Agricultural History Society (1952-1958) and
the American Farm Economic Association (1956-1957).

RS 8/4/20 SFA - 7 NUCMC 65-1307

CATLIN, GEORGE E. (1896-) PAPERS, 1967-1968 .3 cu. ft.

Papers of George E. Catlin, visiting professor of Political Science (1967-1968), including
23 tape recordings and notes for three lectures given in Political Science 345 (Theory and
Practice of Democratic Government). The series includes biographical material and lists
of publications.

RS 15/18/27

CHALMERS, W. ELLISON (1903-) PAPERS, 1948-1964 2.3 cu. ft.

Papers of W. Ellison Chalmers, Professor of Economics in the Institute of Labor and
Industrial Relations (1947-1968), including publications and lecture notes and student
records (1964); a reprint "The Conciliation Process" and collected published items on
labor relations, with emphasis on the steel industry and a Fulbright Lectureship in India
(1962-1963); records of the Champaign-Urbana Council for Community Integration
(1954-1964), with minutes, mailing lists, project files, notes and correspondence of the
Council.

RS 22/2/20 SFA - 3 NUCMC 71-1138

CHAMPAIGN-URBANA PEACE COUNCIL RECORDS, 1951-1963, 1965 .4 cu. ft.

Records of the Champaign-Urbana Peace Council including board minutes, brochures and
membership lists (1951-61); Peace Council newsletters (1951-62); correspondence
(1951-63); press clippings (1951-60); statements, lists and clippings on the International
Student Hospitality Program (1952-54) and files relating to the "Share a Meal with India
Project" (May, 1951) through which a car load of wheat was sent to India.

RS 48/5/10

CHAPIN, GEORGE (1882-1934) PAPERS, 1923 .4 cu. ft.

Papers of George Chapin '06, editorial and executive assistant in the President's office
and publicity director in the College of Commerce (1921-1925), including extensive notes
from published sources for a biography of Thomas J. Burrill and correspondence with Alden
Chester, Thomas Finegan, Harlan Horner and Nicholas M. Butler; notes; publications
(1881-1917) and bibliography of Draper's publications assembled for a biography of
Andrew S. Draper.

RS 2/6/23 NUCMC 71-1139

CHASE, HARRY W. (1883-1955) CORRESPONDENCE, 1930-1933 20.7 cu. ft.

General correspondence or subject file of President Harry W. Chase, including
correspondence, reports, memoranda, publications and files received from or sent to
trustees, deans, administrators at other universities, faculty and the public concerning
admissions policies and enrollment statistics; Council of Administration; reports of
colleges, schools, institutes, bureaus and departments; audits and financial reports;
budgets; committees; faculty appointments; relations with trustees, provost, comptroller
and deans; state departments and federal agencies; student housing and social life;
General Assembly visits and sessions and legislative bills, monthly trustees meetings and
similar administrative affairs.

RS 2/7/1 SFA - 24 NUCMC 72-1502

CHEDSEY, WILLIAM R. (1887-) PAPERS, 1913-1960 .6 cu. ft.

Papers of William R. Chedsey, professor of mining engineering (1946-1955), including
correspondence (1934-1943), unpublished papers and biographical data (ca. 1942-1960),
mineral land and mine surveying notes (1913-1937), "Coal Preparation" extension course
materials (1959-1960), "Anti-Submarine Tactical Training course" materials (1943), mining
publications (1931-1958), stockholders quarterly and annual reports and personal
financial records (1940-1960).

RS 11/9/20 SFA - 3 NUCMC 69-241

CHEEVER, ALICE (1854-1917) NOTEBOOKS, 1871-1875 .3 cu. ft.

Student notebooks of Alice Cheever Bryan, Class of 1874, including notes on Regent John M.
Gregory's lectures on education, ancient and constitutional history, moral philosophy,
history of civilization, political economy, duty, religion, young writers and young
ladies. The series also contains lectures on physiology by Professor Don C. Taft, German
themes, courses of study and notes for music teaching at Seymour.

RS 41/30/4 SFA - 1

CLARK, GEORGE L. (1892-1969) PAPERS, 1914-1968 3.6 cu. ft.

Papers of George L. Clark, professor of chemistry (1927-1953), including correspondence, reprints, manuscripts, research data and biographical material concerning editing encyclopedias on microscopy, spectroscopy and X-Rays; consulting work for Delco-Remy Division, the Ohio Oil Company, the Signal Corps, the Chemical Corps, the Ordinance Corps, General Electric, Parker Pen and Joseph Schlitz Brewing Company; crystallography; spectroscopy; X-Ray diffraction research; University and Analytical Chemistry Division administrative matters; doctoral candidates and teaching; professional societies and fraternities; awards and honors; lectures and symposia; sabbaticals; job offers and the scientific interests of colleagues. The series includes an October 17, 1956 taped interview of Clark by Josef Wright concerning X-Ray studies, laboratories and courses and rubber and aircraft metals research.

RS 15/5/31 SFA - 5 NUCMC 71-1140

CLARK, JAMES G. (1913-) PAPERS, ca. 1936 1.0 cu. ft.

Papers of James G. Clark '35, '39, professor of civil engineering (1943-1956), including a 110-page manuscript on design specifications for steel railway bridges and transcripts and copies of specifications collected from railroad companies, bridge construction companies and the engineers who designed and executed the constructions. While most specifications are for steel and iron railway bridges, there are a few specifications for wooden bridges and highway bridges. The series includes notes taken by Mr. Clark.

RS 11/5/27

CLARK, JOHN F. PAPERS, 1961-1964 .3 cu. ft.

Papers of John F. Clark, professor of sociology (1960-1968), including correspondence relating to and description of a 1963 study of the public attitude toward law enforcement and morality in several cities of Illinois and samples of completed questionnaires, study sheets and block supplements for the study. The series contains Clark's files relating to publications, doctoral examinations in the Sociology Department, personal correspondence and Alpha Kappa Delta, a sociology honorary.

RS 15/21/23 SFA - 1

CLARK, THOMAS A. (1862-1932) PAPERS, 1894-1897, 1906-1908, 1910-1932 .7 cu. ft.

Papers of Thomas A. Clark, dean of men (1909-1931), dean of undergraduates (1901-1909) and instructor and professor of English (1893-1899), including letterpress copybooks of Clark's outgoing personal correspondence (10/9/07 - 8/3/08) and letters sent by Clark as secretary of the North Central Association of Colleges and Secondary Schools (4/29/06 - 5/6/08). The personal letterbook includes a letter to Andrew S. Draper on the state of the University (12/13/07) and the North Central letterbooks include letters on requirements for admission to the Association; Executive Committee meetings (12/1/06); University's appropriation request, Council of Administration and English Department (12/15/06); letters to presidents of colleges and universities accepting or rejecting their membership applications (pp. 439-445). The series includes lists of students (1894-1897) showing name, address, mailing address, parents' name and address. The 1910-1932 material consists of articles published by Clark on student discipline, fraternities and morality.

RS 41/2/20 NUCMC 69-242

CLEARY, EDWARD W. PAPERS, 1952-1965 2.0 cu. ft.

Papers of Edward W. Cleary, professor of Law (1946-1967) consisting of the records of the Illinois Supreme Court Jury Instructions Committee minutes and proposed jury instructions (1958-1959); Illinois Judicial Advisory Council minutes, memoranda, sample bills, addresses, proposals, recommendations and correspondence (1958-1959); Illinois Supreme Court Rules Committee drafts, proposals, minutes, memoranda, reports, releases and drafts (1952-1954, 1963-1965); Joint Committee on Illinois Civil Procedure - Rules Committee draft copies of articles and rules, tentative final draft, subcommittee report, Proposed Revised Supreme Court Rules and Revision of Civil Practice Act (1954).

RS 14/2/22 SFA - 1 NUCMC 71-1141

COBLE, ARTHUR B. (1878-1966) PAPERS, 1903-1953, 1964 1.3 cu. ft.

Papers of Arthur B. Coble, professor of mathematics (1909-1947), departmental head (1934-1947) and president of the American Mathematical Society (1932-1934), including publications, manuscripts, calculations, notes, bibliography and correspondence concerning algebraic and projective geometry; elliptic, theta and abelian function theory; symmetric binary forms and involutions; applications of Cremona transformations and groups and related subjects.

RS 15/14/26 SFA - 8 NUCMC 71-1142

COMMITTEE ON INSTITUTIONAL COOPERATION - AGENCY FOR INTERNATIONAL DEVELOPMENT RURAL
 DEVELOPMENT RESEARCH PROJECT FILE, 1950-1968 25.7 cu. ft.

CIC-AID Rural Development Research Project File, including "Building Institutions to Serve Agriculture, A Summary Report. . . ." published by the Committee on Institutional Cooperation and "AID-University Rural Development Contracts and U. S. Universities" by William Thompson, Earl Regnier, Harold Guither and Kathleen Propp (1968); AID and host country and institution publications; AID participant training program publications and proceedings of campus coordinators' conferences (1963-1966); proceedings of conferences on international agricultural programs (1964-1966); lists of contracts and participant directories; participant questionnaires and participant training evaluation study reports (1963-1967); files inventories; rural development contracts between the AID and universities; project descriptive historical publications; pre-contract survey; end-of-tour, consultant, executive visit, progress, annual and final project reports; expenditure summaries; training proposals; participant biographical data, tables and lists and related studies and correspondence. The project covered 68 rural development contracts in 39 countries undertaken by 35 land grant universities. Contracts included overseas advisory service to host institutions by American university staff members, study in the United States by host institution staff (participant training) and commodity assistance to the host institution. Among nations assisted were Ethiopia, Kenya, Malawi, Nigeria, Sierra Leone, Somali, Tanzania, Tunisia, Uganda, Zambia, Cambodia, Ceylon, Taiwan, Indonesia, Korea, Philippines, Thailand, Bolivia, Brazil, Colombia, Costa Rica, Peru, India, Iran, Iraq, Jordan, Pakistan and Turkey. The series includes research files of Technical Assistance Study Group (TASG) of the Agency for International Development.

RS 8/4/40 SFA - 31

CORT, WILLIAM W. (1887-) RECOLLECTIONS, 1964 .1 cu. ft.

A five-page recollection of Henry B. Ward and instruction in zoology and parasitology by William W. Cort, M.A. '11 and Ph.D. '14 and assistant in zoology (1909-1912), including comments on Ward's laboratory, assistantships, graduate students, fish parasites, Ward's work with scientific organizations, research publications and parasitology in the United States. The series includes a 10-page autobiography of Dr. Cort prepared from notes taken in 1966 for the Columbia University Oral History Collection and distributed on his 80th birthday, April 28, 1967.

RS 26/20/2

CRANDELL, JOHN S. (1884-1953) PAPERS, 1932-1947 1.1 cu. ft.

Papers of John C. Crandell, professor of civil engineering (1926-1951), including correspondence, mimeographed papers, publications and related materials concerning highway engineering, pavements, expansion joints, the Highway Research Board, American City Planning Institute, American Road Builders' Association, Committee on Joints and Concrete Pavements, Clay Products Association and state highway departments.

RS 11/5/25 SFA - 3 NUCMC 69-243

CRATHORNE, ARTHUR R. (1873-1946) PAPERS, 1900-1944 .1 cu. ft.

Papers of Arthur R. Crathorne '98, professor of mathematics (1916-1946), including reprints of publications (1916-1944) and a notebook of readings containing three articles translated and copied from mathematics journals and related mathematics problems. Reprints include "Algebra from the Utilitarian Standpoint" (1916), "Required Mathematics" (1917), "Biology of a Life-Table" (1921), "The Course in Statistics in the Mathematics Department" (1926), "The Law of Small Numbers" (1928), "The Problem of Mathematical Statistics" (ca. 1935) and "Henry Lewis Rietz - in Memoriam" (1944).

RS 15/14/24

CRONBACH, LEE J. PAPERS, 1949-1963 .3 cu. ft.

Papers of Lee J. Cronbach, professor of Educational Psychology (1948-1964) and member of the Bureau of Research and Service (1948-1953) and the Bureau of Educational Research (1953-1964), including reports, studies and correspondence relating to research, teaching, publications and professional activities in measurement and educational psychology. The series includes a 1951 preliminary edition for classroom trial of Cronbach's Educational Psychology.

RS 10/4/20

CUNNINGHAM, HARRISON E. (1877-1966) PAPERS, 1891-1963 11.6 cu. ft.

Papers of Harrison E. Cunningham, director of the University Press (1918-1947) and
Secretary of the Board of Trustees (1914-1950), including correspondence, reports,
manuscripts, minutes, financial records, diaries, scrapbooks, albums, clippings,
photographs, publications, art works and related material concerning the functions,
agenda, actions and minutes of the Board of Trustees; management and publications of the
University Press; the University of Vermont; newspaper work (1904-1906); social life in
Urbana (1912-1950); university administration; selection of a president (1944-1945);
securing increased retirement benefits (1949-1958); vacations (1921-1961); travel;
brother-in-law's United States Consular service in Mexico, Spain, Venezuela, Australia,
England and the Bahamas (1918-1944); genealogy; art; drama; languages; financial affairs
and related subjects.

RS 38/1/20 SFA - 8 NUCMC 67-452

CURTISS, WILLIAM G. (1859-1929) SCRAPBOOK, 1878-1882 .1 cu. ft.

Scrapbook of William G. Curtiss '82, containing programs of literary society meetings,
oratorical contests, class day exercises, senior meetings, junior exhibitions, graduation
exercises, university anniversaries, alumni exercises, meetings of the Adelphic, Alethenai
and Philomathean societies and musical concerts; skits and broadsides for the Tautalogical
Tautogs and Senior Slop; copies of student songs; student government and national election
tickets; course admission cards; study lists; receipts; leaves of absence authorizations;
and related material. The scrapbook includes a list of graduates (1872-1880), a program
for October 28, 1881 Gregorian Society meetings, two bank notes (1839, 1862), school
attendance certificate (1867) and oratorical contest grading sheets.

RS 41/20/2

CUSHMAN, ROBERT E. (1889-) PAPERS, 1915-1938 .1 cu. ft.

Papers of Robert E. Cushman, political science instructor (1915-1919), including journal
reprints on city planning and the courts, municipal war work, war legislation, police
power and the national government, the Supreme Court and constitutional law. The series
includes seven letters (June 7 and 8, 1918) concerning future employment, financial
matters, publishing solicitations and personal matters.

RS 15/18/23 SFA - 1

DANIELS, ARTHUR H. (1865-1940) CORRESPONDENCE, 1933-1934 5.3 cu. ft.

General correspondence or subject file of President Arthur H. Daniels, including
correspondence, reports, memoranda, publications and files received from or sent to
trustees, deans, administrators at other universities, faculty and the public concerning
admissions policies and enrollment statistics; reports; budgets; committees; relations
with trustees, provost, comptroller and deans; state departments and federal agencies;
General Assembly visits and sessions and legislative bills; monthly trustees meetings and
similar administrative affairs.

RS 2/8/1 SFA - 5 NUCMC 72-1503

DAVENPORT, EUGENE V. (1856-1941) PAPERS, 1857-1878, 1889-1941, 1948-1949, 1954 9.5 cu. ft.

Papers of Eugene V. Davenport, dean of the College of Agriculture (1895-1922), including
correspondence, manuscripts, publications, photographs, notes and clippings relating to
agricultural education and educators, students, the College of Agriculture's development,
federal-state relations to University agricultural work, agricultural organizations,
agricultural policies and production, farm life, political and economics affairs, labor
and prices, world affairs and World War I, university affairs at Michigan State and
Illinois, retirement, writing and publication, morality and habits, travel, Brazil,
Alaska, celebrations, reminiscences and family affairs. The papers include a 578-page
autobiography, "What One Life Has Seen." Correspondents include Liberty H. Bailey,
Walter C. Coffey, Lloyd C. Douglas, David Kinley, Herbert W. Mumford and John Russell.

RS 8/1/21 SFA - 9 NUCMC 67-453

DEBOER, JOHN J. (1903-1969) PAPERS, 1936, 1940, 1945-1955 3.1 cu. ft.

Papers of John J. DeBoer, professor of education (1947-), including correspondence
concerning the American Education Fellowship's financial problems, DeBoer's
responsibilities as president (1946-1947), director Vinal Tibbetts, convention and
membership support; correspondence, scrapbook and tape recording of a public meeting of
the Champaign-Urbana Committee to Oppose the Broyles Bills (1949-1955); a recording made
with Professor Albert Lybyer for the Illinois Progressive Party (1948); publications on
reading and communication, human relations, peace education and elementary education
(1940, 1945-1951) and two Ezra Pound letters on economic interests and peace (1936). The
Broyles Bills material includes copies of the bills, publications, publicity releases,
clippings, mailing lists, treasurer's records and correspondence with legislators,
newspapers and opponents of the bills. The series includes a copy of Searchlight, with a
foreward by DeBoer and correspondence (1951) and writings about his professional
activities. The file includes material on the Council on Community Integration
(1953-1968), primarily an activity of Mrs. Henrietta DeBoer.

RS 10/7/20 SFA - 3 NUCMC 69-244

DERICK, CLARENCE G. (1883-) PAPERS, 1965-1967 .1 cu. ft.

Papers of Clarence G. Derick, M.S. '09, Ph.D. '10, assistant instructor and associate
(1908-1916), including recollections of chemistry in 1905, spectrum analysis, Dr. William
A. Noyes' contributions to organic chemistry, Noyes' methods as director of the Chemistry
Department and his work as an editor, author and teacher at the University of Illinois.
An autobiographical recollection covers Dr. Derick's teaching methods, new courses
introduced, manufacture of organic chemicals, qualitative organic chemistry, research in
organic compounds, Chemical Abstracts and his decision to join the National Aniline and
Chemical Company as director of the Schoellkopf Research Laboratory. The series includes
a letter on the dyestuff industry and the fluxing process for hot galvanizing.

RS 15/5/30

DICKINSON, FRANK G. (1899-1967) PAPERS, 1932-1967 .6 cu. ft.

Papers of Frank G. Dickinson '21 (1899-1967), professor of economics (1922-1946),
including correspondence, clippings and publications relating to career and publications
(1965-67), economic planning (1932), war costs (1934), insurance (1939), war bonds
and the national debt (1944), costs of medical care and insurance (1946-50, 1963), social
security and the age factor (1937, 1959-65), philanthropy (1962), mathematics (1943, 1952),
travel (1955, 1957) and football ratings (1941). Prof. Dickinson served as Director of
the Bureau of Medical Economic Research of the American Medical Association (1946-57),
director of a study of philanthropy for the National Bureau of Economic Research (1958-62)
and professor of economics at Northern Illinois University (1962-67). The series
includes bulletins 49-105 and miscellaneous papers 1-118 (1947-58) of the Bureau of
Medical Economic Research.

RS 9/5/27 NUCMC 72-1504

DOLAN, THOMAS J. (1906-) PAPERS, 1929, 1935-1970 2.3 cu. ft.

Papers of Thomas J. Dolan, professor of theoretical and applied mechanics (1937-)
including correspondence, reports, photographs and research data relating to the American
Society of Mechanical Engineers (1940-1954); American Society for Testing Materials
(1947-1965); metal fatigue studies (1948-1964); size effect tests and torsional rapid
loading project for the Air Force (1946-1956); fatigue studies for the office of Naval
Research (1945-1958) and pressure vessel research (1948-1955). The series includes
research publications (1929, 1935-1968).

RS 11/11/23 SFA - 1

DOLAND, JAMES J. (1890-1960) PAPERS, 1938-1960 4.3 cu. ft.

Papers of James J. Doland, professor of civil engineering (1926-1958), including
correspondence, reports, publications, blueprints, notebooks and biographical material
relating to hydraulic engineering, hydrologic studies, airport design and construction,
professional engineering associations, publications, New Salem State Park mill plans
(1938), Upper Mississippi River Improvement Study (1938-1945), University Airport
(1941-1946), Union Electric Company of Missouri flood case (1943-1946), highway drainage
research (1946-1951), hydraulic engineering laboratory (1947-1961), water supply studies
(1951-1954) and related matters. Correspondents include George Farnham and John C.
Guillou.

RS 11/5/24 SFA - 4 NUCMC 69-245

DORNER, HERMAN B. (1878-1955) PAPERS, 1891-1938 1.0 cu. ft.

Papers of Herman B. Dorner, professor of floriculture (1911-1946), including course
syllabi and publications relating to courses in floriculture and horticulture and
professional activities in the American Carnation Society and the Society of American
Florists. The series includes his presidential address to the American Carnation Society
(1938), publications by his father, Frederick Dorner (1871, 1895) and Proceedings of the
American Carnation Society (1871-1942, 1947-1953).

RS 8/12/23 SFA - 2

DORSEY, MAXWELL J. (1880-1966) PAPERS, 1890-1966 2.0 cu. ft.

Papers of Maxwell J. Dorsey, professor of pomology (1926-1948), including school
copybooks, maps, report card, graduation program and address (1890-1897); Michigan State
debate records (1905) and Cornell doctoral thesis in pollenization (1913); reprints of
articles on pomology, horticulture and the hardiness of fruit trees (1912-1941);
correspondence and business records of the American Garden Foundation (1945-51), National
Fruit Foundation (1945-51) and National Garden Institute (1945-49); correspondence
concerning horticulture headship (1940-1941); Dial Club history (1940), correspondence
(1930), programs (1929-1966) and citations (1940, 1955); correspondence, technical data
on density and distribution, photographs (negatives, slides and drawings), publications and
bibliography relating to Osage Orange studies; and catalogs, publications, news clippings,
announcements and statistics relating to archery.

RS 8/12/21 NUCMC 69-246

DOWNS, ROBERT B. (1903-) PAPERS, 1937-1949 1.0 cu. ft.

Papers of Robert B. Downs (1903-), director of libraries and library school and
professor of library science (1943-71), including general correspondence, personal letters,
and copies of articles. Letters concern membership in the Dial Club, Grolier Club and
University Club; lectures and committees; invitations; evaluations of librarians;
Conference of Presidents of Negro Land Grant Colleges; negotiations for directorship at the
University of Illinois (1943); reviews; reprints and offprints of published articles; and
honorary degrees from Colby College and University of North Carolina. Correspondents
include L. Quincy Mumford, Leroy C. Merritt, and Carl M. White and Louis Wilson of the
University of North Carolina. The collection includes committee files (1937-43),
containing correspondence, form letters, minutes and reports concerning the joint
committee of the American Library Association and Association of Research Libraries for
developing The National Union Catalog, several Association of Research Libraries
committees, and The Committee of the National Resources Planning Board on the Conservation
of Cultural Resources.

RS 35/1/22

DRAFFIN, JASPER O. (1884-1960) PAPERS, 1930-1957 3.3 cu. ft.

Papers of Jasper O. Draffin, professor of theoretical and applied mechanics (1923-1953),
including photographic prints, plates and negatives, manuscripts, publications,
correspondence and related documents concerning the history of engineering and the College
of Engineering at Illinois. The series includes a 33-chapter manuscript "History of the
Development of Engineering Progress" (ca. 1955) and supporting correspondence concerning
facts and photographs; history of engineering lecture notes; typescript of "A Century of
American Textbooks in Mechanics and Resistance of Materials" (ca. 1945); photograph
negatives and prints (ca. 1000 each) and plates (ca. 100) relating to the historical
development of engineering, inventions, transportation, industry and the Draffin collection
of portraits of engineers, scientists and departmental faculty, staff and students. The
series also includes manuscripts of talks, material on memorials and honors awarded
Engineering faculty members (1930-1945) and photographs of the Engineering faculty, Talbot
Laboratory and materials testing research work in Theoretical and Applied Mechanics.

RS 11/11/20 SFA - 2

DRAPER, ANDREW S. (1848-1913) CORRESPONDENCE, 1894-1904 6.0 cu. ft.

Correspondence received by Andrew S. Draper from trustees Lucy Flower, Laura Evans, Mary Carriel, Francis McKay, Alexander McLean, Julia Smith, Richard Morgan, Nelson Graham, Samuel Bullard and William McKinley on Board affairs; from university presidents Frank Strong, Charles Van Hise, Charles Thwing, William Thompson, Jacob Schurman, George Maclean, Cyrus Northrop, Edmund James, Richard Jesse, William Harper, G. Stanley Hall, Frank Gunsaulus and William Bryan on university administration, Morrill funds, trustee-president relations, entrance requirements, teacher certification, athletics, hazing, student regulations, curricula, salaries, appropriations, and technical and agricultural education. The correspondence includes letters from Illinois school superintendents, parents, teachers' agencies, interest groups and citizens on the College of Agriculture decline, legislative affairs, invitations to speak, solicitations, fraternities, student discipline, morality on campus, farmer's institutes, placement of graduates, correspondence schools, participation in expositions, university extension, Rhodes scholarships and athletics. Correspondents include Newton Dougherty, Lorado Taft, Jonathan Turner, Henry Dunlap, A. G. Judd, Charles Gibson, B. F. Harris, Gov. John Tanner, Gov. Richard Yates, Charles DeGarmo, Albert True, Frank Vanderlip, Herbert Putnam, Joe Cannon, William Lorimer, Frank Mann, R. T. Crane of Chicago on higher technical education, Melvil Dewey on librarian Katherine Sharp, Robert H. Pratt, Indian School Service Superintendent on the Carlisle "Indians," A. H. Pattengill, Chairman of Michigan's Athletic Board of Control on athletics, E. C. Ray, Presbyterian Board of Aid Secretary on public vs. sectarian institutions and W. T. Harris, Commissioner of Education, on plans for expansion of his office.

RS 2/4/1 SFA - 2 NUCMC 65-1918

DUNLAP, HENRY M. (1853-1938) PAPERS, 1874, 1877-1881, 1886-1895, 1900-1931 2.4 cu. ft.

Papers of Henry M. Dunlap '75, state senator (1892-1912, 1916-1932) including correspondence (1911, 1919-1931), news releases and clippings and account books (1877-1881, 1886-1895, 1906-1917), relating to farm and personal business, university appropriations, Republican party politics and election campaigns (1910-1930), legislative business (1911, 1919-1931) and appointments. Legislative correspondence covers state police bills, gasoline tax measures, highways, prohibition enforcement, taxation and revenue, pensions and relief, education, licensing, election returns and patronage. Correspondents include Charles Deneen, Louis Emmerson, Lloyd Morey, newspaper editors and farm employees. The series includes cousin Burleigh A. Dunlap's 1874 summer surveying journal and Mrs. Dunlap's master farm homemaker file (1927-1932).

RS 26/20/13 SFA - 2 NUCMC 69-247

DUNLAP, LESLIE W. (1911-) PAPERS, 1941-1943, 1955, 1956-1959 .3 cu. ft.

Papers of Leslie W. Dunlap, professor and associate director of the Graduate School of Library Science (1951-1958), including reports, correspondence and memoranda relating to the Centennial History Committee (1957-1958), the Social Committee of the University Club (1956-1957) and the University Senate (1957-1959); reports and memoranda from the Board of Trustees (1958), the Graduate College (1956-1958), the Housing Division (1957), the President's Office (1957) and the Provost's Office (1956-1957). A copy of the 1955 Regulations for Undergraduates is included.

RS 35/3/22 SFA - 1 NUCMC 71-1143

DUNLAP, MATTHIAS L. (1814-1875) PAPERS, 1839-1858, 1867-1877 1.1 cu. ft.

Papers of Matthias L. Dunlap of Leyden (1839-1858) and Savoy, university trustee
(1867-1869), including letterbooks (1851-1858), account books (1839-1858, 1867-1877) and
news clippings (1853-1858, 1868-1872) relating to farm, orchard and nursery business;
family affairs; survey, construction, management of and investments in the Western Plank
Road Company; contributions to the Prairie Farmer; evaluations of farm machinery, land
survey reports and settlement at Savoy. The series includes Dunlap's Chicago Tribune and
Chicago Democratic Press articles on agricultural and horticultural topics under the name
of "Rural" and criticisms of classical academic emphases in the university curriculum.
Correspondents include G. H. Rugg and Cyrus H. McCormick.

RS 1/20/2 SFA - 7 NUCMC 69-248

EAMES, MELVILLE J. (1889-1948) PAPERS, 1907-1908 .1 cu. ft.

Papers of Melville J. Eames '12, including 25 postcards sent to his mother, Mrs. E. P. Eames, his grandmother, Mrs. G. F. Poole and his sister, Miss Margaret Eames, between September 29, 1907 and January 6, 1908, concerning studies, weather, health, family and social activities and travel. The postcards carry photographic views of university and community buildings and campus scenes.

RS 41/20/32

EDENS, WILLIAM M. (1903-) PAPERS, 1950-1951 .6 cu. ft.

Papers of William M. Edens '24, Secretary of the Advisory Committee of the College of Commerce and Business Administration and Assistant Comptroller of the Continental Illinois National Bank and Trust Company of Chicago, including correspondence, press clippings, minutes of meetings, reports, statements and work papers relating to the Advisory Committee's role in gathering and evaluating information and submitting reports concerning controversies in the College and the Department of Economics involving the faculty executive committee, President George D. Stoddard, Dean Howard R. Bowen, and Professor Everett E. Hagen; reports of the Harno and Cleary committees and opinions of faculty, trustees and members of the business community. The file includes correspondence of Chairman Henry C. Hawes and Secretary Edens.

RS 26/20/21 RESTRICTED NUCMC 72-1505

EKBLAW, KARL J. T. (1884-1947) PAPERS, 1917-1929 4.0 cu. ft.

Papers of Karl J. T. Ekblaw '09, M.S. '13 (1884-1947), assistant (1909-11), instructor (1911-13) and associate (1913-17) in agricultural engineering; president of the Alumni Association (1935-36) and the University of Illinois Foundation (1937-1938); professor of agricultural engineering at Kansas State University (1917-19); editor and counselor for the National Farm Power Company (1919-23); engineer and educational director of the Portland Cement Association (1923-28) and vice president of the Frank B. White Advertising Company (1928-30). The papers include photographs and sales and maintenance literature on tractors, trucks, harvesting equipment, concrete construction, electrification, farm buildings, agricultural implements, water supply, tractor tests (1918-19) and travel.

RS 8/5/24 SFA - 3

EMCH, ARNOLD (1871-1959) PAPERS, 1901-1954 1.0 cu. ft.

Papers of Arnold Emch, professor of mathematics (1911-1939), including lecture notes, a manuscript copy of _Algebraic Geometry_, reprints of publications (1901-1941) related to algebraic geometry, Automorphic Functions (1913-1914), and Riemannian Geometry (1924) and a letter from his son (1954).

RS 15/14/23 NUCMC 71-1144

ENGER, MELVIN L. (1881-1956) PAPERS, 1907-1939 .3 cu. ft.

Papers of Melvin L. Enger, professor of mechanical and hydraulic engineering (1907-1926), head of the Department of Theoretical and Applied Mechanics (1926-1934), and Dean of the College of Engineering and Director of the Engineering Experiment Station (1934-1949), including correspondence, drawings (1934), photographs and working papers (1929-1935) relating to the sectional committee on specifications for cast iron pipe, Meehanite and related matters. The series includes photographs, graphs, tables and calculations in water flow and vertical jet research (1908-1918) and photographs of hydraulic laboratory research projects.

RS 11/11/21 NUCMC 69-249

ENGLIS, DUANE T. (1891-1974) PAPERS, 1912-1967 7.1 cu. ft.

Papers of Duane T. Englis (1891-1974), Ph.D. '16, professor of chemistry (1922-1959), including correspondence, retirement banquet material (1959), research notebooks and published articles (1920-58), relating to the analysis of carbohydrates; ion exchangers, spectrophotometric analysis, color of sugar products, levulose from artichokes, water analysis and consulting and professional activities. The papers include material concerning students, including abstracts of theses prepared under Englis' supervision (1933-52), adviser's material (1929-58), laboratory work and test records (1912-57), student notebooks (1927-33, 1938, 1948-49) and material on chemistry and food technology courses including a water chemistry course and an analytical seminar. The series includes subject file material relating to analytical chemistry, artichoke research, quantitative methods, corn, food technology, A. E. Staley Manufacturing Company, starch, sugars and water treatment. Correspondents include Justin J. Alikonis, Harold A. Fiess, Jack M. Gillette, Gordon O. Guerrant, Donald J. Hanahan and Russell J. Kiers.

RS 15/5/34 SFA - 4

ERICKSON, EDGAR L. (1902-1968) PAPERS, 1937-1965 9.6 cu. ft.

Papers of Edgar L. Erickson, professor of history (1938-1967), including correspondence, manuscripts and notes on the history of England and the British Empire, the collection and reproduction in microprint of the British Sessional Papers (1947-1954); the activities of the American Historical Association's Committee on Documentary Reproduction and the Overseas Scholarship (Fulbright) program to reproduce essential foreign records; manuscripts on "The Foundation of the Civil Affairs/Military Government Doctrine of the United States Army in World War II" and "The Introduction of Coolie Labor in the West Indies" and course materials. The papers include many army publications concerning Mr. Erickson's training in Chemical Warfare (1942-1943) and research as historian for the Civil Affairs/Military Government division.

RS 15/13/30 SFA - 16

ERLANGER, MARGARET PAPERS, 1929-1968 5.0 cu. ft.

Papers of Margaret Erlanger, professor of physical education for women (1948-1968) and
dance (1968-), including correspondence, photographs, newspaper clippings, programs,
reprints, reports, films, recordings, posters and scrapbooks concerning
dancers-in-residence (1948-1966); Contemporary Arts Festivals (1956-1967); Dance Division
annual reports (1949-1968); events lists and programs (1948-1965); workshops, concerts,
conferences and symposia (1964-1967); dance curricula (1949-1962); National Dance Section
(1951-1952, 1957-1958); New Zealand (1953) and Japanese (1961-1962) sabbaticals; thesis on
dance drama (1935); reprints of articles and manuscripts (1942-1966); biographical
material (1934-1948); Orchesis minutes (1954-1960, constitution (1950-1960), financial
records (1957-1960) and reports (1955-1957) and dance demonstrations and routines
(ca. 1940); scrapbooks cover May Day festivals (1910, 1913, 1915-1920), Orchesis
(1929-1958), Dance Division News (1960-1967) and tours (1963-1965). Correspondents
include Merce Cunningham, Agnes DeMille, Halim El-Dabh, Ann Halprin, Masami Kumi, Lin Pei
Fen, Katherine Litz, Ruth St. Denis and Paul Taylor.

RS 12/13/20 SFA - 10 NUCMC 71-1145

ESPY, WILLIAM N. PAPERS, 1912-1964 4.0 cu. ft.

Papers of William N. Espy (1893-), M.S. '26, professor of mechanical engineering
(1930-1961), including undergraduate notes, graduate notes, teaching notes, research
results, newspaper and magazine clippings on thermodynamics, heat transfer, and
mechanics, correspondence (1926-63), materials and letters concerning Tau Beta Pi
(1922-50), materials on Pi Tau Sigma (1932, 1939, 1948) and books on mechanical
engineering.

RS 11/8/22 SFA - 1

EVANS, JAMES F. PAPERS, 1924-1949, 1967 4.0 cu. ft.

Papers of James F. Evans, professor of agricultural communications and journalism
(1968-), including a 1967 article "News? That Ain't Hay" and advertising proof books
of the Aubrey, Moore and Wallace agency for International Harvester Company trucks and
industrial power equipment (1924-1949).

RS 8/3/22 SFA - 1 NUCMC 71-1146

FACULTY PLAYERS RECORDS, 1906-1967 2.3 cu. ft.

Faculty Players Records including constitutions (1954, 1961-62), secretary's minutes (1914-38, 1953-67), correspondence (1953, 1956, 1961-67), financial statements (1953-63), membership records (1956-57, 1964), scrapbooks (1906-64), photographs (1906-07, 1914, 1926, 1930, 1935-36, 1946-48, 1951, 1953), programs (1910-63), clippings, posters, publicity flyers, playbooks (1906-69), and glass plates (1906-18). The series includes minutes, annual reports, clippings and pamphlets (1914-16) of the Drama League of America, Champaign-Urbana Centre.

RS 48/3/1

FAIRLIE, JOHN A. (1872-1947) PAPERS, 1885-1947 32.0 cu. ft.

Papers of John A. Fairlie, professor of political science (1909-1941), Managing Editor of the American Political Science Review (1916-1925), including correspondence, notes, text outlines, manuscripts, clippings and reprints concerning public administration, state, county, township and municipal government and related topics. The correspondence includes material relating to the American Political Science Association, the National Municipal League, the Social Science Research Council, the Illinois Special Tax Commission (1910), the Illinois Efficiency and Economy Committee (1913-1915), University and departmental matters, staff appointments, Illinois Public Aid Commission (1941-1947), American Association of University Professors, and family affairs. The series includes chronological correspondence (17 cubic feet), subject file (8 1/2 cubic feet), Efficiency and Economy Committee papers (5 cubic feet) and Special Tax Commission papers (1 1/2 cubic feet). Correspondents include Edmund J. James, Frank W. Taussig, David Kinley, James W. Garner, Frank J. Goodnow, Frederick A. Ogg, Charles A. Beard, Charles E. Merriam, Walter F. Dodd and Frederick A. Cleveland.

RS 15/18/21 SFA - 14 NUCMC 65-1308

FARM FOUNDATION ARCHIVES, 1940-1973 10.6 cu. ft.

Farm Foundation Archives including published annual reports (1957-73); bibliographies (1970, 1973); copies of "Increasing Understanding of Public Problems and Policies," a group study of topics in the field of extension education presented at national agricultural policy conferences (1951-72); publications of the National Public Policy Education Committee (1960-70); minutes of meetings of the National Committee on Agricultural Policy (1949-68) and Interregional Land Tenure Committee (1955-72) and minutes, bibliographies, proposals, papers, research bulletins and reports and reprints from regional meetings on farm management extension and research, land economics, land tenure research, marketing extension and research, resource economics and rural sociology.

RS 8/4/50 SFA - 4

FAUST, ERNEST C. PAPERS, 1919-1933, 1938-1944, 1964 .3 cu. ft.

Papers of Ernest C. Faust, A.M. 1914 and Ph. D. 1917, including Faust's correspondence with Zoology Professor Henry B. Ward relating to parasitology in China, collection of specimens, publications, professional societies, positions, Dr. Charles W. Stiles, paragonimus, Human Helminthology and related topics. The papers include a four-page 1964 recollection of Henry Ward by Faust relating to Ward's correspondence with foreign scientists, Journal of Parasitology, parasitological library, classes, publications and students and Faust's career. Faust was an assistant (1912-1914) and instructor (1917-1919) at Illinois, parasitologist at Peking (China) Union Medical College (1919-1928) and professor of parasitology, tropical diseases and hygiene at Tulane University School of Medicine (1928-).

RS 26/20/1

FAYE, CHRISTOPHER U. (1886-1967) PAPERS, 1934-1961 .1 cu. ft.

Papers of Christopher U. Faye, Library Cataloger (1927-1952) and assistant professor
(1945-1952), including a bibliography of writings on Zulu Philology, religion and theology
and librarianship; notes on Bible exhibits (1934-1935); reprints, book reviews and
announcements and lecture outlines on "The Western Book," "Transcription and
Transliteration" and "The Cataloging of Manuscripts."

RS 35/2/20

NUCMC 65-1309

FILBEY FAMILY PAPERS, 1900-1913, 1920-1961, 1969 1.0 cu. ft.

Filbey Family Papers including commencement, dance and social events announcements,
programs, tickets and accounts (1900-1913, 1920-1944); correspondence (1930-1961) of
Edward J. Filbey (1879-1959), professor of accounting (1919-1947), relating to university
business, accountancy, Wesley Foundation, YMCA and students; a university scrapbook
(1925-1927) of Dorothy M. Filbey Ross '29 and a 122 page typescript copy of "The Early
History of the Deans of Women . . . 1897-1923" by Mrs. Mary L. (N. V.) Filbey (1969).

RS 41/20/38

NUCMC 72-1506

FISCH, MAX PAPERS, 1928-1967 10.0 cu. ft.

Papers of Max Fisch (1900-), professor of philosophy (1946-1969), including
correspondence, research and teaching notes, manuscripts and publications relating to
meetings, conferences, institutes and lectures; the American Philosophical Association
(national and Western Division, 1944-1957); the American Council of Learned Societies
(1953-1959); Interamerican Congress of Philosophers (1956-1958); Case Western Reserve
University (1942-45); East-West Philosophers' Conference (1959-1964); visiting
professorship at Keio University (1958-1959); International Association of Universities
(1950-1955); Graduate College faculty committees (1953-1964) on staff, grading and
social sciences; departmental affairs, course material and student term papers (1945-1964).
Correspondents include Thomas G. Bergin, Lucius Garvin, Cornelius Kruse, Victor Lowe,
Jared S. Moore and George A. Sabine.

RS 15/16/22 SFA - 9

FLEMING, ROBBEN W. (1916-) PAPERS, 1957-1958 .1 cu. ft.

Papers of Robben W. Fleming, Director of the Institute of Labor and Industrial Relations
(1952-1958) and law professor (1957-1965), including correspondence concerning the
Committee on Visiting Speakers, including rules, requests, report forms and rule revisions.

RS 14/2/21

FLEMING, VIRGIL R. (1879-1944) PAPERS, 1904 .1 cu. ft.

Papers of Virgil R. Fleming '05, professor of theoretical and applied mechanics
(1917-1944), including a laboratory notebook describing experimental procedures, data and
results for courses in Testing and Applied Mechanics (experiments A-L) and Hydraulics
(experiments A-K). The notebook includes supplementary graphs and tables.

RS 11/11/22

FLETCHER, HARRIS F. (1892-) PAPERS, 1926-1970 2.6 cu. ft.

Papers of Harris F. Fletcher, professor of English (1926-1962), including correspondence, publications, manuscripts and research materials relating to John Milton studies, seventeenth century English literature, publications, awards and honors, speeches and reports, students and university committee projects. Correspondents include Denis Saurat, Bror Danielsson, James M. Osborn, J. Milton French, Don Allen, H. S. Bennett, Gunnar Qvarnstrom, Frank A. Patterson, Jacques Barzun, T. O. Mabbott, Carl W. Ackerman and University officials. The series includes class record books (1927-1961). The series includes typed copy, editor's notes and galley and page proofs for The Intellectual Development of John Milton (two volumes, 1956, 1961).

RS 15/7/25 SFA - 2

FORBES, STEPHEN A. (1844-1930) PAPERS, 1877-1929 .1 cu. ft.

Papers of Stephen A. Forbes, director of the Laboratory of Natural History (1877-1917), Chief of the Natural History Survey (1917-1930), State Entomologist (1882-1917), and professor of zoology (1884-1909) and entomology (1909-1921), including separates and reprints of published articles and addresses relating to economic entomology (1904-1917); the food of fishes, birds and insects (1877-1888); public school science work (1889, 1904, 1929); limnology (1887) and ecology (1908, 1912, 1929); water pollution (1918-1919, 1926) and his military career (1911). The series includes diplomas and membership certificates, 1898-1923, and State Normal University diploma of Mrs. Forbes, 1872.

RS 43/1/25 NUCMC 65-1919

FORESTER'S CORRESPONDENCE, 1919-1929 4.0 cu. ft.

Correspondence of Robert B. Miller, State Forester (1919 - May, 1925), and Clarence J. Telford, Survey Forester (June, 1926 - September, 1927) and Extension Forester (October, 1927-1929), with U. S. Forest Service officials; school administrators; state foresters, e. g. Edmund Secrest (Ohio), Charles C. Deam (Indiana) and Irvin C. Williams (Pennsylvania); James W. Toumey (Yale); Henry C. Cowles and George D. Fuller (Chicago); Percy Risdale (American Forestry Association); Robert Ridgway and the public concerning surveys and forestry circulars, Arbor Day and memorial tree plantings, advice on planting and growing trees, strip mine tree planting, timber prices, nut trees, forest fire protection, state park sites, forest preserves, training for forestry work and administrative matters.

RS 43/2/1

FORESTER'S WORKPAPERS, 1920-1925 .6 cu. ft.

Forester's workpapers including inventory sheets, lists, maps, tables, worksheets, clippings, press releases, questionnaires and correspondence relating to surveys of timber resources in Illinois counties, studies of markets for woodland products, the State Forester Robert B. Miller's activities, the New York State College of Forestry and related subjects.

RS 43/2/5

FREER, LOUISE (1884-1966) PAPERS, 1941-1953 .1 cu. ft.

Papers of Louise Freer, professor of physical education for women and department head
(1915-1949), including appointment notices (1941, 1947), clipping on retirement (1949) and
alumni citation from Cornell College (1953).

RS 16/4/20

FREIDEL, FRANK PAPERS, 1939-1950 1.3 cu. ft.

Papers of Frank Freidel, professor of history (1949-1953), consisting of a collection of
news clippings from American newspapers and periodicals and related publications arranged
by subject, course syllabi, examinations (1939-1940, 1943-1945, 1948) and reading lists.

RS 15/13/31 SFA - 6

FRIEDMAN, MARTHA PAPERS, 1966, 1968 1.4 cu. ft.

Papers of Martha Friedman, history librarian, including material from the 1968 Democratic
National Convention in Chicago (August 19-29, 1968). The series includes material
relating to press coverage, security, Richard J. Daley, speeches, internal planning,
Credentials Committee, Platform and Resolutions Committee, Rules Committee, Special
Equal Rights Committee and the Democratic National Committee; candidates (including
Lar Daly, Richard Hughes, Hubert Humphrey, Edward Kennedy, Eugene McCarthy, George
McGovern, Edmund Muskie and George Wallace); non-party groups at the convention; and the
protests and demonstrations held in Chicago during the convention including handouts,
newspapers and the City of Chicago's report on the disturbances. The series includes a
1968 pamphlet on the Socialist Labor Party.

RS 35/3/26 SFA - 1

FULLER, HARRY J. (1907-) PAPERS, 1937-1938, 1946-1949, 1956-1958 .6 cu. ft.

Papers of Harry J. Fuller, professor of botany (1932-), including outgoing
correspondence with professors, botanists, students and the general public relating to
botany course work and curriculum at the University, identification of plant specimens and
answers to other botanical questions, letters of recommendation for former students,
botany conferences, publications and work on the Council for Basic Education. The series
includes his outgoing correspondence, as editor of the Plant Science Bulletin, with
professors, botanists, librarians and the Bulletin's editorial board relating to receipt
of articles and news notes, editorial problems and continued publication and future plans
of the Bulletin (1956-1958). The series also includes his outgoing correspondence as
treasurer of the Botanical Society of America, with Society members and officers, relating
to membership status, receipt of dues and other financial matters of the Society
(1956-1957). The series includes two of his publications, Outline of Economic Botany
(1939) and Laboratory Manual for General Botany (1956).

RS 15/4/25 SFA - 4 NUCMC 71-1147

37

FUSON, REYNOLD C. PAPERS, 1924-1964 .4 cu. ft.

Papers of Reynold C. Fuson, professor of chemistry (1928-1963), including correspondence and related material concerning appointments, Alpha Chi Sigma, American Chemical Society, book publication, Center for Advanced Study, Class of 1930, committees, contacts with Italian and German chemists, grants, university lectures, consulting work, organic chemistry research, university and industrial research in chemistry, former students' graduate work and employment, Fuson Fund, honors and awards, John R. Kuebler Award, Honorary degree from Montana State, patent, speaking engagements, sabbatical leaves (1935-1936 and 1952-1953 in Italy) and travel. Correspondents include Roger Adams, A. P. Tanberg, Wallace H. Carothers and Elmer P. Kohler. The series includes "It Happened at Illinois" (January 10, 1966), "Autobiographical Notes" (September 6, 1966) and "Chemistry at Illinois: A Centennial Review" (October 18, 1967) which contain recollections of Fuson's family, school days and graduate study; the Illinois Chemistry Department; faculty; students; textbooks and academic honors. The series includes a bound volume of his scientific papers (1924-1940).

RS 15/5/24 NUCMC 67-456

GAA, CHARLES J. PAPERS, 1948-1954 .1 cu. ft.

Papers of Charles J. Gaa, professor of accountancy (1946-1955), including class record books showing date, course, section, room and student's names and grades on problems, homework and examinations in accounting courses.

RS 9/2/22

GARNER, JAMES W. (1871-1938) PAPERS, 1830, 1891-1939, 1942 3.6 cu. ft.

Papers of James W. Garner, professor of political science (1904-1938), including clippings, correspondence, programs, photographs, diaries (1920-1921, 1935-1936), notes, manuscripts and reprints of publications relating to Reconstruction in Mississippi (1896-1902), criminal law and political science (1907-1914), American and French government and legal systems (1914, 1921, 1929), international law (1914-1938), foreign policy and world peace (1922-1938), arbitration (1924), Monroe Doctrine and Latin American affairs (1926-1930), World Court and League of Nations (1930-1932) and Fascism, Nazism and war threats (1926, 1933-1938). The papers include notes taken at Chicago (1896-1899) and Columbia (1900-1903); manuscripts on the Civil War (1900), state government (1908), Lincoln (1909), municipal government (1910) and Americanism (1920); clippings on lectures in France and Great Britain and addresses at conferences, professional meetings and commencements (1907-1938); testimonial letters from political scientists (1934); travel memorabilia; book reviews and biographical material compiled by John A. Fairlie (1942). The series includes 52 bound reprints of Garner's articles on American and French government and international law (1904-1938).

RS 15/18/20 SFA - 2 NUCMC 65-1920

GILKERSON, HIRAM (1853-1929) and PORTIA PAPERS, 1875-1881, 1890-1910 .3 cu. ft.

Papers of Hiram Gilkerson '77 and Portia Moffett Gilkerson, LAS 1875-1876, including Hiram Gilkerson's photograph exchange album (1875-1877), Portia Gilkerson's diary (1878-1879, 1881, 1892-1897) and autograph album (1888-1893), photographs of relatives' homes in the Carbondale area (ca. 1900) and farm scenes in Kansas (1890's); photographs of 1902 Illinois baseball team, flag rush (ca. 1910), parade and Jennie M. Latzer; photographs of family and farm life in Illinois (ca. 1890-1910) and memorabilia. The diary includes entries relating to farm life in northern Illinois, household work, friends and relatives, health, weather, travel, Worlds Fair and June, 1893 Alumni Reunion.

RS 26/20/5

GLOVER, ANNA C. PAPERS, 1909, 1915-1916, 1920-1928, 1931-1943, 1946-1952 .7 cu. ft.

Papers of Anna C. Glover, Experiment Station secretary and manager and editor of publications (1915-1954), including correspondence with Eugene Davenport (1915-1916, 1920, 1922-1928, 1931-1941), concerning honors, vacations and travel, family affairs, publications and agricultural education; photographs of Davenport; Davenport biographical material (1909, 1915, 1921-1922, 1925, 1928, 1931, 1933-1938, 1941-1943, 1947-1952); Eugene Davenport Portrait Committee report, minutes and correspondence (1931-1934); Timberland Times file (1950); manuscript history of Agricultural Education of Less than College Grade (1939); articles, obituaries and memorials concerning Herbert W. Mumford (1932, 1938) and Henry P. Rusk (1939, 1946-1948, 1952), correspondence (1940-1941, 1948) and correspondence and publications relating to the 50th Anniversary of the Experiment Station (1937-1938).

RS 8/2/20 NUCMC 71-1148

GOBLE, GEORGE W. (1887-1963) PAPERS, 1918-1957 8.7 cu. ft.

Papers of George W. Goble, professor of law (1921-1956), including correspondence, reports, minutes, manuscripts, notes, work papers, publications and teaching material relating to contracts (1920-1953) and insurance (1920-1949) law, legal curriculum (1920-1944), jurisprudence (1920-1954), publications, Retirement System (1937-1956), University boards and committees (1924-1957), War Labor Board (1941-1944) and personal and community affairs (1918-1946). The series contains material on Professor Goble's casebooks on contracts and insurance, his service as legal advisor to the University Retirement System and public member of a regional War Labor Board panel, revision of the state insurance code, committee work on curriculum and examinations for the Association of American Law Schools, Athletic Board, Illini Union Board, Student Affairs Committee, University Council and program committees for Labor Relations and Social Work and Personnel Administration.

RS 14/2/20 SFA - 10 NUCMC 69-250

GOLDMAN, MARCUS S. (1894-) PAPERS, 1917-21, 1931, 1939-46, 1958-72 .1 cu. ft.

Papers of Margus S. Goldman, A.M. '17, Ph.D. '31 (1894-), professor of English (1936-1962), including reviews, a copy of his dissertation, Sir Philip Sidney and The Arcadia (1931), newspaper clippings, Class of 1917 circular letters on reunions (1966-72), memorabilia and a tape recorded interview with comments on growing up in Middletown, Ohio, his experiences at the university, his service with the American Field Service Ambulance Unit in France during World War I and with Military Intelligence during World War II, serving as ground operations officer for the first Bikini atomic bomb tests, the founding of the American Legion in Paris, life as a student at the University of Paris and his association with young writers including Raymond Guthrie, Stephen V. Benet, Gertrude Stein and James Joyce as music and literary critic for the New York Herald European Edition, the Bernbaum-Zeitlin English Department feud, his teaching career at Illinois, his admiration for Irving Babbitt and criticism of Herbert Hoover, and his views on serving in the military and American politics.

RS 15/7/33 SFA - 6

GOLDSTEIN, LADISLAS (1906-) PAPERS, 1947-1972 5.6 cu. ft.

Papers of Ladislas Goldstein (1906-), professor of Electrical Engineering (1951-72) and visiting professor of Physics at the University of Paris-Orsay (1957-58, 1963-64, 1967-68), including correspondence with scientists, research foundations, corporations, government agencies, professional societies, university and departmental administrators, faculty and graduate students and research proposals, contracts, renewals, progress reports, data, photographs, financial statements and reprints relating to gaseous electronics of plasma, microwave propagation through media containing free electrons, infrared radiation detection, and nuclear physics. The papers include administrative documentation relating to the Gaseous Electronics Laboratory and programs and correspondence for international scientific conferences and symposia. Correspondents include John G. Anderson (General Electric), V. A. Bailey (Sydney), Terenzio Consoli (Saclay), Jean-Loup Delcroix (Orsay), Pierre A. Grivet (Orsay), Henry Margenau (Yale), Tadashi Sekiguchi (Tokyo), Joseph Taillet (Saclay), Joseph T. Verdeyen (Illinois) and Stanley D. Winter (Saclay). Goldstein was visiting professor at the University of Rome (May - June 1958) and recipient of a Guggenheim Fellowship (1957-58) and the Microwave Prize (1958).

RS 11/6/24 SFA - 7

GOLDSTEIN, ROBERT (1947-) PAPERS, 1966-1967 .1 cu. ft.

Papers of Robert Goldstein '68, including his files as a <u>Daily Illini</u> reporter on the University's non-recognition of the W.E.B. DuBois Club and the Clabaugh Act. The papers contain photocopies and original releases, publications, letters, resolutions and announcements by the Liberty Council and the <u>Rubicon Review</u>, J. Edgar Hoover, Senate Committee on Academic Freedom and Tenure, Senate Committee on Student Affairs, Faculty Senate, Board of Trustees Committee on General Policy, State Senate, Champaign-Urbana University Committee, American Association of University Professors, Students Against the Clabaugh Act and Students for Free Speech.

RS 41/20/25 NUCMC 69-251

GOLDTHWAITE, NELLIE E. (1863-1946) PAPERS, 1909-1912 .1 cu. ft.

Papers of Nellie E. Goldthwaite, professor of household science (1911-1915), including a report of the "Exercises in Commemoration of the Seventy-fifth Anniversary of Mount Holyoke College" (1837-1912) consisting of a five-page written report, program, festival procession programs and newspaper clippings. The series includes "Contributions on Jelly-Making" (1909-1910).

RS 8/11/21

GOSS, EDNA LUCY (1876-1939) NOTEBOOK, 1900-1902 .1 cu. ft.

A manuscript notebook (1900-1902) kept by Edna Lucy Goss, BLS '02, as a student in the Library School, containing notes on Miss Katherine Sharp's classes in cataloging and classification, with sample cards, reports on visits made to Chicago libraries and directions for practice work at the University Library. The series includes Miss Goss' correspondence with Phineas L. Windsor concerning the notebook (1938) and a manuscript list of book numbers used at Bryn Mawr College Library for Latin and Greek authors.

RS 41/30/6

GOTSHALK, D. WALTER (1901-1973) PAPERS, 1925, 1927-1972 9.3 cu. ft.

Papers of D. Walter Gotshalk (1901-1973), professor of philosophy (1930-65), including correspondence, reports, minutes, programs, manuscripts and notes relating to meetings, programs, lectures and publications of the American Philosophical Association, the American Society for Aesthetics, American Council of Learned Societies and the American Association of University Professors; University Senate, Graduate College Executive Faculty and Staff and Courses Committee, Social Science Division and departmental affairs; graduate training and placement; staff recruitment and promotions; budgets; course offerings, publications and comments on books and articles on philosophy and personal matters. Correspondents include philosophy professors, officers of professional associations, University administrators, relatives and friends.

RS 15/16/20 SFA - 12

GRAHAM, ARCHIE J. (1873-1947) PAPERS, 1905-1923 .5 cu. ft.

Papers of Archie J. Graham, instructor in surgery (1913-), including 53 letters from
Edmund J. James relating to medical education in Urbana and Chicago, alumni activities,
the George Kemp affair, legislative campaigns, College of Physicians and Surgeons property
and stock. The series contains a chronological listing of the letters by Dr. Graham with
his comments. Professor Graham, who attended the University (1895-1898), took his M. D.
at the College of Physicians and Surgeons in 1902. Prominent in Alumni affairs, he was
president of the Association (1913-1914) and active in promoting the affiliation of the
College and the University. A scrapbook includes a collection of souvenirs, records and
newspaper accounts of events connected with the affiliation of the Medical School,
campaigns for appropriations and alumni events. See also Lobbying Days, A. H. Graham,
M. D., a 131-page typescript, in Carl Stephens Source File, "Chicago Colleges," RS 26/1/20.

RS 52/2/18/20 and 26/30/1

GRAHAM, GENE S. (1924-) PAPERS, 1959-1971 1.6 cu. ft.

Papers of Gene S. Graham (1924-), professor of journalism (1965-), including
correspondence; transcripts of tape recorded interviews; newspaper and magazine clippings;
briefs, motions and decisions; notes; manuscript drafts and typewritten copy for
One Man One Vote; The American Levellers, the story of the personalities and the legal
and political factors involved in the Kidd vs. McCanless and Magraw vs. Donovan cases
leading to the Baker vs. Carr decision of the Supreme Court relating to legislative
representation. Correspondents and interviewees include Walter Chandler, Archibald Cox,
James Cummings, Maclin P. Davis, Jr., Frank Farrell, Dan Magraw, Wayne Miller, William E.
Miller, Tommy Osborn, Charles Rhyne, Earl Warren and Ben West.

RS 13/3/20 SFA - 7

GRAY, HORACE M. (1898-) PAPERS, 1921-1966 15 cu. ft.

Papers of Horace M. Gray, professor of economics (1927-1966) and assistant and associate
dean of the Graduate School (1938-1948), containing correspondence, reports, briefs,
manuscripts, publications, clippings, pamphlets, press releases and related material
covering administrative activities (1929-1962) including graduate work, Inter-American
programs, Institute of Labor and Industrial Relations (Director, 1947-1948), future
university programs, teacher training, Fulbright competitions and awards and university
policies; governmental activities (1942-1965) including national and regional War Labor
Board cases, oil depletion allowances, water resources and power, tax studies, natural
resources policy and economic concentration; professional and personal activities
(1927-1966) including utilities studies, water power, public power ownership and policies,
Federal Power Commission, Association of Land Grant Colleges and Universities, science
legislation, water resources and conservation, depletion and amortization, river system
authorities, American Association of University Professors, academic freedom, Midwest
Economics Association and subsidies; and manuscripts and publications (1921-1966) about
the economics of public utilities, air transportation, taxation, rural electrification and
monopolies.

RS 9/5/22 SFA - 15 NUCMC 69-253

GREGORY, ALFRED (1858-1946) NOTEBOOKS, 1877-1878 .1 cu. ft.

Notebooks kept by Alfred Gregory in Regent John M. Gregory's courses on Constitutional
History and Logic.

RS 41/30/2

GREGORY, JOHN M. (1822-1898) PAPERS, 1838-1898 3 cu. ft.

Correspondence, manuscripts, publications and related papers of John M. Gregory, including
early family correspondence (1838-1865); manuscripts of lectures, sermons, articles and
addresses (1839-1867); Union College class notebooks (1845); Michigan State Teacher's
Institute notebooks (1859, 1863); announcements of appointment as President of Kalamazoo
College (1864); The Sunday School Teacher articles (1866-1867); letterbook (1864-1869,
1874-1877); Regent's correspondence (1870, 1878-1879); addresses (1870-1880); drafts of
inaugural address and letter of resignation (1868, 1880); "chapel talks" and "University
Lectures" (1868, 1870, 1875-1877); lecture notes for political economy, mental philosophy
and constitutional history courses; published University trustees' minutes, announcements,
catalogs and advertisements (1867-1880); records of trustee General Mason L. Brayman
(1867-1868); draft bill to establish Illinois Industrial University; clippings, trustees'
correspondence and unpublished committee report censuring trustee Matthias L. Dunlap for
anonymous attacks against the university (1868); draft Military Committee report on the
organization of military training (1867); general correspondence (1880-1898);
correspondence with Louisa Allen Gregory (1881-1885), son Grant Gregory (1884-1896); and
with Dorman B. Eaton and others concerning Civil Service Commission (1883-1885);
recommendations for diplomatic posts (1881, 1887); letters from Jonathan B. Turner (1892,
1898); manuscripts of articles, addresses and lectures (1880-1898); diaries and account
books (1880-1888); journal of European travels (1885-1887, 1889); library inventory (1890);
manuscript of dialectical novel Table Talk and page proofs of revised edition of Gregory's
Political Economy.

RS 2/1/1 NUCMC 65-164

GREGORY, LEWIS T. (1891-1967) SCRAPBOOK, 1909-1913 .4 cu. ft.

Scrapbook of Lewis T. Gregory '13, containing photographs, programs, clippings, brochures,
fraternity newspapers, examinations, "proclamations" and other memorabilia relating to
campus life, fraternities, visits of dignitaries, dances, athletic contests and university
events.

RS 41/20/1

GREGORY, LOUISA ALLEN (1856-) NOTEBOOKS, 1873-1879 .6 cu. ft.

Lecture notes on domestic science and other papers of Mrs. John M. Gregory, including notes
on ventilation, food etiquette and other lectures; manuscripts of addresses on such topics
as "What Every Girl Should Know," "What Should We Teach Our Girls," and "Domestic Science
at Illinois Industrial University;" some notes of lectures attended by Mrs. Gregory.

RS 2/1/4 SFA - 1

43

GRIFFITH, COLEMAN R. (1893-1966) PAPERS, 1919-1963 18.3 cu. ft.

Papers of Coleman R. Griffith, Provost (1943-1953), Director - Bureau of Institutional
Research (1943-1944) and professor of education and educational psychology (1922-1955)
about personal affairs (1921-1962) - correspondence with faculty, university presidents,
Adlai Stevenson and Griffith's father and son about publications, speeches, research,
university presidency, organizations, students, books, dismissal of George Stoddard and
Griffith, politics, conferences, athletics and the University Press; speeches; curriculum
vitae and newspaper clippings; educational psychology (1919-1962) - correspondence with
psychologists and students; experiment notes and projects; student papers and theses;
bulletins; workbooks; speeches; psychology departmental scrapbook; course lecture notes
and exam questions and research project synopsis; university administration (1925-1962) -
correspondence with presidents, department heads, faculty and trustees; reports and
publications about regulations, Bureau of Institutional Research, administrative
organization and controversies in the Colleges of Commerce and Education and the School of
Music; advanced degrees, Stoddard removal, Krebiozen, Division of Humanities, Defense
Research Coordinating Committee, Council of Ten, Allerton Conference on Education, Chicago
Undergraduate Division, Koch Case, Arthur Bestor and honors program; Higher Education
(1935-1962) - correspondence with educators, foundations and publishers about conferences,
academic freedom, research, Office of Statistical Information and Research; budgets,
programs, Division of Higher Education and Adult Education; classroom use and minutes of
meetings; publications (1919-1920, 1927-1929, 1942) on instinctive behavior, nystagmus,
effects of rotation, balance, geneticism, psychology and mental balance and photographs of
research activities and apparatus in educational psychology laboratory and manuscripts of
published and unpublished books and articles.

RS 5/1/21 SFA - 20 RESTRICTED NUCMC 67-458

GRIGGS, CLARK R. (-1915) MEMOIR, 1906 .1 cu. ft.

A memoir of Clark R. Griggs concerning the efforts to locate the University of Illinois,
including discussions of rival communities, legislative lobbying, Griggs' election to the
legislature, political tactics, management of the bill locating the university in Urbana
and the prospects of the university.

RS 2/5/19

GUEVREKIAN, GABRIEL (1900-1970) PAPERS, 1923-1934 .7 cu. ft.

Papers of Gabriel Guevrekian, professor of architecture (1949-1968), including a scrapbook
of architectural plans, designs, sketches and photographs of models. Construction stages
and completed works designed in Paris (1923-1932) and Teheran (1933-1936); newspaper and
magazine clippings, photographs and articles pertaining to architectural works (1923-1934).

RS 12/2/26 SFA - 2 NUCMC 71-1149

GUILD, THACHER H. (1879-1914) SCRAPBOOKS, 1893-1912 1 cu. ft.

Scrapbooks of Thacher Howland Guild, who was a student at Brown (1897-1901), Chicago
(1901-1902) and Harvard (1903-1904) and a member of the English Department at Illinois
(1904-1914). The scrapbooks contain invitations; programs; examinations; playbills;
clippings concerning amateur and professional theatrical events in Boston, New York,
Chicago, Champaign and Providence and related material. Interested in theatre and music,
Guild wrote "Illinois Loyalty" and other songs.

RS 15/7/23
 NUCMC 72-1507

GULLETTE, CAMERON C. (1896-1963) PAPERS, 1931-1954 .1 cu. ft.

Papers of Cameron C. Gullette, professor of French (1930-1962), containing articles relating to the teaching and learning of languages (1931-1939) and an unpublished manuscript entitled "Life and Works of L'Epine, Known as Quatrelles" (1954).

RS 15/9/21

HAGAN, CHARLES B. PAPERS, 1939, 1942, 1951, 1955-1967 .6 cu. ft.

Papers of Charles B. Hagan, professor of political science (1939-1967), including reports (1956-1967) of University Centennial, Search and Graduate Study in Communications Committees and the Educational Testing Service - Government Graduate Record Examination and related correspondence; correspondence with Illinois circuit judge and author, James O. Monroe, Jr. (1960-1965); materials relative to the Leo F. Koch censure case (1960); reprints of published articles (1939, 1942, 1951, 1955, 1958-1961, 1963-1964) and material on the Legislative Staff Internship Program (1966-1967). Committee files include Asian Program Director Search (1963), Committee on Graduate Study in Communications (1956-1961), Committee on the Centennial (1964-1966), Educational Testing Service - Government Graduate Record Examination (1964-1967), Law Dean Nominating Committee (1966-1967) and Third Slate Citizens Committee (1964).

RS 15/18/25 NUCMC 71-1150

HALE, ALBERT B. (1860-1929) PAPERS, 1908, 1910, 1914-1915, 1919-1930 1.6 cu. ft.

Papers of Albert B. Hale, instructor in ophthalmology (1898-1900), including diaries, correspondence, photographs and manuscripts relating to commercial affairs in Central and South America (1914-1915, 1919-1921) and teaching at the University of Puerto Rico (1926-1929). Dr. Hale served with the Pan-American Union as a compiler (1908-1914), with the United States government as commercial attache in Argentina, Uruguay and Paraguay (1914-1916), with several engineering firms as a representative in Chile, Guatemala, El Salvador, Bolivia and Argentina (1919-1921) and as a professor of social science in Puerto Rico. The series includes records of interviews with public officials and representatives in Latin America, comments on economic conditions and Dr. Hale's manuscript translation of Don Quixote and La Epopeya de Artigas.

RS 52/2/8/20 SFA - 2 NUCMC 67-459

HALL, DARL M. PAPERS, 1934-1964 .6 cu. ft.

Papers of Darl M. Hall, professor of agricultural extension (1938-1964), including reprints of articles, copies of publications and other duplicated material relating to program evaluation (1937-1962, conferences, consumer education and rural youth), group dynamics (1940-1963, committee work, group demonstration, leadership), land use (1955-1956, Menard County use of soil reports), physical fitness (1941-1962, 4-H work) and miscellaneous topics (1934-1963, statistical analyses of agricultural problems, urban image of agriculture, rural youth and Dekalb County. Hall was a project supervisor and leader in extension studies specializing in program evaluation.

RS 8/3/20

HAMILTON, MABEL Z. PAPERS, 1893-1897 .1 cu. ft.

Papers of Mabel Zilly Hamilton '97, including programs for freshman banquet (1893), band concerts (1894, 1897), literary society and dramatic club meetings (1894, 1896), Athletic Association meetings and entertainments (1894, 1895) and students' assembly (1894).

RS 41/20/22

HAMILTON, TOM S. (1894-) PAPERS, 1921-1956 .6 cu. ft.

Papers of Tom S. Hamilton, professor of animal nutrition (1937-1962), including
publications related to research in animal nutrition (1921-1951) and committee files on
PH.D. language requirements (1948), the search for a dean for the College of Agriculture
(1951) and the selection of a president (1953-1956). Professor Hamilton was chairman of
the Faculty Committee on Selection of a President. His files include committee minutes,
lists of names, diary (October 14 - December 17, 1954); records of the non-academic and
younger faculty sub-committees; correspondence with Herbert Megran, David D. Henry and
Anthony Janata; records of visits and newspaper clippings.

RS 8/7/23 NUCMC 71-1151

HAMLIN, HERBERT M. (1894-1968) PAPERS, 1911-1968 1.3 cu. ft.

Papers of Herbert M. Hamlin, professor of agricultural education (1938-1962), including
correspondence (1912, 1920, 1931-1964), publications (1924-1962), speeches and lectures
(1926-1962), newspaper clippings (1918-1968), awards and certificates (1918-1967),
photographs (1911-1940) and transcripts (1916, 1939) relating to agricultural education in
Minnesota (1916-1920) and at Iowa State University (1920-1938), vocational agriculture,
adult education, citizen participation in policy making for public education, federal aid
to education and professional associations.

RS 10/9/20 SFA - 10 NUCMC 71-1152

HANSEN, MARCUS L. (1892-1938) PAPERS, 1929-1942 .3 cu. ft.

Papers of Marcus L. Hansen, professor of history (1928-1938), including notes taken from
the works of other writers on urban society and sanitation, the liquor problem, land and
labor, the post-war south, the prairie states and New England; transcription of a series
of letters by members of the Robison Family (1849-1856) concerning farming in Michigan;
copies of reprints on "The Second Colonization of New England" (1929), "The Revolutions of
1848 and German Emigration" (1930) and "Marcus Lee Hansen, Historian of Immigration" by C.
Frederick Hansen (1942). The series includes a copy of The Immigrant in American History
(1940).

RS 15/13/25

HARBESON, ROBERT W. (1903-) PAPERS, 1927-1971 3.3 cu. ft.

Papers of Robert W. Harbeson (1903-), professor of economics (1947-) including
general issuances, reports, minutes and memoranda of the Department of Economics and
the College of Commerce and Business Administration; correspondence, reports, publications
and statements relating to committee activities of the Doctoral Committee, Bureau of
Economics and Business Research Advisory Committee, Fellowship Committee, Division of
Social Sciences Lecture Committee, Economics Seminar Committee, Bureau of Business
Management Committee, Department of Economics Executive Committee, Curriculum Committee
on Undergraduate Study of Economics, and the AAUP Committee on Year-Round Operations;
general correspondence file including character references, recommendations, requests
for reprints, articles, papers and correspondence with academic personnel, advisees,
publishers, editors, private business representatives and federal and state transportation
agency personnel, relating to the economic aspects of the transportation industry;
manuscripts, typescripts, and published articles, reviews and reprints concerning water
transportation, highway finance, the airline industry, railway transportation, wage-price
relationships, rate regulation and transportation legislation.

RS 9/5/26 SFA - 6 NUCMC 72-1508

HARNO, ALBERT J. (1889-1966) PAPERS, 1923-1957 4 cu. ft.

Papers of Albert J. Harno, professor of law (1921-1957), Dean of the College of Law
(1922-1957) and University Provost (1931-1944), including correspondence, speeches, notes,
reprints and Letters to the Law Alumni (1930-1957); Harno's correspondence as a member of
The American Bar Association's Section on Legal Education and Admissions to the Bar
(1941-1946) concerns legal education, refresher courses for returning servicemen and
problems brought on by the war. His correspondence as University Provost relates to the
post-war building program (1942-1944), utilization of university facilities by the armed
forces for education and training programs (1941-1944), university committees (1938-1943)
and institution of a labor and industrial relations program at the University (1942-1945).

RS 14/1/20 SFA - 3 NUCMC 69-254

HARRIS FAMILY PAPERS, 1853-66, 1870-75, 1890-1920 1.5 cu. ft.

Papers of Benjamin F. Harris II, 1887-89 (1868-1920) and Newton M. Harris, 1890-92
(1872-1953), sons of Henry H. Harris (-1914) and grandsons of Benjamin F. Harris
(1811-1905), including financial account books of Benjamin F. Harris (1853-66); farm
accounts (1886-1910), financial records (1893-1910), utilities records (1898, 1905, 1909),
photographs (1902-07), First National Bank in Champaign plans and specifications (1871,
1909-10), First Methodist Church Building Fund Records (1906-07), correspondence and
financial documents with the Peerless Motor Car Company, Chicago Motor Car Supply
Company and Marshall Field & Co. (1909-10), business and political speeches and clippings
of Henry H. and Benjamin F. Harris II (1890-1902), papers of Newton M. Harris (1902-10),
"The Banker-Farmer" (1916), "Home and Progress" (1916-20) and World War I loan, savings
and military training literature (1917).

RS 26/20/26 SFA - 2

HATCH, BRAINARD G. PAPERS, 1917, 1919, 1923 .1 cu. ft.

Papers of Brainard G. Hatch '19, including notes for Mathematics 9-A, photograph of
Mechanical Engineering 81-N class (1917), photograph of field trip to Wagner Electric
Company in St. Louis (1919), songbooks and commencement programs (1919), photograph of Ira
O. Baker (1923) and the Ketchum Induction Addresses (1923).

RS 41/20/24

HENRY, DAVID D. (1905-) PAPERS, 1935, 1938, 1940, 1942, 1944-1971 16.8 cu. ft.

Papers of David D. Henry, President (1955-1971), including speeches (1955-1961), messages
(1944-1971), manuscripts (1953-1971), published articles (1935-1965), honorary degrees
(1946-1970), tape recordings (1958-1971), clippings (1954-1971), photographs and
correspondence concerning Dr. and Mrs. Henry; his appointment, installation, service and
retirement; the state university; higher education; secondary school-college articulation;
the public school system; teacher education; publications; educational broadcasting; alumni
groups; university ceremonies and observances; inauguration of college and university
presidents, Dr. Henry's service at Wayne State University and New York University and
educational missions overseas.

RS 2/12/20 SFA - 37 NUCMC 72-1509

HIERONYMUS, ROBERT E. (1862-1941) PAPERS, 1912-1940 2 cu. ft.

Papers of Robert E. Hieronymus, Community Adviser (1914-1932), including correspondence with high school and college administrators; Y.M.C.A. and Y.W.C.A. officials; community, civic and rural life associations; committee members and family, concerning high school development, speaking engagements, attendance at conferences, Art Extension Committee tours, exhibits and Civic League formation. The series includes photographs of high schools, homes, community projects and groups and art works.

RS 8/3/21 SFA - 2 NUCMC 67-460

HILL, ROBERT D. (1913-) PAPERS, 1947-1965 1 cu. ft.

Papers of Robert D. Hill, professor of physics (1947-1965), including correspondence, manuscripts, reprints, copies of requisitions and related material concerning research in nuclear spectroscopy and elemental particle physics and atmospheric and space electricity; teaching physics courses and graduate students; publications; Physics Library; financial support; purchase of equipment and materials; comments on preprints, reprints and research grant proposals; professional meetings; examination and placement of graduate students and a 1953-1954 sabbatical leave spent at Brookhaven National Laboratory where Professor Hill's interests shifted to the study of K particles and Tau and Pi mesons in high energy physics. Receiving his D.S. at Melbourne in 1945, Professor Hill specialized in the analysis of irradiated tellurium, berylium, samarium, cerium and gold. He exposed emulsion plates in balloon flights and wrote on long-lived tellurium isomers. On sabbatical in London in 1960-1961, he worked in high energy physics with the nuclear emulsion and bubble chamber groups. After 1961, he began work on lightning research.

RS 11/10/21 SFA - 11 NUCMC 67-461

HILLEBRAND, HAROLD N. (1887-1953) PAPERS, 1895-1925, 1934, 1937-1943, 1947 .3 cu. ft.

Correspondence and manuscript material of Harold N. Hillebrand, member of the English Department (1914-1944) and Head of the Department (1939-1944), including letters from Stuart Pratt Sherman about Urbana during World War I (1918-1919); Central Council for Nursing Education and friends and theatrical agents about Hillebrand's play Florence Nightingale; Ida Zeitlin, Sam Raphaelson and Brock Pemberton about the play, The Old Order; John Q. Adams and George Kittredge, about Hillebrand's Variorium Troilus and Cressida and Henry Arthur Jones, William Archer, Ernest A. Boyd and Thornton Wilder about other topics. The papers include handwritten and typed copies of a prompt book of The Wasp, with descriptive notes; handwritten "Notes on 17th Century Plays"; a lecture on comedy; eight reprints on drama (1915-1928) and twelve reprints (1895-1914) of geologist and chemist William F. Hillebrand, Professor Hillebrand's father.

RS 15/7/20 NUCMC 65-1310

HILLER, ERNEST T. (1883-1966) PAPERS, 1927, 1930, 1937, 1941-1942, 1947, 1952, 1966-1967
 .3 cu. ft.

Papers of Ernest T. Hiller, professor of sociology (1928-1949), including The Strike (1928), "A Culture Theory of Population Trends" (1930), an Outline Guide for Principles of Sociology (1934), "The Social Structure in Relation to the Person" (1937), Houseboat and River-Bottoms People (1939), "The Community as a Social Group" (1941), "Extension of Urban Characteristics into Rural Areas" (1941), Institutions and Institutional Groups (1942) and Social Relations and Structures (1947); a copy of a letter on the American Sociological Society and the Society for the Study of Social Problems (1952); an obituary; memorial tributes and letters from Mrs. E. T. Hiller (1966-1967). A copy of Rural Community Types (1928, co-author) is in Record Series 7/1/0/10, Illinois Studies in the Social Sciences. The series includes The Nature and Basis of Social Order (1966) and a photograph of Professor Hiller.

RS 15/21/21 NUCMC 69-255

HINDSLEY, MARK PAPERS, 1967 .1 cu. ft.

Papers of Mark Hindsley, Assistant Director (1934-1948) and Director of University Bands
(1948-), including an August 17, 1967 tape-recorded interview concerning Austin A.
Harding, the early university bands, ROTC, football, concerts, organization of bands, John
Philip Sousa and Illinois songs.

RS 12/9/20 SFA - 2

HOIT, OTIS W. (1857-1936) PAPERS, 1879, 1885-1886, 1906, 1910-1931 .3 cu. ft.

Papers of Otis W. Hoit '79, trustee (1910-1923), including correspondence and publications
relating to the Class of 1879, functions of the trustees, alumni activities, Alumni
Council, German education (1911-1912), Student Army Training Corps (1918), agricultural
affairs and building construction and dedications (1912-1913). The series includes the
Saturnian (1883) and Sophographs (1884-1887 and 1890).

RS 1/20/1 NUCMC 67-462

HOLBROOK, FREDERICK S. (1873-1944) SCRAPBOOK, 1890-1894 .1 cu. ft.

Scrapbook of Frederick S. Holbrook '94, containing programs of athletic contests, field
days, Athletic Association events, oratorical and declamation contests, concerts, dances,
patriotic celebrations and graduations; newspaper clippings concerning football and
baseball teams and games and the university staff; football broadsides, athletic event
officials ribbons; telegrams, receipts, matriculation permit and extension lecture
outline. The scrapbook includes "Facts About the History of the University of Illinois,
1891" attacking Regent Selim H. Peabody.

RS 41/20/3

HOLDEN, PERRY G. (1865-1959) MEMOIR, 1944 .1 cu. ft.

Illustrated personal memoir by Perry G. Holden, assistant professor of soil physics and
professor of agronomy (1896-1900), including reproductions of letters, photographs,
magazine articles, documents, reminiscences, charts and manuscripts relating to Holden's
family and career. As a "corn evangelist," "corn disciple" and "apostle of vitalized
educations," he advocated corn selection and germination testing, sugar beet culture and
agricultural education. From Michigan State, Holden worked closely with Eugene Davenport
in lobbying for an $150,000 agricultural building and an appropriation for the College of
Agriculture. In a reminiscence he recounts his strategy in mobilizing the Farmers
Institute and agricultural leaders in a struggle with President Andrew S. Draper. Holden
helped increase agricultural enrollment by securing Farmers Institute scholarships and
thwarting the president's plan for an agricultural high school. An able organizer,
promoter and partisan, Holden left Illinois to promote sugar beet culture, assist the Funk
Brothers Seed Company, develop the Extension Department at Iowa State through "Corn Gospel
Trains" and serve as director of International Harvester's Agricultural Extension
Department. The memoir contains a copy of Holden's 72-page booklet, "Young Folks, Do
Something, Be Somebody."

RS 8/6/0/20

HOLTON, CARYL A. (1890-1971) SCRAPBOOK, 1906, 1908-1914 .3 cu. ft.

Scrapbook materials of Caryl A. Holton '13, including programs, newpaper clippings,
photographs, scorecards and related material concerning the University Band (1909-1914);
baseball (1910-1912); building dedications (1913); dramatic and musical events
(1909-1913); engineering projects, inspection trips and shows (1906, 1908, 1912-1914);
football (1910-1913); post-exam jubilees, interscholastic circus, maypole and homecoming
(1909-1910, 1912-1913); class proclamations (1910); track (1910-1913) and student life.

RS 41/20/35

HOPKINS, B. SMITH (1873-1952) PAPERS, 1917-1919, 1923-1956, 1961, 1963 .6 cu. ft.

Papers of B. Smith Hopkins, professor of inorganic chemistry (1923-1941), including
correspondence with J. Allen Harris (Canada), Leonard F. Yntema, Charles James, William A.
Noyes, David Kinley, Gerald Druce (England), G. Hevesy (Copenhagen), Manne Siegbahn
(Upsala), R. J. Meyer (Berlin), G. Urbain (Paris), Luigi Rolla (Florence) and other
chemists relating to research work on the rare earths, fractionation of rare earth
solutions, element 61 or "illinium," shipment and use of rare earth salts, ionic migration
method of separating rare earth, x-ray spectrographic analysis of rare earths, Hopkins'
faculty appointment (1919), work of graduate students, textbooks and revisions, x-ray
equipment, laboratory notebooks (1925-1931), chemical manufacturing and Hopkins' genealogy.
The papers include a posthumous list of Hopkins' publications: 12 books and 129 articles,
copies of five articles (1924-1944) and three editions of his General Chemistry for
Colleges (1930, 1937, 1951) and an edition of Essentials of Chemistry (1946). Mrs.
Hopkins' correspondence (1948, 1952, 1954-1956, 1961, 1963) concerns the analysis of
illinium samples by C. C. Kiess of the Bureau of Standards; efforts to locate samples lost
by Argonne National Laboratories and F. Weigel's attempts to secure a sample for analysis.
The series contains spectography plates from Illinium analyses, a graph template of
"Concentration of Illinium" and a box of chemicals.

RS 15/5/22 NUCMC 65-1311

HOPKINS, CYRIL G. (1866-1919) PAPERS, 1898-1916, 1919, 1962 .4 cu. ft.

Papers of Cyril G. Hopkins, professor of Agronomy (1900-1919), including reprints of
articles and addresses relating to corn chemistry, soil fertility, nitrogen, Abraham
Lincoln, scientific farming, phosphorus and experiment station work. The series also
includes documents and medal of award presented to Professor Hopkins by the Greek
government (1919) and a memorial volume. The series includes Elements of Qualitative and
Quantitative Chemical Analysis by G. C. Caldwell (Ithaca, 1890).

RS 8/6/21

HOTTES, CHARLES F. (1870-1966) PAPERS, 1891-1912, 1923-1940, 1951-1965 .6 cu. ft.

Papers of Charles F. Hottes '91, professor of botany (1902-1913) and plant physiology
(1913-1938), including correspondence, photographs and publications relating to university
life, Thomas J. Burrill, botanical research, graduate study at Bonn (1898-1901), botany
headship (1928) and articles in plant physiology, experimental cytology, corn and wheat
(1926-1930). The series includes tape-recorded recollections of Professor Hottes
concerning his student days, a human physiology class, Selim H. Peabody, Thomas J.
Burrill, the student military organization, Stephen A. Forbes, compulsory chapel, Andrew
S. Draper, Edmund J. James, George T. Kemp, prominent townspeople, Edward Snyder, Bonn,
Henry B. Ward, William Trelease, Hottes' lecture technique, David Kinley, Mrs. Edmund
James, Arnold Emch and anti-German feeling during World War I, plant physiology
instruction, William Crocker and Henry Gleason, first use of microscopes at Illinois,
publication and Frank L. Stevens, Alvin C. Beal's seed germination experiment, effect of
acids on germination and related topics.

RS 15/4/21 SFA - 7 NUCMC 67-463

HOUCHENS, JOSIE B. (1884-1974) PAPERS, 1938-1942 .1 cu. ft.

Papers of Josie B. Houchens '05, '12, librarian (1906-1951), containing correspondence, evaluations and reports of the committees to select successors to library directors Phineas L. Windsor (1938-1939) and Carl M. White (1942).

RS 35/2/23 SFA - 1

HOWE, STEWART S. (1906-1973) COLLECTION, 1923-1973 161.0 cu. ft.

Collection of Stewart S. Howe '28 (1906-1973), publicist specializing in collegiate alumni and public relations and fund raising and president of The Stewart Howe Alumni Service (1930-73) and related corporations, including books, journals, newsletters, clippings, photocopies, correspondence, photographs and other documentation on student life and organizations; fraternity and sorority publications on management, fund raising, rushing, pledging, scholarship and history; public relations work; fund raising for educational institutions (1949-59); Kappa Sigma; Interfraternity organizations; American, Illinois and Chicago history; higher education; travel and entertainment; popular culture; contemporary political and social trends (1963-72); material on collecting and personal papers. The collection includes 140 volumes of college and university histories, 119 volumes on higher education and 60 volumes on fraternities and fund raising.

RS 26/20/30 SFA - 100

HUFF, GEORGE A. (1872-1936) PAPERS, 1883-1947 .6 cu. ft.

Papers of George A. Huff, Director of Physical Training and Athletics (1895-1924), Director of Physical Welfare (1925-1932) and Director of School of Physical Education (1932-1936) including class yearbooks, University publications relating to athletic programs and the construction of Memorial Stadium, football game programs, newspaper articles about Huff and the athletic program, commencement programs, programs of class reunions and testimonial dinners, correspondence, memorabilia and photographs of Huff, University students, baseball and football teams (1889-1916), class reunions, University scenes and a baseball team trip through the South (1915-1916).

RS 16/1/21 SFA - 2 NUCMC 72-159

HUGHES, HAROLD D. (1882-1969) and LULU L. (1880-1939) PAPERS, 1901-1911 .1 cu. ft.

Papers of Harold D. '07 and Lulu Lego '03 Hughes, including announcements, programs and clippings for graduation week activities in 1903 and 1907, program for the William McKinley Memorial Convocation (1901), record of expenses (November 19, 1908 - March 22, 1911) and group photographs of mandolin club, senior girls, student battalion officers and a military review.

RS 41/20/31

HULTZEN, LEE S. (1896-1968) PAPERS, 1923-1968 1.0 cu. ft.

Papers of Lee S. Hultzen, professor of speech (1945-1954), including biographical data
(1945-1968); academic appointments (1923-1967); course notes from his lectures at Cornell
(1934), Columbia (1934-1936, 1945), Barnard (1934-1936), UCLA (1936-1940), Missouri
(1940-1943), Illinois (1946-1958, 1959-1964), Ohio State (1961), Queens (1964-1965) and
California (1966-1967) on speech, English, intonation, pronunciation, phonetics and
linguistics; lectures (1940-1963); publications and manuscripts of talks on pronunciation
and phonetics (1924-1967) and correspondence (1941-1968) with Clarence Barnhart of
Thorndike-Barnhart College Dictionary (1965-1967) concerning work at Ohio State University
(1960-1961) and Berkeley (1965), the results of conferences and meetings (1957-1958);
phonetic and phonemic experiments and projects from his classes.

RS 15/23/23 SFA - 1 NUCMC 71-1153

HUMPHREYS, LLOYD G. (1913-) PAPERS, 1936-1969 5.0 cu. ft.

Papers of Lloyd G. Humphreys, professor of psychology (1957-) and department chairman
(1959-1969) including list of publications, reprints and book reviews (1936-1964),
correspondence with administrators, colleagues, students, Rand McNally and Company and his
children concerning budget requirements, applicants and employment, minutes of staff
meetings, preliminary examination questions for doctoral candidates, research projects,
publications and advice on which authors should be published, professional meetings, the
split between practitioners and scientific investigators and personal matters, committee
reports and correspondence with committee members (1958-1969) including the Clark
Committee, Departmental Chairmen of Graduate Training Departments, Executive Committee of
the College of Liberal Arts and Sciences, Publication Board of American Psychological
Association, Board of Scientific Affairs and All-University Committee on Admissions.

RS 15/19/20 SFA - 4 NUCMC 71-1154

HUNTINGTON, WHITNEY C. (1887-1965) PAPERS, 1926-1954 .6 cu. ft.

Papers of Whitney C. Huntington, professor of civil engineering and head of department
(1926-1956), including Notes on Building Construction (1923-1926), Building Construction
(1929), Research in Civil Engineering (1931), Report of the Federal Civil Works
Administration for Illinois (1934) and photographs, Reconnaissance Report on Proposed
Reservoir Sites in the Basin of the Big Muddy River . . . for the Illinois Emergency Relief
Commission (1935), Reports on Expansion Joints for Concrete Pavements (1937-1938), The
Development of the Civil Engineering Department . . . 1934 to 1942 (1942), Water and Land
Resources of the Crab Orchard Lake Basin (1954) and The Distribution of Concentrated Loads
by Laminated Timber Slabs (1954). Professor Huntington was chairman of the C. W. A.
Engineering Advisory Committee (1933-1934) and prepared the 1935 report which resulted in
Crab Orchard Lake in southern Illinois. For his files as chairman of the Building Program
Committee see Record Series 4/6/6. The series includes typed drafts of talks (1927-1954)
given to Civil Engineering freshmen, engineering and mathematical societies and drafts of
encyclopedia articles concerning civil engineering and civil engineers, building
construction, structural engineering, universities and the railroads, dams, caissons,
tunnels, tall buildings and bridges.

RS 11/5/22

IBEN, ICKO (1900-1971) PAPERS, 1920-1971 4.7 cu. ft.

Papers of Icko Iben (1900-71), M.A. in library science '29, professor of library administration (1951-68) and Newspaper Librarian and Archivist (1946-68), including correspondence, publications, manuscripts, book reviews, minutes, programs, reports, speeches, research notes, diaries, newspaper clippings and memorabilia concerning library science and bibliography, library associations, newspaper collection and retention, Illinois newspapers and their preservation, archives administration and business archives, the surveying and protection of university records, the Germanic Press, German literature and history, the history of German libraries, Friesian language and folkways, scientific and literary abstracting, poetry, civic involvement, retirement plans, manuscripts editing and Lorado Taft's "Grandparents Gazette." Correspondents include publishers, editors, librarians, archivists, Georg Leyh, Josef Stummvoll, Lawrence Thompson, officials at Center for Research Libraries and the Illinois State Historical Library. The collection contains records relating to Iben's administration, research and dismissal as librarian at Oklahoma A & M College (1934-39). Lecture notes, class assignments and reading literature are included from the reference and bibliography course taught by Iben at Illinois (1946). The series contains maps, postcards and tour guides gathered from travels in postwar Europe, along with maps, and literature describing Jever and the Friesian countryside where he lived in Germany. Iben was vice-president of the American Water Resources Association and editor of Hydata (1964-70). AWRA correspondence, speeches, proceedings and Hydata are included.

RS 35/3/25 SFA - 6 NUCMC 72-1510

ILLINOIS NATURAL HISTORY SOCIETY PROCEEDINGS, 1861-1867, 1871, 1873, 1879-1885 .3 cu. ft.

Natural History Society proceedings including a volume containing proceedings of the Illinois Natural History Society (1861-1867), the Illinois State Natural History Society (1871) and the School and College Association of Natural History (1873), including an 1861 report of the secretary on the discussion, organization and chartering of the Society in 1857-1861, printed lists of officers and commissioners, copies of the constitution and legislative charter, minutes of meetings and reports of papers presented. The 1871 meeting transferred all property of the old Natural History Society to the State Board of Education with the Society's museum. The second volume contains the proceedings of the State Natural History Society of Illinois (1879-1885) including minutes of field and annual meetings and meetings of the Executive Committee, constitution and by-laws, reports of addresses given and officers and members elected and related material. Organized to study geology, botany, zoology and anthropology.

RS 43/1/20 NUCMC 65-1921

INGOLD, ERNEST PAPERS, 1922-1924, 1927, 1930-1931, 1943-71 .1 cu. ft.

Papers of Ernest Ingold '09, including correspondence with Robert B. Downs (1971); photographs, articles, circulars and diagrams concerning Atwater Kent radios and radio equipment (1922-1924, 1927); meetings and training sessions on radio maintenance and service (1924); an early home-built radio set (1923); 1931 radio market; radio sales; the completion of Ingold's home in the Hillsboro plot on the San Francisco peninsula and economic conditions in the radio industry in 1929-1930. The papers include correspondence with Earl Warren (1945, 1948, 1950, 1953, 1956), Herbert Hoover (1952, 1954, 1956, 1959-60), Frank Merriam (1937), Nelson Rockefeller (1943), Douglas McKay (1952), Alfred P. Sloan and Harlow Curtice (1957) and Richard M. Nixon (1968) about automobile business matters, California political affairs and San Francisco area work for the Boys Clubs of America.

RS 26/20/20

INGWERSEN, BURTON A. (1898-1969) PAPERS, 1967 .1 cu. ft.

Papers of Burton A. Ingwersen, professor of physical education (1947-1966) and assistant football coach (1921-1924, 1945-1966), including a tape-recorded interview concerning the athletic department, coaching, George Huff, Robert Zuppke, traditions, Ingwersen's participation in intercollegiate athletics, Red Grange, great teams, Rose Bowl games, stadium, grants-in-aid, fraternities and sororities, student life, Thomas A. Clark, basketball, Student Army Training Corps and World War I.

RS 28/3/21 SFA - 4

JACKSON, CHESTER O. PAPERS, 1930-1935 .4 cu. ft.

Papers of Chester O. Jackson, professor of physical education (1935-1966), including six scrapbooks covering the annual Interscholastic Circus held at the University of Illinois (1930-1935), containing photographs of events and participants, letters to participants, announcements, judges' sheets, advertisements, tickets to the events, newspaper and magazine clippings relating to the Circus, and a magazine reprint, "Practical Sanitation in High School Athletics."

RS 16/3/20

JAMES, EDMUND J. (1855-1925) PERSONAL CORRESPONDENCE, 1886-1919 9.8 cu. ft.

Private correspondence of President Edmund J. James, including family correspondence with sons Herman G. and Anthony J. James, daughter Helen James Frazer, wife Margaret L. James, brothers George F., Benjamin B. and John N. James and other relatives; private correspondence with educators, economists, politicians and others on university affairs, family business, politics, economics, education and other subjects. Correspondents include Simon N. Patten, Norman Harris, Johannes Conrad, Leonard Wood, Theodore Roosevelt, Hamlin Garland, Lorado Taft, Graham Taylor, Julia Lathrop and Charles DeGarmo. The out-going correspondence for 1904-1906 is in two letterbooks. Only a few scrapbooks, diaries and letters pre-date 1904.

RS 2/5/1 SFA - 10 NUCMC 65-1922

JAMES, HERMAN G. (1887-1959) PAPERS, 1904-1910 .6 cu. ft.

Papers of Herman G. James, A.B. 1906 and A.M. 1910, including notebooks for a music course at Illinois (1907-1909) and law courses at the University of Chicago (1907-1909) and Columbia University (1910). The notebooks include First Year Harmony Exercises (October, 1904 - January, 1905); Histoire Naturelle - Ecole Alsacienne; Evidence - Professor Whittier (1909); Taxation - Professor Goodnow; law school notes; Acts and Epistles; agency; American diplomacy; European diplomacy; government; mortgages and real estate (1907-1908); municipal corporations; trusts - Professor Mack (1910); constitutional law - Professor Hall (1910); constitutional law - Professor Freund, University of Chicago Law School (1909); administrative law - Professor Freund (1909); wills and miscellaneous notes in law courses.

RS 26/20/11

JANATA, ANTHONY J. PAPERS, 1931, 1967 .1 cu. ft.

Papers of Anthony J. Janata, executive secretary (1921-1923) and assistant to the president (1923-1966) and secretary of the Board of Trustees (1950-1966), including tape recorded recollections on University Hall, literary societies, David Kinley, Harry W. Chase, College of Fine and Applied Arts, the president's house, Arthur H. Daniels, Arthur C. Willard, the Illini Union, Galesburg and Navy Pier, World War II programs, dormitories, Lloyd Morey, financing the building program and the functions of the Board of Trustees. The series also includes a program, photographs and an Alumni News account of President Chase's inauguration (1931).

RS 1/1/20 SFA - 5

JOHNSON, BURDETTE A. PAPERS, 1970-1972 .1 cu. ft.

Papers of Burdette A. Johnson '32, including annotated photocopies of a series of letters to the editor of The Phoenix Gazette (November 23, 1970 - February 9, 1972) on "the responsibilities of American citizenship." Topics discussed include freedom of the press, treason, youth, law enforcement, the flag, the Constitution, military power, school prayer, the presidency, freedom of religion, separation of church and state and the United Nations.

RS 26/20/22

JOHNSON, CLYDE S. FRATERNITY COLLECTION, 1931-1970 14.0 cu. ft.

Fraternity subject reference and publications collection of Clyde S. Johnson (1911-1970), member of the National Interfraternity Conference Executive Committee, Executive Secretary of Phi Kappa Sigma (1950-57) and student affairs administrator at UCLA (1945-48) California (1948-50) and Long Beach State (1957-61), including books, magazines, pamphlets, newsletters, bulletins, circulars, dissertations, clippings, correspondence, reports, studies, speeches and programs concerning fraternities, college life, autonomy, hazing, housing, house management, interfraternity councils, pledging, rushing, scholarship, student organizations and personal and business affairs. Johnson was editor of Interfraternally Yours, News and Notes and the Interfraternity Research and Advisory Council Bulletin and author and editor of journals, articles, and monographs relating to fraternity and campus life. The series includes files of Banta's Greek Exchange, (1913-1970); The Fraternity Month (1933-1970); magazines and newsletters of individual fraternities; Bairds Manual of American College Fraternities (1879-1968); the National Interfraternity Conference Year Book (1909-1940); NIC Executive Committee Minutes, (1945-1970); NIC Programs (1948-70) and a 5 x 8 bibliographic card file of articles and books on fraternity and college life. Correspondents include Wilson B. Heller and Leland F. Leland.

RS 41/2/50 SFA - 18 NUCMC 72-160

JOHNSTON, CHARLES H. (1877-1917) PAPERS, 1902-1903, 1907-1917 .3 cu. ft.

Papers of Charles H. Johnston, professor of education (1913-1917) and dean (1917) of the School of Education, consisting of reprints of articles on psychological matters, secondary education and teacher training. The papers include a November 24, 1908 letter from Edward Titchener, photocopies of a July 7, 1902 letter from William James and a May 7, 1903 appointment to a Harvard fellowship. A December, 1917, memorial number of Educational Administration and Supervision, which Johnston edited, contains several biographical sketches.

RS 10/1/20

JOHNSTON, WAYNE A. (1897-1967) PAPERS, 1945-1967 9.3 cu. ft.

Papers of Wayne A. Johnston '19, Board of Trustees member (1950-1967) and president (1967) and president (1945-1966) and Chairman of the Board (1966-1967) of the Illinois Central Railroad, including correspondence with university trustees and officials, Chicago businessmen, alumni and political figures and correspondence, reports and memoranda received from the secretary of the board. The papers include files on the finance, general policy and executive committees; the Krebiozen research controversy; complaints against faculty, notably Leo Koch; H. R. Roberts' charges against Park Livingston; the W. E. B. DuBois Club; the resignation of George D. Stoddard; the hiring of David D. Henry; educational television; the University Foundation; racial discrimination on campus; a Department of Religion; the University Y.M.C.A. and the site selection and construction of the Chicago campus.

RS 1/20/3 SFA - 11 RESTRICTED NUCMC 69-256

JONES, FRED M. (1905-) PAPERS, 1930-1974 1.0 cu. ft.

Papers of Fred M. Jones Ph.D. '35 (1905-), professor of marketing and business
administration (1942-74), including faculty personnel record (1948-72); course materials
for Business Organization and Operations, Marketing and Business Administration courses
(1932, 1951-74); grade books (1930, 1974) and publications (1931-67, 1971). The papers
include files on franchising (1966-73), a graduate program in marketing (1971),
preliminary examinations (1960-71) and retirement (1974).

RS 9/7/20 SFA - 4

JORDAN, GARRET L. (1896-1969) PAPERS, 1930-1961 1.3 cu. ft.

Papers of Garret L. Jordan, professor of agricultural economics (1938-1960), who
specialized in the behavior of agricultural prices and demand for agricultural products,
including a memorial and family genealogy; publications (1930-1958) and texts of speeches
(1938-1960) concerning agricultural prices and economic conditions; correspondence
concerning private consulting work in commodity forecasting and the study of milk
consumption and marketing; reports to Dawe's Laboratories as economic consultant;
contracts, outlines and reports of University-government research projects in agricultural
economics; research data (1910-1962), including graphs, charts and government market
reports; papers related to Jordan's hobby of hybrid rose gardening, including
correspondence with nurseries, an article on rose gardening, a chart of garden plots;
plant lists and publications of gardening clubs and correspondence relating to graduate
fellowships in agricultural economics and lists of candidates.

RS 8/4/25 SFA - 5 NUCMC 72-161

JORDAN, HARVEY H. (1885-1969) PAPERS, 1909-1962 .6 cu. ft.

Papers of Harvey H. Jordan, professor of general engineering (1917-1953), department head
(1922-1949) and associate dean (1934-1953), including correspondence; data and computation
sheets; course materials, reports, speeches, articles and photographs relating to
engineering education, University publications and ceremonies, World War I, aeronautical
education, ROTC, Phi Kappa Phi (1931-1939), Tau Beta Pi (1911-1918) and engineering and
educational problems.

RS 11/7/20 SFA - 1 NUCMC 71-1155

KAMMLADE, WILLIAM G. (1892-) PAPERS, 1972 .1 cu. ft.

Papers of William G. Kammlade (1892-), state leader of farm advisors and associate
director of the extension service in agriculture and home economics (1949-1960) and
professor of animal science and agricultural extension (1923-1960), including a tape
recorded interview with comments on events surrounding his start in agriculture and his
naming as state leader of farm advisors, the founding and development of the Dixon Springs
Experiment Station, the establishment of 4-H Club work in Chicago, the relationship between
the College of Agriculture and the USDA and Eugene Davenport's insistence that Illinois
control its own extension policy, Kammlade's position that the financial connection between
the extension service and the farm bureaus be maintained and the relationship between
extension service and the Farmers Union and Grange.

RS 8/3/25

KAPPA DELTA PI SCRAPBOOK, 1920-1964 .6 cu. ft.

Kappa Delta Pi Scrapbook kept by the historian of the Alpha Chapter of the educational
honorary fraternity, including lists of officers and programs, announcements of meetings,
circular letters, newspaper reports of meetings and addresses, initiation banquet and
regional conference programs, membership rolls (1922-53), summaries of correspondence
(1921-22), treasurer's journal (1920-25), photographs of initiates and members and
related material concerning chapter activities.

RS 41/6/3/45

KESSLER, GEORGE E. (1906-) PAPERS, 1806-10, 1832, 1838-55, 1864-65, 1881, 1902-09 .1

Papers of George E. Kessler (1906-), including memoirs of Amalie von Uttenhoven
(ca. 1897-10); correspondence of Adolphine Clotilde Zetzsche Kessler (1841, 1849, 1855,
1907) and Carl von Meckel (1849); a 19-page letter to Fraulein Uttenhoven (Feb. 7, 1809)
about Prince Louis Ferdinand and Napoleon; birth, marriage and other Kessler,
Zetzsche and Keppe family certificates (1832-1909); poems for Amalie von Uttenhoven
(1806-08, 1839, 1852) and related documents. Mr. Kessler attended the University
from 1925 to 1929.

RS 26/20/23

KETCHUM, MILO S. PAPERS, 1899-1932 .3 cu. ft.

Letterpress copybook concerning business activities of Milo S. Ketchum as contracting and
designing engineer for the Gillette-Herzog Manufacturing Company of Minneapolis in
Houghton, Michigan, where he prepared plans and bids and supervised work on copper mine
trestles, shaft houses, and cars (3/3/99 - 9/29/02); publication of the annual report of
the Illinois Society of Engineers and Surveyors (3/10 - 4/25/00), preparation of plans for
bridges and securing materials, proper construction and payment for his services,
(7/2 - 9/29/02) and bills for surveying lots in Champaign (6/02). The series contains 15
of Ketchum's publications, including A Manual of . . . Methods for . . . Surveying (with
W. D. Pence, 1900), The Design of Mine Structures (1912) and Structural Engineers Handbook
(1914).

RS 11/5/20 NUCMC 65-1312

KILER, CHARLES A. (1869-1962) PAPERS, 1868-1945 2.0 cu. ft.

Papers of Charles A. Kiler '92, including printed university announcements and programs (1868-1879, 1881, 1886-1893, 1902); correspondence of John K. Bangs (1900, 1908, 1910); typescript column by Arthur Brisbane (1931); letters of Oscar O. McIntyre, George Ade, Lois (Montross) Stafford '19, Allan Nevins '12, Carl and Mark Van Doren '07 and '14, Fontaine Fox, Charles M. Dennis '81, Carl Sandburg, Rachel Crothers, Thornton Wilder and others relating to Kiler's collection of journalism manuscripts (1937-1945); material on Carlos Montezuma '84 (1940, 1942) and manuscripts of "On the Banks of the Boneyard" by Kiler and "Early Settlers Records of Champaign County" by Mabel R. Carlock (1942). The series includes a collection of manuscripts by Faith Baldwin, William E. Baringer, Rachel Crothers, Lloyd C. Douglas, Allan Nevins, Lois (Montross) Stafford, Carl Van Doren and Mark Van Doren.

RS 26/20/14 SFA - 3 NUCMC 69-257

KING, AMEDA R. (1893-1972) PAPERS, 1908-1971 4.6 cu. ft.

Papers of Ameda R. King (1893-1972) '22; A.M. 1925; Ph.D. 1931, professor of history (1950-1962), including student notes, papers, and thesis (1908-1931); lecture notes, grade books, teaching and research records for courses in American history, Latin American history and biography (1927-1962); correspondence with brother, colleagues, students, and administration (1919-1969) and travel, meeting and entertainment records relating to historical society meetings, Monticello College, concerts, plays, art exhibits and travel brochures (1921-1969).

RS 15/13/32 SFA - 2

KIRK, SAMUEL A. (1904-) PAPERS, 1933-1934, 1938, 1940, 1946-1967 1.3 cu. ft.

Papers of Samuel A. Kirk, professor of education (1947-1968) and Director of the Institute for Research on Exceptional Children (1952-), including correspondence, manuscripts of speeches and articles (1940, 1948-1951, 1955-1967), publications (1933-1934, 1938, 1948, 1950-1966), and reports relating to the organization, policies, financial support, and administration of the Institute (1952-1958); the education of the mentally handicapped; the Illinois test of psycholinguistic abilities; research in special education; professional meetings; presidential mission to study Russian techniques and developments in treating mental retardation (1962); a controversy concerning certification of teachers for the deaf (1949-1965), and a controversy over the results of Dr. Bernadine G. Schmidt's treatment of the mentally handica-ped (1946-1955).

RS 10/14/20 SFA - 13 NUCMC 69-258

KNEIER, CHARLES M. (1898-1970) PAPERS, 1927-1954 2.6 cu. ft.

Papers of Charles M. Kneier, professor of political science (1930-1964), including correspondence (1934), copies of publications on municipal law and public utilities and course notes from Cornell and Michigan Law Schools (1931-1937).

RS 15/18/28 SFA - 2 NUCMC 72-162

KONZO, SEICHI (1905-) PAPERS, 1958-1961, 1963-1971 .6 cu. ft.

Papers of Seichi Konzo, professor of mechanical engineering (1937-), including
reports, minutes, articles, agendas, cost estimates, blueprints, newspaper clippings,
by-laws of the Athletic Association and a survey of men's sports clubs of selected colleges
and universities in the United States, relating to the Senate Committee on Athletics and
Recreation; student organizations' use of University facilities; student fees to support
the Extramural Sports Program; sports clubs; intercollegiate and intramural athletic
programs; professionalism in intercollegiate athletics; the academic performance of
varsity athletes; the financing, construction and operation of the Intramural and
Co-Recreation Building and a pool addition to the Women's Gymnasium; faculty control of
intercollegiate athletics; space needs; the NCAA-AAU conflict; the commercialization of
college sports; the program, operation, maintenance and ownership of the Ice Rink; the
Hockey Club; the Youth Hockey Association; the slush fund controversy (1968); Big Ten
Intercollegiate Conferences; meetings of the Board of Directors of the Athletic
Association; the administration and reorganization of the Athletic Association and student
representation in the Athletic Association. The series also includes reprints on air flow
research (1965-1967) and tape-recorded comments on Arthur C. Willard, George A. Goodenough,
Oscar A. Leutwiler, Alonzo P. Kratz, the effects of the depression and World War II on
Willard's presidency, building programs, dormitories, student loyalty, size, George D.
Stoddard, financial support for engineering research, Engineering Experiment Station and
the Mechanical Engineering Department.

RS 11/8/21 SFA - 6

KRUGER, P. GERALD PAPERS, 1937, 1949-62, 1966-69 3.3 cu. ft.

Papers of P. Gerald Kruger (1902-), professor of physics (1931-), including papers
relating to Midwestern Universities Research Association (MURA) concerning board meetings
(1953-62); by-laws, articles of incorporation and charter (1953-56, 1960); budgets
(1955-56); conference notes (1955-56); MURA papers and reports concerning high-energy
physics, accelerator sites, funding proposals, history and organization, relations with
participating institutions and relationships with Atomic Energy Commission, Argonne
National Laboratory, Brookhaven National Laboratory, Enrico Fermi Institute and Oak Ridge
National Laboratory (1950-59). The series includes papers relating to Illinois accelerator
development (1951, 1956-59); manuscripts and calculations for scientific papers including
"The Evolution of a Superconducting Quadrupole Lens" and "Final Calculations for the
Quadrupole M4-24" (1966-68). The series contains a list of publications (1969), copies of
scientific articles (1937, 1949, 1956) and cyclotron photos (1937).

RS 11/10/28 SFA - 2

KUNZ, JAKOB (1874-1938) PAPERS, 1908-1938 1.3 cu. ft.

Papers of Jakob Kunz, professor of physics (1909-1938), including a publications list
(1938), reprints (1908-1937); manuscripts on science, religion and peace (1919, 1930-1931,
1936-1937); correspondence on scientific investigations and world peace (1923-1925, 1927,
1930, 1933-1938, 1942) and obituaries (1938).

RS 11/10/26 SFA - 2 NUCMC 71-1156

LARSON, LAURENCE M. (1868-1938) PAPERS, 1876-1938 6 cu. ft.

Papers of Laurence M. Larson, professor of history (1907-1937), including correspondence, research notes, manuscripts, legal papers, clippings, autobiographical sketches, reprints, class records and notes relating to courses taken at Drake (1891-1894) and Wisconsin (1899-1902) and taught at high schools. Correspondence relates to history staff appointments, travel, publications and the American Historical Association. Significant correspondence with Paul Angle, Theodore Blegen, Lars Boe and Ole Rolvaag relates to the history of Scandinavia and especially the history of Norse immigrants to America. The papers include an autobiographical memoir containing recollections of the University of Illinois (1938). Manuscripts include papers prepared as an undergraduate and as a graduate student including Larson's doctoral dissertation dealing with the royal household in England prior to 1066; monographs on medieval Anglo-Saxon and Norse history; articles discussing the political situation in Europe in the early 20th century and attempting to fix responsibility for World War I upon Germany; texts of public addresses relating to Norwegian-American history and to the European political situation; manuscript copies of Larson's autobiography entitled The Log Book of a Young Immigrant; research notes relating to, and a manuscript copy of The Earliest Norwegian Laws, Being the Gulathing Law and the Frostathing Law; notes of lectures and seminars taught by Frederick J. Turner and Charles H. Haskins; research notes, lecture notes, bibliographic notes and syllabi relating to the study and teaching of English history and the history of medieval Europe.

RS 15/13/24 SFA - 3 NUCMC 65-1923

LEE, ALBERT (1874-1948) PAPERS, 1912, 1917-1928 1.0 cu. ft.

Papers of Albert Lee, Chief Clerk of the President's Office (1920-1942), including correspondence, programs, notes and memoranda, relating to the admission, housing and placement of Negro students; organizational and administrative responsibilities in the Masons, Knight Templars and Order of the Eastern Star; the Springfield District and Bethel African Methodist Episcopal Church Sunday school, choir and Bible class; personal, financial and university affairs and related topics.

RS 2/6/21 SFA - 2 NUCMC 71-1157

LEHMANN, EMIL W. (1887-1972) PAPERS, 1906-1972 17.3 cu. ft.

Papers of Emil W. Lehmann (1887-1972), professor and head of agricultural engineering (1921-55), including correspondence (1915-66), manuscripts (1915-64), publications (1920-52), photographs, diaries (1906-07, 1913-15, 1921-63), programs and course materials (1915-54), relating to soil and water conservation (1931-60), farm machinery and equipment, farm buildings, water supplies and sanitation, rural electrification (1923-54), agricultural policy (1925-52), the Agricultural Engineering Department (1921-64), and European travel (1937-38). The papers include files on consulting work for Central Illinois Public Service Company (1928-29), Sears, Roebuck & Company (1937-38), International Harvester Company (1955-58) and Heli Coil Corporation (1961-63); farm safety and the National Safety Council (1950-66); teaching at Missouri (1921) and Southern Illinois Universities (1958-61); alumni activities of Mississippi State University (1923-66), Texas A & M University (1943-53) and Iowa State University (1915-68); the American Society of Agricultural Engineers (1911-67); the Agricultural Research Institute (1960-62) and the Illinois Society of Professional Engineers (1924, 1946-57); the Presbyterian Church (1922-58),Rotary (1934-62), University YMCA (1935-62) and fraternal organizations; the publication and sale of Farm Mechanics (1920-37), a nursery business (1931-48) and related topics. Correspondents include Richard Boonstra, Fred D. Crawshaw, Kirk Fox, J. Arnold Nicholson, Lee C. Prickett, Eugene F. Schneider and Dawson G. Womeldorff.

RS 8/5/22 SFA - 15

LELAND PUBLISHERS RECORDS, 1934, 1938-1970 5.3 cu. ft.

Leland Publishers Records including papers of Leland F. Leland (1899-) and Mrs. Wilma
S. Leland including correspondence, brochures, pamphlets, photographs, art work and
manuscripts concerning national and local fraternities and sororities at colleges and
universities (1941-1965), fraternity publishing, The Fraternity Month (1946-1953, 1959),
the National Interfraternity Conference (1938, 1940-1968) and National Panhellenic
Conference (1949-1965), Tau Kappa Epsilon (1942-1963), and subjects such as the Miss
America Beauty Pageants (1962-1970) and Lloyd G. Balfour (1934, 1956-1962).

RS 41/2/51 SFA - 4

LEONARD, MARIA (1880-) PAPERS, 1927-1949, 1964, 1966 .1 cu. ft.

Papers of Maria Leonard, Dean of Women (1923-1945), including newspaper clippings,
photographs, publications, certificates and correspondence relating to the functions of
the Dean of Women; aims and conduct of college women, lectures and speeches, student
contacts, Alpha Lambda Delta, sororities, women's war work (war bond sales, WATC unit and
recruting for WAC, WAVES and SPARS) and publications. The series includes Miss Leonard's
"Building and Balancing Budgets for. . . Fraternities" (1934) and "The Chaperon and
Housemother, Builders of Youth (1939).

RS 41/3/20 NUCMC 67-464

LEWIS, BYRON R. PAPERS, 1905-1914 .1 cu. ft.

Papers of Byron R. Lewis '07 (1880-), including photographs of military reviews,
literary societies (1908), commencement (1907) and classmates; publications relating
to Champaign-Urbana (1905-06) and correspondence (1911).

RS 26/20/29

LEWIS, OSCAR (1914-1970) PAPERS, 1944-1967 20.6 cu. ft.

Papers of Oscar Lewis, professor of anthropology (1948-1970), including correspondence,
publications, manuscripts, reviews and tapes relating to research in anthropology,
American Indians, North Indian village culture, the sub-culture of poverty in urban Mexico,
Puerto Rico and New York. The series includes correspondence, reviews, typescripts,
galley proofs, tape recordings, transcripts, continuity notes on edited tapes and copies of
edited tape recordings of personal interviews used as source material for The Children of
Sanchez (Random House, 1961); reviews and tape recorded interviews used as source material
for Pedro Martinez, A Mexican Peasant and his Family (Random House, 1964) and the
manuscript and galley proofs for La Vida: A Puerto Rican Family in the Culture of Poverty
- San Juan and New York (Random House, 1966). The series also includes French, Danish,
Swedish, Portuguese and Japanese editions of La Vida, The Children of Sanchez, Five
Families and Tepoztlan, Village in Mexico.

RS 15/2/20 SFA - 45 RESTRICTED NUCMC 69-259

LINCOLN, JENNETTE E. C. (1862-1946) PAPERS, 1892, 1907-1916 .1 cu. ft.

Papers of Jennette E. Carpenter Lincoln, director of physical training for women
(1898-1909), including Maypole Possibilities (1907), "How to Give a Maypole Dance" (1911),
"Christmas at the Manor," music sheets and photographs.

RS 16/4/21 SFA - 1 NUCMC 69-260

LINDSTROM, DAVID E. PAPERS, 1930-1967 1.6 cu. ft.

Papers of David E. Lindstrom, professor of rural sociology (1929-1967), including correspondence, publications, manuscripts, speeches and reports concerning farmers, local organizations, group action in rural communities, education of rural youth, Japanese rural society, rural sociology, rural church, the place of churches in a democratic society and Methodist beliefs and organization.

RS 8/4/23 SFA - 1 NUCMC 69-261

LITMAN, SIMON (1873-1973) PAPERS, 1865-1965 5.0 cu. ft.

Papers of Simon Litman (1873-1973), professor of economics (1908-1944), including correspondence, clippings, manuscripts, publications, photographs, awards and notes on international trade; Russia (1905-55) in the World Wars; the Department of Economics; published speeches, articles and reviews (1903-50); the Menorah Association and Hillel Foundation (1916-57); Israel; the Transoceanic Corporation of the United States (1926-42); friends and travel. The series includes Litman's autobiography, Looking Back, (1963) and a biographical sketch of his wife, Rachel Frank Litman (1956). Correspondents include Ernest L. Bogart (1918-51), Abraham Epstein (1946-58), Benjamin Goldstein (1934-60), David Kinley (1910-42), Edward Nickoley (1925-36), Ivan Racheff (1949-63) and Abram L. Sachar (1942-55).

RS 9/5/29 SFA - 5

LLOYD, JOHN W. (1876-1962) PAPERS, 1899-1940 .6 cu. ft.

Papers of John W. Lloyd, professor of horticulture (1903-1943), including Productive Vegetable Growing (1915), articles in "Transactions of the Illinois State Horticulture Society" (1900-1938), circulars (1902-1928), bulletins (1901-1940), notes on spraying experiments and vegetable crops (1900-1904), course outlines (1899-1900, 1906-1907), correspondence (1901-1906), manuscripts (1901-1902) and a blueprint of a truck farm building.

RS 8/12/24 SFA - 2 NUCMC 72-1511

LLOYDE, CLARENCE A. (1866-1942) NOTEBOOKS, 1884-1885 .1 cu. ft.

Clarence A. Lloyde '87 blueprint course notes (376 pages) for calculus taught by Samuel W. Shattuck.

RS 41/30/9

LOHMANN, KARL B. (1887-1963) PAPERS, 1914-1963 13 cu. ft.

Papers of Karl B. Lohmann, professor of landscape architecture (1921-1948) and city and regional planning (1948-1955), including notes, manuscripts, correspondence, photographs, published articles, clippings, reports and surveys, maps and course material relating to landscape architecture; city planning; regional, county and rural planning; publication of books and articles; professional associations; Illinois planning; campus plans; economic bases; farms; forests; housing; industry; land use; parks; public buildings; recreation; schools; smoke; streets; traffic; water and zoning. The papers contain typescripts of Lohmann's Principles of City Planning (1931), Landscape Architecture in the Modern World (1941), The Municipalities of Illinois (1945) and a history of city planning and landscape architecture at Illinois (1954). Significant correspondents include Carol Aronovici, Harland Bartholomew, Joseph C. Blair, Charles DeTurk, Henry V. Hubbard, Evert Kincaid, John Nolen, James S. Pray, Hideo Sasaki, Stanley White and Henry Wright.

RS 12/4/20 SFA - 3

LOOMIS, F. WHEELER PAPERS, November 19, 1965 .3 cu. ft.

Papers of F. Wheeler Loomis, professor of physics and department head (1929-1957),
including a transcription and tapes of an interview relating to his decision to come to
Illinois, Milo Ketchum, Ward Rodebush, family background, Newton High School and Harvard,
the development of modern physics, rebuilding and recruiting a faculty at Illinois,
theoretical physicists, College of Engineering, Champaign-Urbana, cyclotrons, spectroscopy,
Gerald Kruger, betatrons, Leland Haworth, Robert Serber, Donald Kerst, Gilberto Bernardini,
Moritz Goldhaber, Polykarp Kusch, research at Bell Telephone and General Electric, World
War I work in anti-aircraft ballistics, a sabbatical in England before World War II, the
Radiation Laboratory at MIT, radar, LORAN, staffing the laboratory and writing its history,
relations with industrial firms and the federal government, the atomic bomb project, Harold
Mott-Smith, Louis Ridenour, Control Systems Laboratory, Frederick Seitz and John Bardeen.
The series also includes a typescript copy of "Contributions to Physics of F. W. Loomis"
(July 27, 1962) and "Life with Wheeler in the Physics Department, 1929-1940" by Gerald M.
Almy (May 24, 1957).

RS 11/10/22

LUCAS, CORDA (1858-1923) ALBUM, 1880 .2 cu. ft.

Corda C. Lucas Album containing individual portrait photographs of the Class of 1880.
Presented to the Alumni Association by Miss Mary Lena Barnes '88.

RS 41/20/6

LYBYER, ALBERT H. (1876-1949) PAPERS, 1876-1949 19.3 cu. ft.

Papers of Albert H. Lybyer, professor of history (1913-1944), including correspondence,
memoranda, diaries, notes, photographs, manuscripts, bibliography slips and financial
records relating to courses taken at Princeton and Harvard and taught at Robert College
(1901-1907), Oberlin (1910-1913) and Illinois (1913-1944); service with the World War I
Inquiry, the American Commission to Negotiate Peace and the King-Crane Commission on
mandates in Turkey (1918-1919); schools and relief in the Near East; travel in the United
States, Europe and the Near East; contributions to periodicals and encyclopedias; addresses
and radio talks; service on University committees (1920-1940); manuscript bibliographies on
the Ottoman Empire; historical association committees; conservation; mathematics; real
estate investments in Florida, Iowa, Indiana and Illinois; family history and genealogy and
personal affairs. The series includes 2 1/2" x 3" glass slides of travel scenes in Europe
and the Ottoman Empire (1912).

RS 15/13/22 SFA - 3 NUCMC 65-1925

LYMAN, ERNEST M. PAPERS, 1962-72 2.6 cu. ft.

Papers of Ernest M. Lyman (1910-), professor of physics (1945-), including
material relating to the Policy Committee on Student Affairs (chairman, 1969-71)
including minutes (1968-72) and files on issues before the committee including voluntary
student contributions (1971), Assembly Hall (1969-70), registered organizations (1968-69),
liquor in dorms (1970), drugs (1969-70), films policy (1969-70), discipline (1969-70),
campus recruiters (1970), UGSA (1969), Graduate Student Association (1969-70), and the
Gusfield Report (1966). The series contains material relating to the Senate Coordinating
Council (member, 1966-69), secretary, 1967-69), including committee minutes (1965-69),
notices of committee meetings (1965-69); minutes, reports, and papers of the Urbana-
Champaign Senate (1965-68), the Chicago Circle Senate (1964-68) and the Medical Center
Senate (1965-67). The series includes files on year-around plans at other universities
(1963-65, 1970), the DuBois Club (1966-67), the Clabaugh Act (1966-67) and academic
freedom (1966-67).

RS 11/10/29 SFA - 3

LYTLE, ERNEST B. (1875-1936) PAPERS, 1895-1936, 1965 .3 cu. ft.

Papers of Ernest B. Lytle, professor of mathematics (1924-1936), including correspondence,
manuscripts and reprints relating to mathematics education, Lytle's graduate work in
mathematics and University affairs. Correspondents include Boyd H. Bode, Thomas A. Clark,
Andrew S. Draper, David Felmley, Harlan H. Horner, Henry L. Rietz and ex-students. The
series includes a biographical summary by Mrs. Lytle (1965).

RS 15/14/21 NUCMC 67-465

MATTHEWS, JAMES N. (1852-1910) PAPERS, 1868-1872, 1966-1968 .1 cu. ft.

Papers of James N. Matthews '72, including copies of correspondence (September 15, 1868 - March 4, 1872) concerning student life, faculty, courses, John M. Gregory, political campaigns, weather, dedication of University Hall, and financial matters; poetry by Matthews and James Whitcomb Riley; newspaper clippings concerning Matthews (1966-1968); a photograph of his tombstone and related correspondence (1968).

RS 41/20/26 NUCMC 69-262

McALLISTER, MINNETTE (1859-) ALBUM, 1879 .2 cu. ft.

Minnette C. McAllister Album containing photographs of members of the faculty and the Class of 1879.

RS 41/20/5

McBURNEY, WILLIAM H. (1919-1967) PAPERS, 1964-1966 .3 cu. ft.

Papers of William H. McBurney, professor of English (1958-1967), containing correspondence regarding acquisitions to the Library's collection of eighteenth century English fiction and regarding the preparation and publication of a Checklist of English Prose Fiction 1700-1800 in the University of Illinois Library, his edition of George Lello's Fatal Curiosity and the article "What George Lello Reads." The series includes typescripts of manuscripts and xeroxed copies of early editions of Fatal Curiosity.

RS 15/7/29 SFA - 1

McCLURE, ORA D. (1868-1961) NOTEBOOK, 1887 .1 cu. ft.

Ora D. McClure '91 blueprint course notes for mechanical engineering, including notes on materials of construction (52 pages), valve gears (16 pages and 13 plates) and student's sketches and examination questions.

RS 41/30/8

McKELVEY, FRANK H. (1882-) PAPERS, 1903-1907 .1 cu. ft.

Papers of Frank H. McKelvey '07, including a University of Illinois pictorial album (1903), newspaper clippings on the 1905 football season and 1907 baccalaureate; a program for the Agricultural Beefsteak Dinner (April 10, 1907); programs, tickets and clippings relating to the May 17-18, 1907 interscholastic meet; The Carnival Dope Dispenser (May 14, 1907); a photograph of Dean Thomas A. Clark and congratulatory letters from Clark and George A. Goodenough; class day and commencement programs (1907) and a 1907 commencement program. The series includes photographs of campus activities.

RS 41/20/33

MEDUNA, LADISLAS J. (1896-1965) PAPERS, 1942-1959 3.1 cu. ft.

Papers of Ladislas J. Meduna, professor of psychiatry (1943-1964), including correspondence with physicians, psychiatrists, department heads, publishers and patients concerning carbon dioxide inhalation therapy, metrazol convulsive therapy, publications, research, carbon dioxide symposium, presence of anti-insulinic factor in the blood of schizophrenics, and the nature of psychoses and psychoneuroses. The series includes notes, notebooks and electroencephalograph tracings concerning research, patient treatment and diagnosis (1942-1950); reprints and mimeographed copies of articles by Dr. Meduna; proceedings of and articles resulting from the Carbon Dioxide Symposium (1952); manuscripts and illustrations for the first and second editions of Carbon Dioxide Therapy, with reviews of the books; manuscripts of Oneirophrenia; copies of articles and journals; photographs of Dr. Meduna; and card files listing doctors using carbon dioxide therapy, and a wall chart showing experimental data and observations concerning Central and Peripheral Action of CO_2 on the nervous system.

RS 52/2/15/20 SFA - 11 NUCMC 67-466

MEN'S INDEPENDENT ASSOCIATION SUBJECT FILE, 1945-1969 2.6 cu. ft.

Men's Independent Association Subject File including constitution, lists of officers, minutes, house rosters (1953-1968), grade reports and house rankings (1955-1968), petitions for membership (1961-1966), Dad's Day Revue (1945-1965), MIA projects, manuscript speech of Carl W. Weber on Counseling in independent housing and official and personal correspondence of Assistant Dean Samuel C. Davis (1967-1969), adviser to MIA. The series includes references to problems of black students, Davis' correspondence for New Year Convocation (1968), research on housing, age, home and marital status of black students at Illinois (1965-1967) and a proposal for a program for culturally deprived students.

RS 41/2/11 SFA - 2

MERRITT, RICHARD L. PAPERS, 1969-1971 4.6 cu. ft.

Papers of Richard L. Merritt (1933-), professor of political science and research professor in communications (1969-) and program chairman of the Annual Conference of the American Political Science Association (1970), relating to the annual conference of the A.P.S.A. held in Los Angeles, California, September 8-12, 1970, including correspondence, schedules, memoranda, announcements and requests concerning organization of the program; accommodations for the conference; chairmen, discussants and speakers on panels and workshops; obtaining abstracts of conference papers and publication of the abstracts; and papers concerning general trends in the field of political science, interaction among national systems of government and cross national comparisons of the performance of governmental systems. Correspondents include Ursula Scott, Administrative Assistant of the A.P.S.A.; Karl W. Duetsch, President of the A.P.S.A. (1969-70); Walter Beach, Associate Director of the A.P.S.A.; Nathaniel P. Tillman, member of the Program Committee and Dave Kettler of the Caucus for a New Political Science.

RS 15/18/29 SFA - 2

MEYER, MICHAEL L. PAPERS, 1970 .1 cu. ft.

Papers of Michael L. Meyer '70, including a mimeographed, copyrighted paper titled
"Systematic Perspectives in Social Dynamics, Part I: Theoretical Foundations of Change and
Development" submitted in History 372 - "American Intellectual and Cultural History Since
1877" by a senior in history and geography and "Resident Advisor of Apathy House, Urbana."

RS 41/20/36

MICHAUD, REGIS (1880-1939) PAPERS, 1905-1938 .3 cu. ft.

Papers of Regis Michaud (1880-1939), professor of French (1930-1939), including
agreements with publishers and related correspondence (1909-28, 1962); periodicals
containing articles by and references to Michaud (1929-38); class record books; lecture
material on French and American literary exchange and the dramatist Racine; an outline
for a lecture on Balzac and lecture notes; bibliography on 19th century French literature
and a list of French newspapers and periodicals on the history of the French Popular Front.

RS 15/9/22

MILLER, GEORGE A. (1863-1951) PAPERS, 1898-1947, 1951 .6 cu. ft.

Papers of George A. Miller, professor of mathematics (1906-1931), containing reprints of
articles on group theory and the history of mathematics (1898-1947), galley proofs and
manuscripts of articles, research notes on mathematical theories and terms and birth
certificate. The series includes photographs and newspaper and magazine articles (1951)
received from former pupil Josephine Burns Glasgow '13.

RS 15/14/25 NUCMC 69-263

MILLER, VAN PAPERS, 1931, 1935, 1939-1974 4.3 cu. ft.

Papers of Van Miller, professor of education (1947-) including correspondence,
newsletters, reports, minutes and papers relating to his association with the Harvard
Graduate School of Education (1940-42); Governor's Advisory Council (1949); Strategic Air
Command, Program for Instruction Training (1951); Illinois Association of School
Administrators (1956-61, 1969-73); Harvard Alumni Council (1957-58); National Institute of
Health (1963); American Association of School Administrators (1968/69); Illinois Residence
Program for Education Leadership (1969-71); faculty activities; Faculty Advisory Committee
and Committee on Promotions in Rank and Pay (1949-72); evaluation of schools, school
districts, university departments of education and education classes and programs;
proposals received as President of the University Council for Educational Administration
relating to Board meetings and plenary sessions, articles of incorporation, financial ties
with the W. K. Kellogg Foundation.

RS 10/3/20 SFA - 6

MISSISSIPPI VALLEY INDUSTRIAL ARTS CONFERENCE PAPERS, 1909-1970 2.0 cu. ft.

Mississippi Valley Industrial Arts Conference Papers including correspondence, programs,
reports, resolutions, membership lists, regarding annual Manual Arts Conferences
(1909-1929), 1 1/2 inches of photocopies of correspondence, programs, studies, directories,
outlines, circulars, resolutions and reports relating to the Manual Arts Conferences
(1909-1940) some of which duplicate and supplement the material in the folders, and 21
bound volumes of annual reports and mimeographed outlines of the discussions of the Manual
Arts Conferences (1921-1940) and program bulletins, reports, and other memoranda of the
Mississippi Valley Industrial Arts Conferences (1934-1941, 1946-1970).

RS 10/9/50 SFA - 2

MITCHELL, HAROLD H. (1886-1966) PAPERS, 1906-1966 3.0 cu. ft.

Papers of Harold H. Mitchell, professor of animal science (1918-1954), including an alphabetical subject file (1922-1966), correspondence concerning the administration of research for the saltpeter investigation in the laboratory of physiological chemistry (1906-1912), photographs of the apparatus used in the saltpeter experiment and in metabolism, digestion, perspiration and respiration studies (1907-1940); 80 unpublished manuscripts (1906-1948) and 158 publication reprints (1916-1962) relating to protein and mineral nutrition and metabolism, comparative nutrition and climatic stress research.

RS 8/7/20 SFA - 2 NUCMC 69-265

MOELLER, THERALD PAPERS, 1937-1969 2.0 cu. ft.

Papers of Therald Moeller, professor of chemistry (1943-1969), including biographical sketch; list of publications, symposia proceedings on rare earth ions; instructional films for which he was an educational collaborator (1947-1949); textbooks on inorganic chemistry (1952), qualitative analysis (1958) and general chemistry (1965); a laboratory manual (1965); a book on the chemistry of Lanthanides (1963) with its translations into Italian and Spanish; abstracts of theses done under Moeller (1944-1953); reprints of articles (1937-1968) concerning his work on rare earths (especially gallium, indium, thallium and thorium), radio tracer techniques, chelate chemistry, sulfamide properties, inorganic polymers, physical methods in inorganic chemistry and spectrophotometry; Montana State chemistry institute syllabi (1963-1964) and Air Force contract research reports (1948-1969) concerning the rare earths, compounds of bromine, chlorine and flourine polymers and sulfur-nitrogen compounds; correspondence concerning lectures and visits with Institute for Continuing Education in Engineering and Applied Science (1967), College of St. Theresa (1966), University of Missouri at Rolla (1967), University of San Paulo, Western Michigan University; lecture notes for Chemistry 101 (1967-1968); thorium analysis notes; list of theses in University of Illinois Library dealing with rare earths (1911-1951).

RS 15/5/32 SFA - 2 NUCMC 71-1158

MONROE, WALTER S. (1882-1961) PAPERS, 1912-1913, 1917-1926, 1930-1940, 1949-1950, 1956
 .6 cu. ft.

Papers of Walter S. Monroe, professor of education (1919-1950), director of educational research (1921-1947) and acting dean of the College (1930-1931, 1945-1947), including correspondence, class notes and records, workpapers, manuscripts and reprints relating to arithmetic and reading tests, development and validity of standardized tests, educational research, tests and measurements, learning theory, teacher training, literature, Encyclopedia of Educational Research and classroom lectures. The series includes minutes and reports of the Senate Committee on Educational Policy (1936-1940).

RS 10/10/20 NUCMC 67-467

MONYPENNY, PHILIP (1914-) PAPERS, 1948-1949, 1955, 1958-1968 .6 cu. ft.

Papers of Philip Monypenny, professor of political science (1947-), including correspondence concerning the placement of graduate students and job descriptions (1958-1960). Correspondents include Clyde F. Snider, Gilbert Y. Steiner, Samuel K. Gove, Clarence A. Berdahl, Jack W. Peltason, Charles M. Kneier, Francis G. Wilson, Fred T. Wall, J. Austin Ranney, Antoinette LaVoie, Royden Dangerfield, Charles B. Hagan and George Manner. The series includes reports of the Committee on Personnel and Management (December, 1948 - June, 1949).

RS 15/18/26 NUCMC 71-1159

MOREY, LLOYD (1886-1965) GENERAL CORRESPONDENCE, 1953-1955 20.6 cu. ft.

General correspondence or subject file of President Lloyd Morey including correspondence,
reports, memoranda, publications and files received from or sent to trustees, deans, other
university administrators, faculty and the public concerning admissions policies and
enrollment statistics; reports of colleges, schools, institutes, bureaus and departments;
alumni activities; American Council on Education, Association of Land Grant Colleges and
Universities and other associations of universities and university administrators; athletic
boards, relations and contests; budgets; audits and financial reports; building program;
Chicago branch; Chicago professional colleges; commencement; committees; retirement system;
Civil Service System; Health Service; state departments and federal agencies; selection of
the president; educational policy changes; physical plant; legislative affairs, gifts and
estates; monthly trustees meetings; sabbatical leave requests and reports; military
training; natural resources surveys; scholarships; University Senate; summer session;
public information, and similar administrative affairs.

RS 2/11/1 SFA - 17

MOREY, LLOYD MANUSCRIPT ADDRESSES, 1946-1947, 1951-1955 .6 cu. ft.

Manuscripts of addresses by Lloyd Morey, including handwritten notes, typewritten and
mimeographed copies of addresses, remarks and statements prepared for public meetings and
publications, concerning the University of Illinois, goals and values in higher education,
religion and morality, budget and finance, future development, duties of the president,
government and higher education and welcoming remarks at events sponsored by the
University. This series includes reprints of speeches and correspondence and newspaper
clippings relating to addresses.

RS 2/11/2 SFA - 5

MOREY, LLOYD PAPERS, 1908-1966 19.6 cu. ft.

Papers of Lloyd Morey, comptroller (1916-1953) and president (1953-1955), including
biographical material (1926-1966), personal correspondence (1916-1963), memoirs of friends
(1914-1963), Class of 1911 records (1908-1961), Alpha Kappa Lambda (1927-1963) and Alpha
Kappa Psi (1960-1962) files, correspondence and articles on governmental and educational
finance and accounting (1930-1965), publications and manuscripts (1918-1965), university
presidency clippings (1953-1954), Illinois higher education commission minutes, reports
and articles (1941, 1953-1961), files on financial consulting for the U. S. Department of
Defense (1953-1965), correspondence and scrapbooks as Auditor of Public Accounts and
material on revisions of state audit policies and procedures (1956-1965), university
business management and consulting work files (1950-1963), Champaign County Audit Survey
(1962-1964), concert programs (1910-1964) and music scrapbook (1908-1953).

RS 2/11/20 SFA - 20 NUCMC 69-266

MORROW, GEORGE E. PAPER, 1900 .1 cu. ft.

Typewritten copy of "The Life Work of Professor George E. Morrow" read by Stephen A. Forbes at a memorial service for Morrow at the University Chapel on April 8, 1900. The sketch relates Morrow's personality and work to the development of agricultural education at the University of Illinois. The paper is a carbon copy of a copy found in the files of the College of Agriculture in 1935.

RS 8/1/20

MOSHER, MARTIN L. (1882-) PAPERS, 1937, 1945-1946, 1949-1966 1.3 cu. ft.

Papers of Martin L. Mosher, professor of farm management extension (1923-1950), including 1600 35 mm. color slides and 2 1/2 x 3 1/2 negatives of farmsteads in the United States and Canada, showing date and location of photograph and notes on farm size, crops and buildings. A "Catalogue of Films and Colored Slides for the book Farmsteads of the United States of North America at the Middle of the Twentieth Century" (1965) lists number, date and location of all photographs and indicates if an enlargement is in seven scrapbook volumes located at the Agricultural Hall of Fame and National Center in Bonner Springs, Kansas. The series includes three volumes of "Farmsteads of the United States of North America at the Middle of the Twentieth Century" (1966). Two volumes contain 1,390 black and white prints of farmsteads arranged by state. The entries for each state show its location on a United States map, typewritten data on land and tenure, crop and livestock production and farm income in 1950 and location information for the photograph included. Volume 1 also includes a forward by M. L. Wilson, a preface by the author, autobiographical material on the author's farm boyhood in Iowa, and his photography of farmsteads and photographs of rural churches and schools. Volume 2 also includes an 11-page appendix containing narrative information and maps on agricultural development in the United States and the "author's last word." The third volume contains highway maps of states and provinces showing the author's routes and the locations of farmsteads photographed. The series also includes a copy of Professor Mosher's introduction and narrative for an illustrated lecture on "Farmsteads of the United States," and reprints of articles.

RS 8/4/21 SFA - 64 NUCMC 67-1260

MUELLER, JUSTUS F. PAPERS, 1972-1973 .1 cu. ft.

Papers of Justus F. Mueller, A.M. 1926 and Ph.D. 1929, including a cassette tape recording of the remarks of the 1973 recipient of the American Society of Parasitologists' Henry B. Ward award and Mueller's recollections of the laboratory, library and personality of Henry B. Ward and Mueller's years as Ward's graduate assistant and his contacts with Dean Kendric C. Babcock. The series includes a copy of "How To Be A Parasitologist Without Really Trying" (1972).

RS 26/20/28 SFA - 2

MUMFORD, HERBERT W. (1871-1938) PAPERS, 1919-1938 1.0 cu. ft.

Papers of Herbert W. Mumford, professor of agriculture (1901-1938), Head of Department of Animal Husbandry (1901-1922) and Dean of College of Agriculture and Director of the Agricultural Experiment Station and Extension Service (1922-1938), containing correspondence and subcommittee reports of the Illinois Agricultural Policy Committee (1920-1924); membership lists, minutes and reports of the area livestock committees of the Illinois Agricultural Adjustment Conferences (1928-1930) and Mumford's records while serving on the Board of Directors of the Sixth District of the Farm Credit Administration consisting of correspondence, reports, by-laws and statistics relating to the administration and credit operations of the Sixth District (Arkansas, Illinois, Missouri) (1933-1938). The series includes "The History of the Duroc Jersey Swine" (1919).

RS 8/1/22 SFA - 2 NUCMC 71-1160

MURPHY, FRANK D. PAPERS, 1969 .1 cu. ft.

Papers of Frank D. Murphy '24, business manager (1923-1927), including a November 3, 1969 tape-recorded interview containing comments on the Athletic Association, George Huff, football ticket sales and distributions, athletic publicity, Robert C. Zuppke, the Stadium, baseball, legislative relations and related topics.

RS 28/2/20 SFA - 3

MURPHY, LAWRENCE W. (1895-1969) PAPERS, 1919-1963 1.3 cu. ft.

Papers of Lawrence W. Murphy, professor of journalism (1924-1964) and Director of the School of Journalism (1927-1940), including correspondence, typescript copies of addresses, reports, photographs, clippings, reprints, publications, course material and related documents concerning teaching of journalism in universities, evaluation of curricula, former students, history of journalism, classification of universities teaching journalism, professional associations, editorial work, graduate work and appointments (1919-1939), a legislative act creating a College of Journalism (1927), journalism alumni (1927-1946), School of Journalism Announcements (1928-1949), Notes on the History of Journalism (1929) - a duplicated 118-page collection of biographical sketches of journalists, the Editor's Hall of Fame (1930), a journalism building at Illinois (1931-1936), University presidency (1933), the Illinois Press Association Journalism Building Committee (1934-1936), a poll of former students on journalism courses at Illinois (1939), the University Committee on Educational Programs and Policies in the School of Journalism (1940), Alumni News Notes (1942-1946), Murphy's resignation as director (1942-1943), a study of honor students (1943), a Foundation for Public Relations research and education fellowship for work at Hill and Knowlton in New York (1959) and the Illinois Editorial Review (1956-1957).

RS 13/1/20 NUCMC 65-1926

MUTTI, R. JOSEPH PAPERS, 1943-47, 1965-69 3.3 cu. ft.

Papers of R. Joseph Mutti, professor of agricultural economics (1945-74), including
correspondence, reports, research data, tabulations, publications and maps relating to
dairying and dairy manufacturing in Illinois (1943-47) and marketing staple food crops
in Sierra Leone (1965-69). The dairy plant material includes data arranged by county and
community, Mutti's dissertation, correspondence with governmental agencies, farm advisers
and dealers and statistical information. The Sierra Leone file includes correspondence
with William O. Jones, Alfred S. Cleveland and Paul J. Stanners of the Stanford Food
Research Institute which held the A.I.D. contract for a study of food marketing in
tropical Africa; Dr. Mutti's publications on rice marketing and correspondence with
Dunstan S. C. Spencer and D. N. Atere-Roberts and officials at Njala University College,
the Bank of Sierra Leone, the Sierra Leone Produce Marketing Board, the Rice Corporation,
cooperatives and the Ministry of Agriculture and Natural Resources. Research files
contain data on the production, transportation, marketing and pricing of rice, palm oil,
groundnuts, cassava and foofoo in Freetown markets and other centers.

RS 8/4/27 SFA - 3

MYERS, GEORGE W. (1864-1931) PAPERS, 1887-1913, 1925 .1 cu. ft.

Papers of George W. Myers '88 (1864-1931), professor of mathematics (1890-1900) and
astronomy (1895-1900), 15 photographs of astronomical instruments, newspaper clippings
on astronomical subjects, publications on Beta Lyrae and U Pegasi (1898), book
advertisements and orders, two photographs of Chinese students in a Chungking mission
school (ca. 1900), correspondence and manuscripts. Prof. Myers was on the faculty
at the University of Chicago from 1901 to 1929.

RS 15/14/27

NATIONAL ASSOCIATION OF INDUSTRIAL AND TECHNICAL TEACHER EDUCATORS ARCHIVES, 1936-1973
5.3 cu.ft.

National Association of Industrial and Technical Teacher Educators Archives including
material concerning the founding, organization, functions, activities, officers and
members, constitutions and by-laws, financial matters, meetings and conventions, research
of members, publications, and honors and awards of the National Association of Industrial
and Technical Teacher Educators (NAITTE), The American Vocational Association (AVA),
and the Associated Organizations for Teacher Education (AOTE), including correspondence,
minutes of executive committee meetings and conventions, memoranda, reports, papers
delivered by professionals in the field, directories, and publications including the
Journal of Industrial Teacher Education. This series is concerned primarily with the
NAITTE and material concerning the AVA and AOTE is directly related to the NAITTE.

RS 10/9/51 SFA - 4

NEISWANGER, WILLIAM A. PAPERS, 1950-1953 .5 cu. ft.

Papers of William A. Neiswanger, professor of economics (1937-), including three
scrapbooks containing clippings from Champaign-Urbana and Chicago newspapers relating to
the College of Commerce and Business Administration and Department of Economics
controversies (May, 1950 - July, 1951) with contemporary marginal notations by Professor
Neiswanger and copies of mimeographed statements and typewritten letters relating to Dean
Howard R. Bowen, qualifications of the commerce faculty, administrative procedures and
reorganizations (May, 1950 - June, 1951).

RS 9/5/20 NUCMC 65-1927

NELSON, SEVERINA E. (1896-) PAPERS, 1939-1967 .3 cu. ft.

Papers of Severina E. Nelson, professor of speech (1941-1964), director of the Speech and
Hearing Clinic (1939-1959), containing photographs and clippings relating to the Speech
Clinic and its activities; annual reports; results of aphasia research (1960-1961);
correspondence (1941-1967), including material on Miss Nelson's retirement; and
publications (1939-1959).

RS 15/23/20 SFA - 1 NUCMC 69-267

NEWCOMB, REXFORD G. (1886-1968) PAPERS, 1915-1946 2.3 cu. ft.

Papers of Rexford G. Newcomb, professor of architecture (1918-1954) and dean of the College
of Fine and Applied Arts (1932-1954), including scrapbooks with clippings relating to his
life, books, speeches and positions (1915-1945); diary kept on a European trip (1921);
notebook of architectural descriptions of buildings in Wisconsin and Michigan (1946);
articles relating to color in architecture, early American architects, renaissance
architecture, and ceramics; clippings, pamphlets, articles and photographs relating to the
architecture, culture and history of California, Kansas and New Mexico; and articles and
speeches by Newcomb and others relating to architecture and the American West.

RS 12/2/23 SFA - 2 NUCMC 71-1161

NEWELL, FREDERICK (1862-1932) PAPERS, 1891, 1916, 1919 .3 cu. ft.

Frederick H. Newell Papers, including copies of Results of Stream-Measurements of the United States Geological Survey (1891); Asiatic Turkey - Its Problems and Resources (1919) and a presentation copy or resume of previous work undertaken by J. A. Sargent, prepared for Colonel Theodore Roosevelt in hope of receiving letters of introduction from Roosevelt to M. Aristide Briand, French Premier, and to the Minister of Public Works of France, in order to conduct studies of "industrial preparedness, as co-ordinated with military preparedness in France and Switzerland." Newell wrote a covering letter of introduction and recommendation for the proposal (1916).

RS 11/5/29

NEWMARK, NATHAN M. PAPERS, 1933, 1937-1966 6.0 cu. ft.

Papers of Nathan M. Newmark, professor of civil engineering (1937-), including correspondence, reports and publications relating to the American Concrete Institute Committee on Reinforced Concrete (1937-1940), American Society of Civil Engineers Committee on Design of Structural Members (1939-1945), Consolidated Vultee and Lockheed Aircraft corporations (1939-1945), static strain indicators, materials testing, structural design of buildings and ships and the structural research laboratory.

RS 11/5/26

NUCMC 71-1162

NEWS-GAZETTE NEGATIVES, 1935-1964 56.0 cu. ft.

4"x5" and 3 1/2"x4 1/2" negatives of photographs taken for the Champaign-Urbana News-Gazette including public events, sports, celebrities, natural disasters, social interest photographs, buildings, Champaign-Urbana activities and the University of Illinois. The series includes chronological listings of photographs taken from March 1, 1950 to December 31, 1966, showing date, subject and photographer. Negatives for the September 25, 1960 to January 3, 1962 period were destroyed by fire.

RS 39/2/30

NOYES, WILLIAM A. (1857-1941) PAPERS, 1870-1942 8.6 cu. ft.

Correspondence, manuscripts, publications and photographs of William A. Noyes, professor of chemistry (1907-1926), including essays, notebooks and correspondence from his student years (Iowa College, 1875-1879; Johns Hopkins, 1880-1882); manuscripts of published and unpublished scientific papers; correspondence with colleagues on chemical problems; personal correspondence with family and friends; laboratory notebooks and correspondence and manuscripts on domestic and international affairs, economics and religion. The papers include manuscripts of his early investigations into the structure of camphoric acid and the camphor series, and of his later studies on valence, electron theory, ionization and their relationship to organic chemistry. Of special interest is his correspondence with Linus Pauling, Gilbert Lewis, Robert Mulliken and Julius Stieglitz. Other scientific correspondents include Ira Remsen, Alexander Smith, Roger Adams, Arthur B. Lamb, Arthur Compton, Charles Jackson and Theodore Richard. Numerous files concern Noyes' editorship of the Journal of the American Chemical Society, Chemical Abstracts, Chemical Reviews and Chemical Monographs. His laboratory notes are complete from 1895-1934. Included in his personal and non-scientific papers are manuscripts of articles on war, the economy, fascism, interventionism, religion and similar subjects (1920-1940). Related correspondence stresses his efforts to reunite the international scientific community after World War I, encouragement of economic sanctions against aggressors in the 1930's, work on behalf of European refugees, and support of civil rights organizations. Richard Willstätter, Charles Marie, Marston Bogart, Albert Shaw, Charles M. Sheldon and Arthur Capper correspond on these subjects. Personal correspondence includes letters from his wives and children.

RS 15/5/21 SFA - 7 NUCMC 65-1928

OCKERSON, JOHN A. ALBUM, 1869-1873 .2 cu. ft.

John A. Ockerson Photographic Album, containing photographs of faculty members and students.

RS 41/20/4

O'DONNELL, THOMAS E. (1885-1964) PAPERS, 1919-1961 1.6 cu. ft.

Papers of Thomas E. O'Donnell, professor of architecture (1922-1954), including correspondence (1919-1953); departmental newsletters, reports and announcements; articles and photographs relating to Greek Revival Architecture, Ohio ironwork, wood decoration and doorways; photographs of University buildings; manuscripts relating to Ohio, Indiana and Illinois architecture; Nathan C. Ricker Manuscript Translations; clippings; photographs; articles relating to architecture and drawings (bridges, fences, door knockers, ornamental iron) relating to American colonial and Old English periods.

RS 12/2/24 SFA - 3 NUCMC 69-268

OLDFATHER, WILLIAM A. (1880-1945) PAPERS, 1904-1945 7.6 cu. ft.

Papers of William A. Oldfather, professor of classics (1909-1945), including correspondence, memoranda, reports, studies, notes, reviews, manuscripts and related material concerning classical writings, publications, students, job placement, travels and teaching abroad, hikes and canoe trips, affairs of national and local professional and political organizations, university administration and research. Substantial portions of the papers relate to Oldfather's work as general editor of the Illinois Studies in Language and Literature (1914-1945), American Philological Association (1936-1944), American Committee for Democracy and Intellectual Freedom (1941-1942), University Committee of Nine (1931), Constitution Study Club (1935-1937), General Studies Curriculum (1943-1945), Senate Library Committee (1930-1935), Munich notes (1904-1907), faculty salary study (1944-1945) and Oldfather's publications. Most of the correspondence is for the 1936-1945 period. The series includes publications.

RS 15/6/20 SFA - 6 NUCMC 65-1929

OLIVER, THOMAS E. (1871-1946) PAPERS, 1899-1900, 1915-1916 .1 cu. ft.

Papers of Thomas E. Oliver, professor of romance languages (1903-1940), including notes from graduate coursework taken while an instructor at the University of Michigan (1899-1900) and notes used for instruction at the University of Illinois (ca. 1915-1916).

RS 15/9/20

PAINE, ELLERY B. (1875-) PAPERS, 1916, 1967 .1 cu. ft.

Papers of Ellery B. Paine, professor of electrical engineering (1907-1944), including a tape-recording (1967) concerning Joseph T. Tykociner, Trygvie Jensen, Harold B. Smith, Westinghouse, patents, hazing and pushball; photocopies of recollections of electrical shows, Edmund J. James, George Huff, Nathan C. Ricker, Morgan Brooks, Joseph T. Tykociner, pushball and "Women north of Green Street," and a reprint of an article on voltage regulation of distribution circuits.

RS 11/6/22 SFA - 1

THE PALEONTOLOGICAL SOCIETY RECORDS, 1908-1919, 1927-1928, 1933-1962 1.3 cu. ft.

Records of the Paleontological Society, including correspondence, agendas, proceedings, membership lists and applications, newsletters, brochures, statements and questionnaires by the Society secretaries and relating to the organization of the Society (1908), affiliation with the professional organizations, membership, constitution and by-laws, election of officers, committee work, annual meetings, Pacific Coast branch, publications, abstracts, organization of the American Geological Institute (1943-1944) and related topics. Correspondents include Kenneth P. Caster, Henry S. Ladd and Harry B. Whittington.

RS 15/11/20 SFA - 2 NUCMC 65-1930

PALMER, ARTHUR (1861-1904) PAPERS, 1893-1903 .3 cu. ft.

Letterbooks containing outgoing correspondence of Arthur W. Palmer, professor and head of the chemistry department (1890-1904), including copies of letters concerning chemistry department needs for buildings, laboratory equipment and chemicals; analyses of chemical compounds for public officials and manufacturers; applications for academic positions; instruction in chemistry; pharmacy training; water survey; budgets and related matters. Among topics discussed are pharmaceutical education (December 8, 1893, November 14, 1894, April 22 and May 26, 1897); analyses of air at the state prison (May 6, 1895); public service role of the chemistry department (May 6, 1895) and pure food conference (November 26, 1898). The series includes copies of Palmer's Chemical Survey of the Waters of Illinois for 1897-1902 (1903) and Chemical Survey of the Water Supplies of Illinois (1897).

RS 15/5/20 NUCMC 71-1163

PANHORST, FREDERICK W. (1893-1974) PAPERS, 1914-23, 1930-36, 1946, 1953, 1960-70 .8 cu.ft.

Papers of Frederick W. Panhorst '15 (1893-1974), California Highway bridge engineer.

RS 26/20/34

PARKER, NORMAN A. (1906-) PAPERS, 1948-1952, 1954-1961 2.0 cu. ft.

Papers of Norman A. Parker, professor and head of mechanical engineering (1946-1961), including correspondence, reports, minutes, publications and notes relating to professional work with the American Society for Engineering Education (1954-1956) and the Engineers Council for Professional Development (1960-1961); university service as chairman of the educational policy (1949-1951), building program (1958-1960) and campus planning (1960-1961) committees; College of Engineering service on the Policy and Development Committee's Nontechnical Electives Subcommittee (1949-1951), philosophy and methods committee (1952) and professional degrees committee (1949-1952) and departmental teacher training material, newsletters and graduate program, curricular and special study materials. The series includes material on the selection of architects and federal support of university building projects (1956-1959).

RS 11/8/20 SFA - 2 NUCMC 67-468

PATTON, AUDLEY E. (1898-) PAPERS, 1925 .1 cu. ft.

Correspondence of Audley E. Patton, professor of the economics of public utilities
(1925-1927), with representatives of utility companies and Samuel Insull, concerning a
public utility exhibit held at the University (May 4 - May 9, 1925). The correspondence
deals with procuring suitable exhibits, their transportation and installation in the
gymnasium, accommodations for visitors, arranging for publicity for the event, inviting Mr.
Insull as guest speaker and Mrs. Anna Petersen as demonstrator and letters of thanks to all
those concerned with the exhibition. Mr. Insull spoke on "Why Do So Many Young Men Enter
the Public Utility Business?" The file contains a mimeographed copy of his speech. The
correspondence covers the period from February to May, 1925.

RS 9/5/25

PEABODY, SELIM H. (1829-1903) SPEECHES AND SERMONS, 1881-1891, 1894 .3 cu. ft.

Manuscript and typescript copies of speeches and sermons delivered by Regent Selim H.
Peabody at University baccalaureate services and meetings of the National Educational
Association; State Teachers Association, Farmers' Institute, high school commencements and
University celebrations concerning the origins and development of the University of
Illinois; accreditation; matriculation; scholarships; faculty; student government;
certificates and degrees; buildings and equipment; financial and administrative problems;
development of American high schools and universities; high school curricula; statistics on
higher education; state support of higher education in Illinois and comparisons with
neighboring states; purposes and needs of the University; tool work education and the
education of farm children. The baccalaureate sermons and high school addresses relate to
higher law, conscience, application of Christianity, science and faith, supremacy of law,
academic excellence, intellectual stimuli and the use of abilities and knowledge.

RS 2/2/1 SFA - 3 NUCMC 65-165

PEARMAN FAMILY PAPERS, 1877-1890, 1911-1951 .3 cu. ft.

Pearman Family Papers, including photographs and tintypes of Ida Pearman (Stevens) '80, her
classmates, sisters Minnie Pearman and Myrtle Pearman (Keene), father John T. Pearman
(trustee), brother James O. Pearman '81 and their friends (1879-1890); a history of the
Class of 1880 by Ida Pearman including discussions of attrition, admission standards,
Professor Joseph C. Pickard's classes, class officers and meetings, social affairs and
dating; an 1880 class album containing photographs of class members, faculty and university
buildings; class day program (1880); Sophograph (1889); James O. Pearman's diplomas and
certificates (1878, 1881, 1885, 1938) and photographs, programs and newsletters relating to
alumni reunions of the classes of 1881 (1916, 1930-1931) and 1891 (1911-1951).

RS 26/20/8 NUCMC 69-269

PEASE, MARGUERITE J. PAPERS, 1967 .1 cu. ft.

Papers of Marguerite J. Pease, director of the Illinois Historical Survey (1958-1964),
including a tape-recorded recollection of the Illinois Historical Survey, Illinois
Historical Collections, document copying programs, Survey publications, World War I records
and War Committee, graduate work in history at Illinois in the 1920's and Illinois colonial
records.

RS 7/8/20 SFA - 1

PEASE, THEODORE C. (1887-1948) PAPERS, 1915, 1921-1927, 1933-1938, 1942-1944 .3 cu. ft.

Papers of Theodore C. Pease, professor of history (1920-1948), including an hour
examination in history written by Harold Grange (1925), group photographs of English
historians (1926, 1933) and correspondence and reports concerning history courses for the
Women's Auxiliary Training Corps (1942-1943), foreign area and language studies (1943-1944)
and the Senate Library Committee (1939-1944). The series includes files on the university
military (1923) and legislative (1937-1938) histories, an educational survey (1925-1927)
and publications (1915-1937).

RS 15/13/23

PERRY, BEN E. (1892-1968) PAPERS, 1919-1968 1.3 cu. ft.

Papers of Ben E. Perry, professor of classics (1924-1960), including correspondence
(1952-1968) and eighteen notebooks of transcriptions and notes on original classical
literary sources and codices. Some notebooks were filled in European libraries while a
Guggenheim fellow in 1930-1931. The series includes notes taken for his doctorate, "The
Metamorphoses Ascribed to Lucius of Patrae" at Princeton (1919), reprints of most of his
articles and book reviews, two books (the printed thesis and Secundus the Silent
Philosopher) and his manuscript for The Ancient Romances. The latter grew from his Sather
lectures at Berkeley in 1951. Notebooks also contain notes for university classes and his
studies in Armenian. The series includes a photograph of the Urbana Hiking Club (ca. 1926).

RS 15/6/21 SFA - 1

PETERS, EVERETT R. PAPERS, 1968 .1 cu. ft.

Papers of Everett R. Peters, 1914-1916, Illinois State Senator from Champaign County
(1941-1971), including letters about university budgets, administrators, athletics,
educational policy, Chicago campuses; financial support and legislative action on the
appropriation bill for the construction of the Illini Union Building.

RS 26/20/15

PHELPS, VERGIL V. (1880-) PAPERS, 1882-1968 2.0 cu. ft.

Papers of Vergil V. Phelps, executive secretary (1914-1918), including correspondence,
manuscripts, notes, books, reprints, newspaper clippings, programs and tape-recording
relating to religious education (1895-1916), Edmund J. James, university trustees Laura
Evans and Florence Watson Burrell, World War I service as a YMCA secretary at Camp Travis,
Texas and machine gun officer candidate at Camp Hancock, Georgia, vocational education
(1918-1919), oratorical contests at the College of the City of Detroit (1924-1927),
business education (1925-1941), contacts with former German prisoners of war (1945-1951,
1963), speech education, pronunciation and higher education. The series includes Dr.
Phelps' Yale dissertation "The Pastor and the Teacher in New England" (1910), magazine Do
You Think? (1929-1941), books How to Speak: The Speech Slogan (1927) and Whither?
Rainbows? Sunsets? (1968), manuscripts on public speaking and personality and a
tape-recording (1968) on his family, career, work at the University of Illinois and people
he knew. Published material relates to theology, temperance, World Wars I and II and
vocational training.

RS 2/5/21 SFA - 8 NUCMC 69-270

PHI BETA KAPPA RECORDS, 1900-1961 3.0 cu. ft.

Records of Gamma of Illinois Chapter of Phi Beta Kappa, maintained by the chapter secretary,
treasurer, president and committees including correspondence; minutes; reports; lists of
national and chapter officers and faculty, graduate and undergraduate members; clippings;
manuals and handbooks; programs; constitutions; bulletins and similar material relating to
membership, keys, initiation, approval of new chapters, programs and addresses, academic
records, financial matters, dues, banquets, constitutions and by-laws, organization (1908)
and membership recommendations. The records include correspondence (1900-10, 1914-60),
clippings (1925-55), programs (1908-09, 1920-30, 1934-45, 1949-59), membership lists
(1907-51), treasurer's books (1911-43),treasurer's correspondence and reports (1919-51),
minutes of meetings (1900-52), national office correspondence (1913-19, 1931-32, 1938-42),
national office publications (1931-45), a history of Phi Beta Kappa (1945) and catalog of
members (1922). The series also includes Presidential Addresses (1950, 1957, 1959-61).

RS 41/6/3/46 SFA - 1

PHI KAPPA PHI RECORDS, 1933-1969 2.0 cu. ft.

Records of the Phi Kappa Phi honorary society including correspondence, memoranda, reports,
worksheets, programs, clippings and other documents relating to membership, initiation,
scholarships, officers, faculty citations, constitution and by-laws, annual reports and
meetings. The series includes the May 25, 1933 charter for the Illinois chapter.

RS 41/6/3/50

PIERCE, JOHN L. (1853-1942) MEMORY BOOK, 1872-1883, 1914 .1 cu. ft.

Memory book of John L. Pierce, class of 1874, containing programs and publications
relating to academic and social events, including literary society programs (1872-1874,
1878, 1880-1881), anniversary day programs (1874-1875, 1877-1878), class day programs
(1874-1881), alumni association exercises (1875-1882, 1914), commencement programs
(1875-1883), student activities issuances (1873-1874, 1876, 1880-1881), alumni lists
(1881-1882) and announcement cards. The series also contains Maggie Harris' (Pierce)
matriculation certificate (1872), the University Reporter (1874), the Vindicator (1881)
and photographs of faculty and staff.

RS 26/30/4

POTTHOFF, EDWARD F. (1898-1960) PAPERS, 1926-1960 1.0 cu. ft.

Papers of Edward F. Potthoff, professor of education (1931-1960) and director of the
Bureau of Institutional Research (1945-1960), including copies of reprints (1926-1960)
concerning educational psychology, higher education, examinations, teacher education and
college and university enrollment, and a copy of Professor Potthoff's 1928 dissertation at
Chicago on selective admission of college students.

RS 5/5/20 SFA - 7

POWELL, BURT E. (1867-) PAPERS, 1915-1917 .1 cu. ft.

Papers of Burt E. Powell, Director of Information Office and University Historian
(1914-1918), including material for the University Press Bulletin and replies to letters
sent by Powell as editor of the Bulletin to librarians, newspapers and periodicals. Also
included is an article entitled "The University of Illinois" (1912).

RS 39/1/21
NUCMC 65-1931

POWELL, JOHN H. (1868-1947) NOTEBOOK, 1889 .1 cu. ft.

John H. Powell blueprint course notes for Professor Theodore B. Comstock's course in mining engineering including material on the principles of mining attack (74 pages) and Timbering and Walling (22 pages). Volume contains a complete course outline with many sketches of mining equipment and construction methods.

RS 41/30/7

PRICE, MAURICE T. (1888-1964) PAPERS, 1909-1934, 1937-1940, 1945-1948 7.7 cu. ft.

Papers of Maurice T. Price, visiting lecturer in sociology (1939-1945), including correspondence, notes, newspaper clippings, manuscripts, periodicals, book reviews, student term papers, reprints and related material concerning the sociological and psychological analysis of oriental peoples and cultures; the impact of Christian missions in the Far East; international relations; influence of communism in China; courses in sociology, psychology, philosophy and religion at Chicago (1909-1916); reform movements and college life (1913-1918); living conditions in China; documentary sources of analyses of Nanking Road (5/30/25) and Wahnsien (9/5/26) incidents; sociological study questionnaires; studies for the Bureau of Indian Affairs (1937-1939) and Price's Christian Missions and Oriental Civilizations (1924). Mr. Price was in China from 1917 to 1927, except for 1921-1922.

RS 15/21/20 SFA - 10 NUCMC 67-469

PROGRESSIVE EDUCATION ASSOCIATION RECORDS, 1924-1961 21 cu. ft.

Office records of the Progressive Education Association (American Education Fellowship after 1944) and its magazine, Progressive Education. Association records include financial statements; audit reports; journals; ledgers; directors' and treasurers' reports; promotional material and correspondence relating to status of local chapters; academic freedom; membership; status of the progressive education movement; New Education Fellowship of London; the Association's commissions on educational freedom, Indian Affairs, human relations, the relation of school and college and separation of church and state; Institute for the Study of Personality Development; bureaus and committees; branch and state activities; financial grants; General Education Board; National Commission on Cooperative Curriculum Planning; publications, The Eight Year Study; contributions; conferences and exhibits and officers and members of the Association. The magazine records include financial records, publication materials (galley proofs and page proofs), back copies, reprints, manuscripts and correspondence relating to the content of the magazine, contributions, yearbooks, administrative procedures, advertising, income, subscriptions, and members and officers of the magazine and association.

RS 10/6/20 SFA - 16

PULCIPHER, K. DeWITT (1896-) PAPERS, 1918 .1 cu. ft.

Papers of K. DeWitt Pulcipher '18, including a copy of a covering letter from M. C. Sjoblom and a Report on the Boneyard in Champaign and Urbana (March 6, 1918).

RS 41/20/37

QUINN, J. KERKER (1911-1969) PAPERS, 1926-1969 24.4 cu. ft.

Papers of J. Kerker Quinn, professor of English (1952-1969) and editor of Direction
(1934-1935) and Accent (1940-1960), including personal and business correspondence with
contributors, subscribers and colleagues; manuscripts of poetry, stories and plays; student
papers from Bradley College (1930-1934); copies of Direction and Accent; contributions
record (1940-1961); files on "little magazines;" financial records; lecture and research
notes; Ford Foundation fellowship program for creative writers files (1953-1963); sheet
music; playbills; poetry and fiction bibliographies; newspaper clippings; course materials;
class records and student papers. Correspondents include Nelson Algren, Eric Bentley,
Walter Van Tillburg Clark, Malcom Cowley, E. E. Cummings, Bill Gass, Henry Miller, Marianne
Moore, Katherine Anne Porter, J. F. Powers, George Scouffas, Charles Shattuck, Wallace
Stevens, Eudora Welty and Richard Wright.

RS 15/7/30 SFA - 16 RESTRICTED NUCMC 72-163

RABINOWITCH, EUGENE I. (1901-) PAPERS, 1930-1968 8.3 cu. ft.

Papers of Eugene I. Rabinowitch, professor of biophysics (1947-1968) including
correspondence; manuscript papers, articles and books; reprints; published proceedings of
symposia and meetings; laboratory notebooks; grant proposals and reports; research notes,
calculations, illustrations and graphs; course materials relating to the role of
scientists in society and politics, international scientific meetings, research in
photosynthesis, photobiology and biophysics, publications and university affairs.
Professor Rabinowitch was editor of Bulletin of the Atomic Scientists, and associated with
organizations of scientists for peace.

RS 15/4/23 SFA - 15 NUCMC 69-271

RANDALL, JAMES G. (1881-1953) PAPERS, 1903-1953 6.3 cu. ft.

Papers of James G. Randall, professor of history (1920-1950), including correspondence
with historians Laurence Larson, Evarts Greene, William Dodd, Charles Van Tyne, Allan
Nevins, Louis Pelzer, Louis Sears and Charles Ramsdell on historical subjects, especially
Lincoln, the Civil War and Reconstruction. Manuscripts include student essays at Butler
College (1903), seminar papers and notes from graduate study at the University of Chicago
(1904-1912), lectures by Albion Small, Charles Merriam, Andrew McLaughlin and others;
lectures in history and economics by Randall at Illinois College (1907); manuscripts and
correspondence regarding his doctoral thesis on "Confiscation" (1912-1913); Epworth League
and Sunday School addresses (1905-1919); drafts and finished copies of monographs and
related correspondence on World War I, League of Nations, politics and Civil War history
(1912-1950); manuscripts, correspondence, proofs and reviews of his books, Constitutional
Problems under Lincoln (1918-1926) and The Civil War and Reconstruction (1929-1936); and
lecture notes, syllabi, bibliographies, assignments, exams, rosters and other class records
(1913-1950). The papers include exchanges with Frank Anderson, Charles Ramsdell and John
F. Jameson on "The Diary of a Public Man" (1926-1927); comments of Roy Nichols, Fred
Shannon, Earl Coulter, James Sellers and Charles Sydnor on his The Civil War and
Reconstruction manuscript (1935-1936); material relating to his activities as a member of
the American Historical Association Dunning Prize Committee (1933-1934); Nominating
Committee (1934-1935); Beveridge Fund (1934-1938) and the Mississippi Valley Historical
Association (Nominating and Executive Committees (1930-1939) and President (1939-1940) and
as U. S. Shipping Board historian (1918-1919).

RS 15/13/20 SFA - 4 RESTRICTED NUCMC 65-166

RAPHAELSON, SAMSON PAPERS, 1921, 1959, 1969, 1971, 1974 .3 cu. ft.

Papers of Samson Raphaelson '17, visiting professor in English (1948), including
transcriptions of an interview by the Columbia University Oral History Project (1959),
family discussion tapes (1969, 1971) and taped interviews by Robert Carringer (1973) about
childhood in New York and Chicago, the University of Illinois, writing, short stories,
playwriting, criticism, motion pictures, newspaper and magazine writing, advertising,
Ernst Lubitsch, Alfred Hitchcock and plays including "The Jazz Singer," "Young Love,"
"Accent on Youth," "Skylark" and "Jason."

RS 26/20/38

RAUSHENBERGER, JOHN W. (1905-) PAPERS, 1932-1972 3.0 cu. ft.

Papers of John W. Raushenberger '33 (1905-), professor of art (1949-72), including
correspondence, newspaper clippings, announcements, programs, photographs and publications
about departmental events, art department faculty and students, exhibitions and
competitions, lectures, arrangements for university and traveling exhibits, regional art
associations and conferences, summer art programs, social events and marriages, Lorado
Taft, Charles Bradbury and related topics.

RS 12/3/21 SFA - 1

REECE, ERNEST J. (1881-) PAPERS, 1914-1915, 1944, 1967-1972 .3 cu. ft.

Papers of Ernest J. Reece, instructor (1912-1915), associate (1915-1917) and visiting professor (1949, 1951) of library science, including a 21-page statement concerning education for librarianship, institutional and individual contribution to the education of librarians, American Library Association, Association of American Library Schools, Williamson Report (1923), factors in the development of library schools, curriculum, Columbia, international programs and technological influences. The series includes a statement on "Some American Library Schools As Seen From Within" (1968) and copies of "Race Mingling in Hawaii" (1914), "State Documents for Libraries" (1915), Programs for Library Schools (1943), The Task and Training of Librarians (1949) and The Curriculum in Library Schools (1936).

RS 18/1/23

RELIGIOUS WORKERS ASSOCIATION PAPERS, 1922-1967 1.0 cu. ft.

Papers of the Religious Workers Association, a cooperative organization of ministers and priests of campus religious foundations. Chronological files (1952-1967) include correspondence; minutes and agenda for meetings; committee reports, particularly on religious census and credit courses; budgets; rosters; newspaper clippings; flyers and policy statements. Subject files (1922-1963) contain minutes, reports, correspondence, issuances and publicity concerning Protestant Christian Committee (1949-1952, 1957-1961), Vespers Committee (1938-1952), Sunday Evening Club (1939-1943), Credit Course Committee (1922-1954), Religious Emphasis Weeks (1938-1950), finance (1932-1964), policy (1950-1951) and membership (1950-1960).

RS 41/6/9/70 SFA - 2

RHOADS, MARCUS M. (1903-) PAPERS, 1948-1958 .1 cu. ft.

Papers of Marcus M. Rhoads, professor of botany (1948-1958) including correspondence and reports. The series includes letters accepting appointments to advisory committees of the National Science Foundation and the Atomic Energy Commission; letters of recommendation for students; recommendations for other appointments; letters about writing two chapters for the Handbook of Plant Physiology and reports on genetics research.

RS 15/4/27 SFA - 2

RICKER, NATHAN C. (1843-1924) PAPERS, 1875-1925 2.3 cu. ft.

Papers of Nathan C. Ricker '72, professor of architecture (1874-1917) and Dean of the College of Engineering (1878-1905), including correspondence, publications, examination questions (1883-1889), notes and financial records relating to courses in architecture, architectural publications, the employment and careers of former students, Ricker's 50th anniversary of his graduation and his 80th birthday and the University. Over half the series consists of photographs of Ricker and his family, University scenes, friends, relatives, public buildings, houses, art works and landscape views. Ricker's autobiographical "The Story of a Life" is in record series 12/2/1, Box 15.

RS 12/2/22 SFA - 2 NUCMC 67-470

RICKER, NATHAN C. TRANSCRIPTS AND TEXTBOOKS, 1873-1875, 1884-1890, 1898-1907, 1914-1921
 3.6 cu. ft.

Blueprint, mimeographed and printed transcripts and original texts for use as lecture
materials or class texts, including a printed copy of Elementary Graphic Statics and the
Construction of Trussed Roofs, (New York, 1885); translations of works by Thiersch, Wagner
and Buhlmann (Architectural Composition), Gaudet, Kersten, Landsberg, Lubke,
Muller-Breslav, Planat, Redtenbacher, Semper, Viollet-le Duc (articles from the
"Dictionnaire") and Zillich; notes in advanced graphics, architectural engineering,
heating, and ventilation, stone, brick and metal construction, texts in elements of
construction, graphic statics and history of architecture. The series also includes an
explanation of "The Blue Process" (ca. 1881-1884), a translation by Dickhut of a work by
Gromart; Tables of Dead Weights by E. S. Lemme (Class of '86) and revisions by Wolfe and
Livesay of Ricker's Notes on Graphic Statics.

RS 12/2/21 SFA - 3

RICKMAN, J. THOMAS PAPERS, 1966-1973 .3 cu. ft.

Papers of J. Thomas Richman, M.A. 1966, including a thirty minute (1100') 16 mm. black and
white motion picture produced by Thomas Rickman, Vollmer and Childers (ca. 1966) and
mimeographed copies of screenplays for "The Kansas City Bomber," "Didn't He Ramble" and
"The White Dawn" (March 1973).

RS 26/20/32 RESTRICTED

RIDENOUR, LOUIS N. (1911-1959) PAPERS, 1946-1950 2 cu. ft.

Papers of Louis N. Ridenour, Dean of the Graduate College and professor of physics
(1947-1951), including correspondence, reports, publications (1935-1940, 1946-1950), book
reviews and manuscripts relating to scientific research projects, military research and
development, nuclear energy, atomic and hydrogen bombs, international understanding,
loyalty and security, consulting work, scientific materials and equipment, research and
development contracts, M. I. T. Radiation Laboratory series, appointments at Illinois,
resignation (5/12/50), RAND consultant work (1949), metallurgy, solid state physics,
libraries, Atomic Energy Commission, Office of Scientific Research and Development,
Aberdeen Ballistic Research Lab, Office of Naval Research, Air Force Scientific Advisory
Board Research and Development Report (1949), and the Army Advisory Committee on Research
and Development Contractual procedures. Significant correspondents include Hans A. Bethe,
Vannevar Bush, Karl Compton, I. Bernard Cohen, James H. Doolittle, Lee Du Bridge, Edward
M. Earle, H. H. Harris, James R. Killian, David Lilienthal, Karl Lark-Horovitz, Charles C.
Lauritsen, Leon Linford, Wheeler Loomis, Carl Overhage, I. I. Rabi, Frederick Seitz, George
D. Stoddard, George E. Valley, T. F. Walkowicz, Warren Weaver and Raymond Woodrow.

RS 7/1/20 NUCMC 67-471

ROBERTS, ELMER (1886-) PAPERS, 1918, 1921-1945, 1948, 1967 .3 cu. ft.

Papers of Elmer Roberts, '13, Ph.D. '17, professor of animal genetics (1920-1954),
including copies of 44 publications on research in animal genetics (chickens, swine,
cattle, sheep, rodents and horses), hereditary resistance and susceptibility to disease,
immunity, Mendelian inheritance and related topics and a tape-recorded recollection on
agriculture at the University of Illinois, Eugene Davenport, Agricultural Experiment
Station, animal genetics and the support of the College of Agriculture by farmers and farm
organizations. The series includes Plant and Animal Improvement (1925) and Heredity:
What and How We Inherit (1959).

RS 8/7/21 SFA - 3

ROBERTSON, WILLIAM S. (1872-1955) PAPERS, 1910-1947 1.1 cu. ft.

Papers of William S. Robertson, professor of history (1909-1941), head of department (1937-1941), including manuscripts of France and Latin-American Independence (1939), "The Memorabilia of Augustin de Iturbide" (ca. 1945), "Latin America, the Monroe Doctrine, and the League of Nations" (1930), and "South American Books in the University of Illinois Library" (1916); bibliographies; correspondence (1922-1934) relating to his research and publications; illustrations and photographs; newspaper clippings and research notes relating to Latin America and reprints (1910-1947). The series includes Professor Robertson's correspondence (1937-1940) as department head with President Arthur C. Willard, faculty and private and federal agencies concerning Latin American studies, visitors and attendance at conferences and meetings relating to Latin American history and international relations.

RS 15/13/27 SFA - 2 NUCMC 71-1164

ROBINSON, FLORENCE B. PAPERS, 1928, ca. 1949 .3 cu. ft.

Papers of Florence B. Robinson, professor of landscape architecture (1929-1951), including typescript of "The Imperial Palaces of Peking" translated from the French of Gisbert Combaz; typescript of "Palette of Plants and Its Use" (1949); photographs, sketches and proof copy for "Palette of Plants and Its Use;" "How to Recognize the Hybrid Lilacs" and general notes and class materials.

RS 12/4/21

RODKEY, FRED S. (1896-) PAPERS, 1926-1956, 1965 .1 cu. ft.

Papers of Frederick S. Rodkey, professor of history (1929-1957) including reprints of scholarly articles on Turkish and Russian history and personal views on war and diplomacy. Most of the later articles relate to Rodkey's World War II service as an officer interested in psychological warfare.

RS 15/13/29 SFA - 1

ROGERS, ROBERT W. PAPERS, 1960-1968 2.0 cu. ft.

Papers of Robert W. Rogers, English department head (1957-64) and dean of the College of Liberal Arts and Sciences (1964-), containing correspondence, manuscripts, reports, newspaper clippings, publications, committee minutes, texts of speeches delivered, working papers of international conferences, and English department administrative papers and memos. Organizations, conferences and committees in the series include the Allerton Park Committee, American Association of University Professors, American Comparative Literature Association, American Council on Education, Campus Planning Committee, Council of Colleges of Arts and Sciences, Association of Departments of English, English Department Planning Committee, Search Committee for Graduate Dean (1963), Guggenheim Foundation, International Conference on the Humanities in Higher Education (1966), International Year of the Arts and Humanities (1965-66), Committee on Professional Personnel, Committee on Courses and Curricula and the Basic Foreign Language Committee. The series includes an index to the working papers related to the International Conference on the Humanities in Higher Education and the International Year of the Arts and Humanities.

RS 15/1/21 SFA - 2

ROLFE FAMILY PAPERS, 1885, 1892-1895, 1972 5.0 cu. ft.

Rolfe Family Papers including correspondence, record books, photographs, manuscripts, publications, clippings and tape recording relating to Charles W. Rolfe '72 (1850-1934), professor of geology (1884-1917), Martha Deette Rolfe '00 (1879-1971), and Mary A. Rolfe '02 (1881-1974), including files on ceramic engineering (1907-27); Class of 1900 (1954-64); Class of 1902 (1948-62), Congregational Church (1915-64); Charles and Martha Rolfe's Golden Wedding Anniversary (1927) and estate (1933-38); a trip to Alaska (1938); Champaign Neighborhood House (1902); a research paper on salt (1914-26); property in Champaign and Urbana (1927-60); farms in Alvin (1911-47), Ludlow (1907-51) and Oswego (1908-51), Illinois and a tape recorded recollection by Mary Rolfe of Illinois Field, faculty life, student housing, trees on campus, Charles A. Rolfe, alumni reunions, 1902 commencement, Thomas J. Burrill, Thomas A. Clark and student life. The papers include a county atlas of Illinois from topographic sketches by Prof. Rolfe's geology students prepared for the Columbian Exposition and extensive correspondence and records on the farm south of Oswego (1908-67). The series includes correspondence, publications and photographs relating to Mary Rolfe's Y.W.C.A. and Red Cross service in France during World War I.

RS 26/20/12 SFA - 9

ROLLAND, PAUL PAPERS, 1946, 1949-56, 1958-1966 .3 cu. ft.

Papers of Paul Rolland, professor of music (1945-), including correspondence concerning the Illinois String Planning Conferences (1945-48), students, bow grip and violin neck inventions, music programs, string quartet trip (1955), violin camp (1956), summer youth programs (1958-65), and American String Teachers business. Correspondents include Rex Underwood, Duane Haskell, Frank Hill, Ernest Harris, Phyllis Weyer, Mary Sexton, Leonard Ratner and Max Rostal.

RS 12/5/21

ROOS, FRANK J. Jr. (1903-1967) PAPERS, 1926-1966 3.0 cu. ft.

Papers of Frank J. Roos Jr., professor of art (1946-1967) and head of the Art Department (1946-1948), including correspondence with publishers about the Illustrated Handbook of Art (1937) and the proposed book Approach to Art and with encyclopedia firms; manuscripts and reprints of publications relating to art, art appreciation, the history of art and architecture (particularly American and more specifically Ohio); lecture notes on art appreciation given over station WOSU, Columbus, Ohio (1938); syllabi and lecture notes given at Ohio University (1928-1936), Ohio State University (1936-1946) and the University of Illinois (1946-1967); papers of students (1961-1966) and photographs and reproductions relating to art (color, unity, design) and art history.

RS 12/3/20 SFA - 5 NUCMC 72-164

ROPER, ELEANOR (1873-) NOTEBOOKS, 1896-1897 .3 cu. ft.

Manuscript class notes taken by Eleanor Roper in courses at the Armour Institute of Technology Department of Library Economy relating to the history of books, printing and libraries; cataloging and comparative cataloging; Greek and German literature; bibliography; binding; examination papers and quizzes; classification and reference works. In 1897 the Armour Institute Library faculty moved to the University of Illinois to establish the Graduate School of Library Science.

RS 41/30/3

ROSE, WILLIAM C. (1887-) PAPERS, 1923-1962, 1966 1 cu. ft.

Papers of William C. Rose, professor of chemistry (1922-1955), including correspondence with biochemists concerning committee service, faculty recruitment, recommendations, honors and awards, the second International Congress of Biochemistry (1952), papers for professional meetings, lectures, publications and visits; photographs of biochemists; university committee reports on food research (1944), krebiozen (1951-1952) and honorary degrees (1952-1954); list of doctorates supervised (1958); publications list (1910-1959); manuscripts of published articles on amino acids, threonine, Lafayette B. Mendel and the physiology of amino acid metabolism, and reprints of articles from scientific, technical and popular journals relating to nutritional and growth requirements and the synthesis of amino acids in proteins. The series includes tape-recorded recollections of youth, Davidson, Yale, Pennsylvania, Texas, Illinois, biochemistry, seminars and students, amino acid research, work on pepsin and creatine, honors and awards, World Wars I and II, research support, John R. Young, students, presidents and textbooks.

RS 15/5/27 SFA - 4 NUCMC 67-472

ROSS, BETSY PAPERS, 1967 .1 cu. ft.

Papers of Betsy Ross, niece of President Arthur C. Willard, including tape-recorded comments on social receptions at the president's house, President Arthur C. Willard, deans and faculty, Anthony Janata, duties of the president, Charles C. Havens, dormitory construction, Illini Union, University Hall, World War II, trustees, Medical Center, Amelia Earhart and Robert Hutchins.

RS 2/9/22 SFA - 3

RUSK, HENRY P. (1884-1954) PAPERS, 1915, 1917-1918, 1923-1953 1.0 cu. ft.

Papers of Henry P. Rusk, professor of animal husbandry (1914-1939) and dean of the College of Agriculture (1939-1952) including manuscript notes and publicity relating to speeches on beef cattle production, swine, agricultural research, corn feeding, livestock farming, conservation livestock and meat industry.

RS 8/1/23 NUCMC 71-1165

SAMPSON, JESSE (1900-1965) PAPERS, 1932-1963 .3 cu. ft.

Papers of Jesse Sampson, professor of animal pathology and hygiene (1939-1943), professor of veterinary physiology and pharmacology and department head (1945-1960), including correspondence relating to encyclopedia articles (1962-1963), course outlines (1946) and reprints of published articles on ketosis in cattle and sheep, acid-base balance in cows and ewes and disturbances of carbohydrate metabolism in animals.

RS 17/5/20 NUCMC 69-273

SANDAGE, CHARLES H. (1902-) PAPERS, 1930-1963 2.0 cu. ft.

Papers of Charles H. Sandage, professor of advertising (1946-1968), including surveys and reports on radio listening in Butler County, Ohio (1945-1946), in Champaign County, Illinois (1946-1947, 1949-1950, 1963) and in the Bloomington, Illinois area (1947); correspondence relating to the Department of Marketing, Miami University, Oxford, Ohio (1938-1946); scripts of radio broadcasts on consumer education (1937-1939); correspondence relating to the Office of Price Administration in Ohio (1942-1944) and correspondence, programs and newsletters concerning the American Marketing Association (1940-1948).

RS 13/2/20 SFA - 3 NUCMC 72-165

SANFORD, CHARLES W. (1902-) PAPERS, 1943-1957, 1966-1967 2.3 cu. ft.

Papers of Charles W. Sanford, professor of education (1935-1967) and dean of admissions and records (1956-1967), including correspondence, reports and minutes relating to the Illinois (1943-1957) and National (1952-1956) Associations of Secondary School Principals, the University Committee on Future Programs (1943-1945) and service with state and university groups concerned with educational problems (1944-1956).

RS 25/1/20 SFA - 2 NUCMC 69-274

SAUNDERS, ANNETTA AYERS (1861-1938) ALBUM, 1884 .1 cu. ft.

Annetta Ayers Saunders '84 album containing individual portrait photographs of the Class of 1884.

RS 41/20/10

SCANLAN, JACK A. (1887-1972) SCRAPBOOK, 1907-1911 .1 cu. ft.

Scrapbook of Jack A. Scanlan '11 (1887-1972), including postcard photographs of Phi Kappa Sigma, Kappa Kappa Gamma, campus scenes, university buildings, athletic contests, military formations, University bands, pushball contests, May Day, commencement, Jack Scanlan, faculty members and coeds. The scrapbook includes postcards and programs for May Day, homecoming and other events in 1911.

RS 41/20/39

SCHAFFER, OTTO G. (1886-1970) PAPERS, 1928-1964 .1 cu. ft.

Papers of Otto G. Schaffer, professor of landscape architecture (1926-1954) including American Society of Landscape Architects election certificates as member and fellow (1928, 1943), retirement citation from landscape architecture faculty (1954) and Lake Forest College distinguished service citation (1964).

RS 12/4/22

SCHALLER, WILLIAM F. (1889-) PAPERS, 1906-1915, 1921, 1967 1.0 cu. ft.

Papers of William F. Schaller '10, M.S. '12, including programs, clippings, publications, correspondence and photographs (224) relating to student activities, concerts, commencements, athletic events and campus scenes; class notes (1909-1912) for electrical and mechanical engineering and physics courses and a tape-recorded interview (1967) on electrical engineering at Illinois, Ernst J. Berg, Charles P. Steinmetz, faculty and graduate work.

RS 41/20/23 SFA - 2 NUCMC 69-275

SCHER, MICHAEL (1943-1975) PAPERS, 1969-1974 3.0 cu. ft.

Papers of Michael Scher (1942-1975), professor of history (1972-75), including correspondence, microfilm, notes on interviews and source documents concerning academic work at UCLA, Gustave Hervé, French antimilitarism and socialism. The source documents relate to International and National Socialist Congresses prior to World War I, governmental reports on anarchist and antimilitarist and socialist movements.

RS 15/13/33 SFA - 6

SCHMIDT, EDWARD C. (1874-1942) PAPERS, 1913, 1933-1939 .1 cu. ft.

Papers of Edward C. Schmidt, professor of railway engineering (1901-1903, 1906-1919), 1921-1940) and head of the department (1910-1917, 1921-1940), including reprints of professional articles and reports on curricula and history of the Railway Engineering Department (1933-1937).

RS 11/5/28 SFA - 1

SCHMIDT, GUSTAVUS A. (1879-1971) ALBUM, 1903-1909 .1 cu. ft.

Photograph album of Gustavus A. Schmidt '03, including photographs and postcards of student regiment, University buildings and scenes, classmates, athletic classes and teams, military band, social activities, quarry scenes, picnics, travel scenes, ships, mandolin and glee club, sailing and physiology laboratory.

RS 41/20/14

SCOTT, FRANK W. (1877-1950) PAPERS, ca. 1921 .3 cu. ft.

Papers of Frank W. Scott, professor of English (1912-1925), including manuscripts relating to the history of American newspapers (1895-1920) and magazines, manners and morals in America (1721-1800), British journalism, Daniel Defoe and Isaiah Thomas. The manuscripts were used for lectures and articles. Professor Scott was in charge of journalism courses, 1905-1918 and 1921-1925.

RS 15/7/24

SCOVILL, HIRAM T. (1885-1962) PAPERS, 1915-1959 12.6 cu. ft.

Papers of Hiram T. Scovill, professor of accountancy and head of business organization and
operation department (1913-1953) and Acting Dean of Commerce and Business Administration
(1942-1947), including correspondence, reports, audits, manuscripts, speeches and articles,
programs and administrative officers, boards and committees, budgets, graduate education,
building programs and curricula; honorary and fraternal organizations, including Alpha
Kappa Psi, Beta Alpha Psi and Beta Gamma Sigma; professional organizations, including
American Institute of Accountants (1934-1954) and Illinois Society of C.P.A.s (1927-1954);
auditing work for local governments, religious groups and business concerns; publications
for Wiley and Sons (1922-1958) and civic and personal activities for McKinley Foundation
(1942-1959), Urbana Presbyterian Church (1928-1951), Urbana Association of Commerce
(1926-1952) and other public and private agencies.

RS 9/2/20 SFA - 5 NUCMC 67-473

SECORD, ARTHUR W. (1891-1957) PAPERS, 1938, 1945, 1950 1.3 cu. ft.

Papers of Arthur W. Secord, professor of English (1926-1957), including correspondence
concerning research on Daniel Defoe (1950), a manuscript on "Defoe in Stoke Newington"
(1950) and reprints of a prospectus for Defoe's Review (1938) and an article about Defoe
(1945).

RS 15/7/28 SFA - 1

SEITZ, FREDERICK (1911-) PAPERS, 1935-1965 18.3 cu. ft.

Papers of Frederick Seitz, professor of physics (1949-1968), department head (1957-1964)
and Graduate College dean (1964-1965), including correspondence (1948-1965), reports,
publications (1935-1957), agenda, minutes and proposals concerning the administration of
scientific organizations, programs and research activities; advisory service with federal
agencies on planning scientific research; consultant service with industrial research
programs; evaluations of research projects and personnel; education and training;
publications; membership and research grants. The series covers Seitz' work with the
American Institute of Physics (board chairman, 1954-1959); American Physical Society
(president, 1961); International Union of Pure and Applied Physics; National Academy of
Sciences (president, 1962-1969); North Atlantic Treaty Organization (scientific advisor,
1959-1960); Department of Defense; Naval Research Advisory Committee; Office of Naval
Research; Air Research and Development Command; National Science Foundation; Atomic Energy
Commission; Argonne, Brookhaven and Oak Ridge National Laboratories; Los Alamos Scientific
Laboratory; Midwest Universities Research Association; University of Illinois Department of
Physics and Coordinated Sciences Laboratory; academic institutions; contacts with federal
administrators and congressmen concerning science policy and programs and industrial
research for American Machine and Foundry, Bell Telephone, E. I. duPont, General Atomic and
United Aircraft. The series contains general personal correspondence with physicists and
science administrators concerning solid state physics, research projects, materials,
positions, publications, lectures, meetings, travel and national science policy.

RS 11/10/23 SFA - 24 RESTRICTED NUCMC 67-474

SEYBOLT, ROBERT F. (1888-1951) PAPERS, 1919-1931, 1946-1948 1.0 cu. ft.

Papers of Robert F. Seybolt, professor of education (1920-1951), containing material
relating to publications on 15th century legends, bibliographic references, translations
and notes, source material on St. Nicholas and the Legenda Aurea and an unpublished survey
of 15th century literature. Publications include material relating to the history of
colonial education (1919-1931) and the Legenda Aurea (1946).

RS 10/6/22 SFA -- 2

SHAMEL, CHARLES H. (1867-1954) PAPERS, 1874-1949 16.1 cu. ft.

Papers of Charles H. Shamel, B.S. 1890 and M.S. 1891, including an autobiography, diaries (1881-1888), photographs, papers, notes and correspondence with Clarence Shamel '91, Arch Shamel '98, Katharine Kennard '90, Robert Orr '82, Grace Howe and others concerning University affairs, Selim H. Peabody, faculty appointments, chemistry, evolution, agriculture, military drill, student rebellions, social affairs, literary society activities, lectures, women on the faculty and Board of Trustees, household science, politics, religious meetings, farmers' institutes and alumni activities. The series includes literary society programs, study lists, broadsides, receipts, class cards, excuses, social notes and essays. The diaries include comments on university life, weather, meetings, lectures and religious services. The photographs include prints of students, buildings, athletic events, social activities, laboratories and classrooms. Legal, patent, agricultural, business and travel correspondence and photographs are sorted, but not processed. The series includes an autobiography.

RS 26/20/3 SFA - 6 NUCMC 67-475

SHANNON, FRED A. (1893-1963) PAPERS, 1910-1963 4.0 cu. ft.

Papers of Fred A. Shannon, professor of history (1939-1961), including correspondence (1910-1963) about writing and editing historical publications, teaching and research in agricultural and economic history, positions and placement, Mississippi Valley Historical Association, book reviews, summer and retirement teaching, history departments, radio lectures, the "safety valve" theory and family affairs; manuscripts and proofs of America's Economic Growth (1951), The American Farmer's Movements (1957), The Farmer's Last Frontier (1945) and An Analysis of Walter P. Webb's "The Great Plains" (1939); book reviews and commentaries, lecture notes, poetry, reprints, student papers and shorter manuscripts on "The Mercenary Factor in the Creation of the Union Army (1861-1865)" (1923), "History and History Textbook," "A Century of Monopoly Growth in America" (1957), "The Conscription and Bounty Problem of the North in the Civil War" (1925) and graduate training in American History. Correspondents include Richard Bardolph, Henry S. Commager, Elmer Ellis, Frank Freidel, Paul W. Gates, Jeanette P. Nichols, Clara S. Paine, Arthur M. Schlesinger, David and Raymond Shannon and Walter P. Webb.

 NUCMC 72-1512
RS 15/13/21 SFA - 4 NUCMC 65-1932

SHARP, KATHERINE L. (1865-1914) PAPERS, 1881-1919, 1962-1963 1.7 cu. ft.

Papers of Katherine L. Sharp, Librarian and Director of the Library School (1897-1907), including diplomas from the New York State Library School (B.L.S. 1892 and M.L.S. 1907) and the Columbian Exposition (1894); correspondence as director of the Armour Institute Library School (1893-1897); correspondence with Melvil Dewey and other librarians concerning curricula and Andrew Carnegie (1894-1903); notes on a catechism for librarians (1891), library associations (1896-1905), public library work (1901), and University of Illinois Library history (1903); Library School announcements, information circulars and course descriptions (1895-1908); Illinois State Library Association (1896-1916, 1922); survey of Illinois libraries (1903-1910); photocopies of source material (1881-1898, 1907-1919); memorial letters (1914); research notes, correspondence and manuscripts (1962-1963) and photographs (1894-1907) accumulated by Miss Rose Phelps in writing a biographical sketch and by Miss Laurel Grotzinger in writing a biographical dissertation on Miss Sharp. The series contains material on library legislation in Illinois and other states (1897-1905).

RS 18/1/20 SFA - 2 NUCMC 65-1933

SHAWL, RAY I. (1890-) PAPERS, 1890, 1905-1958 1.3 cu. ft.

Papers of Ray I. Shawl (1890-), '16, M.S. '19, professor of agricultural engineering
(1921-58), including correspondence (1913, 1916, 1919-58), manuscripts (1915-57),
publications (1926, 1930-48), reports and programs (1927-55), student papers (1913,
1924, 1928, 1938), research file (1890, 1910-55), newspaper clippings (1924) and
photographs (1944-48) relating to farm mechanics and the purchase, maintenance,
lubrication and use of farm machinery and equipment including combines, corn pickers
and planters, diesel engines, plows and tractors. Most correspondence is with farm
implement manufacturers, oil companies and agricultural journals regarding research
data and publications on farm machinery and petroleum products. Manuscripts include
speeches presented at short courses, conferences and professional society meetings
and talks given over radio station WILL on farm machinery (1929-57). The series
includes convention programs and committee reports of the American Society of
Agricultural Engineers (1927-55) and material on plowing matches and tractor
demonstrations (1910-19, 1942, 1954).

RS 8/5/23

SHELFORD, VICTOR E. (1877-1968) PAPERS, 1901, 1909-1961, 1965 3.6 cu. ft.

Papers of Victor E. Shelford, professor of zoology (1914-1946), including correspondence,
reports, publications and statements relating to plant, animal and aquatic ecology;
scientific meetings, lectures and papers; field trips and studies; editing and securing
contributions for publications (1924-1956); the organization, development, membership and
functions of the Ecological Society of America and its committees (1937-1945); preservation
of natural areas as sanctuaries for the ecological study of biotic and animal communities;
the political involvement of ecologists in preserving natural areas; grasslands areas and
the Grasslands Research Foundation (1931-1958); wildlife management research (1935-1954);
the University Committee on Natural Areas and Uncultivated Lands (1946-1949); animal
populations and solar radiation (1947-1953); a proposed plant and animal life sciences
building (1952-1955); the history of ecology (1955-1961) and the scientific contributions
of Shelford and his students. The scientific contributions are reprints of articles by
Shelford (4 volumes, 1906-1946) and his students (5 volumes, 1912-1946). The series
includes a 1965 tape-recorded interview with Professor Shelford concerning his work at West
Virginia, Chicago and Illinois; the Ecological Society of America; fellow scientists who
have influenced him, and assisted him in research and publication; field trips; Brownfield
Woods; Laboratory and Field Ecology (1929) and The Ecology of North America.

RS 15/24/20 SFA - 14 NUCMC 65-167

SHERMAN, STUART (1881-1927) PAPERS, 1903-1926 4.6 cu. ft.

Papers of Stuart P. Sherman, associate and professor of English (1907-1924), including incoming correspondence concerning department curriculum; invitations to speak; congratulations on honors; arrangements for and comments on books and articles by Sherman; job offers to and from Sherman; awarding of Pulitzer prizes in 1920, 1921 and 1925; Sherman as a champion of the aristocratic humanism of Irving Babbitt and Paul E. More, his shift to a more democratic humanism and his final shift to a more comprehensive acceptance of many points of view; accounts from former students of post-graduate careers (Gerald Carson, Allan Nevins, Sam Raphaelson, Warner Rice, Lew Sarett) and editorial suggestions and criticisms (Henry S. Canby of Literary Review, Wilbur Cross of Yale Review, John Farrar of Bookman, M. A. DeWolf Howe of Atlantic Monthly Press, Daniel Longwell, Hammond Lamont, Paul E. More, Irita Van Doren, Carl Van Doren of Nation, Will D. Howe, Maxwell Perkins of Scribner's, Ellery Sedgwick of Atlantic Monthly.) Other correspondents include Sherwood Anderson, Irving Babbitt, Hamlin Garland, Ellen Glasgow, Vachel Lindsay, Sinclair Lewis, Percy Kay, Allan Nevins, Llewelyn Powys, Burton Rascoe, Ashley Thorndike and Oswald Garrison Villard. The papers include copies and originals of letters from Sherman to many of the above on same subjects; clippings of serial publications (1908-1926), lecture notes (1906-1924), Harvard themes (1903-1904) and other early manuscripts, published and unpublished typescripts and manuscripts of essays, talks, addresses and reviews, clippings about Sherman and his writing, diaries (1904-1906), journals, notes on reading (1900-1926) and related material.

RS 15/7/21 SFA - 5 NUCMC 65-1934

SHUMAN, CHARLES B. PAPERS, 1965, 1973-74 .1 cu. ft.

Papers of Charles B. Shuman (1907-), B.S. '28 and M.S. '29, president of the Illinois Agricultural Association (1945-55) and the American Farm Bureau Federation (1954-71), including tape recordings of a lecture on "Secretaries of Agriculture as I Have Known Them" containing observations on agricultural policies and political leaders including Henry A. Wallace, Claude Wickard, Clinton Anderson, Charles Brannan, Ezra Benson, Orville Freeman, Clifford Hardin and Earl Butz and thoughts on the current status and policy needs of American agriculture and an interview containing comments on Shuman's impressions as a student in the College of Agriculture, the early growth and development of the Farm Bureau in Illinois and its relationship with the extension movement, agricultural adjustment problems and policies since World War I, political dynamics within the American Farm Bureau Federation and the power balance between sections, the influence of Farm Bureau leaders such as Ed O'Neal and Earl Smith, changes in Farm Bureau policies, Farm Bureau business enterprises, the free market system versus the political system, the "devil theory" of farm problems, national farm organizations and cooperatives such as the milk producers, and political and agricultural leaders. The collection also includes a Time magazine article (September 3, 1965) on Shuman and a short bibliography of published material on the American Farm Bureau Federation.

RS 26/20/31 SFA - 11

SIGMA DELTA CHI RECORDS, 1929-1971 .3 cu. ft.

Sigma Delta Chi Records including correspondence (1936, 1950-); by-laws of the Executive Council (no date); student rosters (1955, 1971); "Souvenir Directory" of Sigma Delta Chi at the University of Illinois, 1912-1935 (1935); pledge certificates (1960-1963); programs (1940, 1947); financial record, bills and vouchers (1929-1964) and a Journalism 211 file (1951-1967).

RS 41/6/7/142

SMITH, B. OTHANEL (1903-) PAPERS, 1949-1969 6.6 cu. ft.

Papers of B. Othanel Smith, professor of education (1945-1969) and department head
(1967-1969), including correspondence with college and university administrators, students,
officers of the National Education Association, the American Education Research
Association, Educational Testing Services and the Philosophy of Education Society and other
professional organizations and governmental officials. The series includes extensive
correspondence with Harold Rugg (1949-1950), R. Bruce Raup (1949-1950), Myron Lieberman
(1949-1969) and Willard Spaulding (1961-1969); manuscripts by B. O. Smith and others and
materials on curriculum development, teacher training, the M. A. degree program, critical
thinking and courses.

RS 10/6/23 SFA - 4 NUCMC 72-166

SMITH, G. FREDERICK (1891-) PAPERS, 1922-1972 .6 cu. ft.

Papers of George Frederick Smith, professor of chemistry (1927-1956), including reprints of
articles on analytical, industrial and food chemistry; quantitative analysis; general
inorganic and perchlorate chemistry; chemistry of the 1, 10- phenanthrolines and related
compounds; in three bound volumes (1922-1963) and loose reprints (1923-1935, 1947-1968).
Volume I of the bound series contains a portrait photo, biographical data, a list of
doctoral theses supervised and lists of his books and research papers. A biographical
sketch by Harvey Diehl is in the 1966 issue of _Talanta_. The series includes photographs,
correspondence and a tape-recorded interview about the chemistry department, the G.
Frederick Smith Chemical Company, perchloric acid, atomic weights, patents, aerosol
containers, ice cream tests, 1, 10- phenanthroline, Francis Case, industrial chemistry,
cerium, Edward D. Campbell and Hobart H. Willard.

RS 15/5/33 SFA - 5 NUCMC 72-1513

SMITH, GERALD W. PAPERS, 1971 .1 cu. ft.

Papers of Gerald W. Smith, Director of Moline Community College, which included the Moline
Cooperative Extension Center of the University of Illinois, including xerox copies of
correspondence with David D. Henry, a short essay on the University Extension Centers
(1946-1949) and attachments (1946-1948) which include memoranda, notes and a description of
the program by Robert B. Browne, Director of the Division of University Extension,
enrollment statistics and the minutes and correspondence of cooperating school boards in
Moline and Elgin.

RS 31/9/20

SMITH, JAMES O. (1909-1970) PAPERS, 1934-1970 3.0 cu. ft.

Papers of James O. Smith, professor of theoretical and applied mechanics (1937-1970),
including biographical data, correspondence while at the Universities of Alabama
(1934-1937) and Illinois (1937-1952), materials relating to the Army Reserve (1950-1952),
class notes (1940's), papers relating to University affairs and participation in
committees (1938-1964), especially the Engineering Policy and Development Committee
(1947-1970), papers and publications relating to engineering education (1966-1970),
material relating to humanities and social sciences in engineering (1962-1965), data and
reports of research (1947-1953) and publications (1939-1970), with some original
manuscripts.

RS 11/11/24 SFA - 4 NUCMC 72-167

SPAETH, J. NELSON (1896-) PAPERS, 1939, 1942-45, 1952, 1960 1.6 cu. ft.

Papers of J. Nelson Spaeth (1896-), professor of forestry (1938-65), including
Agriculture National Defense Program files for World War II, pamphlets, circulars,
directives and correspondence relating to war activities of the Extension Service (1943);
War Board memoranda and minutes (1942-1945); War Food Administration production and
distribution orders (1943-1945); War Production Board conservation and limitation orders
and priorities (1942-45); USDA bulletins, leaflets, circulars, reports and publications
on wartime food production, marketing, planning, manpower and education (1942-1945);
War Information posters (1942-44) and reprints of articles on forestry (1939, 1944,
1952, ca. 1960).

RS 8/10/20 SFA - 1

SPARKS, MARION E. (1872-1929) PAPERS, 1917-1928 .3 cu. ft.

Papers of Marion E. Sparks, Chemistry Librarian (1915-1929), including photograph albums
containing photographs of the campus, buildings, chemistry faculty and students. The
series contains "Chemical Literature and its Use" (1919), notes on 12 lectures in Chemistry
92.

RS 35/3/21

SPAULDING, CHARLES H. (1888-1968) PAPERS, 1908-1914, 1917-1918, 1923, 1926-1968 3.6 cu. ft.

Papers of Charles H. Spaulding '12, including correspondence concerning professional work
in the area of water purification, service as General Superintendent of the Springfield
Water Department (1926-1943) and work as a consulting engineer for water treatment plant
projects (1943-1968). The Springfield material includes correspondence, data, blueprints,
proposals for improvements and facility studies. The consultant's files include
correspondence with the Permutit Company, which installed the Spaulding precipitators which
he patented and individuals involved in installations in cities. Another consultant's file
includes unpublished Great Lakes Water Information Reports which Spaulding prepared under
contract with the Alvord, Burdick and Howson Company (ca. 1952-1954). These files contain
information on water quality and distribution systems for major cities on the Great Lakes.
These data pertain to the corrosion of water mains and the effects of Great Lakes' waters
on purification systems. A group of collected reprints on water treatment (1927-1958)
include fourteen articles by Spaulding (1927-1944) on Operation of the New Water Softening
Plant at Springfield, Preammoniation at Springfield, Natural and Artificial Purification of
the Sangamon River, Water Softening at Bloomington, Illinois, Manipulation of PH at
Springfield, Quantitative Determination of Odor in Water, Contamination of Mains by Jute
Packing, Filter Problems and Water Softening, The New Water Purification Plant for
Springfield, Conditioning of Water Softening Precipitates and related topics.

RS 26/20/19 SFA - 6 NUCMC 72-168

SPENCER, GWLADYS (1895-1947) PAPERS, 1918-1921, 1923-1934 .3 cu. ft.

Papers of Gwladys Spencer, professor of library science (1942-1947), including
correspondence relating to travel and the purchase of art works for college libraries
(1921, 1927-1934), notes on music and hygiene courses at Denison University (1918-1921),
and notes, examination questions and papers written for courses in English, astronomy and
comparative literature at Ohio Wesleyan University (1923-1933).

 NUCMC 67-476
RS 35/3/20

SPITLER, JOHN C. (1882-1973) PAPERS, 1972 .1 cu. ft.

Papers of John C. Spitler (1882-1973), assistant and state leader of farm advisors
(1919-1949), assistant and associate director of agricultural extension (1937-1949) and
professor of agricultural extension (1927-1949), including a tape recorded interview with
comments on the development of the county farm advisor extension program and county farm
bureaus, early extension and farm demonstration work, the insistence of Eugene Davenport
upon local farmer initiative, the policy of the College of Agriculture regarding farm
advisors, the relationship between the Experiment Station and Extension Service and between
the Extension Service and the Farm Bureau, financing the farm advisor program and
Spitler's philosophy of farm extension work.

RS 8/3/24 SFA - 7

STALEY, SEWARD C. (1893-) PAPERS, 1924, 1929, 1941, 1951, 1955, 1960-1961 .3 cu. ft.

Papers of Seward C. Staley, Ph.D. '29, professor of physical education (1923-1960) and
Dean of the College (1936-1960), including reprints and separate copies of publications on
physical education at Illinois (1924, 1929, 1960), sports and military and military
preparedness (1941), sports curriculum (1951, 1955), 10-year program (1960), physical
education program for men at the Chicago campus (1961) and undergraduate professional
curricula (1960).

RS 16/1/20

STARR, BETTY W. PAPERS, 1959-1960 .1 cu. ft.

Papers of Betty Warren Starr, departmental secretary (1939-1960), including correspondence
with Mrs. George (Betty) Belting concerning anthropology faculty, research, travel, parties
and life in Champaign.

RS 15/2/30 RESTRICTED

STEARNS, RAYMOND P. (1904-1970) PAPERS, 1932-1958 1.0 cu. ft.

Papers of Raymond P. Stearns, professor of history (1937-1970), consisting of files of the
American Historical Association's Committee on the Carnegie Revolving Fund for
Publications of which Stearns was a member (1942-1958) and chairman (1952-1958), including
correspondence of committee chairmen John D. Hicks, Sidney R. Packard, Ray A. Billington
and Raymond P. Stearns; correspondence with American Historical Association Executive
Secretaries Guy S. Ford and Boyd C. Shafer, committee members, authors submitting
manuscripts for possible publication and publishing houses; opinions of committee members
on manuscripts submitted; annual reports and the depletion of the Fund. The series
includes reprints of articles by Professor Stearns (1932-1955).

RS 15/13/28 SFA - 3 NUCMC 69-276

STEGGERDA, FREDERIC R. (1903-1971) PAPERS, 1924-1971 20.0 cu. ft.

Papers of Frederic R. Steggerda (1903-1971), professor of physiology (1933-1970),
including correspondence (1929-1971) with scientists, professional societies and Abbott
and Ciba Laboratories; reprints of articles by Steggerda, his brother Morris, his students
and manuscript papers and speeches; grant materials, contracts, progress and final reports,
data sheets, notebooks, charts, photographs, negatives, X-rays and motion picture films
concerning studies of soybean nutrition and the physiological effects of high altitude
and stresses on the human gastrointestinal tract for USDA, USAF and NASA; calcium
metabolism research files for Abbott Laboratories and related foundation grants (1939-1960);
correspondence, reports and reprints for a Fulbright lectureship in Japan (1960-61);
consultant file for Carle Clinic (1966-69); nutrition consultant for Project HOPE (1969);
course materials (lecture notes, outlines, laboratory manuals, exams, student papers,
student notebooks and gradebooks); M.S. and Ph.D. theses of students; student advisee
files; departmental memos, committee minutes and reports; publications of professional
societies and scientific equipment companies; and Steggerda's M.A. and Ph.D. theses,
class notes, civic activities files and vita. Correspondents include Ivan E. Danhoff,
Hiram Essex, Yasuyosi Nisimaru, Robert S. Pogrund, Joseph J. Rackis, Edmund A. Richards,
Grover J. Schock, Maurice B. Visscher, Fredrick F. Yonkman.

RS 15/17/20 SFA - 12 NUCMC 72-1514

STEPHENS, CARL (1884-1951) PAPERS, 1912-1951 13.6 cu. ft.

Papers of Carl Stephens, Alumni Association editor and director (1914-1942) and University
Historian (1943-1950), including source material, biographical clippings and notes used in
writing his unpublished 1947 history of the University of Illinois; Alumni Association
records and correspondence (1912-1950) relating to Illinois alumni associations, budgets,
clubs, committees, constitutions, Council, funds, magazines, secretaries and other alumni
activities. Illinois and other universities; manuscripts of speeches about the University
(1928-1950); Kampus Kibitzers Klub proceedings (1930-1941) and Urbana Rotary Club material
(1930-1950). The historical source material includes original manuscripts, notes and
published documents. Biographical clippings and notes include many short articles clipped
from the Alumni Quarterly. The papers include typewritten copies of drafts of Carl
Stephens' unpublished manuscript history of the University of Illinois and two copies of a
1947 revision of the history. Copy 2 of the revision contains pencilled marginal notations
by Professors Joseph Swain and Theodore C. Pease.

RS 26/1/20 and 26/1/21 SFA - 6 NUCMC 65-1935

STEWART, CHARLES L. (1890-) PAPERS, 1925, 1929-1931, 1936, 1939-1940, 1946, 1967 .1
 cu. ft.

Papers of Charles L. Stewart, professor of agricultural economics (1924-1959), including
reprints of articles on agricultural policies, farm migrations, farm relief and
agricultural adjustment, farm land values and appraisals, institutional land ownership and
foreign agriculture (1925, 1929-1931, 1936, 1939-1940, 1946). The series includes a
tape-recorded interview on Clark R. Griggs, and Professor Stewart's coming to Illinois.

RS 8/4/22 SFA - 1

STEWART, WILSON N. PAPERS, 1951-1965 .6 cu. ft.

Papers of Wilson N. Stewart, professor of botany (1955-1959) and Department Chairman
(1959-1963), including correspondence from students, colleagues and members of research
institutes; departmental circulars; annual reports; committee notices concerning research
projects; statements on special educational materials and programs; reviews of journal
publications; letters of personal activity; letters of recommendation and business
correspondence with national and local educational organizations and groups.

RS 15/4/26 NUCMC 71-1166

STIVEN, FREDERIC B. (1882-1947) PAPERS, 1907, 1910, 1916, 1920-1947, 1951 1.0 cu. ft.

Papers of Frederic B. Stiven, Director of the School of Music (1921-1947), including typewritten manuscripts, notes, correspondence, programs, clippings, journal (1910), diplomas and awards, membership certificates, memorials, photographs and unpublished compositions relating to music education; teachers; musicians; concerts; organ; Stiven's European studies and education; induction as Director (1921); addresses before music student and high school groups; Star Course 50th Anniversary (1942); first international conference on music education (1936) and similar topics.

RS 12/5/20 SFA - 2 NUCMC 67-477

STODDARD, GEORGE D. CORRESPONDENCE, 1946-1953 79.3 cu. ft.

General correspondence or subject file of President George D. Stoddard including correspondence, reports, memoranda, publications and files received from or sent to trustees, deans, other university administrators, faculty and the public concerning admissions policies and enrollment statistics; reports of colleges, schools, institutes, bureaus and departments; alumni activities; American Council on Education, Association of Land Grant Colleges and Universities and other associations of universities and university administrators; athletic boards, relations and contests; budgets; audits and financial reports; building program; Chicago and Galesburg branches; Chicago professional colleges; commencement; committees; relations with trustees, provost, comptroller and deans; extension work and Allerton Park; high school relations; housing; state departments and federal agencies; inaugurations at other colleges and universities; invitations and engagements to speak at public meetings; non-academic personnel; physical plant; recommendations for purchase and vouchers; University Foundations; General Assembly visits and sessions and legislative bills; gifts and estates; monthly trustees meetings; sabbatical leave requests and reports; military training; state natural resources surveys; scholarships; University Senate; summer session; public information and similar administrative affairs. This general subject file contains significant material on educational policy changes, trustees meetings and the 1950-1951 College of Commerce controversy.

RS 2/10/1 SFA - 34

STODDARD, GEORGE D. MANUSCRIPT ADDRESSES, 1933-1955 3.3 cu. ft.

Manuscript copies of public addresses and statements by George D. Stoddard given at public events, educational meetings and academic ceremonies or prepared for publication, including drafts, revisions, final copies, proofs and reprints; special reports and studies; releases for newspapers and special publications; newspaper clippings and related correspondence concerning child psychology, mental health, public education (especially in New York), education in wartime, educational trends, higher education, democracy, postwar planning, UNESCO, University of Illinois, taxation and budgets, alumni and children and youth. The series includes a 1951 bibliography of Stoddard's writings.

RS 2/10/2 SFA - 7

STODDARD, GEORGE D. SUBJECT FILE, 1945-1953 6.0 cu. ft.

Subject file, including correspondence, reports and working papers relating to the Air University Board of Visitors, biennial budgets (1945-1949), Midcentury White House Conference on Children and Youth National Committee, student housing (1946-1947), installation program (1947), football ticket distribution, salary increases (1947-1949), Service Academy Board and staff appointments (1947).

RS 2/10/5 SFA - 2

STRAUCH, BERNARD A. (1882-1967) PHOTOGRAPH COLLECTION, 1890-1950 4.8 cu. ft.

Bernard A. Strauch '08, J.D. '10 Photographic Collection, including prints, negatives and plates relating to student activities, buildings, campus scenes, colleges, conferences, commencements, interscholastic circus, bands, faculty, military, alumni reunions, Champaign and Urbana, student organizations, presidents and visitors. The series includes family photographs (ca. 1890-1945) consisting of glass plates, film and prints of portraits, group photographs and landscapes, including Mendota, Illinois race parade, photography instruction slides, trip to Yellowstone, threshing, children.

RS 26/30/2

STUHLMAN, OTTO (1884-1965) PAPERS, 1907-1910, 1921 .1 cu. ft.

Papers of Otto Stuhlman, Jr. A.M. '09, assistant instructor in physics (1907-1909) and physics professor at Iowa and North Carolina, including postcards concerning student activities and events, university buildings, student interests and family greetings. The series includes a 1907 postcard version of "The Illinois Loyalty Song."

RS 41/20/30

SWANNELL, DAN G. LETTER, 1938 .1 cu. ft.

Letter (October 3, 1938) to President Arthur C. Willard from Dan G. Swannell, literature and arts student, 1892-1893, containing recollections of his grandfather, Daniel Gardner (Trustee, 1873-1881), the forestry, University financial matters, Emory Cobb, and agricultural interests. The series includes President Willard's acknowledgment.

RS 26/20/7

SWANSON, EARL R. PAPERS, 1953-1971 .6 cu. ft.

Papers of Earl R. Swanson, professor of agricultural economics (1952-), consisting of correspondence to colleagues at American and foreign universities, the U. S. AID Mission to India, the U. S. Department of Agriculture, the Federal Reserve Bank at Kansas City, Missouri, the Ford Foundation, IBM and RAND corporations and publishers relating to Swanson's research activities, departmental policies and affairs, appointments, publications and students. The series includes letters of recommendation (1952-67) and a vita and publications list (1971).

RS 8/4/26

SWENSON, GEORGE W. (1922-) PAPERS, 1961-1964, 1969 .3 cu. ft.

Papers of George W. Swenson, professor of electrical engineering and research professor of astronomy (1956-), including correspondence, publications, photographs and duplicated statements relating to the satellite ionosphere program (1957-1964); a visit to Russian radio astronomy installations (1961); the construction, dedication and operation of the University's radio telescope (1958-1962); the ionosphere-eclipse project (1963), an international conference at Geneva on allocation of radio frequencies for space research, satellites and radio astronomy (1963), ionospheric research (1964) and other research activities.

RS 11/6/21

NUCMC MS 67-478

TAFT, LORADO (1860-1936) PAPERS, 1857-1953 15.8 cu. ft.

Papers of Lorado Taft, B.L. '79, M.L. '80 including diaries (1876-1878), course notes and
themes (1875-1879), general correspondence (1881-1936), family correspondence (1882-1900,
1918-1930), lecture notes, manuscripts, photographs, newspaper clippings, books and
reprints, autobiographical accounts and obituaries, concerning Don Carlos Taft, Champaign
and the University of Illinois, Ecole des Beaux Arts (1880-1885), sculptures, casts,
monuments, bas reliefs, busts and medals (1883-1936), photographs of French and American
sculpture (1845-1920), travel, business affairs, children, History of American Sculpture
(1903), lectures and teaching (1914-1934), honors and awards, Dream Museum, YMCA service in
World War I, art organizations (1919-1934), travel in Europe and related topics.
Correspondents include Daniel C. French, Frances E. Willard and Robert E. Hieronymous.

RS 26/20/16 SFA - 23 NUCMC 71-1167

TALBOT, ARTHUR N. (1857-1942) PAPERS, 1877-1915, 1918, 1921-1934, 1937-1938, 1941-1942
 2.3 cu. ft.

Papers of Arthur N. Talbot '81, professor of engineering and mathematics (1885-1890) and
municipal and sanitary engineering (1890-1926), including correspondence with engineers,
alumni, equipment manufacturers and public officials concerning railway engineering, sewage
treatment and water purification plants, alumni reunions and plans, notes and
specifications for public works; 80th birthday (1937) and Talbot Laboratory dedication
(1938); oratorical society, class day, field day, literary society, fraternity,
commencement and alumni reunion programs (1878-1881); student notes (1877-1881); documents
relating to the military rebellion (1880); copies of literary society orations; copies of
examination questions for mathematics, drawing and railway and sanitary engineering
(1885-1894); reprints (1898-1926); manuscripts for talks or reports on Wabash River
pollution (1894), sanitary science (1899), sanitation in town and country (1900),
engineering college graduates (1900), sciences and health (1901), paving bricks (1905),
"The Old Time Faculty at the University of Illinois" (1905), engineering and public health
(1909), Chicago city hall investigation (1910), University baseball, 1879-1881 (1922),
"Engineers I Have Known" (1924) and the University of Illinois 50 Years Ago (1931). The
papers include a copy of "Representative Names in the History of English Literature" used
as a text (9/26/1877); requests for copies of "Railway Transition Curves" and comments on
the work (1891); Mrs. Talbot's history of the Central Illinois Branch of the Association of
Collegiate Alumni (1919); a letter from Herman S. Pepoon with recollections of the
University in 1877-1881 (1930); clippings about Talbot's service in receiving army
construction projects (1918) and a fiftieth anniversary album of the Class of 1888 (1938).

RS 11/5/21 NUCMC MS 65-1936

THOMAS, LYELL J. (1892-) PAPERS, 1933-1965 3.3 cu. ft.

Papers of Lyell J. Thomas (1892-), professor of zoology (1927-61), including personal
correspondence (1933-1965) with and about Ta Hseung Chin, bibliographical data pertaining
to Henry B. Ward, Ward's lectures on parasitology and a list of Ph.D. and M.S. degrees
earned by students in the zoology department while Ward was chairman. The papers also
include research reports (1933-1936) when Thomas was a summer instructor at the
University of Michigan Biological Station, data collected while a consultant at the
U.S. Air Force Arctic Aeromed laboratory (1955) and on a research trip to Bimini (1951)
and a selection of course papers written by his students. The series includes College of
Liberal Arts and Sciences and Zoology department material (1920-33, 1936-39, 1950-66),
lecture notes on parasitology (1912-33) and zoology (1908-40), research notes and drawings
on parasites and material relating to the Illinois Junior Academy of Science (1931-38,
1963, 1970), science clubs and the teaching of science.

RS 15/24/23 SFA - 2 NUCMC MS 72-1515

THOMPSON, CHARLES M. (1877-1963) PAPERS, 1900, 1909-1915, 1919-1925, 1928-1938,
 1942-1963 2.0 cu. ft.

Papers of Charles M. Thompson, Dean of the College of Commerce and Business Administration
(1919-1943), including correspondence, reports, clippings, publications and photographs
relating to appointments (1914-1938), Lincoln Way investigation (1911-1914), Red Grange
(1925), possible appointment as Secretary of Commerce (1928), University presidency
(1929-1934), Urbana Chamber of Commerce distinguished citizenship award (1934), economics
department chairman (1938), retirement (1942-1943), Illinois Post-War Planning Commission
(1942-1943), synthetic rubber program (1942), Commerce faculty rating sheets (1942-1943)
and articles on economics and historical topics. The series contains a 295-page
autobiography concerning family, village life in Southern Illinois, military service in the
Spanish-American War, bakery work, school teaching, study at Illinois and Harvard, academic
advancement, friends, students, philosophy of life, public and community service,
organizations, finances, the academic mind, public speaking, public service, political
activities and university affairs; letters from former students, businessmen and commerce
deans regarding the presidency (4-6/1933) and copies of Economic Overtones (1953-1962), a
printed monthly newsletter by Dean Thompson on his economic philosophy of "individualistic
free enterprise."

RS 9/1/20 SFA - 4 NUCMC MS 67-479

THORNBERRY, HALBERT H. PAPERS, 1961- .3 cu. ft.

Papers of Halbert H. Thornberry, professor of plant pathology (1938-), including a
duplicated "Study Report on a proposed International Center for Science Information
Services in Phytovirology" (1961), a progress report on the phytovirology center (1964),
"Thomas Jonathan Burrill's Contribution to the History of Microbiology and Plant
Pathology" (1964), "Index of Plant Virus Diseases" (1966) with an explanatory letter and
research materials, speeches, newspaper clippings and photographs concerning the Thomas J.
Burrill Anniversary Ceremony, April 25, 1967. The series also includes two copies of "The
History of Plant Pathology in Illinois," Part I.

RS 8/13/20

TIEBOUT, HARRY M. PAPERS, 1941-1963 2.7 cu. ft.

Papers of Harry M. Tiebout, professor of philosophy (1951-), including his thesis,
papers and examinations written at Wesleyan University (1941-1946); letters from F. S.
Cutler, an imprisoned conscientious objector, concerning politics, World War II, atom
bomb, socialism, pacifism, magazine articles, books and prison conditions (1943-1945) and
correspondence between officers and members of the Student-Community Interracial Committee
(1945-1951), the Student-Community Human Relations Council (1951-1955), the
Champaign-Urbana branch of the National Association for the Advancement of Colored People
(1955-1959) and the University of Illinois Chapter of the NAACP (1958-1962) and civil
rights organizations, lawyers, speakers, townspeople, University administrative personnel
and officers of student organizations, newspaper clippings; photographs; pamphlets;
handbills; reprints; news releases; newsletters and affidavits concerning racial
discrimination in newspaper advertising, housing, Illini Union facilities, McKinley
Hospital, restaurants, theaters, public recreational facilities, University and community
employment practices, barbershops, fraternities and sororities and the organization of
student-faculty-community groups to oppose discrimination. Professor Tiebout was community
co-chairman (1953) and Public Relations Director (1955) of the Student-Community Human
Relations Council; Director of Publicity (1955 and 1957), President (1958) and Vice
President (1959) of the Champaign-Urbana branch of the NAACP and faculty advisor to the
University of Illinois NAACP branch (1959-1963).

RS 15/16/21 SFA - 4 NUCMC MS 69-277

TOWNSEND, EDGAR J. (1864-1955) PAPERS, 1905-1919, 1946 .1 cu. ft.

Papers of Edgar J. Townsend, professor of mathematics (1893-1929) and dean of the College
of Science (1905-1913), including photocopies of portions of a manuscript autobiography
covering parents, boyhood, education, school teaching, Albion College (Michigan), Chicago,
Illinois, Gottingen, German graduate work (1898-1900), Dean of Sciences position,
Mathematics faculty, library, mathematical models, publications, retirement and family.
Pages 1-44 and 47-61 contain a narrative and photographs pertaining to the Townsend family.
The series includes incoming correspondence (12 letters) for 1905-1907, 1909; Essentials of
Calculus and articles on mathematics for engineers, science and differentiability
(1907-1919).

RS 15/14/22 NUCMC MS 69-278

TRELEASE, WILLIAM (1857-1945) PAPERS, 1880-1944 1.0 cu. ft.

Papers of William Trelease, professor of botany and head of department (1913-1926),
including correspondence with botanists, curators and collectors in North and Central
America, Europe and Jamaica about research on oaks and agave; acquisition, identification
and loan of specimens; field trips; nomenclature; publication and exchange of publications;
passports (1888, 1894); a typed copy of Trelease's address given at the dedication of the
Natural History Hall (1892); photographs (1913, ca. 1940); obituaries (1945); a file on the
disposition of books, manuscripts and specimens (1945, 1947-1948) and biographical sketches
of forty-seven prominent biologists. The series includes a reprint of Trelease's address
"Botanical Opportunity" given as retiring president of the Botanical Society of America
(1896); Botanical Observations on the Azores (1897); a copy of The Yucceae (1902) with
handwritten notes and 21 reprints (1909, 1912-1927). Correspondents include Liberty H.
Bailey (Cornell), Nathaniel L. Britton (New York), Bruno T. Carreiro (Azores), Simon H.
Gage (Cornell), Asa Gray (Harvard), William Harris (Jamaica) and Benjamin L. Robinson
(Harvard).

RS 15/4/22 SFA - 3 NUCMC MS 65-1937

TREVETT, JOHN R. (1853-1926) PAPERS, 1836-1964 1.0 cu. ft.

Papers of John R. Trevett, student (1868-1870) and trustee (1913-1919), including
correspondence, clippings and momentos of Captain Trevett, his wife Helen M. Trevett,
brother-in-law James T. Lenington, daughter Helen M. Finch and their families. The papers
include family letters, genealogical information (Trevett, Lenington), certificates of
election, clippings on Trevett's service on the Board of Trustees and the World War I Draft
Board, obituaries, legal documents relating to the banking business and family estates.

RS 1/20/4 SFA - 2 NUCMC MS 71-1168

TROTIER, ARNOLD H. (1899-) PAPERS, 1933-1966 1.3 cu. ft.

Papers of Arnold H. Trotier, professor of library administration (1944-66) and associate
director for technical departments (1947-66), including correspondence, reports, minutes and
related material concerning library services, university positions, Illinois Library
Association activities, Illinois State Library, publication of the Association of Research
Libraries' list of doctoral dissertations accepted (1933-55) and related topics.

RS 35/2/21 SFA - 1

TROUTMAN, WILLIAM C. (1892-1969) PAPERS, 1969 .1 cu. ft.

Papers of William C. Troutman '17, instructor and associate in English (1920-1926),
including a May 1969 letter to Diana Moore concerning his role in developing university
theatre work at Illinois, Charles H. Woolbert, Phi Kappa Tau, drama organizations, students
who became stars and his subsequent career at Wisconsin, Kansas City, Kansas State, Memphis
State and Baltimore.

RS 15/23/24

TURNER, FRED H. (1900-) PAPERS, 1931, 1932, 1967 .3 cu. ft.

Papers of Fred H. Turner, '22, M.A. '26, Ph.D. '31, assistant dean (1923-1931) and dean of
men (1931-1943), dean of students (1943-1968) and chairman of the University Centennial
Committee (1966-1968), including two microfilm copies of "The Illinois Industrial
University" a 1002-page doctoral thesis in education (1931); "Misconceptions Concerning
the Early History of the University of Illinois" (1932); a tape-recorded recollection
concerning Thomas A. Clark, Fred H. Turner, Council of Administration, George Huff, David
Kinley, Homecoming, Dad's Day, Mother's Day, Founder's Day, Chief Illiniwek, Daily Illini,
fraternities; faculty, Committee of Nine, student discipline, police, Security Office,
dormitories, veterans, hazing, in loco parentis, the land grant act and the founding of
the University (July 25, 1967) and a Christmas card print of University buildings (1967).
The series includes a 118-page alphabetical name and subject index to the thesis.

RS 41/1/20 SFA - 7

TYKOCINER, JOSEPH T. (1877-1969) PAPERS, 1900-1969 23.4 cu. ft.

Papers of Joseph T. Tykociner, professor of electrical engineering (1921- 1949); professor
emeritus (1949-1969), including awards; photographs of relatives and research experiments;
newspaper clippings; autobiographical and biographical data; bibliography cards; personal
and research diaries (1926-1963); technical letters concerning engineering research at
Illinois (1929-1946); student theses; abstracts, reprints and Experiment Station
Bulletins; research and family slides; charts; tape recordings on zetetics and research;
lectures; sound on film demonstration (1921-1932); financial records and sound on film
patent cases. Research material includes sound on film (1921-1922), antennae models
(1922-1926), cable investigations (1926-1933), velocity selector (1927-1936),
photoelectric research (1922-1925, 1935-1941), ultra high frequencies and millimeter wave
research (1941-1951), striations (1952-1959) and zetetics (1949-1969). Correspondence
with relatives, colleagues, students, publishing companies and industrial firms, regarding
Jews living in Europe and Palestine and immigration before and after World War II, personal
matters, research information, preparation of doctoral theses, recommendations, purchasing
of supplies and publications. The series includes a negative 35 mm. motion picture film
of Professor Tykociner's 1921-1922 sound on film demonstration.

RS 11/6/20 SFA - 69 NUCMC MS 71-1170

TYNDALE, HECTOR H. (1855-1928) NOTEBOOKS, 1874-1875 .1 cu. ft.

Notebooks kept by Hector H. Tyndale '75 in Regent John M. Gregory's courses on political
economy and mental philosophy.

RS 41/30/1

UNIVERSITY CLUB RECORDS, 1894-1896, 1902, 1907-1960, 1964 3.4 cu. ft.

Printed, duplicated and handwritten records of the University Club, including minutes of
the Board of Governors (1909-25, 1927-51, 1958) correspondence (1920, 1927-30, 1934-35,
1938-40, 1942-55, 1958), constitutions and house rules (1894, 1907, 1914, 1916, 1918, 1922,
1934, 1938, 1940, 1944, 1946, 1948, 1956), membership lists (1918, 1928-29, 1934-43, 1946,
1948, 1950-53, 1958), membership literature (1932, 1935, 1949-51, 1953, 1955-57),
announcements of services (1909, 1927, 1939, 1942, 1947, 1951, 1955), social events
calendars (1917-20, 1930, 1933, 1936-37, 1940-41, 1946, 1950-52, 1956-60, 1964), programs
and announcements of dinners, dances, open houses, musicals and social events (1895-96,
1902, 1909, 1911, 1915-20, 1923, 1930, 1935, 1945-49, 1955), building program material
(1894, 1916, 1926, 1945), trust deed and lease (1926, 1934, 1943, 1947), financial
statements and audit reports (1907, 1915-18, 1922-25, 1928, 1931-33, 1935-36, 1942-52,
1957-60), financial records and correspondence (1935-55), cash receipts and payments
(1927-47, 1952-53) and a time record (1946-47). The series includes records of the
University Club Building Association, including a list of stockholders; record of first
meeting of the stockholders and the board of directors; by-laws; minutes of the meetings
of the association and the board of directors and the stockholders; record of stock
issued, surrendered and transferred; dividends paid. The second volume contains the
treasurer's journal.

RS 48/4/2 and 48/4/4

UNIVERSITY WOMAN'S CLUB RECORDS, 1918-1956 .3 cu. ft.

Papers of the University Woman's Club (1918-56) including announcements of social events
(1919-56); auditor's reports (1925-54); club proceedings (1919-44) consisting of committee
reports, minutes of meetings, club correspondence, house rules and president's calendars;
committee manuals (1939-43); constitutions and by-laws (1918-51); membership lists
(1945-55); papers and correspondence for tax exemption (1918); pictures and newspaper
clippings of social events (1941-48) and club house pictures; social calendars and
committee announcements (1929-51); suggested revision of ledger accounts (1942);
treasurer's accounts and records (1919-22 and 1934-35).

RS 48/4/5

UNIVERSITY WOMEN'S TUESDAY TEA CLUB RECORDS, 1906-1962 1.0 cu. ft.

Records of the University Women's Tuesday Tea Club, founded in 1906 as a social club for
faculty wives and female faculty members, including minutes (1906-62) and a list of
officers (1942-61). The series contains records and scrapbook of the Newcomers Club
(1928-62), founded as an auxiliary of the University Women's Tuesday Tea Club, including
secretary's (1928-45) and board (1940-47) minutes, a history of the founding, brief
accounts of each year's activities, constitutions, membership lists, clippings and
photographs and information on the duties and activities of the interest groups and
minutes (1936-56) and correspondence (1946-52) of the Twenty-Eight Club, the first group
of Newcomers.

RS 48/4/3 SFA - 2

VESTAL, ARTHUR G. (1888-1964) PAPERS, 1899-1964 2.0 cu. ft.

Papers of Arthur G. Vestal '11 (1888-1964), professor of botany (1929-57) and Wanda
Pfeiffer Vestal (1882-1969), instructor of botany (1944-45), including correspondence,
photographs, course and lecture notes, manuscripts and publications concerning graduate
study and botany field trips at the University of Chicago (1906-11), undergraduate life
at Illinois (1909-11), expense records of a faculty family at Eastern Illinois (1916-20)
and Stanford (1920-29), biology at Stanford (1920-27), botany field work and summer
teaching in Colorado and neighboring states (1922-30), California grasslands research,
plant community investigation methods and family matters. Correspondents include Charles C.
Adams, Henry C. Cowles, Max M. Ellis, Henry A. Gleason, Roland M. Harper and A. G. Tansley.

RS 15/4/24 SFA - 6

VON FOERSTER, HEINZ PAPERS, 1949-74 14.6 cu. ft.

Papers of Heinz Von Foerster (1911-), professor of electrical engineering (1949-74)
and biophysics (1962-74) and director of Biological Computer Laboratory (BCL) (1958-74)
including correspondence relating to cybernetics, BCL, furutism, alternative living,
cognitive processes, artificial intelligence, artificial language, notation of body
movement and departmental and BCL matters including Ph.D. committees, staff and
administration, student counseling and recommendations on students and associates.
Correspondents include W. Ross Ashby, Murray Babcock, Stafford Beer, Herbert Brün,
Paul Drake, Victor Frankl, Erich Fromm, Herbert Goldhor, Gottard Gunther, Ivan Illich,
Howard Lawler, John Lilly, Lars Löfgren, Warren McCulloch, Humberto Maturna, Margaret
Mead, Gordon Pask, Rowena Swanson and Mrs. Norbert Weiner. The series also includes
a file of materials for courses in electrical engineering, biophysics, heuristics
and LAS 199. Course projects include Whole University Catalog (1969), Ecological
Source Book (1970), Metagames (1972) and Cybernetics of Cybernetics (1974).

RS 11/6/26 SFA - 10

WAGNER, MARTIN (1911-) PAPERS, 1966-1967 .6 cu. ft.

Papers of Martin Wagner, director (1958-1968) and professor (1958-) of the Institute of Labor and Industrial Relations (1958-1969) and Chairman of the Governor's Advisory Commission on Labor-Management Policy for Public Employees (July 1967), including the testimony and proceedings of the Commission and the correspondence leading to the Commission's Report and Recommendations.

RS 22/1/20 SFA - 1

WALDO, EDWARD H. (1866-1950) PAPERS, 1817-1818, 1880-1930, 1943 1.3 cu. ft.

Papers of Edward Waldo, professor of electrical engineering (1907-1934), including class notes (1910-1912) relating to electrochemistry, differential and partial differential equations; class lectures (1909-1930), student papers, statistics, journal articles, charts, diagrams, Some Notes on Transformer Design (1929) concerning the economics of transformer design and A Method of Transformer Design (ca. 1915-1920). The series includes forms and two scrapbooks (1890-1905) from engineering positions at General Electric Company (1890-1894), University of Pennsylvania (1894-1904) and Crocker-Wheeler Company (1904-1907) including diagrams, tables and blueprints pertaining to wiring systems, transformers and motors. The papers also contain personal and family papers (1817-1818, 1880-1943) including genealogy notes (Allen, Beaman, Brinkerhoff, Clark, Hardenbergh, Jewett, Lansing, Stockbridge, Waldo, Worcester), correspondence, inventories, essays, announcements, newspaper articles, religious material, D. Allen's journal, scrapbook, obituaries, poems and a golden wedding anniversary album.

RS 11/6/23 SFA - 2 NUCMC 71-1172

WALLACE, KARL R. (1905-) PAPERS, 1940-1968 1.3 cu. ft.

Papers of Karl R. Wallace, professor of speech and head of department (1947-1968), including correspondence, reports, lectures and publications concerning University and college committees on policy, planning, buildings, centennial observance and statutes; Speech Association of America, Committees on contemporary public address, speech education, professional ethics, nominations, awards, programs on rhetorical theory and the American Association of University Professors.

RS 15/23/22 SFA - 2 NUCMC 71-1173

WANLESS, HAROLD R. (1898-1970) PAPERS, 1916-1970 14.3 cu. ft.

Papers of Harold R. Wanless, professor of geology (1929-1967), including correspondence, reports, manuscripts, photographs, publications, course materials, research data, maps and financial records relating to stratigraphy and sedimentation of carboniferous rocks of North America and Australia; Pennsylvanian geological formations; regional lithofacies studies; cyclical sedimentation; interpretation of aerial photography; academic work at Princeton (1916-1924); field work, conferences and publications of the Illinois and Kentucky State Geological Surveys; paleontology; paleozoic glaciation; Division of General Studies courses in the physical sciences; research, dissertations, placement and publications of graduate students; administration of the Geology Department; service on committees of geological societies; international geological congresses (1933-1960); meetings and conferences; visiting lectureships and sabbatical leaves; research grants; consulting services; bibliographies and publications. Organizational files include material relating to the AAAS, the Geological Society of America, the Illinois State Academy of Sciences and Sigma Xi.

RS 15/11/24 SFA - 22 NUCMC 71-1174

WARD, HENRY B. (1865-1945) PAPERS, 1885-1960 3.0 cu. ft.

Papers of Zoology Professor Henry B. Ward, who received an A.B. degree from Williams
(1885); studied at Gottingen, Freiburg and Leipzig (1888-1890) and received a Ph.D. from
Harvard (1892). In 1909 he came to Illinois from Nebraska and headed the Department of
Zoology until his retirement in 1933. Ward was teacher of parasitologists, studied Pacific
salmon and stream pollution and was in contact with scientific organizations and scientists
throughout the world. His papers include photographs, correspondence, clippings, reprints,
reports and biographical material relating to parasitology, his career as Dean of
Nebraska's Medical School (1903-1909), Alaska and Pacific salmon, the Journal of
Parasitology (1914-1932), scientific meetings, teachers, colleagues, students, field trips
and laboratories. They include college books (1889-1890), diplomas, a personal account
book (1890-1896), a 16 mm. film of Ward on a field trip (ca. 1925), a talk on the duty of
the state concerning medical research (1927), testimonial letters from former students
(1933), a report of the Matamek, Quebec, Conference on Biological Cycles (1935), a list of
Ward's publications (1891-1944) and reports on his zoological library (1935, 1945).

RS 15/24/21 SFA - 10 NUCMC 65-1938

WARDALL, WILLIAM J. (1885-1972) PAPERS, 1931-1943 8.9 cu. ft.

Papers of William J. Wardall '08 (1885-1972), including reports, proceedings, minutes,
briefs, exhibits, findings, press releases, clippings, correspondence and publications
relating to service as trustee in the reorganization of the McKesson & Robbins Drug
Company (1938-1941) and the Associated Telephone Utilities Company and the United
Telephone and Electric Company (1933-1940). The series includes extensive correspondence,
releases, and periodical accounts of the financial activities of Philip Musica, alias
F. Donald Coster, president of McKessen & Robbins.

RS 26/20/24 SFA - 5

WATTENBERG, ALBERT (1917-) PAPERS, 1964-1965 1.0 cu. ft.

Papers of Albert Wattenberg, professor of physics (1950-1951, 1958-), including
photocopies of documents from the files of the Electrical and Metallurgical Laboratory at
the University of Chicago (Manhattan Project) collected by Professor Wattenberg as a joint
editor of the Collected Papers of Enrico Fermi (University of Chicago, 1965, 2 volumes).
The documents consist of minutes and reports of policy committee meetings and decisions
and technical information about the first nuclear reactor.

RS 11/10/25 SFA - 4

WEBSTER, ARTHUR G. (1863-1923) PAPERS, 1892-94, 1898-1902, 1904-13, 1916-20 .6 cu. ft.

Papers of Arthur G. Webster, professor of physics at Clark University (1892-1923) and
recipient of an offer of the headship of a department of mathematical physics at Illinois
(1909), including correspondence with William E. Ayrton, Joseph G. Coffin, Henry Crew,
Samuel P. Langley, Anatole LeBraz, Hendrik A. Lorentz, William F. Magie, Thomas C.
Mendenhall, Ernest Merritt, Henry F. Osborn, Benjamin O. Peirce, Ernest Rutherford, Edward
B. Rosa, Robert S. Woodward and others concerning research on sound vibration and
gyroscopes, scientific notation, professional meetings and elections, appointments, travel,
speeches, honorary degrees and publications.

RS 11/10/24 SFA - 5

WEINARD, FREDERICK F. (1893-1968) PAPERS, 1917-1967 1.3 cu. ft.

Papers of Frederick F. Weinard, professor of floriculture (1927-1967), including correspondence and records of experiments and research on floricultural subjects (1917-1952), monographs and manuscripts, lists of publications, clippings and obituaries of colleagues, and material on consultations with florists and colleagues at other universities.

RS 8/12/22 SFA - 1 NUCMC 69-280

WEIRICK, R. BRUCE (1887-) PAPERS, 1923, 1953-1969 .1 cu. ft.

Papers of R. Bruce Weirick (1887-), professor of English (1924-1955), including Illini Poetry (1918-1923) (1923), "Carl Sandburg's Poetry" (1953), a memorial to Harold Hillebrand, a report on the Carl Sandburg Library (1953), a paper on the English Poetry Prize (1958), a letter about foreign students (1958) and related material. Prof. Weirick contributed an article on Carl Sandburg in the Winter 1952 issue of the Journal of the Illinois State Historical Society and an article on the "Golden Age" at Illinois in the Champaign-Urbana Courier, February 26, 1967; pp. A-2, 4-8 (RS 0/0/1-7).

RS 15/7/32

WELCH, HELEN M. (1914-) PAPERS, 1948-1968 2.0 cu. ft.

Papers of Helen M. Welch (Tuttle), bibliographer (1942-1947), assistant acquisitions librarian (1952-1968), professor of library administration (1962-1968), president of the Resources and Technical Services Division of the American Library Association (1961-1962), including correspondence, reports, minutes and related material concerning her activities in the Library Association and Library School, the History of Science Society, the Film Council and Film Society, the American Library Association, the Council of National Library Associations, Seminars on the Acquisition of Latin American Library Materials, Association of Research Libraries, Phi Beta Kappa and Phi Kappa Phi and her activities for the publications Library Resources and Technical Services and Library Trends.

RS 35/2/22 SFA - 2 NUCMC 71-1169

WELLER, ALLEN S. PAPERS, 1956-71 1.3 cu. ft.

Papers of Allen S. Weller, professor of the history of art (1947-) and dean of fine and applied arts (1954-71), including correspondence, reports, publications, news releases, maps and photographs, relating to the Krannert Center for the Performing Arts and its architectural design, financing, administration of programs, use of facilities and dedication. Correspondents include Herman C. Krannert, David D. Henry, Max Abramovitz, Jack Peltason, John Burrell and Richard Ogilvie.

RS 12/1/20

WESTON, JANET PAPERS, 1912-1934, 1940-1963 .3 cu. ft.

Papers of Janet Weston, professor of economics (1945-), concerning activities of student organizations and including items from a "memory book;" newspaper clippings relating to Gold Feather, Alpha Phi, Torch, Alethenai Literary Society, Alpha Lambda Delta, Theta Sigma Phi, Pi Mu Epsilon, and memorabilia relating to these organizations, Phi Beta Kappa, and the Jamesonian Literary Society (1920-1929). The series includes report cards 1912-1923.

RS 9/5/28 NUCMC 72-1516

WESTON, NATHAN A. (1868-1933) PAPERS, 1897-1933 .6 cu. ft.

Papers of Nathan A. Weston '89, professor of economics (1903-1933) and dean of the College of Commerce and Business Administration (1915-1919), including book lists, bibliographies of new texts and reserve books relating to economics courses (1925-1931), economic course examinations (1921-1933), manuscripts on "Education for Business," "The Principles of Preservation, or the Right of Property," and three untitled items, published articles on "The Cost of Production of Corn and Oats in Illinois in 1896" (1898), "The Studies of the National Monetary Commission" (1922) and "Ricardian Epoch in American Economics" (1933) and student notes compiled as a student at the University of Wisconsin (1897-1898). One bound volume titled "The Scope and Method of Political Economy" relates to a professor's analysis of a course taught by Thorstein Veblen at the University of Chicago.

RS 9/5/23 NUCMC 72-1517

WHITE, CARL M. (1903-) PAPERS, 1938-1943 .3 cu. ft.

Papers of Carl M. White, Director of Libraries and Library School and Professor of Library Science (1940-1943), including general correspondence (1938-1943), personal letters (1941-1943), vouchers, Illinois Library Association correspondence and lists of trustees (1941-1942). Letters concern business affairs, Columbia position, nomination to the Committee on the Use of the A.L.A. Cataloging Code, lectures, Rotary Club Program Committee, Tennessee Valley Authority, negotiations for directorship at the University of Illinois, Oklahoma Baptist University, photograph collection, professional affiliations, reprints and offprints of published articles and a thesis. Correspondents include Robert E. Park, Louis R. Wilson, Herbert Putnam, G. Watts Cunningham, Mrs. William Warner Bishop, Madison Bentley and Phineas L. Windsor.

RS 35/1/21 SFA - 2 NUCMC 71-1175

WHITE, GEORGE W. (1903-) PAPERS, 1924-1971 7.0 cu. ft.

Papers of George W. White, professor of geology (1947-), including correspondence and related material on geological and historical research (1941-1969); university, college and departmental affairs (1941-1957, 1965-1971), University archives, insurance, retirement and search committees; United Protestant Education Board (1951-1952, 1957-1968); Water Resources Center (1964-1970); professional activities and visits to other universities (1953-1961); American Association for the Advancement of Science (1940-1952); American Institute of Professional Geologists (1965-1968); Geological Society of America (1964-1969); International Geological Congress (1948, 1966-1968); Ohio Geological Survey (1953-1963); student and teaching notes (1924, 1932-1933, 1943); ground water and glacial geological research for the Geological Society of America (1941-1943) and the United States Geological Survey (1949-1969); correspondence, manuscripts and publications on New Hampshire and Ohio glacial geology research (1930-1968) and writings on the history of geology and geography (1954-1969).

RS 15/11/23 SFA - 6

WHITNEY, LEONARD H. (1894-1922) NOTEBOOKS, 1912-1917 .6 cu. ft.

Leonard H. Whitney '17 notebooks, including a high school physics notebook (1912-1913), military notebook and lecture notes, examinations and laboratory notebooks for courses in chemistry (1914-1915), geology (1915-1916), mechanical engineering, mining (1913-1917), physics (1914) and theoretical and applied mechanics (1915-1916).

RS 41/30/5

WILLARD, ARTHUR C. (1878-1960) CORRESPONDENCE, 1934-1946 108.0 cu. ft.

General correspondence or subject file of President Arthur C. Willard including
correspondence, reports, memoranda, publications and files received from or sent to
trustees, deans, administrators at other universities, faculty and the public concerning
admissions policies and enrollment statistics; reports of colleges, schools, institutes,
bureaus and departments; alumni activities; associations of universities and university
administrators; athletic boards, relations and contests; audits and financial reports;
budgets; building program; Chicago professional colleges; commencement; committees;
relations with trustees, provost, comptroller and deans; high school relations; student
housing and social life; sabbatical leave requests and reports; scholarships; summer
session; state departments and federal agencies; legal services of the university counsel;
federal aid for the building program; Illini Union and University airport; non-academic
personnel; physical plant; General Assembly visits and sessions and legislative bills;
gifts and estates; monthly trustees meetings; military training; war programs; selective
service and military leaves; army student training program; University Senate; research
grants and laboratories; Galesburg branch; relations with professional, social and
industrial organizations; public information; American Council on Education and Booz,
Allen, Hamilton and Fry surveys and similar administrative affairs.

RS 2/9/1 SFA - 90 NUCMC 65-1939

WILLARD, ARTHUR C. PAPERS, 1900-1947, 1949, 1951, 1954, 1956 14.3 cu. ft.

Personal papers of Arthur C. Willard, professor of heating and ventilating (1913-1934),
head of the Department of Mechanical Engineering (1920-1934), Acting Dean of the College of
Engineering and Director of the Engineering Experiment Station (1933-1934) and President of
the University (1934-1946), including correspondence, addresses, notes, reports, blueprints
and tracings, reprints of articles, technical literature, catalogs, test data, statistical
material, photographs and clippings relating to courses, consulting services, research
programs, professional associations and university and departmental administration.
Consulting services relate to the ventilation of the Holland Tunnel, the Midtown Hudson
Tunnel, the Chicago Subway and the St. Louis Subway.

RS 2/9/20 SFA - 5

WILLARD, ARTHUR C. NEWSPAPER CLIPPINGS AND SCRAPBOOKS, 1920, 1930, 1934-1946 1.1 cu. ft.

Newspaper clippings saved by President and Mrs. Arthur C. Willard from Champaign-Urbana and
Chicago papers and the Daily Illini relating to Willard's appointment as head of the
Mechanical Engineering Department (1920), election of President Harry W. Chase (1930),
election of Willard (3-10-1934), Amelia Earhart's visit (1935), commencement addresses
(1934, 1937-1941), student life (1935-1936), ventilating society award (1936), faculty
testimonial dinner (1936), 69th and 75th Founders' Day celebrations (1937, 1943), Robert
Zuppke 25th Anniversary (1937) and ouster movement (1938), Lorado Taft bust dedication
(1938), Mrs. Willard (1938), support of football (1940), building program (1940), military
training (1940), Illini Union opening (1938, 1941), budgets (1943-1946), military units
(1943), University airport (1944-1945), V-J Day (1945), Griffin-Stoddard controversy (1945),
Veterans Officer controversy (1945-1946), veterans' housing (1946), enrollment and
screening (1946), Navy Pier lease (1946), ouster of Chicago Schools Superintendent (1946),
Allerton Park donation (1946), Stoddard administration (1946) and Rose Bowl (1946).
Scrapbooks compiled by the Public Information Office, concerning Arthur C. Willard
(1878-1960). The clippings (March 1934-December 1937, April 1939) contain information
concerning his election, speaking engagements, honors received, his view of education,
social functions, budget discussions, student union building, housing problems and related
topics. For Willard's presidential scrapbooks see RS 2/9/11 and for his newspaper
clippings see RS 2/9/21.

RS 2/9/21 and 39/1/4

WILSON, FRANCIS G. (1901-) PAPERS, 1912, 1923-1967 6.6 cu. ft.

Papers of Francis G. Wilson, professor of political science (1939-1967), including
correspondence (1929-1967), publications (86 items, 1929-1967), speeches and notes (15
items, 1929-1966), manuscript (The American Political Mind, 1949) and a subject file
(1948-1967), relating to political theory, International Labor Organization, public
opinion, conservatism, democracy, fascism, Marxism, liberalism, Catholicism, Christian
intellectuals, Spanish conservatism and special interests, including Catholic
Conservatives, Center for American Studies, Conservative Co-ordinating Council,
Intercollegiate Society of Individualists, National Republican Coordinating Committee on
"Human Rights and Responsibilities" (1965) and the Catholic Commission on Intellectual and
Cultural Affairs. Correspondence concerns editing and publishing, criticism and reviews,
recommendations for faculty appointments and graduate positions and lecture and travel
arrangements. Among the correspondents are Lynwood M. Holland, Frank H. Jonas, Willmoore
Kendall, Charles E. Martin, J. Benjamin Stalvey and Kenneth O. Warner. The series includes
election materials (1912), prohibition pamphlets and materials (1923-1931) and the Journal
de Geneve (12/3-21/32).

RS 15/18/24 SFA - 17 NUCMC 69-281

WINDESHEIM, KARL A. (1898-1966) PAPERS, 1934, 1937-1954 .3 cu. ft.

Papers of Karl A. Windesheim, professor of speech (1938-1966) including his doctoral
dissertation on the use of sound recordings in speech instruction, recordings including the
voices of Peter and Muriel Windesheim, a record relating to a mental hygiene program (1939)
and recordings made by speech students recorded while Windesheim was at the Universities of
Washington (1937) and Illinois (1939-1954).

RS 15/23/21

WINDSOR, PHINEAS L. (1871-1965) PAPERS, 1890-1899, 1909-1943, 1949, 1961-1965 2.0 cu. ft.

Papers of Phineas L. Windsor, librarian (1909-1940), including New York State Library
School class notebooks and scrapbooks (1897-1899), reprint on university libraries (1916),
correspondence concerning newspapers and card costs (1921, 1934), files relating to service
on the Committee of Nine on university organization (1931) and two disk recordings of an
April 7, 1949 Library School lecture by Professor Windsor concerning building a research
library, the support of President Edmund James, Library policy of buying for faculty and
departments doing the most research, 1925 shift from purchasing special libraries to buying
individual titles, faculty users of the Library, gifts and exchanges and related topics.
The series also includes Council of Administration regulations (1909-1913), university
committee files (1912-1943) and university club material (1914-1916, 1920-1928, 1932-1934),
correspondence (1930-1932, 1938-1943), campus drinking issue (1935-1937) and Committee on
Non-Recurring Appropriations (1934-1939). The series also includes the Northwestern
University Syllabus (1890, 1892, 1894, 1895).

RS 35/1/20 SFA - 5 NUCMC 69-282

WOLFE, CORNELIA KELLEY (1897-1972) PAPERS ca. 1875-1885; 1918; 1930-64 2.3 cu. ft.

Papers of Cornelia Kelley Wolfe (1897-1972), Ph.D. '30, professor of english (1950-67),
including correspondence, manuscripts, publications, speeches, newspaper clippings,
lecture notes, course outlines, examinations and student essays relating to english
grammar and literature, American literature and the career and writings of Henry James.
The papers include family photographs (1875-85), student signature books (1918) from
undergraduate days at Colby College, Maine, diaries and picture postcards of European
travels, a copy of The Early Development of Henry James (1930) by Cornelia Kelley and
copies of The Victorian Newsletter. Correspondents include Leon Edel and members of the
Kelley, Pulsifer, Moor and Thayer families.

RS 15/7/31

WOLFE, WILLIAM S. (1889-1944) PAPERS, ca. 1913-1918 .3 cu. ft.

Papers of William S. Wolfe '13, MS '14, instructor in architectural engineering
(1914-1918), later chief engineer for Smith, Hinchman, and Grylls of Detroit, including
correspondence (1917) concerning publication of articles in professional journals;
manuscript copies of articles published in professional journals; Wolfe's student notes
(ca. 1913) for engineering courses; 32 illustrations of architectural masterpieces;
manuscript copies of chapters in Wolfe's book Graphic Analysis (McGraw-Hill, 1921) and
blueprint diagrams and tables used in Graphic Analysis.

RS 12/2/25

WOOD, WILLIAM T. (1873-1943) PAPERS, 1883 .1 cu. ft.

Papers of William T. Wood (1873-1943), professor of military science (1880-1883),
including resolutions of the faculty and the Board of Trustees expressing their
appreciation of his services at the University.

RS 27/3/20

WORLD WAR I, COMMITTEE ON THE HISTORY OF THE PARTICIPATION OF THE UNIVERSITY 20.6 cu. ft.

Files of the Committee on the History of the Participation of the University in World War I,
include correspondence, publications, reports, scrapbooks, photographs, clippings, index
cards, transcripts and manuscript histories including President's Office files (1916-19),
War Committee and subcommittee files (1917-19), and files of the Committee on the History
of the Participation of the University in World War I (1920-21), School of Military
Aeronautics records (1917-19), Students Army Training Corps records (1918-19), war
publications (1917-21), card indexes of faculty and students and source material for and
manuscript copies of George Chapin's 1158-page "The Military History of the University of
Illinois, 1868-1923". The series includes a comprehensive record of war programs from
pre-war military activities to the memorial stadium and military history, including
detailed records of subcommittee activities, departmental participation, negotiations with
the War Department, military instruction programs, faculty contributions to war literature
and the activities of specific military units composed of unversity personnel.

RS 4/5/50 SFA - 19

WUERKER, RUDOLF G. (1902-1961) PAPERS, 1932-1965 .3 cu. ft.

Papers of Rudolph G. Wuerker (1902-1961), professor of mining engineering (1949-1961),
including biographical data, bibliographies, clippings and publications including
"Die Entwicklung der Stahlbauten im Bergbau" (1932, Streckenbausbau Mit Stahl (1935),
"Annotated Tables of Strength and Elastic Properties of Rocks" (1956), Progress in
Coal Testing (1962) and Gravimetric and Magnetic Observations along the 40th Parallel
in the State of Illinois (1965).

RS 11/9/21 SFA - 1

YEATTER, RALPH E. (1896-1971) PAPERS, ca. 1930-1971 10.0 cu. ft.

Papers of Ralph E. Yeatter (1896-1971), wildlife specialist in the Illinois Natural History Survey (1934-1964), including correspondence, manuscripts, publications, research notes and data, maps and diagrams, field work diaries, wildlife conference reports, and project reports relating to wildlife in Illinois and the Middle West, game management, wildlife refuges, conservation, forestry, rural land use, ornithology, ringnecked pheasants, prairie chickens, hungarian partridges, prairie crops and vegetation, tularemia and rabbits, ecology, hunting and fishing, wildlife legislation, Illinois game and fish codes and research methodology. The papers include copies of and research material involving The Hungarian Partridge in the Great Lakes Region (1934), The Prairie Chicken in Illinois (1943), Bird Dogs in Sport and Conservation (1948), and Tularemia, Weather and Rabbit Populations (1952). A charter member of The Wildlife Society, Yeatter served as field editor of Wildlife News. The papers contain copies of this and other conservation and wildlife bulletins and journals, the Illinois Audubon Newsletter, annual reports of the Prairie Chicken Foundation of Illinois and Annual Reports of the Natural History Survey Section of Wildlife Research. The series includes a research file, arranged alphabetically by subject, of article reprints, pamphlets, leaflets and bibliographies collected largely from associates of Yeatter in wildlife management.

RS 43/7/20

YOUNG, ARTHUR L. PHOTOGRAPHS, 1948-1951 .3 cu. ft.

Photographs taken by Arthur L. Young, professor of agricultural engineering, including black and white 35 mm. photographic slides of campus buildings and scenes; construction of academic buildings, student housing and tunnels; construction and demolition projects in Champaign-Urbana and the 4-H lake at Allerton.

RS 8/5/21

YOUNG DEMOCRATS CLUB RECORDS, 1952-1965 .3 cu. ft.

Records of the Young Democrats Club, including scrapbook; minutes; mailing lists; attendance lists; constitutions; publicity posters; clippings; news releases; correspondence concerning speaking engagements and treasurer's information. The records relate to the club's activities with the National Young Democrats and the Illinois' Citizenship Clearinghouse.

RS 41/6/6/17 SFA - 1

Y.M.C.A. RECORDS, 1884-1973 3.0 cu. ft.

Records of the University Y.M.C.A., including promotional and descriptive material about programs, service and facilities; constitutions; annual reports (1898-1907, 1909); secretary's reports (1926-27), cabinet manual (1928) and program book (1904); membership material; election and installation of officers material; financial support file, building drive issuances and dedication programs; anniversary programs; The Y's Indian (1920-) and Y's Papoose; the Illini; religious meeting material; wartime services; social notices; post-exam jubilee programs (1904, 1912-22); student conferences and Faculty Forums files; lecture announcements and programs; Young Men's Faculty Club file; Meyer Forum material; foreign student directories (1951-53); missions and world service material; international banquet programs and community service material. The records include student handbooks or "I Books" (1884-1954) containing lists of Y.M.C.A. and Y.W.C.A. officers; university information, church directories, street directories and railroad timetables, descriptive matter on student organizations, athletic records and student regulations and traditions. A photographic collection (1922-1971) includes prints of aerial views of campus and community, awards and recognitions, boy's work, student cabinet officers and groups, campus buildings and scenes, chapel worship services, committees, Board of Directors and faculty groups, Faculty Forums, Fraternity All-Pledge Banquets, Freshman Camps and Conferences, Freshman Fellowship and Conference, graduate student groups, International program, International student trips to Springfield and other Illinois cities and towns, International student organizations and suppers, Leadership and Training Conferences, membership, recreation and social, rooms, speakers, staff groups and individuals, student groups and individuals, student officers, Trustees at Poor Memorial Dedication and Carr Recognition, Trustee's portraits, and United Nations activities.

RS 41/6/9/0/32-1 and 2 SFA - 4

YUNKER, GRACE KENYON PAPERS, 1924-1936 .1 cu. ft.

Papers of Grace Kenyon Yunker '32, including programs, publications and newspaper clippings relating to Mother's Day (1929, 1932), football games (1929-30), commencement (1930, 1932), Dad's Day (1930) and unversity events.

RS 41/20/40

ZELENY, CHARLES (1879-1939) PAPERS, 1890-1939, 1944 7.0 cu. ft.

Papers of Charles Zeleny, professor of zoology (1909-1939), including correspondence, research and lecture notes, lectures and related material concerning zoological research and teaching, the University of Minnesota (1896-1909), graduate work at Chicago, Naples and Columbia (1901-1904), field and laboratory work at Indiana (1904-1909), academic appointments and departmental affairs, publications, family and financial affairs (correspondence with brothers Anthony, John, Frank and Joseph, 1897-1909), lecture notes (1903-1904), lectures (1905-1908), course materials (1905-1937) and administrative, scientific and general correspondence (1890-1939). Of particular significance is Professor Zeleny's correspondence with brother John, a physicist, on university affairs and research, with Charles B. Davenport, Carl H. Eigenman, Frank E. Lutz, Thomas H. Morgan, Alfred H. Sturtevant and Edmund B. Wilson concerning research in regeneration, experimental embryology and heredity and with Henry B. Ward on departmental affairs. The papers include a six-page 1944 biographical sketch by Mrs. Zeleny and reprint copies of 54 articles relating to regeneration and embryology.

RS 15/24/22 SFA - 11 NUCMC 65-1940

ZELLER, GEORGE A. PAPERS, ca. 1927 .1 cu. ft.

Papers of George A. Zeller, 1873-76, including a typewritten copy of Chapter 5 of Zeller's autobiography, entitled "The State University" which describes visits of Don C. Taft, student days in Urbana, fellow students, homecoming and the Lincoln Monument dedication in Springfield (1874).

RS 26/20/25

ZNANIECKI, FLORIAN (1882-1958) PAPERS, 1951-1952 .4 cu. ft.

Papers of Florian Znaniecki, professor of sociology (1939-1949), including the typewritten manuscript, galley proofs, page proofs, layouts of cover and title page and signatures of Modern Nationalities (University of Illinois, 1952). The series includes correspondence concerning revision and publication of the manuscript and copies of reprints of articles on "Social Organization and Institutions", "Controversies in Doctrine and Method" (1945) and "Sociological Ignorance in Social Planning" (1945).

RS 15/21/22

ZUPPKE, ROBERT (1879-1957) PAPERS, 1921, 1930-1931, 1934, 1937-1957 3.0 cu. ft.

Correspondence of football coach Robert C. Zuppke concerning football coaches, players and games; coaching conditions and the Athletic Board's attempt to oust Zuppke in 1938; reminiscences and stories; books, magazine articles and newspaper clippings; personal visits and trips; speaking engagements; football awards and honors; football plays and scouting reports; evaluations of football players for college and professional teams; recommendations for coaching positions; paintings, art exhibits and gifts; health; financial matters and family. The correspondence also contains manuscripts of talks, interviews and articles by Zuppke; diagrams of famous plays like the "flying trapeze" and the "flea flicker," pencil and crayon sketches and examples of Zuppke's "Ned Brant" comic strip. Zuppke graduated from the University of Wisconsin (1905); coached football at Muskegon, Michigan (1906-1910), Oak Park, Illinois (1910-1913) and the University of Illinois (1913-1941). His teams won or tied for seven conference championships. He wrote three books on coaching football (1922-1930). After retirement, he coached the college all-stars (1942) and served as advisory coach with the University of Havana and Auburn (1945) and the Chicago Bears. Zuppke corresponded with former players George Clark, Harold Grange, George Halas, Ernest Lovejoy, Albert Nowack, Milton Olander, Harold Pogue, and Jack Wilson; coaches Carl Voyles and Glenn Warner; President Arthur Willard; alumni Charles Moynihan, James Peterson and Merritt Schoenfeld; sports writers Grantland Rice, Christy Walsh and Arch Ward; George Ade and Paul Slater.

RS 28/3/20
NUCMC 65-1941

PART II
Illinois Historical Survey Library

The Illinois Historical Survey Library is a special reference and research library holding published and manuscript material on the History of Illinois and the Old Northwest. The library provides assistance and reference materials in matters concerning state, county, and local history as well as those touching the history of the Spanish, French and British Regimes in the Midwest. Established in 1909 under the auspices of the Graduate School of the University of Illinois, its initial purpose was to assist in the editorial work on the Illinois Historical Collections and to identify, describe, and preserve significant historical records which had come to light in Illinois. Professor Clarence W. Alvord of the History Department was named its first director. He was followed by Professor Evarts Boutell Greene (1920-1923), and by Professor Theodore Calvin Pease who directed Survey affairs from 1924 to 1948. In cooperation with the Illinois State Historical Library in Springfield, the Survey provided the editorial guidance and participated in the publication of nearly thirty volumes of the Illinois Historical Collections, the entire six-volume Centennial History of Illinois, and the five-volume Illinois in the World War. This close working relationship with the Illinois State Historical Library ended in 1939 when the editorial direction was moved to Springfield.

Under Professor Frederick C. Dietz, Director (1949-1956), and Marguerite Jenison Pease, Editor, and later Director, from 1949 until her retirement in 1964, the Survey prepared many calendars and indices and embarked upon a publications program which included several guides to its collections. At present, under the directorship of Professor Robert M. Sutton of the University's Department of History, the Survey is initiating a new program of publications based on its diverse holdings.

The collections of the Illinois Historical Survey include a variety of library materials. There are at present over 7500 books dealing mainly with the history of Illinois and the Old Northwest in the 18th, 19th and 20th centuries. The Survey has copies of each of the county histories in the University Library, as well as many town and organization histories. There are numerous immigrant guides, many early town and city directories, and a valuable collection of 18th century atlases and geographies. The book collection, especially that concerning the Chicago area, is presently being enhanced by selections from the Stewart Howe Collection which was recently presented to the Library.

In addition to books, the Survey possesses a modest collection of Illinois and Midwestern newspaper titles and a vertical file of over two thousand miscellaneous items including pamphlets, brochures, newspaper clippings, and term papers. There is a map collection of moderate size (approximately 1700 items) whose main emphasis is on Illinois, the Great Lakes Region, and the Mississippi River Valley. One large unit, the Karpinski Collection, contains over 500 photocopies of early maps from various French depositories. Another group of maps relates to the activities of the 33rd Division which was part of the American Expeditionary Force in Europe during World War I.

Last year a Broadside and Historical Documents Collection was established which presently contains several hundred items. Besides broadsides, posters, political and business advertisements and pamphlets, this collection contains documents which could almost be classified as manuscripts. The Survey in organizing this material has determined to differentiate between completely handwritten documents and printed documents which are filled out by hand. The former are found in the Manuscript Collections and the latter in this Broadsides and Historical Documents Collection. Examples of material in the broadside arrangement include warrants, bonds, and stock shares. If a collection contains printed documents which are filled out by hand as well as manuscripts, or if it includes printed and handwritten documents, it will be found in the Manuscript Collections.

The present guide to the manuscript collections in the Illinois Historical Survey Library represents a combination, revision, and updating of the earlier guides prepared by Marguerite Jenison Pease (Numbers Five and Six of the Publications of the Illinois Historical Survey). Certain changes will be obvious to those who compare the earlier publications with the present work. The form for entries has been modified in the interest of conservation of space. National Union Catalog of Manuscript Collections entry numbers have been included, and of course, new collections have been added. The two most significant changes are the combination of the previously separate guides for manuscripts of American origin and for those of foreign origin, and the elimination of folio and page numbers in the listings of manuscripts from foreign libraries and depositories. It is in the latter category that the usefulness of the Pease guides is most apparent.

Guide entries are arranged in alphabetical order by individual names or organization titles. Wherever collections represent or were created by governmental bodies, the main geographic or government title precedes the designation of the particular division or agency title (i.e. ILLINOIS. GENERAL ASSEMBLY; or UNITED STATES. WORKS PROGRESS ADMINISTRATION. ILLINOIS.). Manuscripts copied from other depositories (especially foreign) are generally organized in the order of the library from which they were obtained. The manuscripts of foreign origin which previously had been described in Publication Number Five of the Publications of the Illinois Historical Survey have been organized into large manuscript groups under general headings (i.e. BRITISH ARCHIVES AND DEPOSITORIES). The groups are then divided by archives or library. Further explanations are presented at the beginning of each of these entries. These are the only entries which cover more than one page.

The terminology used in the descriptions of individual manuscript collections generally conforms to accepted archival usage. There are, however, a few instances where either definition or additional explanation is necessary. Because of the existence of registered trademarks or tradenames, we deemed it appropriate to eschew such popularly used terms as "xerox" or "photostat", and replace them with "machine reproduction" and "photocopy". The term "calendar" is used to describe that specific type of finding aid which presents a summary of the contents of individual items in the collection. The use of "inventory" is broad and can describe contents of collections at the box, folder, or item level; in the last case, it occasionally can be in the form of cards. The "chronological card file" is a set of cards which presents basic information regarding date, correspondents, and collections, and are arranged chronologically. "Archival card file" is used mainly in reference to collections copied from foreign libraries and depositories; these sets are arranged in the order of the original library.

A perusal of the contents of the Survey's manuscript collections shows that significant portions were copied from other libraries. While some records were deposited in the Survey for general public use and are therefore available to all researchers (i.e. ILLINOIS LAND RECORDS), others will be made available to scholars for examination but not for reproduction in part or in full. Material copied from other libraries, with the exception of materials of a public record nature, may be copied only by obtaining permission from the depository which holds the original record.

The preparation of a manuscript guide is an accumulation of contributions by many staff members who over a number of years organize individual collections and prepare finding aids. The endeavors of Marguerite Jenison Pease cannot be underestimated and were extremely important in providing a sound point of departure. During the last few years several staff members have contributed to different aspects of the project: Mrs. Rebecca Kovaleski, who assisted in the final editing and proofreading; Mrs. Cheryl Scouffas, who earlier edited portions of the guide and who is responsible for the index; Miss Bernice Suhling, who typed the final copy; Miss Conna Judy, who typed early drafts of parts of the guide; and the two previous Librarians of the Illinois Historical Survey Library, Mrs. Claire Booth King and Mrs. Lynn Clare Smith, who guided the early work. The staff of the Illinois Historical Survey Library hopes that this guide will be useful to professional scholars, students, and the general public and an encouragement to further research.

Robert M. Sutton Dennis F. Walle
Professor of History and Director Librarian

ALLEN FAMILY. PAPERS, 1803-1813. 19 items. Inventory.

In the middle of the eighteenth century, two Allen brothers came to Virginia from Northern Ireland. From Virginia their descendants moved to Kentucky. Charles and Robert Allen's grandfather, Joseph, left Kentucky and settled in Indiana. This collection includes correspondence, land indentures, and a note concerning the sale of slaves. The Civil War letters discuss life in the Army, Generals McClelland and Halleck, and the Emancipation Proclamation. [This collection was given to the Survey by Charles and Robert Allen and Deborah Allen Gutschera in 1972.]

ALLISON, JAMES W. (1828-1889), AND JOHN Y. (1802-1869). RECORD BOOK, FAMILY RECORDS, 1802-1915. 1 volume, original. 4 items, machine reproductions. Calendar.

This record book was begun by John Y. Allison of Kansas, Illinois, who was a state senator in 1846-47, and later passed to his son, James W. Allison, an ordained minister and farmer. The elder Allison, treasurer for the school district directors, recorded procedures for establishing a school district and building a school house. Payments and receipts were recorded in the book. James W. Allison recorded in the book two sermons as well as payments to his hired hands. Also there are copies of birth, death, and marriage records from 1802-1915.

ALVORD, CLARENCE WALWORTH (1868-1928). PAPERS, 1906-1920. 41 folders, 12 notebooks, and 12 sets of notes. Inventory. 61-1690.

Clarence W. Alvord contributed to the historical profession as teacher, author, editor, and administrator. He was a member of the History Department of the University of Illinois (1901-1920) and of the University of Minnesota (1920-1923). He served as editor of the Illinois Historical Collections (1906-1920) and of the Centennial History of Illinois, and as managing editor of the Mississippi Valley Historical Review (1914-1923). He was President of the Mississippi Valley Historical Association (1908-1909) and Director of the Illinois Historical Survey (1911-1920). He authored, co-authored, edited or co-edited over a dozen works and numerous articles; and his Mississippi Valley in British Politics won the Loubat Prize in 1917.

This collection consists of 13 folders of papers and correspondence on various personal projects concerning books, articles and court cases; and 21 folders of notes and drafts on his book, the Mississippi Valley in British Politics. There are seven folders of correspondence with various persons relative to historical problems and research. The 12 notebooks are field notes taken by Alvord on various research trips to Southern Illinois, Detroit, Canada and New England. The 12 sets of notes are of different types and subjects containing information on the British and French Regimes, notes for The Illinois Country, bibliographies, and a name index. Among the correspondents are Reuben G. Thwaites, G. S. Ford, Lee Bidgood, Elizabeth M. Shepherd, Wallace Rice, Herbert S. Salisbury, and L. P. Kellogg.

AMERICAN FUR COMPANY. LETTER BOOKS, LEDGER, AND CALENDAR, 1816-1849. 2 items, photocopies. 1 item, transcript. 1 reel, microfilm.

The Survey has photocopies of two of the three letter books kept by Ramsay Crooks and Robert Stuart, factors of the Company at Mackinac, 1816-1828. They contain valuable material about John Jacob Astor's projects and related matters. The Mackinaw Island ledger of the John Jacob Astor Fur Company was obtained on microfilm from the Mark Osterlin Library of Northwestern Michigan College in December, 1970. The ledger records scattered accounts of various individuals, among whom are several Indians, for the period 1803-1851. [The calendar of papers of the American Fur Company in the possession of the New York Historical Society was cooperatively financed by nine historical agencies including the Illinois Historical Survey.]

AMERICAN HOME MISSIONARY SOCIETY. PAPERS, 1825-1853. 2032 items, photocopies. 6 reels, microfilm. Chronological card file.

These letters and reports written by ministers and agents, chiefly Presbyterian and Congregational, to the secretary of the American Home Missionary Society include material for social, economic, and educational history of Illinois, Indiana, Missouri, and Michigan. Some Illinois correspondents include Stephen Bliss, John Ellis, Thomas Lippincott, B. Y. Messenger, and John Mason Peck. The microfilm of Michigan letters was purchased from the Michigan Historical Collections, Ann Arbor. Necia Ann Musser's calendar of these letters was published as a University of Michigan Ph.D. thesis in 1967, Home Missionaries on the Michigan Frontier. A Calendar of the Michigan Letters of the American Home Missionary Society, 1825-1846. (Volumes I-III). [The originals of all the letters are in the Amistad Research Center, Dillard University, New Orleans, Louisiana.]

AMERICAN INSTITUTE OF ARCHITECTS. CENTRAL ILLINOIS CHAPTER. RECORDS, 1917-1951. 5 boxes. Inventory.

The records contain minutes of the chapter meetings, membership lists, financial records, committee reports, bulletins and publications. [The collection was transferred from the Small Homes Council, Champaign, Illinois, to the University Archives and thence to the Illinois Historical Survey in the summer of 1970 under the auspices of Professor Alan K. Laing, Department of Architecture, University of Illinois.]

AMERICAN MISSIONARY ASSOCIATION MANUSCRIPTS, ILLINOIS. PAPERS, 1843-1894(?). 15 reels, microfilm. Inventory.

The American Missionary Association began as an interdenominational missionary organization which was strongly influenced by abolitionism. Its chief characteristics were evangelical abolitionism, and religious and educational work among minority groups, especially Negroes. The microfilm materials in this collection relate entirely to the association's work in Illinois. The 15 reels cover the period from 1843-1894, but the main concentration (12 reels) is over the years 1853-1874. Included are letters, observations, and reports relative to all activities and relationships of the organization including other reform activities besides abolitionism. [The microfilm was obtained by the University of Illinois Library from the Amistad Research Center, Dillard University, New Orleans, Louisiana in 1973.]

AMHERST, SIR JEFFERY (1717-1797). PAPERS AND LETTERS, 1759-1764. 87 items, photocopies. Chronological card file.

This collection contains the correspondence of military commanders at various posts. There are several letters and papers from Neyon de Villiers, French commanding officer at Fort Chartres, concerning details of transferring title of the country to the British. Among the other correspondents are Sir William Johnson, Henry Bouquet, Lord Halifax, and Robert Rogers. [The originals of this collection are in the Amherst collection of the William L. Clements Library in Ann Arbor, Michigan. They were acquired by the Illinois Historical Survey for publication in the Illinois Historical Collections.]

ANDERSON, H. OHERT, FAMILY. LETTERS, 1860-1868. 12 items, machine reproductions. Calendar.

Letters between the ancestors of Mr. and Mrs. H. Ohert Anderson constitute the collection. The majority of the letters concern Civil War soldiers and their families. Also included is a brief history of the families. [Mr. and Mrs. H. Ohert Anderson of Ridgway, Illinois allowed the Survey to make copies of these letters in August, 1973. The originals remain in their possession.]

ANDERSON, RICHARD CLOUGH (1750-1826). OHIO MANUSCRIPTS. RECORDS, 1784-1904. 28 bound volumes. Approximately 10,000 items. 1 reel, microfilm. Calendar. 61-2301.

This collection consists in large part of material relating to the Virginia Military District in Ohio, where the bounty lands, awarded to Virginia soldiers of the Continental Army, were located. The earliest records are the papers of Col. Richard Clough Anderson (1750-1826), who was appointed surveyor-general of the district in 1783, moved to Kentucky, and conducted operations near Louisville. There are early surveys, with plats of land on which were based the 1814 map of Ohio, lists of entries with relevant data, and lists of warrants, together with innumerable documents on transfers of titles; also there are letters from Duncan McArthur, Nathaniel Massie, and many others who acquired large tracts of bounty lands. There are also court documents, petitions, memoranda, patents, constable's and treasurer's bonds, house and senate bills. The papers are arranged chronologically in 169 folders with an inventory of the folder's contents in each file.

There are also twenty-eight bound volumes. These include an entry book for "Virginia District B," 1787-1817, a partial list of Virginia officers and men entitled to bounty lands, surveying accounts, lists of surveys and proprietors, survey records, lists of lands located for refugees of Canada and Nova Scotia by act of Congress, February 1, 1801, and a letter book of John R. Anderson, 1851-1852. When the bounty lands in Kentucky were exhausted, an office of the Virginia Military District was set up in Chillicothe, Ohio, and Allan Latham (1792-1871), son-in-law of Col. R. C. Anderson, was appointed surveyor; his papers are succeeded by those of Latham's associate and executor, Daniel Gregg. [It was from a nephew of Daniel Gregg, Dr. R. V. Lewis, of Madisonville and Cincinnati, Ohio, that the Survey purchased the collection in the years 1912-1914.]

ANDERSON, ROBERT (1805-1871). LETTERS, 1861. 2 items, photocopies. Calendar. 69-1586.

Major Robert Anderson was the officer sent to take command of the forts in Charleston Harbor when secession became imminent. These personal letters were written on January 2 and March 20, 1861, from Fort Sumter, to which he had shifted the garrison on December 26, 1860. [These photocopies were made from the Robert Anderson Letters in the Library of Congress.]

APPLEBEE, BENJAMIN (1820-1897). JOURNAL, LETTERS, AND NOTES 1845-1895. 1 volume. 14 items.

Rev. Benjamin Applebee served as Methodist Episcopal minister in central Illinois for over thirty years. His journal contains reminiscences of his early life and ministry as well as more detailed later entries ending in 1877. Pasted in the volume are his ministerial authorization and his teaching certificate. In addition, there are four letters written by or to him and several notes on sermons and other matters. [This collection was transferred from the Rare Book Room of the University of Illinois Library to the Illinois Historical Survey Library in 1973.]

ARMOUR, PHILIP D. (1832-1901). CORRESPONDENCE, 1890-1900. 33 items, machine reproductions. 69-1588.

There are thirty-three letters in this collection: twenty-six from Armour to Frank Miles, a business associate at the Omaha plant; two to Mrs. Miles; one to Armour's father; one to Ogden Armour; two letters to Armour by an unknown writer and one letter to Frank Miles by an unknown writer.

The correspondence deals with various business problems (personnel, market, plant) in the Midwest and East, sympathetic letters to Miles while he was recovering from tuberculosis, and later plans for a packing plant in Seattle to get the Klondike business (they had to compete with the Cudahy Company in establishing a northwestern market.) [Copies of the original letters are located at the Illinois Institute of Technology, Chicago.]

ARMSTRONG, JAMES AND ROBERT (b. 1805). LETTERS, 1834-1835. 7 items, transcripts.

These letters are written to James Armstrong of Dumfries Shire, Scotland, by his two sons who migrated from Scotland to Peoria County, Illinois. They describe life in Illinois and mention the adjustment to American life and the problems of purchasing and working a farm.

ARNALL, JOHN T. LETTER, April 1, 1852. 1 item.

In this letter to Simon Bonavita, John T. Arnall of Waynesboro [Virginia] orders one hundred pounds of candy for his store.

ARNOLD, LEE ANN. LETTER, August 23, 1933. 1 item, machine reproduction.

This letter, written by Lee Ann Arnold, explains the origin of the name of the town of Opdyke, Illinois, as well as characteristics of Opdyke at the time the letter was written. [It was a gift of Steven Lee Carson, December 8, 1966. The original is in the possession of George Opdyke, Jr., great-great-grandson of Wilbur F. Opdyke, after whom the town was named.]

ATKINSON, JACOB. LETTER, 1846. 1 item.

This letter is from Jacob Atkinson of Dixon, Illinois, to his parents in Maine and describes his living conditions in that town. [It was a gift of Wilbur Duncan, Decatur, Illinois.]

ATWATER, MRS. ELIZABETH EMERSON (1812-1878). RECORD BOOK, ca. 1857-1915. 1 item.

Mrs. E. E. Atwater collected historical specimens and artifacts. This notebook consists of inventory notes, which were pasted over the original publication (the 1875 Transactions of the Illinois Department of Agriculture.)

AYARS, JAMES S. CORRESPONDENCE, DRAFTS, AND NOTES, 1967-1969. 21 folders.

James S. Ayars received the Clara Ingram Judson Award from the Society of Midland Authors in 1969 for his book, The Illinois River. This collection consists mainly of drafts, carbon copies and galley proof copies of this work, many of which bear notations by the author. Also, occasionally there are notes and copies of primary sources as well as seven letters concerning the research and evaluation of portions or all of the work.

AYERS, M. P. & CO. LETTER AND SURVEY NOTEBOOK, 1884, 1887. 2 items.

The survey notebook in this collection concerns Vermilion Slough (probably the Little Vermilion River in Sidney, South Homer, and Ayers Townships in Champaign County). It was made by Mr. E. Crampton, civil engineer, for M. P. Ayers & Co., bankers of Jacksonville, Illinois. The many tables referring to elevation, cuts and figures compare the old ditch with the new ditch to be constructed. Also included in the notebook is a rough map and a profile of the Vermilion Slough. The survey is dated October, 1884. The letter, dated June 28, 1887, is from E. N. Rayner, in Homer, to Messrs. A. E. Ayers & Co. Mr. Rayner states that he is sending Mr. Crampton's profile by mail and compares Crampton's survey figures with those of a Mr. Kyle.

BAIRD, SAMUEL JOHN (1817-1893). CORRESPONDENCE, 1861-1863. 10 items, photocopies. Calendar. 69-1586.

Samuel Baird was a Presbyterian clergyman and an author known for his study of the Presbyterian form of government. At the time of these letters, he was pastor of the church at Woodbury, New Jersey. These letters, to and from him, relate to the Civil War and the clergyman's role. [The originals of these photocopies are with the Baird letters in the Library of Congress.]

BAKER, IRA OSBORN (1853-1925). PAPERS, 1870-1920. 5 items. 69-1622.

This collection is composed of a manuscript history and correspondence relating to it. This manuscript, the "Semi-Centennial History of the College of Engineering of the University of Illinois," was prepared between 1920-1923 at the request of President David Kinley, by Professor Baker who was the last remaining faculty member who had participated in the beginnings of the University. The manuscript itself contains a great amount of material on early Illinois history. The correspondence included in this collection pertains to the publication and format of the history, a format description by the author, and instructions and lists of compositors. [This draft was secured through Mrs. Theodore C. Pease, who did editorial work on the manuscript in 1927-1928 at the request of President Kinley. It was not printed. Upon the retirement of Professor E. E. King, the manuscript was used in the preparation of the two volume History of the College of Engineering, 1868-1945, (Urbana, 1947). By permission of Professor King, the Survey retains this draft of the original Baker manuscript.]

BALDRIDGE, HENRY W. (b. 1869). DIARIES, CORRESPONDENCE, PAMPHLETS, AND RECEIPTS, 1875-1894. 111 items. 5 volumes.

The correspondence in this collection contains personal and business letters. The personal letters are from various young ladies in Macon and Decatur, Illinois. The business letters concern Henry Baldridge's activities as a salesman of Darby Gas Burners. Courtship, social behavior, church programs, town and school activities, and weather were discussed in the diaries. [The collection was given to the Illinois Historical Survey Library in 1974 by Lela E. Hoffman of Decatur, Illinois.]

BANCROFT, MRS. GEORGE (d. 1886), AND BLISS, ALEXANDER (1827-1896). LETTERS, 1861-1865. 18 items, photocopies. Calendar. 69-1586.

Mrs. George Bancroft, who became the historian's second wife in 1838, was the widow of Alexander Bliss, a junior law partner of Daniel Webster. While three letters in this collection are to Mrs. Bancroft, the remainder are addressed to her son, Alexander Bliss, a colonel in the Quartermaster Corps. Topics included in these letters are politics and military matters. Of special interest in the letters are comments upon the assistance rendered by women in the Civil War. [The photocopies were made from the originals in the Bancroft and Bliss Papers, Library of Congress.]

BANCROFT COLLECTION. LETTERS, December 15, 1780. 2 items, facsimiles. Calendar.

The two letters in this collection are an appeal of the inhabitants of Post Vincennes to Don Francisco Cruzat, Commander of the Spanish troops in the Departments of Illinois and Louisiana, and his reply. [The letters are facsimile reproductions from the Bancroft Collection of the University of California.]

BARSTOW, WILSON (1830-1869). LETTERS, 1861-1864. 16 items, photocopies. Calendar. 69-1586.

These letters were written by Captain Wilson Barstow (aide-de-camp to General John A. Dix) who was stationed at Headquarters, Middle Department, and the Department of Virginia (Baltimore, and Fortress Monroe). The letters are addressed to his sister Elizabeth Drew Barstow Stoddard (1823-1902), novelist and poet, and to her husband, Richard Henry Stoddard (1825-1902), poet, author, and editor. Included in the letters are allusions to McClellan, Lincoln, and Hooker with regard to the conduct of the war. [These letters are photocopies made from the Wilson Barstow letters in the Library of Congress.]

BARTLEY, SAMUEL (1828-1909). CORRESPONDENCE, 1857-1890. 22 items, photocopies. Calendar.

Samuel Bartley, a graduate of Ohio Wesleyan in Delaware, Ohio, taught school at Murphysboro, Illinois, from 1858 to 1859, after which he became principal of a school in Ohio. In 1870 he moved to Englewood, Illinois, and served as principal there and in other areas. An important aspect of this collection of correspondence was his connection with the College of Agriculture, University of Illinois at Urbana, Illinois; he was in charge of the experiment station located on his farm, and he had an amateur love and knowledge of botany. These letters indicate that he was helpful in setting up the first guides on insect and botanical boundaries in Illinois. Correspondents include T. J. Burrill, Stephen Alfred Forbes, Robert Kennicott, I. A. Lapham, Cyrus Thomas, and George Vasey. [The originals are in the possession of Mrs. Anna Bartley Weaver, granddaughter of Samuel Bartley. The photocopies were made and received through the generosity of Walter B. Hendrickson, Professor of History at MacMurray College, Jacksonville, Illinois in April, 1968.]

BAYNTON, WHARTON, AND MORGAN. PAPERS, 1757-1799. 6 reels, microfilm. 10 items, transcripts. Inventory and chronological card file.

The microfilm from the Baynton, Wharton, and Morgan papers concerns the Illinois venture of the firm and the subsequent career of George Morgan. The transcribed letters concern political events and trade in Illinois and the West during the British regime. The governing of frontier areas, the establishment of boundaries, disputes with the Indians, and the movement of goods, their quality,and prices are discussed in letters from General Thomas Gage, George Morgan (writing from Kaskaskia), James Rumsey, and Lord Dunmore. [The microfilm and transcripts were made from the originals in the Baynton, Wharton, and Morgan Papers in the Pennsylvania Division of Public Records.]

BEAMAN, DAVID. PAPERS, 1786-1885. 31 items.

Invoices, receipts, deeds (mostly in Jefferson County, New York), and letters of David Beaman of Antwerp, New York, comprise this collection. The two letters in this collection exchanged between David Beaman and his brother Hiram, living near Waterford, Pennsylvania (1846), discuss farm production and prices. [The papers belonged to Dean C. M. Thompson of the College of Commerce at the University of Illinois and were given to the Illinois Historical Survey by Joseph Thompson of Champaign, the son of Dean Thompson.]

BEERLI, MRS. ANNIS C. PAPERS, 1932. 2 items.

Mrs. Beerli, of Taylorville, Illinois, presents in this letter genealogical data on her ancestor, Colonel Joseph Ball, (a grandfather of George Washington's mother), and on John Brown, another descendant of Colonel Ball. In addition, there is a genealogical chart on the Ball-Brown family.

BELL, JOHN (1797-1869). PAPERS, 1860-1861. 17 items, photocopies. Calendar. 69-1586.

The correspondence in this collection concerns the presidential candidacy of John Bell of Tennessee. Among the correspondents are A. H. H. Stewart, who helped organize the Constitutional Union Party; Jeremiah Clemens, a Unionist from Alabama who attempted to prevent secession; and Washington Hunt, a former governor of New York State (1850-1852) and Chairman of the 1860 Constitutional Union Convention at Richmond, Virginia, which nominated Bell and Everett. Also there are photocopies of two speeches, one concerning Kansas and the Missouri Compromise, and the other concerning Texas in relation to secession. [These are photocopies from the John Bell Papers, Library of Congress.]

BELLEVILLE, ILLINOIS. GERMAN LIBRARY SOCIETY. JOURNAL, 1836-1861. 1 volume. 69-1592.

The title of this journal kept by the German Library Society is "Abschrift der Protocolle der Deutsche Bibliotheks - Gesellschaft in St. Clair County" (German Library Corporation). The record runs from the first general meeting on July 17, 1836, to the 74th executive committee meeting on March 10, 1861.

BELOTE, JAMES L. (1833-1863). LETTERS, 1862-1863. 38 items, machine reproductions. 69-1586.

James Belote was a member of the 19th Michigan Infantry in the Civil War. He died of dysentery on April 20, 1863. In these letters to his wife, Belote comments on army life, Indiana and Kentucky, and his belief that the war would soon end. The concluding letters discuss in some detail the battle of Thompson's Station near Franklin, Tennessee, on March 4, 1863, although the Nineteenth Michigan was guarding a rear bridge at the time of the conflict. [The letters have an introduction and are edited by Michael B. Russell, Conesus Lake, New York.]

BENDER, LUCY (b. 1890). PAPERS, 1936. 5 items.

This collection contains a description of work done by Mrs. Walter (Lucy) Bender with Gallatin County records which had previously been missing. There are also three letters between Mrs. Bender and T. C. Pease which concern the sale of the result of her research (including preparation and copy of records) to the Survey. The last item is a twelve page typewritten article entitled, "A Brief History of Shawneetown, Gallatin County, Illinois."

BESAUCON, OCTAVE (d. 1905). PAPERS, 1851-1897. 109 items.

Octave Besaucon, of Oak Lawn Plantation, New Orleans, Louisiana, entered the Confederate Army at age 16 and served in General Bragg's bodyguard. Later, he held various public offices in Jefferson Parish, Louisiana. This collection is predominantly composed of newspaper clippings (primarily New Orleans papers) from the period of the Civil War and the Reconstruction era. Also there are two poems, a letter of honorable discharge for a Confederate soldier, and the front page of the June 13, 1897, issue of The Chicago Sunday Tribune. [The collection was donated to the Survey by Mrs. Florence Besaucon Clarke Michalek in April, 1969.]

BESTOR, ARTHUR E. (b. 1908). PAPERS, PHOTOGRAPHS, FILM. Approximately 400 prints, photocopies. 20 reels, microfilm. 61-2055.

This collection of pictorial materials relating to communitarianism was photographed and assembled by Arthur E. Bestor who was a member of the faculty of the History Department of the University of Illinois from 1947-1962. He was responsible for the Survey's acquisition of its significant collection of communitarian materials. In 1946, he received the Beveridge Award for his book Backwoods Utopias.

This collection of pictorial materials relating to communitarianism is composed of several parts. Part I contains several hundred photographs and postcards showing views of sites and buildings of some thirty communities; parts II-VII are made up of photographs and photocopies of portraits, maps, manuscripts, and printed materials pertaining to the communitarian movement. [This collection was deposited in the Survey in 1951 by Professor Bestor. It is available for use with his permission.]

BEVERIDGE, ALBERT J. (1862-1927). CORRESPONDENCE, 1919-1927. Approximately 225 items. 61-2229.

These are letters written by Albert J. Beveridge to C. W. Alvord and T. C. Pease. The earlier letters, 1919-1923, concern his Life of John Marshall. An extensive correspondence with T. C. Pease concerns the writing of Beveridge's Life of Abraham Lincoln. Mr. Beveridge visited the Survey (February, 1923) immediately after the beginning of this correspondence. The letters exchanged are full of information on Illinois politics of the Lincoln period. There are also six letters from Worthington C. Ford to Mr. Pease (1927), when he was completing the Lincoln manuscript after Beveridge's death (April 27, 1927). There are letters from William H. Townshend, of Louisville, Kentucky, relating to certain Beveridge opinions and interpretations. In addition, this collection contains certain drafts, transcripts, and other materials prepared for Mr. Beveridge.

BIRKBECK, MORRIS (1764-1825). PAPERS, 1774, 1805-1825. 1 item, original. 4 items, transcripts, photocopies. 69-1603.

The original item in this collection is an agreement signed by Morris Birkbeck by which he sold a parcel of land in Edwards County, Illinois to James Forest Jackson. [This item was transferred to the Survey Library from the University of Illinois Rare Book Room in 1973.]

This collection also houses an annotated calendar of seventy-five letters written to and from Morris Birkbeck, one of the founders of the English Settlement in Edwards County, Illinois. [The letters are in the possession of his grandson, Richard Birkbeck, of Brisbane, Australia. The list was secured by Walter Colyer, whose father was born in the English settlement of Albion. His search for Birkbeck papers resulted in two letters from Richard Birkbeck: one in April, 1905, the second on June 4, 1908, enclosing the calendar.]

The photocopied letter is from M. Birkbeck, to "William and Ma: Fairbank." This Birkbeck is probably the father of Morris. The writer of the letter describes his travels through the colonies, visiting groups of friends, and some land he has purchased in North Carolina. [The letter was given to the Survey by Mrs. Nancy Thomas of Richmond, England, on a visit, April 12-13, 1960.] A list records land tracts entered at the Kaskaskia Land Office by Morris Birkbeck, and a sketch map shows their locations. [The data is from the Kaskaskia Land Office Book of Applications and Receipts.]

BISHOP HILL COLONY. HENRY COUNTY, ILLINOIS. CORRESPONDENCE, 1850. 6 items, photocopies. 69-1589.

Bishop Hill Colony was founded in the fall of 1846 and was fairly self-contained, engaging in agriculture, linen weaving, and the production of woolen goods. These letters pertain to the disorders which culminated in the murder of Eric Janson, the leader of this Swedish communitarian colony at Bishop Hill, on May 13, 1850. Five letters are addressed to Governor Augustus C. French. Writers are W. W. Drummond, Britton A. Hill, and Harman G. Reynolds. An affidavit is attached to one of the letters. [The original letters are in the Governor Augustus C. French Papers in the Illinois State Historical Library.]

BLAIR AND RIVES PAPERS. LETTERS, 1860-1861. 2 items, photocopies. Calendar. 69-1586.

John C. Rives (1795-1864) and Francis P. Blair (1791-1876) were publishers of the Congressional Globe. One letter describes the meeting of the last congress before secession, and the other the siege of Washington in 1861. [Both letters are from the Blair and Rives Papers in the Library of Congress.]

BLISS, NEZIAH WRIGHT (1826-1910). RECORD BOOK, 1854-1864. 1 volume.

This ledger was used by Neziah Wright Bliss to record weather statistics at Warsaw, Illinois from August, 1854 to September, 1856. He also used the book as a "diary" in which he noted daily farm activities, natural phenomena, and several recipes. [The Survey acquired the Bliss Ledger from Mr. Glenn E. Stout, in March, 1973.]

BLOXHAM, ALFRED. CORRESPONDENCE, 1833-1847. 14 items. 69-1588.

This correspondence is primarily between Alfred Bloxham, a miller at Nashville, Illinois and members of the family. In them financial, health, and family problems are discussed. Also, there is a certificate of employment.

BLOXSOM, G. W. (d. 1868). LETTER, March 10, 1860. 1 item. 69-1603.

To Joseph Sim from G. W. Bloxsom in Sidney, Champaign County, Illinois, this letter concerns lands available for purchase in the county. [It was a gift of Mrs. Sylvia Renner Hadden, Urbana, Illinois.]

BODEN, JOHN RIDGWAY. REMINISCENCE, 1861-1865. 1 item, carbon copy.

"With the Third Iowa Cavalry" is a reminiscence of the Civil War told to John R. Boden by a friend in 1910. It relates incidents of army life and campaigning and plundering in the South. [This item was transferred from the Rare Book Room of the University of Illinois Library to the Illinois Historical Survey Library in 1973.]

BODMAN FAMILY. DIARIES, CORRESPONDENCE, PAPERS, 1855-1903, 1973. 10 volumes. 101 items, originals. 84 items, transcripts and machine reproductions.

The five Bodman brothers (Samuel, Lewis, Elam, Luther, and Joseph) and other relatives, including Sereno K. Bodman (son of Samuel Bodman), bought extensive tracts of land in Piatt County in the 1850's. Several brothers settled there and engaged in farming. The diaries in the collection include one of S. K. Bodman which concerns daily life in Illinois (1857), and seven diaries of Joseph Bodman which generally relate to fishing and hunting trips. The correspondence is mainly about farming and business matters. In addition, there are State and Federal Land Warrants; and various business papers including contracts, deeds, tax receipts, and mortgages. Other items are a Statement of Incorporation of the Bement Building and Loan Association, the Constitution and meeting notes of the Bement Lyceum (later the Bement Literary Society), and a copy of a petition to replace the postmaster of Bement in 1885. There are transcripts of all of the original items, with the exception of business papers. Also, the Survey holds copies of thirty-one letters written by Lewis B. Bodman to members of his family.

The more recent items are a set of papers concerning the family history written or compiled by Mr. Robert Bodman of Chicago (grandson of S. K. Bodman). They include a set of biographical sketches, a set of copied obituaries, and an essay on the Property and Estate of Joseph Bodman accompanied by a map. [The major portion of the collection was given to the Illinois Historical Survey by Mr. Robert Bodman of Chicago in 1973. The 1866 diary and a copy of one letter were obtained through Robert Bodman from Alfred Bodman of Bement, Illinois. The original of the copied letter is in the possession of Mr. Chapin Barnes of Bement. The Lewis B. Bodman letters are in the possession of Mr. Henry Bodman of Detroit.]

BORNEMAN, HENRY S. (d. 1955). PAPERS, 1840-1849, 1891-1926. 1 reel, microfilm. 69-1589.

These letters, typescripts, and clippings generally relating to Brook Farm and Fourierism, were collected by Mr. Henry S. Borneman of Philadelphia. Most of the letters are to John S. Dwight. Also included is "Reminiscences of Brook Farm and its Founder; A Lecture read at Waltham, Monday, March 26, 1900," written by Frank B. Sanborn of Concord. [The items in this collection were microfilmed in 1942 for Arthur Bestor and were given by him to the Survey in 1951.]

BOSTON UNION OF ASSOCIATIONISTS. RECORD BOOK, 1846-1848. 1 reel, microfilm. 69-1589.

Minutes of meetings and committees, lists of members, and the constitution of the Association are included in this volume. This Society, affiliated with the American Union of Associationists, was devoted to the propagation of Fourierism, and its membership included many participants in the Brook Farm Community. [The original is in the Harvard College Library, Cambridge, Massachusetts.]

BOSTWICK, ALANSON. JOURNALS, 1839, 1841. 2 items, transcripts.

The diary of Alanson Bostwick, a school teacher, gives an account of a journey from his home in Winchester, Illinois, to Chicago and his return, in the summer of 1839. There is also an account of a journey in 1841 from New York to Springfield, Illinois. In addition to pure topographical description, the author mentions social phenomena and institutions. [The transcript was made from a copy by Bostwick's granddaughter, Miss Caroline Rucker, of Minneapolis.]

BOSWELL, N. C. PAPERS, 1898-1899. 2 items, transcripts.

In a letter from Neponset, Illinois, to Dr. W. T. Hall of Toulon, Illinois, Boswell sketches the lives of Martin and Perry Dukes, pioneers of Osceola Grove, Stark County. Also there are excerpts from the Cambridge Illinois Chronicle of November 9, 1899.

BOWLES, SAMUEL, JR. (1826-1878). LETTER, 1877. 1 item, machine reproduction.

Samuel Bowles, Jr., in this letter (November 6, 1877) to Carl Schurz, Secretary of the Interior under President Hayes, discusses an upcoming state election, indicating that it will be a victory for Hayes and reform. He states further that deserters from the Republican party since 1870 are returning. Bowles also writes of his illness from which he died a few months later. [A copy of the letter was acquired by the Illinois Historical Survey from Leonard P. Karczewski of Chicago in 1971.]

BOYLE, JOHN (b. 1830). LETTER, February 28, 1848. 1 item.

From Tremont, Illinois, this letter conveys copies of affidavits of heirs of Major George Walls, who served under General George Rogers Clark and who allegedly received no pay or bounties. [This was a gift of Wilbur Duncan, Decatur, Illinois, in 1957.]

BREESE, SIDNEY (1800-1878). LETTERS, 1829-1869. 12 items, transcripts. 69-1599.

Sidney Breese was a United States Senator, 1843-1849, and a justice of the Illinois Supreme Court, 1857-1878 (chief justice, 1867-1870 and 1873-1874). Three of these letters were written by him to William Martin of Alton about business matters. A fourth is to Myra Bradwell, a lawyer credited with opening the legal profession to women in Illinois. Eight letters, February - December, 1843, are from Breese to Pierre Menard and concern business affairs; Menard seems to have acted as Breese's banker (creditor) and business agent. [The originals of the three letters to William Martin were owned by Dr. Harry E. Pratt of Springfield, Illinois. The original of the letter to Bradwell was owned by Governor Henry Horner. The others are from originals in the Menard Collection in the Illinois State Historical Library.]

BRISBANE, ALBERT (1809-1890). PAPERS, 1830-1832, 1841-1936. 250 folders, originals, transcripts. 2 reels, microfilm. Calendar. 61-2054.

Albert Brisbane was a principal propagandist for Fourierist Socialism in the United States during the 1840's and thereafter. The correspondence in this collection, primarily between Brisbane and his family, includes that of his second wife, Redelia Bates, and his son, Arthur (1864-1936). Albert Brisbane's letters relate to social reform, particularly Fourierism, and industrial democracy, religion, scientific theories, and inventions and patents.

There are papers relating to the case of Lodoiska M. Brisbane v. Albert Brisbane, 1883-1885. Drafts of books and articles by Albert Brisbane are included; these deal principally with Fourierism but were written in the latter part of his life, after the movement had declined in importance. Finally, the collection includes transcripts of Albert Brisbane's column on Fourierism in the New York Tribune, 1842-1843; manuscript writings of Redelia Brisbane; clippings of Arthur Brisbane's newspaper work; and diaries of trips to Malta, Sicily, Calabria, and Naples (1830-1831), and to Paris and Berlin (1831-1832). [The collection, except for the diaries, was presented by the Brisbane Family through Mr. Seward Brisbane, grandson of Albert Brisbane. The originals of the diaries are in the manuscript collections of Syracuse University, Syracuse, New York. The film of the diaries was secured in April, 1964, in return for which the Survey had the correspondence of Albert Brisbane and family microfilmed for Syracuse University.]

BRITISH ARCHIVES AND DEPOSITORIES.

The Illinois Historical Survey's collection of copies of manuscripts in the British Archives has been selected with reference to the study of American colonial history, particularly the history of the trans-Allegheny West and the Mississippi Valley. In addition, this material also represents the research interests of faculty and graduate students at the University of Illinois as the Survey has served as a depository for some of the documents they have used. The earliest copies of documents were acquired in 1906, and were made by copyists, but the bulk of the collection acquired since 1933, is reproduced in the form of photocopies or microfilm. For some aspects of the history of the Survey's acquisitions of British transcripts, see Henry Putney Beers, The French and the British in the Old Northwest (Detroit, 1964).

Guides and Other Finding Aids

This description of the Survey's transcripts is based primarily on its two card files for manuscripts, one arranged in archival order, the other in chronological sequence. However, in order to determine the nature of the Survey's holdings in relation to the depository housing the original documents, and also as a guide to the collections of these various depositories, a number of invaluable published finding aids can be consulted. For the Public Record Office, chief depository of the archives of the British government, there are two descriptive guides published by the Carnegie Institution of Washington: Charles M. Andrews, Guide to the Materials for American History to 1783 in the Public Record Office of Great Britain (Washington, 1912, 2 vols.); also Charles O. Paullin and Frederic L. Paxson, Guide to the Materials in London Archives for the History of the United States since 1783 (Washington, 1914). References to the publications of the Public Record Office and the catalogs of its collections may be found in these volumes.

An invaluable work for the study of the British in the mid-eighteenth century is L. H. Gipson, A Guide to Manuscripts Relating to the History of the British Empire, 1748-1776: Vol. XV of The British Empire before the American Revolution (New York, 1970). Also three specific aids for the Public Record Office are very useful: The British Public Record Office: History, Description, Record Groups, Finding Aids, and Materials for American History with Special Reference to Virginia (Richmond, 1960) is an introductory guide to the use of the Public Record Office, as is Guide to the Public Records, Part I: Introductory (London, 1949); and lastly, the basic descriptive work of the Public Record Office is Guide to the Contents of the Public Record Office (2 vols. London, 1963) which supplements and partially supplants M. S. Giuseppi's earlier volumes.

For materials in the British Museum and certain other collections there is another Carnegie Institution publication: Charles M. Andrews and Frances G. Davenport, Guide to the Manuscript Materials for the History of the United States to 1783, in the British Museum, in Minor London Archives, and in the Libraries of Oxford and Cambridge (Washington, 1908). This publication is supplemented by B. R. Crick and Miriam Alman: A Guide to Manuscripts Relating to America in Great Britain and Ireland (London, 1961). The Guide to the Materials in London Archives for the History of the United States since 1783 by Charles O. Paullin and Frederick L. Paxson, while denoting a different time period, does list some materials in the British Museum prior to 1783. Also, the British Museum has published a continuous series of printed catalogs of their additional manuscripts.

Both the Library of Congress and the Canadian Archives began the acquisition of reproductions of foreign archival materials at an early date; therefore, the guides describing their holdings are indispensable. The history of the Library of Congress acquisitions is given in the introduction to Grace Gardner Griffin's A Guide to the Manuscripts Relating to American History in British Depositories, Reproduced for the Division of Manuscripts of the Library of Congress (Library of Congress, 1946). Descriptive matter and bibliographical references make it useful even beyond its listing of the Library's holdings.

BRITISH ARCHIVES AND DEPOSITORIES.

The transcripts in the Canadian Archives are described and calendared in a long series of publications beginning in 1884. David W. Parker's A Guide to the Documents of the Manuscript Room at the Public Archives of Canada, Vol. I (Publications of the Canadian Archives, No. 10, Ottawa, 1914) describes the transcripts made in England and France, and makes references to the published calendars of the various series of documents. See also David W. Parker's Guide to the Materials for United States History in Canadian Archives (Washington, 1913). Between 1951 and 1967, the Public Archives of Canada published a series of Preliminary Inventories of Manuscript and Record Groups, which describe various collections of manuscripts including those obtained from British and French sources as well as those of Canadian or French Colonial origin. Though still useful, these pamphlets are now being replaced by the General Inventory, Manuscripts. For manuscript collections throughout Canada an invaluable volume is the Union List of Manuscripts in Canadian Repositories (Ottawa, 1968).

Notes

In addition to reproductions of documents, the Illinois Historical Survey also has calendar notes taken on documents by Professor T. C. Pease. Many of these contain extensive quotes, but as they are not full reproductions, they are not listed under the respective document classification. They are found mainly in the following categories: PRO, CO; PRO, SP 78 and SP 94; PRO, WO; Shaftesbury Papers; and the British Museum's Newcastle Papers and Hardwicke Papers.

Organization

The Survey's copies of materials from British sources are arranged by depository in the following manner: national archives, national library and other depositories. The numbering system utilized below closely follows that used by the respective depository. The underlined numbers appearing in the left hand column, unless otherwise indicated, refer to a volume number. The next number, in parenthesis, indicates the items of that volume held by the Survey; these items may take the form of photocopies, office machine copies, typed or handwritten copies, or microfilm. Other indications as to the form of the material are self-explanatory. The dates generally refer to either the inclusive dates of the Survey's holdings or to the dates used by the respective depository. Following this information is a brief description of the material; it is not meant to be all inclusive. To determine the exact items in the Survey's collection of materials from British Archives, it is necessary to consult the archival card file.

Manuscripts

PUBLIC RECORD OFFICE. PAPERS, 1547-1790. 5014 items, 7 boxed or bound volumes. 38 reels of microfilm and 1 calendar. Photocopies, transcripts, microfilm. Archival card file. 61-2206.

Established in 1838, the Public Record Office serves as the main official depository for British governmental archives. Its materials are classified by the department from which they came, or in the case of gifts, under a heading or classification to which they would most appropriately belong. Finding aids to this very important depository have been listed in the introduction above. Those guides also contain references to aids which might prove useful in finding needed information from the collections.

AUDIT OFFICE

This body in the 1963 guide to the Public Record Office is classified under the rubric "Exchequer and Audit Department." These papers are accounts by governors, agents, and others for maintaining the army, building and maintaining forts, and conducting Indian affairs. "Declared accounts" are those which have been settled. For a description of the Audit Office Papers see Andrews' Guide..., II, 67-106; the revised 1963 Guide..., II, 117-122, and also L. H. Gipson's Guide..., 97-103.

Audit Office 1: Declared Accounts

Bundle 163. (2) 1.) April 1, 1765-June 30, 1767. Accounts of Gen. Gage for expenditures in Indian Department and Commisary of Musters Department. 2.) December 2, 1766-June 30, 1770. Account of Lt. Gen. Sir Guy Carleton in the Quartermaster General's Department.

Bundle 164. (1) October 1, 1775-June 30, 1778. Account of Robert Mackenzie, paymaster to Sir William Howe.

Bundle 1530. (2) 1.) 1774-1775. Account of Sir John Johnson, representative of the late Sir William Johnson, sole agent and captain of Indian Affairs. 2.) 1774-1775. Accounts of Col. Guy Johnson, late Superintendent of Indian Affairs. (These transcripts are not complete.)

Bundle 2531. (3) 1.) 1756-61, 1764-67. Accounts of Lt. Col. Harry Gordon, an engineer building and repairing several forts and places in North America. 2.) 1768-1778. Account of John Montresor, late engineer in North America. 3.) 1774-1782. Account of Col. William Spry, late commanding engineer in North America.

COLONIAL OFFICE

This classification contains the papers and records of the Board of Trade and those of the office of Secretary of State. The best guides for this division of the Public Record Office, and a discussion of the changes in its organization of documents, is Andrews' Guide..., I, 78-267; also see the 1963 Guide..., II, 52-92. Care must be used in the use of the Colonial Office papers as the Public Record Office has reorganized this material at least three times. The following group of papers is organized, as was the previous Survey guide to this collection, on the basis of the order in the Andrews guide and the guide by Grace Griffin. See Griffin's Guide..., 11-43, also Gipson's Guide..., 19-55. The researcher might also wish to consult the Calendar of State Papers, Colonial Series, America and West Indies...,Vols. 1-44, 1574-1738.

Colonial Office 5 is one of the most important collections of documents for the study of American Colonial History, and it includes a wide variety of material such as Entry Books, Acts, Journals, instructions, and dispatches. Some topics emphasized in the Survey's collection from this group include Indian trade, the French and Indian War, Pontiac's Rebellion, Colonial South Carolina, and land companies in the West.

Colonial Office 1: Colonial Papers

25. (1) June 27, 1670. Thomas Ludwell to Lord Arlington.

28. (1) January 22, 1672. Sir William Berkeley to Committee for Trade and Plantations.

48. (1) February 16, 1682. Cadwallader Jones to Lord Baltimore.

Colonial Office 5: America and West Indies

Vols. 6-7: Plantations General

6. (1) August 28, 1753. Earl of Holdernesse to the Governors.

7. (1) February 21, 1760. Board of Trade report to Pitt on settlements in America.

Vols. 13-20: Correspondence with Colonial Governors,
chiefly military

13. (20) 1747-1753. Correspondence of Glen, Fox, and James Crokatt; also extracts of reports and journal of assembly.

14. (7) 1754. Correspondence of Dinwiddie and Glen, and joint plans of operations of governors of Virginia, North Carolina, and Maryland.

15. (8) 1754-55. Dispatches from Dobbs, Rutherford, Dinwiddie, and Sharpe; Indian negotiations and Treaty at Mt. Pleasant in 1754; Braddock's address to the Indians, May 10, 1755.

17. (17) November, 1755-July,1756. Letters from Dinwiddie, Reynolds, and Andrew Lewis; disbursements on Ohio establishments; a map of Pennsylvania west of the Susquehanna; and treaties with the Catawba and Cherokee.

18. (19) 1756-1758. Petitions of merchants trading to Maryland, Virginia, South Carolina, and Georgia; and dispatches from governors of Southern Colonies.

19. (16) 1759-1760. Correspondence of various governors with William Pitt.

20. (5) April-May,1761. Affidavits and information on New Orleans.

Vols. 21-37: Orders in Council Sent to
the Board of Trade

21. (3) 1748, 1752. Orders in Council.

22. (1) February 2, 1759. Order for disposal of land surrendered by the Creeks.

23. (1) May 15, 1761. Instructions for Governor of Virginia.

24. (1) June 26, 1767. Board of Trade's report on petition of Col. George Mercer for the Ohio Company.

25. (2) 1768. Order of August 12, 1768, and petition of Bostwick and others for mineral rights near Lake Superior.

26. (2) 1769, 1770. Order in Council to Sir Henry Moore and order appointing John Stuart Councillor Extraordinary.

27. (3) 1772. The Charter to Bostwick and others and the application of Walpole and others for lands on the Ohio.

33. (1) August 8, 1772. Extract of Hamilton to Gage on government in Illinois.

Vols. 46-47: French and Indian War; 1755-56

<u>46</u>. (31) 1755-56. Letters from Braddock, Orme, St. Clair, Shirley, Mercer, Pepperrell. Pitcher, and Bradstreet; battle plans; councils of war and other Indian affairs; instructions to Johnson relative to the Six Nations.

<u>47</u>. (21) May-October,1756. Letters from Lt. Col. James Mercer, Gen. Loudoun, Gen. Shirley and others; a report on the state of Oswego; declaration of rangers escaped from Montreal; and reports of deserters.

Vols. 48-64: Military Correspondence; 1756-1763

<u>48</u>. (10) 1756-1758. Letters from Atkin, Loudoun, and Williams; intelligence from Montreal; intercepted French letters.

<u>49</u>. (5) November-December,1757. Letters from Loudoun, Sharpe, and Dagworthy.

<u>50</u>. (21) 1758. Letters from Generals Abercromby, Loudoun, Forbes, and Governor Vaudreuil.

<u>51</u>. (9) October 8, 1759. Dispatch from General Robert Monckton to Pitt with enclosures relating to the surrender of Quebec, including: the disposal of the British staff; monthly return of British forces; account of arms found in Quebec; casualty list; and Vaudreuil's instructions to Boishebert, May 5, 1759.

<u>52</u>. (1) n.d. Intercepted letter to Mirepoix.

<u>55</u>. (8) April-June, 1759. Correspondence of General Amherst and Brig. General Prideaux relative to latter's expedition.

<u>57</u>. (14) 1759-1760. Letters from Amherst, Sharpe, DeLancey, Watts, Ellis, and William Baker; remarks on the situation in Canada by Maj. Grant.

<u>58</u>. (10) April-August,1760. Letters from Amherst, Monckton, and Dobbs.

<u>59</u>. (76) July-November,1760. The fall of Canada: Amherst's dispatch of October 4, 1760; other Amherst correspondence and letters from Monckton, Dudgeon, and Byrd; also an Amherst circular to the governors, and returns of French troops.

<u>60</u>. (10) October,1760-March,1761. Letters from Amherst, Monckton, and Fauquier; an address of the Virginia House of Burgesses and Amherst's reply.

<u>61</u>. (14) 1761. Dispatches from Amherst; letters from Bernard, Rutherford, and Fauquier; intelligence from Croghan.

<u>62</u>. (11) 1762. Dispatches from Amherst; letters from Eyre, Albemarle, and Gage; a list of trading posts; troop dispositions in December,1762.

<u>63</u>. (76) January-September,1763; May, 1765. Pontiac's Uprising: Amherst's dispatches, letters to governors, and orders, letters from Gladwin to Amherst on loss of posts, a relation of Bouquet's engagement with the Indians near Fort Pitt, a memorial by Washington and others, and letters from Fraser at Kaskaskia to Gage, 1765.

<u>64</u>. (5) 1759-1760. Letters from Stanwix and Atkin to Pitt; a treaty with the Alabama Indians.

Vols. 65-82: Plantations General, 1760-1784

65. (10) 1763-1764. Letters from John Stuart, Johnson, and Bradstreet; an account of hat manufacture; a petition of Pennsylvania merchants; and a plan for imperial control of Indian affairs.

66. (19) January,1764-July,1765. Correspondence of John Stuart, trade regulations, Indian negotiations, and the Treaty at Mobile, 1765.

67. (23) 1766. Letters from John Stuart, Farmar's reports on Indian affairs in Illinois, petition from Phineas Lyman, General Gage's letters to Stuart and the Board of Trade, and negotiations with the Indians.

68. (25) 1762-1767. Letters from John Stuart, chiefly dealing with Indian affairs of the Southern Department.

69. (42) 1763-1768. Indian affairs of the Southern Department: letters from Stuart, Hillsborough, Cameron, and Fauquier; also a Cherokee cession.

70. (66) 1760-1769. The Treaty of Hard Labor; letters from John and Charles Stuart, Johnson, Fauquier, Blair, Hillsborough, and the Board of Trade; also a memorial and letter from Maj. Robert Rogers.

71. (31) 1769-1770. Correspondence between Stuart and Hillsborough, Indian negotiations, and a circular to governors on Indian Affairs.

72. (66) 1765-1772. Letters from Stuart, Gage, and Hillsborough, many concerning Indian Affairs.

73. (79) 1771-1772. Correspondence of John Stuart and papers concerning Indian affairs and boundaries.

74. (41) 1771-1774. Stuart and Dartmouth correspondence, the proposed colony of Vandalia, Indian affairs in Illinois, and Blouin-Dartmouth correspondence on a proposed government for Illinois.

75. (47) 1773-1774. Letters from Dartmouth, Stuart, Taitt, Cameron and Dunmore, many concerning Indian affairs.

Vols. 83-111: Military Correspondence, 1763-1784

83. (42) 1763-1765. Affairs in the West: Neyon de Villiers' letter to the inhabitants of Detroit and to the Indians, Gage-Halifax correspondence, and letters from Illinois Country.

84. (23) 1764-1766. Letters from Gage, Conway, Farmar, and Shelburne; reports from British British officers in Illinois; a memorial by inhabitants of Illinois to Gage; and information concerning Jesuit missions in Illinois.

85. (21) 1765-1767. Dispatches from Gage, proposed disposition of British troops, and an estimate of the fur trade at Michillimackinac.

86. (30) 1763-1768. Dispatches from Gage, replies from Hillsborough, and a report from Fort Chartres.

87. (29) 1763-1769. Gage correspondence and letters from Ulloa, a census of Illinois for 1767, and information on French and Spanish posts on the Mississippi.

88. (29) 1769-1770. Correspondence between Hillsborough and Gage, a letter from Wilkins at Fort Chartres, and Hillsborough's evaluation of the Illinois Country.

89. (21) 1771. Hillsborough-Gage correspondence on intelligence from Fort Pitt; Lt. Hutchins' report on the Illinois Country.

90. (46) 1772-1773. Hillsborough-Gage correspondence and several items on Illinois including such topics as the civil government, French population, land titles, troop dispositions, Gage's Proclamation, and a petition to Gage from the inhabitants of Vincennes.

91. (15) 1773-1774. Letters from Gage, Stuart, Haldimand, and Dunmore; also a land purchase in Illinois.

92. (5) 1775. Gage correspondence.

Vols. 114-117: Petitions, 1768-1781

114. (12) 1769-1772. A petition of Phineas Lyman, a petition for property of the Seminary of Cahokia, and various documents on West Florida.

115. (2) 1773. 1.) Memorial by Daniel Blouin to Gage; and 2.) a memorial by Myles Cooper and others.

Vol. 216: Instructions, Reports, and Various, 1761-1769

216. (3) 1696-1769. Colonial government and its powers.

Vols. 293-357: North Carolina

297. (7) 1754-1757. List of North Carolina militia and taxable persons in 1755; accounts; addresses; and a proposal of a boundary between North and South Carolina.

299. (3) 1760-1762. Correspondence and communications of Dobbs.

310. (15) 1767. Letters from Tryon, Stuart, and Cameron; Cherokee negotiations; and a Boundary agreement.

317. (1) May 5, 1774. Martin to Dartmouth.

318. (5) 1775. Martin to Dartmouth.

Vols. 358-538: South Carolina

370. (4) 1743-1744. Minutes of Assembly and Council, including references to a silver mine and the establishment of Georgia.

371. (6) 1744-1747. Glen's letters to Board of Trade, and a letter from the Emperor of the Cherokees to Glen.

372. (14) 1747-1751. Acts of the Assembly, Glen's letters to the Lords of Trade, and orders for the establishment of Georgia.

373. (20) 1746-1752. A deed of sale by the Cherokee, reports on the export of indigo and exports from Georgia, and various correspondence.

374. (12) 1749-1753. Several memorials by James Crokatt; and letters from Glen and Charles Pinckney to the Lords of Trade.

375. (27) 1754-1757. Several copies of the South Carolina Gazette; letters to the Lords
of Trade from Pinckney, Glen, and Lyttelton; and a proposal for the defense of the
colony.

376. (55) 1757-1760. Letters from Lyttelton and Bull to the Lords of Trade, Indian talks,
a return of militia, and journal of a Chickasaw trader.

377. (39) 1760-1763. Correspondence of Bull and Boone with the Lords of Trade, and an act
to regulate trade with the Cherokee.

378. (7) 1764-1766. Letters from Bull to the Lords of Trade.

379. (1) September 10, 1763. Bull to the Lords of Trade.

383. (2) 1736. Letters from Oglethorpe and Thomas Broughton.

390. (13) 1756-1764. Halifax correspondence, and letters from Boone and Bull.

392. (1) April 10, 1769. Report from a South Carolina Committee.

393. (1) December 6, 1769. Bull to Hillsborough.

395. (1) n.d. Petition of Edward Wilkinson to Dartmouth.

396. (4) 1774. Letters from Bull to Dartmouth.

402. (4) 1747-1754. Letters from the Lords of Trade.

403. (8) 1756-1760. Letters from the Lords of Trade to Pitt and Lyttelton.

455-474, 476-477. (441) 1746-1761. Selections from the minutes of the South Carolina
Council and Assembly. [In addition, the Survey has positive and negative microfilm
copies of the Journals of the legislature of colonial South Carolina. See South
Carolina Colonial Records.]

Vols. 540-573: East Florida

548. (1) September 19, 1763. Memorial by Col. Grant to Halifax concerning the limits of
East Florida.

563. (1) November 3, 1763. Hillsborough et al to the King concerning colonizing and
governing new acquisitions in America.

Vols. 574-635: West Florida

574. (26) 1763-1768. Correspondence of Johnstone concerning his dispute with Maj. Farmar
over conflicting authority, and on western settlement, a post at Iberville, and the
boundaries of Florida.

575. (10) 1766-1768. Correspondence of Johnstone and Aubry, and a representation from the
Council and Assembly.

577. (17) 1768-1769. Correspondence of Browne and Durnford, and memorials from Lyman and
Farmar.

578. (22) 1770-1771. Correspondence of Chester, and an estimate on the cost of a canal
from the Mississippi to Iberville.

579. (22) 1772-1773. Correspondence of Chester, and several petitions for land.

BRITISH ARCHIVES AND DEPOSITORIES.

580. (4) 1763-1777. Instructions and memorials from Coxe and Hutchins.

582. (9) 1763-1765. Letters from Keppel, Farmar, and Caminade; and an Indian Council at Mobile.

583. (1) May 20, 1766. Struthers to Johnstone.

584. (1) June 29, 1767. Browne to Shelburne.

585. (4) 1768. Memorials by merchants trading to West Florida, and letters from Browne and Hillsborough.

586. (5) 1768-1769. Browne-Hillsborough correspondence.

587. (12) 1769-1771. Correspondence of Durnford; and letters from O'Reilly, Nichols, Chester, and Bradley.

588. (4) 1771. Hillsborough-Chester correspondence.

589. (11) 1771-1772. Council minutes, and Hillsborough-Chester correspondence.

590. (13) 1773. Council minutes, and Dartmouth-Chester correspondence.

591. (22) 1774. Dartmouth-Chester correspondence, a description of West Florida, and council minutes.

Vols. 636-712: Georgia

642. (4) 1749-1750. Letters concerning Thomas Bosomworth.

643. (5) 1750-1751. Letters by Habersham, Glen, and Parker.

644. (21) 1747-1755. Papers concerning Thomas Bosomworth; and letters from Martyn, Reynolds, and Habersham.

645. (8) 1775-1756. Several papers concerning Thomas Bosomworth, and several letters from Reynolds to the Lords of Trade.

646. (16) 1757-1760. Several letters from Ellis to the Lords of Trade, the Bosomworth Settlement, and a treaty with the Creeks.

647. (4) 1760. Letters from Ellis to the Lords of Trade.

648. (23) 1758-1764. Correspondence of Ellis and Reynolds with the Lords of Trade, papers on Thomas Bosomworth, several memorials, and a cession by the Creeks.

649. (6) 1764-1765. Letters by Wright, Council minutes, and regulations for trade with the Indians.

651. (21) 1764-1771. Correspondence of Wright concerning Indian affairs.

656. (14) 1747-1750. Papers on Bosomworth; correspondence of Heron; and Indian negotiations.

657. (1) July 4, 1752. Memorial of Edmund Gray.

658. (10) 1763-1767. Wright correspondence.

659. (2) 1768. Council at Savannah, and a letter from Hillsborough to Wright.

<u>660</u>. (3) 1768-1770. Hillsborough-Wright correspondence.

<u>661</u>. (15) 1770-1772. Letters from Wright, Hillsborough, and Habersham.

<u>662</u>. (10) 1773. Wright-Dartmouth correspondence.

<u>663</u>. (28) 1773-1774. Wright-Dartmouth correspondence.

<u>672</u>. (2) 1756. Letters from the Lords of Trade to the King and to Fox.

<u>673</u>. (5) 1758-1759. Letters from the Lords of Trade to Ellis, Pitt, and to the Council.

<u>674</u>. (1) February 27, 1761. Lords of Trade to Wright.

Vols. 713-750: Maryland

<u>721</u>. (2) 1755. 1.) Journal(of a former French soldier, Thomas Forbes) describing some French Forts; and 2.) extracts of letters from Horatio Sharpe to his brother.

Vols. 751-854: Massachusetts

<u>848-851</u>. (7 bound or boxed volumes.) 1686-1765. These abstracts and facsimiles from CO5 848-851 show the records of entrance and clearance of Massachusetts shipping, 1686-1765, with tabulated lists of vessels with dates, owners, masters, cargos, etc. For CO5 848 (1686-1719) there are abstracts; thereafter facsimiles. The project was carried out by English research workers with funds contributed by the Essex Institute of Salem, Mass., with the cooperation of seven institutions including the University of Illinois Library.

Vols. 1037-1232: New York

<u>1070</u>. (1) July 1, 1763. Sir William Johnson to the Lords of Trade.

<u>1088</u>. (1) March 10, 1768. Cabinet minutes.

<u>1197</u>. (5) 1751-1753. Council proceedings at Fort George, New York.

<u>1199</u>. (2) 1755-1758. Council proceedings at Fort George, New York.

<u>1200</u>. (5) 1760-1763. Council proceedings at Fort George, New York.

Vols. 1273-1285: Pennsylvania

<u>1273</u>. (1) July 2, 1752. Petition of Pennsylvania's proprietors to Council in Whitehall.

<u>1274</u>. (2) 1756. Council proceedings for raising men and money for a campaign on the Ohio, and a letter of the proprietors to the Lords of Trade.

<u>1275</u>. (1) April 12, 1759. Council's Order on Franklin's petition (includes petition).

<u>1276</u>. (1) May 9, 1764. Penn to Hillsborough.

<u>1277</u>. (2) n.d. Letters from the proprietors to the Lords of Trade.

<u>1280</u>. (2) 1763, 1767. Letters from Halifax and John Penn.

<u>1281</u>. (4) 1768. Correspondence of John Penn.

<u>1284</u>. (6) 1769-1771. Correspondence of John Penn.

<u>1285</u>. (1) July 30, 1774. John Penn to Dartmouth.

Vols. 1305-1450: Virginia

1326. (4) 1745-1747. Letters from Gooch,and papers on Fairfax boundary.

1327. (31) 1748-1753. Orders in Council; an Ohio Company petition; an account of John
 Salley's journey to the Mississippi; letters by Gooch, Dinwiddie, and Lee; papers
 relevant to the Indian trade; and papers concerning the start of the French and Indian
 War.

1328. (18) 1753-1756. Letters from Dinwiddie, Orders in Council, a petition from the Ohio
 Company, and an account of the present state of Virginia.

1329. (29) 1756-1760. Letters from Dinwiddie and Fauquier to the Lords of Trade, and
 several memorials, including Pitt's, to the Lords of Trade on reimbursement for the
 Southern Colonies.

1330. (26) 1744-1764. Fauquier correspondence, the Treaty of Lancaster of 1744, papers on
 the Cherokee War, Articles of Surrender of Fort Loudoun, and an account of quitrents
 from Virginia for 1762.

1331. (21) 1765-1767. Correspondence of Fauquier and Lewis, negotiations with the
 Cherokee, and memorials from Mercer and the Ohio Company.

1332. (28) 1752, 1768-1770. Botetourt correspondence, Council minutes, several petitions
 and memorials from various persons (including Thomas and Richard Walpole and George
 Mercer) mainly concerning western settlement.

1333. (17) 1749-1772. Memorials from various persons including George Washington, and an
 account of all Orders in Council pertaining to Western Lands between 1744 and 1769.

1334. (5) 1772-1773. Several letters from Dunmore to Dartmouth, and an Order in Council.

1336. (2) 1769, 1773. A Board of Trade report on a Lyman memorial, and a list of
 persons to be granted lands on the Ohio.

1345. (9) 1763-1767. Fauquier correspondence.

1346. (1) June 10, 1768. A Board of Trade report to the King on a Virginia petition
 regarding the return of inhabitants to their Western lands.

1347. (4) 1768-1769. Council minutes, and two letters to Botetourt.

1348. (9) 1769-1770. Correspondence of Botetourt, a resolution of the Burgesses, and
 papers on an Indian threat.

1349. (18) 1769-1771. Correspondence of Botetourt, John Penn, Stuart, Carleton, and
 Colden; a Cherokee land cession; Council minutes; and minutes of a meeting of New York
 and Virginia Commissioners on the Indian trade.

1350. (5) 1772. Dunmore correspondence, an Indian conference, and papers concerning an
 Indian boundary.

1352. (16) 1773-1774. Dunmore and Dartmouth correspondence, a petition of the grantees of
 land on the Mississippi and Ohio, and a purchase by the Illinois Land Company.

1353. (7) 1774-1775. Dunmore correspondence, council minutes, a list of all patents
 granted by him, a description of the western campaign,and his comments on colonial
 politics and the westward movement.

1366. (14) 1745-1752. Letters from the Lords of Trade to Gooch, Lee, and Dinwiddie; and an act for clearing roads over the mountains.

1367. (19) 1753-1760. Letters from the Lords of Trade to the King, to various Secretaries of State, and to Dinwiddie and Fauquier.

1368. (3) 1762-1763. Letters from the Lords of Trade to Fauquier and Egremont.

1429. (45) 1753-1758. Council minutes, and an account of an Indian conference.

1430. (2) 1755. Council minutes.

Colonial Office 42: Canada

1. (7) 1761-1764. Letters from Gage, Halifax and Murray; a memoir on Detroit; and an inquiry as to the state of Canada.

2. (3) 1763, 1765. A memorial of merchants and traders of Montreal and Governor Murray's reply; also a proclamation by him on the Indian trade.

5. (1) December 18, 1783. Petition of George Morgan for an Indiana tract of land.

7. (2) 1769. Letters from Carleton to Hillsborough and to the Lords of Trade.

8. (4) 1771-1773. Letters from H. T. Cramahe to Hillsborough and Dartmouth.

13. (5) 1745-1746, 1755. Letters of Bedford, Newcastle, and Pownall; also a proposal for the reduction of Canada.

23. (1) August 14, 1750. A captured letter from Ligneris to his wife.

37. (14) 1777. Letters from Hamilton, Carleton, Abbott, and Rocheblave, concerning the British at Detroit and Vincennes, and regarding the Indians and Spanish in the West in the Revolutionary War.

38. (8) 1777-1778. Letters from Rocheblave, Abbott, and Hamilton; and an address from the inhabitants of Vincennes to Abbott.

73. (2) 1790. A letter from Major Smith to Captain LeMaistre, and information of Simon Girty.

318. (1) July 28, 1793. Doyle to Simcoe.

Colonial Office 43: Canada

1. (1). June 24, 1766. Instructions to Governor James Murray.

Colonial Office 323: Plantations General

3. (1) 1700. Story of the Mississippi by Monsieur de Tonti, Governor of the Fort St. Louis of the Illinois.

16. (4) 1763. Letters from Egremont to the Colonial Governors and to the Lords of Trade, a plan of forts and garrisons proposed for the security of North America, and a paper on the government of the newly acquired territory.

17. (19) 1763-1764. Letters from Johnson, Amherst, Croghan, Stuart and Ellis; lists and disposition of troops for North America; lists of French posts on the West side of the Mississippi; and letters on Indian affairs and trade in the Southwest.

BRITISH ARCHIVES AND DEPOSITORIES.

<u>18</u>. (7) 1764-1766. Letters and petitions from Gage, Johnson, Conway, Mant, and Mackenzie to the Lords of Trade.

<u>19</u>. (1) April 14, 1764. Gage to Halifax on Five Nations joining against the other Indians.

<u>20</u>. (4) 1764. Letters from Johnson, Stuart, and Gage concerning the management of Indian affairs.

<u>23</u>. (9) 1764-1765. Letters from Johnson, Stuart, St. Ange, and Aubry concerning Pontiac's Rebellion and Indian trade.

<u>24</u>. (5) 1766-1777. Letters from Johnson and MacLeane, and a memorial by Cholmondeley.

<u>25</u>. (5) 1766-1777. Letters from Gage, Johnson, and Shelburne concerning western policy, and a colony in Illinois.

<u>28</u>. (1) May 31, 1768. A memorial of Phineas Lyman.

<u>29</u>. (1) October 6, 1773. Blouin to Dartmouth, concerning charges against Wilkins and the progress of a plan for a government of Illinois.

<u>30</u>. (12) 1764-1765. Letters from Gage, Sedgwick, St. Ange, and Stanhope; Captain Morris' journal of a visit to the Miamis; and Pittman's address to Illinois traders.

<center>Colonial Office 324: Plantations General</center>

<u>17</u>. (1) October 10, 1763. Hillsborough <u>et al</u> to Halifax on Proclamation of 1763.

<u>21</u>. (16) 1763-1775. [Formerly Board of Trade Commercial Papers]. Reports or orders of the Board of Trade relative to grants of land by the French and by Colonial Governors, on the Indian Trade, and the Ohio Company, and the Proclamation of 1763.

<u>43</u>. (1) April 7, 1775. Commission of Mathew Johnson as Lt. Governor and Superintendent at the Illinois post.

<center>Colonial Office 326: Plantations General</center>

<u>15</u>. (1) 1764-1778. List of Maps and Plans relating to North America belonging to the Board of Trade.

<center>Colonial Office 391: Board of Trade Journals</center>

<u>70-82</u>. (14) 1763-1775. Extracts from the Journal of the Board of Trade concerning western trade, settlement, and Canada.

<center>CUSTOM HOUSE PAPERS</center>

The papers in this group contain accounts of the importation of furs and peltries, and their value, from Atlantic seaboard ports in various colonies in North America. For a description of the Public Record Office, Custom Office Papers, see Andrews' <u>Guide</u>...II, 111-130; Griffin's <u>Guide</u>, 43-44; and Gipson's <u>Guide</u>..., 92-96.

<center>Customs 3: Accounts, Ledgers of Imports and Exports</center>

<u>64</u>. (1) Christmas, 1763 to Christmas, 1764. Selections are accounts of furs imported from various colonies.

<u>65</u>. (1) 1764-1765. <u>Ibid</u>.

<u>66</u>. (1) 1765-1766. <u>Ibid</u>.

67. (1) Christmas, 1766 to Christmas, 1767. Selections are accounts of furs imported from various colonies.

68. (1) 1767-1768. Ibid.

74. (1) 1773-1774. Ibid.

75. (1) 1774-1775. Ibid.

Customs 16: Accounts, Ledgers of Imports and Exports

1. (5) January 5, 1768 - January 5, 1773. Accounts of exports from several ports in North America to Great Britain (furs and peltries).

PRIVY COUNCIL OFFICE

This council was the basic decision making body in the British Empire's administrative machinery during the Colonial Period. It received petitions, appeals, complaints, and information from a variety of sources all the way from private individuals to high governmental bodies; its orders were known as Orders in Council. Its relative significance declined with the rise in prominence of the Cabinet Council which kept no official records. For more information see Andrews and Davenport's Guide... (British Museum) 170-187, the 1963 Guide II, 233-235; and Gipson's Guide... 7-8.

Privy Council I: Unbound Papers

Bundle [?] (1) March 18, 1766. Petition of John Rogers and Joseph Treat to King in Council.

Bundle [?] (1) 1768. Petition to Privy Council for the founding of the Mississippi Company.

Bundle [?] (1) July 16, 1773. Report of the Attorney and Solicitor General regarding the grant of lands to the Walpole Company.

Bundle [?] (1) October 28, 1773. Order to the Attorney and Solicitor General to prepare a draft of a grant of lands to the Walpole Associates (Vandalia).

Bundle [?] (1) August 8, 1774. Memorial of Thomas Walpole and associates asking that the land grant and government of the Colony of Vandalia be expedited.

STATE PAPERS

This is the collection of papers of the Secretaries of State for the Northern and Southern Department, as well as (after 1768) the Secretary of State for the Colonies. The "Domestic" papers include correspondence between the Secretary's office and various other governmental offices, while the "Foreign" papers are those concerning relations with foreign powers. The Survey's collection of papers from the latter group mainly concerns the negotiations leading to the Treaty of Paris of 1763. For a description of the State Papers see the 1963 Guide...II, 1-14, Andrews' Guide...I, 26-37, Griffin's Guide...,73-76, and also Gipson's Guide..., 8-18. There are published Calendars for the Domestic Papers of the reigns of Edward VI, Mary, and Elizabeth I.

State Papers: Domestic

State Papers 10: Edward VI

1-19. 4 reels of microfilm. 1547-1553. Complete.

State Papers 11: Mary

<u>1-14</u>. 3 reels of microfilm. 1553-1558. Complete.

State Papers 12: Elizabeth

<u>1-115</u>. 31 reels of microfilm. 1558-1577. Complete.

State Papers 37: George III

<u>3</u>. (2) 1765-1766. St. Ange's Council with the Indians in Illinois in April, 1765, and a letter from Barrington to Conway March 17, 1766.

<u>10</u>. (1) November 27, 1773. Statement regarding Marriott's report on Quebec.

State Papers: Foreign

State Papers 78: France

<u>235-255</u>. (1) Calendar. 1749-1762. This calendar was made by T. C. Pease. In addition to descriptive data, it contains numerous partial and complete transcripts of documents.

<u>243</u>. (1) February - March, 1752. Abermarle to Holdernesse relative to violations of the peace in America and enclosing depositions by John Patton and Thomas Rourke.

<u>246</u>. (1) February 7, 1753. Cosne to Amyand, enclosing depositions of five men on losses at the hands of the French.

<u>251</u>. (1) June 17, 1761. An overture from Choiseul relative to peace and boundaries.

<u>253</u>. (5) 1762. Letters from Bedford and Choiseul concerning peace and boundaries.

State Papers 84: The Netherlands

<u>466</u>. (4) March, 1754. Correspondence of Yorke and Newcastle.

State Papers 92: Savoy-Sardinia

<u>65, 67-92</u>. (90) 1757, 1759-1760. Correspondence between the British government and its representatives in Turin; correspondents include Pitt, Egremont, Halifax, Conway, George Pitt, Dutens, Sherdly, and Mackenzie. One selection is a lengthy statement on Sardinia's commerce.

State Papers 93: Sicily-Naples

<u>14-19</u>. (95) 1756-1761. Correspondence between the British government and its representatives in Naples; correspondents include Fox, Pitt, Egremont, and James Gray.

State Papers 94: Spain

<u>57-59, 163</u>. (7) 1758-1759, 1761. Correspondence between British government and its representatives in Spain.

TREASURY

The Treasury Board was responsible for gathering the revenues for the State and for auditing public accounts. For a description of the Treasury Papers, see Andrews' Guide... II, 136-263; the 1963 Guide...II, 283-300; Griffin's Guide..., 76-78; and Gipson's Guide..., 55-91.

Series I: Treasury Board Papers, In Letters

475. (1) February 15, 1771. John Pownall to Lords of Treasury, transmitting petition for a land grant.

482. (1) January 18, 1771. Hillsborough to Lords of Treasury regarding an illegal peltry shipment.

486. (3) 1770-1771. Letters from Edward Stanley to Hillsborough regarding an illegal peltry shipment on the packet Snow.

Treasury 29: Minute Books

41. (1) 1771. Minutes for July 23 and August 14 concerning the Florida Packet Snow.

WAR OFFICE

The War Office Papers contain the military correspondence of the Secretary at War concerning the military arrangements of the King and Council. This included the raising of troops, maintaining their efficiency, issuing marching orders, and providing for quarters. Among the various divisions within this broad collection one may find the correspondence of generals, records of campaigns, accounts, muster rolls, etc. The Illinois Historical Survey's collection of War Office Papers was selected mainly from War Office 34, the Papers of Lord Jeffery Amherst. For a general description of the War Office Papers see Andrews' Guide...II, 270-303, (this work contains a good description of the British Army and its administration in the Colonial Period), the 1963 Guide...II, 304-333, Griffin's Guide..., 78-84, and Gipson's Guide..., 123-129.

War Office 1: Secretary at War, In Letters

2. (15) 1771-1775. Letters from Gage, Hamilton, and Wilkins concerning "the Wilkins affair" in Illinois.

6. (2) 1765. Letters from Gage to Ellis.

7. (1) March 29, 1766. Letter from General Gage.

8. (1) February 4, 1769. Letter from Gage to Barrington.

9. (4) 1769-1774. The account of Baynton, Wharton, and Morgan with the Crown; and also Hamilton to Barrington on the Wilkins affair.

20. (1) March 11, 1765. Farmar to Gage.

War Office 4: Secretary at War, Out Letters

71. (1) February 12, 1763. Ellis to Amherst concerning troops in America after the Treaty of 1763.

95. (1) December 9, 1775. Barrington to Wilkins on the sale of the latter's commission.

273. (2) 1775. Letters from Barrington to Gage and Hamilton.

988. (2) 1774. Letters from Barrington that concern the Wilkins' affair.

War Office 34: Amherst Papers

5. (20) 1762-1764. Dispatches from Gage to Amherst concerning trade, travel problems, Canada at the end of the War, Havanna, and a description of the West.

10. (2) August, 1761. Correspondence of Amherst and Rocheblave.

19. (18) 1762-1763. Letters from Duncan at Fort Ontario to Amherst, including several pertaining to Pontiac's rebellion; and passes from Gage.

20. (24) 1760-1763. Letters from Amherst to Gladwin, Murray, and Duncan concerning the northern campaign, forts, supplies, trade, and Pontiac's rebellion.

21. (66) 1759-1761. Letters to Amherst mainly from Farquhar, Eyre, and Walters at Niagara concerning trade, travel, and Indian and military affairs.

22. (97) 1762-1763. Letters to Amherst from Walters, Wilkins, and Browning; passes; orders; a court martial; a plea for surgeon's supplies; a sketch of alterations for Fort Schlosser; and a report of an Indian attack.

23. (111) 1759-1763. Letters from Amherst to Eyre, Farquhar, Walters, Wilkins, and Browning; military orders; also items concerning supplies, forts, and Pontiac's rebellion.

33. (1) March 20, 1759. Examination of a Canadian prisoner as to French forts.

34. (93) 1757-1763. Correspondence of Sharpe, Ellis, and Wright with Loudoun and Amherst, which concerns recruitment of troops, ending Pontiac's rebellion, affairs in Georgia, Rangers, and the French in the Southwest.

35. (122) 1756-1763. Correspondence of Dobbs, Lyttelton, Bull, and Boone with Loudoun and Amherst, concerning various military and other affairs; money raised by North Carolina for other colonies; an Indian Treaty; and also an intercepted letter from Kerlerec to Palagio.

36. (108) 1758-1763. Letters from Loudoun, Abercromby, and Amherst to Dobbs, Lyttelton, Bull, and Boone; also several circular letters to the Southern governors.

37. (171) 1754-1763. Fauquier-Amherst correspondence; letters from Blair, Loudoun, and Abercromby; Virginia votes of money; Virginia accounts; and a Treaty with the Cherokee.

40. (149) 1756-1763. Letters from Bouquet, Croghan, Blane, and Ourry with Loudoun, Amherst, and others; returns of various forts; papers on Indian negotiations; casualty lists; and a journal of Grant's expedition against the Cherokee.

41. (49) 1757-1763. Letters from Loudoun and Amherst to Bouquet.

43. (60) 1759-1763. Correspondence between Amherst, Monckton, and Lyman; a report of the Battle of Quebec; items concerning Indian negotiations, military affairs in 1759 and 1760, and problems of provincial troops.

44. (50) 1755-1759. Correspondence between Forbes, Abercromby, and Amherst; a return of casualties; and a list of men in action September 14, 1758.

45. (139) 1757-1761. Correspondence between Stanwix and Loudoun, Abercromby, and Amherst; estimates; returns; accounts; also a council of war at Pittsburgh.

46A. (55) 1759-1760. Correspondence between Amherst and Gage; returns; and Gage's proposal for raising a light-armed regiment.

47. (102) 1759-1762. Correspondence of various officers in South Carolina and Virginia with Amherst; returns; conferences with the Southern Indians; activities of Indian Superintendent Atkin; South Carolina and Virginia Council minutes and Acts.

48. (60) 1757-1763. Letters from Amherst to various officers, and also Atkin's instructions to Gist.

49. (185) 1760-1763. Correspondence between Amherst and Campbell, Gladwin, Hopkins, and Jenkins; returns of Fort Detroit; MacDonald's journal of the siege; memorials of the inhabitants of Detroit to Amherst and to the commandant of Illinois; and a description of the Illinois country.

53. (55) 1759-1763. Correspondence of Amherst with Massey, Darby, and Campbell; also returns of Fort Stanwix and Northern Posts.

54. (26) 1759-1763. Letters to Amherst from Gladwin and Sterling, Gladwin's several warnings of an Indian uprising, and Amherst's orders to Gladwin on that rebellion.

57. (21) 1758-1763. Bradstreet letters to Loudoun, Abercromby, Gage, and Amherst, concerning Fort Frontenac and northern commissary affairs.

60. (8) 1760. Correspondence between Amherst and Lt. Robertson.

65. (53) 1759-1763. Correspondence between Joshua Loring and Amherst, and Loring's lists of vessels on the Great Lakes.

69. (8) 1761-1762. Correspondence between Amherst and Eyre.

72. (6) 1759-1762. Letters from Sharpe to the King and to Pitt, memorials for payment and for supplies, and instructions to governors concerning land grants.

73. (3) 1755-1756. Letters from Shirley to Fox.

74. (6) 1759-1762(?). Several memorials for land grants to Amherst and his reply, a return of provincial troops furnished between 1760 and 1762, and a statement of troops needed for 1762.

76. (7) 1756-1758. A proposal concerning trade at Oswego, information from a captured Braddock guide, and papers relative to Bradstreet's campaign against Frontenac.

82. (2) 1760. Roger's response to Amherst's inquiry about Vaudreiul's papers, and an information against Captain Demere.

83. (3) 1760. Letters to Amherst from Mason, Joncaire, and Meredith.

84. (2) 1760. Orders from Amherst to Gladwin and DeNormandie.

85. (3) 1760. Amherst's letter to Yorke announcing the fall of Canada and his orders to Rogers to take Detroit.

86. (4) 1761. Letters to Amherst from Barre, Rogers, Coventry, and Campbell.

88. (1) February 3, 1761. General Amherst to Commissioners settling Forbes' estate.

89. (2) 1761. A French description of the south shore of Lake Ontario and Amherst's reply to Rogers' request to succeed Atkin.

90. (7) 1761-1762. Lt. Butler's account of Fort Miami and Ouiatenon, La Corne St. Luc's journal of his shipwreck, and several letters to Amherst.

<u>92</u>. (2) 1762. Letters from Amherst to Balfour and Lyman.

<u>93</u>. (1) November 24, 1762. Return of men needed to garrison posts in case of attack.

<u>94</u>. (3) 1763. Letters from Webb and Trent to Amherst.

<u>95</u>. (24) 1763. Letters to Amherst from various persons mainly concerning Indian affairs.

<u>96</u>. (2) 1763. Letters from Amherst to Walton and Webb.

<u>97</u>. (8) 1763. Letters from Amherst to various officers concerning military affairs during Pontiac's Rebellion.

PUBLIC RECORD OFFICE, GIFTS AND DEPOSITS

This classification refers to documents obtained by the Public Record Office by gift, deposit, or purchase. For a description of this material see Andrews' <u>Guide...II</u>, 346-365; this is brought up to date in the 1963 <u>Guide...II</u>, 241-255; also see Griffin's <u>Guide...</u>, 65-67, and Gipson's <u>Guide...</u>, 130-138. The selections in the Survey from the Chatham and Egremont Papers refer mainly to the Treaty of Paris of 1763. The material from the Shaftesbury Papers is described below.

Public Record Office 30:8. Chatham Papers

<u>Bundle 17</u>. (2) October 16 and November 4, 1770. Letters to Pitt from D'Aubarede.

<u>Bundle 31</u>. (1) April 26, 1767. Dunmore to Chatham.

<u>Bundle 40</u>. (1) July 9, 1758. Dr. Hensey to Pitt.

<u>Bundle 49</u>. (4) 1759-1762. Letters from Maghlin and Massey to Pitt, and a map of Fort Niagara.

<u>Bundle 56</u>. (4) 1766-1773. Letters from Shelburne to Chatham.

<u>Bundle 61</u>. (1) June 20, 1761. Temple to Pitt.

<u>Bundle 64</u>. (5) 1758-1763. Letters from Viry to Pitt.

<u>Bundle 68</u>. (6) 1769-1777. Letters from Woodrop to Chatham, and an order to pay Dr. Lee.

<u>Bundle 97</u>. (9) 1763-1769. The Original Articles of Agreement of the Mississippi Company, minutes of its meetings, and Lt. James Eddingstone's description of the Illinois Country and of the British taking possession of Fort Chartres.

Public Record Office 30:24. Shaftesbury Papers

Section IX. Bundle 48

<u>No. 83</u>. (1) n.d. Memo on "Virginia Husbandry" in the hand of John Locke.

<u>No. 94</u>. (1) August 22, 1674. Maj. Gen. Abraham Wood to John Richard giving an account of a journey across the mountains from Carolina.

<u>No. 96</u>. (1) December 31, 1674. Henry Woodward to Shaftesbury giving an account of an expedition to the Ashley River.

BRITISH ARCHIVES AND DEPOSITORIES.

Public Record Office 30:47. Egremont Papers

Bundle 11. (20) 1761-1763. Selections are letters from the Comte de Viry, Sardinian
ambassador in London, to Egremont, concerning the negotiations for peace.

BRITISH MUSEUM. PAPERS, 1671-1858. 1446 items, transcripts, photocopies. Archival card
file. 61-1847.

The British Museum, established in 1759, is second only to the Public Record Office as a
significant British depository for manuscripts relative to American History. Papers
acquired at an early date are arranged by collection; but, with the acquisition of the
"Sloane Manuscripts," the library began numbering its acquisitions consecutively as
"Additional Manuscripts." Often large blocks of papers essentially forming groups will be
found; these are designated by number as well as Collection name, for example, Bouquet
Papers or Newcastle Papers. For a description of the collection in the Survey Library,
attention is called to the Guides listed in the introduction to this section.

EGERTON MANUSCRIPTS

This is a particularly large collection which contains various other collections within it.
Most of the American material is described in the Andrews and Davenport's Guide... (Vol.
2395 is described in detail), 28-50; however, it should be noted that other papers have
been added to it over the years and therefore it is necessary to consult later additions in
the British Museum guides and catalogs. See also the Griffin Guide..., 97-99, the Gipson
Guide..., 171-173, and the Crick and Alman Guide..., 178-180.

2395. (1) n.d. Proposition of Louis Le Page and a description of lakes newly discovered at
the source of the St. Lawrence.

LANSDOWNE MANUSCRIPTS

These are the papers of William Petty, Earl of Shelburne (1764), and Earl of Lansdowne
(1784) and should be used in conjunction with the Shelburne papers in the William L.
Clements Library. They are described in the Andrews and Davenport Guide..., 1-17, in the
Griffin Guide..., 87-88, in the Gipson Guide..., 168-169, and in the Paullin and Paxson
Guide..., 508-509.

809. (1) January 20, 1753. "Historical Account of the Revolt of the Choctaw Indians in
the late War...."

ADDITIONAL MANUSCRIPTS

These are papers which have been added to the manuscript collection of the British Museum
since 1836. They are cataloged by the British Museum in their Catalogues of Additions to
the Manuscripts in the British Museum...; but see also the Andrews and Davenport Guide...,
72-169, the Crick and Alman Guide..., 126-178, the Paullin and Paxson Guide..., 523-555,
the Griffin Guide..., 109-172, and the Gipson Guide..., 173-205.

4432. (2) n.d. (c. 1750); September, 1671. 1) "Remarks on the Journal of Batts and Fallam;
in their Discovery of the Western Parks of Virginia in 1671. By John Mitchell, M.D.,
F.R.S." 2) " A Journal from Virginia beyond the Appalachian Mountains in September,
1671."

15903. (1) 1687. Report relative to English discoveries in Carolina and Florida and the
settlement of English and French claims by Edward Byllynge, Governor of West Jersey.

BRITISH ARCHIVES AND DEPOSITORIES.

Vols. 21,631-21,660: Bouquet Papers

This group within the Additional Manuscripts, is a collection of the papers of Lt. Colonel, later Brig. General, Henry Bouquet. A complete set of these papers is in the Canadian Archives which has published an excellent calendar in its Report for 1889. Many of these papers have been published by the Pennsylvania Historical Commission. For descriptions of these papers see the Parker Guide... Canadian Archives, 10-11, (Washington, 1913), the Parker A Guide to the Documents... Canada I, 195-198, (Ottawa, 1914), and the Griffin Guide..., 127-129.

21,632. (14) 1757. Selections from the Letterbook of Lt. Col. Henry Bouquet.

21,634. (7) 1763. Bouquet-Amherst correspondence, Royal instructions for demobilization, and a plan of the establishment of the 60th Regiment.

21,637. (4) 1763-1765. Letters from Bouquet to Gage.

21,638. (136) 1759-1765. Correspondence between Bouquet, Monckton, Gage, and Stanwix.

21,642. (127) 1758-1765. Letters from Ourry to Bouquet.

21,643. (54) 1758. Incoming correspondence from various persons.

21,644. (113) 1759. Incoming correspondence from various persons.

21,645. (78) 1760. Incoming correspondence from various persons.

21,646. (63) 1761. Incoming correspondence from various persons.

21,647. (38) 1761. Incoming correspondence from various persons.

21,648. (56) 1762. Incoming correspondence from various persons.

21,649. (90) 1763. Incoming correspondence from various persons.

21,650. (90) 1764. Incoming correspondence from various persons.

21,652. (24) 1758-1759. Outgoing correspondence mainly to Forbes.

21,653. (38) 1760-1764. Outgoing correspondence to various persons.

21,655. (106) 1758-1765. Indian affairs: speeches, meetings, and conferences; and also incoming correspondence from various persons.

21,656. (2) 1764. Instructions to Murray, and a suspension of arms with the Indians.

21,657. (8) 1761-1762. Proclamations and instructions, especially one forbidding settlement west of the Allegheny Mountains, and two letters from Rogers.

21,658. (12) 1758-1764. Travel accounts, instructions, memorials, and petitions.

21,660. (9) 1765. The will and inventory of Bouquet's belongings and papers concerning their disposal.

Vols. 21,661-21,892: Haldimand Papers

These are the papers of Lt. Colonel, later Lt. General, Sir Frederick Haldimand who served
in America from 1756 to 1775, and was appointed Governor of Canada in 1778. These papers
have been calendared in the Reports of the Canadian Archives, 1884-1889, and are generally
described in the British Museum's Catalogue... for the years 1854-1860. For further
descriptions see Parker, Guide...Canadian Archives, 12-14, Parker, A Guide to Documents...
Canada I, 198-210, and Griffin, Guide..., 130-138.

21,661. (2) 1762. Correspondence between Haldimand and Amherst.

21,662. (4) 1764-1766. Letters from Gage to Haldimand and Col. Taylor at Pensacola.

21,663. (9) 1767-1768. Correspondence between Gage and Haldimand concerning the Southwest
and the British occupation.

21,664. (4) 1770. Correspondence between Generals Gage and Haldimand, and a letter from
Gage to O'Reilly.

21,665. (30) 1771-1774. Letters from Gage, Haldimand, Hutchins, and Wilkins; concerning
in part the Illinois Country, the Wilkins affair, Indian troubles on the Ohio, the
inhabitants of Vincennes and land titles; and Haldimand's account of the "Tea Party"
and the Camden opinion.

21,666. (1) January 12, 1775. Lt. Col. James Robertson to Haldimand.

21,670. (9) 1773-1774. Haldimand-Johnson correspondence; Haldimand's advice on the Indian
land sales to white settlers; letters concerning the Murray affair; Haldimand's
sending John Hay to Illinois to investigate encroachments on Indian land; and the
announcement of the death of Johnson.

21,671. (2) 1767. Letters from Taylor and Gage.

21,672. (6) 1770-1774. Correspondence of Charles Stuart, a letter from Bellaud to Mollere
on affairs at Cahokia, and intelligence reports from Illinois relative to Indian
violence.

21,673. (2) 1768, 1770. A circular letter to the Governors relative to Indian affairs;
and a letter from Durnford to Haldimand concerning trade in the West and Indian
affairs.

21,675. (3) 1765-1766. Receipts by Maj. Robert Farmar for supplies for expeditions to
Illinois.

21,677. (2) 1768, 1773. Letters from Farmar and Campbell relative to the West.

21,678. (2) 1765. Letters from Fraser to Campbell.

21,687. (10) 1770-1774 (1763?). Letters and papers concerning problems in the Illinois
Country relative to Indians and local French affairs, and a memorial for local
government.

21,693. (12) 1773-1774. Letters from Haldimand to Lord, Hamilton, and Hay relative to
the Illinois Country and Indians.

21,695. (10) 1773-1774. Dartmouth-Haldimand correspondence containing references to the
use of the Camden Opinion to justify land purchases, to Indian land titles, and to tea
importations.

21,696. (4) 1772-1774. Letter from Barrington, and lists of officers who commanded outposts.

21,697. (2) 1773-1774. Dartmouth to Gage on the importance of a government for Illinois; also Lord Chancellor Yorke's opinion of land titles obtained from Indians.

21,699. (1) October 28, 1776. Carleton to Rocheblave.

21,726. (3) 1773. Haldimand letters to Illinois Country.

21,728. (6) 1767-1768. Letters from various persons to Haldimand.

21,729. (1) July 6, 1772. James Willing to Haldimand.

21,730. (6) 1773. Letters of Lord and Hutchins to Haldimand; also a letter from Lord to Gage on Murray's use of the Camden Opinion.

21,731. (2) September 3, 1773; April 2, 1774. 1.) Lord to Haldimand on land purchases from the Indians, and 2.) Major Hamilton to Major Moncrieffe.

21,757. (2) August 3, 1778; June 7, 1778. 1.) Rocheblave's report to Haldimand on his capture by Clark, and 2.) Richard McCarty to John Askin on operations in the West.

21,781. (1) September 15, 1777. Carleton to Haldimand.

21,782. (21) 1774-1780. Letters from Rocheblave, Abbott, and George Rogers Clark relative to the Illinois Country, its government, and Indian affairs.

21,842. (1) August 10, 1781. Clark to Cracraft.

21,844. (2) September 23, and 24, 1779. Clark to Jefferson and Broadhead.

21,845. (1) August 9, 1781. Clark to Lockry.

Vols. 32,686-33,057. Newcastle Papers

These are the papers of Thomas Pelham Holles, Duke of Newcastle, 1697-1768. He served as Secretary of State for the Northern Department under Henry Pelham, his brother. When the latter died in 1754, he became the head of the Cabinet and First Lord of the Treasury; he continued in these positions to 1756 and, at the latter post, from July, 1757 to 1762. The Survey also has extensive calendar notes, gathered by Professor T. C. Pease, on these volumes. For a description of this material see Andrews and Davenport's Guide..., 123-143, Griffin's Guide..., 149-150, and Gipson's Guide..., 182-193. The Catalogue of Additions to the Manuscripts of the British Museum, 1882-1887 contains an excellent index to this group.

32,735. (1) June 14, 1754. J. Hanbury to Newcastle.

32,736. (1) September 23, 1754. Robinson to Newcastle.

32,836. (4) 1754. Letters from Newcastle to Albemarle and Holdernesse, and a letter from Holdernesse to Newcastle.

32,841. (1) December 20, 1752. Philadelphia traders to Albemarle.

32,850. (2) 1754. Newcastle to Albemarle, and an extract of a letter to John Capel Hanbury.

32,851. (1) October 10, 1754. Newcastle to Albemarle.

32,853. (2) March, 1755. Robinson to Keene and to Newcastle.

32,854. (4) April-May, 1755. Letters from Newcastle to Holdernesse and to the King; from Robinson to Newcastle; and from Keith to Holdernesse.

32,866. (1) July 12, 1756. Newcastle to Hardwicke.

32,896. (1) April 27, 1759. Newcastle to Hardwicke.

32,897. (4) October, 1759. Letters from Newcastle to Hardwicke and to the Countess of Yarmouth, and a letter from Pitt.

32,918. (4) February, 1761. Letters from Viry to Newcastle, and a Newcastle memo to Lord Bute.

32,921. (3) April, 1761. Letters from Devonshire and from Hardwicke, to Newcastle, and a memo on a conversation with Pitt.

32,922. (1) May 9, 1761. Bedford to Newcastle.

32,923. (1) n.d. Bedford to Newcastle (?).

32,924. (7) June, 1761. Correspondence between Newcastle, Hardwicke, Devonshire, Bute, and the Earl of Morton.

32,926. (2) July-August, 1761. Newcastle to Hardwicke; Devonshire to Newcastle.

32,927. (7) August, 1761. Newcastle memoranda; and a letter from Bussy to Pitt, and from Grimaldi to Fuentes.

32,928. (9) September, 1761. Newcastle memoranda; letters from Newcastle to Hardwicke, between Newcastle and Bedford, and from Grimaldi to Fuentes.

32,929. (2) October, 1761. Newcastle memo; a letter from Newcastle to Hardwicke.

32,933. (2) January, 1762. James Tierney to John Cleveland; Choiseul to Solar.

32,934. (3) February, 1762. Solar to Viry; and correspondence between Bute and Newcastle.

32,935. (16) March, 1762. Newcastle correspondence, mainly with Hardwicke, Bute, and Mansfield.

32,936. (2) April, 1762. Newcastle-Hardwicke correspondence.

32,937. (9) April, 1762. Letters from Viry and from Egremont to Newcastle and from Newcastle to Hardwicke and Devonshire.

32,938. (1) May 24, 1762. Viry to Newcastle.

32,941. (2) July, 1762. A memo from Newcastle to Devonshire and a letter to Hardwicke.

32,942. (1) September 18, 1762. Sarah Cotter to Newcastle.

32,947. (1) February 17, 1763. Devonshire to Newcastle.

32,950. (1) August 30, 1763. Pitt to Newcastle.

32,951. (3) September, 1763. Newcastle memoranda and a letter to Pitt.

32,973. (1) January 31, 1766. George Onslow to Newcastle.

BRITISH ARCHIVES AND DEPOSITORIES.

32,980. (1) March 31, 1767. List of Rockingham's friends.

32,993-33,000. (4 reels of microfilm, 44 items). 1667-1763. Newcastle memoranda and
 Cabinet minutes.

33,027. (7) 1754. Letters from Albemarle to Robinson.

33,028-33,030. (3 reels of microfilm, 6 items). 1701-1802. Papers on American affairs.

Vols. 35,349-36,278. Hardwicke Papers

These are the papers of the Earls of Hardwicke especially Philip Yorke, Earl of Hardwicke,
(1690-1764). He served as Lord Chancellor, (1737-1756), and in the Cabinet, (July,1757-
May,1762) and was a close confidant of Newcastle. The Catalogue of Additions to the
Manuscripts in the British Museum in the Years 1894-1899 contains a useful index to the
papers. For a further description of this group of papers see Andrews and Davenport's
Guide..., 156-170, and Gipson's Guide, 194-200.

35,420. (4) 1761. Letters from Newcastle and Viry.

35,421. (3) 1762. Letters from Newcastle to Hardwicke and a letter from Viry to Newcastle.

35,423. (1) n.d. Lord Bute to Hardwicke.

35,607. (3) 1762. Letters from Viry.

Vols. 27,952-44,389. Robert Owen Papers

These 41 papers have been gleaned from various collections in the Additional Manuscripts.
Supposedly they comprise all the letters by Robert Owen in the British Museum. Due to the
scattered nature of the papers, no particular volume of the Guides to the Additional
Manuscripts... can be used for reference.

27,952. (1) September 30, 1824. Robert Owen to Messrs. Wheatley and Adelard.

33,545. (9) 1818-1823. Robert Owen to Jeremy Bentham.

37,188. (1) January 2, 1834. Robert Owen to Charles Babbage.

37,949. (3) 1814-1818. Robert Owen to Francis Place.

38,271. (2) 1818. Letters from Robert Owen to Lord Liverpool and to the Archbishop of
 Canterbury.

38,277. (3) 1819. Correspondence between Owen and Lord Liverpool.

38,278. (1) July 14, 1819. Owen to Lord Liverpool.

38,280. (1) November 15, 1819. Owen to Lord Liverpool.

38,284. (1) May 13, 1820. Owen to Lord Liverpool.

38,286. (1) June, 1820. Owen to the Earl of Liverpool.

38,361. (1) 1810. "Outlines of a bill for the formation of character among the poor and
 working classes."

38,574. (1) April 7, 1818. Owen to the Earl of Liverpool.

40,275. (1) March 20, 1818. Owen to the Earl of Liverpool (published).

BRITISH ARCHIVES AND DEPOSITORIES.

40,349. (1) August 12, 1822. Owen to Sir Robert Peel.

40,359. (2) 1823-1824. Letters between Owen and Sir Robert Peel.

40,381. (3) 1825. Letters between Owen and Sir Robert Peel.

40,414. (1) February 16, 1835. Owen to Sir Robert Peel.

40,546. (1) June 7, 1844. Owen to Sir Robert Peel.

40,588. (3) 1846. Letters from Owen to Sir Robert Peel.

43,233. (1) September 2, 1829. Owen to Lord Aberdeen.

43,246. (2) May 16, 1846. Notes exchanged between Owen and Lord Aberdeen.

44,389. (1) February 2, 1858. Owen to Gladstone.

DUKE OF DEVONSHIRE, CHATSWORTH, BLAKEWELL. DEVONSHIRE COLLECTION. PAPERS, 1755-1763.
107 items, photocopies. Inventory.

This selection of papers pertains to William Cavendish, Fourth Duke of Devonshire (1720-1764) who led a Ministry from November,1756 to May,1757. The papers are mainly concerned with the negotiations of the peace of 1763 and the persons involved. See the Crick and Alman Guide..., 33, and the Gipson Guide..., 327.

Catalogue numbers 260, 251-394 (scattering). (79 folio numbers in 278 pages of photocopies)
 1755 to March-November, 1762. Political Diary of the 4th Duke of Devonshire (State of
 Affairs). Interspersed among items in the Devonshire diary are other papers: letters
 from the King of Prussia, Prince Ferdinand, Joseph Yorke, Kinnoul, Pitt, Newcastle,
 Choiseul, Galitzen, Stanley, Solar, and Viry; notes on conversations,
 characterizations, and abstracts of intelligence; papers regarding Fuentes' memoirs
 of June and September, 1760; and an inventory of the jewelry of George II.

Catalogue numbers 580.0-27. (28) October 15, 1758-July 6, 1763. Letters of Comte Francis
 Joseph de Viry to the 4th Duke of Devonshire.

OXFORD UNIVERSITY, WORCESTER COLLEGE LIBRARY. WILLIAM CLARKE PAPERS. PAPERS, 1647-1664.
2 reels of microfilm.

Sir William Clarke was Secretary to the Council of the English Army from 1647 to 1649, and Secretary to General Monck and the commanders of the army in Scotland from 1651-1660. These papers contain documents and letters which pertain to foreign affairs, the army, the court, and the English government in general. Specifically, there are documents pertaining to: royal expenses and revenues; proceedings in Parliament; proceedings against individuals suspected of treason; Cromwell; the army's part in the restoration of Charles II; the "New Model Army"; and treaty negotiations.

Box 1

<u>3.313</u> (243 folios) 8 March, 1659/1660-9 July, 1664. The documents relate to foreign
affairs, royal expenses and revenues, proceedings in Parliament, and proceedings
against individuals suspected of treason.

<u>3.10</u> (203 folios) 1 January, 1657/58-30 December, 1658. The documents contain newsletter
reports of Oliver Cromwell's last year as Lord Protector, his death and funeral;
letters pertaining to affairs abroad: 3.9 the Swedish-Danish conflict, the English
action taken at Dunkirk, Gravelind, and others. [Many representative letters are
printed in <u>The Clarke Papers</u>, ed. C. H. Firth (Camden Society, New Series), Vol. 61,
pp. 131-172.]

<u>3.11</u> (277 folios) January, 1658/59-September, 1659. The documents pertain to army affairs,
proceedings in Parliament under the new Lord Protector, R. Cromwell, and reveal English
interest abroad. [A number are printed in <u>Clarke Papers</u>, Vol. 61, pp. 172-196 and
Vol. 62, pp. 1-58.] The Letterbook cover identifies these as MS. 31.

<u>3.12</u> (254 folios) October, 1659-January, 1660. The documents continue the correspondence
in MS. 31. [A number of General Monck's letters to other officers pertaining to the
army's part in the restoration of Charles II are printed in <u>Clarke Papers</u>, Vol. 62,
pp. 59-240.]

Box 2

<u>6.1</u> (132 folios) March-June, 1647. These documents relate to the Parliamentary plan to
disband the New Model army. [They are printed in part in <u>Clarke Papers</u>, Vol. 49,
pp. 1-141.]

<u>5.7</u> (47 folios) <u>ca</u>. 1660. The documents relate to King Charles II's household expenses:
including a list of persons to have keys to St. James Park, charges for building a
tilt yard. There is also a report on the Barbadoes.

<u>5.14</u> (156 folios) January-October, 1653. Robert Lilburne's letterbook.

<u>6.1</u> (72 folios) September 20-November 30, 1648. Negotiations of the treaty with
Charles I.

ROYAL INSTITUTION OF GREAT BRITAIN. LETTER, 1783. 1 item, transcript.

The papers in this depository relative to America comprise mainly the headquarters papers
of British commanding generals during the American Revolution. For descriptions or
comments see the Andrews and Davenport <u>Guide...</u>, 188, the Crick and Alman <u>Guide...</u>, 298,
and most important, the Griffin <u>Guide...</u>, 190-191.

<u>53</u>. (1) March 5, 1783. Pierce Sinnott to Carleton.

BRITISH ARCHIVES AND DEPOSITORIES.

ROYAL SOCIETY. PAPERS, 1671, 1682. 2 items, transcripts.

This organization was, in essence, the main center for accumulating scientific information for the British Empire. Located in London, the library contains many papers and letters commenting on exploration and scientific observation in the American Colonies. For a description of these papers see the Andrews and Davenport Guide..., 355-368, Crick and Alman Guide..., 299-302, and the Griffin Guide..., 191-196.

Classified Papers (Guard Books) Vol.VIII, Part 1, number 43. (1) September 1-October 1, 1671. "A Journal from Virginia beyond the Appalachian Mountains in Sept., 1671. Sent to the Royal Society by Mr. Clayton and read Aug. 1, 1688 before the said Society." This expedition of Thomas Batts, Thomas Woods, Robert Fallam, "received a commission from the honorable Major General Wood...." (Another copy of this journal is listed under British Museum, Add. Mss., 4432).

The Boyle Papers. Miscellaneous, XL (unpaged). (1) "Report of proceedings... Hudson's Bay Settlement." Signed by John Nixon, 52 pages (with unpaged appendices, 9 pages). Report written in spring and summer of 1682; first date cited is May 22; last is August 9. Sent by Governor Nixon of Hudson's Bay to the company.

STAFFORDSHIRE COUNTY RECORD OFFICE. DARTMOUTH PAPERS. PAPERS, 1763-1777. 121 items, transcripts. Chronological card file. 61-1788.

These are the manuscripts of the Earls of Dartmouth. The most important of these to American History was William Legge, Second Earl of Dartmouth (1731-1809), President of the Board of Trade 1765-1766, Secretary of State for the Colonies, 1772-1775, and Lord Privy Seal 1775-1782. These papers have been moved several times; originally in the possession of the family at Patshull House, Walverhampton, England; they were moved first to the William Salt Library, Stafford, and then to their present location. They are calendared in the Second, Eleventh, Fourteenth and Fifteenth Reports of the Historical Manuscripts Commission. The material is arranged chronologically. For a description of the collection see the Crick and Alman Guide..., 411-418, the Griffin Guide..., 211-216, and the Gipson Guide..., 339-343.

1763.	Governor Aubry's account of the Illinois country.
July 8, 1765.	Rockingham to Dartmouth.
July 9, 1765.	Dartmouth to Rockingham.
September, 1765.	Hillsborough to Dartmouth concerning the latter's appointment.
n.d. [1766].	General Lyman's reasons for a settlement on the Mississippi.
n.d. [1766].	Objections against, and Major Mant's defense of a settlement at Detroit.
n.d. [1766].	Abstract of General Lyman's reasons.
January 27, 30, 31, 1766.	Cabinet Minutes on American affairs.
April 9, 1766.	Townshend to Dartmouth.
April 30, 1766.	Major Thomas Mant to Dartmouth.
June 14, 1766.	Captain Gavin Cochrane to Dartmouth.
[August 14, 1766].	Alexander Clunie to Dartmouth.

July 26, 1767.	Rockingham to Hardwicke.
August 15, 1767.	Rockingham to Darmouth.
October 9, 1767.	Baynton and Wharton to L. McLeane.
July 16 and n.d., 1768.	Notes on documents and letters.
August 13, 1768.	Hillsborough to Gage [Extract].
December 12, 1768.	Rockingham to Dartmouth.
n.d. [1770].	Propositions for the establishment of a colony and government....
February 3, 1769.	Gage to Hillsborough.
April 13, 1769.	Alexander Clunie to Dartmouth.
November 8, 1769.	Rockingham to Dartmouth.
n.d. [1770].	Memorial of George Croghan et al to the King.
February 5, 1770.	Rockingham to Dartmouth.
July 19, 1770.	John McIntire to Governor Peter Chester.
August 25, 1770.	Deposition of Daniel Huay.
September 26, 1770.	Governor Chester to Hillsborough.
January 18, 20 and n.d., 1770.	Correspondence (5) between Guilford and Dartmouth.
December 1, 1771.	Cabinet Minute.
n.d. [1772?].	Memorandum of business.
n.d. [1772].	Edward Abbott to Dartmouth.
n.d. [1772].	Memorial of Rev. Temple Henry Croker.
n.d. [1772].	Petition of merchants, et al, stating reasons for establishing government at White Cliffs.
April, 1772.	Memorial by Captain A. S. Hammond.
April 7, 1772.	Further reasons for establishing a government on the Mississippi.
May 1, 1772.	Henry Basset to Lord Scarsdale.
June 29, 1772.	Henry Basset to Lord Scarsdale.
August 3, 1772.	North to Dartmouth.
August 8, 1772.	John Pownall to Dartmouth.
August 10, 1772.	Frederick Montagu to Dartmouth.
August 18, 1772.	Letter to Dartmouth.

August 26, 1772. Sir Matthew Fetherstonhaugh to Dartmouth.

September 10, 1772. Henry Basset to Lord Scarsdale.

September 11, 1772. Monsieur Lavanchy to Lord Dartmouth.

September 19, 1772. Pownall to Dartmouth.

October, 1772. "A Londoner" to Dartmouth.

October, 1772. Anonymous memorial on Ohio Settlements.

October 6, 1772. Scarsdale to Dartmouth.

October 7, 1772. Pownall to Gage.

October 12, 1772. Dartmouth to Scarsdale.

October 21, 1772. Phineas Lyman to Dartmouth.

November, 1772. Memorial of James Wright.

November 10, 1772. Memorial of Montfort Browne.

November 17, 1772. James Wright to Dartmouth.

December 6, 1772. Captain Hammond to Hans Stanley.

December 8, 1772. Phineas Lyman to Dartmouth.

January 6, 1773. Daniel Coxe to Dartmouth (with enclosure of an Order in Council
 December 21, 1699).

January 22, 1773. Report of Lords of Trade.

January 23, 1773. Hans Stanley to Dartmouth.

June 2, 1773. Governor William Tryon to Dartmouth.

June 17, 1773. Blouin's sketch of a proposed government for the Illinois Country.

June 29, 1773. The Earl of Rochford to Dartmouth.

July 3, 1773. Order in Council concerning the Walpole grant.

July 3, 1773. Memorial of Walpole, et al, enclosed in above.

July 16, 1773. Attorney and Solicitor General's report on the Walpole grant.

July 29, 1773. Sir Sidney Stafford Smythe to Dartmouth.

July 31, 1773. "An American" to Dartmouth (from the Public Ledger).

August 2, 1773. "Fact" to Dartmouth (enclosed above).

August 2, 4, 1773. Council Minutes.

August 10, 1773. Governor Thomas Pownall to Dartmouth.

September 7, 1773. Earl of Rochford to Dartmouth.

September 9, 1773.	Dartmouth to the Earl of Rochford.
September 22, 1773.	Edward Foy to Dartmouth (encloses observations on Virginia lands).
September 23, 1773.	Rochford to Dartmouth.
October 1, 1773.	Lt. Governor H. T. Cramahe to Dartmouth.
October 23, 1773.	William Gerard de Brahm to Dartmouth.
November 18, 1773.	Captain Williamos to Dartmouth.
December 7, 1773.	Case of Col. Mercer.
n.d. [1774?].	John Pownall to Dartmouth.
n.d. [ca. 1774].	William Knox on proposed mode of granting lands in America.
n.d. [ca. 1774].	"An Act granting... powers of Legislation to the Governor and Council of Quebec...."
n.d. [1774].	"Establishment of the Office" – Secretary of State for Colonies.
n.d. [1774].	John Gordon to Board of Trade.
n.d. [1774].	Summary of above.
January 1, 1774.	Mrs. S. Osborn to Dartmouth (with enclosure).
January 25, 1774.	Samuel Wharton to Thomas Pitt.
January 25, 1774.	W. Hey, Chief Justice of Quebec, to the Lord Chancellor.
January 26, 1774.	Lord Chancellor Apsley to Dartmouth (with enclosure).
January 29, February 4, 5, 1774.	Cabinet Minutes.
February 15, 1774.	J. Stevenson to Montfort Browne.
February 16, 19, 28, March 1, 1774.	Cabinet Minutes.
March 6, 1774.	Apsley to Dartmouth.
March 10, 1774.	Cabinet Minutes.
March 17, 1774.	North to Dartmouth.
July 30, 1774.	Frederick Montagu to Dartmouth.
August 10, 1774.	Joseph Galloway to Richard Jackson.
September 10, 1774.	Peter Duval to Dartmouth.
September 25, 1774.	Joseph Reed to Dartmouth.
October 27, 1774.	Thomas Walpole to Dartmouth, encloses four letters.

BRITISH ARCHIVES AND DEPOSITORIES.

November 15, 1774. William Knox to Dartmouth.

December 18, 1774. John Pownall to Dartmouth.

December 21, 1774. Richard Jackson to Dartmouth.

December 24, 1774. Barrington to Dartmouth.

December 30, 1774. William Molleson to Dartmouth.

March 6, 1775. Major David Hay to Dartmouth.

March 30, 1775. Thomas Wharton to Samuel Wharton.

April 17, 1775. William Tryon to Dartmouth.

September 20, 1775. William Grant to David Grant.

1777. William Knox to Dartmouth.

BROMWELL, HENRY PELHAM HOLMES (1823-1903). PAPERS, 1862-1866. 11 items, originals, photocopies. Calendar. 69-1586.

Henry Pelham Holmes Bromwell was a member of Congress, 1865-1869, when he lived in Charleston, Illinois; later he moved to Colorado and continued in public life. Among the original items is a letter written by Major James A. Connolly, "before Savannah," describing the march through Georgia and expounding on the anti-black actions of Union General J. C. Davis. There is also a deposition by Allan Pinkerton regarding Timothy Webster, one of his secret service operators, who was captured in Richmond, given a court martial April 2, 1862, and executed. The photocopies include three letters to Bromwell from W. H. Herndon, who asks assistance in his Lincoln research, and a letter from Bromwell describing arrangements in Springfield for the Lincoln funeral. [The Survey's collection of original papers was presented by Miss Henrietta Bromwell of Denver, daughter of Henry Pelham Holmes Bromwell. The photocopies are from the Bromwell letters in the Library of Congress.]

BROOK FARM COMMUNITY. RECORD BOOK, 1841-1847. 1 reel, microfilm. 69-1589.

This material concerns the formation and government of the Brook Farm Phalanx. Minutes of meetings and of Board of Director conferences discuss the establishment of the Community, and later, the weekly business and problems. Interspersed are drafts of the Constitution of the Community, with subheadings encompassing most phases of government and life at Brook Farm: Name and Purpose, Government, Capital Stock, Guarantees, Division of Profits, Organization of Labor, and Amendments. There is also a document from the Commonwealth of Massachusetts to incorporate Brook Farm Phalanx. [The original is held by the Massachusetts Historical Society, Boston, Massachusetts.]

BROWN, PAUL. PAPERS, ca. 1839. 1 reel, microfilm. 69-1589.

Paul Brown, a radical pamphleteer, was a member of the New Harmony Community on which he had published an extensive account. The item in this collection is "The Woodcutter or a Glimpse of the 19th Century at the West," a manuscript volume evidently designed for publication. The work contains forth-three essays, most of which advocate social reform on extreme equalitarian principles. Some of the sections are descriptive and partially autobiographical. Allusions to New Harmony are present in the work. A reference, page ninety-six, furnished the date of 1839 for at least part of this otherwise undated manuscript. [The original of this work is in the Illinois State Historical Library, Springfield, Illinois.]

BROWN, ROBERT CARLTON (1886-1959). PAPERS, 1919-1942. 164 folders. 61-2052.

Robert Brown was a writer of radical sympathies. He returned to the United States in 1932 after fifteen years in South America. In 1933, he went to Llano Colony, Louisiana, where he gathered material for a history of the colony and other cooperative movements. He circulated questionnaires throughout 1934; and also requested bibliographies, books, and publications. His book, Can We Cooperate, was published in 1940 and is partially autobiographical.

This collection contains various drafts of the chapters of Can We Cooperate and files of orders for the book. In addition, there is a manuscript written by George Peckett, General Manager of Llano Colony, and notes by Ernest Wooster, colonist and author of Communities of the Past and Present (Newllano, 1924). Correspondence, clippings, periodicals, pamphlets, photographs, and other illustrative material, especially for Llano Colony, are included. [The collection was purchased by the Survey in 1951 from Robert Brown, then living in Brazil.]

BROWNING, ORVILLE HICKMAN (1806-1881). PAPERS, 1829-1887. 320 items, transcripts, photographs, photocopies. Index. 61-1729.

The papers consist of 297 letters written by and to Orville Hickman Browning; notes; copies of speeches; memos on cabinet meetings; a photocopy of the address made before the Adams County Bar Association after his death; and photographs of Browning, his family, and Washington colleagues (these by Matthew Brady). Correspondents include Presidents Lincoln and Johnson, as well as Charles Hardin, John McClernand, John Pope, William Seward, William Sherman, Joseph Smith, Edwin Stanton, Gideon Welles, and Richard Yates. Two letters are exchanged between I. N. Arnold and Browning in 1872 regarding Lamon's Life of Lincoln, in which Browning reviews his association with Lincoln. [The originals of the letters of which the Survey has transcripts and photocopies are in the Illinois State Historical Library, in the Library of Congress, and in the possession of the O'Bannon family (Mrs. Browning was Eliza O'Bannon), and various other persons. The publication of The Diary of Orville Hickman Browning brought the editors many letters of reminiscences; these original letters are housed with the collection.]

BRYANT, ARTHUR (1803-1882). LETTER, December 30, 1830. 1 item, transcript.

Arthur Bryant (a brother of William Cullen Bryant) of Jacksonville and Bureau County, Illinois, describes agricultural conditions in Illinois in this letter to his brother, John William Bryant. Planning to settle and farm in Jacksonville, he elaborates upon the types of soil, crops, weather conditions and prices for agricultural goods. [The letter was a gift of Professor Natalia M. Belting, Urbana, Illinois.]

BUCK, SOLON J. (1884-1962). CORRESPONDENCE, PAPER, BIBLIOGRAPHIC NOTECARDS, 1910-1916, 1931. 1 folder, 9 boxes or 6.7 feet of 4X6 notecards. 69-1599.

Solon J. Buck was a member of the staff of the Illinois Historical Survey and a research associate in the University of Illinois History Department from 1910 to 1914. After leaving Illinois, he held the position of Superintendent of the Minnesota Historical Society (1914-1931) and later, Professor of History at the University of Pittsburgh and Director of the Western Pennsylvania Historical Society (1931-1935). He joined the National Archives in 1935 and served as the Archivist of the United States from 1941 to 1948.

This collection contains two letters exchanged between Buck and T. C. Pease in 1931. The letters concern Buck's offer of several papers and sets of notes to Pease. The paper entitled "Material for Illinois History in the Archives of the United States Government at Washington" was accepted by Pease for the Survey. There are also two sets of bibliographic notecards (4X6) in this collection. One set of six boxes is an author-subject bibliography while the other, of three boxes, is arranged chronologically, by topic, by type of work, and other categories. These bibliographies mainly concern Illinois and the Old Northwest. [Other Buck correspondence can be found in the Archives of the Illinois Historical Survey.]

BURR, AMOS SHELTON (1848-1911). PAPERS, 1880-1961. 1,356 items, originals, carbons, photocopies and machine reproductions. Calendar.

Amos Shelton Burr was born in Bridgeport, Connecticut, on February 20, 1848, and came to Bement, Illinois, in 1880 as a representative of the Bodmans of Massachusetts. "Being impressed with the possibilities of Piatt County, he became the owner of the Thornton Farm," although he was trained to be a lawyer and a banker. Thornton Farm was developed by Mr. Burr into one of central Illinois' show places by employing such methods as drainage and the use of fertilizer. On December 27, 1882, Burr married Sydney Amelie Compton of Rapides Parish, Louisiana. Eventually he became the owner of the Amelie Plantation, which was originally part of the Quantico (Corday) Plantation located in Rapides Parish.

The collection includes legal documents, tax papers and ledgers which concern the Illinois property, the Amelie Plantation and some land in Arapahoe County, Colorado. In addition there are included the inventories and papers from the trust set up under the will of A. S. Burr. There are also a few papers and a copy of the will of Carrie S. Burr, the sister of A. S. Burr.

The Burrs had four daughters. The collection includes the papers of two of them. Mary Burr Brown, who eventually became the executor of the A. S. Burr Estate, married Lloyd Warfield Brown, who farmed near Jacksonville, Illinois. They had two sons, Peter and William. The Browns were involved in leasing farms and land in Illinois from Julia Carter (wife of W. C. Carter) and Julius Strawn who were both farm magnates in Morgan County. Besides the papers on their Illinois property, the collection includes a series of correspondence and documents that deal with the Brown's Grand Trunk and Eureka Mines, which eventually became the French Mountain Mining Company.

The other daughter mentioned in the collection is Ellen Burr Simpson, who married Randolph S. Simpson in June, 1914. After the death of her husband on November 3, 1918, she returned to Thornton Farm to live with her mother. This part of the collection includes letters dealing with the gift of five hundred dollars to establish a memorial to her husband in the form of books for the library of French Philosophy at Princeton University. [At the request of the donor, Miss Amelie Blyth, material dated after 1930 requires her consent for its use. This involves part of the papers concerning Mary Burr Brown and the A. S. Burr Estate, and all of the papers on Carrie S. Burr. The entire collection was acquired through the good offices of Mrs. George Scouffas as a gift from Miss Amelie Blyth, niece of Mrs. Simpson, of Bement, Illinois, in November of 1970.]

BUTTERFIELD, JUSTIN (1790-1855). LETTER, 1849. 1 item, photocopy. 69-1599.

This letter is to Rep. Caleb Smith (Indiana) from Justin Butterfield, a Chicago lawyer, U. S. District Attorney for Illinois, 1841, and Commissioner of U. S. General Land Office, 1849. The letter concerns Butterfield's position as a Taylor supporter. He had been a Federalist in 1812.

BUTTLES, M. R. ACCOUNT BOOK, 1852-1873. 1 volume.

Leather goods, agricultural and practical implements, and livestock are the main categories of goods included in this store account book. Customer accounts date from 1852 to 1873, and the store's invoice is dated 1859. The customers were from Illinois, Indiana, Michigan and Wisconsin.

CAHOKIA CITIZENS. LETTER, April 22, 1784. 1 item, transcript.

This letter, written by the residents of Cahokia, was a rebuttal to accusations made by Father de la Valiniere against Father Paul de St. Pierre. The letter was read orally to Cahokia residents after high mass on April 22, 1784. Due to this and other incidents, the residents refused to accept de la Valiniere as "Vicar General of Illinois."

CAHOKIA PARISH RECORDS, DIOCESE OF BELLEVILLE, ILLINOIS. PAPERS, 1783-1929. 4 items, transcripts. 2 reels, microfilm. 71-1774.

The transcripts contain birth and death records. The first film roll, No. 11-3, contains records of burials, baptisms, and marriages, dating from 1783 to 1899, as well as other varied materials. In the second film roll, No. 11-4, there are records of baptisms, marriages, confirmations, regulations of church wardens, and registers of communicants, from 1822 to 1929. [The microfilm was made by the Illinois State Archives from originals in the Diocese of Belleville, Illinois. It was a gift to the Survey from the Director of the Archives, Theodore Cassady, June 5, 1959.]

CAIRO CITY AND CANAL COMPANY. PAPERS, 1839-1842. 5 items.

These items concern the promotion in England of the Cairo City-and-Canal Company. A letter, dated December 13, 1838, from William Strickland (engineer) and Richard C. Taylor (engineer and geologist) to John Wright in London, reports on the site selected to found the city of Cairo. The next item is a prospectus for a Cairo City-and-Canal Company Loan, with a "statement showing the plan of improvements now in progress and the consequent developments." Also included are two stock shares for the company (1839) and a receipt issued to assigners of the estate of Wright et al for Illinois Improvement Bonds. [These papers were purchased in London in 1918.]

CALDWELL, NORMAN W. (1905-1958). LETTER, PAPER, 1948. 2 items. 69-1607.

The paper in this collection "Cantonment Wilkinsonville, A New Chapter in the Career of General James Wilkinson" concerns the preparation, especially by Alexander Hamilton and General Wilkinson, to defend the western lands against the possibility of a rupture in relations with both France and Spain during the period 1796-1800. The letter from Norman Caldwell, dated February 27, 1948, submitted the manuscript to T. C. Pease.

CAMP STOTSENBERG HOSPITAL. PAPERS, 1900-1901. 3 items.

The three items in this collection are a journal, a letter and a newspaper clipping. The journal concerns the hospital at Camp Stotsenberg, Manila Province, Phillippines, which was built and furnished in 1900. First Lieutenant and Assistant Surgeon L. K. Graves recorded reports, inventories and correspondence in it. Also mentioned is the appearance of an isolated case of bubonic plague in the camp on August 9, 1900. The letter in the collection is from Lt. Graves to the Paymaster General informing him of a deposit. The newspaper clipping (October 7, 1900) concerns a Lt. Kennedy's comments on the Filipinos' conception of government. [This collection was acquired by the University of Illinois Library in June, 1942.]

CAMPBELL, ORIN SHEPHERD. ACCOUNT BOOKS, 1836-1857. 3 volumes.

Dr. Campbell was a physician near Pittsfield, Illinois. This collection contains Campbell's business records, which list the patient, the date of visit, the service rendered, and the fee charged.

CANADIAN ARCHIVES AND DEPOSITORIES.

The Survey's collection of copies of materials from Canadian archives and depositories has been selected mainly with reference to the study of the fur trade in the Old Northwest and the activities of the French missionaries in Illinois. These materials represent the research interests of both Professor C. W. Alvord and T. C. Pease and those of numerous graduate students over the years. The earliest copies seem to have been obtained in 1907. A few of these items were published in Volumes XVI and XXIII of the Illinois Historical Collections.

Guides and Other Aids

For information regarding the manuscript collections in the Public Archives of the Dominion of Canada, the Annual Reports beginning in 1881 are of primary importance. Though few of the volumes are indexed, calendars and other materials scattered through the series may be located through David W. Parker's A Guide to the Documents in the Manuscript Room at the Public Archives of Canada (Publications of the Archives of Canada No. 10, Ottawa, 1914). The records in the archives have undergone some reorganization, and the Preliminary Inventories of various manuscript and record groups have been published. The Preliminary Inventories are being replaced by the General Inventory, Manuscripts.

Other important guides are: (1) David Parker's Guide to Materials for United States History in Canadian Archives (Carnegie Institution of Washington, 1913) describes depositories of the provinces as well as the Dominion Archives at Ottawa; (2) the very useful Union List of Manuscripts in Canadian Repositories (Public Archives of Canada, 1968) similarly covers the provinces and Dominion Archives, but in addition it presents a fairly modern list of Canadian manuscript holdings; (3) a volume which represents a broad coverage of manuscript materials is L. H. Gipson's A Guide to Manuscripts Relating to the History of the British Empire, 1748-1776, Vol. XV of The British Empire Before the American Revolution (New York, 1970); (4) Andre Beaulieu, Jean Hamelin, and Benoit Bernier, Guide D'Histoire Du Canada (Les Presses de L'Universite Laval, 1969); (5) the article by Arthur Doughty "Sources for the History of the Catholic Church in the Public Archives of Canada," Catholic Historical Review XIX, 148-166, describes the wealth of religious materials in the Dominion Archives.

More selective are two reports compiled by Dr. Wayne E. Stevens of Dartmouth College in the summers of 1923 and 1924. The Survey joined with the Minnesota Historical Society in sponsoring this search for materials for American History in the Canadian libraries and archives, particularly relating to the fur trade in the upper Mississippi Valley in the late 18th century. Dr. Stevens' report for 1923 covered a survey of depositories in Montreal: Redpath Library, McGill University; Bibliotheque St. Sulpice; McCord National Museum; and the Archives, District of Montreal. In 1924, he visited Ottawa and made a report on the Public Archives of Canada. Both are a valuable supplement to Parker's Guide. In addition to the reports, Dr. Stevens prepared a card calendar of important materials of regional interest in Canadian depositories, and had copies made of numerous documents. His reports (in manuscript), calendars, and reproductions of documents are all to be found in the Survey.

Organization

The Survey's copies of materials from Canadian sources are arranged by depository in the following manner: Dominion Archives; Provincial Archives; public library; and others (including religious, university, and museum sources) in alphabetical order. The document arrangement is generally that of the depository from which the copies were obtained. Wherever possible the latest organizational classification is used; this is especially important for the Public Archives of Canada since some of the Survey's materials were obtained prior to the present numbering system.

CANADIAN ARCHIVES AND DEPOSITORIES.

Manuscripts

PUBLIC ARCHIVES OF CANADA. PAPERS, 1759-1793. 540 items, photocopies and transcripts.
61-1787.

The Public Archives of Canada located in Ottawa constitute the basic Dominion archival
depository. Besides Canadian public archives, copies of French and British public
documents as well as personal collections are housed within it. Manuscript materials are
found in two basic groups, Manuscript Groups and Record Groups. The Survey has copies of
manuscripts from Manuscript Groups 8, 11, and 23 and from Record Group 4. This last group
contains lists and copies of Indian trade licenses.

The abstracts of Indian trade licenses from the Public Archives of Canada were made under
the direction of Dr. Wayne E. Stevens of Dartmouth College in the summer of 1925; the
results were typed on form sheets in the Minnesota Historical Society. For illustrative
purposes, photocopies of a number of trade licenses were made and are filed with the
abstracts. There is also a "Report to accompany abstracts and returns of Indian trade
licenses" by Dr. Stevens which includes a description of the licenses and returns, and a
historical sketch of the control of the fur trade, 1760-91. This was a joint project in
which the Illinois Historical Survey participated with the Burton Historical Collection of
the Detroit Public Library, the State Historical Society of Iowa, the State Historical
Society of Wisconsin, and the State Library of Indiana, under the general direction of the
Minnesota Historical Society.

For a further description of the Public Archives of Canada and its holdings see the
General Inventory, Manuscripts, the Preliminary Inventories for Manuscript and Record
Groups, both Parker Guides, and Gipson's Guide..., 403-417. Wherever possible, in this
section, the old classifications of the manuscript materials will be given in parentheses
after the description. Other copies of manuscript materials can be found in the Survey's
collection of items from the British Public Record Office, especially under CO 5, CO 42
and 43, and WO 34.

Manuscript Group 8E, No. 4

"Registre du Conseil Militaire de Quebec, Contenant Les ordonnances Reglements, Sentences
 et arrets de La ditte Cour de Justice Et autres Actes des Notaires Commance Le 4 9bre
 1760 et finit Le 13 Juin 1761." (This document was formerly classified M640. The
 Survey's photocopy covers the dates Nov. 4, 1760 to Dec. 17, 1760.)

Manuscript Group 11

1) Amherst's dispatch, with enclosures, on the fall of Quebec, Oct. 4, 1760. (This item,
 formerly M216, was obtained from what is now P.R.O., CO 5, Vol. 59.)

2) Report to the Lords of the Committee for Plantation Affairs, on Several Papers
 Relative to Ordinances and Constitutions Made by the Governor of Quebec. Sept. 2, 1765.

3) "A List of Papers annexed to the Report...."

4) Board of Trade to the King, Sept. 2, 1765.

5) John Pownall to Charles Lowndes, Sept. 10, 1765. (These four items, formerly
 classified in Q56 were obtained from what is now P.R.O., CO 42, Vol. 87.)

6) Instructions from the King to Gov. Guy Carleton, Jan. 3, 1775. (This item was printed
 in Canadian Archives Report for 1904, pages 229-242.)

7) Extract from a letter from Capt. Doyle to Lt. Gov. Simcoe, July 28, 1793. (This item,
 formerly classified as Q280:363 was obtained from what is now P.R.O., CO 42 Vol. 318.)

CANADIAN ARCHIVES AND DEPOSITORIES.

Manuscript Group 23, G II, Series 1; Murray Papers

<u>Vol. 1</u> (2) 1759. Proclamation on coins and a letter from Murray to Amherst.

<u>Vol. 2</u> (12) 1763-1765. Letters from Murray to Amherst, Gage, Halifax, Gov. Burton, Lord Gordon and others.

<u>Vol. 3</u> (3) 1760-1764. Letter from Murray to Pitt, and letters to Murray from Amherst and George Ross.
(These items were formerly classified as M898A, B, and D respectively. See <u>Canadian Archives Report</u>, 1912).

Record Group 4, B28. Vols. 110-115

1) Abstracts of Indian Trade Licenses (487) 1767-1776. Accompanying these items is Wayne Stevens' "Report to Accompany Abstracts and Returns of Indian Trade Licenses."

2) Trade Licenses and Bonds (14) 1766-1781. These items are samples of forms of trade licenses and bonds.

3) Lists and accounts of Indian Trade Licenses (12) 1777-1779, 1781-1783, 1785-1790.

4) "Number of Indians at Detroit and places depending thereon, 1782" (1) 1782.

5) "Standing Orders to be observed in future at the several posts in the upper country." (1) April 4, 1787. These orders were issued by Brig. Gen. Henry Hope.

ARCHIVES DE MONTREAL. PALAIS DE JUSTICE. RECORDS. 1679-1704, 1793. 88 items, transcripts. Chronological card file. 61-1539.

This depository contains, among other materials, French and Canadian notarial records. These documents constitute a record of business agreements of the period, including business contracts, marriage agreements, and the hiring of voyageurs and clerks. The notarial records in Canada are arranged first by individual notary and then by year. The Survey has a few transcripts from the notarial records of B. Bosset and C. Mangue; but by far the greatest number are the records of Jacques Adhemar. These notarial acts relate mainly to LaSalle, de la Forest, and Tonty, and concern the organization of their fur trading and exploring expeditions to Illinois between the years 1679 and 1704. The transcript of the 1793 agreement was made by Dr. Wayne Stevens to typify later notarial records; it is an agreement signed by John McDonell to serve five years as a clerk with McTavish, Frobisher, and Co. The Survey has arranged these items in chronological order.

For a description of these records, the preface and introduction of T. C. Pease and R. C. Werner, <u>The French Foundations</u>, (<u>Illinois Historical Collections</u>, Vol. XXIII), should be consulted. Thirty-eight of the documents are printed in French and in English translation in that volume. See also Parker's <u>Guide...</u> (1913), 271-272, and Gipson's <u>Guide...</u>, 423-424; and especially useful is Wayne Stevens' "Report on Canadian Archives, 1923," pages 14-18.

Notarial Records

1) <u>Adhemar Notarial Records</u> (79) 1683-1704.

2) <u>Bosset Notarial Records</u> (5) 1684-1689.

3) <u>Lukin Notarial Records</u> (1) May 10, 1793.

4) <u>Mangue Notarial Records</u> (3) 1679-1687.

CANADIAN ARCHIVES AND DEPOSITORIES.

TORONTO PUBLIC LIBRARY. BUSINESS AGREEMENT, April 6, 1778. 1 item, transcript.

This library's manuscript collections contain extensive documents relative to the fur trade in Canada and the Northern Great Lakes. For a description see Guide to the Manuscript Collection in the Toronto Public Libraries (Toronto Public Libraries, 1954), especially pages 66-67.

William Dummer Power Papers, David McCrae and Company. "Agreement for Indian Trade
 between William and John Kay, Montreal, and David McCrae, John Kay, Peter Barthe, and
 Charles Gratiot, Partners under the Firm of David McCrae and Company of
 Michillimackinac, Montreal, April 6, 1778."

ARCHIVES DE L'ARCHEVECHE DE QUEBEC. PAPERS, 1768-1778. 19 items, transcripts.
Chronological card file, lists. 61-1499.

This repository is one of the two main ecclesiastical archives in Quebec; the other is the Archives of the Seminary of the University of Laval. The Survey's collection of copies of these manuscripts consists mainly of correspondence and papers relating to missions in Illinois. Some of these items were published in the Illinois Historical Collections, Vol. XVI. For a further description see Parker's Guide... (1913), 224-270. Since the Survey's holdings from this depository are not extensive, they are arranged in chronological order.

Included with this material are two letters from the Abbe Lionel Lindsay, Archivist of the Archbishopric of Quebec, to C. W. Alvord, December 2, 1907 and October 19, 1908, conveying information on materials relating to the mission to the Illinois. Included in these are lists and calendars of letters and documents entitled "Missions des Illinois," 1767-1838 (1907 letter); "Letters from Father Gibault," 1768-1788 (1908 letter); "Letters from Father Meurin, S. J., and others," 1767-1776 (1908 letter); "Other Documents relating to the Illinois," 1786-1792 (1908 letter); "Letters to Father Meurin, S. J. and other documents regarding the Illinois Mission," 1767-1777 (1908 letter); and "Letters addressed to Father Gibault or documents concerning him (exclusive of Meurin Correspondence)", 1768-1775 (1908 letter). Also there are two additional letters from Abbe Lindsay to C. W. Alvord, in 1913, concerning manuscript materials relating to Illinois.

n.d. Memorandum of the Sale of Property of the Missions Etrangeres.

July 28, 1768. Father Gibault to Bishop Briand.

March 22, 1770. Bishop Briand to Father Gibault.

March 22, 1770. Bishop Briand to Father Meurin.

June 11, 1770. Father Meurin to Bishop Briand.

June 15, 1770. Father Gibault to Bishop Briand.

August 16, 1770. Bishop Briand to Father Gibault.

August 19, 1770. Bishop Briand to Father Gibault.

April 24, 1771. Bishop Briand to Father Meurin.

June 20, 1772. Father Gibault to Bishop Briand.

April 30, 1774. Vincennes. Judgment allowing recovery of goods from Father Gibault.

March 29, 1775. Father Meurin to Father Gibault.

August 10, 1775. Bishop Briand to Father Gibault.

CANADIAN ARCHIVES AND DEPOSITORIES.

October 9, 1775. Father Gibault to Bishop Briand.

December 4, 1775. Father Gibault to Bishop Briand.

May 23, 1776. Father Meurin to Bishop Briand.

April 26, 1777. Bishop Briand to Father Gibault.

April 27, 1777. Bishop Briand to Father Meurin.

August 5, 1778. Dr. Laffont to George Rogers Clark.

ARCHIVES DU SEMINAIRE DE QUEBEC. LAVAL UNIVERSITY. PAPERS, 1680-1768. 24 items, transcripts. Chronological card file. 61-1499.

This second most important ecclesiastical repository in Quebec is housed in Laval University. The Survey's materials consist mainly of papers relative to missions and religious jurisdictional disputes. Included with the collection are two lists entitled "Kaokias, Papiers concernant le mission des Kaokias, de depot aux Archives du Seminaire du Quebec" and "Tamarois et Kaokias" sent by Abbe Gosselin, the Archivist of the Seminary, in 1906 and 1907 respectively. This collection is arranged chronologically for the purposes of the guide.

n.d. "Les Tamarois ou Kaokias." (This document describes the mission and the fertility of the soil in the area.)

n.d. "Memoire au sujet de la Mission des Tamarois."

n.d. "Memoire touchant la mission des Tamarois."

1680[?], 1691. "Titre de concession de terre aux Ilinois - 1680? et 1691. Extrait du registre du Conseil d'Etat."

May 1, 1698. "Lettres patentes de Mgr. de Quebec en faveur du Seminaire de Quebec pour les Tamarois..."

July 14, 1698. "Document relatif aux Lettres patentes du 1er Mai 1698 donnees por Mgr. de Quebec en faveur du Seminaire pour les Tamarois..."

September 25, 1698. Mgr. de Laval and Mgr. de St. Vallier to Madame de Maintenon.

September 25, 1698. Mgr. de Laval and Mgr. de St. Vallier to Pontchartrain.

September 25, 1698. Mgr. de Laval and Mgr. de St. Vallier to Maurepas.

September 25, 1698. Mgr. de Laval and Mgr. de St. Vallier to Mgr. de Paris.

1699-1724. "Memoire sur l'etablissement de la mission des Tamarois de 1699 a 1724."

February, 1700. Father Bergier to the Bishop of Quebec.(Extract).

March, 1700. M. de St. Cosme to Mgr. de Laval. (Extract).

June 14, 1700. Father Bergier to _____. (Extract).

July 17, 1700. "Memoire touchant la mission des Tamarois, la necessite de son union au Seminaire de Quebec, 1700."

April 13, 1701. Father Bergier to _____. (Extract).

CANADIAN ARCHIVES AND DEPOSITORIES.

June 7, 1701. "Accord menage par Mgr. l'archeveque de'Auch au sujet de la mission des Tamarois."

June 22, 1722. "Copie du titre de concession d'un terrain donne par M. de Boisbriant pour la mission des Tamarois."

April 12, 1735. "Explication du plan et etablissement de la Seigneurie de la mission des Tamarois."

May 21, 1735. Father Mercier to _____.

October 31, 1763. "Protestation des habitants de Kaokias contre le vente des biens de la mission."

May 3, 1767. Boiret and Pressart to Father Meurin.

June 10, 1771. Father Gibault to the Superior of the Seminary of Quebec.

1849. "Mission du Seminaire de Quebec chez les Tamarois ou Illinois, sur les bords du Mississippi." by E.A.T. Ptre. (Father, later Cardinal, Taschereau). This is a very interesting and important document. Cardinal Taschereau, who had previously been superior of Quebec Seminary and rector of Laval University, was archbishop of Quebec from 1870 until his death in 1898.

MC CORD NATIONAL MUSEUM. RECORDS, 1802-1806. 4 items, photocopies. Calendar. 61-1539.

The museum, located on the campus of McGill University, Montreal, contains some materials relating to the fur trade in the Great Lakes region. Housed with these items in the Survey is a list entitled "Copies and Notes of Manuscripts of the Mackay Papers in the David Ross McCord National Museum, Montreal." For a brief description of this collection, see the Union List of Manuscripts in Canadian Repositories and Wayne Stevens" Report on Canadian Archives, 1923."

May 6, 1802. Bill of Lading for Canoe No. 25.

1804. (2) Engagements of Augustine Roy and Baptiste Reáume.

1806. Bill of Lading for Canoe No. 17.

MC GILL UNIVERSITY LIBRARY. PAPERS, 1787-1808. 21 items, photocopies and transcripts. Calendar, lists. 61-1539.

The Survey contains several important items from this Montreal depository concerning the fur trade in the Great Lakes region. Of particular interest are the journals and diaries relating the travel and explorations in the area. These items are described briefly in the Union List of Manuscripts in Canadian Repositories and more extensively in Wayne Stevens' "Report on Canadian Archives, 1923."

Beaver Club Records (3) 1807.

1. Rules for the Beaver Club, 1807.

2. Members elected since establishment, 1787-1800.

3. List of founding members (1785) with years they first went into the Indian country.

CANADIAN ARCHIVES AND DEPOSITORIES.

Frobisher Letterbook (11) April 15, 1787 - August 25, 1788. Selections of letters mainly
concerning business matters.

Masson Collection (7) 1794-1808.

Diary of Edward Umfreville, 1784 (describes expedition seeking an alternate route to
the Grand Portage in Minnesota).

Diary of John McDonell, 1793 (a partial description of a journey from Montreal to the
Northwest by way of Grand Portage in Minnesota).

Diary of Archibald Norman McLeod, 1800-1801 (describes region north of the Minnesota-
Canada boundary and relates the life and activities of a Northwest trader).

Lists of the men at the various departments of the Northwest Company for 1805 (the
Survey's copies concern the departments in Minnesota).

Roderic Mackenzie's circular and letter to agents of the Northwest Company April 21,
1806 (this letter represents and explains the origin of the Masson Collection).

Dr. McLaughlin. "The Indians from Fort William to the Lake of the Woods," [1807?]
(describes Indians and the country north of Minnesota).

Description of Falls of the Steep Rocks near Fort William, June 22, 1808 (the
description was probably written by Donald McKenzie).

UNIVERSITY OF MONTREAL LIBRARY, BABY COLLECTION. PAPERS, 1765-1833. 84 items,
photocopies and transcripts. Calendar. 61-1539.

This very important collection on Canadian History was collected by Judge Baby and given
to the University of Montreal. It was housed for a period of time in the Bibliotheque St.
Sulpice from which place the Survey's copies were obtained on the basis of Dr. Wayne
Stevens' report of 1923. There is a very useful guide by Camille Bertrand entitled
Catalogue de la Collection Francois - Louis-Georges Baby (Published by the Service des
Collection Portionheres, Bibliotheques de l'Universite de Montreal, 1971).

DOCUMENTS DIVERS

G. Commerce et Finance

G 1. Grandes Compagnies-Fourrures

Boite 52. (27) 1766-1778. "Prix des Pelleteries du Canada."

Boite 52. (1) July 5, 1765. Address of the Traders at Michilimackinac to William
Howard, Esqr Captain in His Majesty's 17th Regiment Commanding at Michilimackinac.

Boite 52. (1) [1781?] James Stanley Goddard to _____. A report on Indian
accounts and presents extracted at Michilimackinac.

Boite 53. (1 set) 1801-1811. Minutes of the Northwest Company.

Boite 54. (1) Oct. 11, 1833. Agreement as to the disposal of property of
Michilimackinac Company, between John Forsythe, Samuel Gerrard, and Toussaint Pothier.

CANADIAN ARCHIVES AND DEPOSITORIES.

CORRESPONDANCE GENERALE

<u>1766-1768.</u> (13) Correspondence of Sir William Johnson, Maj. Robert Rogers, Gov. James
 Murray; petitions of traders; and instructions relative to the fur trade at
 Michilimackinac and Montreal.

<u>1792-1794.</u> (40) These are "in papers" of the Montreal firm of Grant Campion and Co. They
 comprise letters from correspondents, chiefly Etienne Campion and Co., Michilimackinac;
 John Reeve and Nicholas Marcheassaux, traders; receipts and invoices, drafts; wages
 due men; and other items. They show the method employed in the fur trade about 1794.

CANNON, JOSEPH GURNEY (1836-1926). PHOTO ALBUM, 1898-1908. 1 volume.

This album, formerly belonging to "Uncle Joe" Cannon, is a pictoral study depicting the
building, occupants, employees, surrounding grounds, and events of the Veterans'
Administration Hospital (formerly a branch of the National Home for Disabled Volunteer
Soldiers) in Danville, Illinois. Cannon was apparently responsible for bringing the Home,
which opened in 1898, to Danville. [The album was purchased in August, 1970, from Mrs.
Muriel Libby of Champaign, Illinois.]

CARLTON, DAVID DUDLEY (b. 1841). DIARY, MUSTER-OUT ROLL, PHOTOGRAPH, 1861-1864. 1 item,
machine reproduction. 1 item, photocopy. 1 item, photograph.

David Dudley Carlton was born near Mantua, Ohio. He joined the 42nd Ohio Volunteer
Infantry, as a teamster, in September, 1861. During the war, he sent sections of the
diary to his father, Epahro Carlton, to be re-copied in ink. The diary describes camp
life, illnesses, weather conditions, other units, skirmishes and battles (Cumberland Gap,
Tazewell, Champion Hill, and Vicksburg), and maneuvers. Also, there is a muster-out roll
for Company A of the 42nd Ohio Volunteer Infantry. [The collection was copied by the
Illinois Historical Survey Library in 1973, through the generosity of Dean Karl Gardner,
grandson of David Carlton.]

CARRIEL, MARY TURNER (1845-1928). PAPERS, 1864-1927. Approximately 125 items. Inventory.

Mary Turner Carriel was the daughter of Jonathan Baldwin Turner (q.v.) and wife of H. F.
Carriel, Superintendant of the Jacksonville State Hospital. She served on the University
of Illinois Board of Trustees, 1897-1903, being the first woman to do so.

The collection represents the literary and travel interests of Mrs. Carriel. She prepared
many essays, especially for a woman's club of Jacksonville. Often these were based on her
travel experiences and observations. There are plot synopses of many works Mrs. Carriel
read and preparatory notes for lectures on art history and literary figures. There are
also several items relating to Mrs. Carriel's organizational activities for the Woman's
Columbian Exposition Club in Morgan County during 1892. The collection contains travel
diaries for Mrs. Carriel's 1910 trip to Europe and 1912-1913 journey through South America.
The major portion of the brief correspondence deals with the preparation and marketing of
Mrs. Carriel's biography of her father. The collection contains some geneological
information gathered by Mrs. Carriel relating to the families of her father, mother, and
husband. Charles A. Carriel, son of Mary T., is represented by a diary for the year 1908.
He worked for the YMCA in South Dakota and in Chicago during that year.

CARROLL COUNTY, ILLINOIS. COUNTY COMMISSIONERS' COURT. ESTRAY BOOK, 1839-1843. 1 volume.

Kept by William B. Goss, the county clerk, this estray book contains accounts of stray animals found in the county and of their restoration to their owners through declarations of witnesses (if owners were located). Animals include hogs, horses, and cows.

CARTWRIGHT, PETER (1785-1872). LETTER, January 1, 1833. 1 item, photocopy. 69-1592.

The letter refers to a bill Peter Cartwright proposed to introduce in the legislature at Vandalia "to carry the State Seminary to Springfield," an allusion to the earliest effort toward state-supported higher education in Illinois and a part of a general interest in moving the state capital to Springfield.

CATHOLIC MISSIONARIES. MEMORANDUM, 1653-1764. 1 item, transcript.

This is an annotated list of missionaries who worked among the Indians on either side of the Mississippi River before the founding of St. Louis, 1764. [The transcript is from the Archdiocesan Archives of St. Louis and is written in Latin.]

CHADWICK, HARRY W. (b. 1857). LETTER, December 1, 1918. 1 item.

Addressed to Harry W. Chadwick of Urbana, Illinois, this letter was written from Milan, Italy, by "coz Fred", who worked for the American Red Cross in Milan. The letter describes conditions in Italy, and a visit to the King's aunt. [The letter was a gift (December, 1968) of Dr. John W. McLure, State University of Iowa, Iowa City, Iowa.]

CHAMPAIGN COUNTY CEMETERY SURVEY. RECORDS, 1858-1937. 16 items. 69-1607.

The two journals in this collection record data concerning war veterans. Included are the name, service, G.A.R. (Grand Army of the Republic) post, date of death, and place of burial of soldiers, as well as articles about the G.A.R. Other material consists of lists of soldiers' graves in various cemeteries, record sheets of the State of Illinois Military and Naval Department, a plat of the Mount Hope Cemetery (Urbana), a list of cemeteries in Champaign County, a plat book of Champaign County with cemeteries indicated, and two mounted newspaper articles concerning war veterans.

CHAMPAIGN COUNTY, ILLINOIS. SCHOOLS. EXERCISE BOOKS, 1877-1893. 10 items. 69-1592.

Included in these student exercise books are six volumes from the Urbana Schools, plus one each from Seymour, Stewart, Dunham and Gifford Schools. Reading, spelling, history, geography, penmanship, mathematics, and botany are illustrated as they were taught in the late nineteenth century.

CHARLESTOWN (VIRGINIA) DAY BOOKS. BUSINESS RECORDS, 1804-1805, 1808-1816. 2 volumes. Calendar.

These journals are general store day books giving itemized lists of sales to various individuals. The first one deals with dry goods, yard goods, clothing and liquor. The second book shows sales of yard goods, grain, milk products, liquor, and hardware. The book also contains several contracts and receipts for the rental of houses and rooms; the items were signed by various people and countersigned by Rebecca Ann Frame. [Both journals were acquired by the University of Illinois Library from Putnam's Book Store, Bloomington, Illinois, in September, 1941, and were later transferred to the Illinois Historical Survey.]

CHASE, GEORGE W. PAPERS, 1841-1853. 13 items. Calendar.

George W. Chase, Esq., came to Dixon, Illinois, from Portland, Maine, in 1837; by 1840 he was a clerk in the Lee County Circuit Court. These papers, mostly letters, concern legislative matters in Springfield and personal affairs (especially relating to properties owned by Chase). By 1846, however, there is evidence of a severe drinking problem which culminated in Chase's return to Maine. There, he was issued a document calling for his appearance in Probate Court (1851).

CHESAPEAKE AND DELAWARE CANAL COMPANY. RECORDS, 1828-1919. 1 reel, microfilm. Calendar.

The Chesapeake and Delaware Canal played a prominent role in the development of transportation in the United States. This collection of records includes the Chesapeake and Delaware Canal drawings; Board minutes from 1828 to 1919; and legislation relating to the Chesapeake and Delaware Canal Company. [The microfilm was purchased from the Delaware State Archives, Hall of Records, Dover, Delaware, in 1960 by the University of Illinois History Department, for the use of Ralph D. Gray in writing his doctoral dissertation entitled, "A History of the Chesapeake and Delaware Canal, 1760-1960." Upon completion of Dr. Gray's dissertation in July, 1962, the film was given to the Illinois Historical Survey.]

CHICAGO CITIZENS. LETTER, August 5, 1827. 1 item, photocopy.

This letter, signed in Chicago, August 5, 1827, by seven people on behalf of Chicago citizens, was addressed to "Capt. Morgan and the Officers and Soldiers under his command" (from Vermilion County) thanking them for assistance during the attack on Fort Dearborn. Signers were John Kinzie, James Kinzie, Russell E. Heacock, David Hale, G. S. Hubbard, Stephen J. Scott, and J. B. Beaubien. [The photocopy was acquired by the Survey along with the collection of Williams-Woodbury Papers.]

CHICAGO COMMISSION MERCHANT. ACCOUNT BOOK, 1866-1884. 1 volume.

This book records consignments of foodstuffs for various individuals, probably small business men, for the year 1866. It also records family expenses and summaries for the years 1873-1884. [The account book was purchased from D. C. Allen, Three Oaks, Michigan, for the Survey in June, 1969.]

CHILDRESS, GEORGE L. DIARY, 1862-1865. 1 item, transcript. 69-1586.

In this copy of the diary of George L. Childress, a member of the 66th Illinois Volunteer Regiment, are brief entries which concern the author's daily life in the army. He describes camp life, marching, battles, and skirmishes mostly in Mississippi. Also he includes a list of items, which he purchased while on duty, and their individual prices. [The original belonged to his son, E. M. Childress of Fairfield, Illinois, when it was copied and collated by the Illinois Historical Survey in 1913-1914, under the direction of S. J. Buck.]

CLARK, JACOB (b. 1814). LETTER, August 30, 1846. 1 item.

In this letter written from Bethel, Illinois, Jacob Clark offers condolences to his brother John Clark for deaths in the family.

CLARK, WILLIAM (1770–1838). JOURNAL, 1794. 1 item, transcript.

This work is "A Journal of Major-General Anthony Wayne's Campaign Against the Shawanee Indians in Ohio in 1794-1795." The journal entries commence in Greenville, July 28, 1794, and conclude October 26, 1794. William Clark, who took part in the campaign, details the structure of authority; the functions of the various soldiers in the campaign; the skirmishes; traveling; obtaining of supplies; and punishments administered. [The transcript was copied from originals in the possession of Rogers Clark Ballard Thruston of Louisville, Kentucky.]

CLAY COUNTY, ILLINOIS. ELECTION. POLL BOOK, April 14, 1827. 1 item, photocopy.

The results of an election for sheriff and coroner, held in Maysville, Clay County, Illinois, are included in these pages of a poll book. [The original pages were taken from the papers of Ben Hagle, Louisville, Clay County, and loaned to the Survey for duplication by his grandson, Ray Stine of Flora, Illinois.]

CLEMANS, WILLIAM (1847-1934). PAPER, 1860-1865. 1 item, carbon copy. 69-1586.

A member of the 20th Illinois Infantry, William Clemans participated in the battles of Vicksburg and Atlanta. In this narrative, Clemans describes various aspects of the war, primarily concerning army life. The account runs from before his enlistment to the mustering out of the regiment. [The manuscript was typed by Mrs. Lena Wack, the daughter of Clemans, and is a gift of Dr. Lewis Robinson, Westmont College, Santa Barbara, California.]

CLEMENS, JAMES, JR. INVOICE, May 4, 1831. 1 item.

This invoice from James Clemens (St. Louis) bills Hoxsey and Gray merchants (Carlinville, Illinois) for clothing materials, utensils for sewing, dry goods, and hardware which they had purchased.

CLINTON, DE WITT (1769-1828). LETTERS, 1823-1824. 2 items.

Governor De Witt Clinton at Albany wrote two letters to Dr. John W. Francis, professor in the College of Physicians and Surgeons, New York, which concern primarily the manuscript of Clinton's memoirs, and also comment on politics and the prevalence of yellow fever in New York. [These letters were attached to the Survey's copy of David Hosack's Memoirs of De Witt Clinton (New York, 1829). This copy is inscribed "Presented by the author to the New York Athenaeum, 1829."]

CLINTON, GOVERNOR GEORGE (c.1686-1761). LETTERS, 1750-1752. 5 items, photocopies.
Chronological card file.

These letters to Governor George Clinton of New York were written by Governor James Glen of South Carolina and concern Indian affairs in his colony. [The originals are in the Clinton Collection of the William L. Clements Library in Ann Arbor, Michigan.]

COALE, BENJAMIN. RECORD BOOK, 1845-1858. 1 volume.

Benjamin Coale came to Huntington County, Indiana, as a school teacher in 1845. He took up farming in 1846 although he continued to teach for two more years. The book includes farm and household accounts, diary notes, and teaching lessons on spelling, copying, and algebra.

COLE, ARTHUR CHARLES (b. 1886). NOTES, 1912-1920[?]. 32 boxes (7x10). 1 reel, microfilm. 62-2164.

Historian Arthur C. Cole was a faculty member at the University of Illinois between 1912 and 1920, and thereafter at the Ohio State University, Western Reserve University, and Brooklyn College. Among the works which he authored are The Irrepressible Conflict, The Whig Party in the South and The Era of the Civil War, 1848-1870 (Volume III of the Centennial History of Illinois.)

The notes comprising this collection were used in preparation of the latter work, and for a chapter in Volume V of the Centennial History of Illinois. They are almost entirely quotes from primary sources, mainly newspapers. The organization is basically by time span; and within each period the arrangement is by subject. The division is as follows: 1820-1849, 2 boxes; 1850-1859, 8 boxes; 1860-1869, 12 boxes; 1870-1879, 3 boxes; 1880-1889, 3 boxes; 1890-1900, 1 box; and 1917-1919, 5 boxes. In addition, the Survey has a microfilm copy of Box 1.

COLES, EDWARD (1786-1868). PAPERS, 1820-1858. 33 items, photocopies, transcripts. Chronological card file. 69-1599.

The photocopies in this collection are Madison County circuit court records involving a case, political in nature, brought against Edward Coles for his failure to give bond at the time of the manumission of slaves which he brought from Virginia. Records include summons, charges, plea, verdict, reasons for new trial, bond, plea for discontinuance, and bill of exceptions.

The letters, written by Edward Coles, the second governor of Illinois, are largely to Isaac Prickett and concern business interests in Edwardsville and vicinity, mortgages, debts, and interest owed to Coles. There is also a lengthy letter in which Coles wrote about Morris Birkbeck, in answer to inquiries from the Historical Society of Chicago. A newspaper article is included which contains a letter from Coles to Senator W. C. Flagg. [The original letters are in the Chicago Historical Society.]

COLFAX, SCHUYLER (1823-1885). LETTERS, 1861-1864. 3 items, photocopies. Calendar. 69-1586.

Schuyler Colfax was a Republican member of the House of Representatives from Indiana (1855-1869), Speaker of the House (1863-1869), and Vice-President during Grant's first term. The letters discuss the election of Lincoln, the necessity for compromise, and the payment of senators. [These photocopies were made from the Colfax letters in the Library of Congress.]

COLLEGE PROFESSORS IN POLITICAL ECONOMY AND POLITICAL SCIENCE. RECORD BOOK, 1887-1888. 1 volume.

An unknown author in Philadelphia or vicinity compiled an incomplete list of college professors by state in this volume. Included also is a separate list of names with local addresses.

COLLINS, ELIZABETH WITT. LETTER, July 25, 1850. 1 item.

E. W. Collins was the widow of William Burrage Collins, for whose family the town of Collinsville, Illinois, was named. In this letter to Newton Bateman, she asks for the payment of a loan. [This letter was a gift of Wilbur Duncan, Decatur, Illinois.]

CONFEDERATE STATES. PAPERS, 1861-1865. 25 items.

This collection is composed of multifarious materials. First, there are letters exchanged primarily between Confederate State Depositories in Arkansas, Georgia, and Louisiana, and E. C. Elmore, Treasurer of the Confederate States, regarding deposits and other business. Also included are certificates for the 1861 election of a commissioner of public works for four Virginia counties.

More directly concerning the war are letters to Governor William Smith of Virginia (1864) regarding exemptions from military service, a blank monthly company return form (found on the field of Bull Run), guard reports from Confederate States Military Prisons, and requisitions, bids, receipts, and War Department warrants. Finally included in this collection is a railroad ticket from Richmond to Knoxville on the East Tennessee and Virginia Railroad.

CORDINER, JESSIE C. (TURNER). FAMILY HISTORY. 1 reel, microfilm.

"History of the John Turner Family of Roxbury and Medfield, Massachusetts and some of their inlaws through John1 - John2 - Ebenezer3 - Joseph4 - Edward5, and some of the descendants of Edward and Hannah (Fisher) Turner of Templeton, Worchester County, Massachusetts, compiled by Jessie C. Turner Cordiner [and others]..." It contains a preface which explains the problems encountered tracing the genealogy of Jonathan Baldwin Turner's family, together with genealogy charts, and a description of the persons included. [This film was made by the University of Illinois from the original manuscript sent by Mrs Ernest A. Schmidt of Blair, Nebraska. The originals were returned to Mrs. Kenneth Brown.]

CORRIE FAMILY. PAPERS, 1793-1964. 1 reel, microfilm. Inventory.

In 1828 five Corrie brothers from Scotland and England settled in Wabash County, Illinois. One of these was Robert Corrie (1779-1863) who with his wife Sarah (1785-1864) maintained an active correspondence with other members of the family, particularly those who remained in England. The correspondence was continued by their children: Jane (1827-1908), who married a Presbyterian minister, Samuel C. Baldridge; and John Robert (1816-1897), who maintained the family farm in Wabash County. Lester Linn Corrie of Urbana is the grandson of John Robert Corrie.

This collection highlights an emigrating family's continuing cross-Atlantic ties. There are also references to contemporary events, Presidents, and the Civil War. The Corries had extensive land holdings which are frequently an item in the correspondence. [The original collection was loaned to the Illinois Historical Survey by the Lester L. Corrie family of Urbana, Illinois, in 1971 and microfilmed in 1972.]

CRANE, VERNER (b. 1889). PAPERS, 1916-1919. 4 items. 69-1587.

Verner Crane, historian, is the author of the manuscript in this collection entitled "The Southern Frontier in Queen Anne's War." It was sent to C. W. Alvord on December 3, 1918, and was later published in the American Historical Review, April, 1919. The other three items are letters which discuss a forthcoming monograph and the sources to be used.

CRAYCROFT, W. T. LETTERS, 1897-1898. 3 items. Calendar.

W. T. Craycroft, an agent of the Massachusetts Mutual Life Insurance Company, wrote these letters to Henry Abbot concerning Abbot's insurance policy. W. T. Craycroft and Albion Pease were managers of the Insurance Company's office in Kansas City, Missouri.

CRIPPIN, EDWARD W. (d. 1863). DIARY, 1861-1863. 1 volume.

Corporal Edward W. Crippin served in the Civil War in the 27th Illinois Volunteer Regiment. The last entry is for September 19, 1863, and describes the Battle of Chickamauga. He died December 24, 1863 of wounds received at the Battle of Missionary Ridge, November 25, 1863. [This volume was transferred from the Rare Book Room of the University of Illinois to the Illinois Historical Survey Library in 1973.]

CROGHAN, GEORGE (d. 1782). LETTER, 1768. 1 item, transcript. 69-1587.

In this letter, written at Philadelphia (December 21, 1768) to Jeremiah Warder and David Franks, George Croghan denies the existence of a further debt owed by himself and Mr. [William] Trent. [The original is in the Missouri Historical Society, St. Louis, Missouri.]

CROLL, P. C. (b. 1852). LETTER, October 30, 1915. 1 item.

The Rev. P. C. Croll, pastor of the First Evangelical Lutheran Church, Beardstown, Illinois, was a historian of the synod and collected church periodicals. In this letter to C. W. Alvord, Croll discusses these and other sources of Lutheran history.

CULMANN, KARL (1821-1881). TRAVEL ACCOUNT, 1850. 1 item, machine reproduction.

Karl Culmann, a German engineer, traveled through the United States and England from 1848 through 1850. During this tour, Culmann kept a journal of his observations. This collection contains excerpts which discuss his visits to Cairo, St. Louis, the Illinois-Michigan Canal, Joliet and Chicago. He comments on American bridges, canals, water-works, industrial machinery, steamboats, etc. [These selections are from Max Steiner's translation of the original Culmann journal, which is housed in the Library of the Swiss Federal Institute of Technology, Zurich, Switzerland. Mr. Steiner, a resident of Beverly Hills, California, allowed the Survey to copy his translations in February, 1973.]

CUNNINGHAM, JOSEPH O. (1830-1917). INTERVIEW, 1914. 1 item, transcript. 69-1592.

Judge Cunningham, who came to Urbana, Illinois in 1853, was one of the publishers of the Urbana Union, 1853-1858, and was a delegate to the Republican state convention in Bloomington, Illinois,in 1856. He was a lawyer, county judge, and writer on various legal and local subjects. Also, he was a member of the Board of Trustees of the University of Illinois, 1867-1873.

An interview which Miss Frances Morehouse held with Judge Joseph O. Cunningham of Urbana in May, 1914, is preserved in this stenographic transcript. Judge Cunningham makes brief comments on Senator S. M. Cullom, abolitionism in Champaign County, Judge David Davis, J. M. Palmer, John T. Stuart, and the founding of the University of Illinois.

CURREY, JOSIAH SEYMOUR (1844-1928). LETTER, NEWSPAPER CLIPPINGS, 1908. 2 items.

J. S. Currey, president of the Evanston Public Library, gave an address entitled "Chicago's North Shore" to the Illinois State Historical Society. This address was printed in an Evanston, Illinois,newspaper. The clippings and the letter in this collection were sent to Evarts Boutell Greene by the author.

CURRIE, MRS. H. S. SKETCHES, n.d. 1 item, original. 11 items, photocopies.

These pencil drawings with notes by Mrs. Currie are of old buildings in Kaskaskia, Illinois, as they appeared in the last half of the 19th century. Included are sketches of the residences of Shadrach Bond, William Morrison, and Nathaniel Pope. [The photocopies were made in March, 1957, from originals in the Illinois State Historical Library, Springfield.]

CURTIS, HENRY B. (b. 1799). LETTERS, 1839-1848. 8 items. 69-1603.

These letters to Henry B. Curtis, a lawyer in Knox County, Ohio, are from a brother in Scott County, Illinois, and from other correspondents. The letters concern primarily legal problems involving claims to land and money. [The letters were a gift of Wilbur Duncan, Decatur, Illinois.]

CURTIS, JAMES BURRILL (1821-1898). LETTERS, 1842-1843. 19 items. 69-1589.

James Burrill Curtis and his more famous brother, George William Curtis (1824-1892), were students at the school that formed part of the Brook Farm Community, West Roxbury, Massachusetts. These letters to Burrill Curtis' father were written from Brook Farm. In writing to his father about the different programs of the community, Burrill defined the role of a boarder, an agricultural student, and an associate. He also discussed the philosophy of the community, his personal relations and philosophy, and his financial needs. [The original manuscripts were purchased by the University of Illinois for the use of Professor Arthur Bestor who then deposited them in the Survey.]

DARNALL, M. D. LETTER, August 17, 1847. 1 item.

This letter from M. D. Darnall (Maysville, Clay County, Illinois) to Lindsay and Blakiston of Philadelphia, Pennsylvania, concerns the remittance of money owed for a subscription to the Examiner.

DARROW, CLARENCE S. (1857-1938). INTERVIEW, CORRESPONDENCE, PAPERS, 1877-1937. 1 item, original. 1 reel, microfilm. 69-1599.

The interview with Clarence S. Darrow, a Chicago lawyer, was conducted by Agnes Wright Dennis of the Illinois State Historical Library Editorial Staff in 1918. Having been a law partner of John P. Altgeld, he comments on the Haymarket anarchist trial and pardon and Altgeld's role as a Democratic governor. The microfilm reel contains correspondence between Darrow and George Murphy, Frank Murphy and Moses L. Walker. Letters by Ruby A. Darrow and letters concerning a speaking engagement at the University of Michigan in 1911 are included. The microfilm also contains a newspaper article concerning Darrow and the Wishart-Darrow debate, held in Grand Rapids, Michigan, in 1928. [The microfilm was made in 1971 from originals in the Michigan Historical Collections of the University of Michigan. It was given to the Survey by James Campbell.]

DAUGHTERS OF THE AMERICAN REVOLUTION, ILLINOIS CHAPTER. HISTORIC SITES OF ILLINOIS. REPORTS, PAPERS, 1926-1936. 10 folders.

Reports and other papers relative to the D.A.R.'s effort to publish a guide to historic sites in Illinois are contained in this collection. The material is organized by county and by town. Also, it includes papers indicating the location of Revolutionary War soldiers' graves in Illinois. [After the project was abandoned, the materials were presented to the University of Illinois Library by the State Board of the D.A.R. They were transferred to the Illinois Historical Survey Library in 1959.]

DAVENPORT, EUGENE (1856-1941). CORRESPONDENCE, 1913-1914. 35 items. Calendar, inventory.

Eugene Davenport was Dean of the College of Agriculture at the University of Illinois from 1895 to 1922. One of his projects during these years was to collect descriptions of the characteristic features of pioneer life in Illinois. This collection contains the correspondence which resulted from Davenport's attempt to gather accounts of early Illinois superstitions and remedies. His correspondents include many prominent Illinois citizens. [These letters were donated to the Survey by Professor Elmer Roberts, University of Illinois, Urbana, Illinois, in 1972.]

DAVIS, DAVID (1815-1886). CORRESPONDENCE, 1862-1884. 44 items, transcripts. Chronological card file. 61-1728.

These transcripts of David Davis papers are from various collections. Correspondents include Judge Thomas Drummond, Ward Lamon, General William Orme, Leonard Swett, and John Wentworth. The letters discuss political issues, court appointments, and various court cases. Ten telegrams concerning the Liberal - Republican nomination of 1872 are also included.

DAVIS, GEORGE T. M. (1810-1888). LETTERS, 1833-1843. 9 items.

The letters concern the business of the Davis & Krum law firm at Lower Alton, Illinois. The collection contains a letter from W. G. Timberlake who desired to relocate himself in Alton with the aid of G. T. M. Davis, a letter on the collection of funds from Daniel Baldwin, a statement of bankruptcy by Samuel Legate, and letters on the sale of land.

DEARBORN, HENRY (1751-1829) AND DEARBORN, HENRY A. S. (1783-1851). PAPERS, 1802-1827.
19 items, machine reproductions. Calendar.

The collection contains letters and papers that concern the careers of both Dearborns.
There are several receipts signed by both men in their capacities as collectors of the
port of Boston, as well as some signed by the elder Dearborn while Secretary of War.
Several letters from Henry Dearborn concern his tenure as senior major-general of the
American armies in the northeast theatre during the War of 1812. Correspondents include
Charles Bagot, Leonard Covington, James Fenner, and William Tatham. The letters to and
from Henry A. S. Dearborn concern the possible invasion of Portland, Maine, in September,
1814; an inquiry about a loan; and Boston's internal political situation in 1827. His
correspondents are Colonel J. B. Davis, James C. Jewett, and Lyman Perk. [The machine
reproductions of the letters and papers were acquired in the spring of 1971 through the
generosity of Leonard P. Karczewski, who has the originals.]

DELANO, COLUMBUS (1809-1896). CORRESPONDENCE, 1869-1873. 5 volumes.

As a Whig and as a Republican, Columbus Delano represented the State of Ohio in Congress.
At the beginning of Grant's administration he was appointed Commissioner of Internal
Revenue, and in 1870, he became Secretary of the Interior. These letter-press copy books
cover the periods from his start in the first office to his third year as head of the
Department of the Interior. A large number of the letters deal with appointments and
patronage; and a few concern Indian affairs. [These volumes were transferred to the
Illinois Historical Survey Library in January, 1974.]

[DELIETTE, SIEUR PIERRE]. PAPER, October 20, 1721. 1 item, photocopy.

The so-called DeGannes Memoir ("Memoir concernant le pays Illinois") is a narrative
ascribed to the Sieur Pierre Deliette, who arrived in the Illinois county in 1687. [The
photocopy is made of the only known copy, which is in the possession of the Newberry
Library of Chicago.]

DEMING, MINOR RUDD (1810-1845), AND DEMING, ABIGAIL. PAPERS, 1826-1849. 35 items.
Calendar. 61-3375.

Minor Deming came to Hancock County, Illinois, in 1838 (after teaching in Ohio) and was a
brigadier general of the Illinois militia when the Mormon troubles culminated in the arrest
of Joseph and Hyrum Smith. Deming was placed in charge of the companies at Carthage after
Governor Ford, who proceeded to Nauvoo with an escort, disbanded the militia. In Deming's
absence from Carthage on June 26, 1844, the Smiths were murdered. Most of these letters
were written by Minor R. Deming and his wife, Abigail, to his family and friends in
Litchfield, Connecticut. The last letters are from his wife, who eventually moved to
Galesburg to educate her sons at the newly established Knox College. In addition to the
family letters, there are several other papers and orders: letters of James W. Woods to
Governor Ford; Brigadier General Deming to the Smiths on June 26; Col. Thomas Buckmaster
to the governor, from Nauvoo, June 26; orders issued by Deming; and a letter from Governor
Ford to Deming, July 1. [The letters were presented to the Survey by Macey F. Deming, a
grandson of Minor and Abigail Deming, of Tappan, New York, in 1930.]

DEMOCRATIC PARTY. 18th CONGRESSIONAL DISTRICT, ILLINOIS. RECORD BOOK, 1876-1878. 1 item.

The records of the Democratic Central Committee of the 18th Congressional District were
written at Cairo and other southern Illinois towns and concern the activities of Southern
Illinois Democrats. Included are lists of committee and party members, voting statistics,
fund raising notes, nominations, reports on the state of the party, and reports of
meetings.

DENISON, GEORGE STANTON (1833-1866). PAPERS, 1860-1865. 37 items, photocopies. Calendar. 69-1586.

The contents of the letters in this collection, exchanged between George Denison, Collector of Internal Revenue in New Orleans, and family and friends are largely political. Denison describes the mood of the South from the time of secession until the end of the war. In letters from Salmon P. Chase, Secretary of the Treasury under Lincoln, economic problems are discussed. Dudley Chase Denison, later a member of Congress (1875-1879), is also a correspondent. Two other items in this collection are an article entitled the "Southern Rebellion" from the Burlington Free Press, and a copy of a letter (August 9, 1864) from Lincoln to General Banks concerning support for the new constitution adopted in Louisiana. [The photocopies are from the George S. Denison Papers in the Library of Congress.]

DENLINGER, HENRY K. REMINESCENCE, ca. 1905. 1 item, transcript.

"The Second Church as I Knew It" is a history of the Second Presbyterian Church of Bloomington, Illinois, written by the Rev. Henry Denlinger. Beginning in the spring of 1899 when the Rev. Mr. Denlinger became the pastor, the history is basically an account of preacher-congregation relations within this particular church through 1905.

DIOCESE OF SPRINGFIELD. PAPERS, 1916-1920. 4 items. Calendar.

Granville H. Sherwood, Bishop of Springfield, wrote to the Standing Committee of the Diocese of Springfield requesting their consent to the sale and purchase of Church property in Centralia. The request was granted March 27, 1919. A second letter from J. W. Ware, President of the Standing Committee of the Diocese of West Virginia to the Standing Committee of the Diocese of Springfield [Illinois] asks consent to the election of a Bishop Coadjutar on the ground of the "Extent of Diocesan Work." Also included are an article by Joseph Dutton entitled "Molokai" for publication in the Catholic Encyclopedia and a song sheet of "God of Our Fathers" by Rudyard Kipling. [The collection was transferred from the University of Illinois Archives to the Illinois Historical Survey in February, 1971.]

DOHRMAN, ARNOLD HENRY (1749-1813). PAPERS, 1777-1833. 267 items. Calendar.

The Dohrman brothers were merchants of Dutch background who operated separate mercantile houses--Jacob Dohrman in Lisbon and Arnold Henry Dohrman in New York. Their correspondence gives news of arrivals of vessels, cargoes, prices of commodities, and general information concerning trade conditions in Europe, especially in Portugal and Spain during the period 1777-1808. Some of the earlier letters deal with the assistance given by A. H. Dohrman to American sailors imprisoned in Portugal during the American Revolution. Also represented are the claims of Arnold Dohrman against the American government for recompense, with papers substantiating these claims. One of the letters is a letter of introduction from Arthur Lee. Later letters give contemporary accounts of the Napoleonic wars. [The Dohrman papers were found with the Heinrich Rattermann Collection in the University of Illinois Library and were transferred to the Illinois Historical Survey in June, 1966.]

DOUGLAS, STEPHEN ARNOLD (1813-1861). PAPERS, 1832-1861. 515 items, photocopies, transcripts. Inventory. 61-2053, 69-1590.

The items in this collection are mainly letters, most of which were written by Douglas. The majority of the letters are political in nature and pertain to his activities as a United States Senator. Such subjects as the slavery question, the grant of lands for the Illinois Central Railroad, the Banking Law, the state of the Democratic Party, the question of Douglas' running for the Presidency, and the Nebraska Bill are discussed. Among the correspondents are Presidents and candidates for the presidency; included are also: Sidney Breese, Ninian Wirt Edwards, Jesse W. Fell, Augustus C. French, John J. Hardin, Charles H. Lanphier, John A. McClernand, Jonathan Baldwin Turner, and Levi Woodbury.

Other materials in the collection include copies of newspaper articles referred to in the correspondence and an autobiographical sketch by Douglas, dated September 1, 1835. [Judge Robert M. Douglas of Greensboro, North Carolina, supplied the transcript in 1908. Copies of a few of the letters were acquired from Mrs. James W. Patton, Springfield, Illinois, daughter of Mr. Lanphier. Professor Robert W. Johannsen gathered most of the papers for his publication of The Letters of Stephen A. Douglas. Forty-four items in the collection were not included in the publication.]

DRAPER MANUSCRIPTS. PAPERS, 1735-1858. 9 items, transcripts. 71 items, photocopies. 64 reels, microfilm. Chronological card file, inventory.

This collection includes the following papers on microfilm: George Michael Bedinger Papers; Daniel Brodhead Papers; George Rogers Clark Papers; George Rogers Clark Miscellanies; Jonathan Clark Papers; William Clark Papers; William and George Croghan Papers; Forsyth Papers (Major Thomas); Frontier Wars; Georgia, Alabama and South Carolina Papers; Josiah Harmar Papers; William Henry Harrison Papers; Thomas S. Hinde Papers; Illinois Papers; Kentucky Papers; North Carolina Papers; Robert Patterson Papers; Pittsburgh and Northwest Virginia Papers; Pension Statements; John and James Potter Papers; William Preston Papers; David Shepherd Papers; John Cleves Symmes Papers; Tennessee Papers; Virginia Papers.

The collection also contains seventy-one photocopies and nine transcripts of documents in the Draper Manuscripts. These are: Draper's Life of Boone, 1 item; Border Forays, 2 items; George Rogers Clark Papers, 2 items; William Clark Papers, 7 items; Thomas Forsyth Papers including his map of the Northwest and early correspondence with Ninian Edwards, Illinois governor, 21 items; Frontier Wars Papers, 1 item; William Henry Harrison, 2 items; Illinois Papers, 34 items; William Preston Papers, 2 items; David Shepherd Papers, 3 items; Virginia Papers, 2 items. There are also three unidentified transcripts: a diary dated 1812 and two pieces in French dated 1776 and 1782. [The Survey purchased this microfilm from the State Historical Society of Wisconsin in June of 1949.]

DREER COLLECTION. LETTERS, 1765-1771. 2 items, transcripts. Chronological card file.

Indian and military affairs in the Illinois Country are the subjects of these letters, one written by General Thomas Gage, the other by Colonel John Wilkins. Specific references are made to the occupation of Fort Chartres by the British, the nature of different Indian tribes after the Pontiac Uprising, and the problem of getting food through to the English troops. [These transcripts are from the Dreer Collection in the Historical Society of Pennsylvania.]

DUNCAN, JOSEPH (1794-1844). RECORD BOOK, 1834-1841. 1 volume. 69-1599.

This volume contains a combination of various personal records of Joseph Duncan, Governor of Illinois from 1834-1838. Included are a series of ten sketch maps of certain townships in which Duncan notes his land holdings; 165 numbered pages (with an index) in which are pasted newspaper clippings regarding Duncan's administration, with notes and some extended diary entries; pages from the Journals of the House and Senate for 1840-1841; and excerpts from other state documents in which Duncan's speeches and proposals, 1834-1838, were printed.

DUNCAN FAMILY. CORRESPONDENCE, 1849-1882. 24 items, transcripts. Chronological card file. 69-1586.

Mrs. Elizabeth Caldwell Duncan (1808-1876), the wife of Joseph Duncan, Governor of Illinois from 1834-1838, and other members of the Duncan family, are authors of the letters in this collection. Topics include personal news, the status of slaves, the abolition problem, the Civil War, and the funerals of President and Mrs. Lincoln. [The letters were presented to the Survey in 1928 by Miss Elizabeth Duncan Putnam (d. 1928), granddaughter of the governor who wrote a number of articles on family history and edited some of the family papers.]

DUNLAP, MATTHIAS LANE (1814-1875). JOURNAL, 1842-1846. 1 item. 69-1603.

Matthias Lane Dunlap moved from New York to LaSalle County, Illinois, in 1835. Later, he became involved in various business and farming activities in Cook County and developed one of the most extensive horticultural nurseries in the West. He served in the General Assembly and was a deputy county surveyor. In 1857, he moved to Champaign County, Illinois, where he continued his nursery business. He was an advocate of a state university and an agricultural correspondent for two Chicago newspapers. The journal, in this collection, is a book of land surveys which he kept in his capacity of deputy county surveyor in Cook County.

DURFEE, GEORGE S. (b. 1840). CORRESPONDENCE, PAPERS, 1861-1901. 182 items. Inventory.

Upon the outbreak of the Civil War, George S. Durfee of Decatur, Illinois, joined the 8th Illinois Volunteer Regiment. He served with that unit to 1866, and eventually rose to the rank of captain. The correspondence in this collection contains relations and descriptions of camp life, various political and military figures and policies, and campaigns and battles,(especially Fort Donelson and Vicksburg.) The last few army letters concern the occupation of Texas. Other later items concern family matters and his appointment by Governor Richard Yates in 1901 as a member of the commission to determine and mark the positions of Illinois troops in the siege of Vicksburg. [The collection was purchased for the Illinois Historical Survey by the University of Illinois Library in November, 1973.]

DWIGHT, JOHN SULLIVAN (1813-1893). CORRESPONDENCE, 1840-1850. 1 reel, microfilm. 69-4.

The Rev. John Sullivan Dwight, later famous as a music critic, was a prominent member of the Brook Farm Community, West Roxbury, Massachusetts, 1841-1847, and one of the editors of its journal, the Harbinger. He wrote extensively on Fourierism. These letters in this collection were written to him by various persons during the period of the Brook Farm experiment. Many of them deal with that community. [The original manuscripts are in a bound volume in the Boston Public Library; items 18-79 of the volume are on the microfilm, which was made for Professor Arthur Bestor in 1942 and presented by him to the Survey in 1956.]

EAMES FAMILY. LETTERS, 1837-1868. 10 items. Chronological card file.

These letters were written primarily from Illinois by Stephen Eames, a niece Emmeline Eames, and a nephew Darius Plumb, to family members in Vermont and New Hampshire. Working first in Amesbury, Massachusetts, Eames in 1839 bought land in Knox County, Illinois, and his letters from that time on, come from Walnut Grove, Illinois. Stephen Eames comments on breaking prairie, prices of crops, growth of the settlement, migrations of neighbors, health conditions, the Mormon settlements, and schools. One letter from Darius Plumb was written on the eve of his departure for the California gold fields. [The letters were presented to the Survey in 1920 by Miss Lelia Bascom of Madison, Wisconsin.]

EARLIDGE, JAMES. LETTER, DOCUMENT, 1843. 2 items.

The letter in this collection is from J. M. Earlidge (Jackson) to James Earlidge. In it the writer (who states he is still known as Jackson in the area) describes the country around Albion, Illinois, mentions George Flower and General Pickering, and asks for a power of attorney to handle a transaction involving a tract of land on the Mississippi. The document is an agreement (unsigned and undated) whereby Thomas Jennings conveys a two thousand acre tract of land in West Florida to James Earlidge. [These items were transferred to the Illinois Historical Survey Library from the Rare Book Room in 1973.]

EAST, ERNEST E. (1885-1960). CORRESPONDENCE, 1934-1935. 17 items. 69-1587.

East corresponded with Theodore C. Pease, Abel Doysie, and Aegidius Fauteux in an effort to obtain information concerning Sieur Pierre Deliette. Information contesting C. W. Alvord's statement that Deliette was the nephew of Henri de Tonti is given; he is referred to as being a cousin of de Tonti. Information about French settlement in Peoria is also found in this collection.

EATON, C. L. (b. 1820). BUSINESS RECORDS, 1876-1885. 1 volume. 13 items.

C. L. Eaton was born and raised in Ross County, Ohio, but he later represented Franklin County and the city of Columbus in the Ohio legislature, 1853-1854. Coming to Champaign County, Illinois, in 1861, he managed a twenty-five thousand acre estate near Broadlands until 1871. He then moved to Vermilion County where he apparently managed several other farm properties. Various lists of incomes and expenditures in east central Illinois are recorded in this journal. Miscellaneous notes and bills and a brochure advertising Youman's Dictionary of Every-Day Wants are also included.

EDDY, HENRY (1798-1848). PAPERS, 1822-1848. 882 items, transcripts. Calendar, name index. 61-1727.

Henry Eddy, newspaper publisher and lawyer, was born in Pittsfield, Vermont, attended school in Buffalo, New York and served two months in the New York Militia. Moving to Pittsburgh he learned printing, studied law, and, in 1818, went down the Ohio to Shawneetown, where he established the second newspaper in the state of Illinois. He became well known as a lawyer and was active in Illinois politics. He was elected a representative to the Illinois General Assembly in 1820 and 1846. Eddy's correspondents included most of the significant public figures in Illinois during this time span. Included are Benjamin Bond, Shadrach Bond, Sidney Breese, Daniel Cook, Ninian Edwards, Alexander P. Field, and Elias K. Kane. In addition to a calendar, the Survey has an index of all names appearing in the Eddy manuscripts. There are a considerable number of papers for the General Assembly session of 1846. [Transcripts were made from the original papers in the possession of Charles Carroll of Shawneetown, Illinois.]

EDGAR, JOHN. SEARCH WARRANT, August 23, 1779. 1 item, transcript. 69-1587.

This transcript is of a search warrant issued by Captain R. B. Lernoult, British commander at Detroit. The warrant was issued to search the house of John Edgar and to seize papers and arms.

EDWARDS, NINIAN (1775-1833). PAPERS, 1799-1880. 2 volumes. 1 item, contemporary copy. 98 items, transcripts. 62-1215.

This collection contains papers and correspondence of Ninian Edwards who was Governor of the Illinois Territory (1809-1818), U. S. Senator (1818-1824), and Governor of Illinois (1826-1830). The two volumes in this collection are copy books that contain eighty-eight letters from friends and colleagues. The main correspondents are Albert Gallatin, John McLean, and William Wirt. The contemporary copy is an indenture between Edwards and Jonathan Taylor of Kentucky for a lease of Salt Springs; it is dated June 19, 1817. [The two volumes of copies of letters to Ninian Edwards were deposited in the Survey by Professor Avery Craven, April 24, 1928. They were the property of Ben E. McCoy, Champaign, Illinois.]

The Survey's ninety-eight transcripts include drafts of letters from numerous correspondents in state and national public life. In addition, these volumes hold copies of documents and addresses. [The letters, papers, and manuscripts of Governor Edwards were presented to the Chicago Historical Society in 1883 by his son, Ninian Wirt Edwards (1809-1889). The transcripts were made from volumes 49-51 of the collection.]

ELLET, CHARLES, JR. (1810-1862). PAPERS, 1827-1929. 25 reels, microfilm.

This collection contains correspondence of Charles Ellet, Jr. and his family, newspaper clippings, papers, and reports. Charles Ellet's varied interests and activities as a civil engineer and innovator in naval tactics, and the interests of his family, are covered in this collection. [The original Charles Ellet, Jr. papers are in the University of Michigan's Transportation Library. The microfilm copies of these papers were presented to the Survey by Dr. Robert Sutton.]

ELSTON, DANIEL (d. 1855). PAPERS, 1833-1852. 36 items. Chronological card file. 69-1588.

Daniel Elston, an English merchant, came to Chicago in 1833. That year with his partner, he began the manufacture of soap and candles. He later erected a small distillery and brewery. Elston served as school inspector and alderman, but when his lands were removed from the city bounds by the legislature (1844) he was relieved of civic and honorary offices. The collection includes twenty letters written by Elston at Chicago to Harry Surnam, his friend and solicitor in London. The correspondence deals mainly with Elston's business affairs in England, but there are also comments on developments in Chicago, business conditions, and Elston's particular interests.

EMERSON FAMILY. PAPERS, 1830-1853. 31 items, machine reproductions. 69-1592.

These papers of the Emerson, Brinkerhoff, and Jacobus families relate to school work at the La Grange Collegiate Institute, Ontario, Indiana. Included are letters of the students, religious exercises, songs, and lists of goods purchased by the students. Also included is the first annual catalogue of the Wolcottville Young Ladies Seminary (1852-1853) of Wolcottville, Indiana. The papers illustrate the type of "moral-academic" work expected of the students and expressions of the student's attitudes toward education. Much of the material describes the kinds of activities in what was then a rural, semi-frontier region. The three families were related by marriage and the Jacobus family was related to Lincoln's minister to France, Joel Dayton. [These papers were a gift of Dr. Jack Nortrup, Tri-State College, Angola, Indiana.]

ETTING COLLECTION. PAPERS, 1765-1774. 24 items, transcripts. Chronological card file.

These transcripts from the Etting Collection of the Historical Society of Pennsylvania pertain to the affairs of Barnard (1738-1801) and Michael (1740-1811) Gratz, Philadelphia merchants trading in the West. Generally, the papers include letters of B. and M. Gratz, accounts of William Murray, and a journal of George Croghan in 1765. The letters and accounts are concerned with business affairs relating to trade, the shipment and delivery of goods in the Illinois Country, the problems of underhanded methods of competitors (destruction of goods, etc.), and the role of the Indians in economic affairs. Two of the letters were to a plantation owner from his overseer and mentioned his capture and his experiences with the Kickapoo Indians. George Croghan's journal of a trip through Indian territory reveals the animosity of the English toward the French and the delicate relationship between each European interest and the different Indian nations.

EUREKA CLUB. EUREKA, ILLINOIS. RECORD BOOK, 1858-1862. 1 volume.

The Eureka Club recorded its constitution, by-laws, and minutes in this journal. The club, formed "for the purpose of mutual enlightenment on all matters of controversy," concerned itself with current events by debating relevant questions. From 1861 to 1862 the organization was called the Eureka Lyceum.

EVERETT, EDWARD (1794-1865). LETTER, December 11, 1852. 1 item.

From Edward Everett to T. H. Pease in Albany, this letter conveys the signature of Everett as requested by Pease. The envelope was addressed by Everett also.

FLETCHER, DAVID. BUSINESS RECORDS, 1799-1849. 1 volume.

This account book is composed of various business records of David Fletcher of Groton, Massachusetts. Included are accounts for the sale of agricultural products; pasturing of animals; renting of mules, oxen, horses and carriages; odd jobs; and debts.

FOLLET, CALVIN AND FOLLET, JANE ROUNDS. CORRESPONDENCE, 1852-1882. 9 items.

Jane and Calvin Follet were New Englanders, who in the mid-nineteenth century settled on the Illinois prairie in the town of New Michigan, Livingston County. This collection consists of the Follets' letters to Jane's family in the East, particularly to her brother, Charles Rounds. These letters relate the experiences of the Follets in Illinois. They discuss their way of life, their neighbors, and their personal health and state of mind. [The letters were given to the Illinois Historical Survey by Elizabeth Rounds Lawton of Wilton, Connecticut in 1972.]

FORBES, HENRY CLINTON (1833-1903). PAPERS, 1865-1955. 5 items. 69-1586.

An officer of the 7th Illinois Cavalry, 1861-1865, Henry C. Forbes wrote many of the Civil War letters included in the Survey's Stephen Alfred Forbes Collection. After the war he was a farmer, teacher, writer and eventually served as business agent and librarian of the Illinois State Laboratory of Natural History, later called the Illinois Natural History Survey. These papers include a copy of his commission from Andrew Johnson as brevet colonel in 1865; a biographical sketch of him by his son, Robert H. Forbes; a picture of him in military attire; an excerpt of one of his letters; and a short paper by Forbes entitled "Grierson's Raid, An Epic of the Civil War."

FORBES, STEPHEN ALFRED (1844-1930). PAPERS, 1830-1955. 1223 items, originals, transcripts. 1 reel, microfilm. Inventory. 62-1221, 69-1592.

An entomologist of international reputation, Stephen A. Forbes served throughout the Civil War with the 7th Illinois Cavalry and attained the rank of captain. In 1877, he established the Illinois State Laboratory of Natural History, which became the Illinois Natural History Survey in 1917; he directed it until his death in 1930. The agency moved to the campus of the University of Illinois in 1884 where Mr. Forbes served successively as Professor of Zoology and Entomology, as well as Dean of the College of Science, 1885-1905. He received the rank of emeritus professor in 1921.

This collection includes diaries, letterbooks, and papers relating to Forbes' service in the Union Army during the Civil War and to his participation in Grierson's Raid. The balance of the letters pertain to family matters, including memorials and obituaries, in addition to certain papers pertaining to Forbes' academic and scientific career. [One of the donors of this collection is Mrs. Ethel Forbes Scott, who in 1936 compiled family letters and journals, transcribed them into a volume, and sent copies of this volume to various descendants. The microfilm copy of Mrs. Scott's transcript was presented to the Survey in 1953 with miscellaneous material; the Survey received the typed transcript from Mrs. Scott in 1968. In 1958, one hundred S. A. Forbes letters were presented to the Survey by Mrs. Bertha Forbes Herring, as were five additional transcripts from Mrs. Scott. In 1966, Professor Richard M. Forbes gave 1100 pieces of correspondence and other papers to the Survey.]

FORD, B. LETTER, October 12, 1836. 1 item, contemporary copy.

This copy of a letter from B. Ford of Ford and Jones, Clyde [New York], operator of a sawmill on the Erie Canal, to Elam Lynds and Son, makers of the boiler and engine ordered for the mill, is an enthusiastic endorsement of steam power.

FORT CHARTRES SURVEY. PAPERS, 1847. 6 items, transcript, photographs. 69-1607.

Thomas Singleton, in April,1847, investigated the ruins of Fort Chartres and made a sketch of it, including a description of building materials and structures. Also in the collection are photographs of the powder magazine ruins together with the inside view of the fort. These were made from photographs in the Mason Collection of the Champaign Public Library. [The transcript of the Singleton report was made in 1915 by Albert R. Gardner, County Superintendent of Highways, Waterloo, Illinois.]

FORT DAVIS AND MARFA RAILROAD. PAPERS, 1883-1885. 9 items, machine reproductions. Calendar.

The Fort Davis and Marfa Railway Company was organized in the 1880's in order to build a 24.9 mile line from Fort Davis to Marfa and Presidio, Texas. Estimates of capital stock were set at the sum of $150,000.00 The collection contains a plan of construction and estimated costs; a statement of incorporation; and letters from William H. Owen,the engineer who did the preliminary survey, to General B. H. Grierson. There also exist four books of preliminary survey which have not been duplicated for this collection. [The original papers, as well as the books of preliminary survey, are in the possession of Leonard P. Karczewski of Chicago, Illinois. Copies were made for the Survey in 1971.]

FRANCE. ECCLESIASTICAL JURISDICTION. RECORDS, 1695. 1 item, transcript.

This transcript is of a royal enactment, issuing from Versailles in April, 1695. It concerns ecclesiastical jurisdiction, especially the codifying of previous regulations with the object of unifying application and enforcement.

FRANKLIN, BENJAMIN (1706-1790). CORRESPONDENCE, 1763-1784. 80 items, transcripts. 15 items, photocopies. Chronological card file. 69-1593.

These letters to and from Benjamin Franklin concern various aspects of the relationship between the colonies and Great Britain. In addition,there is information about colonial life, Indian affairs, trade and trading companies. Correspondents include members of the firm of Baynton, Wharton and Morgan; Henry Bouquet; George Croghan; William Franklin; Joseph Galloway; David Hartley; Sir William Johnson; and Thomas Pownall. [Transcripts were made from the Franklin Papers in the American Philosophical Society, Philadelphia, and in the Historical Society of Pennsylvania. The photocopies were made from the Franklin Papers in the Library of Congress and from those in the William L. Clements Library, Ann Arbor, Michigan.]

FRENCH, ALVIN S. (1840-1864). PAPERS, 1856-1864. 85 items, originals, transcripts, clipping. Chronological card file. 61-1726.

Alvin S. French, son of Alonzo W. French of Pittsfield, Illinois, made his home in Springfield with his uncle, Dr. A. W. French (1821-1909), dentist and early Springfield resident. He enlisted in the 114th Illinois Infantry in 1862. He was killed in action in the late spring of 1864.

Most of the items in the collection are letters. The early letters (pre-Civil War) are primarily from friends and relatives who had settled in or travelled to various western territories, i.e. Minnesota, Kansas, and Utah. The letters of the Civil War period contain information about various companies organized and attached to Illinois regiments. The original items in the collection include an article originally in the Richmond Dispatch calling for people to rally behind the Southern cause; there are also three items concerning commencement and exhibitions at the Illinois State University in Springfield. [The originals from which these transcripts were made belonged to Miss Effie French of Springfield.]

194

FRENCH ARCHIVES AND DEPOSITORIES.

The Illinois Historical Survey has been acquiring copies of manuscripts from French Archives and depositories relating to American History since 1907. The work was mainly the result of the efforts of the first two directors of the Survey, Clarence W. Alvord and Theodore C. Pease, but interest continues to the present. The earliest copies are handwritten, but the greater part of the collection, secured in the years 1933-1948, is in the form of photocopies or microfilm. This material when added to the microfilm of the Cahokia and Kaskaskia records and the appropriate items from the British and Spanish Collections forms a most significant body of papers on the colonial period in the Illinois Country. Many of the French documents were reproduced in various volumes of the Illinois Historical Collections. A history of the Survey's activities in obtaining its copies of manuscripts is discussed in two books by Henry Putney Beers, The French in North America (Baton Rouge, 1957) and The French and the British in the Old Northwest (Detroit, 1964).

Guides and Other Finding Aids

For both a general description and a detailed listing of materials relating to American history which are available in the official French archival repositories and in the libraries of Paris, these publications of the Carnegie Institution of Washington are important: Waldo G. Leland (editor), Guide to Materials for American History in the Libraries and Archives of Paris, Vol. I, Libraries, (Washington, 1932) and Vol. II, Archives of the Ministry of Foreign Affairs (Washington, 1943). An excellent chronological list of manuscripts is to be found in N. M. Miller Surrey (editor), Calendar of Manuscripts in Paris Archives and Libraries Relating to the History of the Mississippi Valley, to 1803, Vol. I, 1581-1739 (Washington, 1926), Vol. II, 1740-1803 (Washington, 1928). Useful also is L. H. Gipson's A Guide to Manuscripts Relating to the History of the British Empire, 1748-1776, Vol. XV of The British Empire Before the American Revolution (New York, 1970). In addition see "Copies of French manuscripts for American History in the Library of Congress", Journal of American History, II, 674-691.

Because of the extent of its holdings, guides to the transcripts in the Canadian Archives are also invaluable. The Canadian Archives began a program of copying appropriate French archives in 1883. Its Annual Reports and other publications contain calendars and descriptive material relating to the document series from the various depositories. Also, they include many documents printed in full. Particular reference should be made to David W. Parker's A Guide to the Documents in the Manuscript Room at the Public Archives of Canada, Vol. I, Publication of the Archives of Canada No. 10 (Ottawa, 1914). This author's descriptions of the various series of French archives include references to calendars and descriptions previously printed in the Annual Reports. In addition, the Preliminary Inventories of Manuscript and Record Groups published by the Public Archives of Canada are of value; however, they are at present being replaced by the General Inventory, Manuscripts.

The copies of manuscripts from French archives and depositories are in the form of microfilm, photocopies, and typed or handwritten transcripts. To aid the scholar, chronological and archival card files exist. As in the case of the British collection, there are also extensive calendar notes on various groups of French papers. These were made by Professors C. W. Alvord and T. C. Pease.

FRENCH ARCHIVES AND DEPOSITORIES.

Organization

The Survey's copies of French manuscripts are arranged alphabetically by depository with the national archives preceding other libraries (as in the case of the Survey's British material). The numbering system utilized below is basically that used by the respective depository. The underlined numbers appearing in the left hand column, unless otherwise indicated, refer to a volume number. The next number, in parenthesis, indicates the items of that volume held by the Survey; these items may take the form of photocopies, office machine reproductions, typed or handwritten copies, or microfilm. Other indications as to the form of the material are self-explanatory. The dates generally refer to either the inclusive dates of the Survey's holdings or to the dates used by the respective depository. Following this information is a brief description of the material which is not meant to be exhaustive. To determine the exact items in the Survey's collection of materials from French Archives, it is necessary to consult the archival card file.

Manuscripts

ARCHIVES NATIONALES. PAPERS, 1671-1808. 3319 items including items in one bound volume and on four reels of microfilm. Transcripts, photocopies, microfilm. Archival card file. 61-2205, 61-1839.

The main and most significant French archival depository is the Archives Nationales located in Paris. The Illinois Historical Survey has reproductions from these four important collections: the Archives des Colonies, the Archives de la Guerre, the Archives de la Marine, and the Archives Nationales - Section Ancienne.

ARCHIVES DES COLONIES

This group contains the records and correspondence relative to the administration of the French colonies. It is but one of several important French archival sources relevant to the colonies. The history of the Colonial Archives and their relationship to the Marine Archives is described in the General Inventory, Manuscripts, I, 1-4. See also Gipson's Guide..., 362-367, and Parker's Guide... (1914), 212-254.

Series A: Actes du Pouvoir Souverain

22. (2) 1718, 1734. Letters patent accepting the retrocession of Louisiana from Crozat, and an ordinance granting land to veterans.

23. (8) 1715-1744. Decrees of the Council of State.

Series B: Lettres Envoyees

11. (3) 1684-1685. King's letters and instructions to LaBarre and Denonville.

12. (2) May 31, 1686. King's instructions to Tonty and his memorial to Denonville.

13. (1) March 30, 1687. King's memorial to Denonville and Champigny.

15. (3) 1688-1689. King's memorial to Denonville, Champigny, and Frontenac.

16. (3) 1691-1693. King's memorials to Frontenac and Champigny.

17. (1) May 8, 1694. King's memorial to Champigny and Frontenac.

19. (2) 1696-1697. King and Pontchartrain to Champigny and Frontenac.

20. (5) 1698-1699. Orders and dispatches from the King and Pontchartrain to Callieres, Champigny, DuGuay, Frontenac, and the Bishop of Quebec.

22. (6) May-June, 1701. Orders and dispatches from the King and Pontchartrain to Callieres, Champigny, Tonty, and the former Bishop of Quebec.

23. (3) 1701, 1703. Orders and dispatches from the King and Minister to Callieres and Iberville.

25. (1) February 13, 1704. Pontchartrain to LaSalle.

27. (7) 1705-1706. Orders and dispatches from the King and Minister to Cadillac, LaForest, Raudot, and Vaudreuil.

29. (18) 1707-1708. Memorials, letters, and instructions from the King and Minister to Artaguiette, DeMuy, Raudot, Vaudreuil, and others.

30. (13) 1708-1709. Dispatches from Pontchartrain to Begon, Mesnager, Raudot, and others.

31. (1) September 18, 1709. Minister to Begon.

32. (15) 1710. Letters and dispatches from the King and Minister to Cadillac, Raudot, Remonville, Vaudreuil, and others.

33. (10) July 7, 1711. Memorials and letters from the King and Minister to Vaudreuil, Begon, LaForest, and others.

34. (25) June-December, 1712. Memorials and dispatches to Begon, Vaudreuil, Tonty, LaForest, and others.

35. (19) February-July, 1713. Memorials, letters, and instructions to Begon, Cadillac, Tonty, Vaudreuil, and others.

36. (34) 1714. Orders and dispatches to Beauharnois, Begon, Dubuisson, LaForest, Lusancay, Tonty, Vaudreuil, and others.

37. (13) February-July, 1715. An Order of the King and dispatches to Beauharnois, Begon, Louvigny, Ramezay, and others.

38. (19) 1716. Orders, letters, and dispatches from the King, Minister, and the Marine Council to Beauharnois, Begon, Cadillac, Duclos, and others.

39. (15) May-October, 1717. Orders, memorials, and dispatches from the King and Council to Begon, Bienville, Boisbrisant, Vaudreuil, and others.

40. (15) 1718. Orders and dispatches from the King, Minister, and Council to Begon, Cadillac, Ramezay, Vaudreuil, and others.

41. (7) 1719. Orders and dispatches from King and Council to Begon, Saujon, Vaudreuil, and others.

42. (13) 1720. Orders and dispatches from King and Council to Begon, Launay, Law, and Vaudreuil.

42 bis. (47) 1712-1721. Ordinances, decrees, instructions, and letters patent relating to Louisiana and Illinois under the Company of the Indies.

43. (53) 1721-1730. Commissions, regulations, memorials, instructions, and other papers concerning Louisiana under the Company of the Indies.

44. (9) June-November, 1721. Orders and dispatches from King, Minister, and Council to the Company of the Indies, Begon, Bienville, and Vaudreuil.

<u>45</u>. (13) May-June, 1722. Orders and dispatches from King, Minister, and Council to Begon, Vaudreuil, and others.

<u>46</u>. (1) May 13, 1724. Minister to Artaguiette.

<u>47</u>. (10) May-August, 1724. Orders and dispatches from King and Minister to Vaudreuil and the Intendant Robert.

<u>48</u>. (11) March-August, 1725. Orders and dispatches from King and Minister to Vaudreuil and Chazel.

<u>49</u>. (5) January, May, 1726. Orders and dispatches from King and Minister to Governor Beauharnois, Intendant Dupuy, and Longueuil.

<u>50</u>. (8) April-July, 1727. Orders and dispatches from King and Minister to Beauharnois, Dupuy, and Perier.

<u>51</u>. (3) 1728. Dispatches from the Minister to the Directors of the Company of the Indies and to Le Peletier.

<u>52</u>. (16) February, May, 1728. Orders and dispatches from King and Minister to Beauharnois, Dupuy, Perier, and others.

<u>53</u>. (11) March-May, 1729. Orders and dispatches from King and Minister to Beauharnois, Hocquart, and Lignery.

<u>54</u>. (13) March-May, 1730. Orders and dispatches from King and Minister to Beauharnois, Hocquart, and Father duParc.

<u>55</u>. (31) 1731. Orders, dispatches, and memorials from King and Minister to Beauharnois, Hocquart, Perier, Salmon, and others.

<u>56</u>. (8) 1732. Minister's dispatches concerning Louisiana trade.

<u>57</u>. (39) March-November, 1732. Orders, dispatches, and memorials from King and Ministers to Bienville, Beauharnois, Hocquart, Salmon, and others.

<u>58</u>. (5) 1733. Memorial and dispatches from King and Minister to various persons.

<u>59</u>. (29) January-September, 1733. King's memorial and Minister's dispatches to Beauharnois, Bienville, Hocquart, Salmon, and others.

<u>60</u>. (5) 1734. Minister's dispatches to Beauharnois, Champigny, and Orgeville.

<u>61</u>. (31) 1734, 1735. Orders and dispatches from King and Minister to Beauharnois, Bienville, Hocquart, Salmon, and others.

<u>62</u>. (8) 1734, 1735. Minister's dispatches to Beauharnois and others.

<u>63</u>. (16) April, August-December, 1735. Minister's dispatches to Beauharnois, Bienville, Hocquart, and Salmon.

<u>64</u>. (23) March-November, 1736. Orders and dispatches from King and Minister to Bienville, Beauharnois, Hocquart, Salmon, and others.

<u>65</u>. (17) February-September, 1737. Minister's dispatches to Beauharnois, Bienville, Hocquart, Salmon, and others.

<u>66</u>. (16) March-December, 1738. Orders and dispatches from King and Minister to Bienville, Beauharnois, Hocquart, and Salmon.

67. (2) July, September, 1738. Minister's dispatches to Fulvy and to the Comte de Claire.

70. (18) February-October, 1740. Orders and dispatches from King and Minister to Beauharnois, Bienville, Hocquart, and Salmon.

71. (6) 1740. Minister to Grassin, Bigot, Combe, Saur, and others.

72. (11) April-October, 1741. Orders and dispatches from King and Minister to Beauharnois, Bienville, Hocquart, and others.

73. (2) September 18, November 13, 1741. Minister to Fagon.

74. (16) 1742. King's memorial and Minister's dispatches to Bienville, Beauharnois, Hocquart, Salmon, and Vaudreuil.

76. (10) April-June, 1743. Minister's dispatches to Beauharnois, Hocquart, and Vaudreuil.

77. (1) December 17, 1743. Minister to Belamy.

78. (17) January-March, 1744. Ministers dispatches to Beauharnois, Salmon, Vaudreuil, and others.

81. (7) April, June, 1745. Orders and dispatches from King and Minister to Beauharnois and Hocquart.

83. (17) April-October, 1746. Orders and dispatches from King and Minister to La Jonquiere, Lenormant, and Vaudreuil.

85. (17) March-December, 1747. Orders and dispatches from King and Minister to La Jonquiere, Lenormant, and Vaudreuil.

86. (1) August 13, 1747. Minister to Abbe de la Combe.

87. (23) 1748. Orders and dispatches from King and Minister to Hocquart, La Galissoniere, Michel, and Vaudreuil.

88. (2) April 1, 17, 1748. Minister to Machault d'Arnouville.

89. (10) January-June, 1749. Orders and dispatches from King and Minister to Bigot, La Galissoniere, La Jonquiere, Michel, and Vaudreuil.

91. (16) February-October, 1750. Orders and dispatches from King and Minister to La Jonquiere, Michel, and Vaudreuil.

93. (1) August 27, 1751. Minister to La Jonquiere.

95. (7) May-October, 1752. Minister's dispatches to Bigot, Duquesne, Kerlerec, and Michel.

97. (2) April, June, 1753. Minister's dispatches to Duquesne.

99. (3) May-August, 1754. Minister's dispatches to Duquesne.

100. (2) April, September, 1754. Minister's dispatches to Colom and to Rouille.

101. (4) 1755. Minister's dispatches to Duquesne, Dieskau, Drucourt, and Kerlerec.

103. (2) January, March, 1756. Minister's dispatches to Kerlerec and Vaudreuil.

107. (4) 1758. Minister's dispatches to Bigot, Descloseaux, and Vaudreuil.

111. (2) October, December, 1761. Minister's dispatches to D'Ossun and Neyon de Villiers.

113. (3) March, October, 1761. Minister's dispatches to D'Ossun and Neyon de Villiers.

114. (4) January-February, 1761. Minister's dispatches to Kerlerec and D'Abbadie.

115. (2) June, 1762. Minister's dispatches to Belestre and to the Comptroller General.

116. (1) February, 1763. King's memorial for D'Abbadie.

117. (1) October 15, 1763. Minister to Chattillan.

120. (5) April-October, 1764. Minister's dispatches to Fuentes, Kerlerec, and Praslin.

123. (1) May 17, 1766. Minister to Foucault.

125. (2) March, June, 1766. Minister's dispatches to D'Ossun and Dupont.

129. (2) June, August, 1768. Minister's dispatches to Aubry and Foucault.

143. (3) April-August, 1772. Minister's dispatches to Le Prestre and a safe conduct to Neyon de Villiers.

144. (2) April, December, 1773. Minister's dispatches to D'Aiguillon and to the Marquise de Durfort.

198. (1) April 3, 1788. Minister to Marbois and Vincent.

218. (1) 15 Fructidor, Year IV (1796). Instructions to the Minister Plenipotentiary in the United States.

219. (1) 12 Fructidor, Year V (August 29, 1797). Instructions to the Minister of Foreign Relations.

247. (2) March, October, 1807. Letters to Deluyines and Renaud.

250. (1) September 27, 1808. Letters to the Imperial Procurator General.

Series C: Correspondance A L'Arriveé

C 2: India

15. (3) 1720, 1721. Memorial and extracts of letters for the Company of the Indies; letter to Boisbriant.

16. (1) 1725. Memorial on the organization of the Company of the Indies.

23. (1) May 30, 1730. Father Beaubois to Loison.

25. (1) 1732. Memorial on the Jesuit mission of Louisiana.

C8A: Martinique

26. (1) June 21, 1719. Feuquieres and Benard to the Council.

C 11 A: Correspondance Generale, Canada

<u>3</u>. (4) October-November, 1671. Letter and memoranda by Talon.

<u>4</u>. (4) 1673. Letter from missionaries and Frontenac, memorial on Canada by Talon.

<u>5</u>. (4) October-November, 1679. Letters from Duchesnau and Frontenac to King and Minister.

<u>6</u>. (2) May, November, 1684. Memorial on La Durantaye's expenses and Boisguillot to La Barre.

<u>7</u>. (1) November 13, 1684. Denonville to Seignelay.

<u>8</u>. (4) 1686. Denonville correspondence.

<u>9</u>. (2) 1686, 1687. Tonty to Seignelay.

<u>10</u>. (1) October 15, 1689. Denonville to the King.

<u>13</u>. (3) 1695. Frontenac and Champigny to Pontchartrain, and a memorial on the Beaver trade in Canada.

<u>18</u>. (1) [1700]. La Forest and Tonty to Pontchartrain.

<u>19</u>. (1) [1701]. Juchereau to Pontchartrain.

<u>20</u>. (4) 1702. Letters from Beauharnois, Boishébert, and Callieres; and a general account of the Company of Canada.

<u>21</u>. (2) November, 1703. Beauharnois and Vaudreuil to the Minister, and a memorial on the Company of New France.

<u>25</u>. (1) 1706. Memorial of Pascaud.

<u>30</u>. (1) September 22, 1710. Duplessis' Report on the Company of Canada.

<u>31</u>. (10) 1710, 1712. Letters, orders, and conference with Indians by Vaudreuil; and letters from Aigremont, Argenteuil, and De Lino to the Minister.

<u>32</u>. (10) 1711. Letters from Vaudreuil, Raudot, Ramezay, Marigny, and La Forest to the Minister.

<u>33</u>. (10) 1712. Vaudreuil correspondence; a conference with the Indians; letters from Begon; and a memorial on Canada.

<u>34</u>. (22) 1713, 1714. Letters and memorials from Vaudreuil, Begon, Ramezay; and Indian conferences.

<u>35</u>. (14) 1715. Letters from Begon, Louvigny, and Ramezay to the Minister.

<u>36</u>. (21) 1701-1702, 1715-1716. Letters from Begon, Juchereau, and Vaudreuil to the Minister and Council; and minutes of an Indian conference.

<u>37</u>. (5) 1717. Council minutes and petitions.

<u>38</u>. (13) 1717. Letters from Begon, Louvigny, and Vaudreuil to the Council; trade permits; accounts.

<u>39</u>. (6) 1718. Letters from Begon and Vaudreuil to the Council, and Sabrevois' memorial on Indian tribes.

40. (13) 1715, 1719. Begon and Vaudreuil to the Council, memorials on trade, and a court martial.

41. (9) 1719, 1720. Council minutes.

42. (8) August, October, 1720. Letters and memorials from Begon, Louvigny, and Vaudreuil.

43. (11) 1721. Council minutes; letters from Begon and Vaudreuil to the Council.

44. (11) 1719, 1721-1722. Letters from Begon, Ramezay and Vaudreuil to the Council; and an Indian conference.

45. (13) 1723. Letters from Begon, Ramezay, and Vaudreuil to the Minister; trade permits.

46. (8) 1724-1725. Correspondence from Begon and Vaudreuil with the King and Minister.

47. (6) 1725. Letters from Begon, Longueuil, and Vaudreuil to the Minister; a petition from the people of Montreal; and two memorials on the West.

48. (21) 1722, 1725-1727. Letters from Beauharnois, Begon, and Longueuil to the Minister; Dupuy correspondence; and a memorial from the King.

49. (16) 1715, 1727. Letters from Beauharnois and Dupuy to the Minister, Indian conferences, and departmental memoranda.

50. (33) 1727-1730. Letters from Aigremont, Lignery and Beauharnois to the Minister; and from the Minister to Beauharnois and Dupuy; and Indian conferences.

51. (32) 1729. Letters from Beauharnois, Hocquart, Tilly, and Father Guignas.

52. (17) 1729-1730. Letters from Beauharnois and Hocquart to the Minister, and Noyan's memorial on Canada.

53. (12) 1729-1730. Letters from Deschaillons, Hocquart, La Corne, and Lignery; accounts for supplies and provisions.

54. (21) 1731, 1733. Letters from Beauharnois and Hocquart to the Minister, and an Indian conference.

55. (4) 1725, 1731. Letters from Beauharnois and Hocquart to the Minister, and a statement of expenditures.

56. (19) 1724-1725, 1731. Letters from Du Tisne, Lignery, Vaudreuil, and missionaries; reports on Indians; and memorials on Indians and trade.

57. (22) 1728-1733. Letters from Beauharnois and Hocquart to the Minister, accounts for supplies and expenditures, and memoranda on Indians.

58. (5) 1728, 1732. Reports on Indians, Detroit, and Michilimackinac.

59. (13) 1733. Letters from Beauharnois and Hocquart to the Minister.

60. (5) 1733. Letters from Beauharnois, Hocquart, and the Coadjutor of the Bishop of Quebec to the Minister; and memoranda on Indians and trade.

61. (6) June, October, 1734. Letters from Beauharnois and Hocquart to the Minister.

62. (1) September 25, 1734. Statement of expenditures for Boishebert, Noyelle, Douville, Dubreuil, and Joncaire.

63. (4) 1734-1735. Letter from Beauharnois and Hocquart to the Minister, reports and extracts of correspondence on Indians, and a proposal on copper mines.

65. (11) 1736, 1739. Letters from Beauharnois, Hocquart, and Michel to the Minister; and an Indian conference.

66. (1) October 8, 1736. Hocquart to the Minister.

67. (13) 1737. Letters and memorials from Beauharnois and Hocquart to King and Minister.

68. (7) 1733, 1735, 1737. Letters from Hocquart to the Comptroller General and to the Minister; and various statements of presents and accounts.

69. (18) 1736, 1738, 1739. Letters from Beauharnois and Hocquart to the Minister, various statements of supplies and accounts, and an Indian conference.

70. (3) 1738. Letters from Beauharnois and Hocquart to the Minister and to the Company of the Indies; and a report on Indians.

71. (11) 1739, 1740. Letters from Beauharnois and Hocquart to the Minister; and accounts.

72. (15) 1733, 1737-1739. Statements, accounts, and vouchers concerning expenses, presents and trade.

73. (89) 1739-1740. Letters from Hocquart to the Minister; and various vouchers, statements, receipts, and memoranda for supplies.

74. (32) 1739-1740, 1742. Letters from Beauharnois to the Minister; Indian conferences; and various vouchers, receipts, and memoranda on supplies and expenses.

75. (16) 1740-1742. Letters from Beauharnois and Hocquart to the Minister; and Indian conferences.

76. (39) 1740-1743, 1748. Orders and dispatches from King and Minister to Beauharnois and Hocquart; and various vouchers, receipts and memoranda on supplies and expenses.

77. (10) 1742. Letters from Beauharnois and Hocquart to the Minister, and an Indian conference.

78. (21) 1737, 1739, 1741-1742. Letters from Beauharnois, Hocquart, and the Bishop of Quebec to the Minister; and various vouchers and memoranda for supplies and expenses.

79. (20) 1742-1743. Letters from Beauharnois and Hocquart to the Minister, and Indian conferences.

80. (18) 1741-1743. Statements, receipts, and memoranda on expenses, supplies, and trade; lists of troops.

81. (26) 1735, 1740-1744. Letters from Beauharnois and Hocquart to the Minister, and vouchers and memoranda on expenses and supplies.

82. (2) 1744. Letter from Hocquart to the Minister and a memorandum on supplies.

83. (14) 1744-1745. Letters from Beauharnois and Hocquart to the Minister, an Indian conference, and memoranda on expenses and supplies.

84. (3) 1745-1746. Memoranda on expenses and supplies.

85. (7) 1745-1746. Letters from Beauharnois and Hocquart to the Minister.

86. (6) 1745-1746. Statements and memoranda for expenses and supplies.

87. (10) 1746-1747. Letters from Hocquart and La Galissoniere to the Minister; and memorials and a journal on Canada and Indians.

88. (1) September 24, 1747. Hocquart to the Minister.

89. (3) 1747. Letters from Mme. de Longueuil and Raymond to the Minister.

91. (1) November 8, 1748. La Galissoniere to the Minister.

92. (4) 1748. Letters from Bigot, Raymond, and Machault d'Arnouville.

93. (1) [1748] Observations on the responses furnished by the Company of the Indies.

95. (1) October 15, 1750. La Jonquiere to the Minister.

97. (9) 1747-1748, 1751. Letters from La Jonquiere to the Minister, and memoranda on trade.

98. (2) 1752. Bigot to the Minister and a report on Indians.

99. (5) 1754. Letters from L'Abbe de L'Isle Dieu and Dusquesne to the Minister.

100. (5) 1755. Letters from Dusquesne and Contrecoeur to the Minister.

102. (1) October 26, 1757. Vaudreuil to the Minister.

103. (10) 1758. Letters from Vaudreuil to the Minister, and Bougainville's reflections on the next campaign.

104. (1) May 5, 1759. Vaudreuil to the Minister.

105. (3) 1760, 1762. Letters from Neyon de Villiers and Belestre; and an Indian conference.

106. (1) October 18, 1730. Petition of the Seminary of Quebec.

107. (1) 1739. Memorial on the Cahokia mission.

111. (1) 1715. Extracts of letters from Begon, Dadencour, Mannoir, and Ramezay.

112. (1) October 26, 1744. Cugnet, Gamelin and Taschereau to the Minister.

113. (3) 1718, 1727, 1732. Aigremont to the Minister, and statements of expenses.

114. (6) 1738-1742. Beauharnois to the minister; accounts, receipts, and statements of expenses.

115. (13) 1741-1747. Statement of expenditures.

116. (3) 1749. La Galissoniere to the minister, and statements of expenses.

117. (Volume almost complete) 1744-1747. General expenditures for Canada (western posts) for 1747.

118. (1) February 10, 1746. Memorial for expenditures at Chikagou.

120. (10) 1711-1729. Letters from Beauharnois, Hocquart, Raudot and Vaudreuil to the Minister; and a list of officers.

121. (1) June 26, 1751. Memorial on the Canadian beaver trade.

122. (2) 1710, post 1719. Letters (a portion of "Relation par lettres de l'Amerique Septentrionale) and a memorial by Raudot.

123. (11) 1712-1716. Letters from Begon, Tonty, and Vaudreuil; requests for honors and pensions; Council minutes.

124. (20) 1718-1723. Council minutes and a Royal decree on trade and western posts.

125. (3) [1725]. DeLino to the Minister and extracts of petitions from Canada.

C 11 E: Des Limites et Des Postes

3. (1) May, 1750. Report on news from Canada.

4. (1) 1714. Memorial on boundaries.

7. (3) 1755. Memorials and notes sent to Rouille; draft of articles on negotiations with the British.

9. (2) 1720. Extracts of papers on North America from d'Estrees to Auteuil, and a memorial on boundaries by Bobe.

10. (2) 1747, 1757. La Galissoniere and Hocquart to the Minister, and a memorial on the Cherokees.

13. (6) 1723-1750. Various memorials on Indians, posts, and services; instructions for Lt. Louis Coulon de Villiers.

15. (40) 1710-1743. Cadillac correspondence and affairs at Detroit; Boishebert's map of a part of Lake Erie; and letters and observations of Beauharnois, Begon, Hocquart, and Vaudreuil.

16. (48) 1717-1746. Letters and memorials from Beauharnois, Begon, Charlevoix, Hocquart, La Verendrye and Vaudreuil.

C 11 G: Raudot-Pontchartrain; Ile Royale

5. (5) 1710. Correspondence of Raudot and Vaudreuil with the Minister.

7. (1) July 17, 1715. Royal memorial to Ramezay.

8. (3) 1714-1722. Lists of latitudes of various places, a deed of grant to Cadillac, and a decree relating to Detroit.

C 13 A: Correspondance Generale, Louisiana

1. (13) 1695-1717. Letters from the Seminary of Quebec, Bienville, La Salle to the Minister; and reports from missionaries.

2. (49) 1707-1711. Letters from Bienville, Boisbriant, Cadillac, Artaguiette, and La Salle to the Minister; and memorials on missionaries, Louisiana, and trading companies.

3. (36) 1707-1712. Letters and memorials from Bienville, Cadillac, Duclos, Duche, and Olivier to the King and Minister; memorials from the King; and memorials on trade, population, and Louisiana.

4. (41) 1715-1716. Council minutes and reports; memorials from the King; letters from Cadillac, Duclos, and Epinay; and memorials on marriage, trade, and Louisiana.

5. (20) 1717-1719. Council minutes and reports and letters from Bienville, Epinay and Hubert to the Minister and the Council.

6. (16) 1720-1723. Council minutes and reports; papers concerning the governing of Louisiana by a Council for the Company of the Indies; and letters from Bienville, Father Bobe, La Tour and Delisle.

7. (17) 1723. Minutes and decrees of the Superior Council; letters from Bienville, La Chaise, La Tour, and Purry; and an Indian conference.

8. (20) 1723-1728. Minutes and memorials of the Superior Council; letters from Bienville and Boisbriant; and correspondence of Pere Raphael.

9. (18) 1725-1726, [1731]. Minutes and correspondence of the Superior Council; and letters from Boisbriant to the Minister.

10. (16) 1725-1728. Letters from Boisbriant, Perier, and from missionaries Raphael, Beaubois, and Raguet; memorials on spiritual matters, missionaries and Louisiana.

11. (29) 1723, 1728-1729. Minutes of the Council of the Indies; and correspondence of Beaubois, Perier, La Chaise and Raguet.

12. (27) 1729-1730. Correspondence of La Chaise, Perier, Raguet and others; memorials on missions and ecclesiastical jurisdiction.

13. (17) 1731, 1759. Letters and memorials from Artaguiette, Perier, and Salmon; memorials on Louisiana; and minutes of the Council of State and of the General Assembly of the Company of the Indies.

14. (10) 1731-1732. Letters from Bienville, Perier, and Salmon to the Minister; minutes of a court martial.

15. (15) 1729-1733. Correspondence of Salmon; and extracts of Roullet's Journal.

16. (11) 1733. Letters from Bienville, Perier, and Salmon to the Minister.

17. (19) 1733. Letters from Artaguiette, Louboey, Salmon, St. Ange and others.

18. (7) 1734-1735. Letters from Bienville and Salmon to the Minister.

19. (3) April-May, 1734. Letters from Salmon to the Minister.

20. (15) 1735. Letters from Bienville and Salmon to the Minister; and inventories and a statement of accounts.

21. (12) 1736. Letters from Bienville, Artaguiette, and Salmon to the Minister.

22. (10) 1737. Letters from Bienville, Cremont, Artaguiette, and Salmon to the Minister.

23. (6) 1737-1738. Letters from Bienville and Salmon to the Minister; and a decree of the Superior Council on marriages of French men with Indian women.

24. (8) 1739. Letters from Beauchamp, Bienville, and Salmon to the Minister.

25. (12) 1740. Letters from Bienville, Louboey, and Salmon to the Minister.

26. (14) 1740-1741. Letters from Beauchamp, Bienville, Louboey, and Salmon to the Minister.

27. (13) 1742. Letters from Bienville, Louboey, and Salmon to the Minister; the Retrocession of Louisiana.

28. (26) 1743-1744. Letters from Bienville, Louboey, Salmon, and Vaudreuil to the Minister.

29. (12) 1745-1746. Letters from Lenormant, Louboey, and Vaudreuil to the Minister.

30. (21) 1746. Letters from Lenormant, Louboey, and Vaudreuil to the Minister; Beauchamp's journal; and the statement of expenses for 1746.

31. (21) 1747, 1748. Letters from Lenormant, Louboey, Vaudreuil, and others to the Minister; and statements of payments and accounts.

32. (23) 1748. Letters from D'Auberville, and Vaudreuil and others to the Minister; memorial of the King on Indian affairs.

33. (11) 1749. Letters from D'Auberville, and Vaudreuil to the Minister; memorials on Louisiana.

34. (20) 1749-1750. Letters from Michel, Tixerant, and Vaudreuil to the Minister.

35. (25) 1751. Letters from Michel, Vaudreuil, and others to the Minister; and a list of troop dispositions.

36. (15) 1752. Letters from Macarty, Michel, and Vaudreuil to the Minister; and a court martial.

37. (14) 1753. Letters from D'Auberville, Kerlerec, Macarty, and others to the Minister; a court martial; and lists of cannon.

38. (24) 1754. Letters from D'Auberville, Kerlerec, and others to the Minister; and a statement of expenses.

39. (21) 1755-1759. Letters from D'Auberville, Kerlerec, and others to the Minister.

40. (41) 1754-1759. Letters and memorials from de Larochette, Neyon de Villiers, Kerlerec, and others to the Minister; a census of Ft. Toulouse.

41. (6) 1759. Letters from Kerlerec and Rochemore to the Minister; and memorials on Louisiana and Canada.

42. (13) 1760-1761. Letters from Kerlerec, Macarty, and Rochemore to the Minister.

43. (18) 1762-1764. Letters from D'Abbadie, Neyon de Villiers, Foucault, and Kerlerec and others; memorials on the Jesuits; and D'Abbadie's Journal for 1763-1764.

44. (17) 1764. Correspondence of D'Abbadie, Neyon de Villiers, and Farmar; a statement of expenses for Louisiana.

45. (10) 1765. Letters from Aubry and St. Ange; Indian conferences; "Proces-Verbal de la Cession du Fort De Chartres."

46. (1) January 27, 1766. Aubry to the Minister.

52. (1) 19 Prairial, Year XI (June 8, 1803). Laussat to the Minister.

C 13 B: Correspondance Generale, Louisiane

1. (20) 1700-1780. Letters from Bienville, Rochemore, and others to the Minister; an inventory; and a narrative of the wars in Louisiana (1729-1736).

C 13 C: Louisiane

1. (16) 1713-1762. Memorials on Louisiana concerning commerce, boundaries, posts, rivers, Indians, and migration.

2. (9) 1710-1722. Letters from John Stewart (South Carolina); memorials on Louisiana, Mobile, and Crozat's enterprises; and a journal of Delisle's journey to the Illinois River.

3. (12) 1680-1720. Account of La Salle's journey to the Mississippi, 1680; letters and memorials by Tonty and La Forest; Council minutes; and various papers concerning La Salle.

4. (21) 1715-1781. Letters from Beauharnois and Bourgmont to the Minister, the Company of the Indies, and the Commissioners; various travel accounts; and memorials on trade, mines, and Indians.

D 2 C: Troupes des Colonies

4. (1) 1747-1758. List of officers in Louisiana.

50. (1) 1731. List of officers for Louisiana.

51. (19) 1715-1757. Lists and muster rolls of troops.

52. (5) 1759-1767. Lists and returns of officers and soldiers.

D 2 D: Personnel Militaire et Civil

10. (5) 1718-1757. Lists of Jesuits, Ursulines, officers, marines, gunners and employees at various posts.

F1: Fonds des Colonies (Finances)

18. (1) February 27, 1713. Purchase order for supplies for girls sent to Louisiana.

21. (4) June-July, 1720. Orders for payments to Father Charlevoix and Cadillac.

22. (2) 1721-1722. Orders for payments to Father Charlevoix.

30. (2) 1731-1732. Estimates and statements of expenses.

F3: Collection Moreau de Saint-Mery

6. (1) June 7, 1701. Arrangement between the Jesuits and the Missions Etrangere concerning the Tamaroa mission.

9. (2) 1710, 1711. Raudot's ordinance on the sale of liquor to the Indians; Vaudreuil to Ramezay.

10. (1) June 6, 1721. Royal memorial to Vaudreuil and Begon.

11. (6) 1727-1730. Correspondence of Beauharnois; La Verendrye's memorial on the West; and an account of the defeat of the Fox Indians.

FAIRFIELD, WAYNE COUNTY, ILLINOIS. TOWN RECORD BOOK, PAPERS, 1846-1862, 1875. 1 volume.
4 items.

The record book for the town of Fairfield, Wayne County, Illinois, begins with a meeting
for the incorporation of the town on June 1, 1846. Included are election results,
boundary settlements, the constitution and by-laws, ordinances, records of the Board of
Trustees meetings, and a treasurer's report from January to July, 1875. Other items are
a list of road taxes in 1859, a certificate of the election of town trustees, June 1, 1861,
and a petition regarding the incorporation of the town. [These items were presented to the
Survey by John M. Rapp, Fairfield, Illinois.]

FELL, JESSE W. (1808-1887). PAPERS, 1829-1911. 177 items, original, transcripts.
Chronological card file. 61-1708.

Jesse W. Fell came to Illinois in 1832. In 1833 he began the practice of law in
Bloomington, and later became involved in real estate and other business enterprises.
Considered the founder of Normal, Illinois, he was responsible for the location there of
the first state normal school in 1857. He was an early friend of Abraham Lincoln, took
part in organizing the Republican Party in Illinois, and was active in the campaign of
1860. Appointed paymaster by Lincoln in 1862, he served for two years.

The Fell papers are composed primarily of letters, memoranda, drafts, and telegrams. The
correspondence includes letters from O. H. Browning, David Davis, Joseph Duncan, W. L. D.
Ewing, J. B. Foraker, Abraham Lincoln, John Logan, Richard J. Oglesby, John M. Palmer,
John Reynolds, N. H. Ridgely, Leonard Swett, and Lyman Trumbull. There are resolutions
passed by the Bloomington Bar Association on the death of Fell (March 14, 1887). Nineteen
letters in this collection, written by Jesse Fell to Dr. Richard Edwards, discuss the
Larchwood (Iowa) land project; Fell was selling his land to colonizers for the purpose of
paying his debts. There are transcripts of portions of a memorial to Jesse Fell compiled
about 1911 and a eulogy by Dr. Edwards, as well as some newspaper clippings about Fell and
a document nominating him as paymaster, signed by Abraham Lincoln and Edwin Stanton,
Secretary of War. In addition, there is a contract for the sale of some land lots. [Most
of the Survey transcripts were made in 1913 when the originals were in the possession of
Alice and Fannie Fell of Normal, Illinois. The originals were later owned by E. L.
Richardson, Milwaukee, Wisconsin. The letters concerning the Larchwood project, the
eulogy by Edwards, and the contract for the sale of some land lots were located in Iowa by
Dr. Helen Marshall of Illinois State University. The transcripts are a gift of Dr.
Marshall, June 17, 1957. The paymaster's vouchers issued by Fell as paymaster, formerly
in the Survey's collection, are now in the Illinois State Archives, Springfield.]

FESSENDEN, WILLIAM PITT (1806-1869). LETTERS, 1860-1861. 5 items, photocopies. Calendar.
69-1586.

These letters largely concern the political problems of the Union and the Republican Party.
Correspondents include I. F. Butterworth, Hamilton Fish, W. W. Gitt, John R. Shepley, and
Horace White. [These are photocopies of the Fessenden letters in the Library of Congress.]

FIELD, ELEANOR. CORRESPONDENCE, 1837, 1839. 2 items. 69-1592.

This correspondence is to and from Eleanor Field, the daughter of Colonel A. P. Field.
The first letter is probably from Eleanor's mother, and concerns sewing and mending. The
letter written in 1839 is from Eleanor to her father, requesting that he visit her at the
Menard Academy in Kaskaskia.

FIRST, H. C. LETTER, 1918. 1 item.

This letter by H. C. First contains a summary of Baptist activities in Illinois from 1787 to 1848 and includes statistics taken from the Baptist Association minutes, 1848, on churches in the state.

FIRST ITALIAN PRESBYTERIAN CHURCH, CHICAGO,ILLINOIS. RECORDS, 1891-1940. 1 reel, microfilm.

Book I of this collection contains the Minutes of the Session for 1891-1913, while Book II includes those for 1913-1926. In addition, there is for each group of years a Church Register, listing the pastors, elders, deacons, communicants, baptisms and baptized persons, marriages, and deaths for the First Italian Presbyterian Church. A third volume contains the Minutes of the Session of the Samaritan, later Waldensian, Presbyterian Church, a splinter group of the First Italian Presbyterian Church. These cover the years 1923-1940. [No extensive use is to be made of these records without the prior permission of the elders of the respective churches or of the Presbytery of Chicago. Permission to microfilm the records was obtained by John R. McQuown, Chicago, Illinois, and, under the auspices of Professor Natalia M. Belting, University of Illinois, Urbana, the film was made in 1965 and deposited in the Survey.]

FISHER, WALTER M. LOWRIE (1862-1935). AUTOBIOGRAPHY, 1931-1932. 1 item, machine reproduction. 69-1599.

Written by Walter Fisher in his 70th year, this item is an autobiography intended for his family. He describes his family background, and his legal and political careers. A participant in Republican reform activities including civil service reform, he served as the Secretary of the Interior under Taft and also founded the Municipal Voters League in Chicago. [This autobiography is the gift (September, 1959) of Walter T. Fisher, son of Walter M. Lowrie Fisher.]

FLAGG FAMILY. DIARIES, PAPERS, PAMPHLETS, 1819-1948, 1973. 33 volumes, 161 items, originals. 27 published volumes. 106 items, transcripts. 13 photographs. Inventory, chronological card file.

Three generations of the Flagg family are represented in this collection. Gershom Flagg (1792-1857) migrated from Vermont to Illinois and settled in Madison County in 1818. He was a farmer, a postmaster, a representative to the General Assembly from Madison County, 1846, and a delegate to the Constitutional Convention, 1847. Over sixty items of this collection are letters and papers of Gershom Flagg; several papers deal with his observations on the constitution drafted in 1847. Correspondents include George Churchill, Gershom's brother Azariah C. Flagg, his son Willard C. Flagg, John Johnson, Evan McPherson, Israel Smith, and J. R. Stanford.

The papers of Willard C. Flagg (1829-1878) concern his years at Yale as well as matters of agricultural and political interest, a projected history of Madison County,and information on German settlers. Since he was a member of the first Board of Trustees of the University of Illinois, some papers concern early university affairs. Among the correspondents are Newton Bateman, T. J. Burrill, S. P. Chase, Joseph Gillespie, J. M. Gregory, John A. Logan, W. T. Norton, Richard J. Oglesby, John Reynolds, Lyman Trumbull, and Richard Yates.

Norman G. Flagg (1867-1948) was a member of the Illinois House of Representatives, 1908-1926, and of the State Senate, 1926-1930, 1938-1946. His papers include 33 diaries and several folders of personal papers and memorabilia mainly concerning Washington University and alumni affairs. [The transcripts of the Flagg Manuscripts were made, 1910-1913, from the originals then owned by Norman Flagg of Moro, Illinois. The original and printed materials in the collection were presented to the Illinois Historical Survey Library in 1974 by Mr. Willard G. Flagg.]

12. (2) 1733-1737. Letter and memorial from La Verendrye to Beauharnois.

14. (2) 1752, 1755. Minister to Duquesne; Contrecoeur's account of the Battle of Monongahela.

15. (2) 1758. Letters from Vaudreuil and Ligneris.

24. (13) 1713-1741. Letters from Duclos, Perier, Villiers, and others; Articles of Capitulation of Pensacola; an Indian conference; and memorials on Illinois.

25. (9) 1764, 1778. Correspondence of D'Abbadie; memorials on Illinois and Louisiana; and Indian conferences.

95. (1) 1735. Beauharnois to Artaguiette.

159. (1) 1732-1739. Statement of finances of Louisiana.

241. (4) 1714-1715. Papers concerning Crozat's trading privileges; and letters from the King and the Council to Cadillac and Duclos.

242. (2) 1724, 1733. Deliberations of the general assembly of the Company of the Indies on Jesuit missions; and a decree of the Superior Council concerning a marriage.

243. (1) May 1, 1747. Declaration of Vaudreuil and Le Normant on sending Negroes to Illinois.

F 5 A: Missions Religieuses

226. (1) November 20, 1729. Abbe Raguet to the Company of the Indies.

G 1: Registres de l'Etat Civil,
Recensements et Documents Divers

412. (3) 1723-1724, 1726. Registers of births, marriages, and deaths for Kaskaskia and Fort Chartres; and a memorial on personal requests for information about persons in Louisiana.

465. (3) 1734, 1746. Bienville and Salmon to the Minister; Dupuis' memorial on Illinois and on mines; and a statement of powers on land grants.

ARCHIVES DE LA GUERRE

These papers, though not as significant for the French Colonial Era as those in the Archives of the Colonies and of the Marine, are nonetheless important. While French Army units seldom served in America before 1746, its officers sometimes did. Also, correspondence relative to trade and colonial matters can be found in its holdings. For further information see especially General Inventory, Manuscripts, I, 49-69, and also Gipson's Guide..., 365-367.

$A^1$2592. (8) 1720-1721. Correspondence and memoirs of the Company of the Indies, including letters from Boisbriant.

$A^1$2868. (2) September 3, 1738. Minister of War to the Minister of Marine.

FRENCH ARCHIVES AND DEPOSITORIES.

ARCHIVES DE LA MARINE

The Department of the Marine's main significance in French colonial affairs was that this department supplied the majority of the military units for New France. The correspondence of the department includes, besides military and naval matters, papers concerning trade, and religious and administrative affairs. For information on the Marine materials see the General Inventory, Manuscripts, I, 22-25, and Gipson's Guide..., 364.

$B^1$2. (1) 1714. Abstract of petition of Recollet Friars for payment of 2850 livres.

$B^1$8. (19) March-April, 1716. Council minutes concerning the Fox War, Indians, Indian trade, coureurs de bois, various posts, Iroquois, slaves, and English-Canadian boundaries.

$B^1$9. (6) July-December, 1716. Council minutes on Fox War, Choctaws, Cherokees, mines, trade, and Louisiana.

$B^1$19. (7) January-April, 1717. Council minutes on English-Indian trade, land grants, and western posts; and an account by Father Leblanc.

$B^1$21. (5) November-December, 1717. Council minutes on the Fox and on Vaudreuil and Begon's memoir.

$B^1$50. (3) March, 1720. Council minutes on memoir and letters from Vaudreuil.

$B^1$51. (5) March-May, 1720. Council minutes on letter and petitions from La Salle's family, Begon, Mme. La Forest, and Ramezay.

$B^1$52. (2) November-December, 1720. Council minutes on a request of the children of Francois Plet, and a dispatch from Vaudreuil.

$B^1$55. (3) January, May, 1721. Council minutes on Vaudreuil letters and on Cadillac's claims.

$B^2$221. (2) May 10, 14, 1721. Minister to Imbercourt.

$B^3$207. (1) July 4, 1712. Clairambault to Minister.

$B^3$209. (1) [1712]. Memo on English trading company and on Crozat.

$B^3$226. (1) March 11, 1714. Desmaretz to Minister.

$B^4$9. (3) May-October, 1684. Beaujeau to Minister.

$B^4$10. (1) July 8, 1685. Beaujeau to Minister.

$B^4$50. (1) March 17, 1741. Nouailles d'Ayme to Minister.

$B^7$16. (1) November 10, 1712. King of Spain to Minister.

FRENCH ARCHIVES AND DEPOSITORIES.

ARCHIVES NATIONALES - SECTION ANCIENNE

This manuscript group of the National Archives includes records and documents of the Old Regime. It is one of six such groups. For further information on its organization and classifications see the General Inventory, Manuscripts, I, 31–43. See also Gipson's Guide..., 364–365.

Series K: Monuments Historiques

1232. (1) June, 1678. Part of an account of La Salle.

1374. (5) 1699. Letters from Montigny, La Source, and St. Cosme; and a note on Canadian missionaries.

Series M: Melanges

204. (1) 1704. Minister to Vaudreuil and Beauharnois.

Series V7: Commissions Extraordinaires du Conseil Prive, 1689–1776

345. (58) 1748–1766. Vouchers for wages, supplies, travel, ammunition, and other expenses for Canadian posts.

MINISTERE DES AFFAIRES ETRANGERES. PAPERS, 1720–1766, 1773. 225 items, including items on 20 reels of microfilm and filmstrips. Transcripts, photocopies, microfilm. Archival card file. 61–1789.

The archives of the Ministry of Foreign Affairs are divided into three main groups Correspondence Politique, Memoires et Documents, and Correspondence des Consuls; in addition, there is a supplementary section to the first group. The Survey has reproductions of manuscripts from the first two groups mentioned, as well as from the supplementary section. Within these groups, documents are arranged by country, and subdivided chronologically. For a description of this material see Leland's Guide..., Vol. II, Parker's Guide... (1914), 255–262, and also Gipson's Guide..., 367–382.

The Survey's material from this archival group forms part of the basis of the monograph length introduction by Theodore C. Pease to Anglo-French Boundary Disputes in the West, Illinois Historical Collections, Vol. 27 (Springfield, 1936). Many of the following documents are printed in that text (some are incomplete).

CORRESPONDENCE POLITIQUE

Angleterre

434. (2) 1752. Mirepoix to Rouille; and an Albemarle memoir to Rouille protesting the arrest of British traders.

437. (2) 1754. Order and memoir to Mirepoix on the Braddock expedition and American affairs.

438. (25) January–April, 1755. Memoirs and correspondence of Mirepoix and Rouille relative to diplomatic negotiations with the British.

439. (4) May, 1755. Correspondence between Mirepoix and Rouille and an exchange of memoirs with the British.

440. (1) March 1, 1756. Draft of a treaty.

FRENCH ARCHIVES AND DEPOSITORIES.

442. (1) January 9, 1760. Projected preliminary articles of peace between Great Britain and France.

443. (6) June - July, 1761. Correspondence between Bussy and Choiseul on boundary questions.

444. (15) July - September, 1761. Correspondence between Bussy and Choiseul on negotiations; and several French memoirs.

446. (11) June - August, 1762. Documents on peace negotiations, and correspondence between Choiseul and Egremont.

447. (24) September - October, 1762. Correspondence between Choiseul and Nivernois, and observations on preliminary articles of peace.

448. (10) November - December, 1762. Correspondence of Nivernois, Praslin, and Bedford on peace negotiations.

449. (11) January - February, 1763. Correspondence of Nivernois and Praslin, and observations on negotiations.

450. (2) April, July, 1763. Letters to Praslin.

451. (2) August, October, 1763. Letters to Praslin.

501. (1) April 12, 1773. Minister of Marine to Guines.

Espagne

295. (4) April, 1720. Letters from the Minister of Foreign Affairs; and memoirs on Pensacola and Louisiana.

300. (1) February 24, 1721. Answer of the King of Spain on the restitution of French conquests.

301. (1) May 7, 1721. Draft of a secret agreement of the Kings of France, Spain and Great Britain.

310. (1) February 21, 1721. Memorandum on a discussion of a France-Spanish treaty.

343. (1) December, 1726. Memoir on English colonial operations in the West Indies and America.

345. (1) December, 1726. Memoir of the Company of the Indies to the King.

352. (1) August, 1726. Memorandum on points useful in peace negotiations.

374. (1) July 23, 1730. Secret memoir of Noguichart.

446. (3) July, December, 1738. Decoments on the adjustment of Anglo-Spanish differences.

448. (2) July, 1738. Correspondence of Florida boundaries.

522. (1) November, 1757. Memoir on Spain's attitude towards France and England.

527. (3) January - February, 1760. Choiseul-Ossun correspondence.

529. (2) July, 1760. Choiseul-Ossun correspondence.

533. (2) July, 1760. Choiseul-Ossun correspondence.

536. (5) June - July, 1762. Choiseul correspondence.

537. (6) August - September, 1762. Choiseul-Ossun correspondence.

Turin (Sardinia)

229. (3) 1758. Correspondence between Abbe Bernis and the Marquis de Chauvelin.

230. (12) 1758-1759. Correspondence of Chauvelin, Choiseul, and Arnaud.

232. (9) January - March, 1760. Chauvelin-Choiseul correspondence.

233. (4) April, June, 1760. Chauvelin-Choiseul correspondence.

234. (2) October, 1760. Chauvelin-Choiseul correspondence.

241. (1) January 11, 1764. Chauvelin to Praslin.

242. (7) September - December, 1764. Chauvelin-Praslin correspondence.

245. (6) January - May, 1766. Sabatier letters to Praslin and Choiseul.

246. (3) July - December, 1766. Sabatier and Choiseul letters.

Etats - Unis Supplement

6. (3) July - August, 1761. Memoranda on Louisiana boundaries.

MEMOIRES ET DOCUMENTS

Amerique

1. (1) October 20, 1725. Bienville memoir on Louisiana.

2. (1) [1746]. Proposal for a post at the junction of the Wabash and the Mississippi.

7. (5) 1720-1730. Perier correspondence, and memoirs on Louisiana.

9. (1) August 1, 1750. Bigot's memoir on French claim to Canada.

24. (5) 1751-1759. Memoirs on Canada.

33. (1) February 1, 1756. Bertrand to Abbé Fricheman.

Angleterre

9. (1) October, 1739. Plan for negotiations between England and Spain.

46. (1) October, 1747. Memoir of Silhouette.

69. (1) October, 1750. Memoir on English designs.

France

1990. (1) June, 1731. Plissay memoir on French Commerce and Louisiana.

1991. (2) September 18, 1729, [1739]. Desruaux memoir on suppressing the Company of the Indies, and Abbé Raguet's memoir on Louisiana.

1992. (2) [1727] Company of the Indies to Perier, and a memoir on Louisiana.

FRENCH ARCHIVES AND DEPOSITORIES.

<u>2019</u>. (1) 1730. Plan to increase French commerce.

ARCHIVES, SERVICE HYDROGRAPHIQUE. PAPERS, 1706-1737. 23 items including items on 1 reel of microfilm. Photocopies, microfilm. Archival card file.

These records include the maps, plans, and papers concerning maps, mapping, and travels in the French Colonies in North America. For a notation on this material see <u>General Inventory, Manuscripts</u>, Vol. I, 23.

<u>64-5</u>. (1) [1722]. Notes and observations on Bellin's memoir.

<u>64-8</u>. (2) 1706, 1725. Letter and memoir by Noutron.

<u>64-9</u>. (1) [1722]. Bellin's memoir on maps of Eastern Canada and Louisiana.

<u>67-2</u>. (3) 1714, 1722. Memoirs of observations of the Mississippi by Baron, Beranger, and Bourmont.

<u>68-4</u>. (1) [1733]. Bellin's opinion of Popple's map.

<u>115-10</u>. (4) 1711-1721. Extracts of Le Maire Letters; an account of a journey to Natchitoches with a census of the Choctaws and Chickasaws; and a letter from Lallement to the Company of the Indies on his trip on the Mississippi.

<u>115-11</u>. (8) 1731-1737. Extracts of correspondence and memoirs relative to La Verendrye search for the Sea of the West.

<u>115-16</u>. (2) 1710, 1720. Correspondence between Father Bobe and Delisle on Louisiana.

<u>115-17</u>. (1) August 28, 1723. Delisle's memoir on the Mississippi.

BIBLIOTHEQUE NATIONALE. 1644, 1666-1756. 136 items. Transcripts, photocopies. Archival card file. 61-1786.

This depository, one of the world's largest libraries, contains several large manuscripts collections. The Survey has material from the Manuscrits Francais, Manuscrits Francais (Nouvelles Acquisitions), and the Collection Clairambault. For descriptions of these collections and this depository see the <u>General Inventory, Manuscripts</u>, Vol. I, 107-121, Gipson's <u>Guide...</u>, 382-394, and Leland's <u>Guide...</u>, Vol. I, 1-219.

Manuscrits Francais

<u>8989</u>. (1) 1716-1722. Journal of La Harpe's voyage and discoveries in Louisiana.

<u>9097</u>. (3) 1700, 1704. Letters from Alphonse and Henry de Tonty.

<u>12105</u>. (1) March 1, 1717. Le Maire's memoir and map of Louisiana.

<u>23664</u>. (2) 1716. Minutes of the Council de Regence on decision to revoke Cadillac's commission and on the decision to send four companies and one hundred girls to Louisiana.

Manuscrits Francias, Nouvelles Acquisitions

2550. (3) 1723-1728. Memoir on hostilities of the Natchez, an account of Grand Soleil, and Gonner's report of the discovery of a tidal river west of Lake Superior.

2551. (2) 1725, 1732. Bourgmont's notes on Indians of Louisiana and memoir of La Verendrye's enterprise to discover the Sea of the West.

2552. (2) 1732, 1735. Extract of a letter on a defeat of the Fox, and a note on the first cultivation of wheat in Illinois.

2560. (2) 1720, 1735. Account of a riot in St. Antoine, and a memoir on newly discovered Canadian copper mines.

5398. (1) January 5, 1714. Varlet to his brother.

7485. (2) 1678-1690, 1699. Tonty memoir on the exploration of the Mississippi, and Montigny's account of the trip down the Mississippi.

7497. (30) 1683-1684. Letters (or portions thereof) from Bernou to Renaudot.

9288. (17) 1660-1704. Notes, letters, and memoirs relating to La Salle.

9289. (1) [1703]. Joutel to Delisle.

9290. (24) 1680-1756. Notes, extracts, and papers relating to La Salle's enterprises and death; and letters of Abbe Tronson, Abbe Jean Cavelier, and Raudot.

9292. (6) 1678-1730. Notes, letters and papers on La Salle, Tonty, and the Illinois Country.

9293. (21) 1644, 1762. La Salle family papers.

9294. (2) 1677, 1699-1700. Extracts of correspondence of Dubos, D'Iberville, and Serigny; and a letter from Abbe Galinee to Coullard.

9300. (1) April 25, 1734. Bienville's list of officers in Louisiana.

9302. (1) [1720]. Petition of Marianne de la Marque.

21,395. (1) [Undated]. Memoir on the discovery of copper mines in Canada.

22,804. (1) March 17, 1694. Jaques Gravier to Villermont.

Collection Clairambault

1016. (12) 1677-1687. Memoirs and letters relating to the voyages and discoveries of La Salle, Tonty, Radisson and others (from the papers of Abbè Bernou).

FRENCH-ILLINOIS DICTIONARY. PAPERS, Eighteenth Century. 1 reel, microfilm.

This manuscript, compiled early in the eighteenth century by Jesuit priests working among the Illinois, consists of the following: (1) French-Illinois dictionary, 157 manuscript pages; (2) grammar, 3 pages; (3) 35 chapters of Genesis, paraphrased; (4) 2 collections of prayers to be used at Mass; (5) 52 selections from the Gospels arranged according to the church calendar; (6) The Apostles Creed; (7) 2 catechisms. [The original manuscript is owned by the John Carter Brown Library, Providence, Rhode Island.]

FULTON, JAMES ALEXANDER (1822-1895). JOURNAL, 1854-1855. 1 reel, microfilm.

This journal is a record of James Fulton's "pleasure" trip to the West and South begun on October 1, 1854. He journeyed, by all methods of transportation which existed at that time, to Kansas and Nebraska, then to Mississippi and Texas. He observed topographical features, types of plants, especially edible ones, and local habits. He also describes land prices, Mormons, Indians, Negroes, cotton-picking, slavery, slave sales and markets. At the end of this diary he lists the towns which he visited and includes a detailed sheet of expenses incurred during his travels. [The Survey's copy of the diary was copied from the original by Cecil C. Fulton of Dover, Delaware, and microfilmed by the Delaware State Archives in June, 1960.]

GAGE, GENERAL THOMAS (1721-1787). PAPERS, CORRESPONDENCE, 1759-1775. 1291 items, transcripts and photocopies. Chronological card file. 69-1587.

This collection is composed of papers and correspondence of General Thomas Gage, British Commander in the American colonies. They deal primarily with military administration and campaigning in the French and Indian War, Pontiac's Rebellion, and afterwards. Topics included are the British occupation of Illinois, reports of French officers, Indian negotiations and settlement in the West. Among the important correspondents are John Bradstreet, Henry Bouquet, George Croghan, Sir William Johnson, and other officers and British officials. [The papers in this collection were gathered from several libraries for publication in the Illinois Historical Collections. These libraries include the William L. Clements Library (Gage Papers, 1204 items), Harvard College Library (Gage Letters, 52 items), the Massachusetts Historical Society (Parkman Collection, 12 items), the New York Public Library (Bancroft Collection, 20 items; Myers Collection, 1 item), the Randolph-Macon College Library (Branch Historical Papers, 1 item), and the Virginia State Library (Clark Papers, 1 item).]

GALLATIN COUNTY, ILLINOIS. DOCUMENTS, 1814, 1816, 1883. 4 items.

The varied items in this collection are an account of debts, an oath and a report of the appraisers of an estate, a summons to an administrator of an estate, and an extract from a police magistrate's docket. [These items were given to the University of Illinois Library in 1939 by Miss Mildred Ellis. They were transferred from the Rare Book Room to the Illinois Historical Survey Library in 1973.]

GALLOWAY, GRACE GROWDEN (d. 1789). PAPERS, 1778-1779, 1803, 1934. 5 items, original, transcript, photocopies. 69-1587.

Grace Galloway, wife of Loyalist Joseph Galloway, stayed in Pennsylvania to protect her husband's property after he went to England. However, she was turned out of her house in August, 1779. Her diary describes her "ouster" and her life in the years immediately after that event. Included in the collection are a family tree, a photocopied letter, her husband's burial certificate, and a letter, written in 1934, which contains additional information about her life. [The diary of Grace Galloway was in the possession of her great granddaughter, Lady Grace Denys-Burton, of Pollacton, Carlow, Ireland, when R. C. Werner secured the transcript and edited it for the Pennsylvania Magazine of History. Later, the Historical Society of Pennsylvania acquired the diary and other papers from Lady Denys-Burton. The Survey transcript includes entries which were not published.]

GALLOWAY, JOSEPH (1731-1803). PAPERS, 1756-1783. 22 items, photocopies. 69-1587.

This collection contains a petition addressed to Parliament on January 4, 1775, for redress due to the comparatively disadvantageous state of trade in North America; and nine letters written between 1756 and 1783 to, from, and about Joseph Galloway. [All of these are from the collections of the Historical Society of Pennsylvania.] Also included is a draft, in Galloway's hand, of a letter to Burgoyne; an article entitled "Some Letters of Joseph Galloway, 1774-1775, Contributed By Mrs. Theodore W. Etting"; a treatise titled The Nature and Extent of Parliament Power Considered; excerpts from several Pennsylvania newspapers (1768, 1779); and a House of Commons Paper, June 18, 1779, entitled "Examination of Joseph Galloway on Conduct of Sir William Howe," with annotations in Galloway's hand. [The letter to Burgoyne is found in the Library of Congress.]

GENERAL STORE LEDGER. BEARDSTOWN, ILLINOIS. ACCOUNT BOOK, 1840-1849, 1885. 1 volume.

This ledger of a General Merchandise Store is composed of invoices of goods and services bought by individual customers. It often indicates if and how each account was settled. Also, there is an entry in the ledger for Thomas Beard, the founder of Beardstown.

GERE, ASA O. (b. 1846). LETTER, January 7, 1941. 1 item, machine reproduction.

This letter from Asa Gere to Clayton Daugherty of Champaign, Illinois, contains reminescences about his life in Illinois and about his acquaintance with Lincoln. At the time it was written, Gere was Senior Aide de Camp of the Grand Army of the Republic. [This letter was copied from the original with the permission of Clayton F. Daugherty in 1974.]

GERMAN SETTLEMENT IN ILLINOIS. PAPERS, LETTERS, 1822,1832-1836, 1846, 1872, ca. 1900. 1 item, original. 9 items, transcripts. 2 items, machine reproductions. Calendar.

This collection contains eight transcripts dealing with climatic conditions, a development of a rural settlement near St. Clair County, Illinois, and inflation in St. Louis. Included among the items are Gottfried Duden's description of his journey in Missouri, a guidebook for German emigrants taken from Das Westland, and Gustav Koerner's review of geographical and political situations concerning the German emigrants. Four letters complete the collection. They present descriptions of early German Settlements, farming and land prices and the scarcity of money. [The reproductions were given to the Survey in 1968, by Dr. David Schob, who purchased them from the Collection of Regional History and University Archives, Cornell University.]

GERMER, ADOLPH (1881-1966). PAPERS, 1918, 1928, 1930-1931. 44 folders. Inventory. 69-1594.

Adolph Germer was a Wisconsin and Illinois labor leader as well as a Socialist Party official. These letters were written during his tenure as Vice-president of the United Mine Workers of America, Reorganized (1930-1931). The correspondence is between Germer and local union officials, officers in industry, judicial figures, a historian and an economics professor, senators, and other persons. Clarence Darrow and Norman Thomas are two correspondents, and their letters relate to the split in the U. M. W. A. between the Germer-Walker faction and the Lewis faction. Among other correspondents are: Frank J. Bender, Joseph Claypool, Harry Fishwick, Alexander Howat, William Jardine, Charles M. Keeney, J. M. Thornton, and John H. Walker. [The Germer papers were given to the University of Illinois about 1955. In September of 1966, they were transferred to the Survey from the University's Institute of Labor and Industrial Relations.]

GIDDINGS, JOSHUA REED (1795-1864). CORRESPONDENCE, 1846-1848. 1 reel, microfilm.

This correspondence of Joshua Giddings is largely political in nature. The Mexican War, tariffs, admissions of new territory, Gidding's renomination to the United States Congress after being censured by that body, and the problems of slavery are discussed. Some of the letters were mainly written to his wife in the course of a trip or campaign in the Northeast where he met with political leaders of various communities. The list of correspondents, aside from Gidding's family, includes Charles F. Adams, Salmon P. Chase, Cassius M. Clay, Henry, Horace Greeley, John Jay, Wendell Phillips, William H. Seward, Thaddeus Stevens, and Thurlow Weed. Also included in this collection is a poem about slavery and the burdens of the black man. [The letters are from the Giddings Papers of the Ohio Historical Society and were a gift (1957) of Professor Norman Graebner.]

GILCHRIST, R.J.B. LETTER, 1826. 1 item.

This letter by R.J.B. Gilchrist to his brother, C.C.P. Gilchrist in Kentucky, tells of
conditions on his journey down the Ohio River. He planned to travel the Mississippi to a
point about one hundred miles below Natchez to sell his corn crop.

GODWIN, PARKE (1816-1904). PAPERS, 1844-1893. 1 reel, microfilm. 69-1595.

These manuscripts concern the Fourierist movement in which Godwin, the son-in-law of
William Cullen Bryant, was active during the 1840's. More than half of the letters passed
between Godwin and Charles A. Dana. Among correspondents are S. D. Bradford, Hugh Doherty,
and George Ripley. Also there is a letter from Dana to Louis Blanc, as well as five
letters from Charles Sears to Horace Greeley relating to the North American Phalanx. The
letters generally discuss the Brook Farm Phalanx and related subjects. [The microfilm was
made in 1939 from the originals in the Bryant-Godwin and Ford collections in the New York
Public Library for Professor Arthur E. Bestor, who later deposited the film in the Survey.]

GOODELL AND SOUTHWORTH. BUSINESS RECORDS, 1860-1865. 1 volume.

This volume concerns the business affairs of Asabel D. Southworth and Addison Goodell, land
brokers in Iroquois County, Illinois. The journal's contents are letter press copies of
letters written to their clients.

GRAHAM, HUGH. FEE BILL, December 10, 1841. 1 item.

This fee bill pertains to the case of Hugh Graham vs. John Dixon, John W. Dixon and Elijah
Dixon, to be levied against said Hugh Graham, December, 1841. The copy is certified by the
Clerk of the Supreme Court of the State of Illinois, March 5, 1842.

GRAHN, WILHELM JULIUS (1840-1930). DIARY, NOTE, 1870-1873, 1965. 2 items, transcripts.

This collection includes a diary kept by Grahn and a biographical sketch about him by his
daughter, Mrs. Lena Prahl. The diary mentions his trip across the Atlantic from Germany
and his arrival in Wisconsin. He served in the army for five years and most of the diary,
which terminates in 1873, is about camp life. In 1880 Grahn settled in Clay County,
Illinois, where he farmed. [The items were a gift of Mrs. Erma Koehn, Mansfield, Illinois.]

GRAND ARMY OF THE REPUBLIC. COL. NODINE POST NO. 140. RECORDS, PHOTOGRAPHS, 1880-1935.
15 volumes. 3 folders. Inventory.

Originally founded in 1880 as the Champaign Veteran Soldiers Historical Society, the Col.
Nodine Post No. 140, G. A. R. was organized in 1882 and disbanded in 1935. The minutes of
the society and the post from the first meeting in 1880 to the dissolution in 1935 are
contained in the first nine volumes of this collection. Pasted in these volumes are
letters and newspaper clippings mainly relating to encampments, deaths, and Memorial Day
services. In addition, there are four volumes which record names of members as well as
other information,including locations of graves. Two of the other volumes concern Civil
War reminiscences; the first is a typed copy of some war experiences written by Edwin
Green, and the second contains the relations of war experiences of over fifty members of
the post. The three folders contain varied materials including a typed list of names of
members, a set of photographs, and miscellaneous papers found in the bound volumes. [These
records were presented to the University of Illinois Library by Walter E. Price in 1935.
They were transferred to the Illinois Historical Survey in 1973.]

GRAND ARMY OF THE REPUBLIC. KYGER POST NO. 204. DUE BOOKS AND RECEIPTS. 1895-1908. 2 volumes. 10 items.

The two volumes record the names and dues paid of the Kyger Post's members of Georgetown, Illinois. Supply slips and receipts are also included in the colleciton. [The collection was transferred from the University of Illinois Archives to the Illinois Historical Survey Library in 1974.]

GRANT, ELIJAH P. (1808-1874). PAPERS, 1843-1848. 1 reel, microfilm.

Grant was a prominent advocate of Fourierist socialism and founded a phalanx in Ohio in the 1840's. This microfilm includes the following sections of the collection in the University of Chicago Library: letterbooks, 1843-1845, 5 volumes; diary, 1845, 1 volume; letters received, 1847-1848, 4 items; miscellaneous papers, 4 items. [These materials were microfilmed for Professor Arthur Bestor in 1940 and were presented by him to the Survey in 1956.]

GRANT, JOEL (1816-1873). LETTER, November 30, 1846. 1 item.

This letter from Joel Grant, a minister in Lockport, Illinois, to the Rev. S. W. Eaton in Platteville, Wisconsin, discusses the spiritual "sluggishness" of the local population and the disease from which Grant is suffering. The letter also includes a short note from Grant's wife, Abby.

GRANT, ULYSSES S. (1822-1885). PAPERS, 1863-1873. 40 items. Chronological card file. 61-2051.

This collection includes twenty-seven letters written by U. S. Grant to William Elrod, who operated Grant's farm in St. Louis County, Missouri. The first letter from Grant to Elrod describes Grant's property, which included the home site of his father-in-law, Frederick F. Dent. Miscellaneous papers include an insurance policy for $2,000, taken out by General U. S. Grant on the house occupied by William Elrod on "Dent's Farm,"; state and county property tax receipts (1871-1873), which describe the location of the farm; and various newspaper clippings. There is a facsimile document of manumission for "my negro man William" at St. Louis, Missouri, March 29, 1859, attested by Stephen Rice. Also, there is a photograph of Grant. [The papers were purchased in 1940 from Miss Sadie B. Elrod of Centralia, Illinois. The manumission paper is from the Missouri Historical Society.]

GRANT, W. H. (b. 1873). INTERVIEW, 1962. 1 item, tape recording.

The Explorer Post of Jefferson Junior High School in Champaign, Illinois, interviewed W. H. Grant, a Spanish-American War veteran, on October 1, 1962. Grant mentions such things as the eagerness of people to volunteer for service at the outbreak of the war, the military mortality rate from disease in Cuba, the climate of that island, and the fact that Theodore Roosevelt's famous charge was not really made on San Juan Hill. [The tape was received through the generosity of the Explorer Post and Dr. John W. McLure.]

GRATIOT, CHARLES (1753-1817). LETTERS, 1792-1796. 9 items, photocopies.

Charles Gratiot, born in Lausanne, Switzerland, emigrated to Canada after receiving a mercantile education in London. From Canada he set up posts for the fur trade at Cahokia and Kaskaskia. Gratiot played a large role in supplying provisions to George Rogers Clark and his army. At the end of the Revolution, he moved to St. Louis, still engaging in commerce. These letters from a letterbook are to various relatives and business firms. They include a description of the commercial assets of Louisiana, especially New Orleans; a discussion of business matters; and impressions of Anglo-American relations. Also included are a biographical sketch of Gratiot, prepared in 1966 by Jocelyn Ghent, and a photograph of a portrait of Gratiot. [These copies were made from photocopies at the State Historical Society of Wisconsin. The originals are in the Missouri Historical Society.]

GRAVENHORST, ALBERT A. (b. 1839). ACCOUNT BOOK, 1871-1885. 1 volume.

Albert Gravenhorst was the proprietor of the Eldorado Saloon in Effingham, Illinois. This account book held the financial records of patrons of the store; the most frequent items listed were drinks and beer. There are also records of Gravenhorst's accounts with wholesalers from whom he purchased goods to supply his store.

GRAVES, JAMES A. LETTER, October 17, 1844. 1 item.

This letter by James A. Graves from Jacksonville, Illinois, to lawyer John R. Wright in the Iowa Territory, requests Wright's aid in gaining legal permission to sell lands for the widow of William McAmmon.

GREELEY, HORACE (1811-1872). CORRESPONDENCE, 1842-1862. 2 items, transcripts. 1 reel, microfilm. Chronological card file.

The microfilmed letters, mostly from the office of the New York Daily Tribune, are personal letters. One transcript is a letter from Greeley to S. McKnight, Sault St. Marie, Michigan, asking for specimens of Lake Superior ore to give to the British Institution of Practical Geology. The second transcript is of an endorsement on the back of the letter with a note from S. McKnight to B. F. Eaton, asking that ore be supplied. [The microfilmed letters of Greeley are from various collections in the Library of Congress.]

GREEN, HENRY I. (b. 1929). PAPERS, 1969-1970. 3.5 feet. Inventory.

Henry I. Green, a prominent resident of Urbana, Illinois, was elected as a delegate to the Illinois Constitutional Convention of 1970. He served on several committees, especially the Committee on Suffrage and Constitutional Amending. This collection represents the material accumulated by Henry Green as a member of that convention. Included are correspondence, testimony, committee proposals and reports, background information, drafts of constitutions, and a journal of the Convention. [The collection was presented to the Illinois Historical Survey by Henry I. Green.]

GREENBACK CLUB, NO. 131. LINCOLN, ILLINOIS. PAPERS, 1876-1880. 1 volume. 11 items.

The Greenback Party branch in Lincoln, Illinois, was formed in October, 1877. The volume contains the minutes of party meetings in Lincoln. It also includes a letter concerning talks to various branches of the party; resolutions; a booklet of rules with a constitution and platform; a membership application form; and the Club's charter. Also there is a declaration of loyalty to the Greenback movement and five newspaper clippings with political polemics about the monetary problem.

GREENOUGH, OGDEN (1840-1864). PAPERS, 1858-1864, 1903, 1935-1940. 57 items, originals. 61 items, transcripts. 3 items, photographs. Calendar. 69-1596.

Ogden Greenough graduated from Marshall College, Illinois, in 1859 and began studying law in Cincinnati, Ohio. He joined the 38th Regiment Illinois Volunteers as 2nd lieutenant in 1861. Greenough served in Tennessee, Mississippi (Vicksburg) and Georgia and was killed by a rebel sharpshooter on June 15, 1864.

The collection includes an essay on "Religion and Science"; detailed letters written while he was a student and when he was in the army in the Civil War; service papers; and letters, obituaries, and lists of Civil War dead from newspapers. In the letters he discusses school, town, and camp life; experiences in campaigns and battles (such as that of Fort Donelson); political issues; and sociological aspects of the war. The Civil War letters were written from Illinois, Tennessee, Alabama, and Georgia. Notes on Greenough family history written in 1935 and 1936 by Miss Frances E. Greenough, sister of Ogden Greenough, are included with the collection, as are miscellaneous notes from the Greenough family Bible and a Whitlock family record. [These letters were transferred in 1960 from the University of Illinois Archives where they were found among the papers of Dr. Albert Lybyer (Mrs. Lybyer was Greenough's niece.)]

GRIFFIN, CYRUS (1748-1810). LETTER, November 2, 1779. 1 item. 69-1603.

Cyrus Griffin was the last President of the Continental Congress. This letter is from Griffin to the Speaker of the House of Delegates of Virginia and tells of recent events in connection with the Indiana and the Vandalia Land Companies' appeal to the Continental Congress for redress, after Virginia had refused to recognize their land grants.

GRIMES, JAMES WILSON (1816-1872). LETTER, December 5, 1856. 1 item. 69-1599.

James W. Grimes, born in New Hampshire, came to Iowa in 1836, settled in Burlington, practiced law there, and filled many public offices, including those of United States Senator and Governor of Iowa. This letter from Iowa City, written to I. M. Richards, C. O. Thompson, and Charles L. Wilson, comments on the Illinois election of 1856. At that time Grimes was a Republican and fought the extension of slavery.

GRIMKE, SARAH MOORE (1792-1873). PAPERS, 1856-1861. 1 reel, microfilm. 69-1589.

These items relate to the Eagleswood School in Perth Amboy, New Jersey, which was the successor to a Fourierist community. The letters, written primarily by Sarah Moore Grimke to her friends, Sarah G. and Augustus Wattles, discuss education, the Eagleswood School, slavery, the proposed admission of Kansas into the Union, and some general philosophical beliefs held by other correspondents. In addition, there is a statement indicating the general purpose of the school. [These papers were selected from the collection of Weld-Grimke Papers in the William L. Clements Library at the University of Michigan.]

GROW, DAVID T. (1848-1871). LETTERS, 1864-1865. 25 items, machine reproduction. 69-1586.

David Grow was a member of the 30th Illinois Infantry. He sent letters to his parents and sister from Springfield, Illinois; from Camp Butler, Illinois; and from Kentucky, Tennessee, Alabama, and Georgia. The letters discuss camp life, Grow's battle wounds, the battle of Kennesaw Mountain, and Sherman's march to the sea. [The letters were presented to the Survey in 1965 by Mr. L. B. Jobusch of Champaign, Illinois, through the courtesy of Mr. Harold F. Cahalan of Champaign.]

GULICK, CHARLES WESLEY (1836-1916). ACCOUNT BOOK, 1871-1872. 1 volume.

This is an account book for a dry goods store located in Rantoul, Illinois. The store dealt in, among other things, groceries, clothing, hardware and boots.

222

GULLEY, ROY ARBI (1887-1945). DIARY, 1925-1944. 1 item, machine reproduction. 69-1599.

Roy A. Gulley was a Republican Representative in the Illinois 63rd and 64th General Assemblies. He was born and raised near Benton, Franklin County, Illinois, and lived in Sesser, Franklin County, Illinois, from 1912 until his death on January 18, 1945. His various activities included school teaching, farming, real estate, insurance, and being superintendent of Sesser's schools and its postmaster. He was active in local politics and was serving his second term in the General Assembly at the time of his death. The diary, written for himself and his family, contains personal information as well as remarks on more general events. He includes a brief summary of his life up to 1925. [It was donated to the Illinois Historical Survey by Mrs. Mary Alice Gulley, his wife, in 1967. The original typewritten diary is still in the family's possession.]

GUTMANN-STEVEN FAMILY. PAPERS, 1807-1918. 1 reel, microfilm. Calendar.

The major part of the collection consists of letters received by Laura Ernestine Gutmann (later Mrs. James Steven, Jr.) and James Steven, Jr. She came from Hartford, Connecticut, to Sadorus, Champaign County, Illinois, with her family in mid-1857. Most of her letters are from her school friend, Mary Leonora Green (later Mrs. Horatio Harrison Pollard.) The letters to James Steven, Jr., are almost entirely from his brothers: William, a painter in Chicago, and Stewart, a sailor from Arbroath, Scotland. James Steven, Sr., came to the United States in 1854 with all his family, except Stewart, and settled in Champaign County, Illinois.

The letters are predominantly personal and contain little formal business correspondence. There are descriptions of Hartford, Arbroath, and Chicago, and news of friends and family. Of a more general nature are the comments on the Civil War, prices of land and goods, and business conditions. Many certificates for both families are included in the collection. Those for the Gutmann family are generally in German and pertain to birth, baptism, marriage, and citizenship. Those for the Steven family primarily concern naturalization and indenture. [The originals were loaned to the Survey in 1968 for processing and microfilming; they were then returned to the donor, Mrs. Wilbur (Doris) Weasel of Sadorus, Illinois.]

HALLOWELL, ROBERT CHRISTY (b. 1834). BUSINESS RECORDS, 1875-1892. 1 volume. 4 items.

Personal income and expenses are listed in this account book, with the article and price listed in each entry. There are various goods and services such as lumber, corn, mules, cows, hay, tobacco, beef, sewing machines, freight on pumps, and dues to a Building and Loan Association. Furthermore, there are records of the sale and rental of Hallowell's extensive property holdings in the vicinity of Leroy, Illinois. Some of his items of expense have to do with reading and music, including tickets to a library concert and the theatre, dues to the "Library and Reading Room Association," and orders for organ parts and sheet music. Separate items enclosed in the account book are two tax forms, a bill of goods, and a campaign leaflet.

HAMILTON, CHARLES SMITH (1822-1891). PAPERS, 1842-1886. 99 items.

Born in Oneida County, New York, November 16, 1822, Charles Smith Hamilton graduated from West Point in 1843 and later served meritoriously in the Mexican War. Engaging in farming and in flour manufacture at Fond du Lac, Wisconsin (1853), he organized the Third Wisconsin Volunteers in 1861 and served as colonel of the regiment. Early in 1863, he was commissioned major general which provoked a dispute over rank and led to his resignation.

The majority of the correspondence deals with the period 1862-1863, when Hamilton commanded troops at the siege of Yorktown, in the Shenandoah campaign, at the battles of Iuka and Corinth (Mississippi) and in the District of West Tennessee. A rough draft of his letter to Stanton, as well as the acceptance of his resignation, is included. A few letters pertain to the periods prior to and following the Civil War. Three maps are included in the papers, as are orders from commanding officers and correspondence relating to a patent issued to Hamilton. [The papers were given to the Survey by a great-granddaughter of General Hamilton, Mrs. William E. Kappauf, Champaign, Illinois, on February 28, 1969.]

HAMLIN, HANNIBAL (1809-1891). LETTERS, 1860-1865. 17 items, photocopies. Calendar. 69-1586.

These letters were written by Hannibal Hamlin to his wife. They discuss political events, conflicts and policies during his term as Vice President, and also personal and family matters. [Miss Louise Hamlin placed the original letters in the custody of Miss Elizabeth Ring of Portland, Oregon. The letters were reproduced for the Survey in 1940.]

HANNA, JAMES E. Y. CORRESPONDENCE, OATH, AGREEMENT, SURVEYS, PLATS, ca. 1859-1884. 79 items, original. 1 item, photocopy.

James Hanna served as County Surveyor in Pope County, Illinois. The papers in this collection reflect the activities of a county surveyor including the partitioning of estates for heirs, settling disputed land titles and determining disputed boundaries. Almost all of the papers and diagrams concern Pope County; two cases,however, relate to Hardin County, Illinois. In addition, there are hand drawn plats of seven cities in Pope County. [This collection was transferred to the Illinois Historical Survey Library from the Map and Geography Library in January, 1974.]

HARPER, JAMES (d. 1868). LETTERS, 1848. 3 items, machine reproductions.

The letters in this collection describe James Harper's purchase of land and settlement in Shelby County, Illinois. Weather, landscape, produce, transportation and social activities are discussed. [The collection was machine reproduced by the Illinois Historical Survey Library in 1974. Mrs. Gladys H. Meyers, of Assumption, Illinois, possesses the original letters of her ancestor James Harper.]

HARPER, WILLIAM RAINEY (1866-1906). LETTER, December 16, 1886. 1 item.

William R. Harper sent this letter from New Haven, Connecticut, where he was the Principal of the Institute of Hebrew. It is addressed to Thomas H. Pease of Chicago and discusses a book in which they were both interested.

HARRIS FAMILY. PAPERS, PHOTOGRAPHS, NEWSPAPER CLIPPINGS, ca. 1870-1923. 6 items, originals. 2 items, machine reproductions. 1 volume, photographs. 20 cards of mounted newspaper clippings.

The various materials in this collection relate to Benjamin Franklin Harris, of Champaign County, Illinois, and to members of his family. Harris arrived in Illinois in 1835 where he engaged in the cattle business and farming. He became a prominent figure in the Champaign County area and held several county offices. The main item in this collection is a copy of his reminiscences written in 1899 which presents a view of the early development and settlement of Champaign County. In addition, there is a copy of Mary Vose Harris' introduction to her M.A. Thesis, "Autobiography of Benjamin Franklin Harris."

The original papers and the newspaper clippings relate to the deaths of members of the Harris family. They include a death announcement, letters of sympathy, and newspaper stories and obituaries. The photo album contains thirty-one photographs and one tintype. [The Harris memoir, obtained through the courtesy of Mr. Roger Winsor, was duplicated in 1971 from one in the possession of Mr. Newton Dodds, Champaign, Illinois.]

HARRISON, CARTER H., JR. (1860-1953). CORRESPONDENCE, 1884, 1947. 1 item, original. 1 item, carbon copy. 1 item, transcript.

These items include a letter from Carter H. Harrison, lawyer, publisher, and mayor of Chicago for five terms, to Theodore C. Pease. It discusses three William Russells, Harrison's ancestors, and their participation in American wars. Included is Pease's reply, as well as a copy of a letter from Lyman C. Draper to the senior Carter H. Harrison (1825-1893), father of the above, and himself mayor of Chicago for five terms, concerning the services of Colonel William Russell in the War of 1812.

HASTINGS-WILLSON FAMILIES. CORRESPONDENCE, TAX RECEIPT, 1862-1885. 19 items, machine reproductions. Inventory.

The correspondence in this collection originates from various members of the Hastings and Willson families in Ohio. Several of the letters from the Civil War period contain comments on the draft and Morgan's Raid. The tax receipt is for payment made on land in Cumberland County, Illinois, by Bazil Willson. [This collection was loaned to the Illinois Historical Survey for reproduction by Mr. Leland Baird, a descendant of these families, in December, 1973.]

HATCH, JOHN PORTER (1822-1901). LETTERS, 1861-1863. 11 items, photocopies. Chronological card file. 69-1586.

John Porter Hatch, the author of these letters, graduated from West Point in 1845. He attained the rank of captain in the Mexican War, and for his services in the Civil War he was brevetted brigadier general. Reverting to the rank of major, he served twenty years on the western frontier. These letters to his father and sister cover his campaigns in Virginia, especially technical aspects. He also discussed the nature of the battles, political and military figures, and division of troops. [These photocopies are from the Hatch letters in the Library of Congress.]

HAYES, SAMUEL J. (1804-1841). LETTER, July 24, 1837. 1 item, photocopy. Calendar.

Samuel Hayes migrated to Bloomington, Illinois from Granby, Connecticut in the winter of 1836-1837. This letter to his sisters discusses the weather and land conditions in Illinois, as well as land and labor costs. He describes various types of buildings and the number of inhabitants in Bloomington, and he mentions his marriage to Jerusha Crowdery, also from Granby, Connecticut. [The original copy was lost several years ago. A photocopy was received through Dean Louis B. Howard of Sebring, Florida, July 6, 1973.]

HAYS, JAMES WELLEN (b. 1848). NOTEBOOKS, RECORD BOOK, PHOTOGRAPH, 1865-1900. 8 volumes. 1 photograph.

James Wellen Hays, educator, served as Principal or Superintendent of the schools in Urbana for over twenty years. This collection includes a notebook kept by him while at the State Normal School, notebooks containing essays and speeches, and a record book of Urbana School disbursements and receipts (1881-1883). The photograph is unidentified. [These materials were transferred into the Illinois Historical Survey Library in 1974.]

HAYS, NORRIS. LETTER, April 12, 1844. 1 item, transcript.

This letter is from Norris Hays, Fayette County, Illinois, to members of the Rock Springs, Illinois, Baptist Church and concerns an offense against the observance of the Sabbath. [The original is in the Mercantile Library, St. Louis, Missouri.]

HEADEN, WALTER C. (b. 1851). PAPERS, 1849-1934. 271 items. Calendar.

Walter C. Headen was born in Shelbyville, Illinois. He read law under Moulton and Chafee until he was admitted to their firm in 1875. He was active on the local community level as Public Administrator of Shelby County, 1875-1879, and as City Attorney of Shelbyville, 1879-1881. He was twice a member of the Illinois General Assembly in 1884 and 1891.

This collection consists of newspaper articles dealing with Walter Headen's interest in politics; scrapbooks of newspaper clippings; and printed materials on political issues such as the tariff, education, greenbacks and temperance. [The collection was acquired by the University of Illinois on February 19, 1937, from Mrs. W. C. Headen (Shelbyville, Illinois).]

HEMENWAY, ROBERT WRIGHT (d. 1877). PAPERS, 1848-1877. 61 volumes. 203 items. Calendar. Inventory.

This collection includes many of the technical papers of Robert W. Hemenway in his capacity as Chief Engineer of the Western Air-Line Railroad, later the American Central Railway. Among these papers are numerous estimates of costs and work needed to complete the railroad, which were addressed to the President of the road, Hon. R. C. Schenck. There are also numerous bills drawn on the company; various memoranda of work completed on the road bed; and drawings of depots, bridges, and maps of rights-of-way. Seventeen of Hemenway's diaries are included, as are dozens of survey, transit, and level books used to determine proper grading along the right-of-way. Of a more personal nature, the collection includes some of Hemenway's correspondence (1861-1864, 1872-1877) written from Vermont and concerning the township bonds he bought while in Illinois. [The Hemenway Collection was given to the Survey in 1971 from two different sources: Mr. Leonard Karczewski of Chicago, and the University of Illinois Archives.]

HEREFORD, FRANCIS H. LETTERS, 1842-1843. 2 items.

The two letters in this collection were written by Francis Hereford, the postmaster of Hillsboro, Illinois, and both were franked. The first letter is addressed to George R. Michael in St. Louis, Missouri, and asks for a small supply of his pills as the market for them seemed to be good. The second letter, written June 22, 1843, is to his sister in Dover, Tennessee. He discusses the bad wheat and corn crops for that year.

HEWETT, EDWIN CRAWFORD (b. 1828). CORRESPONDENCE, 1861-1864. 13 items.

These letters were written by former students of Dr. Edwin Crawford Hewett of the Illinois State Normal University at Normal, Illinois. Dr. Hewett joined the faculty soon after the institution was founded and served as its president for fourteen years.

The correspondents who were Hewett's students were at this time in the Union Army. They were: Joshua Baily, 73rd Illinois Infantry; Charles M. Clarke, 8th Illinois Infantry; Richard A. Huxtable, 77th Illinois Infantry; Logan H. Roots, 81st Illinois Infantry; and J. E. Willis, 2nd Brigade, 3rd Division, 13th Army Corps. The letters discuss activity in the army camps, the battles, the political issues involved in the war, and the feelings of each correspondent toward the conflict. There are specific references to the Emancipation Proclamation, Copperheads, traitors, the fall of Vicksburg, and a review by General Grant and General Banks. [The letters were the gift of Hewett's grandson, Dr. Edwin Hewett Reeder, College of Education, University of Illinois, January 6, 1954.]

HEYWOOD, THOMAS (1820-1868). JOURNAL AND ADVERTISEMENT, 1856-1865. 1 volume. 1 item.

Thomas Heywood was the organist and choir director of his church in Heywood, England. In 1856, he, his wife, and their children left England for America. This volume contains the experiences of their voyage. The daily entries record sea sickness, the types of passengers, and the daily tasks and habits on board ship. The remainder of the volume is an account book which contains itemized amounts earned for labor. The family settled in Wyoming, Stark County, Illinois. Found in the journal is a sheet advertising and giving instructions for the use of "Self-Rakers." [The journal was given to the Survey November 9, 1963, by Miss Alice Dunlap (Chicago, Illinois) and Mrs. Robert J. Nowlan (Toulon, Illinois), both descendants of the Heywoods.]

HILGARD FAMILY. PAPERS, 1833-1910. 37 items, originals, transcripts. 69-1597.

The letters in this collection were written by Theodor Hilgard from Belleville, Illinois, to his mother, Madame Maria Dorothea (Engelmann) Hilgard, who lived in the Rhenish Palatinate, Bavaria. In addition to the letters there is a composition entitled "Geschichte der Auswanderung Einer Deutschen Familie" ("The Story of the Emigration of a German Family") by Theodor Hilgard. The autobiography of Eugene W. Hilgard in this collection is in three parts: "Biographical Memoir of Eugene Woldemar Hilgard," "Home Life in Illinois," and "Botanical Features of the Prairies of Illinois in Ante-Railroad Days," the latter being also a semi-scientific treatise. Other items are a list of Hilgard's publications; a Memoir of Julius Erasmus Hilgard, 1825-1891, read before the National Academy, April, 1903; and an article in the California Alumni Weekly on Eugene Hilgard. [The letters and other Hilgard items were the gift of Professor Eugene Hilgard.]

HILL, ROBERT L. (b. 1798). LETTERS, 1842. 2 items. 69-1603.

These two letters are from Robert L. Hill in Jerseyville, Illinois, to Judge William Martin in Alton, Illinois. Hill checked local land records for Martin in connection with a lawsuit about mortgaged land.

HILLER, C. H. LETTER, February 24, 1918. 1 item, machine reproduction.

Writing from France during World War I, C. H. Hiller discusses his duties as "Town Major," which included billeting troops and protecting the community. [The letter was found with the Emerson Family papers, the originals of which are in the possession of Dr. Jack Nortrup of Angola, Indiana.]

HINCH, BENJAMIN P. CORRESPONDENCE, 1850-1858. 3 items.

The first letter is from J. T. Lusk to Benjamin P. Hinch, and it discusses the possibility of a trial in order to collect money from a debtor. The next letter, from Charles Slocumb is concerned with the possibility of the opening of a mercantile business. Finally, there is a letter from Hinch to his wife in which he informs her of local events in Hew Haven, Illinois. [The letters were a gift of Wilbur Duncan, Decatur, Illinois.]

HOCH, JOHN (1835-1917). DIARY, 1862-1865. 1 item, original. 1 item, translation.
69-1586.

John Hoch, born in Germany, came to the United States at the age of fourteen. A shoemaker by trade, Hoch enlisted in the 96th Illinois Infantry at Galena, Illinois in 1862, and served to the end of the war. This diary is an account of his Civil War service. Most entries are brief and describe daily routine: marches, meals, etc. [The diary was given to the Survey by Hoch's daughter, Lillian Hoch Schaefer in 1953; the translation of the diary from German to English was made by her.]

HOUGHTON, RHESA C. (b. 1843). LETTERS, 1862-1871. 39 items. Inventory.

This collection consists mainly of war-time letters from Rhesa C. Houghton to his parents, George W. and Susan M., in Wellington, Loraine County, Ohio. Houghton belonged to the 103rd Ohio Volunteer Infantry which became part of the XXIIIrd Army Corps. His army letters reflect the drudgery of a soldier's life in the field, the problems encountered in camp life, and the military activities of his unit. The major military actions that Houghton describes are the Knoxville, Atlanta, and Franklin and Nashville Campaigns, and the North Carolina department, 1865. The letters from Ohio show both the problems faced by a family engaged in agriculture and something of the political climate of northern Ohio. After the war Houghton emigrated to the west, eventually settling with his new wife in Kansas. [This collection was given to the Survey by the University of Illinois Archives, February, 1974.]

HOUSE FAMILY. CORRESPONDENCE, 1842-1857. 26 items. 69-1603.

Fielding House moved from Kentucky to Illinois in 1835 and invested his father's money in three sections in Macon and Christian County. These family letters concern land taxes and titles, legal disputes, family affairs, politics, and crop prices in Illinois. [The letters were given to the Survey by Wilbur Duncan of Decatur. He purchased them from Ted Trevor, Decatur, who had obtained them from a dealer.]

HOWELL, JOSEPH C. (b. 1815). PAPERS, ca. 1850-1888. 6 items, transcripts.

Joseph C. Howell, came to Illinois in 1836 from New Jersey. He served as Carlinville postmaster, as justice of the peace, and, in 1850, as assistant United States marshall for taking the county census. He also sold real estate and agricultural implements. Howell made the first map of Macoupin County and Carlinville.

This collection contains miscellaneous items relating to Macoupin County and the town of Carlinville. There is a "Brief History of Macoupin County" from 1822 to 1858. In it Howell discusses in detail the first settlements of the county. There are also censuses for 1853 and 1854, lists of houses built in Carlinville from 1854 to 1858, lists of voters, minutes of a meeting of old veterans, and a diagram of the square and surrounding buildings in Carlinville. [The original collection belonged to Professor J. D. Conley, and these transcripts were copied from it in 1912.]

HUMISTON, LINUS (b. 1825). LETTERS, 1848-1850. 5 items.

Linus Humiston, from Washington County, Ohio, arrived in Jersey County, Illinois, in 1847, settling in what later became the village of Otterville. His occupations included those of a farmer, school teacher, carpenter, and miller. These letters were written from Otter Creek addressed to his cousins in Beardstown, Illinois. The letters discuss Humiston's teaching, his land purchases, settlement of Oregon, family news, and surveying. [The letters were a gift of Wilbur Duncan of Decatur, Illinois.]

HURLBUT, STEPHEN AUGUSTUS (1815-1882). PAPERS, 1871-1872. 3 items, machine reproductions. 69-1599.

These materials concern Stephen Hurlbut, Illinois politician, Civil War General, first Commander-in-Chief of the G.A.R., and American Minister to Columbia and Peru. The two letters in this collection were written to D.A. Phillips, the Provost-Marshall for Southern Illinois and resident of Anna-Jonesboro, and concern the coming election of 1872, the Republican Party, the Negro question, and the mistreatment of Hurlbut in the Chicago Tribune. There is also an article entitled "The Radiant Home Base Burner," about the coal stove. [The collection was a gift of Dr. Jack Nortrup, Angola, Indiana.]

HUSTON, LUTHER. ACCOUNT BOOK, 1845-1861. 1 volume.

Luther Huston lived near Piqua, Ohio, and owned a farm which specialized in produce and livestock. This account book records Huston's expenditures on farm labor and on personal goods such as tobacco, flour, shoes, and clothing. [The book was donated by Miss Elizabeth Huston, Paris, Illinois, in June, 1964.]

HUTCHINS, THOMAS (1730-1789). PAPERS, 1750-1789. 4 items, transcripts. 1 reel, microfilm. Chronological card file.

The transcripts in this collection are two essays, a short journal, and a letter. The essays are entitled "Extract from Gordon's Journal Down the Ohio, 1766" and "Remarks on the Country of the Illinois". The "Journal of a March from Fort Pitt to Venango and From thence to Presqu' Isle," and the letter, written to Thomas Jefferson, describe characteristics of rivers and surrounding areas.

The microfilm contains volumes one through three of the original papers in the Historical Society of Pennsylvania. All the items are supplemented by hand-drawn maps. The letters were written in connection with his geographical findings and the publication of his maps. There are some bills of payment, together with a document from the British Government which appointed Hutchins as Captain Lieutenant of the Second Battalion of the 66th Royal American Regiment (September 24, 1775). [The transcripts and microfilm were obtained from the collections in the Historical Society of Pennsylvania.]

HUTCHISON, PHEBE JANE MORRISON (1854-1931). MEMOIR, _ca_. 1930. 1 volume, machine reproduction.

Phebe Jane Morrison Hutchison was born at Cherry Fork, Ohio, in 1854, and came to Illinois with her family in 1856. The Morrison family settled in Oak Grove, near present-day Carlock, McLean County. This memoir contains descriptions of school and church events, family and community gatherings, as well as a variety of household and farming experiences. Reactions during the Civil War to enlistments, deaths (especially Abraham Lincoln's), and victories are noted. [The memoir was duplicated from the original copy held by Mr. Robert R. Hutchison, son of the writer, of Birmingham, Michigan; the reminiscences were obtained through the courtesy of Mrs. Theodore Gladhill, Champaign, Illinois, in 1972.]

ICARIAN COMMUNITY. MARRIAGE RECORD, 1853. 1 item, machine reproduction.

This document is from the register of the acts of marriage of the commune of St. Julien de Sault for the year 1853. It records the marriage of Gabriel Nicaise and Rose Brunolf on November 2, 1853. [The copies of this document were donated to the Survey by Mr. James Nelson, Boulder City, Nevada, on August 5, 1970.]

ILLINOIS ARTILLERY. 1st REGIMENT. RECORD BOOK, 1812-1814. 1 volume.

Captain Joseph Cross's company saw duty at Bellefontaine, Louisiana Territory, and Fort Massac, with detached services at Fort Madison and Fort Osage. This company muster book includes a table of contents; priority rolls of enlistment and description; registers of men tried, discharged or transferred; registers of dead, deserted, and missing; provision returns; accounts of clothing and equipage; and individual accounts. Various pages were used as a fee book, 1837-1838.

ILLINOIS. AUDITOR OF PUBLIC ACCOUNTS. PAPERS, 1814-1818. 13 items, transcripts. 69-1603.

These transcripts of a number of significant documents were selected from the records of the Kaskaskia and Edwardsville land offices. They deal with Michael Jones' administration, the location of claims, surveys, military lands, and other matters. Documents include resolutions of the Illinois Territorial Legislature, petitions to Congress, and correspondence. [The originals are now in the Illinois State Archives.]

ILLINOIS CANAL COMMISSIONERS. PAPER, 1824. 1 item, transcript.

This is a report made by Erastus Brown and Emanuel J. West, Commissioners, to Thomas Sloo, Jr., of Alton, Illinois, on the investigation made by themselves and engineers of the route of the proposed (Illinois and Michigan) canal. [The original document is with the Historical and Philosophical Society of Ohio.]

ILLINOIS CENSUS, FRAGMENTS. PARTIAL CENSUS ENTRIES, 1810, 1818, 1830, 1850. 2 items, transcript. 3 items, photocopies. 69-1598.

This collection is composed of fragmentary census entries: "Persons Within the Division Allotted to T. C. Patterson, November 24, 1810"; a portion of the Census of 1818 for Bond County; a photocopy fragment of the 1830 census for Macon County; and two photocopied fragments of the 1850 census for Springfield, Sangamon County, November 7, 1850, and for Naperville, Du Page County, August 26, 1850. These items serve as examples of forms and entries of the different census records in the ante-bellum era in Illinois.

ILLINOIS CENTRAL RAILROAD COMPANY. CORRESPONDENCE, PASS, 1858-1870. 1 item, original. 2 reels, microfilm.

The correspondence in the collection deals with the activities of the Illinois Central Railroad Company between 1858-1870. The first reel of microfilm contains reports concerning the state of the countryside, as well as the value of the road itself; and one letter from the Midland Railway of Derby, England, describes the procedures necessary to switch from coke to coal. The second reel of microfilm contains selections from the letterbooks of J. C. Clarke, G. B. McClellan, J. M. Douglas, and W. H. Osborn. Also included are Records of the Office of the Quartermaster General, 1861-1866. [The microfilm was obtained from the Newberry Library and donated to the Illinois Historical Survey by Robert M. Sutton.]

ILLINOIS. COMMISSION ON ILLINOIS-INDIANA BOUNDARY. REPORT, 1821. 1 item, photocopy.

This is a 15 page report, supplemented by maps and tables of latitude and longitude, concerning the drawing of boundaries between Indiana and Illinois. The report was made to the Governor and the General Assembly of the State of Illinois. [It was copied from the original which is now in the Illinois State Archives.]

ILLINOIS. CONSTITUTION, 1870. CONSTITUTION, FRAGMENT, 1870. 1 item, photocopy.

This is a reproduction of page one of the "Constitution of the State of Illinois, adopted in Convention at Springfield," May 13, 1870. [The reproduction was given to the Survey by the Illinois State Archives where the original is located.]

ILLINOIS. DEPARTMENT OF PUBLIC WORKS AND BUILDINGS. PAPERS, 1935-1942. 13 items.

A. Fort Chartres restoration, 1935-1942, 11 items. The correspondence of Theodore C. Pease and Natalia M. Belting with Joseph F. Booton, Chief of Design of the Division of Architecture and Engineering for the State of Illinois, concerns information which was needed to restore Fort Chartres. There is included a translation by Dr. Belting of an inventory of the chapel's furnishings. In connection with the restoration there are extensive and detailed blueprints of the fort.

B. Cahokia Court House restoration, 1938, 2 items. With an introductory letter, Joseph F. Booton sent to Professor Theodore Pease a copy of the preliminary report of the research work done in connection with the restoration of the Cahokia Court House.

ILLINOIS. GENERAL ASSEMBLY JOURNAL (10th), 1837. FRAGMENT, February 27, 1837. 1 item, photocopy.

This page of the Senate Journal contains the minutes of a session which discussed the formation of Coffee County (what is today predominately Stark County), an act to locate a state road, an act to incorporate a railroad company and a manufacturing company, and other subjects. [The photocopy is from the Illinois State Archives.]

ILLINOIS GOVERNOR, 1818-1822. PROCLAMATION, December 22, 1818. 1 item, transcript.

This proclamation, issued by Shadrach Bond, announces the admission of Illinois as a State in the United States and calls a meeting of the Illinois General Assembly in the month of January in Kaskaskia. [The transcript is from the Executive Records, 1818-1832, in the Illinois State Archives.]

ILLINOIS LAND RECORDS. FEDERAL SURVEYORS' FIELD NOTES, TOWNSHIP PLATS, TRACT BOOKS, SALINE RECORD BOOKS, 1804-1868. 84 reels, microfilm. 5 maps. Index, inventory.

This collection contains the field notes and township plats of the original federal survey of Illinois townships. The fifty-nine microfilm reels of surveyors' field notes describe the natural and artificial marks and boundaries of each Illinois township, and the seven reels of plat maps illustrate each township and its markings. There are also four maps included in this collection which serve as an index to the notes and plats. The tract books on 17 reels of microfilm were kept at the ten U.S. land offices in Illinois. They record the original sales of government land. A map indicating the boundaries of the districts is included. The saline record books primarily concern the sale of the saline lands in Gallatin County, Illinois. [The original Illinois Field Notes and Township Plats are located in the Illinois State Archives.]

ILLINOIS. LAWS. ACT, March 30, 1819. 1 item, transcript.

This is "AN ACT respecting free Negroes, Mulattoes, Servants, and Slaves." Among the provisions were that, after the date of the act, no Negro could enter the state unless he had a certificate proving his freedom, nor could any Negro be hired unless free.

ILLINOIS MILITIA, 3rd REGIMENT, COMPANY A. RECORD ROOK, 1846. 1 volume.

The record book of the 3rd Regiment of the Illinois Volunteer Militia, Company A (Ferris Foreman, Colonel) begins with General Order No. 1, which directs that an election for Major take place at the batallion camp in Alton. The remainder of the journal contains lists of casualties and discharged, followed by a descriptive roll of the company.

ILLINOIS. MONTGOMERY COUNTY RAILROAD RECORDS. PAPERS, 1871-1896. 50 items. 69-1618.

These papers are reports from railroad companies in Montgomery County, Illinois. Information they supply is as follows: inventory of property, i.e. railroad track, rolling stock, tools and materials for repairs, all other personal property and real estate (for tax purposes); the location and listed value for the several railroads operating in and through Montgomery County; a report by Isaiah Whitten, Montgomery County Surveyor, and E. R. Styles for the St. Louis, Alton, and Terre Haute Railroad Company to the Montgomery County Court concerning the condition of railroad crossings; two statements from the Auditor of Public Accounts to the County Clerk of Montgomery County, for the years 1887 and 1890, indicating the assessed valuation of each railroad operating in Montgomery County; and a letter from Joseph Moses, Special Tax Agent for the Cleveland, Cincinnati, Chicago and St. Louis Railway Company to John Green, Montgomery County Treasurer, concerning local tax assessment of railway property.

ILLINOIS NATIONAL GUARD, 9th REGIMENT, 1st BRIGADE, COMPANY D. INSPECTION ROLL, 1878. 1 item.

This inspection roll of 1878 lists the names, ages, heights, dates of enlistment, residences, occupations, and number of drills attended by the members of the Champaign-Urbana (9th) Regiment of the Illinois National Guard (1st Brigade, Company D). [The manuscript was transferred to the Survey from the University of Illinois Library's Rare Book Room in 1967; it had been a gift of David L. Rooks.]

ILLINOIS. SECRETARY OF STATE. PAPERS, 1809-1820, 1822, 1860-1861, 1862. 62 items, transcripts. 69-1610.

This collection is divided into four parts by date. The first group (1809-1820) concerns the administration of justice, militia commissions, the escape of Indian prisoners, kettles at the Saline, and other matters. The second group (1822) concerns the disputed Shaw-Hansen election for state representative from Pike County and includes a poll book. The third group (1860-1861) comprises tables and returns of various Illinois elections, which were prepared and collated in 1923 by S. J. Buck and W. E. Stevens from records in the Illinois State Archives. The last group (1862) contains returns relative to the vote on the Constitution of 1862 and for state and federal offices; they were compiled from returns in the Illinois Secretary of State's Office.

ILLINOIS TERRITORY. PAPERS, 1801-1822. 20 items, transcripts. 69-1610.

This is a collection of miscellaneous notes and transcripts concerning the Illinois Territory. It is composed of the following materials: notes concerning the 1818 census schedule, a record of cattle marks, lists of territorial office holders, a tally of votes in the election of the Edwards County delegates to the 1818 Convention, a record of Randolph County marriage licenses (1809-1822), an excerpt from the Edwards County Commissioners Record A (1818), a signed petition from the inhabitants of Gallatin County to have Hugh Robertson appointed Justice of the Peace (1818), a letter from Daniel Pope Cook (February 6, 1817), two letters concerning Michael Jones, Register of the Land Office at Kaskaskia (1814, 1822), two excerpts from the Annals of Congress, a petition concerning the seat of Illinois government (1818), a list of Edwards County land entries (1818), an announcement of the formation of the town of Waterloo, notes concerning the surveying and sale of lands and the establishment of post roads, and a map of Illinois which indicates lines of survey, of settlement, and of the Indian boundary (n.d.).

ILLINOIS (TERRITORY) LEGISLATURE. PAPERS, 1807-1818. 32 items, originals. 9 items, transcripts. 62-1237.

These papers contain five acts, passed on September 17, 1807, October 25, 1808, and December 8, 1813, the first three of which were actions of the Indiana Territorial Legislature (Illinois at that time being a part of the Indiana Territory). They concern the introduction of Negroes and mulattoes into the Indiana-Illinois region and make provisions for the indenture of servants. The other two items are a law of December 8, 1813, revising a previous law and requiring viva voce voting, and an act to incorporate the City and Bank of Cairo, approved January 9, 1818.

Thirty-two of the documents are drafts of bills and acts of the Territorial Legislature of Illinois, 1813-1816. The acts cover various legal and procedural matters, civil matters, and the formation and size of counties. There are also various bills covering the revenue laws, taxes, and counterfeit money. Three items include a bill authorizing a road survey, 1814; a long memorial to Congress regarding the powers of the executive under the Ordinance of 1787; and an act regarding slavery, 1817. [These last three transcripts were made from the Papers of the Secretary of State, now in the Illinois State Archives, Springfield.]

ILLINOIS, UNIVERSITY OF. ILLINOIS HISTORICAL SURVEY. ARCHIVES. PAPERS, 1903-1972. Approximately 25 feet. Inventory.

These papers reflect the origin, development, and activities of the Illinois Historical Survey of the University of Illinois. Included in the files are materials reflecting Clarence W. Alvord's searches for sources on Illinois History and his work as editor of the Illinois Historical Collections. A very large portion of the papers concerns Theodore C. Pease's term as director of the Survey and editor of the Illinois Historical Collections.

These archives contain Minutes of the Board of Trustees of the Illinois State Historical Library, Editors' Reports, and Trustees correspondence; and files on the Illinois Centennial Commission, the Thirty-Third Division (the First World War), Historical Records Survey, and the Fort Chartres Restoration Project. There is also extensive correspondence relative to various professional organizations such as the American Historical Association, Mississippi Valley Historical Association, and the Society of American Archivists. In addition, a large portion of the archives contains information relative to the copying of foreign manuscripts in Great Britain, France, Spain, and Canada. Finally, there are the papers which reflect research requests and other aspects of the daily work of a historical agency.

ILLINOIS, UNIVERSITY OF. ILLINOIS HISTORICAL SURVEY. ILLINOIS IN WORLD WAR I. PAPERS, 1917-1924. 14 folders. 61-3389.

The War Records Section of the Illinois State Historical Library contains reports, working files, form letters, and bibliography. This organization was set up in 1919 to make the collection of the state's war records which is now in the Illinois State Historical Library in Springfield. The Survey's collection contains duplicates of some of the working files. There are reports of the work of the War Records Section made to the Board of Trustees of the Illinois State Historical Library, 1921 and 1922, and a summarizing report sent to N. D. Mereness, Washington, D. C., in May, 1924, as well as articles and papers on the work of the W. R. S. Copies of 117 form letters sent out to county and local members of war agencies, together with a file of the War Records Bulletin published for the purpose of stimulating local war records collections, are included. The bibliography was prepared in connection with the publication of the volumes on Illinois in the World War.

The second group in this collection is composed of the papers of the University of Illinois War Service Committee. These files belonged to E. B. Greene, then head of the History Department and director of the Survey, who served as chairman of the University's War Service Committee. The files include correspondence, reports, publications, memos on the University's participation in the war, particularly the war issues courses. They also cover fund-raising activities for various European relief organizations.

The third group of papers covers the Champaign County Council of Defense; the County Fuel Administration, 1917-1919; the War Camp Community Service; the Cooperating Committee on Tuberculosis War Problems; the Food Production and Conservation Committee; the Liberty Loan Committee, 1917-1919; and the Champaign County Four Minute Men, with a separate folder on working materials belonging to this organization.

The last section is a folder of correspondence and data assembled by Arthur C. Cole for his chapter on the World War in Illinois Centennial History, Volume 5. [The material for the War Records Section was deposited by Marguerite J. Pease, who directed the work in the years 1920-1924.]

ILLINOIS, UNIVERSITY OF. ILLINOIS HISTORICAL SURVEY. UNIVERSITY OF ILLINOIS IN WORLD WAR II. PAPERS, 1942-1943. 42 items. 61-3318.

These papers contain reports by various University officials, clippings of news stories, miscellaneous publications and letters relating to the University's participation in World War II. There are twenty-two pamphlets which encourage people to stretch their resources and use rational methods of production, especially relating to agriculture. Other types of support for the war effort, such as investing in savings bonds, were encouraged. [Some of the material was passed out at an Illinois press inspection tour of the University, October 22, 1943. The papers were given to the Survey by Marguerite J. Pease.]

ILLINOIS-WABASH LAND COMPANY. PAPERS, 1773-1782, 1810. 5 items, facsimile, transcripts. 69-1603.

After the union of the Illinois and Wabash Land Companies in 1778, it was resolved that the deeds of the two companies should be copied in a book of records, which would also contain the proceedings of the proprietors through March, 1779. Further materials in the collection include: a transcript of a memorial presented by the United Illinois-Wabash Land Companies to the United States Congress on December 21, 1810; and an "Account of the Proceedings of the Illinois and Ouabache Land Companies in Pursuance of Their Purchases Made of the Independent Natives, July 5th, 1773, and 18th October, 1775." In addition, there is a copy, from the Journals of the Continental Congress, of the petition of the Illinois-Wabash Company to the Continental Congress concerning the division of territory. [The facsimile of the record book was obtained by reproduction of the original in the possession of Cyrus McCormick. Other materials in the collection concerning land were obtained from H. Joseph and Company, Montreal.]

ILLINOIS. WAR COUNCIL RECORDS. PAPERS, 1940-1945. 7 folders. 61-3317.

This state agency, which was organized on April 25, 1941, co-ordinated state war activities through a central organization and advisory groups. The papers of the Council are divided into seven sections, with the first section containing correspondence, minutes, memoranda of the Division of War Records and Research, a list of the membership, and proposals for a war history. The second section is a report of the "Activities of Local Councils of Defense." Part three is the War Records Program of the Illinois War Council. Section four comprises a report of the "Activities of the State Council of Defense" and the Illinois War Council. The fifth section is composed of a Report of the Activities of the Illinois War Council, and the sixth section is a supplement. Finally, part seven is a Report of the Activities of the Division of War Records and Research. [These files were contributed by Marguerite J. Pease, a member of the Advisory Committee to the Division of War Records and Research.]

INDIAN CLAIMS. POTAWATOMIS, OTTAWAS AND CHIPPEWAS. PAPERS, ca. 1839-1846, 1953-1959. 230 items, originals, photocopies, transcripts. 69-1600.

These are materials on land values collected for a report for the Potawatomis and Associated Tribes (Ottawas and Chippewas) in their suit against the United States Government, heard by the Indian Claims Commission, January and February, 1959. The collection was given to the Survey by Professor Natalia M. Belting, University of Illinois, who was consulted in the case.

1. A report on land cessions under the Treaty of Prairie du Chien, July 29, 1829.

2. The report of Dr. John Lee Coulter for the Indian Claims Commission.

3. A memorandum to the Council from Ida Fox concerning the agricultural aspects of cessions 147 and 148, submitted April 30, 1956.

4. A tabulation by township of land sales in the ceded territory in the 1820's and 1840's.

5. Two photocopied maps of Wisconsin showing density of population.

6. A photocopied map showing prairie soils in Illinois.

7. A "List of Canal lands sold in 1841 and 1842."

8. Lists of land sold in northern Illinois (Chicago and Dixon) in 1842 at the Land Office in Chicago.

9. 188 Plats of Northern Illinois townships, tracts 147 and 148.

10. Mimeographed materials from various sources describing land features and mineral wealth in Northern Illinois and Wisconsin.

11. The Citizen Band and the Potawatomi Nation (Docket No. 71-A).

12. "Findings of Fact" of the "Indian Claim Commission..."

13. Several items, particularly petitions, briefs, and reply briefs, filed with the United States Supreme Court, the United States Court of Claims and the Indian Claims Commission.

14. An appraisal report of Royce Area 99 filed with the Indian Claims Commission in 1955 by Berkley W. Duck.

15. A report by Ida Fox on the development of lead mining in Illinois between 1816-1829 on lands claimed by the United Nations and Winnebago Indians.

INDIAN LANGUAGES. PAPERS, 1827-1908. 15 items. 69-1600.

This collection includes the following items: three Indian-English vocabularies
(Algonquin) in manuscript; word lists of terms used by New England tribes; lists of
"Muskokee" (Muskogee) Indian words; words of the St. Francis Indian dialects; and, in a
letter from C. L. Hall to Professor John B. Dunbar (August 19, 1879), word lists of
Arickaree Indians. There are also texts of three Arickaree war songs, with interlinear
English translations, from C. L. Hall. This collection also contains a letter from
Wilberforce Eames, September 9, 1888, referring to a hymn book in a South African native
language.

These items were perhaps part of a collection belonging to Professor John B. Dunbar, a
philologist especially interested in the languages of the tribes of Kansas, Nebraska and
Missouri. His father, the Rev. John Dunbar, was a missionary to the Pawnee. In addition
to the manuscript items, these folders contain John B. Dunbar's "The White Man's Foot in
Kansas" (1908) and other excerpts from publications of the Kansas Historical Society.

INDIAN TRADE LICENSE. LICENSE, 1765. 1 item, facsimile.

This licence, issued by John Penn, allowed trade with the Indian Nations which lived under
the protection of the English King and subjected the holders of the license to existing
trade regulations.

INGERSOLL, HENRIETTA (CROSBY). CORRESPONDENCE, 1862-1865. 4 items, photocopies.
Calendar. 69-1586.

These letters are from John P. Hale, senator from New Hampshire, to Mr. G. W. Ingersoll
and from Horace Greeley to Mrs. H. C. Ingersoll. The letter from Hale (1862) was written
in response to a request from Ingersoll that the senator try to get Ingersoll's son into
West Point. The three letters from Greeley discuss issues such as the problems of his
Tribune and the desire that Lincoln not be re-elected. [The photocopies were obtained from
the H. C. Ingersoll letters in the Library of Congress.]

INMAN, HIRAM. LETTER, August 25, 1845. 1 item. 69-1603.

In his desire to sell some land he owned in Steuben County, Indiana, Hiram Inman wrote
this letter to the County Clerk in that county for assistance in the sale.

IROQUOIS COUNTY, ILLINOIS. SCHOOL DISTRICTS. RECORDS, 1896-1936. 2 reels, microfilm.

These registers for several schools in Iroquois County, Illinois, contain varied
information: lists of children's and visitors' names, days absent and reasons for some
absences, grades, promotions, text books used, behavior problems, and course outlines.
Included are registers for Pittwood School (1896, 1902-1911), Columbia School (1902-1909),
Victory School (1901-1904, 1904-1909), Elgin School (1910-1917, 1923-1929), Center School
(1923-1929, 1930-1936) and West Watseka School (1912-1924). [The registers were loaned to
the Illinois Historical Survey for microfilming in April, 1972, by Mrs. H. Edmond Pratt of
Watseka, Illinois.]

ITALIAN ARCHIVES.

This collection of transcripts and microfilm copies of manuscripts from Italian archival depositories was given to the Illinois Historical Survey by Professor Mary Lucille Shay, a member of the History Department of the University of Illinois. These materials were collected by Prof. Shay while she was engaged in a study of Comte Francois Joseph de Viry (1707-66). Viry, who was the Sardinian minister to London, 1755-1763, had the ear of the leaders of all political factions and acted as a trusted channel of communication. The part he played, together with the Sardinian ambassador in Versailles, in the negotiating of the peace treaty of 1763 is described in the introduction of T. C. Pease, Anglo-French Boundary Disputes in the West, 1749-1763. The Viry-Solar correspondence in part is also printed in that volume.

Guides

To aid in locating materials in various Italian archival depositories the following guides may prove to be of use: Carl Russell Fish, Guide to the Materials for American History in Roman and Other Italian Archives (Washington, 1911); David M. Matteson, List of Manuscripts concerning American History preserved in European Libraries and noted in their Published Catalogues and similar Printed Lists (Washington, 1925); Gli Archivi di Stato Italiani (Bologna, 1944); and most important, Professor Shay's chapter in Daniel H. Thomas and Lynn M. Case, Guide to the Diplomatic Archives of Western Europe (Philadelphia, 1959).

Organization

The papers from the Turin State Archives are organized on the basis of the arrangement of the original depository; first, by classification of type and origin of letter, and then by mazzi (bundles). Since the volume or bundle numbers of copies of manuscripts from the Florence State Archives are not available, the Survey's organization is based on film strip number.

Manuscripts

ARCHIVO DI STATO (TURIN). CORRESPONDENCE, 1755-1763. 268 items, microfilm strips. 62-87.

The diplomatic correspondence of the Kingdom of Sardinia and of Savoy are among the papers housed in this depository. Because of the activities of the Comte de Viry, they have particular bearing on the diplomatic negotiations and affairs during the Seven Years War. For a description of the depository and its holdings, see especially Professor Mary Lucille Shay's article in the Thomas and Case, Guide..., 125-131, and Gli Archivi De Stato Italiani, 405-448.

Letters of the Ministers to England, 1755-1763

59. (1) October 23, 1755. Letter from Viry to the King.

60. (8) 1756. Letters from Viry to the King and to the Secretary of State Ossorio.

61. (3) 1757. Letters from Viry to the King.

63. (18) 1758. Letters from Viry to the King and to Ossorio; Desjacques to Ossorio.

64. (11) 1758-1759. Correspondence of Viry with the King and Ossorio; Raiberti to Viry.

65. (7) 1759-1760. Correspondence of Viry with the King; Viry to Ossorio.

66. (13) 1760-1761. Correspondence of Viry with the King and Ossorio.

67. (11) 1761-1762. Letters from Viry to the King and to Ossorio; King to Viry.

68. (11) 1762-1763. Correspondence of Viry with the King; letters from Viry to Raiberti; Ossorio to Viry.

ITALIAN ARCHIVES.

<u>69</u>. (2) 1763. Letters from the King and Raiberti to Viry.

Negotiations, English

<u>1, addizione</u>. (2) 1755, 1756. King's Instructions to the Comte de Viry and to Baron Joseph Marie de Viry de la Perriere.

Letters of the Ministers to France

<u>203[?]</u>. (2) 1762. Letters and memorial from Solar de Breille to the King.

Negotiations, Great Britain

<u>Ultima addizione (18th century)</u>. (1) May 30, 1762. Solar de Breille to Viry.

Sardinia, Letters of the Intendant General, 1720-47.

<u>[No Mazzo Number.]</u> (9) 1745-1746. Letters from Viry to the Secretary of State, St. Laurent.

Letters of the Ministers to Switzerland, 1738-1741

<u>42</u>. (34) 1738-39. Letters from Viry to the King; memorials from the King to Viry; projected alliances and articles.

<u>43</u>. (18) 1741. Letters from Viry to the King; memorials from the King to Viry; projected Plan and Treaty.

Letters of the Ministers to Holland, 1751-1754

<u>47/2</u>. (19) 1751. Letters from Viry to the King; memorials from the King to Viry.

<u>48</u>. (31) 1752. <u>Ibid</u>.

<u>49</u>. (44) 1753. <u>Ibid</u>.

<u>50</u>. (23) 1754. <u>Ibid</u>.

ARCHIVO DI STATO (FLORENCE). PAPERS, 1755-1763. 81 items on microfilm strips. 61-1474.

Among the papers housed in the Florentine depository are the diplomatic correspondence of the Grand Duchy of Tuscany. The Survey's letters from this group are from Vincenzo Pucci, who was the agent of the Grand Duke of Tuscany in London from 1738 until his death in July 1757, and from his successor Domenico Pucci from 1757 to 1766. They are written to the Comte de Viry and thus have bearing on the diplomatic negotiations and affairs during the Seven Years War. For a description of the depository and its holdings see especially Prof. Mary Lucille Shay's article in the Thomas and Case <u>Guide...</u>, 142-144, and <u>Gli Archivi Di Stato Italiani</u>, 67-106.

<u>Film Strip #1</u>. (8) 1755-1756. Letters from Vincenzo Pucci to Viry.

<u>Film Strip #2</u>. (4) 1756. <u>Ibid</u>.

<u>Film Strip #3</u>. (8) 1756. <u>Ibid</u>.

<u>Film Strip #4</u>. (9) 1757-1758. Letters from Vincenzo and from Domenico Pucci to Viry.

<u>Film Strip #5</u>. (11) 1758-1759. Letters from Domenico Pucci to Viry.

ITALIAN ARCHIVES.

Film Strip #6. (9) January–March, 1759. Letters from Domenico Pucci to Viry.

Film Strip #7. (13) 1759–1761. Ibid.

Film Strip #8. (11) 1762–1763. Ibid.

Film Strip #9. (8) 1762–1763. Ibid.

JACKSON, JAMES. DOCUMENTS, 1822. 3 items.

These documents include two bills of sale, one by Alan and Nancy Emerson and another by James Forest Jackson, to James Jackson. The other item is an agreement whereby James Forest Jackson promised to reside on and improve a farm owned by James Jackson. [These items were transferred to the Illinois Historical Survey Library from the Rare Book Room of the University of Illinois Library in 1973.]

JAMESON, ROBERT EDWIN. LETTERS, 1860-1862. 5 items, photocopies. Calendar. 69-1586.

These letters from Robert Edwin Jameson, a surgeon, to his mother and other members of his family were written while he was serving in the Union Army, primarily in the vicinity of Washington, D. C. In them he discusses his political views concerning the secession of the South, together with personal matters. He also describes some experiences he had with his regiment: the pursuit of food, the stops at towns, a visit to Washington D. C., living conditions, and his seeing Generals McClennan [McClellan] and Burnside. [These are photocopies from the R. E. Jameson Papers in the Library of Congress.]

JEFFERSON, THOMAS (1743-1826). PAPERS, 1783-1833. 11 items, photocopies. 3 reels, microfilm.

The photocopies are composed of letters, a numerical system of classification of books, and notes found in his copy of "Diodorus Siculus." The letters are between Jefferson and Joseph Cabell (who assisted Jefferson in founding the University of Virginia), between Jefferson and James Madison, and between Madison and W. A. Duer. They are concerned with education both on the primary and college level and discuss the inculcation of liberal values (freedom, republicanism, etc.), textbooks, and the passage of bills favoring the writers' conception of education.

The microfilm contains a catalogue of Jefferson's library begun in 1783 and added to until 1814; minutes of the Board of Visitors, University of Virginia; and a catalogue of the books in the University of Virginia Library (1825). [The photocopies of the letters involving Madison were taken from the Madison Papers in the Library of Congress, and those of the other letters are from the Jefferson Papers in the University of Virginia Library. The microfilm are from the Massachusetts Historical Society and the Alderman Library, University of Virginia.]

JENNINGS, JOHN (ca. 1738-1802). JOURNAL, 1766-1768. 1 item, transcript. Calendar. 69-1613.

This "Journal, From Fort Pitt, to Fort Chartres, in the Illinois Country" extends from March 8, 1766, through April 10, 1768. The journey, with Captain William Long and a Major Smallman, began on the Ohio River and continued to the Mississippi. John Jennings describes Kaskaskia and Fort Chartres and relates skirmishes with the Indians at Fort Chartres, as well as friendly contacts with them. In May, 1768, he went down the Mississippi to New Orleans. [The transcript was made from a copy of the journal in the Historical Society of Pennsylvania.]

JEWETT, GEORGE O. LETTERS, 1863-1865. 3 items, photocopies. Calendar. 69-1586.

These letters were written by three soldiers in the Civil War. They discuss the problems of long marches, of drunkenness, and morale, and concomitantly, of provost duty in and near the cities. Political issues discussed were conscription, the use of Negroes as soldiers, the effectiveness of the Emancipation Proclamation, and the problem of remaining within the bounds of the Constitution while fighting the war. [The letters are from the papers of George E. Jewett (17th Massachusetts Volunteers) in the Library of Congress.]

JOHNS, JANE M. CORRESPONDENCE, 1918. 2 items. 69-1599.

In these reminiscences about Abraham Lincoln, contained in a letter to C. W. Alvord, Mrs. Johns stressed the historic importance of the senatorial election of 1855 and the sacrifice Lincoln made when he broke from his party to advocate "free territory for free men." Also included is a return letter from Mr. Alvord to Mrs. Johns.

JOHNSON, ANDREW (1808-1875). CORRESPONDENCE, 1860-1869. 18 items, photocopies. Calendar. 69-1586.

These letters include four from Orville H. Browning, Secretary of the Interior under Johnson, and correspondence between Johnson and his cabinet concerning their recollections of a cabinet meeting relating to General Grant's services. The remaining letters contain discussions of the Philadelphia Convention and the problem of cabinet members, and include four letters from Illinois correspondents. [The letters from the correspondents in Illinois are from miscellaneous collections in the Library of Congress. The remainder are from the papers of Andrew Johnson in the Library of Congress.]

JOHNSON, WILLIAM (1715-1774). PAPERS, 1763-1774. 235 items, transcripts, photocopies. Calendar. 69-1587.

Except for eight items, these transcripts were made from the Sir William Johnson manuscripts in the New York State Library, and many are published in Illinois Historical Collections. Fires in the New York State Library did serious damage to the Johnson Manuscripts, and the Survey transcripts made before 1915 were, in 1934, borrowed back by the New York Library for copying. [Four letters from Johnson to William Franklin (1766-1769) and one to Benjamin Franklin (1766) are from the American Antiquarian Society. Two items, photocopies of Johnson's portraits, were received from the New York State Education Department-Division of History in 1915. One item, a statement by Johnson on the authority of the commissaries (1767) is from Documents Relative to the Colonial History of the State of New York.]

JOHNSTON, HARRIET LANE (1830-1903). LETTERS, 1861-1864. 21 items, photocopies. Calendar. 69-1586.

These letters were written to Miss Harriet Lane (later Harriet Lane Johnston), the orphan niece who served as hostess for her uncle, President James Buchanan. The letters were sent to Wheatland, Pennsylvania where Miss Lane and James Buchanan were living after his Presidency, and concern personal and family matters. Two articles in the collection deal with Lincoln's first reception and problems of government after Lincoln's death. [The originals of the letters are with the Buchanan-Johnston Papers in the Library of Congress.]

JONES, TIGHLMAN HOWARD (d. 1864). PAPERS, 1861-1864. 12 items, originals, transcripts. 1 reel, microfilm. 69-1586.

Tighlman Jones, a sergeant of the 59th Illinois Volunteers, was mortally wounded in the fighting around Nashville and died on December 25, 1864. The letters in this collection, both on microfilm and in the transcripts, were exchanged between Jones and his family. Writing from Missouri, Arkansas, Kentucky, Tennessee, and Georgia, he described the countryside, the towns, and the nature of his regiment's marches. He discusses subjects of a wide political range, as well as the politics of Union officers and their tendency toward inebriation. He also reported on the battles of Atlanta and Murfreesboro.

There are also two diaries in which he made various types of entries, including accounts, pictures, maps, fragments of short stories, thoughts on politics, philosophy and nature, extracts from periodicals, and letters. [These papers were given to the History Department of the University of Illinois around 1955 by Delcie Harper of Yale, Illinois, and subsequently were transferred to the Survey.]

JORDAN, ELIJAH (1875–1953). PAPERS, 1905–1959. Approximately 5 feet, originals, carbon copies, and photocopies. Calendar.

Elijah Jordan, raised in southern Indiana, served as professor of Philosophy at Butler University from 1913 until 1944. He authored eight books (one published posthumously) and numerous articles. Jordan's writings developed a philosophical system which sets him apart from contemporary philosophical trends. This collection contains between one and five draft revisions for each of Jordan's books. The correspondence covers the years from 1905 through 1953. Many letters refer to Jordan's graduate school experiences (at the Universities of Cornell, Wisconsin and Chicago) and his difficulties in obtaining a teaching position. Occasionally Jordan and his correspondents entered into lengthy discussions of current philosophical trends. Other topics include the preparation and publication of Jordan's books and the reactions of scholars to them. Among his major correspondents are J. E. Creighton, Max Fisch, Warner Fite, D. W. Gotshalk, Thomas Haynes, Robert D. Mack, Glenn Negley, M. C. Otto and Forrest O. Wiggins.

Other materials in the collection relate to the efforts of Dr. Max H. Fisch to compile a biography and bibliography for inclusion in the volume, Metaphysics, edited and published after Jordan's death. [The Jordan material was given to the University of Illinois Foundation in 1955. It was housed in the University Archives before being turned over to the Illinois Historical Survey in February, 1971.]

JORDAN CONFERENCE COLLECTION. PAPERS, 1956–1959. 177 items. Calendar.

This collection centers around correspondence of Max H. Fisch who organized two conferences on the Social and Political Philosophy of Elijah Jordan. These conferences were financed by a grant from the Rockefeller Foundation through the American Philosophical Association's Committee to Advance Original Work in Philosophy. Correspondence concerns business and organizational matters as well as views and assessments by participants. [The Jordan Conference Collection was donated by Dr. Max H. Fisch of the University of Illinois Philosophy Department in October, 1972.]

JOYES, THOMAS (1789–1866). DIARY, NOTES, 1816–1817. 1 volume. 1 item. 69–1603.

This diary of a surveying trip made in the winter of 1816–1817 was kept by a U. S. Deputy Surveyor, Captain Thomas Joyes, of Louisville, Kentucky. The diary begins November 13, 1816, and ends January 12, 1817. There are additional notes, sketches of the rivers, and drawings of one township. The party started up the Mississippi River from St. Louis and, breaking ice along the way, proceeded via the Illinois River to Fort Clark near Peoria and then back to camp. The diary includes notes on the location of good land, timber, coal and mineral deposits, and desirable mill sites. Notes show that the survey was being made of townships 8–12 north, range 6 east of the fourth principal meridian. [The diary was given to the University of Illinois by Morton V. Joyes of Louisville, grandson of the writer.]

KANE, ELIAS KENT (1794-1835). PAPERS, 1809-1835, 1839, 1847. 193 items, transcripts. Chronological card file.

Elias Kent Kane, born in New York and graduated from Yale, came to Kaskaskia in 1814 and began to practice law. Early in 1818 he was appointed a judge of the Territory of Illinois. He was a member of the First Constitutional Convention of 1818 and became the first Secretary of State for Illinois. In 1824 he was elected to the General Assembly (Representative, St. Clair County) but resigned to take a seat in the U.S. Senate to which he had been elected that year. Re-elected to the Senate in 1831, he died before the end of his second term.

The correspondence and documents in this collection concern legal matters and politics, with the former relating mainly to the collection of debts, and the latter dealing with issues and elections in Illinois, Indian affairs, internal improvements, national road, postal service, U.S. Bank, national politics, and patronage. Fifteen of the letters are written by Kane. [These transcripts are from the collection of Kane Manuscripts in the Chicago Historical Society.]

KASKASKIA COMMONS TRACT. PAPER, ca. 1909-1910. 1 item.

The "Chronological Resume [beginning 1700], Abstract or Chain of Title to the Lands known as Kaskaskia Commons Tract..." was drawn up for a case before the Supreme Court in which the "President and Trustees of Kaskaskia Commons" challenged a law of 1909 which deprived them of their vested rights. Mr. C.W. Alvord testified in this case. [The abstract was a gift of Dr. Natalia M. Belting, University of Illinois, Urbana.]

KELLOGG, ACHSAH. LETTERS, 1844, 1846. 2 items.

These two letters are from Achsah Kellogg in Tremont, Illinois, to her parents in Schenectady, New York. They discuss local weather and prices and include notes from her husband, P. H. Kellogg.

KENTUCKY ENABLING ACT, 1786. LAW, January 10, 1786. 1 item, facsimile.

An act concerning "the erection of the District of KENTUCKY into an independent STATE" of the American Confederacy and establishing the number of representatives for each county. [This facsimile was reproduced from the collection of Thomas W. Streeter, Morristown, New Jersey.]

KING, MARGARET A. CORRESPONDENCE, 1864. 17 items.

These letters are mainly from Mrs. King to her husband, Philander B. King, who had gone west in an apparent effort to avoid the Civil War draft. She relates difficulties which she and the children encountered in running a farm. Prices of goods and produce are mentioned frequently. Three letters, one each from J. E. Scace, J. M. Barber, and D. C. Allen, to Philander B. King are also included. Two letters from King to his wife give a glimpse of life in Washoe City, Nevada Territory. [The letters were purchased from Mr. Arthur W. Osborn in 1967.]

KINZIE AND FORSYTH. INDENTURE, 1804. 1 item, transcript.

Jeffre Nash of Wayne County was bound to Kinzie and Forsyth, Chicago merchants, and required to serve for seven years from May 22, 1804. [The original indenture is in the Draper Collection of the Wisconsin State Historical Society; it was copied and collated by Solon J. Buck.]

KNIGHT, CHARLES. CORRESPONDENCE, 1798, 1813, 1818. 3 items, transcripts. 64-1603.

All three letters are to Charles Knight of Maysville, Kentucky. One is from his brother-in-law; one is from his son Andrew, who describes the action with Commodore Oliver H. Perry on the Great Lakes (1813); and the other is from a second son George, who settled in the Illinois Territory [Palmyra, Edwards (now Wabash) County] and who describes the characteristics of the land there.

KNIGHT FAMILY. CORRESPONDENCE, 1853-1888. 71 items. Calendar. 69-1602.

Two sisters, Martha (later Mrs. John T. Mack) and Isabella (later Mrs. Harvey J. Knight) Gill, born and orphaned in Ireland, are respectively the author and recipient of the first letters in this collection. The second group of letters are mainly from the Mack family to the Knight family and are filled with family news; livestock reports; livestock, land and crop prices; local news, especially of Bloomington-Normal and Towanda; and inducements to relatives in Ohio to come and settle in Illinois. In November of 1866, Knight brought his sheep to Towanda, Illinois, and the next summer his family joined him. They bought a farm near Normal, Illinois, where Mattie and Anna began their schooling. The remaining letters in the collection deal with life around Normal and, to a great extent, Mattie and Anna's schooling and their subsequent careers as school teachers. [The correspondence was transferred from the Rare Book Room of the University of Illinois Library in 1967.]

KNOTT, WILLIAM ERNEST (1871-1937). PAPERS, 1881-1896. 12 items. 69-1592.

These papers of Mr. Knott (a school teacher and principal of schools) consist of two grade cards, teaching certificates for Champaign and De Witt Counties, six rhetoric papers, a physics notebook, and an Illinois State Normal University Commencement program for 1896. Included with the material is a sketch of the life and activities of Mr. Knott. [The sketch was compiled by his daughter, Mrs. R. E. Moshier of Springfield, Oregon, the donor of the papers.]

KOERNER, GUSTAV P. (1809-1896). PAPERS, 1842. 3 items. 1 photograph. 69-1599.

Gustav Koerner came to the German-American settlement of St. Clair, Illinois, in 1833 and played an active part in state and national politics. He was a representative from St. Clair County to the Illinois General Assembly in 1842. Included are two printed copies of a speech made in the legislature in regard to the Canal Bill. Another speech is written in French, probably in Koerner's hand. His purpose was to inform the constituency of his sentiments and views on the general nature of government as well as on specific issues such as the National Bank, the depreciation of money, and his anti-Martin Van Buren stand. A portrait of Koerner is also included.

KOPFLI, SOLOMON (b. 1815). LETTERS, 1833. 4 items, transcripts.

These letters, written by Solomon Köpfli of Highland, Illinois, to members of his family in Switzerland, were intended for publication in Der Deutsche Nordamerickaner of St. Gall, Switzerland. [The transcripts are from Der Nordamerickaner, May-December, 1833.]

KRATZ, EDWIN A. (b. 1844). BUSINESS RECORDS, 1875-1901. 2 volumes. 2 items.

The two account books in this collection record family financial affairs as well as Kratz's records of his medical profession and his property, which was rented out. Also included is a handwritten inventory of the property of Susan Biedler [?] made October 15, 1894; and a check signed by T. A. Burt made out to E. A. Kratz as administrator of the estate of Susan Biedler. Kratz lived in Champaign, Illinois.

LAMOILLE VALLEY (VERMONT) RAILROAD. RECORD BOOK, July 18, 1876. 1 volume.

This volume contains a copy of an agreement by which the Lamoille Valley Railroad Company agreed to merge with the Montpelier and St. Johnsbury Railroad and Essex County Railroad Companies in a chartered corporation. The agreement was signed by the Lamoille Valley President Waldo Brigham and Horace Fairbanks, the president of the other two railroads.

LANDER, EDWARD P. DIARY, 1863-1864. 1 item, transcript. 69-1586.

Edward P. Lander of Belvidere, Illinois, was a bugler in the 9th Illinois Calvary during the Civil War. His regiment saw action in Tennessee and Mississippi. The diary includes poems about war, accounts of skirmishes, battles, marches, and daily routine.

LANDRUM, HAWKINS. LETTER, <u>ca</u>. 1840. 1 item, machine reproduction.

Hawkins Landrum's letter is written to the editor of the <u>Alton Telegraph</u>, George T. M. Davis, presumably for publication in the newspaper. In the letter Landrum gives his background and then launches into a description of what his uncle has said about various issues of the day: tariff and trade, national and state banks, and low wages for labor. [The letter, duplicated from the original in the Illinois State Historical Library, Springfield, was given to the Survey in 1968, by Dr. David Schob.]

LARSON, LAURENCE M. (1868-1938). PAPERS, 1901-1943. 7 items.

Professor Laurence Marcellus Larson taught in the History Department of the University of Illinois from 1907 to 1938 when he died. He was the author of at least six books and many articles. This collection consists of two copies of a brief autobiographical memoir begun in 1937; two copies of an inventory of Larson's personal papers made by Charles Paape in 1943; and transcripts of two letters to Larson written by Frederick Merk. Also, there is a set of class notes taken by Larson when he studied under Frederick Jackson Turner.

LA SALLE, ROBERT CAVELIER, SIEUR DE (1643-1687). PAPERS, 1667-1720. 45 items, transcripts. 61-1747.

This collection of transcripts from various sources deals with the career of La Salle, particularly in the period of early explorations. Some of these documents from the Bibliotheque Nationale were secured for Dr. Frank E. Melvin's use in the compilation of his unpublished monograph, "La Salle and the Alleged Discovery of Ohio." A second folder of transcripts consists of translations from documents published in Pierre Margry, <u>Decouvertes et l'etablissements de francais dans l'ouest et dans le sud de L'Amerique Septentrionale.</u>

LAUT, AGNES CHRISTINA (1871-1936). PAPER, NOTE, 1908. 2 items, transcripts. 69-1587.

Agnes Laut, a Canadian historian, found Abraham Wood's narrative, "Supposed to be the Carolina Colonies' first journey to the Mississippi," in the Shaftsbury Papers. This article, entitled "The First Crossing," concerns Major General Abraham Wood's expedition to the Mississippi Valley, 1670-1674. The note in this collection is to C. W. Alvord and indicates that this is a first draft of an article for <u>Harper's Magazine</u>.

LA VALINIERE, PIERRE HUET DE (1732-1806). PAPER, 1786-1788. 1 item, photocopy.

"Simple et vrai recit de la conduite au Rev. Huet de la Valiniere depuis son arrivee aux Illinois la 20 juin 1786. Francois et Anglois" is the title of these papers which discuss, in French and in English, La Valiniere's story in Illinois. After leaving France, he worked in Montreal parishes, where he was suspected of treason in connection with the American invasion of Canada. This, among other reasons, caused him to come to the United States and eventually to Illinois where he had been appointed the Vicar-General by Bishop John Carroll. [The original of this manuscript is in the Parkman Papers of the Massachusetts Historical Society.]

LAVINIA,W. T. S. (d. 1870). LETTER, November 4, 1837. 1 item. 69-1603.

This letter from Ottawa, Illinois, to the Board of Illinois and Michigan Canal Commissioners, pertains to land (lots) and business affairs.

LAVIS, PETER. LETTERS, 1854-1856. 8 items, photocopies.

These letters, written in German from Lavis to his wife and family, include a discussion of his service in the Wisconsin State Legislature and information about the Know-Nothing Movement in Wisconsin.

LEAGUE OF WOMEN VOTERS. CHAMPAIGN COUNTY, ILLINOIS. RECORDS, 1923-1971. 39 volumes. 9 folders. 35 photographs. Approximately 1,000 newspaper clippings. Inventory.

This collection contains records of, and materials collected by, the League of Women Voters of Champaign County, Illinois, reflecting the activities and interests of the organization. The official records include minutes kept by the secretary both of general meetings and Board of Directors meetings from the League's founding in 1922 through 1966. Also included are financial ledgers from 1940 through 1971 and financial papers for 1960 through 1969. Various committees of the League kept files of newspaper clippings which related to their area of interest. Usually these clippings were mounted in scrapbooks. The collection contains eleven general scrapbooks which deal with the League's meetings and social activities from 1932 through 1967. There are also thirteen volumes related to particular governmental and social problems about which the League was concerned. In addition there are numerous unmounted clippings mainly related to special concerns. [The collection was deposited in the Illinois Historical Survey Library in 1971.]

LEAGUE OF WOMEN VOTERS. CHARLESTON, ILLINOIS. RECORDS, PUBLICATIONS, 1963-1973. 2 boxes. Inventory.

This collection consists of a complete set of copies of the agenda and minutes of the Board of Directors of the Charleston, Illinois League of Women Voters, a complete set of publications, a set of reports on annual meetings (1963, 1965-1973), a set of the organization's monthly newsletter, League Link, and a School Agenda (1966-1968). These materials thoroughly reflect the operations and activities of this local citizen action group. [The collection was deposited in the Illinois Historical Survey Library in 1973, through the generosity of Mrs. Ruth Dow, President of the Charleston League of Women Voters.]

LEAL, CLARK. LETTER, 1836. 1 item.

This letter, from Leal to a cousin, was written at Fountain Green, Hancock County, Illinois and describes a trip by wagon from Champaign County, Ohio. [The letter was a gift from Wilbur Duncan of Decatur, Illinois.]

LESCHER, JOHN J. DEED, April 2, 1864. 1 item.

This deed provides testimony to the purchase of seventy-two acres of land by John J. Lescher. It was recorded in Mount Carmel, Wabash County, Illinois.

LESUEUR, CHARLES ALEXANDRE (1778-1846). Sketchbooks, 1815-1837. 6 reels, microfilm. 61-1743.

Charles Alexandre Lesueur, French naturalist and artist, met the geologist William Maclure in Paris and in 1815 agreed to join him in an expedition to the West Indies to collect specimens and make notes and drawings. Lesueur's American sketchbooks record the twenty-one years in America which followed: four months in the Lesser Antilles; travels through the eastern states; eight years in Philadelphia where he taught and carried on his scientific work until 1825; a winter journey to New Harmony by keelboat with the founders of the colony; and twelve years residence at New Harmony during which he made trips to New Orleans, Illinois, Tennessee, and Missouri. [The selection of sketches on the first reel of microfilm was procured from the American Antiquarian Society. In 1956, the Survey acquired a complete reproduction of the sketchbooks made for the American Philosophical Society.]

LEVERICH, CHARLES. LETTERS, 1836-1850. 9 items.

These letters to Charles Leverich, a New York merchant, are from his family and business associates in Philadelphia and New Orleans. They concern business matters such as the charter of ships to Louisiana to transport goods, sales of property and goods in the South, and bills of exchange. [The collection was a gift of Wilbur Duncan of Decatur, Illinois.]

LEWIS, JOHN L. (1880-1969). PAPERS, 1879-1969. 4 reels, microfilm.

This collection contains material which Lewis did not deposit with the United Mine Workers of America Archives. It includes biographical material, speeches, reports, union records, personal documents, memorabilia, clippings and photographs. [The Survey purchased this microfilm edition of the John L. Lewis papers from the Wisconsin State Historical Society, where the original papers are deposited.]

LIBRARY CLEARING HOUSE. CHICAGO, ILLINOIS. ACCOUNT BOOK, LETTERS, NOTES, 1877-1888, 1901-1903. 1 volume. 9 items.

The account book records the daily transactions of this book store. Julius Doerner was the proprietor. The letters and notes concern book sales and tabulations. [This collection was transferred from the Rare Book Room of the University of Illinois Library to the Illinois Historical Survey Library in 1973.]

LINCOLN, ROBERT TODD (1843-1926). LETTER, October 19, 1896. 1 item.

Robert Todd Lincoln, the son of Abraham Lincoln, wrote this letter to Walter Colyer explaining the impossibility of speaking in Albion because of previous engagements in Indiana and other parts of Illinois.

LINCOLN ADMINISTRATION. PAPERS, 1846-1881. 114 items, photocopies, transcripts. Calendar. 61-3064.

These items, largely letters, were written by Abraham Lincoln, his associates, and others during the Civil War. The materials were acquired by Professors Theodore C. Pease and James G. Randall from various collections during the preparation of The Diary of Orville Hickman Browning, 1850-1881 (Illinois Historical Collections, Volumes 20 and 22). The letters deal basically with political and military affairs and with war-time financing. [These transcripts were obtained from papers in seven historical agencies and from miscellaneous government archives and private owners.]

LINCOLN WAY. PAPERS, 1913-1915. 51 items.

These papers consist of materials gathered by C. M. Thompson, who directed the investigation of the route followed by the Lincoln family when they moved from Indiana into Illinois in 1830. The papers consist of letters; legal affidavits, which contain evidence of witnesses; newspaper articles; and pamphlets. The two pamphlets included in the collection contain the findings of this investigation.

LINDSEY, MARTHA M. JOURNAL, ca. 1850-1890. 1 volume.

Martha Lindsey, wife of the John Lindsey who taught at Eureka College, kept this journal as an autograph book. The entries are composed of poetry, autobiographical material, and signatures.

LINTON, G. A. LETTER, December 29, 1881. 1 item.

This letter from G. A. Linton to John H. Burnham discusses the location of a fort and battle site in McLean County. Reference is made to the uncovering in 1858 of graves and a gun barrel, and the later investigation of Indian Mounds. The fort mentioned in the letter is probably the "Fox Fort" built in 1730 and the battle site is probably the "Arrowsmith Battlefield."

LIPPINCOTT, THOMAS (1791-1869). PAPERS, 1860, 1864-1865. 2 folders, transcripts. 69-1599.

Thomas Lippincott, who settled in Edwardsville soon after 1818, was a strong foe of slavery and active in opposing the adoption of a pro-slavery constitution for Illinois in 1824. In 1825-1826 he edited, in association with Hooper Warren, the Edwardsville Spectator. He then became a minister of the Presbyterian Church and associated himself with its activities throughout Illinois.

The first paper in this collection, entitled "The Conflict of the Century," is an account of pro-slavery agitation in Illinois culminating in the convention movement of 1824. It originally appeared anonymously in the Alton Courier. A note by the author dated Duquoin, Illinois, July 30, 1860, preceded a reprinting of the revised annotated articles in the Henry Weekly Courier. The second set of papers, entitled "Early Days in Madison County," was written at the request of W. C. Flagg, then secretary of the Madison County Horticultural Society; they appeared in the Alton Telegraph, 1864-1865, in forty-seven numbers. [The Survey's transcripts were made in 1913 from a scrapbook made by Lippincott, then owned by W. T. Norton of Alton, Illinois, and from sets of the Telegraph articles in the possession of Norman Flagg of Moro, Illinois.]

LITTLE, HENRY G. (1813-1900). PAPERS, 1835-1896. 4 volumes. 18 items. 61-3373.

Henry G. Little came to French Grove, Peoria County, Illinois, from Connecticut in 1835. He served on the "Committee of Purchase" for the Wethersfield Settlement in Henry County, Illinois. Later, he helped lay out the settlement and resided there for many years. After he moved to Grinnell, Iowa, he wrote his reminiscences of Connecticut and Illinois. These articles, which were published in several newspapers, are contained in four scrapbooks in this collection.

The manuscripts include some drafts of the Newington letters and some correspondence in 1897-1899 with Henry Smith of Plantsville, Connecticut, who enclosed a report of his Yale Class of 1844, thirty years after graduation. There is also correspondence with L. A. Berry of Chicago and J. C. Dodge of Boston. [This collection was given by Mrs. W. A. Noyes of Urbana, Illinois, granddaughter of Henry G. Little.]

LITZELMANN, JOSEPH. PAPERS, LETTERS, POSTCARDS, PHOTOGRAPHS, 1882-1959. 172 items.

Joseph Litzelmann was a resident of Newton, Illinois, and proprietor of the American House, a boarding house in Newton. This collection contains letters, business papers and other items pertaining to Joseph Litzelmann and his family, particularly his daughter, Claire Litzelmann Keavin. [This collection also contains photographs and postcards presumably belonging to Mrs. J. C. (Bessie Finn) Huddleston of Hidalgo, Illinois.]

LODGE, HENRY CABOT (1850-1924). LETTER, 1922. 1 item.

This letter, from Senator Henry Cabot Lodge in Washington to Charles M. Woodbury in Danville, thanks Woodbury for some cigars and for his approval on some unmentioned project.

LOGAN, JOHN ALEXANDER (1826-1886). LETTER, 1880. 1 item. Calendar.

This letter from Logan to Mortimer C. Edwards, an active Republican from Perry County, Illinois, urges Edwards to work for General Grant's nomination as the Republican presidential candidate in 1880.

LORIMER, WILLIAM E., JR. (1861-1934). CORRESPONDENCE, LETTERS AND NEWSPAPER CLIPPINGS (1917-1934). 52 items, machine reproductions.

This collection consists of personal, business, and political correspondence and papers of Illinois political figure, William E. Lorimer, Jr. The political papers include printed articles, speeches and newspaper clippings. They concern the Len Small Case, the Republican Party, and William Lorimer's proposed political comeback. [The collection was donated to the Illinois Historical Survey for machine reproduction, by William Lorimer's grandson, Walter M. Lorimer, of Beverly Hills, California in September, 1973.]

LOUDOUN PAPERS. PAPERS, CORRESPONDENCE, 1740-1755. 93 items, photocopies. 1 item, transcript and microfilm copy. Chronological card file.

This collection in the Huntington Library contains the papers and correspondence of the Campbells, the Earls of Loudoun; especially of John Campbell, Fourth Earl of Loudoun. It is separated into two divisions: the French Colonial Manuscripts, the Vaudreuil Papers; and the English Colonial Manuscripts. The French Colonial Manuscripts contain papers and correspondence of the Marquis de Vaudreuil, governor of Louisiana and New France; letters of Macarty-Mactigue, commandant of the Illinois post after 1750; and letters of Francois Saucier, an engineer sent to build a new fort at Kaskaskia. The letters of these men give a detailed picture of affairs in Illinois during Vaudreuil's stay as governor. In addition, this division includes other letters, orders, census lists, troop dispositions and a general census for Illinois for 1752. The English Colonial Manuscripts contain mainly the papers of Lord Loudoun while commander-in-chief in North America. Among these papers is the report of Edmund Atkin to the Board of Trade, May 30, 1755. [This collection was copied from the originals in the Huntington Library for publication in the Illinois Historical Collections.]

LOVEJOY, OWEN (1811-1864). LETTER, April 6, 1860. 1 item, transcript. 69-1599.

A private communication, this letter was written by the brother of Elijah P. Lovejoy, in Washington, April 6, 1860, the day after his speech in Congress on the "barbarism of human slavery." The subject of the letter was that speech. [This transcript was made from a copy furnished in 1912 by E. P. Lovejoy, the son of Owen Lovejoy.]

LYMAN FAMILY (1780-1873). JOURNAL, 1833. 1 item, transcript. 69-1618.

This paper is a family narrative of five brothers who, in a group of fifty-two people, travelled from New York to Sangamon County, Illinois, by wagon in eight weeks. Settlement was made in what is now Gardiner Township, nine miles northwest of Springfield. [The transcript was received from Mrs. George Lyman, Fort Smith, Arkansas.]

MC ALLISTER MANUSCRIPTS. RIDGWAY LIBRARY. PAPERS, 1765–1774. 8 items, transcripts. Chronological card file.

These letters and accounts relate to business affairs of George Croghan, Barnard and Michael Gratz, L. A. Levy, and Joseph Simon. The accounts are of regular sales and "For Sundrys for the Use of the Indians." The letters are about bills and payments, selling of goods, such as peltry, and surveying lands.

MAC ARTHUR, ARTHUR (1845–1912). REPORT, NEWSPAPER CLIPPING, 1865, 1899. 2 items. 69–1586.

Arthur MacArthur, the father of General Douglas MacArthur, served with the 24th Wisconsin Infantry during the Civil War and was brevetted colonel in 1865. He subsequently was commissioned in the U. S. Army and commanded a brigade and a division in the Philippines from 1898–1899 where he was military governor, 1900–1901. MacArthur retired in 1907 with the rank of brigadier general. The paper in this collection is Major MacArthur's quarterly return of ordnance and ordnance stores, 24th Wisconsin Infantry, March 31, 1865. The clipping from the Chicago Record, March 28, 1899, describes his career in the Philippines.

MC CHESNEY, JOSEPH HENRY. PAPERS, 1859–1875. 73 items. Calendar.

The bulk of this collection reflects McChesney's activities while United States Consul at Newcastle-on-Tyne, England, 1863–1869. These include the disposition of a Roman tablet found in Scotland and purchased by McChesney; the creation of a scientific exchange program between the United States Department of Agriculture and various agencies or groups in England and Germany; and consideration of a letter forwarded by the Secretary of State requesting aid in finding information about a missing United States seaman. There are bills from shops and inns in Europe and the United States relating to McChesney's travels. Several letters comment on the Civil War and political events in both the United States and Great Britain. Other items concern McChesney's work as an Illinois state geologist before the war; the problems and service of O. M. Dorman, a unionist from St. Augustine, Florida, during the war; a description of oil properties in Washington County, Ohio; a letter from C. H. McCormick to Trustees of Lake Forest University concerning creation of a college named after McCormick and several letters requesting out-of-print Smithsonian Institution Reports.

MC CONNELL, J. E. REPORT, January 6, 1862. 1 item. Calendar.

The financial report of the London and Northwestern Railroad, written by J. E. McConnell to the Locomotive Expenditure Committee, gives a detailed account of expenditures for increasing locomotive tonnage and shed cover. [The report was acquired by the University of Illinois Library from Grafton, Illinois, in 1940 and was later transferred to the Illinois Historical Survey.]

MC CORMICK, CYRUS H. (1809–1884). PAPERS, 1868–1884. 128 items, transcripts.

The letters, telegrams, and addresses in this collection pertain largely to politics, especially in McCormick's capacity as Chairman and in his participation in the campaign of 1876. There are references to his becoming a candidate for Governor of Illinois (1875) and to his nomination for the United States Senate. Other letters discuss prospects for the Democratic Party in the elections, communicate the need for acquiring speakers at rallies and public meetings, and note the donation of $10,000 given to the Democratic Party by McCormick. Among the speeches is one which was given by McCormick before the Democratic Convention. Also there is a typed statement by C. C. Copeland which summarizes McCormick's political activities. [The transcripts were made from the McCormick Collection which is now in the Historical Society of Wisconsin.]

MAC DONALD, A. J. (d. 1854). PAPERS, 1851-1854. 1 reel, microfilm.

This collection includes articles and statements of people concerned with communitarianism in the United States, histories of communities set up in the 1700's, and a description and review of over fifty communities set up in the 1820's, 1830's and 1840's. Some of these communities were the Brook Farm Phalanx; Hopedale Community; Skaneateles Community; Oneida Community; The Icarian Community at Nauvoo, Illinois; New Harmony Community; Trumbull Phalanx; Sodus Bay Phalanx; Raritan Bay Union; Social Reform Unity; and North American Phalanx. [These materials were collected for a projected volume, The Communities of the United States, announced in 1851, but never completed because of MacDonald's death by cholera. They were microfilmed from the originals in the Yale University Library.]

MAC DONALD, DONALD (1791-1872). PAPERS, 1824-1826. 1 reel, microfilm.

In these diaries of his two journeys from England to New Harmony, British Army officer Donald MacDonald describes his trips, founding of the New Harmony Community, the daily meetings and arguments, and the formation of several communities to try to promote peace. [The diaries were microfilmed from photocopies of the originals in the Indiana State Library.]

MC KENDREE COLLEGE. PAPER, n.d. 1 item, transcript. 69-1592.

This report of the visiting committee appointed by the Illinois Annual Conference to attend the examination of the students at McKendree College describes favorably the state of learning, the subjects taught, and the attendance at chapel. However, it then expands on the immorality of musical instruments, other than the voice, being used at the college. [The original was owned by Solon J. Buck, and this transcript was taken from it.]

MC LEAN COUNTY (CHRISTIAN) COOPERATION SOCIETY. RECORDS, 1864-1887. 2 volumes.

This organization is called variously "McLean County Cooperation Society," "Christian Missionary Society of McLean County," "Missionary Cooperation," "McLean County, Missionary Cooperation Society," and "Missionary Society of McLean County." The first volume contains records of meetings held between August 27, 1864, and February 22, 1879, as well as the constitution of the organization, dated February 10, 1862. The records include the dates, the names of the delegates, and the business performed at each meeting, e.g. pledges to the society, prayers, readings from the Bible, and activities. The second volume, from 1879-1887, contains the "Articles of Agreement," adopted by the Churches of Christ in McLean County in order to have more cooperation in Christian work. There are also records of meetings of this body, the names and addresses and membership of churches in McLean County, and the officers of this group.

MC LEAN COUNTY, ILLINOIS. MARTIN TOWNSHIP, SCHOOL DISTRICT NO. 4. PAPERS, 1869-1892. 1 volume. 19 items.

The journal in this collection is both a book for School District No. 4 and "David Bierbower's Day Book" (Bierbower was a resident of Saybrook, Illinois, and clerk of the Board of Directors of Martin Township School). It includes records of the elections of directors of the school district, levying of taxes to support the school, and accounts for building and maintenance purposes. The remainder of the journal is Bierbower's personal accounts for goods bought and sold. Other items include vouchers, a treasurer's statement (by Bierbower), and notes. [The collection was transferred in 1967 from the Rare Book Room of the University of Illinois Library.]

MC LEAN (VILLAGE), ILLINOIS. BOARD OF TRUSTEES. RECORD BOOK, PAPERS, 1890-1908. 1 volume. 12 items.

The volume in this collection contains reports of meetings held by the Board of Trustees for McLean (Village) from April 17, 1890, to August 6, 1906. Other items are ordinances pertaining to the construction of cement sidewalks, two treasurer's reports, an oath taken by Lafayette Archer on becoming a trustee, and a newspaper article.

MACLURE, WILLIAM (1763-1840), AND FRETAGEOT, MARIE (d. 1833). CORRESPONDENCE, 1820-1833. 2 reels, microfilm. Calendar. 69-1605.

William Maclure was a geologist, a patron of science and education, and the founder of the New Harmony Working Men's Institute. These letters of William Maclure and Marie D. Fretageot are part of the New Harmony Manuscripts, Working Men's Institute, New Harmony, Indiana. The collection was arranged, catalogued, and microfilmed under the direction of Arthur Bestor for the Illinois Historical Survey in 1952. The catalog appears on the film.

MAC VEAGH, FRANKLIN (1837-1934). PAPERS, 1873-1923. 59 items, machine reproductions. Calendar.

This collection contains the papers of Franklin MacVeagh, a lawyer, businessman and Secretary of the Treasury under President Taft. It includes letters and papers that indicate MacVeagh's interest and support of the gold standard; his dealings with railroads, including the Illinois Central; and some of the requests he received as Secretary of the Treasury. Several pieces of correspondence concern charges against Fletcher Maddox, a solicitor for the Internal Revenue Bureau. [The collection was copied in 1971 from the originals owned by Leonard P. Karczewski of Chicago, Illinois.]

MARSH, CUTTING (1800-1873). PAPERS, 1834. 1 reel, microfilm. 69-1599.

Cutting Marsh kept a "Diary of a Trip to Visit the Sauk and Fox Indians" while on his expedition to the Rock Island and Des Moines areas in the summer of 1834. He related his experiences within the villages, describing a wedding ceremony, divorce rules, various dances, and general tribal customs. [The original papers are located in the State Historical Society of Wisconsin.]

MASON, WILLIAM ERNEST (1850-1921). LETTER, April 24, 1911. 1 item, machine reproduction.

William Mason's letter, written to Senator Thomas Henry Carter in Washington, discusses the forthcoming nominations and elections. Specifically, it mentions Governor Charles S. Deneen, William Howard Taft, and the Lorimer election. [This copy was donated to the Survey by Dr. J. Leonard Bates, University of Illinois, Urbana, in October, 1968. The original letter is part of the Thomas Henry Carter Papers in the Library of Congress.]

MAY, EDWIN (d. 1893). PAPERS, 1862-1924. 97 items. 61-2837.

Dr. Edwin May served as assistant surgeon of the Thirty-third Infantry Regiment and later was made surgeon of the Ninety-ninth Infantry during the Civil War. In this collection there are some letters from old comrades during and after the Civil War, and thirty-nine official reports of "Sick and Wounded" from September, 1862 - December, 1864. There are also three issues of the National Tribune of Washington with an account (written by Col. Charles E. Hovey, 33d Illinois) of the march through Arkansas in 1862. In addition, the collection includes scattered reports of the proceedings of the reunions of the 33d Illinois Infantry Veteran Association, from the first in 1875 to the one in 1924, as well as badges and photographs of various officers and men. Filed with this collection is Gen. Isaac H. Elliot's History of the Thirty-Third Regiment, Illinois Veteran Organization. [Miss Clara May of Oberlin, Ohio, presented these papers to the Survey.]

MEADE COUNTY, KENTUCKY. CIRCUIT COURT. SUBPOENA, January 18, 1843. 1 item.

This legal notice issued by the Commonwealth of Kentucky requests any justice of the peace of the State of Illinois to question an individual named McCrilli concerning a case pending in Kentucky.

MENARD, PIERRE (1766-1844). PAPERS, 1741-1910. 27 volumes, 87 items, originals. 17 items, photocopies. 35 items, transcripts. 29 reels, microfilm. Inventory. 61-2056, 69-1606.

The Survey's collection of Menard papers is composed of a letter book of 124 letters (1829-1843); volumes and notes concerning business matters; store blotters and wastebooks; ferrybooks; accounts of Indian trade, travel and school expenses; a "Livres des Presents" (1801-1833) recording gifts to Indians; school texts and exercise books of Menard's sons, Pierre, Jr., and Francois; and a volume, prepared by the W.P.A. in 1941, of copies of an inventory of Menard's estate and other documents. Also there are transcripts of letters from Menard's son, Louis Cyprien and his daughter Sophie.

This collection also contains microfilm of the Menard Papers in the Illinois State Historical Library. Included are personal correspondence and business papers of Pierre Menard and his family, 1791-1910; business ledgers of Pierre Menard, Edmond Menard, Menard and Valle, Bryan and Morrison, Burr and Christy, and papers of Barthelemi Tardiveau covering his business enterprises, 1785-1827.

MESSINGER, JOHN (1771-1846). PAPERS, 1799-1846, 1860. 2 volumes, originals. 4 items, newspaper clippings. 138 items, transcripts. Inventory. 61-2312.

John Messinger migrated to Illinois in 1802 where he became involved in politics; in addition, he was an important surveyor, cartographer, and educator. He was the author of A Manual; or handbook, intended for convenience in Practical Surveying (St. Louis, 1821) one of the earliest scientific publications in the Middle West. Also in the collection is a notebook, the "John Messinger Memorandum Book," about half of which is filled with surveying notes. Further materials include: clippings from the Belleville Daily News-Democrat which gives stories of the marking of the graves of John and Anne Messinger; letters which discuss migration from the East to the West, some politics, and the purchase of property; and miscellaneous documents such as land deeds and agreements for millwright work. [The Survey's transcripts were made from originals in the Illinois State Historical Library, Springfield.]

MICHELSON, TRUMAN (1879-1938). PAPER, LETTER, September 26, 1916. 2 items.

This "Report of Peoria Indians" by Truman Michelson was based upon three weeks of field work authorized by the Illinois Centennial Commission. He discusses the inroads of other cultures on the Peoria Indians' linguistics, folklore, mythology, social organization, dances, population, and historical relations. The letter, addressed to C. W. Alvord, conveyed the report.

MILLAR, DANIEL. ACCOUNT BOOK, 1822-ca.1870. 1 volume.

This distillery and general accounts book was kept by Daniel Millar of Franklin County, Pennsylvania. Apparently, he kept accounts for a number of businesses, but his position in these businesses cannot be ascertained. Some of the earlier entries have been pasted over by poetry and clippings from the 1870's. [The account book was acquired by the University of Illinois in 1941 from Putnam's Book Store in Bloomington, Illinois.]

MISSOURI MISCELLANY. PAPERS, 1857. 11 items.

The letter in this collection, entitled "Sheriff's Sale," is the notification of an auction to be held for the purpose of selling the property of John N. Nelson (near Liberty, Missouri) to satisfy debts owed by him. The other items, business cards, are for nine St. Louis [Missouri] merchants and one St. Joseph [Missouri] lawyer.

MISSOURI VOLUNTEERS, SECOND BRIGADE. ORDERLY BOOK, 1861-1862. 1 volume. 69-1586.

The order book of the Second Brigade, Missouri Volunteers, has entries for August 27, 1861, through March 13, 1862, which consist of orders for recruitment, for the formation of the Brigade and regiments within the Brigade, for drill maneuvers and movements of the group.

MITCHELL, WILLIAM (d. 1849). LETTER, January 2, 1840. 1 item.

This letter, written in Peoria, Illinois, to William Jessop and Sons of New York, concerns credit and debit accounts.

MOOR, AUGUSTUS (1814-1883). CORRESPONDENCE, BUSINESS AND MILITARY PAPERS, PAMPHLETS, 1838-1883. Approximately 3.5 feet.

Born in Saxony, Augustus Moor migrated to America and lived in Philadelphia and Cincinnati. He served in the Seminole, Mexican and Civil Wars. In the Civil War, he commanded the 28th Ohio Volunteer Infantry and later a brigade in Western Virginia; he was breveted Brigadier General in 1864. The major portion of the papers in this collection concern General Moor's activities in the Civil War and include many different types of military papers, including reports and correspondence. The post war papers are mainly personal correspondence and business receipts. [This collection was obtained by the University of Illinois as part of the Heinrich Rattermann Collection. It was transferred to the Illinois Historical Survey Library in 1974.]

MOORE, JAMES (1750-1788). PAPERS, 1782, 1787, 1914. 7 items, originals, photocopy, transcript.

The early papers in this collection pertain to the commission of James Moore as Captain of Militia at Bellefountain, Illinois, by the State of Virginia. A later (June 12, 1787) continuation and endorsement of the commission is written in French and signed by F. Saucier, Lieutenant. There are also three letters, written by descendants of James Moore, which discuss his life.

MOORE, RISDON C. (b. 1820) AND DALY, MRS. THOMAS. GENEALOGICAL NOTE, n.d. 1 item.

This is a biographical note written about Risdon Moore by a descendant, Mrs. Thomas Daly of Mount Carmel, Illinois.

MORGAN, GEORGE (1743-1810). PAPERS, 1766-1826, 1907-1957. 257 items, originals. 12 items, transcripts. 13 items, photocopies. 4 items, photographs. 5 reels, microfilm. Inventory. 62-940, 69-1608.

This collection is composed of varied materials. There are genealogical tables and biographical data about George Morgan and family, as well as letters from his various descendants. A significant portion of the correspondence in this collection is between Morgan and Baynton and Wharton. There are transcripts of three letterbooks (1774-1779) which were written during the period when Morgan was chiefly at Fort Pitt serving as Indian agent of the Middle Department and Deputy Commissioner General of Purchases for the Western District. Other papers include letters and documents concerning Thomas Hutchins (1730-1789), a military engineer and geographer, who was appointed "geographer to the United States" in 1781, and more papers of George Morgan, such as estimates of the expenses of the Indiana Company (1763-1793), transcripts of proceedings of a Court of Inquiry at Fort Chartres, French maps illustrating surveys, and a speech Morgan gave to various Indian tribes. [Between 1928 and 1930 the Survey purchased from Colonel Robert Reed of Washington, Pennsylvania, a descendant of George Morgan, a collection of 251 documents, throwing light on all phases of Morgan's career, including a large body of the material relating to his sojourn in the Illinois country and to his later speculation in Missouri lands in connection with the colony of New Madrid. An additional nine items were given to the Survey in the years 1956-1958 by Mr. L. A. Hopkins of San Francisco, California.]

MORGAN, THOMAS J. (1847-1912). PAPERS, 1880-1910. 64 folders. 19 bound volumes. Inventory. 61-2048.

Thomas J. Morgan, a lawyer, socialist, and labor leader, was born in Birmingham, England, and came to Chicago where he became president of the Machinists' Union in 1874. From that year he was active in numerous labor organizations as an official, speaker, writer, investigator and promoter of political action for labor interests, and a labor and socialist nominee for diverse offices on various occasions. His wife, Elizabeth Chambers Morgan, was also active, making an investigation of sweatshop conditions among women workers in Chicago in 1891. Thomas Morgan represented the labor organizations on the committee promoting the Chicago World's Fair in 1893. From 1909 to 1911 he issued a weekly publication, The Provoker.

This collection contains letters, pamphlets, posters, reports, minutes of various organizations, speeches, reports of trials, and clippings on all phases of Morgan's activities and interests, as well as a file of The Provoker. The material in this collection concerns labor, labor organizations, and socialism, as well as political, social, philosophical and legal subjects. Specifically mentioned in relation to labor are trusts and the anti-trust laws, the unemployment problem, the right to work, the formation of unions and of a labor party, women's suffrage, taxation, and education. Correspondents, aside from Thomas and Elizabeth Morgan, include: John P. Altgeld, J. Mahlon Barnes, Charles L. Breckon, Eugene Debs, John and Paul Ehmann, G. T. Fraenckel, Samuel Gompers, "Mother" Mary Harris Jones, E. W. Latchem, R. W. McClaughry, Aaron L. Voorhees, and John M. Work. [The Survey's collection was microfilmed in 1967 and is primarily available for use in that manner.]

MORGAN COUNTY, ILLINOIS. ELECTION. RECORDS, August 2, 1824. 1 item.

In this clerk's copy, of a poll book of an election held in Morgan County, the voters are listed by precinct. There are also sworn statements concerning the number of votes each candidate received.

MORRIS, EMMA. LETTERS, 1900. 4 items. Calendar.

Three of the letters written by Emma Morris were directed to her husband. The family's state of health and Mrs. Morris' disappointement in her husband's delayed return are discussed. The fourth letter speaks of a visit to Mt. Vernon [Illinois] and asks for news from home [DuQuoin, Illinois.] [The letters were transferred from the University of Illinois Archives to the Illinois Historical Survey in February, 1971.]

MORRIS, JOHNSON. STATEMENT, July 5, 1892. 1 item.

Johnson Morris held this account with A. J. Laurence, a dealer in "Staple and Fancy Dry Goods, Carpets, Boots, Shoes, etc." in Paxton, Illinois. The statement lists purchases made by Morris from January 12 through June 25, 1892. [Mrs. Theodore Gladhill of Champaign, Illinois, donated the statement to the Illinois Historical Survey on February 21, 1972.]

MORRISON, ELEANORA HORINE (d. 1904). LETTERS, 1891. 2 items.

These letters, written from "Willard's Hotel" in Washington by Ella H. Morrison during the service of her husband, William Ralls Morrison, as Congressman from Illinois to a member of the family in Waterloo, Illinois, discuss local activities and cultural and personal affairs. [The letters were a gift of Mrs. Stephen D. Pyle of Oakland, California, in January, 1961; Mrs. Pyle was formerly Eleanora Morrison, a namesake of the writer.]

MORRISON, WILLIAM (1763-1837). PAPERS, 1804-1855. 7 reels, microfilm. Calendar. 62-888.

William Morrison was a member in the firm of Bryan and Morrison. The selection of Morrison papers in this collection which are from the Chester Public Library (4 reels) includes four daybooks, six ledgers, an index to Ledger D, seventeen blotters, and a folder of miscellaneous papers. Two volumes belong to William Morrison's brother, Robert, who carried on some merchandising activity and was a mail contractor. One ledger was kept by William's son, Lewis Morrison, a farmer and merchant.

The papers from the Illinois State Historical Library (2 reels) include three Bryan and Morrison daybooks for the Kaskaskia store, 1805-1808; a ledger and two daybooks for the Cahokia store, 1800-1813; and three other volumes. One volume, a Missouri ledger, may have belonged to the Bryan and Morrison Mines Store in the Moses Austin settlement near Potosi, Missouri. The others, unidentified, are a ledger and daybook which parallel the Bryan and Morrison materials.

Ledger D, 1809-1825, of the Cahokia Store is perhaps the most valuable record of the Cahokia business. The original is owned by the Chicago Historical Society, (1 reel).

MOUNT PLEASANT BAPTIST CHURCH. RECORDS, 1829-1865. 1 item, transcript.

The Mount Pleasant Baptist Church was established near Browning's Hill in Franklin County, Illinois. This journal contains records for the church for a period of thirty-six years. [The transcript was made by H. L. Walker in 1944 from the original church record book then in the possession of W. R. Browning, Burton, Illinois.]

MOWDER, LOUISA. ALBUM, 1857-1903. 1 volume.

This "Album of Love" belonged to Louisa Mowder of White Hall, Illinois. It contains poems and personal sentiments written by her friends and relations in Illinois and Ohio between the years 1857 and 1903. Among those who signed the album were Peter Cartwright, Methodist preacher, and Louisa's granddaughter, Ameda Ruth King, a former member of the University of Illinois History Department. [The Survey received the album from I. Bruce Turner of Urbana, Illinois on behalf of Phi Alpha Theta from the estate of Dr. King.]

MUNROE, THOMAS (1807-1891). PAPERS, 1832-1894. 10 items.

Thomas Munroe graduated from the University of Maryland with the M. D. degree in 1829, practiced medicine in Baltimore for several years, and moved to Illinois in 1834. He practiced in Jacksonville until 1843, moving that year to Rushville. From 1862-1864, Munroe served as Surgeon to the 119th Illinois Volunteer Infantry and in 1875 was appointed United States Examining Surgeon for Pensions.

The letters in the collection concern the families of Munroe and of his wife. The earlier letters, from Royal R. and John E. Hinman, deal with the transfer of land and of money into stocks and bonds. Two letters were written during the Civil War, the first to his father and the second from Reuben Woods. Two items, an invitation to exercises at the Young Ladies' Athenaeum and a program for the Junior Prize Exhibition of Illinois College, evidently concern William Munroe, who graduated from the latter(Jacksonville, Illinois), institution in 1882. In an 1894 power-of-attorney document Thomas Munroe, Jr., gives that power to his brother Hinman Munroe for property of the former in Schuyler County, Illinois. [The papers were a gift of Luther Gordon of Rushville, Illinois, in 1938.]

NEEF, FRANCIS JOSEPH NICHOLAS (1770-1854). PAPERS, 1799-1849. 1 reel, microfilm. Calendar. 69-1589.

These papers of Francis Joseph Nicholas Neef, a disciple of Heinrich Pestalozzi, throw light on the communitarian movement and education. They include: three writings by Neef, one being a letter to Pestalozzi; thirteen letters to Neef, of which ten are from William Maclure and one is from Benjamin Tappan (1773-1857); Maclure's agreement to finance Neef's coming to America, 1806; Neef's will, 1849; and four official documents. [The original manuscripts are owned by Mrs. Aline Owen Neal of New Harmony, Indiana. They were microfilmed for the Survey in October, 1950.]

NEILL, EDWARD DUFFIELD (1823-1893). CORRESPONDENCE, 1848. 2 items, transcripts.

These letters from J. G. Mattinger and R. W. Patterson of Ottawa, Illinois, to the Rev. E. D. Neill concern the Presbyterian Church in northern Illinois. [The originals are with the Neill Papers in the Minnesota Historical Society.]

NEW ENGLAND LOYAL PUBLICATION SOCIETY. PAPERS, 1863-1864. 56 items, photocopies. 2 reels, microfilm. Chronological card file. 61-1687.

This society was formed during the Civil War to distribute "journals and documents of unquestioning loyalty." Two papers in this collection express the Society's desire to republish and circulate articles about important issues and to influence public opinion through the newspapers. Aside from a newspaper article about slavery and papers pertaining to the establishment of the Society, the rest of the material in the collection consists of letters, largely to Charles Eliot Norton, the editor of the Society's broadsides. The letters discuss the business of the club, arrange for the exchange of articles and documents, and often allude to political matters.

One reel of microfilm contains a fragmentary portion of an index, "New England Loyal Publication Society: Scrapbook of Material on the Civil War, 3 vols., 1862-1868: Alphabetical Index to the Broadsides," prepared by the Boston Public Library for use with its collection of Society material. [These papers, copied from the originals in the Boston Public Library, were a gift of Dr. Frank Freidel, Harvard University, Cambridge, Massachusetts.]

NEW HARMONY, INDIANA. RECORDS, 1814-1880. 3 folders. 29 items, photocopies. 3 reels, microfilm. Partial inventory. 61-1688, 69-1609, 69-1589.

This collection is divided into five parts. The first group contains eleven photocopies of letters and documents concerning the formation and activities of New Harmony. The second group comprises three folders of photocopied legal documents pertaining to Robert Owen's purchase of New Harmony and the litigation following its disintegration. The third part, consisting of two items and two reels of microfilm, contains accounts of the New Harmony Community and journals of the Education Society founded in connection with it in 1826 by William Maclure (most of these items constitute Series III of the New Harmony Manuscripts in the Working Men's Institute of New Harmony.) The fourth part is a one reel microfilm copy of the correspondence in Series I, folder 1-25 of the New Harmony Working Men's Institute. The last section is a collection of sixteen photocopied maps (they constitute Series VIII of the New Harmony Manuscripts of the Working Men's Institute.)

NEWLIN, WILLIAM H. (b. 1842). REMINISCENCE, 1907. 1 item, photocopy. 69-1586.

W. H. Newlin was a first lieutenant in the 73rd Regiment, Illinois Volunteer Infantry, of Springfield. This item describes prison life, the threat of a "Northwestern Confederacy", and military campaigns.

NORTH AMERICAN PHALANX. NEW JERSEY. RECORDS, 1843-1855. 1 reel, microfilm. 69-1589.

The proceedings of the North American Phalanx and their minutes of the meetings of the Executive Council and resident members are included in these records. There are also some miscellaneous documents from 1843-1855. [The materials were microfilmed from the originals in the Monmouth County Historical Association, Freehold, New Jersey.]

NORTH CAROLINA DOCUMENTS. RECORDS, 1584-1868. 13 items, facsimiles.

These facsimile copies of North Carolina documents cover a variety of records over the period 1584-1868: charters, deeds, constitutions, commissions, petitions, minutes, resolves, and ordinances. [They were obtained from the State Department of Archives and History, Raleigh, North Carolina.]

NORVIEL, J. B. NOTEBOOKS (1915-1916?). 2 volumes.

These notebooks were made by Rev. J. B. Norviel, pastor of a United Brethren in Christ Church in Urbana. He served his Church in other capacities including Itinerant and Conference Superintendent for the Lower Wabash Conference. There are two notebooks in this collection but only one is complete. The complete notebook lists his traveling expenses for the Conference Year, 1915-1916; pastors' contracts and salaries arranged by town; Lay Delegates to the Lower Wabash Conference; presents received; and "pastors to be." The other notebook is missing over 50 pages and only a list of Lay Delegates remains. [These notebooks were purchased at an estate sale of Mrs. Ethel Lemay of Urbana, daughter of Rev. Norviel. They were a gift to the Survey by Dennis F. Walle.]

NORWOOD, JOSEPH GRANVILLE (1807-1895). PAPERS, 1806-1876. 7 items, transcripts. Calendar. 1 reel, microfilm.

Prior to his appointment as Illinois State Geologist (1851-1858), Joseph Norwood served as printer, newspaper owner, and surgeon. As State Geologist, Norwood wrote to Dr. Robert Peter concerning the formation of the Kentucky Survey, the activities of the Illinois Survey, and the death of Mr. Varner, Norwood's geological assistant. Upon dismissal from his appointment as Illinois State Geologist, Joseph Norwood continued to work with other geological services, lectured at various universities, and continued to publish geological papers.

Included among the transcripts are copies of tax records for the Norwood families of Woodford County (July 31, 1807-1840) and of Fayette County, Kentucky (1816-1826). [These transcripts were taken from the collection of the Kentucky State Historical Society.] The microfilmed letters of Norwood and Worthen are addressed to Fielding Bradford Meek (1817-1876), renowned paleontologist at the Smithsonian Institution. Geological findings, new publications, and expeditions are discussed in the correspondence. [Transcripts of the letters (Norwood to Peter) were made from originals in the possession of the Transylvania College Library's Peter Collection; the microfilm was obtained from the Smithsonian Institute. Both were gifts from Dr. John W. McLure, State University of Iowa, Iowa City, in July, 1969.]

O'HARA, JAMES (1752-1819). PAPERS, 1800-1819. 1 reel, microfilm. Inventory. 69-1610.

James O'Hara, immigrant from Ireland, was employed as a government Indian agent; later he entered into a partnership with Major Isaac Craig in the manufacture of glass. The first thirty items of the collection are letters and documents pertaining to the business career and activities of James O'Hara; they contain accounts of the business situations around Kaskaskia written by his agent, Joseph McFerron. The other items are letterbook copies of correspondence sent by O'Hara to three western merchants: James Morrison of Lexington, Pierre Chouteau of St. Louis, and Pierre Menard of Kaskaskia. [The papers are from the Denny-O'Hara Collection in the Historical Society of Pennsylvania. They were microfilmed for John Tevebaugh and purchased for the Survey, June, 1957.]

O'HARROW. LETTER, 1837. 1 item, machine reproduction.

This letter is from the deputy postmaster of Tamerack, St. Joseph County, Indiana, to a Mr. O'Harrow, Clinton Post Office, Lanawe[?] County, Michigan. He briefly describes the land and natural resources of the area while on a land scouting trip through Northern Illinois. [This letter was acquired from Mr. Brichford of the University of Illinois Archives. He received the letter from Kenneth P. Scheffel of the University of Michigan. The original is part of the Michigan Historical Collections, University of Michigan, Ann Arbor, Michigan.]

OHIO COMPANY. PAPERS, 1768-1782. 33 items, transcripts. Chronological card file. 69-1613.

The affairs of the Ohio Company, which merged in 1770 into the Walpole or Great Ohio Company, are described in the form of journals, minutes, agreements, orders in council, petitions, and letters. The papers are largely concerned with the acquisition of land, especially in relation to agreements between traders and the Indians. Correspondents are Hugh Crawford, George Mercer, George Morgan, William Murray, William Trent, and Samuel Wharton. [These are copies from the Ohio Company Papers of the Historical Society of Pennsylvania.]

OLD SETTLERS SOCIETY. RECORDS, 1873-1911. 1 reel, microfilm.

These records are primarily minutes of the annual meeting of the Old Settlers Society of Logan County, Illinois. A few newspaper clippings of the meetings are also included. [The records were transferred to the Illinois Historical Survey from the University of Illinois Archives.]

ORME, WILLIAM W. (1832-1866). PAPERS, 1855-1873, 1883-1894. 72 items, originals. 127 items, transcripts. Calendar. 61-3144.

William W. Orme settled in Bloomington, Illinois, where in 1850 he formed a law partnership with Leonard R. Swett (1825-1881); in 1862 he became a colonel and in 1863 a brigadier-general in the Union Army.

These letters are mainly to William Orme from David Davis. The reports in the collection are from Georgetown College, Georgetown, D. C., on the academic work of Joseph and Francis Orme. In addition there is a draft of a speech for the campaign of 1860, probably in Orme's writing, and a four-page folder of notes on the voting records of Owen Lovejoy and Richard Yates on various measures. Other correspondents include James Orme, Joseph Orme, Adlai and Letitia Stevenson, and Leonard and Laura Swett. The letters discuss Illinois and national politics in the Civil War period, military questions, legal and other business affairs, and personal matters. [The papers were a gift of Lucy Orme Morgan of Bloomington, Illinois, daughter of General Orme.]

ORVIS, MARIANNE (DWIGHT) (1816-1901). LETTERS, 1843-1847. 1 reel, microfilm. 69-1611.

Mary Ann Dwight, younger sister of John Sullivan Dwight, was a resident member of the Brook Farm Community, West Roxbury, Massachusetts, where she was married, in 1846, to John Orvis. These letters were written at Brook Farm, most of them to Anna Q. T. Parsons. They describe the life at Brook Farm, personal happenings, and financial matters of the community. Most "business" of Brook Farm is tangential to Mary Ann (sometimes signed Marianne) Orvis' personal life. [The originals are in the Massachusetts Historical Society. The complete collection was microfilmed in 1942 for Professor Arthur Bestor and presented by him to the Survey in 1956.]

OWEN, RICHARD (1810-1890). PAPERS, 1836-1888. 1 reel, microfilm. Calendar. 61-3063.

Richard Owen, the son of Robert Owen, was a geologist, officer in the Mexican and Civil Wars, and professor of the natural sciences at Indiana University from 1864-1879. The collection includes twenty-nine letters from his brother, Robert Dale Owen; four from another brother, David Dale Owen; and about thirty from Richard Owen, mostly to members of his immediate family, and including several letters written from Europe in 1869. In addition there are letters from scientists James Dwight Dana, Joseph Henry, and Benjamin Silliman, as well as from other public figures. There are also a number of military documents from both wars in which Colonel Owen served, including two orders issued by General Ulysses S. Grant, as well as a number of memoranda and speeches by Richard Owen. Three small notebooks are included, two of which contain diaries of Richard Owen covering the years 1868-1869 and 1882-1885. [The original manuscripts were owned by Mrs. Aline Owen Neal of New Harmony, Indiana. The collection was arranged, cataloged and filmed under the direction of Professor Arthur E. Bestor, Jr., during the period, 1950-1952.]

OWEN, ROBERT (1771-1858). PAPERS, 1815-1858. 12 reels, microfilm. 111 items, photocopies. Calendar, chronological card file. 61-1640.

This collection contains correspondence, deeds, and other papers concerning the New Harmony Community and other Owenite movements. Robert Owen wrote the greatest number of letters. Other correspondents include George Flower, Marie Fretageot, Joseph Hume, Thomas Jefferson, William Maclure, James Madison, James Monroe, Robert Dale Owen, William Owen, Robert Peel, Nicholas P. Trist, and Frances Wright. [Eleven reels of microfilm are from the Manchester Collection in possession of the Cooperative Union Limited, Holyoke House, Manchester, England. The other reel of microfilm, containing fourteen items, is from the Dorsey-Owen collection in the Indiana Historical Society Library. (James M. Dorsey was an advisor and agent of Robert Owen at New Harmony.) The photocopies are from the following depositories: Library of Congress, Indiana Historical Society Library, Manchester Cooperative Union, American Philosophical Society, Illinois State Historical Society, Historical Society of Pennsylvania, and the New York Historical Society.]

OWEN, ROBERT DALE (1801-1877). PAPERS, 1831-1873. 1 reel, microfilm. Calendar. 61-1713.

Robert Dale Owen, eldest son of Robert Owen, was a participant in the New Harmony Community, a social and educational reformer, a member of Congress, minister to Naples, and a spiritualist. The collection comprises ten letters from Robert Dale Owen (the earliest of which is dated 1871) and approximately forty letters to him (mostly in the 1870's) which include letters from James Freeman Clarke, Charles W. Eliot, and also Henry James. There are several legal documents, including Owen's certificate of naturalization (August 5, 1831), and several certificates of election. There are a number of memoranda in Owen's hand, one of which is a memorandum to President Lincoln on "The Pardoning Power as an Element of Reconstruction," September 30, 1863. Most of the other memoranda, and a considerable part of the correspondence, relate to spiritualism and belong to the early 1870's. [The original manuscripts were owned by Mrs. Aline Owen Neal of New Harmony, Indiana, and were duplicated for the Survey in July, 1952.]

PACIFIC RAILROAD OF MISSOURI. RECORD, 1869. 1 item, photocopy and microfilm.

This selection, from the Board of Directors' Minute Book, concerns action on a petition from members of the Board of Directors who served as lobbyists for the railroad during the Civil War both at Washington, D. C., and Jefferson City, Missouri. In their request for a claim adjustment the lobbyists explain their services in securing payment from the Federal Government for military use of the Pacific Railroad and obtaining a bill from the state legislature in March, 1868, which enabled the road to restructure its organization thereby preventing a take-over by eastern capitalists. [The original is in Archives of the Missouri Pacific Lines, Missouri Pacific Building, St. Louis, Missouri.]

PARKER, ALETTA L. LETTER, December 3, 1917. 1 item. 69-1599.

This letter from the widow of Joseph Parker gives biographical data concerning her husband, who was a member of the 1869-1870 Constitutional Convention from Ogle County.

PARMELEE, REXFORD CLARK. WEDDING SERVICE, May 11, 1935. 1 item.

This service was used at the wedding of Sylvia Badieh Paine and Rexford Clark Parmelee on May 11, 1935. [The records were transferred to the Illinois Historical Survey from the University Archives in February, 1971.]

PATRONS OF HUSBANDRY. CHAMPAIGN COUNTY GRANGE. RECORDS, 1873-1877. 3 volumes. 62-1911.

These records were kept by W. F. Hardy of Champaign, Illinois. The first journal contains proceedings of the Champaign County Grange, Patrons of Husbandry, from its inception (September 5, 1873) through September 25, 1877. The second journal contains proceedings of the Champaign County Grange, formed from existing local granges within the county, at Tolono. The last journal is the proceedings of the Farmers Cooperative Association of Champaign County from 1875 to 1877. [These were deposited in the Survey by Mrs. Edith Sweney of Urbana, Illinois, granddaughter of W. F. Hardy.]

PEASE, THEODORE CALVIN (1887-1948). CORRESPONDENCE, BIBLIOGRAPHIES, NOTES, 1910-1948. 5 items. 8 folders. 27.1 feet of 3x5 and 4x6 cards. Memorabilia. List. 69-1592.

Theodore Calvin Pease first became associated with the Illinois Historical Survey in 1910, and taught in the History Department of the University of Illinois from 1914 to 1948. He became Head of the Department in 1942. Dr. Pease authored, co-authored, edited or co-edited more than a dozen works and his The Leveller Movement won the Herbert Baxter Adams Prize of the American Historical Association in 1915. He served as Editor of the Illinois Historical Collections (1920-1939) and of the American Archivist (1937-1946), Director of the Illinois Historical Survey (1939-1948), Chairman of the Historical Manuscripts Commission of the American Historical Association (1925-1931), and President of the Illinois State Historical Society (1946-1947).

This collection illustrates many of Professor Pease's activities and interests. The correspondence in the collection is with L. M. Larson and Phineas L. Windsor. The Course and Subject notes contain the categories of Western History (1664-1807), the History of the West to 1818, and courses taken by Pease at the University of Chicago. Materials on scholarly works are: two typewritten copies of an unpublished pamphlet bibliography of The Leveller Movement; a handwritten copy of the Introduction to Anglo-French Boundary Disputes in the West, 1749-1763; a galley proof of the Story of Illinois; notes on County Archives of Illinois, The Frontier State, Illinois Election Returns, Illinois on the Eve of the Seven Years War; and Dictionary of American Biography articles on John J. Hardin, Robert R. Hitt, Stephen A. Hurlbut, John M. Peck, and G. B. Raum; and a name index on The French Regime. The memorabilia in this collection includes various World War I pins and tags, Illinois Veterans' Medals, World War II Ration Books, and unidentified photographs. [These historical items were a gift of Marguerite J. Pease.]

PEASE-LYMAN FAMILY. PAPERS, 1819-1936. 632 items. Calendar.

The Reverend Orange Lyman, married to Marcia Dewey, was pastor of the Madison Congregational Church in Madison, Ohio, before emigrating to Downers Grove Township (21 miles west of Chicago) in 1838. He began farming with his family in 1839, and continued to preach in the vicinity of DuPage, Illinois. Included in this collection are some of his sermons and oratories dated in the 1840's. Orange and Marcia Dewey Lyman had three sons: Thomas, Stephen D., and Henry Martyn. Concerning these individuals there are letters from the brothers to Henry and his wife, Lovancia Pease; and from Mrs. Orange Lyman after the death of Orange in 1851.

Lovancia Pease, born in 1821, attended Oberlin College and taught school for about ten years before marrying Henry Lyman in 1850. They settled in Downers Grove, Illinois. This collection contains memorabilia from her youth, letters from their courtship and letters which they received from both sides of the family. He died in 1894 and his wife in 1912.

There are a large number of Pease family letters in this collection. Lovancia Pease Lyman's sister, Sarah Pease Wilson, writing mostly from Faribault, Minnesota, can be considered the family chronicler as it is from her letters that most of the family information can be derived. She provides family genealogical information and gives "news" from the 1890's. There are also letters from Lovancia's brothers, Granville and Lauren Pease. Besides family letters, the collection also contains a biography and genealogy of Lovancia Pease, Pease family records, Lyman family records and miscellaneous papers.

PECK, JOHN MASON (1789-1858). PAPERS, 1827-1858, 1931. 32 items, transcripts. 14 items, machine reproductions. 1 reel, microfilm. Calendar. 69-1612.

John Mason Peck was a Baptist preacher, author, and editor who came to Illinois in 1822. The correspondence in the collection relates to Shurtleff College, which he helped to found; higher education in Illinois; the Bethel Baptist Church, Rock Spring, Illinois, of which he was a pastor; and the Baptist Church activities in Illinois. Correspondents include Warren Leverett and Ebenezer Thresher, professors at Shurtleff College; David Benedict; Caleb Blood; S. S. Cutting; Jonathan Going; George Haskell; William Leverett; Daniel Sharp; John S. Williams; and trustees of the Baptist Missionary Society of Massachusetts.

The journal in the collection, labelled "J. M. Peck, Rock Spring, Illinois," contains entries made by Peck from 1854-1858, plus some notes on earlier years. Included are diary entries for short periods during 1855-1856, expenses for travels, other expenditures, lists of subscribers for various Baptist publications, notes on land purchases and taxes paid, references to Shurtleff College and various agencies with which he was associated. [The transcripts, photocopies, and microfilm were made from originals owned in part by Shurtleff College, Alton, Illinois; Andover Newton Theological School Library, Newton Centre, Massachusetts; and Mrs. Roy A. Blair, Alton, Illinois (granddaughter of Warren Leverett).]

PEPPER, WILLIAM ALLEN (b. 1831). DIARY, LETTERS, 1862-1865. 8 items, machine reproductions.

William Allen Pepper of Kentucky, moved to Coles County, Illinois in 1838. He served in the Civil War with the 123rd Illinois Volunteers in Kentucky, Tennessee, Georgia, and Alabama. The letters, written to his sister and his mother, concern the preparation for a battle with General Bragg's Army in Kentucky; the march south from Louisville through Kentucky; the aftermath of a battle, with descriptions of the wounded and dying; the pleas for news from home; and information about friends also in battle. The diary, covering the period from July, 1864 through August, 1865, deals in general with the weather, travel conditions, rations, and camp life. The final portion of the diary concerns his travels to Minnesota after the war to stake a homestead claim of one hundred acres in Faribault County. [The transcripts were a gift to the Illinois Historical Survey from A. Kent Kilen, great-grandson of William Allen Pepper.]

PETRIE, JOHN. LETTERS, 1838. 2 items.

These two letters are from John Petrie in Griggsville, Illinois, to his brother [in-law?],
Eli English, in Hartland, Vermont. They describe local commercial and agricultural
conditions, and give personal news.

PHILLIPS, J. W. JOURNALS, 1863-1876. 9 volumes. 61-1965.

These journals were kept by J. W. Phillips, a resident, first of Washington, Tazewell
County, and then (by 1870) of Peoria. He was in the nursery business and referred to
himself as a "tree agent." The journals are a combination of personal and business notes
and records of finances. He records long trips made to sell fruit trees and other nursery
products. [These items were purchased from Paul North, Columbus, Ohio, in December, 1954.]

PIATT FAMILY. RECORD BOOKS, 1879-1913. 3 volumes. 69-1588.

All three record books concern farm business around Monticello, Illinois. The volume kept
from 1894 to 1898 lists prices for the sale of cattle and sheep, the purchase and sale of
corn, and payments on loans and dry goods. The book kept from 1879 to 1906 contains
entries for more personal business, such as payments to hired workers, bills, and purchase
of household goods. The third volume records the dealings of Piatt and Ridgely, a company
which imported and sold draft horses, mostly Percheron mares and stallions. In addition,
there are some letters attached to a few pages concerning the purchase of the horses.

PIERSON, CHARLES. DIARIES, SPEECH, 1857-1864. 3 volumes. 1 item.

Charles Pierson farmed near Lima, Ohio, and Rantoul, Illinois. The diaries include
entries of Samuel Pierson (February 1860-August 1861), A. D. Pierson (August 1860-October
1864), and Charles Pierson. Various entries concern farming procedures, weather reports,
family circumstances and reactions to the Civil War, especially the draft. Also included
is a speech describing changes in navigation and Christopher Columbus. [The collection
was transferred from the Rare Book Room of the University of Illinois Library to the
Illinois Historical Survey Library in October, 1973.]

PIKE, ROBERT, JR. LETTER, 1846. 1 item. 69-1589.

This letter from Robert Pike in Utopia [Chenango County, New York] to W. E. Woodward in
Waltham, Massachusetts, discusses the printing of books. [The letter was purchased from
the Symmachus Trading Company of Boston in 1952.]

POPE, NATHANIEL (1784-1850). LEGAL DOCUMENT, 1834. 1 item. 69-1603.

This is a certificate of the clerk of Randolph County Commissions Court that Nathaniel
Pope has entered specified land for taxation in 1834. [This was a gift of Wilbur Duncan
of Decatur, Illinois.]

POST HOSPITAL, IRONTON, MISSOURI. LEDGER, 1862, 1866. 1 volume.

This ledger served two purposes. The first of these concerns the Post Hospital at
Ironton, Missouri, from January through June, 1862. Accounts are kept for supplies
bought for the hospital and for individuals there evidently as patients or personnel.
Also found within the ledger are monthly statements of the Hospital Fund, an inventory of
the hospital's supplies, a roll of soldiers employed on extra duty as cooks and nurses,
and accounts of hospital stores and furniture and of rations issued. A second section of
the ledger is written from LeRoy, Illinois, in 1866. The first part of these entries
concerns a nearly daily diary of a doctor in LeRoy. Included are reports of his patients'
conditions and medicines prescribed for them. The second part of the LeRoy entries
concerns the opening of the Empire Hotel by a Mr. M. C. Byrney. [The ledger was acquired
by the University of Illinois Library in September, 1945, from Putnam Bookstore,
Bloomington, Illinois.]

PRESBYTERIAN CHURCH. PARIS, ILLINOIS. RECORDS, 1824-1895. 8 items, transcript.

These records of the session and trustees of the Presbyterian Church of Paris, Edgar
County, Illinois, contain "Minutes of Congregational Meetings" and accounts of financial
business. The records begin with the first meeting (1824), where they note the
establishment of the church and the election of Ruling Elders. [The transcript was
compiled by Paxson Link of Paris, Illinois.]

PRICKETT, JOHN A. (1822-1897). PAPERS, 1846-1851. 12 items, transcripts. 69-1607.

John A. Prickett, born in Edwardsville (1822), helped organize Company E, 2nd Illinois
Volunteers in 1846 and served as first lieutenant until he was wounded in the shoulder at
the Battle of Buena Vista on February 22, 1847. He returned home in April, 1847, was
elected county recorder of deeds (1847), and county clerk (1849), serving twelve years.
He also operated a flour mill, and in 1869 established a bank, J. A. Prickett and Sons.

The items in this collection consist of letters and a series of articles by Prickett. Ten
of the letters written during his service in the Mexican War were sent to Miss Elizabeth
Barnsback of Edwardsville, whom he married on November 7, 1847. One letter was written
to Elizabeth's father, J. L. Barnsback. The letters discuss the trip toward New Orleans
and Galveston before Prickett engaged in battle, as well as the countryside of southern
Texas and northern Mexico. He also describes the life of the volunteers and the
skirmishes. A transcript of an incomplete series of articles appearing in the Madison
Record of Edwardsville (1850 or 1851), is entitled "Scraps of History; an account of the
battle of Buena Vista," and describes battles in the Mexican War and the general
atmosphere of army life during the war. [The newspaper transcripts and the transcripts
of the letters were made in 1912 from the originals in the possession of Mrs. William H.
Jones, Edwardsville, Illinois.]

PROGRESSIVE PARTY OF VERMONT. PLATFORM, July 22, 1912. 1 item, machine reproduction.
Calendar.

This platform of the National Progressive Party of Vermont was written by Wallace
Batchelder on July 22, 1912, and adopted at Burlington, Vermont, the next day. It
strongly criticized the National Republican Convention held at Chicago that year. [Dr.
Louise Dunbar of Urbana, Illinois, loaned the platform to the Survey for duplication
(March, 1871) before donating it to the Vermont Historical Society, Montpelier, Vermont.]

QUINBY, ALFRED AND R[EUBEN]. BUSINESS LEDGER, 1827-1841. 1 volume.

Alfred and Reuben Quinby (often referred to as Quimby in the ledger) were merchants in New York City. In this ledger appear lists of sales to individuals and receipts from importers and domestic dealers in dry goods, groceries and yard goods. [This ledger was acquired by the University of Illinois Library in May, 1931, and later transferred to the Illinois Historical Survey Library.]

RAILROAD BUSINESS PAPERS. LETTER, SUBPOENA, PAPERS, 1840-1882. 41 items. Inventory.

The letter in this collection requests information on the location of a cattle crossing. The subpoena calls a railroad to court to answer claims for the killing of a mule and the building of a fence. Among the business papers are a pass, debt and stock statements, and receipts and waybills. [This collection was a gift to the Illinois Historical Survey from the Commerce Library in 1971.]

RANDOLPH COUNTY, ILLINOIS. PAPERS, 1720-1853. 5 items, originals and photocopies. 81 items, transcripts. 62 reels, microfilm. Calendars, inventories, abstract, index. 61-1686.

Randolph County was created in 1795 by dividing St. Clair County (which was organized in 1790) and included both Kaskaskia and Fort Chartres, the seat of government from 1719-1765, except for nine years when the government was at Kaskaskia. Kaskaskia was named county seat in 1795; in 1847 Chester became the county seat.

The Survey's various holdings pertaining to the early Randolph County Records are: (1) Randolph County Records in the Office of Circuit Court and Recorder and records of the County Clerk, 1718-1870, 48 reels. (2) Kaskaskia Record Book I, 1736-1782, and 269 miscellaneous records, 1718-1834, 2 reels. (3) Randolph County Records, Circuit Court for Randolph County, 1739-1849, 10 reels. (4) Parish records, 1692-1799, 2 reels. (5) Papers, 1768-1773. 81 items, transcripts. (6) Miscellaneous papers, 1726-1783. 5 items, originals and photocopies. These items are the Vincennes Oath, a Notarial Record (October 26, 1783), a letter from Manuel to Langlois, a receipt (October 8, 1726), and a Proclamation by Wilkins (1770).

For this collection, the Survey has a variety of finding aids. Housed with the collection are: an abstract of Kaskaskia marriage contracts, 1720-1778; a revised inventory of 53 reels of microfilm; a calendar of the Court Record Book, 1768-1775; a calendar of Kaskaskia Manuscripts, Public Documents, 1720-1816, prepared under C. W. Alvord; and a Master Calendar of Randolph County Records microfilmed in 1952 and 1960. In addition there are at least two other indices, calendars, and card files including a chronological card file.

C. W. Alvord first saw the records at Chester in 1905, and designated them "Kaskaskia Manuscripts." They were secured on loan from the Randolph County Commissioners by the University of Illinois. At the University they were classified, repaired, and mounted on silk; also, some of them were published. Transcripts, indices, and abstracts were prepared and placed in portfolios (24 volumes.) The records were then returned to the Randolph County officials. Records not examined by Mr. Alvord were found in the Chester Court House in 1950 by Mr. John Allen. These were loaned to Southern Illinois University where Professor Norman Caldwell sorted the documents into folders, selecting a few manuscripts from each folder to calendar and photocopy. In 1952, the Archives Section of the Illinois State Library microfilmed the complete collection (through the territorial period) then to be found at Chester. Some records which were found at the University of Illinois in 1959 were also microfilmed and then returned to Randolph County. Finally, in 1961 the Allen-Caldwell collection, of which only selected documents had been microfilmed previously, was loaned to the Illinois State Archives for processing and microfilming.

RANDOLPH COUNTY, ILLINOIS. LIBERTY PRECINCT COURT DOCKET. RECORD, 1860-1868. 1 volume.

This volume, which is in very poor condition, contains a record of cases which were heard in the Liberty Precinct Court, Randolph County. The majority of readable cases, 1860-1861, were handled by Justice of the Peace, E. J. Ward. There is a very limited index. [This item was given to the Survey by the University of Illinois Archives in 1973.]

RATIONAL BRETHREN OF OXFORD, BUTLER COUNTY, OHIO, AND COAL CREEK COMMUNITY AND CHURCH OF GOD, FOUNTAIN COUNTY, INDIANA. RECORDS, 1816-1817, 1823-1832. 1 reel, microfilm. 69-1589.

This record book contains the constitutions and other documents of these two organizations. [The original volume, with some pages missing, is in the Indiana State Library.]

RATTERMANN, FRIEDRICH SCHILLER (b. 1859). LETTERS, 1905. 3 items. 69-1615.

Friedrich Rattermann was the son of Heinrich A. Rattermann, historian, editor, and author. These letters, written from Davenport, Iowa, to his father and to his sister, Katheryne, concern the appointment of an agent to sell his father's poems.

RATTERMANN, HEINRICH A. PAPERS, (1845-1923). Approximately 12 feet.

Heinrich A. Rattermann of Cincinnati, Ohio, was a German-American poet, historian, businessman, and editor. His papers include bills and receipts; published and unpublished literary manuscripts; deeds, bonds, and other legal material; personal, business, cultural and legal correspondence relating to German language instruction, curricula in the German language schools, American education, German-American publishing and journalism, Der Deutsche Pionier, German-American insurance, Cincinnati Orpheus Society, Ohio politics and the Civil War. The papers include manuscript records of the Narren Club, Liedertafel, German Literary Club of Cincinnati, as well as others. Many papers concern the impact of the German-American on the history of the development of America. Among the correspondents are Julius Hilgard, Gustav Koerner, and Oswald Seidensticker. [This collection was obtained by the University of Illinois Library in 1915. It was transferred to the Illinois Historical Survey Library in 1974.]

RAUM, JOHN (1793-1869). LETTERS, 1832-1856. 16 items. Chronological card file. 69-1599.

John Raum, the father of Green Berry Raum, was born in Pennsylvania, and served in the War of 1812. He came to Illinois in 1823 and was a brigade major in the Black Hawk War. Among the elective or appointed offices which he held were state senator (1832), postmaster of Golconda (1834), and clerk of the circuit court of Pope County, 1835-1868.

Writers of these letters to John Raum include Zadok Casey, Henry Eddy, John Reynolds, and others. The letters concern topics such as land speculation, the split between Free-Soilers and pro-Slavery men, elections in the Illinois Senate, and politics in general. Many of them relate to personal business and claims on losses sustained in the army.

RAYMOND, BENJAMIN WRIGHT (1801-1883). LETTER, March 12, 1851. 1 item.

Benjamin Raymond, the third mayor of Chicago (1839), was on the first board of directors of the Galena & Chicago Union Railroad. This letter from him transmits confidential information, concerning the imminent choice of a route from Elgin to Belvidere on the Galena & Chicago Union Railroad, to Anson Sperry, a proponent of the "northern route."

REA, JOHN J. (1852-1941). RECORDS, 1897-1943. 1 reel, microfilm.

This film was made of a scrapbook held by John J. Rea, Jr., son of T. Wayne Rea and the grandson of John J. Rea, Urbana attorney. The material is primarily concerned with the period, 1900-1920, and is mainly in the form of newspaper clippings. News articles relate to the early history of Urbana-Champaign and Mahomet, as well as the destruction of Galveston, Texas, and the San Francisco, California, earthquake of 1906. [The scrapbook was microfilmed in April, 1962, by the University of Illinois, and the film was deposited with the Illinois Historical Survey.]

RECORD OF THE RESTORATION OF THE THIRD STATE HOUSE, VANDALIA. REPORT, 1930-1945. 1 reel, microfilm.

Written by Joseph F. Booten and George M. Nedved for the Division of Parks and Memorials of the Department of Public Works and Buildings, this report discusses the research and the process of restoration undertaken for Illinois' Third State House. The essay begins with the historical background of the building and the conditions which determined its construction and includes a description of the interior and exterior. The major portion of the report deals with the furnishings and furniture of the restoration and gives detailed descriptions. Also, there is a discussion of the stone used in the foundation and two pages of floor plans. [This microfilm is a reproduction of the original in the State Archives in Springfield.]

RECTOR, WILLIAM (d. 1826). FIELD NOTES, 1805-1806. 1 reel, microfilm.

The William Rector field notes are in two notebooks. The first notebook contains Rector's field notes of the survey of the southern boundary of Illinois from the west bank of the Wabash. The second notebook has Rector's notes on his survey of the meridian line north from the confluence of the Ohio and Mississippi Rivers. The last pages of this notebook contain affidavits of faithful surveys by three assistant surveyors: Isaac Richardson, Thomas Tolbert and William Smith. [The original field notes are in the possession of the Indiana Historical Society.]

REED, JOSEPH F. LETTERS, 1829-1843. 29 items.

These are letters mainly from publisher and farmer, Joseph F. Reed, to his brother-in-law, William W. Billing of Washington, D. C. In Ohio, he published two papers: the Jackson Sentinel (1829-1833) in Mansfield, Ohio, and the Tiffin Gazette (1836-1837) in Tiffin, Ohio. When he moved to Prairietown, Illinois, he farmed and served as School Commissioner of Richland County. The letters are concerned basically with personal and business news, local prices and living conditions, land speculation, and the scarcity of cash. Political points discussed are the slavery question, the division of the nation, and the political nature of Reed's newspapers. [The letters were acquired by the Survey in 1951 from Mrs. Tom Frusher of Mystic, Connecticut.]

REED, SAMUEL BENEDICT (1818-1891). DIARY, May 27-October 3, 1865. 1 item, transcript.

After working on the Erie Canal, Samuel B. Reed went to Illinois in 1842 and was associated, in turn, with the Michigan Southern Railroad, the Chicago and Rock Island Railroad, and the Mississippi and Missouri Railroad. In 1864 Thomas C. Durant hired Reed as locating engineer of the Union Pacific. The following year, Reed was put in charge of all surveys west of the Continental Divide, while in 1866 he was appointed Engineer of Construction and Superintendent of Operations for the advancing line.

This diary covers the summer of 1865, when Reed led surveying parties primarily east from Salt Lake City. In addition to accounts of the road's progress, Reed describes the terrain, the water shortage, and relations with the Mormons of the area. [The transcript of Reed's diary was transferred to the Illinois Historical Survey from the University of Illinois Commerce Library in March of 1972.]

REEVES, MONTRAVILLE (b. 1829). PAPERS, 1863, 1963. 17 items. 69-1586.

Montraville Reeves enlisted from Douglas County in the Civil War as a private in the 79th Infantry, and he rose to the rank of 1st lieutenant. The letters are primarily addressed to his brother, Ransom R. Reeves, and to their uncle; they were sent from Tennessee and Alabama. In them Reeves describes his personal life in the army, a skirmish near Murfreesboro, the Shiloh battlefield after the conflict, the importance of the Copperheads, the battle of Chickamauga, and his opposition to Negro troops. [This collection was given to the Survey through Professor Norman Graebner in 1963. He had received the letters from Artie Lee Reeves. Information concerning the family was procured from a great-aunt, Mrs. M. S. Vance, Tuscola, Illinois.]

REYNARD, I. D. LETTER, December 18, 1852. 1 item.

Addressed to the Rev. George I. Donmyer from I. D. Reynard in Fairfield, Illinois, this letter deals with the business affairs of the deceased S. S. Miles.

REYNOLDS, JOHN W. (1788-1865). CORRESPONDENCE, 1835-1842. 4 items. Chronological card file. 69-1603.

These four letters include three written by John Reynolds, legislator, governor, and congressman, to Major P. W. Winchester of Carlinville concerning a pension and a land grant. The last letter is from Thomas A. Blake, Commissioner of the U. S. General Land Office, to John Reynolds.

RICE, EDWIN (1820-1883). DIARIES, 1859-1862, 1865. 2 items, transcripts.

Of these two diaries, the first describes his stay in Chicago and discusses primarily Rice's attendance at church services. The second recounts his round trip from Lisbon, Illinois, via New York City, the West Indies, Panama, San Francisco, Nevada, Salt Lake City, and Denver. He writes of his reaction to the news of Lincoln's death, of his experiences in a then relatively unsettled portion of the American West, and of observations about the people and the land. [The transcripts were made in 1964 from diaries in the possession of Mrs. Helen Moffet Hay, Urbana, Illinois.]

RIPLEY, GEORGE (1802-1880). PAPERS, 1838-1880. 1 reel, microfilm. 69-1589.

The letters in this collection pertain to Brook Farm and to Ripley's activities after its demise. Correspondents include George Bancroft, Edward Everett, and Theodore Parker. There are letters pertaining to a charter for the Brook Farm Community, legal advice, the idea behind the Community, standards of schools in Massachusetts, biographical data for publications, and the publication of George Bancroft's second volume of the History of the United States.

The papers include an act of incorporation for the Community, a biography of Fourier, and a work by Ripley entitled "Books and Men: A Series of Critical and Bibliographical Studies", which contains illustrations of contemporaneous literary history. [This collection of Ripley papers and a few items from other collections was microfilmed from the originals in the Massachusetts Historical Society.]

ROBINSON, SIDNEY (1834-1893). LETTERS, 1862-1865. 117 items, transcripts. 61-1685.

Sidney Robinson of Madison County, Illinois, was mustered into the 117th Illinois Infantry, in 1862, and served to August 5, 1865. The letters are written to Robinson's father, mother, and brothers (Joseph A. and William Jule). In them he describes conditions at every fort and camp area at which he was stationed, the marches, the battles and camp life. Specific issues which he discusses are the Negro, diseases among the troops, the political situation and the assassination of Lincoln, the making of peace, scarcity of supplies, and Robinson's plans to farm after his discharge.

ROEDTER, HENRY. PAPERS, 1834-1857. Approximately .5 feet.

Henry Roedter of Cincinnati, Ohio, was a lawyer, editor, U. S. Deputy Marshall, judge and politician. This collection is composed mainly of correspondence and some legal papers and documents. Among the subjects discussed are mid-nineteenth century legal procedures and problems, German-American cultural affairs, slavery, abolition, and the Kansas-Nebraska Act. [The collection, originally a part of the Rattermann Collection, was transferred to the Illinois Historical Survey from the Rare Book Room of the University of Illinois Library in 1974.]

ROOSEVELT, THEODORE (1858-1919). LETTERS, 1915, 1917. 2 items.

These letters by Theodore Roosevelt were sent to Walter Colyer of Albion, Illinois, and to Laurence M. Larson of the University of Illinois. The first is an acknowledgment of a letter and the second sets forth his views on the preparedness of the United States for war.

ROOSEVELT, THEODORE, JR. (1887-1944). LETTER, March 23, 1925. 1 item.

This letter from Roosevelt to Charles M. Woodbury of Danville, Illinois, speaks of an undefined problem with which the Izaac Walton League was concerned.

ROSEVILLE TEMPERANCE UNION. RECORDS, 1867-1870. 1 volume.

This journal of the Roseville Temperance Union includes a statement of purpose for the organization, a constitution, records of the meeting which founded the organization and of subsequent meetings, and a treasurer's account.

RUTHERFORD, HIRAM (1815-1900). PAPERS, 1841-1847. 1 item, original. 25 items, transcripts. 69-1604.

Dr. Rutherford settled in Oakland (first named Independence), Coles County, Illinois, in December, 1840. The letters, written chiefly to John J. Bowman, Elizabethville, Dauphin County, Pennsylvania, describe a doctor's practice in the region, trade, farming, and the development of the settlement. Included are three other letters, one each written by Lucinda Rutherford, George E. Mason, and C. O. Ashmore. A manuscript sketch entitled "Jonas Bragg, a Personal Sketch," is also a part of the collection. Bragg (d. 1863) was a farmer, horsedealer, trader, and later, a hotel operator who lived in Vermilion County, as well as in Camargo and Urbana.

ST. CLAIR, ARTHUR (1736-1818). PAPERS, 1788-1815. 119 items, microcards.

Arthur St. Clair was a major general in the Revolutionary War and the first governor (1787-1802) of the Northwest Territory. This is a collection of correspondence and personal papers which include legal, financial, administrative, and military papers relating primarily to the Northwest Territory. [The original collection is in the Ohio State Library.]

ST. CLAIR COUNTY, ILLINOIS. ARCHIVES. REPORT, 1938-1939. 1 item, carbon copy.

This report is entitled "Land Titles in Cahokia, 1783-1938", and deals with the Cahokia Memorial Survey which was conducted during 1938-39 by the Cahokia Historical Society, St. Clair County Board of Supervisors, and the Illinois W. P. A. It contains explanations and listings of owners of land in Cahokia as well as a map of the area.

ST. CLAIR COUNTY, ILLINOIS. ARCHIVES. "PERRIN COLLECTION." PAPERS, 1722-1809. 2 items, transcripts. 3 reels, microfilm. 61-1684.

These papers are official records of the French, British, and early American periods in Illinois found in the archives of St. Clair County. Survey holdings pertaining to these records are as follows: (1) Perrin Collection, 3 reels. On the first two reels there are miscellaneous papers for 1722-1809. They include the Registre des Insinuations des Donations aux Siege de Illinois, 1737-1769, which is the oldest court record in the Upper Mississippi Valley, kept from 1737-1768. Another item of interest on the microfilm is "Record Book A" of the Court of Common Pleas, 1795-1796. The third reel contains marriage contracts, 1763-1802; marriage certificates, 1791-1807; and marriage records, Volumes A, C, and D, 1807-1845. (2) Cahokia Records, Folios 22-39. 2 items, transcripts. These documents concern a suit (1786-1787) between Laurent Durocher of St. Louis and Pollard and Masson of Detroit over a consignment of goods. [The Cahokia records in Belleville, the county seat, came to the attention of Mr. J. Nick Perrin in 1890. With the consent of the board of supervisors he gathered a collection of the county records which became known as the "Perrin Collection." C. W. Alvord examined the records in 1905 and published a portion of the documents in Cahokia Records. The Perrin Collection now is housed in the Illinois State Archives. The Survey has a complete microfilm copy of the collection.]

ST. CLAIR COUNTY, ILLINOIS. POLITICS. PAPERS, 1837-1869. 16 items.

These are letters and drafts of resolutions originating in St. Clair County. The drafts are as follows: an 1841 draft of resolutions regarding the free banking system and internal improvements, an 1843 draft of an open letter to "Mr. Calhoun," a draft of an open letter by a member of the Consitutional Convention of 1847, an 1849 draft of resolutions against the free banking system, an 1849 draft of a letter in behalf of the candidacy of General James Shields for the United States Senate, an 1852 draft of resolutions on the death of Thomas Carlin, an undated resolution endorsing Hungarian independence, and a draft of a resolution of non-interference in the right of nations to choose their own government. There is also a letter (Carlyle, June 4, 1842) endorsing the candidacy of Sidney Breese for governor.

SATTERLEE, BERINK W. ACCOUNT BOOK, 1859-1880. 1 volume.

Berink Satterlee, of Salisbury, kept various accounts in this book.

SAYER, MARTHA. EXERCISE BOOK, 1796. 1 volume.

This volume of mathematical exercises contains weights and measures of wine, cloth and land; exercises about time and money; and multiplication and division problems.

SCHILLING, GEORGE A. (1850-1938). INTERVIEW, n.d. 1 item. 69-1599.

This interview is with Schilling, the Secretary of the State Board of Labor Statistics under Governor John P. Altgeld. Schilling gives his impressions of Altgeld.

SCHMIDT, OTTO LEOPOLD (1863-1935). PAPERS, 1683-1935. 500 items, originals, transcripts. Chronological card file. 61-3304.

The first section of this collection includes material from 1683-1778. The papers in this section are primarily notarial records concerning the fur trade in the West during the French regime, beginning with the enterprises of La Salle, Tonti, and La Forest.

The second section contains correspondence and biographical material of Otto Schmidt, physician and civic leader, from 1925-1935. Part of the correspondence is with Theodore C. Pease concerning the Illinois State Historical Library. Schmidt was the chairman of that Library's board of trustees. Other correspondence with Pease concerns Schmidt's service on the Chicago School Board (1927-1928), editorial matters, and historical questions. There is also correspondence between Pease and Laurence Marcellus Larson when they wrote separate memoirs of Schmidt for the Journal of the Illinois Historical Society after his death. Pease and Larson's correspondents include Paul Angle, Dr. and Mrs. W. F. Peterson, Lessing Rosenthal, Mrs. Otto L. Schmidt, Richard Schmidt, L. H. Shattuck (director of the Chicago Historical Society), Paul Steinbrecher, and A. W. Vander Kloot. [These papers are from the Otto L. Schmidt Collection of the Chicago Historical Society.]

SCHUYLER COUNTY, ILLINOIS. COUNTY COMMISSIONERS' COURT. LAND ABSTRACT, 1838. 1 item.

This is an abstract from a list of resident lands in Schuyler County, dated October 4, 1838. It was certified by the county clerk. [The abstract is a gift from Wilbur Duncan of Decatur, Illinois.]

SCOTT, MATTHEW THOMPSON (1828-1891). Papers, 1852-1861. 1 reel, microfilm. Calendar.

Matthew Scott was a businessman and landowner, and these materials are warrants, agreements, deeds, accounts, memoranda, letters, and notebooks relating to the establishment and development of a 55,000 acre frontier estate in several different counties in East Central Illinois. The estate was established by Scott, acting in conjunction with various members of his family, and George W. Brand, Richard and Joel Higgins, Samuel P. Humphreys, William H. Latham, Courtney Pickett, James Robbins, James Suydan, and Stephen Swift.

Notebooks and papers dating from 1852 describe in detail entries of land from the federal government, purchases from private individuals, purchase and sale of land warrants, development of tenant farms in McLean County, costs of breaking prairie, construction of houses, fences, well-digging, planting of fruit trees, purchase of farm equipment, seed and stock, hiring of farm hands, and records of crop yields. There is especially detailed information on the development of the town of Chenoa. One of the primary values of the material is in documentation of prices, wages, and land in McLean County for 1852-1861. [The collection was acquired from Dr. David E. Schob in 1969. He selected these items from the Matthew Thompson Scott Papers in the Collection of Regional History and University Archives, Cornell University Library.]

SCRIPPS, WILLIAM ARMINGER (b. 1798). DIARY EXTRACTS, 1833. 1 item, transcript. 69-1618.

William Arminger Scripps, a London publisher, made a journey to Rushville, Illinois, in 1833, to visit relatives. These are extracts from his diary and letters. The diary describes the trip from Buffalo to Detroit, with Black Hawk as a fellow traveler. Other excerpts describe the journey across Michigan and Illinois to Rushville and conditions in Illinois in 1833. Footnotes by the author regarding later conditions in Rushville are also included. [These extracts were copied from James E. Scripps, Memorials of the Scripps Family, A Centennial Tribute. This copy was obtained from Mrs. Grace L. S. Dyche of Evanston in May, 1917.]

SCULLY, WILLIAM (1821-1906). PAPERS, 1906-1968. 18 items. 69-1603.

William Scully, born in Ireland, began his purchase of Illinois land in 1851, eventually owning 30,000 acres in Logan County alone and a total of 211,000 acres in Illinois, Missouri, Nebraska, and Kansas. In the 1860's he began to lease large tracts of land and experimented with scientific methods of farming, including the introduction of alfalfa.

These papers pertain to these lands, which were inherited in part by Thomas A. Scully after William's death. There are several newspaper articles from the Lincoln Courier-Herald, October 15, 1906, which describe William Scully's landholdings, provisions and conditions of renting, the practice of scientific farming on his lands, and a story of Scully's life and business practice. The letters, correspondence between Arthur C. Cole with Trapp and Fox, the managers of Scully Estates, concern largely the nature of Scully's business practice. There is also a lease form of Thomas A. Scully.

SEAMAN, LOUIS LIVINGSTON (1851-1932). PAPERS, 1880-1932. 75 items. 432 photographs. Calendar.

Louis Livingston Seaman was born on October 17, 1851. He was a graduate of Cornell University (1872) and received his medical degree from Jefferson Medical College (1876). Seaman pursued several areas of interest while serving as a military surgeon, including researching epidemics and diseases. He participated in three wars, the Spanish-American, Russo-Japanese, and World War I, and observed six others. He and other army surgeons actively opposed the abolition of army post canteens. Seaman, also an author and public speaker, died in 1932 at the age of eighty-one.

The collection consists of letters and papers concerning specific areas of Seaman's interest, including atrocities in German East Africa, the victory of the Japanese in the war with Russia, disease, and the abolition of the army post canteen. Four hundred and thirty-two photographs of his travels are also included. [The collection was a gift of Mrs. Helen Moffett Hay of Urbana, Illinois, in May of 1971.]

SEINEKE, KATHERINE WAGNER (b. 1908). PAPERS, 1890, 1963, 1964. 10 items, transcripts, machine reproductions. 69-1587.

These are papers, mainly genealogical, pertaining to French settlers in St. Clair County, Illinois. There are three articles by Kathrine Seineke entitled: "Some Answers and Questions Addressed to the Pensoneaus of Illinois, 1964"; "Notes on Some St. Clair County Families Who Trace Back to Francois Saucier, Engineer of Fort de Chartres"; and "Petit Histoire Caillot dit La Chance." Attached to the "Notes..." is a copy of an article on John B. Calio from History of Sacramento County, published in 1890. Also included are translations of four documents from the Kaskaskia Manuscripts pertaining to Nicolas Caillot dit La Chance, a document concerning the purchase of land, the purchase of slaves and household goods, and a receipt for a lease. Finally there is a manuscript entitled "A Family of French Colonial America, Saucier" and a clipping of a letter to the editor in the Chicago Tribune, March 1, 1967, on weather stories. [These materials were presented by Mrs. Seineke of El Granada, California.]

SHAFFSTALL, ADAM. LETTERS, 1862-1863. 2 items, machine reproductions. 69-1586.

These letters written in Fort Marshall, Baltimore, Maryland, and Oppolousas, Louisiana, are from Adam Shaffstall to his parents. They tell of the preparation for the Peninsula Campaign and of his later service in Louisiana. [The letters were a gift of Dr. Jack Nortrup, Tri-State College, Angola, Indiana.]

SHAKERS. PAPERS, 1806-1896. 13 reels, microfilm. 61-1723.

These papers are largely from Shaker colonies in Kentucky, with some also from New Lebanon, New York; from Canterbury (Shaker Village), New Hampshire; and from Union Village, Ohio. The Shaker settlements represented in Kentucky are Pleasant Hill, South Union, Mill Point, and Jasper Springs. The papers include account books, diaries, journals, church records and documents, minutes of meetings, letters, copies of religious tracts, and song books.

The manuscripts of the Church of Pleasant Hill, Kentucky, compose three reels of microfilm. The remaining ten reels contain, in general, journals of daily community life kept by individuals; account books of blacksmiths, storeowners, and other communal activities; letters; religious journals, such as "Record of Visions, Messages, and Communications Given by Divine Inspiration" and the "Society of Believer's Daybook"; and the Constitution of the United Society in New Lebanon, New York. [The three reels of microfilm containing manuscripts of the Church of Pleasant Hill, Kentucky, were microfilmed by the University of Kentucky Library; the originals are at Harrodsburg, Kentucky. The reel of microfilm of the papers of Union Village, Ohio, was made from originals in the Library of Congress. The original manuscripts filmed in the remaining nine reels are at Western Reserve University, Cleveland, Ohio.]

SHATTUCK, NOAH. RECORDS, 1814-1856. 1 volume.

One section of this book is entitled "Military Book 1814, Fort Warren," and contains the militia record of a Massachusetts Militia unit of which Shattuck was captain. The men of the company are listed by name and town. The next entries, beginning in 1824, concern the account of Caleb Blood, apparently Shattuck's married hired hand. Some miscellaneous accounts follow, ending with a date of June, 1835. The other section of the book, entitled "Account Book, Noah Shattuck, 1815," contains his personal accounts and records of the generous amounts of money and land that he gave to his eight children.

SHELBURNE COLLECTION (1737-1805). PAPERS AND LETTERS, 1749-1780. 3 volumes. 309 transcripts. 1 photocopy. Chronological card file, calendar.

This collection of the political and official papers of Sir William Petty; second Earl of Shelburne, first Marquis of Lansdowne was selected mainly for publication in the Illinois Historical Collections.

The three bound volumes in this collection are complete transcripts of the correspondence of the Sardinian Ambassadors at London and Paris, the Comte de Viry and M. le Brilli Solar de Breille. This correspondence was copied from Volumes 9-11 of the Shelburne Collection in the William L. Clements Library (Volumes 1-3 of the Viry-Solar Correspondence). Over three hundred of the transcripts were made in 1909 when the papers were still in the possession of the family. They cover the period when Shelburne served as Secretary of State for the Southern Department. Included are letters, abstracts, memoranda, estimates and plans for new settlements. Subjects discussed are administrative matters and costs, Indian trade and problems, rations and quarters for troops, colonial conditions, religious matters and the government of Quebec. [The originals of this collection are in the Shelburne Collection of the William L. Clements Library in Ann Arbor, Michigan.]

SHIELDS, W. A. LETTERS, 1935. 2 items.

These two letters, dated August 29, 1935, and November 23, 1935, from W. A. Shields, secretary of the La Salle Chamber of Commerce, to Josef F. Wright, Station WILL, Urbana, give information concerning the background history and present (1935) situation of the city of La Salle, Illinois.

SHIPS' PAPERS. PAPERS, 1779-1780. 4 items, photocopies.

These papers are of <u>St. Luis</u>, otherwise <u>Alexander</u>, of the New Orleans registry, with Bartholomew Toutant Beauregard as master. They consist of a bill of lading for goods (April 27, 1779); an affidavit attesting to perishable conditions of certain skins (July 8, 1779); a claim of Patrick Morgan, prisoner of war at New Orleans, with affidavits (November 16, 1780); and papers relating to the entry of the cargo of the <u>Neustra Senora del Carmen</u> (September 16, 1780).

SIMONIN, AMEDEE H. (b. 1822). PAPERS, 1855-1856, 1868. 1 reel, microfilm.

Simonin was the French agent in New York for the Fourierist colonizing venture led by Victor Considerant and others from Paris. It resulted in the establishment of the colony of Reunion near Dallas, Texas. These papers include Simonin's diary, from November, 1855, to June, 1856; a map of Reunion; fragmentary accounts and bills; and letters to him. Correspondents include a number of American Fourierists (James T. Fisher, E. P. Grant, and Marcus Spring), Paris officers of the Societe de Colonization Europeo-Americaine au Texas, and settlers in Texas including Considerant and Cantagrel. [These papers were filmed from originals in the Library of Congress.]

SMITH, JOHN M. (1885-1971). INTERVIEW, January 14, 1969. 3 items, tape recordings. Calendar.

John M. Smith, born August 10, 1885, was a black farmer from Broadlands, Illinois, at the turn of the century. His father, George W. Smith, came to Springfield from the South after the Civil War to begin farming. Later he moved south of Homer where he raised grain, cattle, and horses; he was a success in his farming where others had failed because he drained the land of excess water. Among John M. Smith's interests were showing horses, farming, and township government. [The tapes were given to the Illinois Historical Survey by Station WILL, University of Illinois, Urbana.]

SMITH, JOSEPH (1805-1844) AND HYRAM (1800-1844). PAPERS, 1844-1845. 5 items, machine reproductions. Inventory.

Four of the items in this collection concern the trial of the murderers of Joseph and Hyram Smith. Included is a copy of a published transcript of the trial of Joseph Smith's murderers, two excerpts taken from the official Circuit Court Journal record of that trial, and a list of witnesses subpeoned for the trial of Hyram Smith's murderers. Also in this collection is a Guardian Bond stating that Joseph Smith, Hyram Smith and William Law share responsibilities for the Lawrence children. [These items were copied for the Survey by Mr. Eugene Johnson.]

SMITH, ROBERT (1802-1867). PAPERS, 1836, 1842. 2 items.

The first item is a record of a proposal made by Robert Smith at a meeting in Upper Alton, Illinois (January 30, 1836), concerning the location of the Cumberland Road. The second is a letter to Alexander M. K. Dubois, clerk of the circuit court at Carlinville, about the payment of a mortgage and costs on some Macoupin County land.

SOCIALISM, FOURIERIST. CORRESPONDENCE, 1842-1868. 1 reel, microfilm.

These are letters of Albert Brisbane, Felix Cantagrel, Victor Considerant, Horace Greeley, and Arthur Young. They pertain basically to communitarian issues, such as investment of capital in communes and subscriptions to stock in them; propagation of Fourierist ideas and discussion of their ideas on human nature and Fourierism; translation of Fourier's work; Simonin's trip to Europe; and machinery (threshers) received in Reunion, Texas. [The items in this collection are from various collections in the Library of Congress, including the Trist and the Simonin papers.]

SOCIETY OF FRIENDS. BENJAMINVILLE, ILLINOIS. RECORD BOOK, 1861-1885. 1 volume.

The "Benjaminville Preparative Meeting Book" contains entries for meetings between 1861 and 1885 in McLean County, Illinois. The 1861 entries are copies of minutes of the Blue River Quarterly Meeting of Friends which led to the establishment of the Benjaminville Preparative Meeting of Friends. [This item was transferred from the Rare Book Room of the University of Illinois Library to the Illinois Historical Survey Library in 1973.]

SODUS BAY PHALANX. RECORDS, 1844-1846. 1 reel, microfilm. 69-1589.

The Sodus Bay Phalanx, a communitarian experiment based upon Fourierist principles, was organized in Rochester, New York, and occupied a domain on nearby Sodus Bay. Included in these records of this phalanx are a volume containing the constitution, by-laws, and signatures of the members; a volume of minutes from February 3, 1844 - November 25, 1844; a volume of data on individual members including occupation, number in the family, amount of subscription to stock; two account books (Journal and Ledger) February 3, 1844 - October 21, 1844; one volume of stock certificates; a printed constitution; and loose papers, principally receipts and agreements. [The records were microfilmed in their entirety from the originals in the Rochester Historical Society.]

SOUTH CAROLINA COLONIAL RECORDS. LEGISLATIVE AND INDIAN RECORDS, 1706-1775. 39 reels, microfilm. Inventory. 69-1617.

These colonial records include Council Journals and Upper House Journals from 1721-1774, certain transcripts from the Public Record Office in London of proceedings and minutes of the Council, 1734-1769, and the Commons House Journals, 1706-1761, as well as some transcripts from the Public Record Office. There are also five reels of microfilm which contain the Letterbook of Charles Garth, Provincial Agent of South Carolina, 1766-1775, and the South Carolina "Indian Books," (Journal of Indian Commissions, 1710-1715, 1716-1718 and volumes II-VI, 1749-1760.) [This microfilm was made in 1941 by Charles W. Paape for the Illinois Historical Survey from originals, transcripts, and photocopies in the Historical Commission of South Carolina.]

SOUTH EASTERN RAILWAY. PAPERS, 1894-1895. 8 items. Calendar.

The South Eastern Railway, founded in the 1840's, served a populous suburban district in the area of southern London. In the collection appears a history of the South Eastern Railway written by G. A. Sekon which evaluates the company from its first merger in the 1840's to its status fifty years later. It discusses routes, construction, and fares. The collection also includes a description of "the sensational bullion robbery", a criticism by Thomas H. Lee of the written history, a list of rolling stock, and two letters from Myles Fenton, the manager.

SPANISH AND LATIN AMERICAN ARCHIVES.

The Illinois Historical Survey's collection of copies of manuscripts in Spanish and Latin American Archives was selected with reference mainly to the study of the Spanish in Louisiana and the Mississippi River Valley and their relationship with the French, British and Americans. Unlike the manuscript copies from other nations which are grouped by depository, this collection is divided into two parts: The Cunningham Transcripts and a set of papers referred to as Spanish and Latin American Archives, Translations. The bulk of the Spanish material is contained in the former group and all copies are handwritten or typewritten transcripts.

Guides and Other Finding Aids

To aid in locating material in various Spanish and Latin American Archives several useful guides exist. Many of these are appropriately in Spanish, but some of the important ones in English are as follows:
1. Herbert E. Bolton, Guide to Materials for the History of the United States in the Principal Archives of Mexico. Carnegie Institution of Washington, 1913. (Description of archival institutions, and descriptive listings of notable groups of documents.)
2. Charles E. Chapman, Catalogue of Materials in the Archivo General de Indias for the History of the Pacific Coast and the American Southwest. University of California Publications, VIII, Berkeley, 1919. (This volume has an introduction describing the archives of the Archivo General de Indias and the author's procedure in selecting and calendaring 6257 items relating to the Pacific coastal region and the history of the American Southwest.)
3. Roscoe Hill, American Missions in European Archives Publication No. 108 of the Instituto Panamericano de Geografia e Historia, Comision de Historia. Mexico, 1951. (Contains a good history of the acquisition of Spanish materials for American libraries, including the activities of Charles Cunningham. However, the holdings of the Illinois Historical Survey are not mentioned.)
4. Roscoe Hill, Descriptive Catalogue of the Documents relating to the History of the United States in the Papeles Procedentes de Cuba deposited in the Archivo General de Indias at Seville. Carnegie Institution of Washington, 1916. (The Papeles de Cuba were moved from Cuba to the Archivo General de Indias in Seville 1888-89. From this collection which is rich in materials for the study of Spain in America, Mr. Hill has selected certain legajos to describe. Indexed.)
5. Ronald Hilton (ed.), Handbook of Hispanic Source Materials and Research Organizations in the United States. Stanford: Stanford University Press, 1956.
6. Luis Manico Perez, Guide to the Materials for American History in Cuban Archives. Carnegie Institution of Washington, 1907.
7. J. A. Robertson, List of Documents in Spanish Archives relating to the History of the United States which have been printed, or of which transcripts are preserved in American Libraries. Carnegie Institution of Washington, 1910. (A chronological listing, giving location or original documents and published copy of transcript.)
8. W. R. Shepherd, Guide to the Materials for the History of the United States in Spanish Archives (Simancas, Archivo Historica Nacional, and Seville.) Carnegie Institution of Washington, 1907. (A general description.)

In addition to these published guides, the Illinois Historical Survey contains several other aids. These are of use in working with the material in the Survey Library and also in other libraries as well. They are as follows:
The Chronological Index. This is a generally complete card index of the Cunningham Transcripts. Where one document is attached to, or grouped with another, the chronological card refers to the date of the file where it may be found. Further processing, in the form of cataloging and indexing of the transcripts, is necessary and remains to be done. However, the Survey catalog may be used to advantage in connection with the Library of Congress Lists issued in 1928. These lists follow.
Library of Congress Lists of Transcripts and Facsimiles. The Survey has these four lists compiled by Dr. Thomas R. Martin in 1928:
1. Archival List of Library of Congress Transcripts and Facsimiles from Archivo General de Indias, Seville, 1454-1835. Photocopies 70 double folio pages.

SPANISH AND LATIN AMERICAN ARCHIVES.

2. Chronological List of Library of Congress Transcripts and Facsimiles from Archivo
General de Indias, Seville.
1454-1699. Photocopies. 33 double folio pages.
1700-1759. " . 26 " " " .
1760-1779. " . 25 " " " .
1780-1800. " . 33 " " " .
1801-1835. " . 13 " " " .
3. Chronological List of Library of Congress Transcripts and Facsimiles from Papeles...
de...Cuba in Archivo General de Indias, Seville. 1751-1822. Photocopies. 21 double folio
pages.
4. Archival list of Transcripts and Facsimiles from Papeles...de...Cuba Archivo General de
Indias, Seville. 1751-1822. Seccion 11. Series 1-23. Legajos 1-2375. Photocopies. 22
double folio pages.
Calendar. Sparks Collection, Harvard College Library. This is a four page, handwritten
calendar of Spanish papers in that library for the years 1776-1781. The main
correspondents listed are Grimaldi, Vergennes, Aranda, Floridablanca, and Galvez.

Manuscripts

CUNNINGHAM TRANSCRIPTS. PAPERS AND CORRESPONDENCE, 1600-1830. Approximately 40 feet and
five bound volumes, transcripts. 61-2187.

This collection of transcripts is so named because it was made under the supervision of Dr.
Charles H. Cunningham over a period of years for the Illinois Historical Survey and other
libraries. During that span of time, he successively was a member of several college
faculties, and filled various assignments for the United States government in Mexico,
Spain, Portugal, Cuba, Peru, and Ecuador. Typing and collating of the transcripts began in
1917 but was suspended in 1931 due to various circumstances. There are several aids to the
use of this collection and they include the Chronological Index, the Library of Congress
lists, and the published guides described above.

These transcripts were made in four archival depositories as follows:
1. Archivo Historica Nacional, Madrid. Transcripts from this collection number 1768
pages. Subjects of the documents are the affairs of the residencia of Santo Domingo, the
legal investigation of the insurrection in Louisiana in 1783-1800, relations between
Florida and Louisiana and the United States 1790-1803, and the insurrection of Bowles.

2. Archivo General de Simancas. The transcripts, over 30,000 pages, from this collection
include a great body of diplomatic correspondence between the Spanish minister of state
and Spanish ambassadors in London, St. Petersburg, Paris, on various subjects: Spain's
interest in and attitude toward the American Revolutionary War, and the interests of
European powers in Louisiana and Florida during that period; the progress of the American
republic; the Nootka Sound controversy, 1791-94; and the attitude of the United States on
the South American wars of independence. Transcripts also cover materials on military and
administrative affairs in Louisiana and Florida and various Indian insurrections.

3. Archivo General de Indias. The greatest bulk of the transcripts, about two-thirds of
the collection, come from this depository and cover every phase of Spain's activity and
interests in North America. Subjects include: Administration and commerce in the West
Indies, Florida, Louisiana, and the Philippines; Relations between Colonial Mexico and the
United States during the Revolutionary War and the first part of the 19th century; Attitude
of England and the United States toward the revolt of the Spanish-American colonies;
Correspondence of the Governor of Cuba with reference to the secret mission of Rendon and
Miralles in the United States; History of Louisiana, Florida, and Mississippi Valley, 1730-
1800; Spanish rivalry with France in the Mississippi Valley and with the English in the
Southeast; History of the Caribbean area and the naval struggle between England, Holland,
and Spain in the 17th century; Spanish commerce and trade relations with the United States,
1780-85.

SPANISH AND LATIN AMERICAN ARCHIVES.

4. <u>Archivo General de la Nacion de Mexico</u>. Transcripts from this collection numbering 5811 pages concern the American Revolution and the war between England and Spain, beginning in 1780; relations between Colonial Mexico and the American colonies during that period; England's efforts against the Philippines as part of the struggle; commercial relations of Spanish America, during 18th-early 19th century.

SPANISH AND LATIN AMERICAN ARCHIVES. CORRESPONDENCE AND TRANSLATIONS, 1777-1804. 36 items, transcripts. 61-1744.

The documents, relating to the Spanish regime in Louisiana, fall into the following three groups:
<u>Archivo Nacional, Republica de Cuba</u>, 19 items, 1777-1785. Transcripts and translations. These are letters of Bernardo de Galvez, governor of Louisiana, chiefly to Joseph de Galvez, Secretary of the Indies, describing assistance of Spaniards to American colonists and military events. See Louis Marino Perez, <u>Guide to the Materials for American History in Cuban Archives</u>. Pp. 87, 90, and 92.

<u>Clark Manuscripts, Draper Collection, Wisconsin Historical Society</u>, 9 items, 1779-1795. These are mainly translations of documents in the Archivo General Central in Alcala de Henares, Spain. Chiefly letters of Carondelet, governor of Louisiana, they relate to fortifications, projected settlements, relations with Americans, the Genet affair, and other topics.

<u>Spanish Depositories</u>, 8 items, 1784-1804. Archivo General de Indias (1 item); Department of War, Archivo General de Simancas (1 item); and documents from the Papeles de Cuba in the Archivo General de Indias, Seville (6 items). These concern the restriction of navigation on the Mississippi, Tardiveau's proposal to establish a colony of Illinois French in Spanish Louisiana, the new settlements, external dangers at St. Louis and its defenses, reinforcements of the posts, Indian affairs, and threats from the Americans.

SPARKS MANUSCRIPTS. LETTERS, 1765-1770. 4 items, transcripts. Chronological card file.

The letters in this collection are from Joseph Galloway and Thomas Wharton to Benjamin Franklin; and from General Thomas Gage to the Earl of Hillsborough. Topics include George Croghan's departure for the Illinois country, the plans of the Ohio Company and Gage's ideas on western settlement. [These transcripts were copied by the Illinois Historical Survey from the originals in the Sparks Collection of Harvard College Library.]

STANNARD, ELIJAH. LEDGER, 1841-1858. 1 volume.

Called a "Ledger and Day Book" by its owner, this journal records sales of a blacksmith and general merchandise shop in Tennessee. The shop dealt in hardware, dry goods and notions, as well as in some groceries and tobacco. Also Stannard apparently bought cotton and resold it, acting as a middle man.

[STEAMBOAT]<u>LEANDER</u>. RECORDS, 1843-1845, 1854-1855. 1 volume. 69-1618.

This record book lists the passengers, fares, crew names and wages, freight, and other accounts for various trips between St. Louis, Cincinnati, and New Orleans, 1843-1844. The journal also contains an inventory and accounts of a St. Louis merchant for the years 1844-1845 and 1854-1855.

STEPHENS, ALEXANDER H. (1812-1883). PAPERS, 1860-1865. 60 items, photocopies. Calendar.

This collection is composed of letters to and from Alexander Stephens. Most of the papers are concerned with the crisis between the North and the South. The letters continue through the Civil War. There are also two articles, entitled "Civil War" and "Hampton Roads Conference." [These photocopies were made from letters in the Library of Congress.]

STEVENS, WAYNE E. (1892-1959). PAPERS, ca. 1920-1959. 7 folders. 62-1214.

As a graduate student at the University of Illinois, Wayne E. Stevens participated in several studies made for the Illinois Centennial History and later (1923-1924) compiled an inventory of Canadian archives for a study of the Mississippi Valley. These papers are related to the preparation of the first volume of the proposed publications of the Alvord Memorial Commission. They include transcripts of pamphlets, articles by Stevens, papers relating to the volume of pamphlets, editing projects, an exchange of letters and reports concerning the projects, vouchers and notes, and the editor's preface and manuscript for the publication of the "Vandalia Pamphlets" ("British Pamphlets Relating to the West".) [This collection was given to the Illinois Historical Survey by Mrs. Wayne E. Stevens in November, 1959.]

STEWART, CHARLES LESLIE (b. 1890). PAPER, LETTERS, 1913-1914. 3 items.

The main item of this collection is a report entitled "Illinois County Quintennial Population Statistics, 1820-1865." It was written by Charles Stewart, a graduate student working at the University of Illinois with Solon J. Buck. There are also two letters from Stewart to Buck pertaining to the completion of the census paper.

STORRS, EMERY A. (1833-1885). RECORD, 1882. 1 item.

This is a handwritten edition of Emery Storr's closing defense argument to the jury in the case, The People of the State of Illinois v. Porter G. Ransom, in the Circuit Court of Marshall County. Porter G. Ransom was indicted for the murder of Henry W. Bullock, killed on May 2, 1881.

STOUTENBUGH, DAVID. LETTER, August 10, 1849. 1 item.

Written by David Stoutenbugh in Waukegan, Illinois, to A. K. Thompson in New York, this letter speaks of some tangled business affairs and of the existence of widespread cholera and rainy weather.

SUTTON, ANN ELIZABETH (MCKINNEY) (1842-1914). CERTIFICATES, 1869-1871. 2 items. 69-1592.

These two certificates were issued at Edwardsville, Madison County, Illinois. One, which accredits Miss Ann E. McKinney to teach second grade, was issued by the county superintendent (April 8, 1869) and was signed by J. W. Van Cleve (county superintendent of schools) and H. H. Keibler. It was renewed on April 8, 1870. The other certificate is for the marriage of Ann McKinney and George Riley Sutton, signed by Edward M. West, April 27, 1871. [The certificates were a gift in October, 1968, of Dr. Robert M. Sutton, University of Illinois, Urbana, Illinois.]

SWERINGEN, C. T. LETTER, January 21, 1846. 1 item.

This letter, mailed at Whitehall, Illinois, deals with agricultural prices and the sale and rental of land. It is from C. T. Sweringen of Montezuma, Illinois, to his brother, J. T. Sweringen in St. Louis, Missouri.

TANNER, SARA JANE (b. 1832). JOURNAL, August 17 - September 11, 1874. 1 volume.

Written by Sara Jane Tanner, this journal or travel diary describes a trip by train and wagon from Hinckley, Illinois, to northern and western Iowa, and the return to Illinois. She was accompanied by her husband and a family named Brooks. [Sara Jane Tanner was the grandmother of the late Professor Harold R. Wanless, Professor of Geology at the University of Illinois (1929-1967). The dairy was copied by the Illinois Historical Survey Library in November, 1973 with the permission of Mrs. Harold Wanless.]

TATE, ROBERT NICHOLSON (b. 1804). DIARY, 1809-1871. 1 reel, microfilm. 69-1588.

Robert Tate was born in England and emigrated to the United States in his youth. He came to Illinois in 1839 and a few years later he formed a partnership with John Deere which was dissolved in 1852. After that, it appears that Tate went into the business of plow manufacture on his own. This microfilm of Tate's diary includes an index at the end made by Florence M. Bradford. The diary traces Tate's life, beginning with his school days in England, and describes life and work on his farms. [This copy was filmed from one owned by Mr. H. M. Railsback, Deere and Company, Moline, Illinois.]

TAWNEY, MARIETTA BUSEY (1879-1949). PAPERS, 1927-1949. 393 items. 61-2296.

Mrs. Marietta Busey Tawney was a member of an Urbana pioneer family and a graduate of Vassar College in 1899. She resumed her Urbana residence in 1930 when her husband, Professor Guy Tawney, was appointed to the University faculty. She immediately became active in civic and welfare activities. A state officer and local board member of the League of Women Voters, she was primarily interested in efficiency in government, and her papers include many drafts, notes, pamphlets, and reports on League studies in civil service, constitutional amendments, and local and state finance. She was the downstate chairman of the organization which promoted legislation to permit Illinois cities to adopt a city-manager form of government. She was also state co-chairman for the Illinois Public Health Committee, 1942-1947, which advocated the organization of county health units. She served as president of the Community Chest and was a member of the County Emergency Relief Committee.

These papers, composed of letters, speeches, notes, pamphlets, laws, and other items, contain information about the above-mentioned activities. There are papers concerning Community Chest and other social agencies; the Champaign County Emergency Relief Committee; the Champaign County League of Women Voters; the Illinois Conference on the City-Manager Plan; local surveys, studies, and reports on township and county government; local finance studies; and others.

TEAGUE, W. F. LETTER, March 18, 1893. 1 item.

This letter, written at New Columbia (Massac County), Illinois, reminisces about earlier times when the writer's father was alive.

TEMPLETON FAMILY. LETTERS, 1832-1856. 14 items, machine reproductions.

The letters dated 1832-1842 were written by James Templeton of Hennepin, Illinois, to his brother Samuel Templeton in New Berlin, Pennsylvania. The brothers were primarily concerned with bookselling, land costs, farming conditions, and the shortage of money. Those letters dated 1849-1856 were addressed from Samuel Templeton, then of Freeport, Illinois, to Philip Grass, New Berlin. Topics included are labor, land, produce and interest costs, farming conditions, frontier diseases, politics, the need for a post office and craftsmen, and the possibility of exchanging eastern property for land in Illinois. [The copies of the letters were a gift from Dr. David Schob, who obtained them from the originals which are located with the Collection of Regional History and University Archives, Cornell University, Ithaca, New York.]

THOMAS, CHARLES G. LETTER, ca. 1840. 1 item.

Writing from Galena, Illinois, to his son C. L. Thomas, at school in New Haven, Connecticut, Charles Thomas mainly discusses family affairs.

THOMAS, WILLIAM (1802-1889). REMINISCENCE, 1826-1877. 1 item, transcript. 69-1599.

Judge William Thomas, who came to Jacksonville, Illinois, in 1826, was a circuit judge, a member of the General Assembly, and a member of the Constitutional Convention of 1847. He served on the board of trustees of various institutions located in Jacksonville.

This paper is entitled "Early Times" and contains reminiscences of his trip from Kentucky to Illinois (in the course of which he stopped at New Harmony, Indiana). He talks about his teaching in Jacksonville, his volunteer service in a militia unit to fight the Winnebagos, and his practice of law. It was printed in the Jacksonville Weekly Journal, April 18, 1877.

THROOP, GEORGE ADDISON (1810-1849). CORRESPONDENCE, 1843-1848. 10 items, photocopies. 69-1589.

These letters, exchanged primarily between George Throop and his family, discuss family and personal news, as well as the subject of communitarianism. More specifically, there are enthusiastic discussions of Fourierism and abortive plans for a community in the vicinity of Hamilton, New York. Philosophical principles such as equality, the nature of man, and possibilities for man's improvement are discussed. [These letters were selected from the Throop papers in the Collection of Regional History, Cornell University, Ithaca, New York. Included also in the Survey collection are photocopies of relevant pages from a collection of Throop's letters privately printed in 1934.]

TILDEN, SAMUEL J. (1814-1886). LETTERS, 1844-1848. 1 reel, microfilm.

This microfilm contains Samuel Tilden's letters which concern New York politics, elections (especially of Polk), the Free-Soil movement, the law for the government and organization of Texas into a territory, and the issue of slavery. [The letters were the gift of Professor Norman Graebner, University of Illinois, Urbana, Illinois, in 1957. They were purchased by him from the New York Public Library.]

TILLSON, JOHN, JR. (1796-1853). LETTER, September 7, 1827. 1 item.

This letter, addressed to E. T. Warren (Hallowell, Maine), discusses travel arrangements to Illinois. Tillson was the postmaster at Hillsboro, Illinois.

TINKHAM, CHARLES JOHNSTON (1825-1891). NOTEBOOK, NOTES, TAX RECEIPT, ca. 1856, 1865. 1 volume, 3 items.

The volume in this collection, entitled Field Notes of the Original Surveys of Champaign County, Illinois, contains one hundred and two pages of plats and forty pages of "timber notes" and covers all of Champaign and most of Vermilion County. However, the measurements and notes are incomplete. The title page bears the signature "Charles J. Tinkham, Homer, Illinois" who was the original owner of the notes. He attended West Point, served in the Civil War, and later worked as a surveyor, civil engineer, and businessman. Tinkham's notebook is essentially an abridged copy of the original U. S. General Land Office surveys of Champaign County which were made between 1812 and 1823. The other items are two notes containing plats and notes and a tax receipt for a payment made to the Champaign County Treasurer's Office by M. D. Coffeen, father-in-law to Charles Tinkham. [These materials were transferred to the Illinois Historical Survey from the Map and Geography Library of the University of Illinois Library in January, 1974.]

TODD, DAVID (1821-1874) AND FARNSWORTH, CHARLOTTE (1825-1847). LETTERS, 1846-1874. 84 items, machine reproductions. Inventory.

David Todd's correspondence is divided into two sections. The first section (July, 1846-July, 1847) contains letters to and from Charlotte Farnsworth, a student at Oberlin College, where he graduated as a minister in 1843. Charlotte Farnsworth wrote about academic and social life at Oberlin, as well as her attachment to David Todd. David Todd's letters describe the countryside of Illinois; his desire to establish a church; and family affairs. The correspondence ended in 1847 with her death.

The last section contains correspondence (1855-1874) primarily between David Todd and his brother, John Todd, who also graduated from Oberlin as a minister. Both brothers were members of the American Missionary Association. David describes his ministry in Providence, Illinois; his anti-slavery work in Arkansas during the Civil War; the political situation during the 1850's and 1860's; and his friendship with the Owen Lovejoy family. The correspondence ends with C. B. French informing John Todd of his brother's death. [The original collection was given to the Illinois Historical Survey to reproduce, by Mrs. Thomas Shedd of Urbana, Illinois, in August, 1973.]

TRUMBULL, LYMAN (1813-1896). PAPERS, 1849-1872. 615 items, photocopies, transcripts. Chronological card file, index.

These Lyman Trumbull manuscripts shed light upon state and national developments including the origin of the Republican Party, the Lincoln-Douglas campaign issues, the Civil War, and Reconstruction. Some correspondents in this collection include Jesse K. Dubois, O. M. Hatch, William H. Herndon, Norman B. Judd, Gustav Koerner, General John M. Palmer, and Governor Richard Yates. [The originals of the letters from which the photocopies and transcripts were made are in the Library of Congress.]

TURNER, FREDERICK JACKSON (1861-1932). CORRESPONDENCE, PAPERS, 1901-1931. 36 items. Inventory.

The correspondence in this collection is between F. J. Turner and C. W. Alvord (1908-1916) concerning both details of their research and the American Historical Association. There are also two letters from F. J. Turner to Professor W. S. Robertson. In addition the collection includes a typed list of publications in the field of early Western history, with comments on the value of each in the hand of F. J. Turner; a newspaper (The Harvard Bulletin, November 17, 1909) which contains an article on Turner's appointment to Harvard; and a pamphlet entitled Is Sectionalism in America Dying Away? by F. J. Turner.

TURNER, JONATHAN BALDWIN (1805-1899). PAPERS, 1834-1910. 3 folios, 18 folders, 350 items, originals. 200 items, machine reproductions. Inventory. 62-3470.

This collection of papers is representative of Turner's interests throughout his career. The letters in the collection are authored by, among others, the following correspondents: Ezra Cornell, Stephen A. Douglas, Augustus C. French, John Logan, Owen Lovejoy, Justin S. Morrill, Charles Sumner, Lyman Trumbull, Richard Yates, and the first two regents of the University of Illinois, John M. Gregory and Selim Peabody. Other materials are two patents issued to Turner--one for a seeding machine and another for a clod breaker. There are minutes of meetings, circulars, subscription lists, and clippings from newspapers for the period. After J. B. Turner's death, his daughter, Mrs. Mary Turner Carriel, gathered notes and correspondence on his career. Some of this material is also included in the collection. Finally, there are some deeds, abstracts, lecture notes, Turner's undergraduate thesis, sermons, and some biographical material on Turner. [In February, 1961, the University Library transferred from the Illinois Room its collection of "Papers and Correspondence of Jonathan Baldwin Turner." The collection had been acquired by gift in December, 1935, from the Rev. Charles A. Carriel, a grandson of Turner and son of Mrs. Mary Turner Carriel. Judith Hancock presented the Survey her notes and copied material used in preparation of a dissertation on Turner.]

UNDERWOOD, JOHN CURTISS (1809-1873). CORRESPONDENCE, 1860-1864. 6 items, photocopies. Chronological card file. 69-1586.

John Curtiss Underwood was appointed Auditor of the Treasury by Lincoln in 1861. Three years later he was appointed judge of the district court of Virginia, and in 1866 he presided at the trial of Jefferson Davis. These letters to and from Underwood discuss interviews with Lincoln, the possibility of a position in the cabinet, political movements and elections, and military strategy. The correspondents include W. W. Gitt, J. J. Jackson, Abraham Lincoln, and Charles Sumner. [The photocopies are from the John C. Underwood Papers in the Library of Congress.]

UNDERWOOD-FERGUSON COLLECTION. CORRESPONDENCE, PAPER, 1918. 6 items. 69-1599.

The five letters in this collection are mainly between Margaret Underwood Ferguson and C. W. Alvord. They concern a biographical paper by Mrs. Ferguson and the possibility of submitting some personal papers of her father to the Survey. The biographical paper is a brief one page sketch of William H. Underwood's life. He had been a district attorney, judge, state senator and delegate to the Constitutional Convention in 1870; also, he edited seventeen volumes of the Illinois Supreme Court Reports. [The gift of the sketch and the loan of the other Underwood materials, for the use of C. W. Alvord, were made in 1918 by Mrs. Ferguson.]

UNITED STATES. BUREAU OF INDIAN AFFAIRS. LETTERS, LETTERBOOKS, RECORDS, 1800-1839. 32 items, transcripts. 49 folders, photocopies. 6 reels, microfilm. Inventory. 69-1620.

Between 1789 and 1849, Indian affairs were administered by the War Department. In 1824, its Bureau of Indian Affairs became the Indian Office; and in 1832, a Commissioner of Indian Affairs was appointed to direct activities. The agency was transferred to the newly created Department of the Interior as the Office of Indian Affairs in 1849.

The material in this collection covers a wide range of subjects relative to Indian life on the frontier, such as treaty negotiations, land titles, the fur trade, liquor traffic, removals to reservations, and annuities. Some of the items are: letters received by the War Department concerning Indian affairs (1812-1820) written primarily by Indian agents in Chicago, Rock Island and Michillimackinac; letterbooks (1800-1838) which are copies of letters of the Secretary of War and succeeding administrators of Indian affairs with instructions to superintendents; letters and letterbooks of the Michigan Indian Superintendency (1814-1834); letters of the Sault Ste. Marie Indian Agent, H. R. Schoolcraft (1816-1832); letterbooks of the Office of Indian Trade (1807-1820); letterbooks of the Superintendents of Indian Trade (1812-1823); letters received by the Office of Indian Affairs pertaining to the Sac and Fox Agency (1824-1833); and a collection of receipts for Fort Edwards (1812, 1818-1823) from the Records of the Bureau of Indian Affairs. [These materials were copied from originals in the National Archives.]

UNITED STATES. CIVIL WORKS ADMINISTRATION, ENGINEERING ADVISORY BOARD. ILLINOIS. RECORDS, 1933-1934. 39 items.

The first item in these records concerns the organization of the Engineering Division of the Civil Works Administration in the State of Illinois. The University of Illinois was asked to provide a technical staff for this body. In addition, there are minutes, letters, and a memorandum pertaining to the civil works projects. Also, there are two charts which explain the function of the Advisory Board within the Federal Civil Works Administration for the State of Illinois.

UNITED STATES CONGRESS. 5th, 33rd, 37th CONGRESS. PAPERS, 1798, 1854, 1862. 1 reel, microfilm.

These are mainly bills proposed in sessions of Congress: the 5th Congress, 2nd session (1798); the 33rd Congress, 1st session (1854); and the 37th Congress, 2nd session (1862). The bills were designed to better define treason, sedition, and to provide for the punishment of crimes committed against the state; to organize the territory of Nebraska and Kansas; and to authorize the President of the United States to establish provisional governments in each district of the country within the limits of North Carolina, South Carolina, Georgia, Florida, Alabama, Mississippi, Louisiana, Texas, Arkansas and Tennessee. Also, there are reports from committees within Congress and amendments to bills included. [The papers were microfilmed in 1960 from records in the National Archives.]

UNITED STATES CONGRESS. HOUSE AND SENATE REPORTS. RECORDS, 1845-1859. 17 items, photocopies.

These photocopies are of House and Senate bills from the 29th to the 35th Congresses and concern the organization of territorial governments and statehood for several areas. There is a bill to protect the rights of American settlers in the territory of Oregon, as well as bills to organize territorial governments and statehood for Wisconsin, Oregon, California, Minnesota, New Mexico, Utah, Washington, Nebraska, Arizona, Dacotah [Dakota], and Kansas.

UNITED STATES CONGRESS. HOUSE OF REPRESENTATIVES. PAPERS, 1803-1820. 93 items, photocopies. 61-1691.

These papers are memorials, petitions, and other communications primarily from the people in the Illinois country. They concern such questions as the separation of Illinois from the Indiana Territory, land grants and titles, slavery, Indian trade and expenditures, protection of the frontier, postal service, and roads.

UNITED STATES CONTINENTAL CONGRESS. RECORDS, 1780-1788. 22 items, transcripts. 69-1610.

These transcripts cover matters concerning the inhabitants of the Illinois country in the period before the organization of the Northwest Territory. Three items are letters regarding General George Rogers Clark's expedition against the Wabash Indians in 1786. One of them is from Clark to the President of Congress, May, 1786. There are three census lists--one for Cahokia and two for Vincennes. Thirteen items are memorials and petitions to Congress from Cahokia, Kaskaskia, Vincennes and other groups of inhabitants in the western country. [These transcripts are from the official records of the Continental Congress, now in the Library of Congress.]

UNITED STATES. DEPARTMENT OF STATE. RECORDS, 1788-1820. 109 items, photocopies, transcripts. 69-1621.

These are photocopies and transcripts of a selection of letters and papers from the State Department; they are divided into the following categories: (1) American letters, 1788-1794, 6 items; (2) Domestic letters, 1793-1819, 14 items; (3) Miscellaneous letters, 1792-1820, 56 items; (4) British Legation Notes, 1791-1794, 12 items; (5) Territorial Papers, 1790-1819, 21 items. [These photocopies and transcripts were made from originals in the archives of the State Department. They are classified according to the Mereness Calendar into the above categories.]

UNITED STATES DOCUMENTS. RECORDS, 1734–1865. 47 items, facsimiles, machine reproductions. Calendar.

A. These are facsimile copies of the following early United States documents: the Declaration of Independence, a Revolutionary War recruiting broadside (1776) submitted to the United States government in connection with the claim for pension of a Revolutionary War widow, the Treaty of Alliance with France (1778), the Articles of Confederation (1778), the Treaty of Paris of 1783, the Plan for the Government of the Western Country submitted by Messrs. Jefferson, Chase, and Howell (1784), and the Northwest Ordinance (1787). [They were obtained in May, 1971, from the National Archives, Washington, D. C., where the original documents are maintained.]

B. This group of papers contains both colonial and national documents that concern appointments to public office (1734–1811); stocks, bonds, and other financial papers (1784–1865); handbills (1852–1865); licenses for public houses (1778–1836); passports (1804–1831); public summons (1777–1786); shipping papers (1734–1827); and, a broadside of the resolves of the General Assembly of Massachusetts (1777). [These documents were acquired in the spring of 1971 through the generosity of Leonard P. Karczewski who has the originals.]

C. This facsimile copy of the "Emancipation Proclamation" issued by Lincoln (September 22, 1862) was published in Chicago by A. Kidder; no publication date is indicated.

UNITED STATES. GENERAL LAND OFFICE. RECORDS, 1793–1868. 38 items, originals, transcripts, photocopy. 69–1603.

The letters in this collection all concern the settlement of land in the Midwest. There are those which exhibit the legal and administrative aspects of land ownership, those which concern the political aspects, and those which contain actual warrants proving land ownership in various sections of Illinois. Some of the correspondents include Secretary of the Treasury Albert Gallatin, Michael Jones, and Elijah Backus. The particular letter from Gallatin to Jones and Backus, both of whom were land commissioners at Kaskaskia, concerns charges made against them by Governor Ninian Edwards. Other items in the collection are three certificates (1854–1856) which grant some military bounty lands in Iowa to three persons upon the return of warrants issued for service in the War of 1812. In addition, there is a list of lands entered in Shelby County, Illinois. Also there is an official notice by Thomas A. Blake, commissioner of the General Land Office, which announces sales of public lands in various places in the Wisconsin and Iowa Territories and in Illinois.

Finally, included with this collection are some supplementary materials. There is a list of land entered at the Vincennes Land Office on January 1, 1819; the list was compiled by Newton D. Mereness for use in preparing a map of "Illinois in 1818." Mereness also compiled an inventory of records in the General Land Office. [The three certificates which granted military bounty lands in Iowa were presented to the Survey by Professor L. M. Larson, University of Illinois, Urbana, Illinois.]

UNITED STATES INDUSTRIAL CENSUS. ILLINOIS. CENSUS SCHEDULES, 1850–1880. 11 reels, microfilm.

The Census schedules for 1850, 1860, 1870, and 1880 contain a wealth of information on American manufacturing and industrial activities. They present a variety of information including name and type of business, location, size, production figures, and capital investment. Specifically, these film reels contain: from the 1850 Census, Agriculture, Manufactures, and Social Statistics; from the 1860 Census, the Industry Census; from the 1870 Census, the Agriculture, Industry, and Social Statistics (incomplete); and from the 1880 Census, Manufactures. The 1870 Census was partially destroyed by fire. [This microfilm was obtained from the Illinois State Archives in 1973.]

UNITED STATES. POST OFFICE DEPARTMENT. RECORDS, 1789-1930. 108 items, transcripts. 3 reels, microfilm. 69-1614.

This collection has been divided into the following four sections:

A. Records, 1814-1859. 1 reel, microfilm. These mail route registers cover the states of Massachusetts, Kentucky, Indiana, Missouri and Illinois. Included are names and routes of mail deliverers.

B. Records, 1832-1930. 2 reels, microfilm. This collection is an extensive list, organized by counties, of appointments of postmasters in Illinois and Kentucky. [This material was microfilmed for Wilbur Duncan of Decatur who gave the microfilm to the Survey in 1957.]

C. Records, 1856-1861. 16 items, transcripts. These are letters written to the Postmaster General's office in Washington, D. C., and to other officials, from Iowa, Wisconsin, and Illinois. They are either reports or contain requests about mail service in certain areas.

D. Records, 1789-1893. 92 items, transcripts. This collection is largely composed of letters originating in the office of the Postmaster General of the United States. They are addressed to post office establishments in the area of Illinois and the Midwest and discuss matters relating to the mails, i.e. personnel, regulations, salary, routes, schedules, and various physical problems in transporting the mails. There are also some charts and schedules pertaining to mail service. [This collection was a gift of Wilbur Duncan, Decatur, Illinois, in February, 1958.]

UNITED STATES. WAR DEPARTMENT. RECORDS, LETTERS, 1819-1843. 140 items, transcripts, machine reproductions. 1 reel, microfilm. Calendar.

This collection contains the following three sections:

A. Records, 1822-1843. 133 items, machine reproductions. Calendar. Reproduced from War Department records in the National Archives, these papers are mostly ordnance letters pertaining to mining and related business activities in Galena, Illinois' lead mines. [These copies were acquired through the courtesy of Dr. Natalia M. Belting, University of Illinois, Urbana, Illinois, in the spring of 1966.]

B. Records, 1819-1843. 7 items, transcripts, machine reproductions. These are reports of the Inspector General's Office of the United States War Department. They are composed of troop inspections, the condition of troops, instructions, recommendations, and a description of forts. Five of the reports were made by Colonel George Croghan, one by General H. Brady, and one by Colonel A. P. Hayne.

C. Letters, Inspection Reports, 1819-1832. 1 reel, microfilm. These letters from the Quartermaster General's Office were written by commanding officers at Fort Armstrong, Illinois to Quartermaster General, T. S. Jessup. They discuss repairs, surplus supplies, deserters and other matters. Also included are Inspection Reports of Fort Armstrong from the Inspector General's Office dated August, 1826 and June 1, 1827. [The originals of these materials are in the National Archives.]

UNITY SOCIETY. MONMOUTH, ILLINOIS. RECORDS, 1881-1896. 3 volumes. 21 items.

The Unity Society, or Unity Church, was formed by members of the Unitarian and Universalist Churches in Monmouth, apparently in 1882. The three volumes in this collection are an account book for the years 1882-1890, the "Ladies Social Circle" secretary's book which includes a list of Sunday School receipts and expenses, and the "Ladies' Society of Unity Church" treasurer's book which lists payment of dues, other receipts, and expenses. The "Ladies Social Circle" of the Unity congregation also wrote a constitution which is included in this collection. In addition, there are three letters pertaining to religious matters, as well as several vouchers, receipts, and lists.

USHER, JOHN P. (1816-1889). LETTER, April 16, 1865. 1 item, photocopy. Calendar. 69-1586.

This letter from John P. Usher, Secretary of the Interior, to his wife reports the assassination of Lincoln and the circumstances surrounding it. [This is a photocopy of the original letter which is in the Library of Congress.]

VAN SELLAR, HENRY (b. 1839). CORRESPONDENCE, 1860-1892. 159 items. Inventory. 69-1623.

Henry Van Sellar settled in Illinois in 1860 and taught school until the outbreak of the Civil War. During the war he rose to the rank of colonel. After the war he became a lawyer, mayor, state senator, and judge. The correspondence is between Henry Van Sellar and his future wife, Sallie Pattison, and between her and her family and friends. Letters between Sallie and Henry Van Sellar contain accounts of the Civil War, reference to the assassination of Lincoln, and some description of the South. They also contain considerable information on the social and religious ideas and customs of two young people during the Civil War era. The collection also contains such items as undated letters, mementos, invitations, and pictures of the Van Sellars. [The collection was donated by B. F. Henderson of Georgetown, Illinois, in March, 1967.]

VINCENNES, BANK OF. PAPERS, 1820-1821. 6 items, transcripts.

The items in this collection, except one, are correspondence between Secretary of Treasury W. H. Crawford and others, notably officers of the Bank of Vincennes. The exception is a note from the Bank of Vincennes notifying a widow about the estate left by her husband. The letters illustrate the operation of Crawford's policy of designating state banks in the West as deposit agencies and granting them fixed government deposit balances.

WALKER, JOHN HUNTER (1872-1955). PAPERS, 1910-1955. 66 boxes. Inventory. 69-1624.

John Hunter Walker was an Illinois labor leader and political figure. During his most active years, Walker held the positions of: President of the Illinois Federation of Labor (1913-1930); President of District 12 (Illinois); United Mine Workers of America (1906-1913 and 1931-1933); and International Secretary of the United Mine Workers of America, Reorganized (1930-1931). Walker served as political advisor to Frank O. Lowden, Len Small, Louis L. Emmerson, Charles S. Deneen, William Hale Thompson, and Frank L. Smith. At different times, in addition, he held positions of responsibility in the Republican, Democratic, Farmer-Labor, and Socialist parties.

The papers in this collection concern Walker's personal, political, and business life. There is much material relating to Walker's political contacts. Among many others, his correspondents included: Clarence Darrow, Felix Frankfurter, Adolph Germer, Samuel Gompers, Mary Harris Jones, John L. Lewis, and Norman Thomas. [About 1955 the Walker papers were given to the University of Illinois. In September of 1966, the papers were transferred from the University's Institute of Labor and Industrial Relations to the Illinois Historical Survey.]

WALKER, PICKNEY HOUSTON (1815-1885). NOTEBOOKS, 1860-1861. 2 volumes. 69-1599.

Judge Walker's pocket notebooks contain his notes for opinions on cases assigned to him during his term on the State Supreme Court. [The papers were purchased from Professor J. L. Conger of Galesburg, Illinois, in 1942.]

WALKER FAMILY. PAPERS, 1737-1868. 297 items. 61-2050.

This is a collection of papers of Thomas H. Walker and his family. The family had its original home in Brownsburgh, Rockbridge County, Virginia. The papers are composed of letters, some commercial papers, and a petition to release one of Walker's sons, James, from service in the army due to bad health.

The letters are mostly personal and are written largely among relatives within the Walker family. They contain personal news and information about: regional conditions; farm and manufacture prices; marketing and transportation methods; life at college and seminary; conditions in newly settled areas and fringe areas such as Tennessee, Missouri, and Kentucky; the whiskey trade; religion; the temperance movement; and political news, including some local election results. The business letters concern the distillation of liquor and the purchase and sale of land. The letters offer a good description of society at the time. Most of the commercial papers are bills of sale and agreements for sharecroppers and laborers. [Avery O. Craven made the selection of these materials, which were chosen from a considerable body of material collected in Virginia.]

WALSH, THOMAS JAMES (1859-1933). PAPERS, 1879-1967. 35 volumes, 1119 items. 59 photographs. 126 cards of mounted newspaper clippings. Calendar, inventory.

Thomas James Walsh was born and educated in Wisconsin where he taught school and received a law degree. From there he moved to the Dakota territory where he and his brother practiced law. In 1889, he married Elinor C. McClements of Chicago and, a year later, they moved to Helena, Montana. He was a successful lawyer, a devoted adherent of the Democratic Party, and was elected U. S. Senator four times. His biggest claim to fame was exposing the Teapot Dome oil scandals in 1924. A renowned constitutional lawyer, he was Attorney General-Designate in the first cabinet of Franklin D. Roosevelt when he died two days before the latter's inauguration.

The richest part of the collection is a group of approximately 275 letters between Walsh and his wife, from 1890-1916. There is also a great deal of material from his teaching and student days. Other aspects of the collection include his campaigns for re-election, particularly that of 1930. Walsh was also permanent chairman of the Democratic Conventions in 1924 and 1932 and won wide acclaim for the way he handled those meetings. The expose' of the oil scandals receives a great deal of attention, particularly in the newspaper clippings. Walsh's correspondence includes letters from Newton D. Baker, Claude G. Bowers, William G. McAdoo, Franklin D. Roosevelt, Al Smith, and Mr. and Mrs. Woodrow Wilson. A number of books in the collection outline the actions taken in his legal cases, and numerous ledgers illustrate his financial history prior to 1913. Included in the collection also are letters relating to research done on the Senator after his death. [The collection was deposited in the Illinois Historical Survey by Mrs. Genevieve Walsh Gudger, daughter of the Senator, through Professor J. Leonard Bates. Its use is restricted.]

WALTON, THOMAS WILLIAM (1883-1942). PAPERS, ca. 1912. 2 items.

Thomas Walton was the director of the YMCA at the University of Illinois between 1910 and 1920. In this collection is a handwritten paper by Thomas William Walton, entitled "The Spending of Home Mission Money in Illinois." Also included is a copy of grades received by Walton at college.

WARNER, EDWARD B. (b. 1826). PAPERS, 1858-1869. 238 items. 61-2049.

Edward B. Warner, the son of Jabez Warner, was one of the proprietors of Prophetstown, Whiteside County, Illinois. He served as Treasurer of Whiteside County continuously from 1858-1869. In 1872 and 1876, Mr. Warner was elected a member of the State Equalization Board. The letters in this collection concern official and business matters, local, state, and national politics, and family news. Primary correspondents include Isaac N. Arnold, Thomas G. Bryant, H. C. Burchard, S. H. McCrea, A. J. Mattson, S. H. Robinson, George R. Shaw, and A. J. Warner. There are, in addition, numerous business papers.

WARREN COUNTY, ILLINOIS. CIRCUIT COURT. DOCUMENTS, 1841-1842. 1 item, contemporary copy.

These are copies of documents pertaining to the case of Cicero Hamilton vs. Samuel Johnson. The case concerns the failure of Johnson to pay a borrowed sum of money. The copies were sent in a letter postmarked Macomb, Illinois.

WASHBURNE, ELIHU B. (1816-1887). PAPERS, 1849-1869. 7 items, originals. 1 item, photocopy. Chronological card file. 69-1599.

Four of the letters from Elihu Washburne were written to Edward B. Warner, two to Thomas Gregg, and one to Caleb B. Smith. They discuss the slavery problem, the 1864 presidential campaign, enforcement of the draft, and other political subjects. Included also in this collection is a speech made by Washburne in opposition to appropriating money for the United States to be represented at the Paris Exposition in 1867. [The original of the letter from Washburne to Caleb Smith is with the Lyman Trumbull Collection in the Library of Congress.]

WATER RESOURCES CENTER. PAPERS, 1967. 85 folders, transcripts, machine reproductions.

Under the direction of Professor Robert M. Sutton and Professor George W. White, Thomas P. Schlunz gathered material for a project entitled "Evaluation of Water Resources Development in Illinois." The material consists mainly of extracts from travel narratives and early descriptive literature. It focuses on the water resources of Illinois from 1673-1850. This was a joint venture involving the Illinois Historical Survey and the Water Resources Center of the University of Illinois.

WEISS, REMIGENS. ESSAYS, ca. 1850. 3 items.

This collection consists of three essays by Remigens Weiss. The first is A Critique, written for the Mount Carmel Lyceum. The others are An Essay on Human Greatness and On Emerson. [The essays were acquired by the University of Illinois Library in 1917.]

WELLES, GIDEON (1802-1878). CORRESPONDENCE, 1865-1878. 10 items, photocopies. Chronological card file. 69-1586.

Gideon Welles was the Secretary of the Navy during the administrations of President Lincoln and President Johnson. Correspondents of these letters to and from Secretary of the Navy, Welles, are Edward Bates, Montgomery Blair, Orville H. Browning, and Charles Sumner. In these letters post-war problems are discussed, including the issue of suffrage in the Southern states and equality for the freed Negro, and the disorder of government administration after the war and resultant fear of anarchy. In addition, there is a discussion of articles and a book which concerns Seward's controversial role in Lincoln's administration and the Civil War. [These letters are photocopies from the papers of Gideon Welles in the Library of Congress.]

WELLS, JOSEPH B. (d. 1856). LETTER, April 14, 1841. 1 item.

This letter, written at Stephenson, Rock Island County, Illinois, rallies "our Democratic friends" to support the Banner and Stephenson Gazette, edited by H. McGrew (McGrere), through subscriptions.

WERNER, RAYMOND C. (1893-1952). PAPERS, 1927-1950. 105 items. 61-3056.

Raymond C. Werner was a member of the Department of History at the University of Illinois from 1927-1952. The content of this collection relates primarily to his interests in the life and work of Joseph Galloway. It includes papers written by Werner, as well as correspondence, notes, and bibliographical material concerning Galloway. Material relating to Raymond Werner's history courses, together with miscellaneous papers, book reviews, and pamphlets, are also included in the collection.

WESTERN METHODIST BOOK CONCERN. PAPERS, 1865-1875. 531 items. Calendar. 69-1625.

This collection is composed of printed questionnaires and handwritten replies. The majority of material concerns returns for 1865-1869 and 1871 from various Methodist Literary Institutions, answering questions about the particular institution involved. The information requested included the name of the institution, its locations, the president or principal, the date of foundation, the number of students (male and female separate), the number of instructors (male and female separate), the purpose, the value of buildings and equipment, the debt, the endowment fund, other property, income, and number of volumes in the library.

The remainder of the material concerns Methodist Conference statistics for 1865, 1870, 1871, and 1874 as to effective preachers, supernumerary preachers, superannuated preachers, number of members, deaths, probationers, local preachers, adults baptized, children baptized, number and value of churches and parsonages, and conference claimants. There were also questions about the Missionary Societies concerning costs by Churches, by Sunday-schools, church extension, tract society, American Bible Society, Sunday-school unions and the number of Sunday-schools, number of officers and teachers, number of scholars, volumes in library, and conversions in Sunday-school.

WETHERSFIELD SETTLEMENT. LETTERS, 1841-1857. 5 items.

The Wethersfield Settlement in Henry County, Illinois, was deliberately undertaken by a group of residents of Wethersfield, Connecticut, who sent commissioners to Illinois in 1836 to investigate possible sites and purchase ninety-eight quarter sections. This collection contains a circular of the meeting of the Connecticut Association held at Wethersfield, Connecticut, August 9, 1836, reporting the purchase of land. There is a letter directing that surveys be made, plus later letters from persons migrating to the new settlement written to their families back home. [These letters were a gift of Mrs. M. L. Macy of Grinnell, Iowa, daughter of Henry G. Little; the writers were members of Mrs. Macy's family.]

WHARTON, SAMUEL (1732-1800). MEMORIAL, PAMPHLETS AND MAPS, 1770-1781. 11 items, photocopies, transcripts. Inventory. 69-1603, 69-1613.

This collection is composed of three types of material: a memorial, pamphlets and maps. The memorial by Benjamin Franklin and Samuel Wharton and the five pamphlets were written to support the land claim for the formation of a colony. The five maps are of Eastern America. They illustrate, in part, the boundaries of the claimants' interests.

WHARTON, THOMAS (1730-1782). PAPERS, 1766-1776. 37 items, transcripts. Chronological card file. 69-1613.

These papers, mainly letters, are written in connection with the Baynton, Wharton, and Morgan trading house of colonial Philadelphia. The collection pertains, in general, to trade, land settlement, purchase and sale, Indian problems which affected trade and settlement, the growing antipathy between the colonies and England, the Boston Tea Party, and the closing of the Boston Port, activities of the colonies and the Continental Congress of 1774, and company business. The collection includes, in addition, articles of agreement signed respectively by William Franklin, Sir William Johnson, George Croghan, John Baynton, Samuel Wharton, George Morgan, Joseph Wharton, Sr., Joseph Wharton, Jr., John Hughes, Joseph Galloway, John Hughes, Jr., Thomas Hood, and Isaac Hughes, which pertain to the establishment of a civil government by England in the Illinois country near Fort Chartres. [These transcripts are from the Wharton Manuscripts in the Historical Society of Pennsylvania.]

WHEAT, ALMERON (1813-1895). CORRESPONDENCE, 1830-1871. 113 items. 61-3046.

These letters are addressed to a law firm in Quincy, Illinois, of which Wheat was a member. Wheat was associated with Orville H. Browning in some enterprises. Some of the issues discussed are land surveys, the bidding on redeemed lands, case decisions and their execution, mortgages, settling of claims and law suits (especially for collection of debts), a divorce case involving custody of children, an appointee for public administrator, conveyance of messages by telegraph, and local politics.

WHEELER, JOEL. LETTER, May 1, 1844. 1 item.

This letter was written by Joel Wheeler of Galena, Illinois, to the Rev. Benjamin M. Hill, the corresponding secretary of the American Baptist Home Missionary Society. In the letter, Wheeler reports his ministerial activities and applies for money which belongs to him.

WILEY, BENJAMIN LADD (1821-1890). DIARY, July 6 - December 22, 1847. 1 item, transcript. 69-1607.

Ben Wiley was a member of the 1st Regiment of Illinois Volunteers and later became the acting quartermaster sergeant for the regiment. This diary is a record of the regiment's march from Fort Leavenworth, Missouri, to Santa Fe during the Mexican War. Wiley describes in detail the countryside, the marching, the camping, and other activities related to the march. [This copy of the diary was conveyed to the Survey by Dr. Harry E. Pratt of the Illinois State Historical Library. The original was presented by Barbara Beers Hubbs, of Southern Illinois University, to the Illinois State Historical Library.]

WILLIAMS, AMOS (1797-1857). WILLIAMS-WOODBURY PAPERS, 1820-1900. 16 volumes. 161 folders. Inventory. 62-942.

Amos Williams was the clerk of the Vermilion County Commissioner's Court at its first meeting in 1826; as county agent he conducted the first officially advertised sale of lots in Danville in 1827. Williams held other county offices and was appointed the first postmaster in Vermilion County at "Vermilion Station," later renamed Danville; he served in this capacity from 1826 until 1844.

This collection consists of the papers of Amos Williams and his son-in-law, Dr. W. W. R. Woodbury (1824-1901). It contains several thousand items which cover a wide range of subjects. For example, it illustrates the local politics of the day, with special reference to Vermilion and Edgar Counties in the 1830's and 1840's, and contains a number of letters from important political leaders of the state and from various early residents of eastern Illinois. The main interest in the collection, however, is in the information provided about the details of business in a small town of Illinois in the nineteenth century. It reveals the routine business of the postmaster, the land agent, the county official, and the storekeeper.

In addition to his official business and storekeeping, Williams' interests included farms, ferries, saw-mills and grist-mills, saline works, roads, railroads, lands, schools, and other matters. The Woodbury papers concern drug and general merchandising, farms, seed orders, and road improvements, as well as historical, community, and family interests. In addition, there are some papers relating to Gurdon S. Hubbard and the Indian trade near Danville, as well as papers concerning various Vermilion county settlers. The sixteen bound volumes are ledgers of Amos Williams and the Woodbury Drug Company, scrapbooks, notebooks, classbooks, bankbooks, and feedbooks. [Williams-Woodbury items to be found in Danville are described in reports made in the course of the work of the Historical Records Survey. The Woodbury and Williams papers were carefully preserved by the family, arranged by the late Amos G. Woodbury of Danville, son of W. W. R. Woodbury, and acquired by the Survey from his sister and executor, Miss Flo Woodbury.]

WILLSON, WILLIAM. LETTER, September 9, 1842. 1 item.

This letter was written from Rushville, Illinois, to Willson's brother, M. K. Willson, in Brandenburg, Kentucky. In response to a court action against him, Willson proclaims his innocence concerning criticism of the quality of lime he sold to the plaintiff.

WINTER, A. E. LETTER, 1847. 1 item.

This letter from A. E. Winter to his sister in Massachusetts discusses his feelings in relation to their father's death. It also includes a description of Winter's experiences at the Philadelphia Industrial Association, a Fourierist community near South Bend, Indiana.

WINTER & WAGGONER. ACCOUNT BOOK, 1859-1866. 1 volume.

This book contains accounts for a general store which sold hardware, lumber, some vegetables and fruit. It provided services, including horseshoeing, hauling of goods, and repairing tools. For each patron there is an account, which lists items purchased and their cost.

WITHROW, JAMES EDGAR. DIARY, 1863-1864. 1 volume. 69-1586.

James Withrow of Macomb, Illinois, served in the 78th Illinois Regiment during the Civil War. This diary, written by Withrow, describes the aftermath of the battle of Chattanooga, conversations with Southern troops, and the problems of obtaining rations for survival. In addition, there are comments upon the Southern towns and people. [The diary was given to the Survey by Major Charles B. Jackson of the Western Military Academy of Alton, Illinois, in return for a typescript to be supplied to the author's descendant, James E. Withrow, III.]

WOMEN'S CHRISTIAN TEMPERANCE UNION. 10TH CONGRESSIONAL DISTRICT, ILLINOIS. RECORDS, 1883-1902. 1 volume.

This volume contains a record of the annual meetings of the Women's Christian Temperance Union in central Illinois; the meetings took place in Peoria, Chillicothe, and other towns. The records include the substance of meetings in which the presentation of papers, the formation of resolutions, and the holding of devotional meetings occurred. The Union engaged in such activities as the organization of YMCA's and efforts to prevent people from using alcoholic beverages.

WRIGHT, J. C. LETTER, January 10, 1820. 1 item. 69-1603.

This letter was written by J. C. Wright in Edwardsville, Illinois, to his brother, Nathaniel Wright. In it Wright describes his bounty lands and the scarcity of cash which prevents their sale.

WYNNE, ALBERT R. LETTERS, 1839-1858. 7 items, machine reproductions. Calendar.

The collection contains letters to Colonel Albert R. Wynne and his son Robert B. Wynne of Castilian Springs, Tennessee. Albert Wynne owned land in Kentucky and Tennessee. He also had railroad business interests that were passed on to his son, Robert, who was involved in the construction of a new line. [The letters were acquired in the spring, 1971, through the generosity of Leonard P. Karczewski of Chicago, Illinois, who has the originals.]

YANTIS, JOHN WESLEY (1855-1945). CORRESPONDENCE, FLIERS, PAMPHLETS, AND NEWSPAPER CLIPPINGS, 1897-1928. 123 items.

This collection consists of correspondence and papers concerning the business and political activities of John Wesley Yantis, prominent member of the Democratic party in Shelby County. The correspondence deals primarily with the Bryan League, Century Coal Company, election of 1908, and the Democratic party.

YATES, RICHARD (1815-1873). CORRESPONDENCE, 1861-1864. 14 items, originals. 69-1599.

The letters in this collection were written to Richard Yates by Jesse Fell and his brother, K. H. Fell, of Bloomington, Illinois. They are letters of introduction or of application for aid in civil or military appointments. One letter is from Governor Yates to Jesse Fell. The letters have endorsements as to action taken in the Executive Office.

YERKES, HIRAM (1840-1913). PAPERS, 1862-1932. 43 items, machine reproductions. Calendar.

Hiram Yerkes' family moved from Ohio to Indiana when he was young. He lived there until the outbreak of the Civil War, and then served in the Union Army for the duration of the war. In 1865, he married Hester Prevo and settled in Fairmont, Illinois where he became a prominent citizen. After his wife's death in 1877, he remarried. Yerkes remained in Fairmont until 1909, and then moved to Colome, South Dakota. Three years later he moved to Los Angeles where he died in 1913.

Thirty of the letters in this collection were written by Yerkes to Hester E. Prevo while he served in the Union Army. In these letters, he told of his daily experiences and activities with the Indiana Infantry as they moved through Indiana, Kentucky, Tennessee, Georgia, North Carolina and Virginia. Several of their battles, notably engagements at Wilmington, Nashville and Atlanta, are described. Also revealed are the emotions he felt during his years in the service and his opinions on subjects as varied as religion in the army to McClellan's nomination for the presidency.

Two of the letters are from Yerkes to his granddaughters and were written in 1910 from South Dakota. In them he relates his experiences in his new home and the hardships he must endure before he can successfully farm the "wild sod" of South Dakota. In addition, this collection also contains eleven newspaper clippings about Hiram Yerkes and his family. [Mr. Charles M. Redmond allowed the Illinois Historical Survey to make copies of the Yerkes materials in December, 1972. The originals remain in his possession.]

YORKE-CAMDEN OPINION. PAPERS, 1774. 3 items, transcripts.

These papers contain one document which states that "Your Majestys Letters Patents" are not required in the transfer of land by Indian grants; this is an alteration of the Yorke-Camden Opinion. The other two items, which are letters, discuss the problem of having a government established at Vandalia and a free government in Transylvania (parts of Kentucky and Tennessee).

ZELLER, JACOB. WILL, 1831. 1 item, machine reproduction. Calendar.

Jacob Zeller owned an estate of at least 1,000 acres in Washington County, Maryland. In this will Zeller gave directions for the emancipation of three of his Negro slaves. The will also contains a letter to Zeller from D. Sprigs, the lawyer who drew up the will. [The original will is in the possession of Leonard P. Karczewski, Chicago, Illinois; a copy was acquired in the spring of 1971.]

ZYBELL, ALBERT B. ACCOUNT BOOK, RECEIPTS, 1906-1921. 1 volume. 59 items.

Albert B. Zybell, undertaker, embalmer, and furniture dealer, resided in Monticello, Illinois. The account book records funeral expenses, including such items as clothes, vaults, coffins, flowers and accessories. [The collection was purchased by the Illinois Historical Survey Library in 1974.]

PART III

Business Archives

History Library

Rare Book Room

This section of the Manuscripts Guide contains descriptions of literary manuscripts held in the Library's Rare Book Room, the History Library, business archives administered by the University Archives and the Mendel Collection in the Natural History Museum.

The Rare Book Room and Business Archives holdings are identified by the symbols RBR and BA at the left on the bottom line of each entry. Collections in the History Library are indicated by the symbol HL. Published guides to collections are cited in the last lines of the descriptions.

This section of the Guide includes the following collections

Collection	Number of Collections	Volume in Cubic Feet
Rare Book Room	74	314.6
Business Archives, Processed	14	225.5
Unprocessed	62	342.3
History Library	3	21.0
Natural History Museum	1	.3
Total	154	903.7

Material described in Seymour de Ricci, Census of medieval and renaissance manuscripts in the United States and Canada, with Supplement, (New York, 1935-62), are not included in the Guide. The Rare Book Room holdings are especially strong in 19th century and 20th century British publishing houses. Several Rare Book Room collections conform to manuscripts sales procedures rather than the principle of provenance and are described as the papers of the prominent literary figure who wrote the letters rather than the recipient.

Collected in the 1940s, the Business Archives contains a representative sample of Illinois wholesale and retail merchants in the state as well as in the Champaign-Urbana area. Processed business archives collections included in this section are arranged as special series under the College of Commerce and Business Administration in the University Archives.

While the fifty-seven collections listed under the general heading of Business Archives are unprocessed, the entry listing indicates firm name, location, type of business, dates of records and volume. Additional information about these series may be obtained from the University Archives.

We wish to thank Gerald Grinde, who inventoried the Rare Book Room collections and J. Frederick Nash and Mary Ceibert who read the descriptions. Susan Shattuck provided information on the Carl Sandburg Collection. Charles Elston and Richard Szary inventoried the Business Archives.

Maynard Brichford

AGASSIZ, LOUIS (1807-1873) PAPERS, 1847-1896 .1 cu. ft.

Papers of Louis Agassiz, Swiss-American zoologist, geologist, naturalist and educator,
including 30 letters written by Agassiz, two written by James Barnard, one written by
Alexander Agassiz, and three Agassiz memorial announcements dealing with his geological
and zoological activities, especially the correct methods to be used in studying natural
history with emphasis on "characters and affinities" and references to the Revolutions
of 1848.

RBR RESTRICTED

ALLINGHAM, WILLIAM (1824-1899) PAPERS, 1846-1920 2.0 cu. ft.

Papers of William Allingham, an Irish poet, editor of Fraser's Magazine and a supporter of
the Pre-Raphaelite movement in art and literature, and his wife, Helen Patterson Allingham
(1848-1926), an artist, including notes, sketches, portraits, documents, letters and
holograph manuscripts of seven poems relating to the Pre-Raphaelite movement, its members,
their literary and artistic interests and ideals and the jealousies and personality clashes
among members of the movement; Alfred Tennyson; Thomas Carlyle; Irish literature and Irish
nationalism; the dispute between Allingham and James A. Froude over the editorship of
Fraser's Magazine and the Germ, the magazine of the Pre-Raphaelite Brotherhood.
Correspondents include Charles H. Aide, Matthew Arnold, William Barnes, Max Beerbohm,
Walter Besant, Barbara Bodichon, G. P. Boyce, Andrew Boyd, Ford M. Brown, Thomas Carlyle,
Aubrey de Vere, Charles G. Duffy, Samuel Ferguson, James A. Froude, Richard Garnett,
Edmund Gosse, James Hannay, Thomas Hardy, Nathaniel Hawthorne, Alfred E. Housman, William
and Mary Howitt, Arthur Hughes, W. Holman Hunt, Thomas Huxley, Gertrude Jekyll, Charles
Kingsley, William Lecky, William Longman, John E. Millais, John Morley, Alex Munro,
Francis W. Newman, Francis Palgrave, Coventry Patmore, George Petrie, Arthur Rackham,
Dante G. Rossetti, William M. Rossetti, John Ruskin, William B. Scott, Leslie Stephen,
Frederick G. Stephens, Whitley Stokes, Algernon Swinburne, Henry Taylor, Alfred Lord
Tennyson, Ivan Turgenev, Thomas Woolner and William B. Yeats.

RBR

ARON, RICHARD (1854-1912) COLLECTION, 1722-1912 2.0 cu. ft.

Papers of Richard Aron, teacher, collector and student of pedagogy, including 54 volumes of
letters, documents, autographs and diaries relating to German school organization, school
discipline, lecture notes and school exercises, minor poems (mostly anonymous) the bylaws
of the Pädagogische Gesellschaft and the Pietistic movement in the German Lutheran Church.
Correspondents include over 100 German schoolmen of the early and middle nineteenth
century, the most important of whom are the philologists Hans F. Massman and Eberhard G.
Graff. Also included are letters to August H. Francke, 21 of which are from his mother,
Anna Francke, a fragment of the diary of Christoph F. Mickwitz (1722) and the diary of
Francke's son, Gotthilf A. Francke.

RBR NUCMC 62-4652

AUSTRO-HUNGARIAN MONARCHY-HEER-FELDARTILLERIE-BRIGADE KOMMANDO, No. 13
DIARY, 1917-1918 .1 cu. ft.

A diary of Headquarters, 13th Brigade, Field Artillery of the Austrian army, 13 August 1917
- 3 November 1918.

RBR

BARTON, WILLIAM E. (1861-1930) PAPERS, 1890-1930 13.0 cu. ft.

Papers of Rev. William E. Barton (1861-1930), Robert S. Barton, his son, and Alonzo
Rothschild (1862-1915) of Boston relating to Abraham Lincoln. William E. Barton wrote
more than a dozen Lincoln books, including a two volume biography published in 1925.
Robert Barton and Alonzo Rothschild were associated with the Lincoln Group of Boston.

HL

BASKETTE, EWING C. (1903-1959) COLLECTION, 1894-1959 1.5 cu. ft.

Papers of Ewing C. Baskette, lawyer, librarian and bibliographer, including 19th century
speeches, letters and manuscripts on cases dealing with anarchism, the Centralia case,
communal living, syndicalism, socialism, the International Workers of the World, freedom of
expression and censorship. Correspondents include the American Civil Literties Union
officers, William J. Bryan, Robert Burns, C. V. Cook, John Dos Passos, Theodore Dreiser,
Peter Kropotkin, Henry L. Mencken, Upton Sinclair, Josiah Warren and Langston Hughes.

RBR

BEACONSFIELD, BENJAMIN DISRAELI, 1st. EARL (1804-1881) PAPERS, 1835-1880 1.0 cu. ft.

Papers of Benjamin Disraeli, British Prime Minister, politician and novelist, including
18 letters by Disraeli, one letter by Sarah Disraeli, and one letter by Mrs. Catherine F.
Gore, the novelist; 300 mounted clippings and handwritten entries, about 120 portraits and
caricatures, 14 obituary notices, papers for Wilfred Meynell's biography and cartoons
relating to business and literary legal matters, Disraeli's literary affairs and social
life, Duke of Wellington, Robert Peel, government affairs and House of Commons.
Correspondents include Disraeli's attorney, Alfred Turner, Mrs. Catherine F. Gore,
Lord Halifax and Sarah Disraeli. Most of the letters are to his wife, Sarah Disraeli.

RBR NUCMC 61-2102

BENTLEY, RICHARD AND SON PAPERS, 1806-1915 29.0 cu. ft.

The files of Richard Bentley and Son, a London publishing house, 1829-1898: Richard
Bentley, 1794-1871; George Bentley, 1828-1895 and Richard Bentley II, 1854-1936, including
literary and business correspondence; ledgers, minutes of company meetings and legal
agreements; personal and business diaries; authors' manuscripts; clippings and
advertisements relating to literary, legal and business matters; the Henry Colburn
publishing firm (1806-35), subscription and publication lists. Correspondents include
William H. Ainsworth, Mrs. Alexander (Annie F. Hector), Alfred Austin, John Banin,
Walter Besant, Marguerite Blessington, Rhoda Broughton, Robert Buchanan, Henry Bulwer,
Edward Bulwer, Rosa Carey, Mary Cholmondeley, Mrs. Lucy Clifford, Wilkie Collins,
Edward Creasy, John Doran, Maria Edgeworth, Annie B. Edwards, Jessie Fothergill, George
R. Gleig, Mrs. Catherine F. Gore, Edmund Gosse, Gerald Griffin, Mary Herbert, Walter F.
Hook, Theodore Hook, Charles Hoofen, Edward Howard, William Howitt, Geraldine Jewsbury,
Fanny Kemble, Henry Kingsley, Sheridan Le Fanu, Charles Lever, Eliza Lynn Linton,
Maarten Maartens, William Maginn, William H. Mallock, Anne Manning, Frederick Marryat,
Florence Marryat, Helen Mathers, William H. Maxwell, Florence Montgomery, William E.
Norris, Caroline Norton, James Payne, Charles Reade, Mrs. William E. Riddell, Albert Smith,
Emily A. Strangford, Jemima von Tautophoeus, Eliot Warburton, Charles Wood, Mrs. Henry
Wood, Edmund Yates. The papers include scattered correspondence from William Carlton,
Thomas Hardy, Benjamin Haydon, Henry James, Richard Jeffries, Herman Melville, William
Prescott, Edith Somerville, Robert Louis Stevenson, Anthony Trollope and Mark Twain.
Correspondents listed in Gordon N. Ray, "The Bentley Papers" in The Library, 5:7:3:
178-200 (September 1952).

RBR Name index

BLOOMINGTON BANK RECORDS, 1857–1937 80.0 cu. ft.

Bloomington Bank Records including Bank of Bloomington ledgers (1860–68); First National
Bank of Bloomington ledgers (1868–1921), journals (1902–19) and transaction records
(1916–31); National State Bank ledgers, journals, registers and account books (1878–1927);
Third National Bank registers and accounts (1882–1911); State Trust and Savings Bank
ledgers and records (1905–19); Illinois Savings and Trust registers and journals (1910–20);
First Trust and Savings Bank statements (1911–29); Bloomington Clearing House accounts with
eight banks (1895–1931); Safe Deposit Company records (1907–37) and unidentified bank
account books (1857–1931).

BA

BUCKLE, HENRY (1821–1862) PAPERS, 1857–1880 3.0 cu. ft.

Papers of Henry T. Buckle, English essayist and historian and author of English History,
including commonplace books, notes for books and articles, letters, drawings, photographs
and articles relating to Egyptian history, literary criticism, problems of writing and
publishing, English history, the impact of women on the progress of knowledge. Buckle's
Middle Eastern journey (1861–62) and his death. Correspondents include Agnes Strickland,
George Capel, Henry Huth, Mrs. Henry Huth, Alfred Huth, Edward Huth, Theodore Parker,
Thomas B. Sandwith and John S. Mill.

RBR NUCMC 62–265

BUNN, JACOB, GENERAL STORE RECORDS, 1843–1853 .5 cu. ft.

Daily Sales (June 1843–February 1847), and accounts receivable ledgers (August–December
1853) for the Jacob Bunn General Store, Springfield, Illinois, showing names of purchasers,
goods purchased and amount paid or owed.

BA

BURLEIGH, JOHN AND FAMILY PAPERS, 1707–1849 1.1 cu. ft.

Papers of John Burleigh, a blacksmith, wheelwright and storekeeper in Newmarket,
New Hampshire, including business papers, account books, deeds, labor books, day books
and lumber books relating to business conditions and practices of an eighteenth- and
nineteenth-century New England family business.

RBR

BURRARD, DIARY OF THE AIDE-DE-CAMP OF GENERAL, 1807 .1 cu. ft.

A manuscript diary of the aide-de-camp of General Sir Harry Burrard (1755–1813) concerning
the Copenhagen expedition during the Napoleonic Wars.

RBR

BUSINESS ARCHIVES, 1845–1960 315.3 cu. ft.

Archival records of business firms, which are partially processed

State Community	Firm name, type of business, inclusive dates of records	cubic feet

Illinois
 Bloomington

	Kirkpatrick Furnishing Co., Furniture, 1894–1941	35.0
	Meadows Manufacturing Co., Heavy Equipment, 1922	.1
	North British & Mercantile Co., Insurance, 1910–13	.2
	Peasley and Wheeler Co., Machinery, 1889	.1
	J. H. Read and Brothers, Hardware, 1898–1906	1.0
	Somersworth Western Mfg. Co., Machinery, 1888–1891	.2
	L. B. Thomas & Son, Insurance, 1904–13, 1921–26	.5

 Cairo

	Green and Gilbert, Attorneys, 1874–1916	.5
	New York Store Mercantile Co., Wholesale Grocers, 1891–1935	12.5

 Champaign

	L. T. Brownfield, Hardware Store, 1909–35	5.6
	Burton and Trelease Agency, Real Estate and Travel, 1933–42	1.6
	L. W. Faulkner and Co., Drugstore, 1855–1935	.4
	J. F. Hessel, Finance Company, 1926–37	.3
	G. C. Willis, Clothing Store, 1898–1953	13.0

 Chatsworth

	Jackson's Store, General Store, 1892–1912	.2

 Chicago

	Coal Company, 1903–10	.2
	Crescent Linseed Oil Co., 1894–1906	1.5
	First National Bank, 1920–30	.4
	F. W. Harvey Co., Building Supplies, 1861–63	.2
	Mechanics Type Foundry Company, 1871–97	.8
	Nichols, Terry and Wilson, Attorneys and Brokers, 1925–45	1.6
	Pure Carbonic Inc., 1935	.3

 Danville

	Danville Brewing and Ice Co., 1894–1932	30.0
	Fecker Brewing Co., 1894–1932	7.0
	Hofbrau Catering Co., 1912–24	.3
	Yeomans and Shedd Hardware Co., 1869–1943	30.0

 East St. Louis

	St. Clair Dairy Co., 1909–27	1.0

 Effingham (and St. Louis, Mo.)

	Haas–Lieber and Schulte's Wholesale Groceries, 1915–35	33.0

 Fulton

	J. C. Snyder and Son, Grain Fuel and Buildings, 1881–1923	1.0

 Geneseo

	Ainsworth, Lynch & Simons, General Store, 1853–65	.2

 Georgetown

	First National Bank of Georgetown, 1924	1.0
	William Frazier and Son, Shoe Store, 1869–1933	5.6

 Jeffersonville

	J. Q. Rapp General Store, 1865–70	.8

 Joliet

	Joliet Manufacturing Co., Farm Implements and Machinery, 1860–1941	26.0

 Olney

	Olney Mills, 1874–82	.3

 Ridgefarm

	National Bank, 1933–34	1.0

BUSINESS ARCHIVES, 1845-1960 (continued)

	cubic feet
Rochelle	
F. W. Hackett Co., Jewelry Store, 1906-22	8.0
Rockford	
Frank Noble, Cloth Merchant, 1872-76	.3
West End Furniture Co., 1910-11	.2
Wilson Bottling Co., 1914-37	3.3
Sidney	
Wesley and Rising, Grain and Coal, 1921-38	2.0
Springfield	
Buck's Hat Store, 1865-66, 1905-18	.3
Tolono	
Bank of Tolono, 1899-1940	10.0
Grocery Store, 1869-80	.2
Urbana	
Knowlton and Bennett, Drugstore, 1884-1923	10.3
Oldham Brothers, Drugstore, 1897-1929	15.0
Michigan	
Grand Rapids	
Hart Mirror Plate Co., 1899-1960	18.6
Missouri	
Kansas City	
Long-Bell Lumber Co., 1928-40	5.0
Pickering Lumber Co., 1934-40	.5
St. Louis	
Compton and Sons, Lithographing and Printing, 1874-1901	.5
Hoffman Brothers Produce Co., 1911-38	5.8
Scruggs-Vandervoort-Barney Dry Goods Co., 1883-1930	.6
Talman Plumbing Co., 1920-44	15.0
Whitnel and Branery, Attorneys, 1927-37	4.0
Albert Wittich & Co., Raw Fur House, 1932-35	2.0
New Hampshire	
Exeter	
A. Merrill's Store, 1845	.3

BA

CAVAGNA COLLECTION, 1116-1913 90 cu. ft.

Collection of Count Antonio Cavagne Sangiuliani di Gualdana (1843-1913), Italian nobleman, writer and bibliophile, consisting of 138 portfolios of unbound manuscripts arranged alphabetically by place, 290 bound volumes of manuscript material (only 6 earlier than 1600), 60 volumes of mixed printed and manuscript material (ca. 50 items earlier than 1600) and 100 volumes of later transcripts from Italian archives. The collection includes legal documents; maps; investitures; official documents on Italian local history; statutes of Italian communes and cities; regulations on banks and banking and bibliographical, biographical and genealogical accounts of Italian families and individuals. The documents relate to economics, history, law, banks and banking, architecture, fine arts, chivalry, heraldry, biography, academies and universities. Documents are listed and cataloged in Meta M. Sexton, comp., Manuscripts and Printed Documents of the Archivo Cavagna Sanguiliani in the University of Illinois Library (Urbana, 1950, 600 pp.)

RBR Published guide NUCMC 61-3067

CHAMPAIGN-URBANA MANUSCRIPTS 27.0 cu. ft.

Organization and inclusive dates of records	cubic feet
American Association of University Women, 1935-65	7.3
Burnham Athenaeum, Library, 1879-1921, 1936	5.5
Champaign County Public Schools, 1877-1941	6.0
Daughters of the American Revolution, Alliance Chapter No. 642, 1923-56	4.3
Rotary, 45th District, 1920-30	.3
Urbana Association of Commerce, 1914-35	3.6

BA

CHESTER, JOHN N. (1864-1955) COLLECTION, 1761-1939 .4 cu. ft.

Papers of John N. Chester, civil engineer and collector, including 109 manuscripts, of which about 70 are autograph letters and the rest signed documents or autograph poems, including letters and documents dealing with Napoleon and his family and military staff; American history and American literature.

The Napoleonic material includes
 two documents signed by Napoleon; a collection of letters and military documents signed by marshals and generals of Napoleon, many accompanied by engraved portraits; letters from the Duke of Wellington, Marie Louise of Austria, Sir Hudson Lowe, Louis Bonaparte, Napoleon III and members of the Bonaparte family.

The American History material includes
 letters from Henry Knox, Jefferson Davis, Varina Davis, Robert E. Lee, Ulysses S. Grant, William T. Sherman, Dolly Madison and John C. Fremont; documents signed by James Madison and Rutherford B. Hayes and documents relating to a John Chester, the earliest dated 1761.

The literary material includes
 letters of Mary Shelley, James F. Cooper, Henry W. Longfellow, Oliver W. Holmes, Mark Twain and William D. Howells and manuscript poems by George Ade, Robert J. Burdette, Bliss Carman, Oliver W. Holmes and Louise C. Moulton.

RBR NUCMC 61-3021

CLAYTON, SIR ROBERT (1629-1707) PAPERS, 1579-1744 5.0 cu. ft.

Papers of Sir Robert Clayton, merchant, politician and Lord Mayor of London, including correspondence, receipts, bills, bonds, promissory notes, petitions, wills, affidavits and indentures relating to the business activities of Clayton; charges brought against Sir Edward Herbert and the Duke of Norfolk. Correspondents include Matthew Wren, Bishop of Ely; Francis Turner, Bishop of Ely; Sir Edward Herbert, Earl of Portland and Henry Howard, 7th Duke of Norfolk.

RBR Finding aid NUCMC 62-1516

CLEAVELAND, Parker (1780-1858) PAPERS, 1822-1857 1.0 cu. ft.

Papers of Parker Cleaveland, American scientist, professor of mathematics and natural history at Bowdoin College (1805-1858) and author of the first American work on mineralogy and geology, including holograph note books on mineralogy, natural history and geology, compiled between 1822-1857.

RBR

COBBETT, WILLIAM (1763-1835) PAPERS, 1797-1835 .5 cu. ft.

Papers of William Cobbett, English radical reformer, politician, and editor of the Weekly Political Register, including letters and documents relating to British politics, William Pitt, Charles Fox, the Napoleonic Wars, the Irish question, Corn Laws, Lord Castlereagh, parliamentary reform, America, War of 1812, education, criticism of English judges, courts-martial, Cobbett's publications and other literary matters, criticism of Cobbett, English agriculture and details of Cobbett's farm operation. Correspondents include Ralph Benson, James Kensington, Richard Hinxman, Viscount Folkestone, Dr. French Laurence, William Windham, John Wright, Richard Bagshaw, John Dean and William Gutsell.

RBR

COLES, H. C., MILLING COMPANY RECORDS, 1838-1899 12.0 cu. ft.

H. C. Coles Milling Company Records, Chester, Illinois, including day books (1839-1880), wheat and flour records (1854-1886), ledger books (1851-1882), journals (1838-1886), bills of lading (1871-1887), cash books (1841-1887), blotter books (1853-1867), storage records (1882-1892), foreign collections (1872-1876). The volumes show prices of goods, cash accounts, payments for work, storage and foreign collections. A cash book (1866-1899) includes a memorandum of wheat bought each year from August 1858 to December 1888, "showing number of bushels, cost and average price paid each year."

BA

COLET, LOUISE (1810-1876) PAPERS, 1852-1863 .1 cu. ft.

Papers of Louise Colet, French novelist, poet and author of Lui and La Jeunesse de Goethe, including 47 letters, most of which are written to Jules Champfleury. Subjects include her rivalry with George Sand, discussions of her works, Sunday literary gatherings at her salon, literary criticism, nature, schools, religion, Giuseppi Garibaldi, Gustave Flaubert and her novel, Lui. Correspondents include Jules Champfleury, Alfred de Vigny and Pierre Béranger.

RBR

COVENT GARDEN THEATRICAL FUND, PAPERS, 1839 .1 cu. ft.

A list of members of the Covent Garden Theatrical Fund compiled by Drinkwater Meadows, secretary, and containing information on claims, dues owed and deaths.

RBR

CROKER, JOHN W. (1780-1857) PAPERS, 1843-1852 .1 cu. ft.

Papers of John W. Croker, an English Tory politician and writer, including letters from Edward G. Stanley, 14th Earl of Derby (1799-1869) and British prime minister, regarding Louis Napoleon's coup d'état in France, Robert Peel and the Peelites, Free Trade, Irish franchise, English radical reformers, the pace of English political change and party reorganization.

RBR

DARWIN, CHARLES R. (1809-1882) PAPERS, 1840 .1 cu. ft.

Letter of Charles Darwin, English natural scientist and zoologist, 20 March 1840, to an unnamed scientist in which Darwin discusses earthquakes, comments on his scientific writings and promises to send his correspondent, referred to him by the geologist Sir Charles Lyell, a copy of a forthcoming essay.

RBR

DEWEY, STEPHEN ACCOUNT BOOK, 1824-1828 .1 cu. ft.

Account Book of Stephen Dewey (-1826) and Loring D. Dewey, his son and the administrator of his estate, containing the business records of a farmer and landowner of Sheffield, Massachusetts. Forty accounts show the name of the other party, date, type of work or commodities involved, amount debited or credited and settlement. Stephen Dewey died January 3, 1826. The estate account runs from February 14, 1826 to December 26, 1826. The book shows prices of hauling logs and wood, highway work, plowing, oxen, beef, horse shoeing, surveying, metal work, corn, hay, cider, beans, oats, rye, pork, apples and straw.

BA

DOERNER, JULIUS, BOOKSTORE CORRESPONDENCE, 1851-1916 1.6 cu. ft.

Correspondence of Julius Doerner, owner of the Library Clearinghouse, 140 Wells St., Chicago, including business and personal correspondence, photographs, and albums. Business correspondence concerns bills, summons and inquiries about books. Correspondents include lawyers J. M. Camelon, E. M. Elliott and Thomas Lawlor; tax and bill collectors W. P. Moore and John R. Thompson; J. Defenbaugh of The American Lumberman; George Houghton of Hub Magazine, Henry L. Mencken of Baltimore Evening Sun; Curt Kirch and Milton Fuessle of the Saturday Night Lantern; Albert Britnell and J. P. Nelson, books and antiquities, and Ernst Hertzberg, binding and John Anderson, Jr. (later Anderson Auction Co.). Correspondence from friends, often relating to books and antiquities, includes letters from G. W. Barker, Chicago bookdealer (with original copies of music Barker wrote); Alfred A. Goldschmidt; Mrs. Mena G. Pfershing; Paul Wenzel and B. Vass Wiberg. Family correspondents include Carl, Fannie, Nelda and Thusalda Doerner, and the Grant and Eda Russell family, all of Coudersport, Pa.; Mathelda and A. T. Hollenbeck family, the James Phillips (father-in-law) and Jesse Ropa (brother-in-law) families, and Willis A. Parker. Photographs include family, friends and Chicago political figures W. France, John H. Helwig, and Michael McInerney Albums (1851-1872) belonged to C. S. Armstrong (Union Theological Seminary, class of 1856); Mary Cracraft (1851-52, Washington County, Ohio); "Kate" (1857, Ohio); and "An Employee in Gen. J. McArthur's Machine Shop", "The Tight Fitter," poem in "Machine Verse" written and illustrated by hand, 1872.

BA

DONNE, WILLIAM B. NOTEBOOKS, 1849-1874 .5 cu. ft.

Notebooks of William Bodham Donne, Examiner of All Theatre Entertainments and Inspector of Theatres, entitled "Theatrical Entertainments Examined, 1849-1874, and theatres inspected 1866-1873."

RBR

EDWARDS, ANNIE B. (1831-1892) PAPERS, 1866-1889 .2 cu. ft.

Papers of Annie B. Edwards, English novelist, journalist, Egyptologist and author of Barbara's History and Lord Brackenbury, including letters relating to copyright problems, her works, her system of writing and its problems, royalty disputes, plot ideas for new short stories and novels, traveling, ancient Egyptian excavation and personal matters. Correspondents include George Bentley and Richard Bentley.

RBR

THE ELLIPTIC CONCAVE LEAF SPRING COMPANY RECORD, 1881 .1 cu. ft.

Record book for The Elliptic Concave Leaf Spring Company including minutes of the organizational meeting (August 9, 25, 1881) in New York, and copies of the certificate of incorporation (August 2, 1881), by-laws, treasurer's bond (August 9, 1881), certificate of full payment of capital stock (August 25, 1881), contract between the United States Concave Spring Company and Krepps Brothers for rights to Edward Spaulding's February 18, 1881 patent of "a new and improved concaved spring" (July 7, 1881), Krepps brothers assignment of the contract to the Elliptic Concave Leaf Spring Company (August 9, 1881). The volume provides an example of business law forms and nineteenth century penmanship.

BA

EVANS, CHARLES (1850-1935) PAPERS, 1869-1935 3.0 cu. ft.

Papers of Charles Evans, librarian, bibliographer and author of American Bibliography, 1639-1820, his wife, Lena Y. Evans, and his sons Charles Evans, Jr., Eliot H. Evans and John Evans, including letters, scrapbooks, bankbooks, published and unpublished literary and scholarly manuscripts, manuscript speeches, ledger books, personal documents, notes and photos, graphs relating to the preparation of American Bibliography, personal finances, American Antiquarian Society, Bibliographical Society of America, public libraries, literary matters, speeches on libraries, American peace movement of the 1920's, John Lothrop Motley, Boston Athenaeum, Farm and Trades School, McCormick Theological Seminary, Indianapolis Public Library, Indianapolis Literary Club and Indianapolis Union Trust Company. Correspondents include Lena Y. Evans, Charles S. Brigham, Mary A. Bean, Clarence S. Brigham, Grace E. Channing, Melvil Dewey, Samuel Eliot, William I. Fletcher, Worthington C. Ford, Waldo G. Leland, William S. Merrill, William F. Poole, Enoch Pratt, Emily E. Skeel, Justin Winsor and Lawrence C. Wroth.

RBR Finding aid RESTRICTED

FERNÁNDEZ BOÁN, PEDRO, PAPERS, (1648?) .1 cu. ft.

History of don Servando, bishop of Orense, translated into the Galician language and added
to by don Pedro Seguin, also bishop of Orense who lived around 1191. Transliterated from
the original in Gothic script by don Joseph Pellicer of Tovar, chronicler of His Majesty,
Year 1648. After a summary history from the creation to the eighth century, the work
consists chiefly of accounts of well-known Spanish families.

RBR

FORD, W. (1816-?) PAPERS, 1837-1841 .1 cu. ft.

A manuscript diary of W. Ford, an officer on H.M.S. "Racehorse," relating to his
experiences on a British patrol ship in the western Atlantic and Caribbean, and including
observations on British naval life, information on the British naval mission and the
social and economic life of ports-of-call in Canada, the United States and the West Indies.

RBR

GRAEVIUS, JOHANNES, G. (1632-1703) MANUSCRIPT, ca. 1690 .1 cu. ft.

"Dictata Clarissimi", a manuscript dealing with the techniques, methods and rules used by Johannes G. Graevius, a Dutch editor of classical works.

RBR

GOODWILL INDUSTRIES CORRESPONDENCE, 1936-1937 .1 cu. ft.

Goodwill Industries correspondence, reports, memoranda, and publications relating chiefly to sales and promotional activities of the Goodwill Industries, Inc. in Champaign and St. Louis. The series includes correspondence of Ross C. Adair, Executive Secretary, regarding promotional ventures and business transactions; "Goodwill Glimpses," January and February 1937; "Why I give to the Goodwill Industries;" a clipping from The Chicago Daily News, March 22, 1938 - "In Chicago's Pushcart Army;" Reader's Digest, December 1935; reports and memoranda, prepared by the Auditing Department on sales, 1936-37; weekly sales reports (1936-37), prepared by the Operating Department on branches in St. Louis and the Mississippi Valley.

BA

GREGORY, BERNARD (1796-1852) PAPERS, 1828-1842 4.0 cu. ft.

Papers of Bernard Gregory, an actor, blackmailer and editor of The Satirist or the censor of the Times, a London weekly, including letters to The Satirist, with verse and prose contributions and personal correspondence relating to pieces of scandal submitted for publication, material on politics, the Church, debtor's prison, poor law reform, blackmail and libel. Correspondents include the Earl of Devon, J. L. Lawton, J. T. Holman, R. Noel, J. F. Richardson, J. Bond, Jonathon Wesley, James Thompson, William Dykes, J. Dickson, E. F. Sylvester, John Dicas, J. Churchill, C. L. King, Thomas B. Rose, J. Nelson, Alexander Walker, L. L. Ternan and the Duke of Buckingham.

RBR NUCMC 61-1602

HAITI - BUREAU DE LA DOUANE, PAPERS, 1822 .2 cu. ft.

"Livre des feuillets de douane, 1822." A manuscript containing 693 entries of customs declarations for the year 1822, made by ship captains to the Haitian Director de la douane, N. D. Lafargue.

RBR

HAWKS, STANLEY AND COMPANY PAPERS, 1839 .1 cu. ft.

A March 20, 1839 tender by Stanley Hawks and Company of Gateshead for wheels and axles for the North Midland Railway Company.

RBR

HEATH, SIR ROBERT (1575-1649) PAPERS, 1614-1699 3.5 cu. ft.

Papers of Sir Robert Heath, English lawyer, Solicitor General (1620-1625), Attorney-General (1625-1631), Chief Justice of the Common Pleas (1631-1632), Chief Justice of King's Bench (1642-1645), member of Parliament, and author of Maxims and Rules of Pleading, including letters, documents, commonplace book, and a diary relating to London legal life, Parliament, the royal prerogative, prosecution of recusants, Star-Chamber prosecutions, Puritanism, English Civil War, personal and family matters and English agriculture. Correspondents include Arthur Parfey, Richard Lour, Mary Morley, Lucy Heath, John Heath, Edward Heath, James Harrington, Edward Harrington, William Ayshcombe, Ephraim Wright, Henry Croke, Richard Dawson, William Sharpe, Susanna Croke, Katherine Wirdnam, Thomas Allanson, John Dunkin, Colonel Thomas Waite and John Wood.

RBR

HERON, FLODDEN W. COLLECTION, 1876-1895 .1 cu. ft.

Collection of Flodden W. Heron relating to Lewis Carroll (Charles L. Dodgson) including letters, photographs and memorabilia.

RBR

HEYDT, KARL AND ELIZABETH VON DER PAPERS, 1905-1921 .4 cu. ft.

Papers of Karl and Elizabeth von der Heydt, including 109 letters received by Karl and Elizabeth von der Heydt from Rainer Maria Rilke (1875-1926), German lyric poet and writer, relating to personal matters and Rilke's work.

RBR

HINRICHS, GUSTAVUS D. (1836-1923) PAPERS, 1842-1917 8.3 cu. ft.

Papers of Gustavus D. Hinrichs, chemist and meteorologist including correspondence, manuscripts, books, pamphlets, articles, reviews, reports, notebooks, lecture notes, log books, financial documents, newspaper clippings, photographs, postcards, maps, diagrams and memorabilia concerning teaching at the State University of Iowa at Iowa City (1864-1889) and St. Louis University (1903-1907); scientific research in meteorology, astronomy, meteorites, physics, chemistry, crystallography, spectral analysis and molecular and atomic structure; weather observations and the Iowa Weather Service of which Hinrichs was founder and director (1875-1888); Iowa geological survey and coal resources; participation in scientific conferences; legal proceedings as an expert witness in cases dealing with chloroform and phenacetine; European background, education and travels; public controversy surrounding the administrative reorganization of the State University of Iowa (1885-1898) and his son Carl G. Hinrichs.

BA

HOLLANDER, JACOB H. (1871-1940) COLLECTION, 1660-1936 .3 cu. ft.

Collection of Jacob H. Hollander, American economist, author and professor of political economy at John Hopkins University (1900-1935), including letters dealing with economics, chiefly nineteenth-century English economics. Correspondents include Jacques Necker, Adam Smith, Jeremy Bentham, William Godwin, Thomas R. Malthus, Matthew Carey, Jean Say, David Ricardo, Hutches Trower, James Mill, William Cobbett, Robert Owen, Robert Dale Owen, Alexander Baring, Sydney Smith, Henry Brougham, Samuel Romilly, Harriett Martineau, W. Nassau Senior, Francis Lieber, John Stuart Mill, Thomas Chalmers, W. Stanley Jevons, Edwin A. Seligman, Frederick W. Taussig, Simon N. Patten, Alfred Marshall and Sidney Webb. A catalog of economists' correspondence is published in Elsie A. G. Marsh, comp., The Economic Library of Jacob H. Hollander (Baltimore, 1937) which is reprinted in Volume 10 of the Catalog of the Rare Book Room, University Library, University of Illinois (G. K. Hall, Boston, 1972, 382 pp.).

RBR Name index

HOOK, THEODORE E. (1788-1841) PAPERS, 1823-1841 .1 cu. ft.

Papers of Theodore E. Hook, English novelist, editor, biographer and author of Maxwell, Jack Brag, and The Life of Sir David Baird, including letters regarding editorial disputes, Hook's chronic financial problems, publication schedules and problems, libel, writing problems associated with his biography of Sir David Baird and personal matters. Correspondents include Richard Bentley, Henry Colburn, Daniel Terry and Mrs. Charles Matthews.

RBR Guide

HORNER, HARLAN H. (1878-1965) PAPERS, 1936-1960 6.0 cu. ft.

Papers of Harlan H. Horner '01 (1878-1965) and Mrs. Henrietta Calhoun Horner '01
(1880-1964), including correspondence and scrapbooks relating to Abraham Lincoln,
publications about Lincoln and collecting Lincolniana.

HL

HOUSMAN, ALFRED E. (1859-1936) PAPERS, 1898-1911 .1 cu. ft.

Papers of Alfred E. Housman, English poet, classical scholar, author of The Shropshire Lad,
Last Poems and More Poems and editor of classical editions of Juvenal and Manilius,
including letters to Grant Richards concerning publishing agreements and disputes,
royalties, Housman's printing instructions regarding subsequent editions of The Shropshire
Lad, critical comments on American scholars, publishing Housman's critical editions of
Juvenal and Manilius, setting his poetry to music and international publishing agreements.

RBR

JENKINS, EDWARD (b. 1744 ?) PAPERS, 1765-1810 .1 cu. ft.

A holograph notebook written by Edward Jenkins consisting of lecture notes and
miscellaneous exercises written while Jenkins was a student at Jesus College, Oxford, notes
made aboard a ship bound for Charleston, South Carolina, in September and October, 1772 and
a list of books in Jenkins' library at Exeter, August, 1810.

RBR

JOLIET MANUFACTURING COMPANY CORRESPONDENCE, 1905-1939 25.0 cu. ft.

Joliet Manufacturing Company correspondence with customers and representatives (1905-39,
especially 1917-36), the branch office in Bloomington, Illinois, and regional distributors-
Diets Machinery Company, Bloomington, Illinois; Lininger Implement Company, Omaha,
Nebraska; Moline-Hooper Company, Memphis, Tennessee; Parlin and Orendorff Implement
Company, St. Louis, Missouri; Rock Island Implement Company, Kansas City, Missouri and
Oklahoma City, Oklahoma; Rock Island Plow Company, Rock Island, Illinois and Minneapolis,
Minnesota; and Southern Plow Company, Dallas, Texas concerning marketing and sale of
corn shellers, oat sprouters (1922-26), and power hoists (1926-35), information about
the machinery, requests for parts, statements of accounts paid or payable, requests for
franchise rights, and discounts to and terms applicable to distributors, legal documents
concerning franchises, invoices of accounts, advertising, receipts, shipping orders,
shipments, bills of sale, foreign sales and sales opportunities primarily in Latin
America and the Soviet Union, purchases by the Joliet Manufacturing Company from other
manufacturers and from distributors for their own plant and manufacturing use, and
letters from individuals and distributors stating their opinions of Joliet machinery.

BA SFA - 5

JONES, SAMUEL A. (1834-1912) PAPERS, 1860-1905 3.0 cu. ft.

Papers of Samuel A. Jones, homeopathic physician and scholar of American Transcendentalism,
including personal records; diaries; reading logs; records of book acquisitions; documents
and correspondence pertaining to his service as a Civil War surgeon; records of homeopathic
drug provings; manuscripts of medical lectures; manuscripts and proofs of published works;
unpublished poems and essays; a collection of early newspaper clippings related to the
Concord Transcendalists; photographs of Concord and nineteenth century literary figures; a
collection of autograph letters, including those of Henry W. Longfellow, Harriet Beecher
Stowe, Samuel Hahnemann, Wendell Phillips, Sophia Thoreau, and Henry D. Thoreau; a
manuscript leaf of Ralph W. Emerson and a manuscript poem of Oliver W. Holmes.
Correspondents include Oliver W. Holmes, George W. Curtis, Charles E. Norton, Daniel
Ricketson (1890-91), Henry Salt (1890-1905), Franklin B. Sanborn, Harrison G. O. Blake
(1890-92), Calvin H. Greene (1897-98), Alfred W. Hosmer (1890-99), Horace Hosmer (1891-93)
and Edward Emerson (1891-98).

RBR

KAUFMAN'S INC. RECORDS, 1879-1950 62.5 cu. ft.

Records of Kaufman's Inc., clothing firm of Champaign, Illinois, formerly Ottenheimer
Brothers (1877-1910) and J. M. Kaufman and Company (1910-29). The series covers
affiliated stores in Madison, Wisconsin and Danville, Rantoul and Decatur, Illinois. The
series includes correspondence with manufacturers, suppliers, employees and customers
concerning orders, credit, collection attempts, advertising, audits, leased departments,
legal action and Hart Mirror Plate Company (1890-93, 1902-05, 1909, 1929-49); corporate
documents and seals (1910-46); legal documents; photographs of the store (ca. 1879-1929);
appraisals of furnishings and stock (1923-46); journals and ledgers (1899-1945); profit
and loss statements (1925-42); inventory and merchandise purchase records (1879-84,
1922-46), daybooks (1879-98, 1919-36); cash sales and expense books (1887-1924); daily
sales reports (1930-31, 1940-49); departmental records (1902-1948); delivery and mailing
records (1942-48); accounts receivable (1880-1909, 1920-48); accounts payable (1879-1911,
1921-24, 1929-48); business expense records (1892-98, 1925-59); payroll records (1925-48);
tax records (1916-45); banking records including statements, stubs, a check register
and sample checks (1879-88, 1913-49) and Kaufman family financial records (1888-92,
1914-50).

BA SFA - 8

KAYE-SMITH, SHEILA (1887-1956) PAPERS, 1917-1925 .1 cu. ft.

Papers of Sheila Kaye-Smith, British novelist and author of Susan Spray and Sussex Gorse,
including letters concerning her works, plot ideas, publication agreements, international
copyright agreements and disputes, royalties, writing problems and Noel Coward.
Correspondents include Arthur H. Dakers and A. W. Evans.

RBR

KEMBLE, FRANCES ANNE (1809-1893) PAPERS, 1841-1890 .1 cu. ft.

Papers of Frances Anne Kemble, English poetess and autobiographer, including 122 letters
to her publisher, George Bentley, relating to the publication of her works, negotiations
and agreements on financial arrangements and copyrights, publication of her memoirs,
instructions to Bentley on anonymity of certain persons in the autobiography and editing
disputes.

RBR

KILER, CHARLES A. FURNITURE STORE RECORDS, 1901-1947 34.0 cu. ft.

Records of the Charles A. Kiler Furniture Store, Champaign, Illinois, including business
correspondence with manufacturers and suppliers of furniture, housewares, appliances,
carpets and toys and with customers concerning orders, advertising, prices, catalogs and
payments (1921-22, 1926-46); purchase orders (1915-19, 1932-33, 1939-46); invoices of
Mittendorff and Kiler, predecessor of the Kiler Furniture Store (1901) and the Kiler
Furniture Store (1914-47); receipts (1921-30, 1933, 1936-46); cash and expense tickets
(1946); cash book (1903-12); bank statements, sample checks and check stubs (1916-46);
Retailer's Occupational Tax Records (1932-44); catalogs and magazines (1932-35);
inventories (1918-25); daybooks (1909-10, 1916-39); accounts payable (1918-21, 1923-25,
1928-40); accounts receivable (1901-39); inventory records (1921-27) and expense books
(1929-41).

BA SFA - 3

LAMARCK, JEAN (1744-1829) PAPERS, 1795-1816 .1 cu. ft.

Papers of Jean B. Lamarck, a French naturalist, including letters, statements of account, drafts and receipts relating to financial matters and publication correspondence. Correspondents include Dr. Marchant of Besancon, Mme. Lamarck and Mme. Agasse.

RBR

LAMBERT, JOHN (fl. 1811) PAPERS, 1801-1807 .1 cu. ft.

A holograph manuscript written by John Lambert entitled, "Serio-comical moments! Or, a miscellaneous collection of poetry, anecdotes, bon-mots, and other morsels of wit, compiled chiefly from various eminent authors and interspersed with many humorous pieces entirely original."

RBR

LANGE, WILHELM R. (ca. 1815-) PAPERS, 1834-1845 .1 cu. ft.

Papers of Wilhelm R. Lange, a German Lutheran minister in Kösen and other German cities, entitled "Acta personalia de āō, 1834-1845," including correspondence, diplomas and other personal documents and papers.

RBR

LEIBER, FRITZ R. (1882-1949) COLLECTION, 1909-1950 .2 cu ft.

Collection of Fritz Leiber, a Shakespearean actor and producer during the first half of the twentieth century, containing correspondence with his son; business records and contracts; scrapbooks and photograph albums relating to his association with Robert Mantell, the Shakespearean actor; publicity releases; prompt books; programs; manuscript copies of plays written by Leiber; recordings of his Shakespearean roles and biographical material. Correspondents include Henry L. Shipley, Rupert Hughes and George J. Nathan.

RBR

MADRID, SPAIN PAPERS, 1590-1668 .1 cu. ft.

A collection of notarial documents relating to a property in the Calle Francos in Madrid,
30 July 1590 - 20 October 1668.

RBR

MANCHESTER, SHEFFIELD AND LINCOLNSHIRE RAILWAY COMPANY PAPERS, 1854-1857 .1 cu. ft.

Papers of the Manchester, Sheffield and Lincolnshire Railway Company, including a
manuscript report on rolling stock belonging to the railroad, 31 January 1857, and a
manuscript statement of the miles run and the cost of repairs and renewals of locomotive
engines, 1 July 1854 - 1 November 1856.

RBR

MARSH, BOWER (1866-) PAPERS, ca. 1900 .4 cu. ft.

Papers of Bower Marsh, English scholar and editor, including a manuscript alphabetical list
of London apprentices, 1554-1640.

RBR

MC DUFFIE, NEAL PAPERS, 1811-1840 .1 cu. ft.

A manuscript diary and account book of Neil McDuffie, a farmer near Tioga Point, Bradford
County, Pennsylvania, consisting chiefly of entries of wages, costs and prices of farm
products.

RBR

MEINE, FRANKLIN J. (1896-1968) COLLECTION, 1890-1965 .1 cu. ft.

Collection of Franklin J. Meine concerning Mark Twain (Samuel L. Clemens) including
letters and clippings.

RBR

MENDEL, GREGOR (1822-1884) PAPERS, 1850-1911 .3 cu. ft.

Papers of Gregor Mendel collected by Hugo Iltis for a 1924 biography of Mendel including
photographs, examinations (1850) and memoranda.

Natural History Museum

MONMOUTH REBELLION COLLECTION, 1685-1698 .1 cu. ft.

Collection of letters relating to the Monmouth Rebellion, especially with reference to the
Rev. John Hickes' share in the rebellion, including letters regarding Hickes' capture and
imprisonment, Hickes' trial and execution, conditions in Monmouth's army, reconciliation
of prisoners with the Church, non-conformity and duties owed a lawful prince.
Correspondents include Rev. John Hickes, Rev. George Hickes, Rev. Robert Woodward, Sir
Ralph Freeman, Rev. Robert Eyre, William Hickes, Thomas Keightley and Dr. Ralph Hickes.

RBR

MORRIS, WILLIAM T. PAPERS, 1897-1939 .4 cu. ft.

Financial and reportorial records of William T. Morris of DuQuoin, Illinois, mine
inspector and union organizer, including notebooks relating to mine inspections and surveys
(1907-1913, 1918-1924), expense accounts (1900-1905), disbursements of food and money to
miners (1897-1898, 1930-1932), daily diaries (1898, 1902-1907, 1909-1914, 1916, 1919-1925),
receipt books (1898, 1904-1905), notebooks relating to mine accidents (1909-1910), time
record books (1902), and miscellaneous notebooks (1906, 1939).

BA

MUDIE, CHARLES E. (1818-1890) COLLECTION, 1816-1897 .3 cu. ft.

Collection of Charles E. Mudie, English collector and proprietor of Mudie's Circulating
Libraries including letters, photographs, broadsides, passports and a travel diary (1859),
regarding subscriptions to Mudie's Circulating Library, 19th century books, the book trade,
British politics, Italian unification, European travel, opening of Mudie's Great Hall in
1860, literary matters, family genealogy and personal matters. Correspondents include
George Bentley, Louis Blanc, Wilkie Collins, D. W. Craik, George Cruikshank, Charles
Darwin, John Forster, M. E. Gaskell, Kate Greenaway, Thomas Hughes, Alexander Ireland,
Charles Kingsley, Anne Manning, Giuseppe Massini, Joseph Mazzini, Sir Francis Palgrave,
Gilbert Rawling and Frances Trollope.

RBR Name index

NICHOLAS FAMILY PAPERS, 1576-1782 .1 cu. ft.

Papers of Sir Edward Nicholas (1593-1669), secretary of state to Charles I and Charles II,
his brother, Matthew Nicholas (1594-1661), dean of St. Paul's Cathedral, London and other
members of the Nicholas family including petitions, memorials, affidavits, certificates
granting patronage employment and other legal documents; bills, receipts and account books;
rent rolls; manuscript poetry and notes on eighteenth century literature; and letters
relating to debts owed the Nicholas family, the system of prosecution and punishment in
English law, landlord-tenant relationships, copyhold law, politics under George I,
"pocket boroughs," balance of power in European history, South Sea Bubble, the "Gilbert
Douglas Affair" and personal and family matters. Correspondents include George Buchanan,
Edmond Ryars, Edward Nicholas, Walter Caldwall, William Perkins, William Hodder, Charles
Whitaker, Jane Nicholas, Giles Rogers, John Ashburnham, Joseph Nicholas, Elean Longhurst
and William M. Nicholas.

RBR

NICKELL, LLOYD F. (1884-1962) LIBRARY CATALOG, 1950 .4 cu. ft.

A catalog of the 2000-volume library of 18th-century English literature collected in
1930-48 by Lloyd F. Nickell, Champaign, Ill., while he was in England as chairman and
managing director of the Monsanto Chemical Ltd., London.

RBR

PERCIVAL AND MOOREHEAD HARDWARE STORE RECORDS, 1909-1928 .5 cu. ft.

Records of Percival and Moorehead Hardware Store of Champaign, Illinois, including a cash journal (November 10, 1910-April 3, 1922) listing cash payments and a brief explanation of each transaction and a ledger (1909-1928) showing cash transactions for each account maintained by the store. University of Illinois departments, staff members and faculty are included among those who held accounts. The ledger includes an alphabetical account name index.

BA

PERKINS, HUGH PAPERS, 1834-1838 .1 cu. ft.

A manuscript diary of Hugh Perkins, English traveler, relating to Perkins' residence in St. Petersburg, Russia and his observations on Russian society and culture.

RBR

PERRIN, PORTER G. (1869-1962) COLLECTION, 1818-1960 .5 cu. ft.

Papers of Porter G. Perrin, a literary collector, anthologist and professor at the University of Maine, Colgate University and the University of Washington, including 310 letters from literary figures of the nineteenth and twentieth century, manuscript prose and poetry, and clippings relating to plot outlines and analyses, literary criticism, descriptions of specific works by their authors, business affairs and personal matters. Correspondents include Goodman Ace, George Bancroft, Mary A. Benjamin, William Black, Vina Delmar, John Dos Passos, Max Eastman, Jeffery Farnal, Harry Ferguson, Harry A. Franck, James E. Froude, Richard W. Gilder, Martha Hardy, Rupert Hughes, Robert U. Johnson, D. H. Lawrence, Brander Matthews, Bill Nye, Martha Ostenso, Vincent O'Sullivan, Ouida (Marie Louise de la Ramée), Melville D. Post, Ezra Pound, Matthew P. Shiel, John Spargo, Leonard A. G. Strong, Frank Swinnerton, Josiah F. Willard and Herbert G. Wells.

RBR Author list

POPE, JESSIE (?-1941) PAPERS, 1913-1915 .1 cu. ft.

Papers of Jessie Pope, English journalist, children's writer, poetess and essayist, including letters to Grant Richards regarding the publication of Robert Noonan's (Robert Tressall, pseud.) The Ragged Trousered Philanthropists, Pope's problems of editing the work, editorial controversies, efforts to change the title, working-class novels, literary reviews of the book and financial arrangements.

RBR

PRESBYTERIAN SERMONS, SCOTTISH, PAPERS, 1672-1706 .4 cu. ft.

Scottish Presbyterian sermons, including holograph sermons written by George Blair (1678-1712) between 4 January 1702 and 28 February 1706 while Blair was serving St. Madois Parish, Presbytery of Perth, Scotland and a holograph manuscript entitled, "Praedic°m liber...tertius, Sabbato 2° Decs anni 1672 inchoatus annum 2m Christi publicae praedic°s continuans ad Orationem Dominicam...April 1679," written by Robert Edward (ca. 1616 - 1696) while Edward served the Murroes Parish, Presbytery of Dundee, Scotland.

RBR

PROUST, MARCEL (1871-1922) PAPERS, 1893-1922 3.7 cu. ft.

Papers of Marcel Proust, French novelist and author of <u>A la recherche du temps perdu</u>,
including published and unpublished manuscripts, documents and letters about the Dreyfus
Affair, John Ruskin, Gothic escapism, the nature and function of literary criticism,
personal and business problems of writing and publishing, the philosophical basis of the
novel and the character of the French bourgeoisie and nobility before World War I.
Correspondents include Maurice Barrès, Henri Bergson, Prince Antoine Bibesco, Jacques
Blanche, Princess Matilde Bonaparte, René Boylesve, Ernst Curtius, Leon Daudet, Lucien
Daudet, Charles Du Bos, Anatole France, André Gide, Reynaldo Hahn, Lionel Hauser, George
de Lauris, Robert de Montesquiou, Paul Morand, Countess de Noailles, Louis de Robert,
Jules Romains and Cecil Sorel.

RBR Name index RESTRICTED

PUTNAM FIRM PUBLISHERS RECORDS, 1891-1938 6.5 cu. ft.

Records of the London office of the G. P. Putnam firm, a New York publishing house,
consisting of business records and abstracts of publishing agreements (1891-1938),
American manuscript record (1920-1925), readers' reports (1911-1934), binding records
(1903-1922), abstracts of American agreements (1919-1928) and private ledger (1910-1931).

RBR

RANDALL, RUTH P. (1892-1971) PAPERS, 1932-1964 2.0 cu. ft.

Papers of Ruth P. Randall (1892-1971), including correspondence and manuscripts relating to Mary Todd Lincoln.

HL

RENNIE, GEORGE AND SONS RECORDS, 1818-1860 .2 cu. ft.

Records of George Rennie and Sons, a London naval engineering firm credited with numerous innovations in the design and construction of marine engines, including letters, estimates, notes, specifications, clippings, accounts and journals about the Rochester bridge, trans-Atlantic passenger travel, Pola arsenal, dredging of the Tarra River, construction of marine engines and engine houses, ship design and construction, improved navigation and trade on the Danube River, single trunk marine engine principle and Indian gunboats. Correspondents include Lord Viscount Melville, John W. Croker, Earl of Darnley, John McPherson, Robert Brown, Edwin E. Merrill, Charles Cunningham, Richard Griffith, and A. B. Black.

RBR

RICHARDS, GRANT (1872-1936 30.2 cu. ft.

Papers of Grant Richards, British publisher and author, including correspondence; incomplete typescripts of novels and other personal papers; advertisements; book reviews; photographs; account books; early agreements, 1905-1920; publication ledger, 1897-1902; and author agreements, 1906-1930 relating to routine publishing house business, copyright problems and other legal matters, literary publicity and literary history in general. Correspondents include Arnold Bennett, A. Conan Doyle, Theodore Dreiser, James Joyce, Rudyard Kipling, Katherine Mansfield, John Masefield, Ezra Pound, Edith Sitwell, Gertrude Stein, Algernon C. Swinburne, Evelyn Waugh and Hugh Walpole.

RBR NUCMC 61-2210

RICHARDSON, JOHN (1787-1865) PAPERS, 1812-1849 1.5 cu. ft.

Papers of Sir John Richardson, Arctic explorer, naturalist, and physician, including journals, letters, documents and notebooks relating to Richardson's personal journal of Sir John Franklin's first polar expedition (1819-1822), his dossier of documents on the organization of his search for Franklin (1847-1849), the activities of members of Lt. Commander William E. Parry's first Arctic expedition (1819-1920), and a manuscript notebook belonging to Midshipman Charles Palmer on ca. 500 words with their Eskimo equivalents. Correspondence includes several letters describing the character of Midshipman Charles Palmer, signed by Lt. Cmdr. Parry and others (1812-1820) and letters to Palmer dealing with medals.

RBR

ST. LOUIS TURNVEREIN RECORDS, 1923-1932 .4 cu. ft.

St. Louis Turnverein Records including lists of officers, founders, and members; committees of the St. Louis Turnverein; official minutes of the 33rd convention of the American Turnerbund (1931); correspondence concerning fiscal matters (1923-32); publications (1931-32) and correspondence, programs, historical presentations and speeches concerning the Camp Jackson Day celebration (1931-32).

BA

SALTER, JOHN W. (1820-1869) PAPERS, 1855-1865 .3 cu. ft.

Papers of John W. Salter, American paleontologist, including a manuscript catalogue of fossil invertebrates containing 45 drawings, 60 illustrations, several cuts from books, four letters and three papers written by Salter.

RBR

SANDBURG, CARL (1878-1967) COLLECTION, 1898-1962 12.0 cu. ft.

Papers of Carl Sandburg, American poet and author, including typescripts and corrected galley proofs of Sandburg's works and correspondence (1916-62) with literary and public figures, scholars and admirers about writing, American folksongs, Abraham Lincoln, journalism and lecture tours. The collection also contains a Spanish-American War diary (1898), lectures (1908-09), recordings and transcriptions of Sandburg's radio broadcasts and lectures and magazine articles and newspaper clippings by and about him. Correspondents include Nelson Algren (1948-49), Sherwood Anderson, Paul M. Angle (1928-54), Oliver Barrett (1926-53), Mary H. Bradley, Fanny Butcher, Witter Bynner (1920-45), Henry S. Canby, Negley D. Cochran and The Day Book, Eugene V. Debs (1895-1924), J. Frank Dobie, Robert Frost, Harry Golden, Alfred Harcourt, Sam T. Hughes and the Newspaper Enterprise Association (1918-19, 1939-40), Lloyd Lewis, N. Vachel Lindsay (1916-35), Amy Lowell (1916-21), Archibald MacLeish (1932-62), Henry L. Mencken (1925-32), Christopher Morley, Julia Peterkin, Ezra Pound, James G. Randall (1931-47), Franklin D. Roosevelt (1937-42), Lew Sarrett (1919-51), Adlai E. Stevenson, Alfred Stieglitz (1921-39), Ida Tarbell (1925-40), Harry S. Truman (1945-52), Louis Untermeyer (1915-53), William A. White (1920-41) and Frank L. Wright (1927-57). The papers include Lombard College publications (1898-1902), material concerning the Chicago Daily News (1917-32) and books relating to Sandburg's interests.

RBR

328

SECKER, MARTIN, LTD., PUBLISHERS RECORDS, 1910-1931 2.8 cu. ft.

Records of Martin Secker, Ltd., a London publishing firm, including eight volumes of outgoing typewritten correspondence to publishers, printers and authors, relating to literary, legal and business matters; the receipt, rejection and acceptance of manuscripts; publishing agreements and disputes; advertisements and publicity; subscription correspondence and printers' correspondence. Correspondents include Lionel Allshorn, Lascelles Abercrombie, C. K. Burrows, Thomas Barrington, Gordon Craig, Allen Fea, Douglas Goldring, Emil O. Hoppe, Granville Barker, Richard Lluellyn, David H. Lawrence, Compton MacKenzie, Lewis Melville, Arthur Machen, Frederic Niven, Oliver Onions, R. Harold Paget, Arthur Ransome, R. Ellis Roberts, Frank Swinnerton, George S. Street, Hugh Walpole, Arnold Bennett, Basil de Selincourt, Thomas Hardy, John Masefield, Ezra Pound, Herbert G. Wells, Hilaire Belloc, Hughes Massie, Ford M. Ford, Conrad Aiken, Siegfried Sassoon, Louis Untermeyer, Max Beerbohm, John Gunther, Martin Armstrong, Raymond W. Postgate and Leonard Woolf.

RBR

SHAW, GEORGE B. (1856-1950) PAPERS, 1905-1932 .1 cu. ft.

Papers of George B. Shaw, Irish comic dramatist, political writer, and lecturer, including letters, photographs and clippings regarding literary criticism, English socialism, Shaw's works and his literary technique. Correspondents include Hugh Kingsmill, Lord Oliver B. Escher and Henry Furniss, Jr.

RBR

STEELE, JAMES (1840-1905) PAPERS, 1869 .1 cu. ft.

Papers of James W. Steele, American soldier and writer, including "Sketches of Travels on the Plains and New Mexico," a holograph manuscript written while Steele was stationed at Fort Cummings, New Mexico.

RBR

STETTIN, GERMANY - RATHSSCHULE PAPERS, ca. 1850 .1 cu. ft.

"Reglement der Stettinischen Rathsschule", a manuscript outlining the curriculum of the five classes of the Stettin Rathsschule.

RBR

STURM, FRANK P. (1879-1942) PAPERS, 1916-1938 .2 cu. ft.

Papers of Frank P. Sturm, English poet and scholar, including twenty letters written by Sturm to William B. Yeats, and twenty-three letters written by Yeats to Sturm relating to their literary work.

RBR

THACKERAY, WILLIAM M. (1811-1863) PAPERS, 1841-1860 .1 cu. ft.

Papers of William M. Thackeray, English novelist, consisting of 17 unpublished letters
from Thackeray about personal and family considerations, and Thackeray's work.
Correspondents include Mrs. Carmichael Smyth (Thackeray's sister), Eliza Cragie and
Mrs. E. E. Crowe, both of whom were childhood friends of Thackeray.

RBR

TOOLE-STOTT, RAYMOND PAPERS, 1940-1950 .1 cu. ft.

Papers of Raymond Toole-Stott, English bibliographer, including 25 letters from W. Somerset
Maugham (1874-1965) to Raymond Toole-Stott, and the typescript of Toole-Stott's <u>Maughamiana</u>
with notes and corrections in Maugham's hand, relating to bibliographical details of
Maugham's books.

RBR Finding aid

TROLLOPE FAMILY PAPERS, 1830-1912 .6 cu. ft.

Primarily the papers of Anthony Trollope (1815-1882), English novelist, playwright and
poet; and Alfred Austin letters (1869-1900), including letters, journals, diaries,
manuscripts of unpublished and published novels and poems relating to literary matters,
Percy Shelley, Trollope's projected history of literature, American civilization,
immigration to New Zealand and English politics. Correspondents include Alfred Austin,
Algernon C. Swinburne, Bulwer-Lytton, J. A. Symonds, Lord Salisbury, John Cardinal Newman,
Count Metternich, Lord Curzon, Lord Balfour and members of the Trollope family including
Anthony, Fred, Rose, Harry, Thomas, H. M., and Mrs. Francis Trollope.

RBR

TUPPER, MARTIN F. (1810-1889) COLLECTION, 1830-1890 7.5 cu. ft.

Papers of Martin F. Tupper, English poet, playwright, novelist and author of <u>Proverbial
Philosophy</u>, including scrapbooks containing notes, clippings, letters, photos and
published and unpublished manuscripts about literary criticism, bookreviewing, coronation
of Queen Victoria, the world peace movement, mesmerism, colonization of slaves, Liberia,
American civilization, American Civil War, anti-popery, the poet laureateship, Crimean War,
National Rifle Clubs, Anglo-Saxon racism, High and Low Church of England controversy,
spiritualism, anti-vivisection, General Gordon and the fall of Khartoum and William E.
Gladstone. Correspondents include Elihu Burritt, Lord Shaftesbury, William E. Gladstone,
Alfred Lord Tennyson, Harriet B. Stowe, Queen Victoria, Sidney Herbert, Zachary Taylor,
Abbott Lawrence, Mary Chase, Elliott Cresson, Thomas Hughes, Thomas Woolner, Henry W.
Longfellow, Charles H. Spurgeon, Andrew Boyd, Charles Sumner, William C. Bryant, Oliver W.
Holmes, John J. Astor, Thomas Cooper, Charles B. Birch, John G. Wood, Richard Owen,
Sir Stafford Northcote, Sir Henry Ponsonby, James A. Froude, William J. Evelyn, Lord Ronald
Gower, Shirley Brooks, Joseph Durham, John Murray, James C. Richmond, John Tenniel,
Nathaniel P. Willis, Harold Browne and Edmund Yates.

RBR Index

WELLS, HERBERT G. (1866-1946) PAPERS, 1880-1946 81.5 cu. ft.

Papers of Herbert G. Wells, English novelist and essayist, including correspondence about
business and legal affairs, taxes, investments, tax books, real estate, receipts, account
books, inventories and law suits; diaries, journals, passports, diplomas, drawings;
juvenalia; address books; publication records; family documents; manuscripts and proofs
of published works; speeches; unpublished material, including an unpublished novel, "Kipps
and Waddy"; and photographs relating to literary correspondence with authors and
publishers, family affairs, business affairs, "Rights of Man" problems, Czechoslovakia,
British and international politics, science and religion, League of Nations, socialism,
P. E. N. affairs, U. S. S. R., Fabians, the peace movement, Thring-Vowles dispute and
the Deeks V. Wells plagiarism case. Correspondents include James Barrie, Arnold Bennett,
Gilbert K. Chesterton, Joseph Conrad, Ford Madox Ford, John Galsworthy, George Gissing,
Thomas Hardy, James Joyce, Rudyard Kipling, George B. Shaw, Aneurin Bevan, Winston
Churchill, Albert Einstein, Sigmund Freud, Thomas E. Lawrence, Franklin D. Roosevelt, Leon
Trotsky, Edward Benes, Elizabeth Healey Bruce, Richard A. Gregory, Sidney Low, Frank
Swinnerton, G. Herbert Thring, Sidney and Beatrice Webb, A. P. Watt and Son, Lord
Beaverbrook, Kurt Bütow, Arthur Morley Davis, Sibyl Colefax, Maxim Gorki, Philip Guedalla,
John B. S. Haldane, Kier J. Hardie, E. S. P. Haynes, James F. Horrabin, Thomas L.
Humberstone, Julian Huxley, Sir Harry Hamilton Johnson, Corliss Lamont, Mr. and Mrs. Thomas
Lamont, Harold Laski, Vernon Lee (Violet Paget), Sinclair Lewis, Mr. and Mrs. Henry B.
Marriott-Watson, Jan Masaryk, John Masefield, W. Somerset Maugham, George Meek, H. J. Muir,
Viscount Northcliffe, Emaline Pankhurst, Ezra Pound, John B. Priestly, Sir William
Rothenstein, A. L. Rowse, Siegfried Sasscon, Jan C. Smuts, Mr. and Mrs. W. H. Thompson,
Henrik. W. van Loon, Graham Wallas, Leonard and Virginia Woolf and Sir Frederick MacMillan.
A catalog of correspondence from and to Wells is published in Volume 11 of the <u>Catalog of
the Rare Book Room, University Library, University of Illinois</u> (G. K. Hall & Co., Boston,
1972, 547 pp.).

RBR NUCMC 62-537

WESTMINSTER, ENGLAND, ST. MARTIN'S-IN-THE-FIELDS PARISH PAPERS, 1611-1750 .1 cu. ft.

Papers of St. Martin's-in-the-Fields Parish including a manuscript entitled "Brief of the
Register Book of Parish Officers," 1611-1730, and another manuscript containing extracts
from the "Book of Orders of the Vestry of St. Martin's-in-the-Fields," relative to the
appointment of Church wardens.

RBR

WYSE FAMILY, OF WATERFORD, IRELAND, PAPERS, 1816-ca. 1942, 13.3 cu. ft.

The archives of the Wyse family, a prominent Irish literary family, including diaries,
journals, letter books, unpublished literary productions, account books, common place
books relating to literary matters, especially the Provençal literary movement known as
the "Félibrige," and other poetry; Irish history, education and travel. The papers include
early nineteenth century poetry and travel journals of Sir Thomas Wyse; diaries, journals,
letters and manuscripts of Sir Thomas' son, William Charles Bonaparte Wyse, the most
important figure in the collection; and the mid-twentieth century verse of Nellie
Bonaparte Wyse. Correspondents of William Wyse include George Meredith, Edmund Gosse,
Stephane Mallarmé, Aubrey de Vere, Frédéric Mistral, Joseph Roumanille and Donnadieu.

RBR

YONGE, CHARLOTTE M. (1823-1901) PAPERS, 1854-1895 .1 cu. ft.

Papers of Charlotte M. Yonge, English novelist, writer of children's stories and author of
The Lances of Lynwood, The Little Duke and The History of Sir Thomas Thumb, including
letters to Mrs. Henry Blackburn, the illustrator of some of the author's early books,
relating to problems of writing and illustrating The History of Sir Thomas Thumb, and
future children's books.

RBR

338

339

344